The History, Art and Architecture of

GLOUCESTER CATHEDRAL

To
Rosemary, Richard, Sarah, Christopher and Claire

ὅσα ἐστὶν ἀληθῆ, ὅσα σεμνά,
ὅσα δίκαια, ὅσα ἁγνά, ὅσα προσφιλῆ, ὅσα εὔφημα, ἔ
τις ἀρετὴ καὶ ἔ τις ἔπαινος, ταῦτα λογίζεσθε.
καὶ ὁ θεὸς τῆς ἔσται
μεθ᾽ ὑμῶν.

The History, Art and Architecture of

GLOUCESTER CATHEDRAL

DAVID WELANDER

CANON OF GLOUCESTER

Alan Sutton

First published in the United Kingdom in 1991 by
Alan Sutton Publishing Ltd · Phoenix Mill · Far Thrupp · Stroud · Gloucestershire

First published in the United States of America in 1991 by
Alan Sutton Publishing Inc · Wolfeboro Falls · NH 03896–0848

British Library Catloguing in Publication Data

Welander, David
 The history, art and architecture of Gloucester Cathedral.
 1. Gloucestershire. Gloucester. Cathedrals : Gloucester
Cathedral, history
 I. Title
 942.414

 ISBN 0-86299-821-2

Library of Congress Cataloging in Publication Data

Welander, David
 The history, art, and architecture of Gloucester Cathedral
 D. St V. Welander.
 p. cm.
 Includes bibliographical references and index.
 ISBN 0-86299-821-2
 1. Gloucester Cathedral. I. Title
NAS5471.G5W45 1991
726'. 6'0942414–dc20

Typeset in Garamond 11/12.
Typesetting and origination by
Alan Sutton Publishing Limited.
Printed in Great Britain by
The Bath Press, Avon.

CONTENTS

PREFACE

Among England's many cathedrals and former abbey churches Gloucester has a place of particular interest and architectural importance. It contains outstanding examples of Romanesque and early Perpendicular work, and a fan-vaulted cloister and central tower of unrivalled grandeur and grace. The crypt, like the choir ambulatory, the tribune gallery and the crossing is Norman work of the late eleventh century, and the nave, with its huge cylindrical columns, diminutive clerestory and north aisle is early twelfth-century work. Little survives from the Early English period apart from the nave vault, a few windows and *piscinæ*, and a beautiful reliquary in the north transept. However, from the so-called Decorated period, there is the rebuilt south aisle of the nave festooned inside and out with ball-flower ornament. Between 1337 and 1357 the south transept and choir were overlaid with delicate Perpendicular panelling from floor to vault. The earliest surviving fan-vaulting on any scale gives to the fourteenth-century cloister a beauty that is without comparison.

Everywhere in the building there is evidence of the skill and daring of the Gloucester masons and their apparent love of innovation. This may be seen in the three-centred arches in the crypt, the sudden appearance in 1331 in the south transept of the four-centred arch (never adopted in other parts of Europe), in the flying spans beneath the arches of the north and south crossing, and in such details as the parallel ribs either side of the ridge rib in the lierne vault of the choir, copied in the early fifteenth-century reconstruction of the west end of the nave, in the north transept and in the lady chapel. Fan-vaulting may not have originated at Gloucester, but it displays the same innovative skills. Recent writers, such as Priscilla Metcalf, have drawn attention to 'signs of a regional style centred on a monastic works department at Gloucester'.

Apart from the richness and variety of its architecture, another distinctive feature of Gloucester Cathedral is the extent of its monastic remains. Everywhere there is evidence of its Benedictine past. Much of the medieval wall which surrounded the abbey is still standing, as well as one of its principal gates. Behind the thirteenth-century façade of Church House, adjoining the west end of the church, is the Norman abbot's lodgings and, on its north side and standing on a thirteenth-century undercroft is part of a fine medieval hall known as the Parliament Room. In houses around the Close (which at Gloucester is divided into College Green and Miller's Green) there are extensive remains of medieval buildings. On the north side of the precincts substantial parts of the infirmary range survive, including the misericord (the infirmary dining room), the little

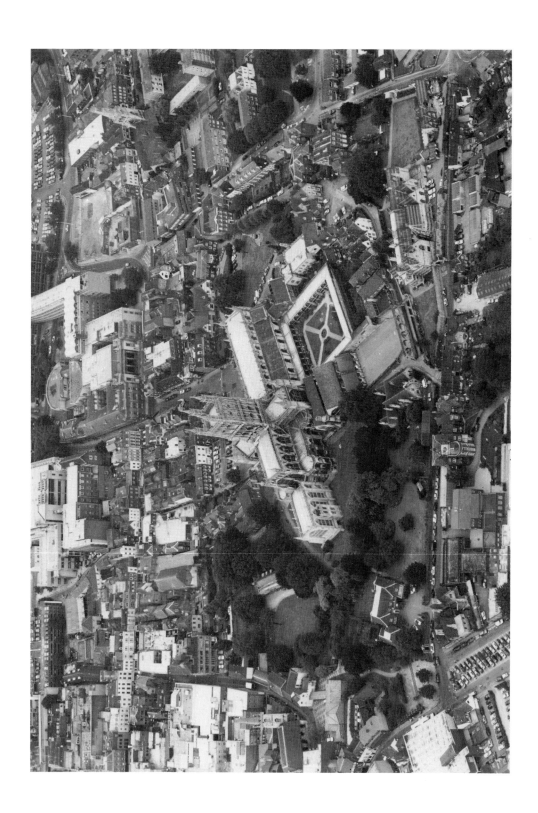

cloister (possibly used as a herb garden) and part of the west entrance and south arcade of the infirmary itself.

The great cloister encloses a quiet garden (*garth*), and off its walks doorways give access to the chapter house, the library and the *locutorium*, where conversation was permitted. This long barrel-vaulted passage provided access from the cloister to the monks' burial ground. On the west side of the cloister there is an entrance lobby from the outer court where members of the community could talk with visitors. A doorway on the north side of this lobby led into the abbot's lodgings, as did a small doorway further along the west walk of the cloister. At the north end of the same walk there was another doorway (now filled by a window) which led up to the refectory (the dining hall). In the north walk is the monks' *lavatorium* (the washing place) with a towel cupboard opposite. In the south walk there is a series of carrels (study recesses), used on occasions as a *scriptorium*, which, like the *lavatorium*, is perfectly preserved.

Within the church itself, there are many reminders of the days when the cathedral was the great church of the Benedictine Abbey of St Peter. The general plan of the building, with its nave forming a large open arena for processions and the enclosed liturgical choir, with its fine canopied stalls and misericords, show that it was designed for the use of a religious community. The same is true of the broad ambulatory round the choir and the three chapels radiating off the eastern apse. Everywhere there are features which evoke the building's monastic past and its long history as the centre of the life of a community devoted to prayer and worship, study and service.

With the closure of the monasteries by King Henry VIII in the 1530s, many of the abbey's records and books were removed, as well as its Communion and other plate and fine works of medieval art. The building also lost many other treasures, notably figures carved in wood and stone which once filled the many niches in and around the church. Much stained glass was destroyed or allowed to decay, though the great east window, one of the finest fourteenth-century, stained-glass windows in England, has survived and a fascinating mosaic of medieval fragments has been preserved in the east window of the lady chapel. In the choir a series of forty-eight, fourteenth-century misericords remain intact, and elsewhere a number of medieval reredoses, though bereft of their statuary.

Other treasures have been added over the centuries since the Dissolution. Some of these, including work by William Kent, the distinguished eighteenth-century architect, and by Michael Bysaak have been removed as fashions in design have changed. The choir owes much to Sir George Gilbert Scott, including the handsomely carved forestalls and a reredos containing figures by the gifted young sculptor, J.F. Redfern. Ten or more of the best known Victorian stained-glass firms contributed to the reglazing of the building. There are a number of windows by Charles Eamer Kempe, and the lady chapel contains some of the finest work of Christopher Whall, the stained-glass artist of the Art and Crafts Movement. Thomas Gambier-Parry of Highnam Court, near Gloucester, designed and worked on the frescoes which enrich the south transept chapel. Among the monumental sculptures there are examples of the work of John Flaxman and Sievier, of W.S. Frith and the Ricketts of Gloucester. In this century works by Stephen Dykes Bower, Professor L. Evetts, Bryant Fedden, Leslie Durbin and George Hart have been added.

It is impossible for anyone to write with authority on more than one or two aspects of

a building like Gloucester Cathedral. It is essential to draw on the specialist knowledge of many others, for the building contains, in its past and present, an enormous wealth of aesthetic and architectural interest. There is far more to a cathedral than its architecture and treasured possessions. For centuries the cathedral at Gloucester, being the seat or *cathedra* of the Bishops of Gloucester, has been closely involved with the Church's work in the diocese. It has also been at the centre of the life of the community of both clergy and lay people, who have lived or worked within the precincts. Thus the history, art and architecture of the cathedral can only be fully appreciated as it is seen in the context of the faith and times of those who built it and have sustained and served it through the centuries. It is the story, as the *Historia* reminds us, of a long line of abbots and monks many of whom were deeply involved in the affairs and controversies of their times; and later, of bishops, deans and canons; of organists, lay-clerks and choristers, of school masters and boys, of vergers and bedesmen all sharing in the daily offering of worship. Others have maintained and enriched the fabric of the building; architects and craftsmen working in stone, wood, metal and glass.

ACKNOWLEDGEMENTS

Many visitors to the cathedral and research students as well as established scholars in various fields have generously shared their knowledge with me over the past fifteen years. Among them I am particularly grateful to those who attended and addressed the Conference of the British Archaeological Association at Gloucester in 1981, and who have allowed me to draw on their research which was published in *Transactions* in 1985. Through the years Professor P.K. Kidson has made a major contribution to our understanding of the architectural history of the cathedral, and Miss Jill Kerr to our knowledge and appreciation of its medieval stained glass. Dr Christopher Wilson's paper, at the 1981 conference, on the Norman abbey church is also an important contribution, as was his earlier study of the origins of Perpendicular. Unfortunately, his study, *The Gothic Cathedral*, appeared too late to enrich these pages. Since the conference Dr Malcolm Thurlby has been a frequent visitor to Gloucester, and he has shared his enthusiasm for the building and his knowledge of Romanesque with me, and with a wider audience when he gave the Serlo Memorial Lecture on the Norman abbey church in the autumn of 1989. Those familiar with the writings of these scholars will recognize the debt I owe them.

Fortunately the *Victoria History of the Counties of England, Vol. 4 The City of Gloucester* was published in 1988. The editor, Dr N. Herbert, and his associates have placed all students of Gloucester's long and fascinating history greatly in their debt by this thoroughly reliable work of reference. The purpose of the bibliography and chapter notes is to acknowledge this debt and to direct the reader to recent work on a variety of specialist subjects. I am also grateful to those who have contributed directly to these pages, in particular to the Revd William Barber for his translation of the *Historia*, and for allowing it to be published as an appendix to this work. All serious students of the cathedral's history and architecture will recognize this as a major contribution. I am also grateful to David J.H. Smith, the County Archivist, for selecting and providing notes on medieval leases, and to the late Dr Roger Whiting for his note on the King's School. Brian Frith has contributed to the biographical material, and Geoffrey Frith to the note on heraldry.

The Revd Patrick Irwin, Chaplain of Brasenose College, Oxford has read the present work in proof and made many valuable suggestions. I am much indebted to him; he bears no responsibility for any errors that may remain. I would also express my gratitude to Alan Sutton Publishing, and in particular to Richard Bryant for his encouragement and guidance, and for his work on plans and drawings, and to Lyn Flight for overseeing

the production of the book. Among those who have contributed photographs I would mention especially Mark Fiennes (with gratitude to Pitkin Pictorials Ltd), and Edward Piper for his photographs of the stained glass. I am also grateful to Jack Farley, who over the years has produced many fine photographs of the cathedral and its treasures. Robert Rudge of Jones Photography has taken many detailed photographs for this publication.

Other photographs and illustrations have been supplied by or are reproduced by kind permission of the following: The Principal and Fellows of Jesus College, Oxford; The Bodleian Library, Oxford; The Public Records Office, London; The Victoria and Albert Museum, London; The Conway Library, The Courtauld Institute of Art, London; Institut der Philipps Universität, Marburg; The Society of Antiquaries of London; The University and Society of Antiquities of Newcastle-upon-Tyne; The General Editor of the *Victoria County History*; The Lord Bishop of Peterborough; Dr C. Wilson and Thames and Hudson; Miss Jill Kerr; The Revd Canon M.H. Ridgway; R.J.L. Smith of Much Wenlock; John Rhodes, Director of Museums for the City of Gloucester; Cecil A. Hewitt.

The publication of this book has been assisted by most generous grants from: the Marc Fitch Fund, the Sylvanus Lysons Trust, Gloucester City Council, the Ernest Cook Trust and the Friends of Gloucester Cathedral.

<div align="right">David Welander</div>

EARLY HISTORY

681–1022

'First a man shall love God with all his heart . . .'
The Rule of St Benedict

When the Romans arrived in the Severn valley in 47 AD four years after their invasion of Britain in 43 AD they established a fort about a mile to the north of Gloucester's present city centre. But in the late '60s this fort was dismantled, and a new fort built on some rising ground further to the south. The Romans realized the strategic importance of the position of this new fort, opposite the lowest fordable crossing of the River Severn. Later, when they had established defensive positions further west during their conquest of Wales, they made the fort into a permanent settlement. The former legionary fortress become a *colonia*, that is a town for retired veterans of the Roman army, and was given the name *Glevum*. Its first permanent inhabitants built themselves houses and public buildings such as baths, a forum and basilica. Finberg described the founding of the town which was to become Gloucester as:

> A rectangular area comprising some forty-five acres was marked out on the top of the hillock and laid out in Roman fashion. A century later massive stone walls, with a tower at each corner, were built to enclose it. The main entrance was constructed at the junction of the direct road from Kingsholm and the diverted Ermin Way. It is here that Northgate Street turns and enters the heart of the modern city. From the west gate a causeway led over the divided channels of the Severn towards the Forest of Dean.[1]

SOME ROMAN REMAINS

Centuries later when Serlo, the first Norman abbot of St Peter's, Gloucester (1072–1104), came to set out the foundations of his great church (now the cathedral) he built it across the north-west corner of the old Roman town. The line of the Roman city wall crossed the east end of the nave at an angle, across the north transept to the south-east

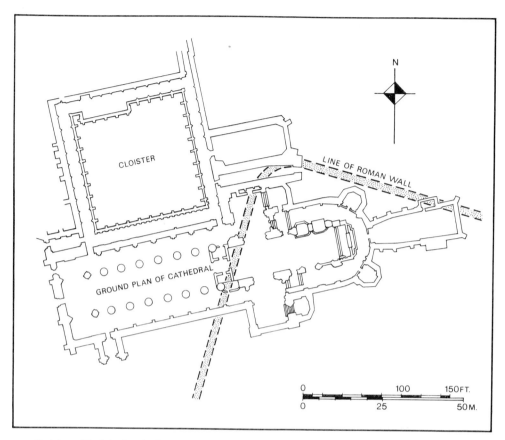

Position of Serlo's church, begun in 1089, across the remains of the walls of the Roman town

corner of the Chapter House. Here the wall turned at a right angle to pass close to the north-east corner of the lady chapel and so out of the precincts roughly on a line through Cathedral Way to the north gate of the Roman town.[2] This whole section of the wall must have been in a fairly ruinous condition in Serlo's time. The tumbled down remains of Roman buildings which were lying around would have provided the Norman builders with a useful quarry of material with which to begin work. Little is known about the foundations of the Norman abbey church, but not a few of the massive stones which once formed part of the Roman walls may well be incorporated in the foundations.

Other material from Gloucester's Roman past now incorporated in the fabric of the building can be more easily identified. The Norman builders used a number of Roman bricks in walls and columns, sometimes to fill in between ill-fitting ashlar. These are usually set vertically into the masonry and being red in colour can be easily identified. On rare occasions when the rubble core of the cylindrical columns of the nave has been exposed during repair work fragments of bricks and other Roman debris have been found. Of even greater interest is the sentorial stone in the roof space over the south aisle

of the nave, set in the stone work behind a triforium arch. It is of oolitic limestone and measures $4\frac{3}{4}$ in × $9\frac{1}{2}$ in long (12 cm by 24 cm). It is cracked through at one end and the bottom is broken off at the other. The surface shows some old abrasions and weathering. The inscription reads as follows:

LEG[ionis] XX V[aleriae] V[ictricis] C[o] H 0
C[enturia] CORNELI[i] CRESC.

This may be translated as: From the cohort of the twentieth legion Valeria Victrix [and the . . . cohort]. The century of Cornelius Crescens [built this]. It is impossible to say, with any certainty, where the stone came from, but it may have been set originally in some Roman masonry structure in the town, possibly in a section of the wall.

While there is increasing archaeological evidence of a Christian presence in the area during the period of Roman occupation, for example at Cirencester and Uley, nothing has been unearthed as yet within the walls of Roman Gloucester that can be identified specifically with Christian beliefs and rites. Yet considering the rapid expansion of the Christian mission through the Graeco-Roman world of the first century, it is highly probable that among the soldiers, administrators and traders who came to Britain from Rome and other parts of the Empire there were some who were Christians. The first written evidence of Christians in Britain is given by Tertullian in his tract against the Jews, written about 208 AD. He writes of parts of Britain, inaccessible to the Romans, which had already been 'conquered by Christ'. At the time Christianity was still a *religio ilicita*, that is a religion not protected by Roman law, so that from time to time its

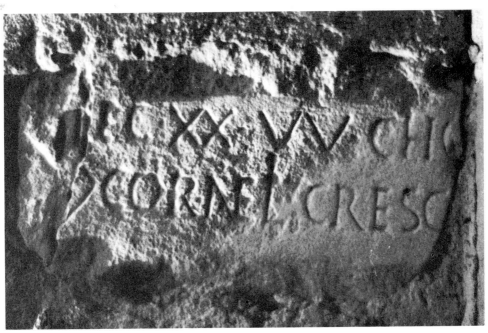

Roman sentorial stone set in south arcade wall of the nave (in roof space over the south aisle)

adherents were subjected to bitter persecution by the Roman authorities. But when it became a *religio licita*, a permitted religion, and indeed the official religion of the Roman Empire in 313 AD, a Council of Bishops was called at Arles and among those present were three bishops from Britain; Eborius of York, Restitutus of London and Adelphius of Lincoln. Less than a century later, with the collapse of the Empire, the Romans withdrew from Britain leaving the country open to Anglo-Saxon invaders who started arriving in the south-east of the country shortly after 400 AD and spread gradually westwards. But in the early years of the sixth century the Severn valley was still under the control of Celtic princes. There is little historical or archaeological evidence to indicate how the people of Glevum faired at this time, but Heighway believes 'the town was probably still inhabited, perhaps by a small population living in humble circumstances among the decaying Roman ruins.'

THE SAXON CONQUEST

The old Romano-British families and their Celtic overlords felt increasingly insecure because of Saxon incursions, and many in the countryside around sought shelter within walled towns such as Gloucester. By the late sixth century the Saxons had arrived in force in the southern part of the Avon and Severn valley. The *Anglo-Saxon Chronicle* records that 'in 577 Cuthwine and Ceawlin fought against the Britons and killed three kings, Conmail, Condidan and Farinmail, at the place which is called Dyrham, and they captured three of their cities, Gloucester, Cirencester and Bath.' Finberg describes the battle and its long-term consequences:

The Principality of the Hwicce

In 577 a Saxon warband led by Cuthwine and Ceawlin of Wessex captured Bath, stormed the Cotswold heights at Dyrham, and followed up the rout of the Britons by taking both Corinium and Glevum. In 628, Corinium [Cirencester] witnessed another clash of arms, this time between Cynegils of Wessex and the Mercian Penda. The treaty which ensued removed the Cotswolds permanently from the orbit of Wessex and into that of Mercia. There is every reason to believe that the principality of the Hwicce, comprising Worcestershire, Gloucestershire east of the Severn, and the western half of Warwickshire, dates from this time; it may indeed have been Penda's own creation.[3]

In his discussion on *The Princes of the Hwicce* Finberg makes the important suggestion that Penda and his Mercian warriors may not have fought alone in the battle near Corinium in 628, but had at their side a powerful war-band of Northumbrian origin. After the triumph the area they had subdued was organized as a separate political unit, the under-kingdom or principality of the Hwicce. 'I suggest' he writes 'that Penda rewarded the assistance of his allies by entrusting the principality to a Northumbrian ruling family.' This would account for the close connection between the Hwicce and Northumbrian ruling families, and at the same time of the Hwicce rulers' relationship with the Mercian royal house. As Heighway points out: 'Links with Northumbria are a persistent theme in the history of the town and its shire, culminating in 909 with the translation of the bones of St Oswald, king of Northumbria, to a final resting place in Gloucester'.[4]

The principality of the Hwicce, as formed in the first half of the seventh century, covered much of the Severn valley and the surrounding hills, and from the beginning was subject to the great Kingdom of Mercia to the north. The Christian faith was late

King Ethelred's Foundation Charter 681, from
Register A (f.9) *c.* 1397

in entering Mercia owing to the power of Penda, a heathen king, but in 653 he allowed four Christian missionaries to come and work freely among his people. In the main the missionaries were from the Celtic tradition, and so looked to Lindisfarne rather than Canterbury for direction. However, after the Synod of Whitby in 664 which was called to settle the date of Easter which divided the Christians of Northumbria from those in the south, the influence of Canterbury grew over the whole of the English Church.

Archbishop Theodore of Canterbury (669–90) in the course of establishing dioceses to serve each of the major kingdoms and sub-kingdoms of the Anglo-Saxons appointed a bishop for the Hwicce people in 680, with his seat or *cathedra* at Worcester. It was during this period of comparative stability in the country and of reform in the Church that a great many monasteries were founded. Among them many *monasteriole*, as Knowles called them, small convents which never entertained any ambition to become great monastic houses. It was as part of this movement that in 676, Osric, described as the *sub-regulus* or under-king of the Hwicce, founded a monastery at the old Roman town of Bath. A few years later he was involved in founding a monastery in another old Roman town, Gloucester, now within the newly formed diocese of Worcester. In one of the documents relating to this foundation, (*Cartularium Saxonicum* 60), there seems to be reference to two transactions. The first involved the gift to Osric by Ethelred of Mercia of 300 *tributarii* at Gloucester, a considerable area of land. And the second, some time later, in which Osric purchased the city *cum agro suo* with the object of founding a convent within its walls. The former gift was probably intended to provide the new foundation with an adequate income.

PRINCE OSRIC'S FOUNDATION

The monastery Osric founded at Gloucester in *c.* 679 and dedicated in honour of St Peter was designed to house a community of both men and women in separate enclosures but within the one compound. There had been similar houses for some time in north-eastern Gaul (France). They were essentially communities of nuns, to which monks were attached for liturgical duties and heavier manual work. In England they were often aristocratic foundations, housing the daughters and dowagers of kings and ruled by abbesses of royal or noble blood. Wimborne in Dorset, for example, was founded and governed by two sisters of King Ine of Wessex. St Mildred, the founder and Abbess of Minster-in-Thanet, came from the royal family of the Hwicce, as did Kyneburga the first abbess of the double monastery at Gloucester.

The nuns and their clerks lived under some form of monastic rule, using the one chapel and probably a common eating hall. A number of servants enabled them to live in the style to which their royal background had accustomed them. The monks or clerks would have assisted in the management of the convent's estates. As a community they would also safeguard the local interests of the royal house to which they were attached by birth or marriage. Bede (*c.* 673–735), and others later, complained that the high ideals of the founders of many of these monastic houses had been set aside, and that the nuns and monks lived in considerable luxury, and indulged in all kinds of worldly pursuits:

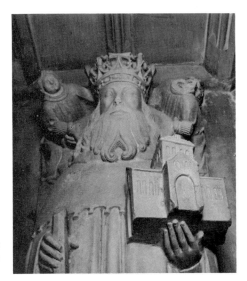

Prince Osric, founder of the first monastic house on the site. Detail of the effigy on his sixteenth-century tomb

All of them, men and women alike, are either sunk in unprofitable sleep, or else wake only to sin. Even the cells, which were built for prayer and study, are now converted into places of eating, drinking, gossip or other amusements. When they have leisure even the nuns, vowed to God, abandon the propriety of their calling and spend their time weaving fine clothes which they employ to the peril of their calling, either to adorn themselves like brides or to attract attention from strange men.[5]

It is generally thought that Osric built his monastery just inside the north-east corner of the old city wall. Many of the buildings of the former Roman *colonia* would have been visible as substantial ruins. A painting by Richard Bryant commissioned for the 1981 Gallery Exhibition gives an impression of the town and the monastery *c*. 690. All around the town are the remains of Romano-British buildings, and within the monastic compound a small stone church and two enclosures with halls, one for the nuns and the other for the monks. A preaching cross stands in the churchyard. 'Whatever their reaction may have been to Romano-British buildings' writes Professor P.K. Kidson:

. . . they were certainly indifferent to them as an architectural inheritance. It is true that here and there Roman cities such as York, Lincoln, Canterbury and London appear to have survived in some form or other to become the local capitals of Anglo-Saxon kingdoms; but in terms of actual buildings this does not mean very much. During the early stages of the occupation the amount of sheer destruction must have been considerable, and nearly all those vestiges of the comparatively highly organized way of life of Roman Britain which were not destroyed outright seem to have been treated by the newcomers with the disdain of incomprehension. Buildings such as baths, temples, basilicas and theatres lay wholly beyond the range of their experience. From the Anglo-Saxon point of view perhaps the most important aspect of Roman buildings was the facility with which they could be exploited for building material.[6]

While this is generally true, there is an Anglo-Saxon poem which describes, with a sense of awe and wonder, certain Roman remains. In the surviving lines of 'The Ruin' (in the *Exeter Book*) an eighth-century poet gazes at the ruins of a Roman city, probably Bath, and describes it as 'the work of giants' (*esta geweore*), adding that a wall was 'grey with

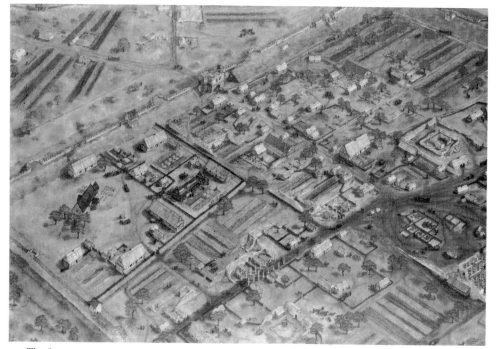

The Saxon monastery, within the north-west corner of the old Roman town of Glevum, *c.* 690.
Detail from Richard Bryant's reconstruction (1981)

lichen tinctured with red.' The poet goes on to reflect on the joys and treasures of those who must once have lived there. Perhaps the disdain was not universal.

Osric's sister Kyneburga was the first abbess of the Saxon monastery of St Peter in Gloucester. She ruled the convent for twenty-nine years and died in 710 having increased considerably the number of benefactions to the house. The second abbess, Eadburt, a kinswoman of Kyneburga, was probably also of royal blood. She is said to have 'governed the nunnery prudently and religiously' for twenty-five years. She died in 735 and was buried near her predecessor in the small convent church. Osric died in 729, and was buried 'in front of the altar of St Petronilla' on the north side of the church. The third and last of the abbesses was Eafe, at one time the wife of Ethelred, King of Mercia (or of Wolphere, son of Penda, King of Mercia). She is said to have 'increased the income of the monastery, and to have gained confirmation of former donations in many synods.' In 767, after thirty-three years as head of the house, she died and was buried beside her predecessor.

The medieval records relating to the early history of St Peter's Abbey, and limited archaeological excavations carried out within the precincts over the past hundred years yield no firm evidence as to where the church of Osric's monastery was located. All that can be said is that the church was probably situated somewhere within the north-west angle of the wall of the old Roman town. In view of the fairly haphazard arrangement of buildings in Celtic and later Saxon monasteries it is difficult to be more specific. The foundations of the church, if they have survived, may be beneath or on the south side of

the present building. The matter is complicated by an ambiguous statement in the *Memoriale* to the effect that in 1056 Aeldred, Bishop of Worcester, built the Benedictine community a new church *de novo . . . a fundamentis* 'a little nearer to the sides of the city.' These words can be interpreted in a variety of ways, leaving the exact location of the old Saxon church as well as Bishop Aeldred's church a matter of speculation. One day more solid evidence may be unearthed in an archaeological excavation.

Prince Osric, as the founder of the first monastic house on the site, is commemorated in a fine Tudor tomb on the north side of the high altar. The tomb was constructed during the abbacy of William Parker (1514–39), the last Abbot of St Peter's, and at a time when religious communities were competing with each other to emphasize the antiquity of their foundations. When John Leland, whom Henry VIII appointed as King's Antiquarian in 1533, visited Gloucester shortly after the Dissolution of the Monasteries, he wrote 'Osric, founder of Gloucester Abbey, first laye in St Petronell's Chapell, thence removed into our Lady Chapell, and thence removed of late dayes and layd under a fayre tomb of stone on the north syde of the high aulter. At the foote of the tomb is this written on a Norman pillar *Osricus Rex primus fundator hujus Monasterii 681*.' Leland obtained this information from one of the former monks of the house, who may well have witnessed the translation of Osric's remains from the Lady Chapel.

On the night of 7 January 1892, according to a contemporary account, the dean, accompanied by Canon St John the sub-dean, Canon William Bazeley the librarian, Mr Waller the architect, the sub-sacrist and two skilled masons 'caused two panels on the south side of the large stone loculus, or stone chest, on which the effigy of Osric rested, to be removed, and at once a long leaden coffin was disclosed. The upper end of the leaden coffin had fallen in, apparently crushed by the weight of the stone effigy of Osric, and thus exposing to view the contents of the lead coffin' The account describes what was found in the coffin. 'A few small bones or pieces of bone mingled with cement . . . and at the lower end grey dust marked the position where the legs and feet had rested. No attempt was made to discover royal insignia or fragments of vesture. The remains were left untouched.'

SECULAR PRIESTS OCCUPY THE MONASTERY 767–1022

It seems the office of abbess came to an end in 767 with the death of Eafe. During the hostilities between King Egbert and the King of Mercia the nuns were 'deflowered and dispersed', that is raped and forced to leave the monastery. It had been thought that the buildings then lay derelict for some fifty years, during which time they became *spoliatum et ruinosum*, and that in 823 Beornwulf, King of Mercia, repaired them and gave them to secular priests. He is said to have confirmed for their support a large part of the lands which Ethelred, Ethelbald, Offa, Kenwolf and others had given to the convent. But Finberg questioned this traditional interpretation of the evidence:

It is usually said on the authority of the Gloucester *Historia* that after Eafe's death St Peter's lay derelict for several decades. This abandonment, however, is hard to reconcile with the list of benefactions and with independent evidence which points to the continued existence of a religious community at St Peter's. The truth seems to be that an establishment formed originally, like many in its time, as a

home for royal and noble widows and a place of education for their children, with a number of resident priests ministering to them, ceased to bear this character after the death of Eafe, but remained in being as a college for secular priests.[7]

It seems therefore that, after Osric and the rule of the abbesses (679–767), the monastery passed immediately into the possession of a college of secular priests. Though little is known about the community during the following two hundred and fifty years surviving records show that until the middle of the ninth century the foundation continued to attract a steady flow of benefactions. The lands belonging to the community were confirmed in a charter of King Burgred of Mercia dated 862. But after this charter, St Peter's passes entirely out of historical records until early in the eleventh century. This is not surprising since at the end of the ninth century largely because of the Danish invasions religious life in England was at a very low ebb and organized monastic life had virtually ceased to exist. But in the middle of the tenth century there was a widespread revival of monastic life inspired by three bishops; Dunstan of Canterbury, Aethelwold of Winchester and Oswald of Worcester. Many new monasteries were founded and old houses were revived and reformed. These communities modelled their daily life and liturgical practice on the Rule of St Benedict. In spite of the fact that one of the leaders of the revival was their diocesan bishop the movement for renewal did not immediately affect the situation at St Peter's, and the secular priests continued to occupy the old monastic buildings, until they were evicted by Cnut in *c.* 1022. Leland wrote that Cnut 'for ill lyvynge expellyd secular clerks, and by the counsell of Wolstane [Wulfstan], Bysshope of Wurcestar, bringethe in monkes.'

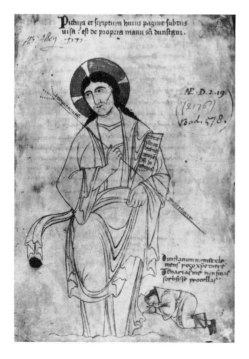

St Dunstan (*c.* 909–88). Abbot of Glastonbury *c.* 943, later Bishop of Worcester and of London, and then Archbishop of Canterbury, kneeling at the feet of St Benedict

For many years before they were expelled from the monastery the secular community at St Peter's Abbey had been somewhat overshadowed by St Oswald's Priory which, according to William of Malmesbury, was founded by Ethelfleda of Mercia in *c*. 900. The priory was built on land adjoining the Abbey, at the north-west corner of the precincts. In 909 it received the relics of King Oswald of Northumbria and thereafter was closely connected with the palace and royal administrative centre at Kingsholm, a half-mile to the north. Heighway thinks the Mercian council which met in Gloucester in 897 may have met in the great hall at Kingsholm:

> In the 10th century Gloucester acquired, apparently quite suddenly, an administrative and military status which it is tempting to equate with the revival of towns elsewhere in southern England. Although not listed in the surviving records as a Mercian burh, Gloucester was organized for defence by 914, and the failure of the Mercian register to mention the refortification of Gloucester between 902 and 914 may imply that it was fortified before that period by Ethelfleda.

The founding of the new minster of St Oswald's may therefore be seen as a sign of special royal favour towards the town which, under Mercian rulers, was already moving towards the importance it was to have under the Norman kings.

THE INTRODUCTION OF BENEDICTINE MONKS

There is some uncertainty about exactly when the Benedictines took over St Peter's Abbey. The *Historia* states:

> In the year of the Lord 1022 Wolstan, Bishop of Worcester, who later was made Archbishop of York after the resignation of King Cnut, the leader of the Danes, who held Holy Church in high esteem and renewed and promoted her ancient liberties . . . this Wolstan canonically and under the Benedictine rule summoned the clergy who formerly had governed and guarded the church of Saint Peter with the protection of God and the Apostles Peter and Paul and consecrated one Edric as abbot and guardian of that monastery. However he lost much of its wealth, for in his time were permanently estranged and sold the manors of Badgeworth and Hatherley.

But Wulfstan held the see of Worcester jointly with York from 1003–16; after 1016–17 he was Archbishop of York only, having resigned Worcester. Knowles therefore prefers an earlier date, 'not later than 1017', to that usually thought to be the date of their occupation of the monastery.

Pages of a manuscript or manuscripts written in Anglo-Saxon, some in almost pristine condition, were found in the late 1850s in the binding of Abbey Register C. In all seven leaves were recovered most as pastedowns but one as a flyleaf in the contemporary binding of the Register of Abbots Braunch (1500–10) and Newton (1510–14). They contained parts of three of Aelfric's homilies and of the life of St Mary of Egypt, but one contained an extract from the *Rule of St Benedict* beginning 'In the first place, to love the Lord God with all one's heart, all one's soul, and all one's strength. . . .' The section is that appointed to be read on 18 January, 19 May and 18 September. The *Rule* goes on to remind the monks of their calling:

Page of Anglo-Saxon manuscript *c.* 980 (Gloucester Cathedral Library)

To deny oneself in order to follow Christ
To chastise the body
Not to seek soft living
To love fasting
To relieve the poor
To clothe the naked
To visit the sick
To bury the dead
To help the afflicted
To console the sorrowing
To avoid worldly conduct
To prefer nothing to the love of Christ.[8]

The folio with its quotation from the *Rule of St Benedict* in Anglo-Saxon has been dated on palaeographical grounds to 'the early decades of the eleventh century' (N. Ker), that is, from the time when the Benedictines took possession of the Abbey of St Peter's Gloucester.

A DAMAGED ROUNDEL OF CHRIST

Another survival, possibly from the late Anglo-Saxon period, is a badly damaged stone carving, in relief, of a bust of a human figure which was found in the early years of this

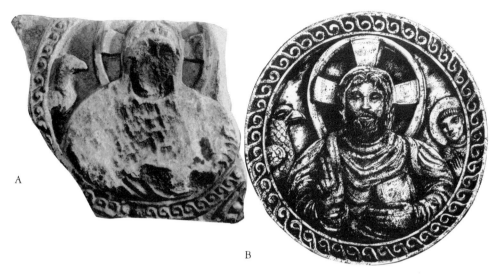

(A) Roundel of Christ tenth/eleventh century. (B) Reconstruction by Ian MacKillop

century set into the garden wall of the Bishop's Palace (now the King's School). It was first described by Keyser in 1912 'as a sculptured Norman tympanum'. But in 1933 Dobson included it in an article on *Anglo-Saxon Buildings and Sculptures in Gloucestershire* concluding it represented the head and shoulders of Christ. She noted that the border was composed of a caulicula or voluted crockets, a well-known Carolingian motif. In similar Byzantine and Carolingian figures 'Christ Almighty' or 'Pantocrator' is represented as clasping a book in one hand and holding the other up in blessing. Similar representations of Christ were common in the eastern Church and in western Europe during the medieval period. They are found in ivories and miniatures, on coins and in mosaics from the sixth century. There is a magnificent 'Christus' as 'Pantocrator' in the central dome at Daphni, Greece (1100); or much earlier, a 'Christ Enthroned' in the Godescale Evangelistary, made for Charlemagne and his wife Hildegarde 781–3. Though badly damaged, the Gloucester 'Christus' appears to be very similar to these classic examples in its general design.

There can be little doubt that it is local work since it is carved in oolitic limestone. On the back of the sculpture there is evidence of another work which appears to have been deliberately erased. At the bottom right-hand corner of the sculpture there is a fragment of an arc, of a similar curve to the main sculpture, with bead decoration which suggests that there were other roundals attached to it. It has been dated to the first half of the tenth century. Professor Joan Evans wrote of the fragment: 'Time has battered it, but it is great art. There is no reason to suppose it is not local work; it sets Gloucestershire in the main current of European art somewhere about 950.'[9] But on evidence which Professor G. Zarnecki brings forward, in his study of *Romanesque* (1989), the 'Christus' could be dated as late as the twelfth century. On the assumption that it originally came from the Church of St Peter's Abbey, rather than from nearby St Oswalds, the whole composition, with its attached roundels, may have formed part of the external decorative work, in the gable or above the door at the west end of the Norman building.

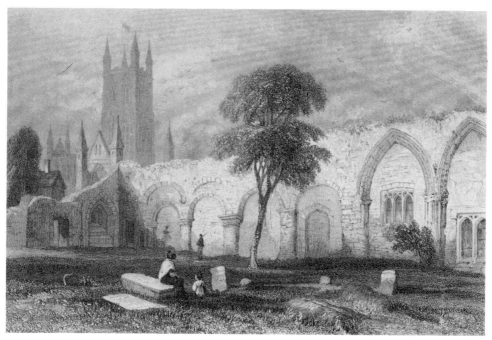

The ruins of St Oswald's Priory in the early nineteenth century

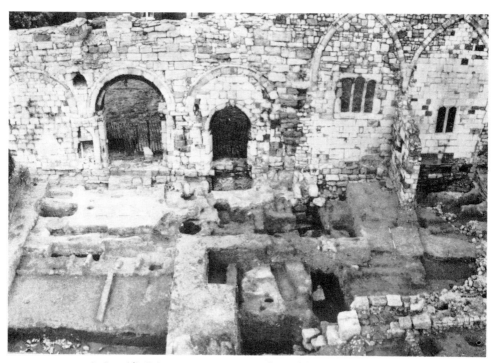

St Oswald's Priory, recent excavations directed by Carolyn Heighway

Whether the crypt contains any late Saxon material, from the church built by Bishop Aeldred, is still a matter of debate. Some antiquarians in the nineteenth century argued that much of the late Saxon church has survived in the central chamber. It was noted that the central chamber is more than 2 ft (61 cm) below the level of the ambulatory around. The columns and capitals of the central space contrast sharply with those in the ambulatory even before the strengthening work was applied. There are faint carvings of acanthus leaves on two of the capitals and a curious face or mask on an adjoining capital which could be dated to pre-Conquest days. The three-centred arches are not paralleled in any part of the Norman building. And, possibly most significant of all, there are none of the masons' marks on the stonework of the central chamber which are to be seen everywhere on Serlo's Romanesque church. Considerations such as these have led some writers to the conclusion that the Normans either left much of the late Saxon church intact, and built a broad ambulatory around it, or reused a substantial amount of material from Bishop Aeldred's church in building the crypt of their new church.

More recently Professor Eric Fernie, in his *The Architecture of the Anglo-Saxons* (1983), has argued the case again. He wonders whether the crypt is, in fact, all of one period:

> The level of the floor in the central part, as defined by the bases of the columns, is considerably lower than that of the aisles and radiating chapels, suggesting that it belongs to a separate build. This possibility is supported by the appearance of two layers in the arcade walls, with the outer build on to the inner, that is the wall of the central chamber. If one assumes that the outer layer along with the ambulatory chapels is Serlo's, then the earlier phase could either be a false start in 1089 or a remnant of the church built by Ealdred, Bishop of Worcester, and consecrated, according to the *Anglo-Saxon Chronicle* in 1058. The normal attribution of this work to the late eleventh century gives some indication of the thoroughly Norman character of its volute capitals, tooling, vaulting and general layout.

He wonders therefore whether Gloucester's crypt may not constitute another 'independent instance of Norman influence before the Conquest.'[10] There is, however, still a consensus of scholarly opinion convinced that the crypt is entirely the work of Serlo, the first Norman abbot, and dates from the foundation of the present building in 1089. As

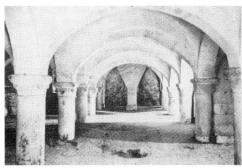

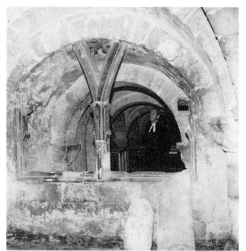

Above: Central chamber of the crypt, showing nineteenth-century infilling obscuring the bases of the piers. Right: The crypt inner wall from the south ambulatory looking into the central chamber

Professor Willis put it, when addressing the Archaeological Institute at Gloucester, 'when the foundations of the church were laid, the crypt was planned to receive the existing superstructure and no other. In its design it is far too complicated for a Saxon church. The building is in conception a Norman church from bottom to top.'

ST PETER'S ABBEY BEFORE SERLO 1022–1072

When St Peter's became a Benedictine house in *c*. 1022 Wulfstan, Bishop of Worcester, appointed Edric, one of the secular priests, as abbot. Edric took upon himself the habit of a Benedictine and ruled the house until 1058. However, in the words of St John Hope 'The Benedictines introduced by Cnut do not seem to have been a success', and after thirty-seven years under a weak abbot, whose long rule was marked by great decay of discipline, the *Memoriale* says: 'God permitted them to be extirpated, and the monastery in which they were established to be devoured by the fiercest flames, and the very foundations and buildings to be rent asunder, razed to the ground, and utterly destroyed.' What credence should be given to this statement, and exactly when the fire swept through the buildings of the old Saxon monastery is not clear. This was not the only disaster that befell the community during Edric's rule. Local feeling against the new monastic community seems to have run so high that, according to Abbot Parker's rhyming account of the history of the abbey, in 1033 a certain Wolphin (or Ulfine de Rue) murdered seven of the monks on the road to Churcham. As penance he was ordered to provide for the maintenance of seven monks at the abbey, which he was said to have done by making over the manors of Churcham and Highnam to the abbey.

After Abbot Edric's death, Aldred, Bishop of Worcester, appointed a kinsman of his, Wilstan, abbot. At the same time the bishop built the community a new church *de novo . . . a fundamentis*, and to have done so not on the same site as the old church but, according to the *Memoriale*, 'a little further from the place where it had first stood, and nearer to the side of the city.' It is impossible to know what this ambiguous statement means. In 1060 Bishop Aldred left to become Archbishop of York having alienated the manors of Northleach, Odyington, Standish and Barton as compensation for the cost of building the new church. On moving north he annexed the confiscated manors to the see of York.

Abbot Wilstan died in 1072 while on a pilgrimage to Jerusalem. Even allowing for some exaggeration in the account of the Anglo-Norman chronicler whose evidence underlies the statements of the *Historia* on this point, St Peter's Abbey had reached a very low ebb at the time of the Norman Conquest. Indeed when Abbot Wilstan died and the first Norman abbot arrived in Gloucester in the summer of 1072 the community was said to consist of only two monks and eight boys. But Serlo, an able and energetic monk from the thriving Benedictine monastery of Mont St Michel in Normandy, soon set about the task of turning the practically defunct Abbey of St Peter into one of the great Benedictine houses of England.

CHAPTER TWO

ABBOT SERLO
1072–1100

*'He raised the place from meanness
and insignificance to eminence and splendour.'*
William of Malmesbury

When Duke William invaded England in 1066 the monasteries of Normandy were growing rapidly in size and wealth. Many of them had been founded, or refounded, in the previous thirty years. Ambitious building programmes were underway in all parts of the duchy. This confident expansion was due, in part, to the influence of the great Abbey of Cluny in Burgundy which had inspired high standards of discipline, theological study and liturgical practice in religious houses throughout France and in Italy and Spain. But, more immediately, it was due to William's own energy and encouragement of the monastic movement. Judged by Norman standards monasticism in England was lax and worldly. There had been a revival of monasticism in the previous century under Dunstan, Oswald and Ethelwold but much of the enthusiasm had gone by the time Duke William crossed from Normandy. The situation at the Abbey of St Peter in Gloucester, where there were said to be only two monks, was typical of a number of religious houses in England at the time.

As aging prelates appointed by the Anglo-Saxon kings died, King William appointed Norman churchmen as bishops and abbots. By far the most important of these appointments was that of Lanfranc as Archbishop of Canterbury in 1070. Lanfranc came originally from northern Italy, and for some years had been at the newly-founded monastery of Bec which he made famous through his scholastic achievements. When he was brought over to Canterbury he was Abbot of Caen, where William had founded the Abbeye aux Hommes, and his wife Matilda the Abbeye aux Dames. He was a staunch supporter of the Conqueror, and being one of his closest advisers, became the dominant figure not only in the life of the Church, but also in the government of the country. He issued rules for the stricter observance of monastic life at Canterbury and rebuilt its cathedral. He instituted far-reaching reforms including the holding of councils of the

church, the removal of the seats of bishoprics from villages to important towns, and the organization of cathedral chapters, archdeaconries and separate ecclesiastical courts.

Among other men of outstanding ability who were brought over to fill high office in the church were Paul of St Albans, Simeon of Ely, Gilbert Crispin of Westminster, and Serlo whom William appointed Abbot of Gloucester in 1072. Serlo was a chaplain to the Conqueror. He was in sympathy with the reforms initiated by Lanfranc, and set about implementing them in the life and work of St Peter's Abbey. But the contrast between the depressed and delapidated monastery at Gloucester and the expanding and thriving monastery he had left behind could not have been more marked. There was the new church completed only fourteen years earlier by Bishop Aldred, but it had been built in the style and on the scale of Anglo-Saxon churches which would have seemed to him, with his ambitions for the monastery, mean and inadequate. Nothing is known about the condition of the rest of the buildings, but with the monastery so run down in numbers and morale, the claustral buildings were probably old and delapidated.

THE DOMESDAY BOOK

From late-Saxon times the king's court or witan met at the royal palace at Kingsholm in Gloucester for the Feast of the Nativity. William the Conqueror, probably because of the strategic position of the town, continued this tradition and summoned his court to Gloucester for Christmas, to Winchester at Easter and to Westminster for Pentecost. Herbert points out that, though 'by 1086 and until the beginning of Henry I's reign Gloucester was the accepted venue for the Christmas crown-wearing of the Norman kings . . . in practice William I and his son seem to have kept as many Christmases at Westminster as at Gloucester.'[1] But, according to the *Anglo-Saxon Chronicle*, the Conqueror was at Gloucester in 1085 and had 'deep speech with his witan', which led him to order the survey of the country and the compilation of Domesday Book (1086).

No one knows where in Gloucester the Christmas court was held. It has long been assumed that it took place in the old Norman chapter house. There were burials in the chapter house as early as 1085. Walter de Lacy was buried there with great pomp in 1085 so, as Masse comments 'the room must have been ready or nearly ready for use in that year.' Earlier Fosbroke had also stated the obvious when he wrote that 'they could not have been buried in this room before it existed.' Thus though the present building dates, in the main, from the twelfth century, there must have been an earlier part-timbered building on the site. The calcination on the inner surface of the west wall of the chapter house is thought to be evidence that this timber structure was severely damaged or completely destroyed in the fire of 1102. Though the church was not begun before 1089, the growing community would have needed a chapter house, if only a temporary timber building. The chapter house at Durham was built ten years before the foundation stone of the great church was laid, so that the position of the chapter house in relation to the church building could have been worked out and the ground cleared. But this does not prove the Council was held in the chapter house of St Peter's Abbey. The *Anglo-Saxon Chronicle* does not mention any building, only that the witan was held at Gloucester.

Heighway believes the more likely venue was the late Saxon palace at Kingsholm;

VIII

GLOWECSCIRE.

[The main body of this page is a facsimile reproduction of medieval Latin manuscript (Domesday Book) handwriting, which is not legibly transcribable.]

Entry in *Domesday Book* relating to the possessions of St Peter's Abbey

'The most likely place for the Council would have been the royal palace of Edward the Confessor's time, which . . . had been well-accustomed to large numbers of visitors back in the 1050s. The Saxon hall would have been the setting for the Council's decision, just as it was the Saxon hundredal system of local government which enabled the Domesday Commissioners to carry out their immense task.'[2] The tradition that the Council was held in the chapter house may go back no further than the late fourteenth century when the palace at Kingsholm had long been abandoned. With its associations with the Norman kings, the recent burial in the abbey church of the murdered King Edward II, and the parliament of Richard II held at the abbey in 1378, the chapter house of the Norman abbey would have seemed the natural place, in the late fourteenth century, for the witan to have taken place.

Domesday Book, the great statistical account of the condition of England in 1086, was drawn up by commissioners sent out by King William to every shire to inquire into its resources, population and ownership. The name of every householder was set down, together with the valuation of his manors, and an account of the service and money due from him to the king, It did not give merely a rent-roll of the estates, but a complete enumeration of the population, divided up by status into tenants-in-chief of the Crown, sub-tenants who held land under these greater landowners, burgesses of towns, free sokmen, villeins, and serfs of lower degree. But in 1087 before the ink was hardly dry on the great document, the Conqueror died in Normandy from severe internal injuries from being thrown by his horse against the high pommel of his saddle. He was buried in the Church of the Abbeye aux Hommes at Caen which he had founded before the Conquest.

THE ABBEY ESTATES

Serlo's first priority in the seventeen years after his arrival in Gloucester and before the laying of the foundation stone of the abbey church in 1089, was to build up the community in both numbers and wealth. The Conqueror himself is said to have given Nympsfield (Glos.) to the abbey in Wulfstan's time, and other properties in Serlo's time, notably Barnwood. Apart from these royal grants, the abbey received few donations in Serlo's earlier years in Gloucester. Indeed, according to Domesday Book, their total value amounted to only £9 10 s. However, grants were made by Walter de Lacy and his wife Emmelina (Upleaden, Glos. and Duntisbourne Abbots, Glos.) and by Arnulf de Hesdin (Linkenhold, Hants.) from 1080 onwards. Domesday Book confirms that the abbey's estates were worth £99 in 1086 and that Serlo, by a policy of energetic estate management, had doubled their value since 1066. The land-holdings, in hides, of neighbouring ecclesiastical tenants give some indication of the relative wealth of St Peter's in 1086:

Church of Worcester	145
St Peter's, Gloucester	99
Winchcombe Abbey	78
Evesham Abbey	55
Church of Hereford	30
Pershore Abbey	22

Archbishop Thomas of York held forty-nine hides, at Standish, Oddington and Northleach, formerly belonging to St Peter's, Gloucester. Even so, St Peter's was not a particularly wealthy foundation. It has been calculated that the monastery was in twenty-second place in a list headed by Glastonbury whose lands were worth nearly £828.[3]

From the early 1090s the abbey received a flood of donations as is evident from numerous charters in the Gloucester Cartularies, from benefactions listed in the *Historia*, and from William Rufus's confirmation charter which is dated 1096. Dr David Bates points out that though the latter is an example of the type of monastic confirmation charter into which interpolations might periodically be made there are no good reasons for doubting that the grants recorded were actually made at the time Serlo's abbey church was being built.[4] These donations came from royal and local benefactors. William Rufus gave Rudford (Glos.), and Roger de Berkeley granted land at Clingre, Arnulf de Hesdin churches at Kempsford and Hatherop, and Hugh de Lacy the Church of St Guthlac in Hereford as a priory. The lands given to the abbey at this time lay mainly in Gloucestershire, Herefordshire and Worcestershire but also in others parts of the country from Plymtree in Devon to Littleton in Hampshire.

Some of the grants made after 1090 were the donations of men who were engaged in the consolidation of the Norman conquest and, in particular, in the pacification and settlement of Wales. Other donations came from men such as Hugh de Port and Roger Bigod who had made careers out of administrative service to the Norman kings and had probably visited Gloucester on several occasions in the course of their duties at the royal court. With the restitution of Standish, Oddington and Northleach in 1096 and the

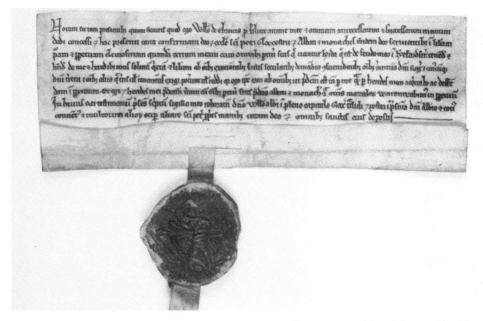

A Grant by Abbot Thomas (Carbonel) and the convent of Gloucester to Elyas Palmer, of land in Gloucester. The recipient had to pay 5 s. twice annually to the abbey almonry. The private seal of Abbot Thomas is attached

grants mentioned above it is estimated £72 would have been added to the income of the abbey in the 1090s. Since together these represent only a part of the income of St Peter's, it is probably true to say the abbey's income more than doubled during the years 1090–1100 as the abbey church was being built. The *Historia* gives much of the credit for this substantial increase in the abbey's wealth to Odo, the cellarer, who 'by his hard work and industry caused the lands and possessions of Gloucester's monastery to increase many times over.'

THE NORMAN ABBEY CHURCH

In 1088 a fire swept through the old monastic buildings. This gave Serlo the opportunity he had been waiting for. He cleared the ground and marked out the foundations and the following year he began to build his great church. The *Historia* gives details of the laying of the foundation stone. 'In 1089 on the day of the festival of the Apostles Peter and Paul [29 June] in this year were laid the foundations of the church of Gloucester, the venerable man Robert, Bishop of Hereford, laying the first stone, Serlo the abbot being in charge of the work.' A few weeks later, on 11 August, there was an earthquake which did considerable damage to the newly-laid foundations of the building. But it is most unlikely that the strengthening work in the crypt was put in at this time. Work on the building continued for eleven years until on 15 July 1100 the church was dedicated in honour of St Peter. Again, the *Historia* gives details of the occasion. 'On Sunday 15th July the church of Gloucester which Serlo of revered memory had built from its foundations was consecrated by Bishops Sampson of Worcester, Gundulph of Rochester and Heureas of Bangor with great ceremony.' Florence of Worcester in his accounts adds that Gerard, Bishop of Hereford was also present.

The statement of Florence of Worcester may seem to infer that the entire building was completed by July 1100. Some historians and antiquarians of the nineteenth century argued that this was the case, and that the eleven years 1089–1100 would have been sufficient to complete the entire building. Though this would have been possible, given a sufficient and skilled work-force, the date of certain decorative features in the nave indicate that the work went on for some time after 1100. In all probability it was only the eastern arm that was completed by 1100 viz. the crypt, the choir, the ambulatory and the chapels radiating from it, with work still going on in the transepts and on the tower. A bay or two of the nave arcade may have been built not so much to provide buttressing on the west side of the crossing as for liturgical reasons. With the first phase of building work completed the community was able to use the choir and ambulatory chapels for their daily Hours of prayer and meditation, the *Opus Dei*, and for the conventual Mass. The community must have found it increasingly difficult living in the cramped conditions of the old Saxon monastery, and with such massive building works in progress close by their living quarters. But the monks must have got used to living on a building site for their church was constantly being repaired, altered and extended in the centuries that followed. Some of the monks would have been involved in the building work, and would have regarded it as part of their daily offering of work and worship, to the glory of God, which was summed up in the *Opus Dei*.

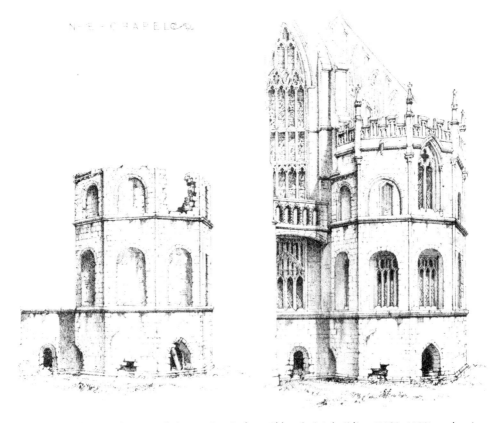

Remains of the north-east ambulatory chapel, from Abbot Serlo's building (1089–1100), and as it appears today. F.S. Waller's drawing of 1856

After the dedication of the church in 1100, work may have been concentrated for a while on the claustral buildings, that is the dormitory, refectory, kitchens etc. At Durham the great cloister and some of the essential domestic quarters were probably built before the eastern arm of the church was completed. The practical needs of a rapidly growing community had to be provided for. Such a break in construction might explain, at least in part, the contrast between the bare simplicity of the eastern arm, with its groin vaults and transverse arches of simple section, and the comparatively complex design of the nave elevation with its decorative detail on the arches and capitals. The contrast, however, in the elevation of the Norman choir, with its two storeys of almost equal height, and the elevation of the nave, with its immensely tall piers and diminutive triforium, does not necessarily imply a revision of the original design after 1100. The liturgical requirements of the community account for the three storey arrangement at the eastern end of the building, providing as it does for five chapels on each of the three levels; and the lofty hall-like design of the nave served as an impressive arena for many occasions, and every day for the community's processions from the west door of the great cloister to the choir.

ABBOT SERLO'S MEMORIAL

Four years after the dedication of the abbey church Serlo died. The *Historia* states: 'In the year of our Lord 1104, having with him Lord Odo the cellarer as fellow worker and helper, in about the 60th year of his age and the 33rd year of his prelacy, on the Thursday after Ash Wednesday, 3rd March, the day now drawing to its end at the time of Vespers, he was released from the flesh, leaving after him one hundred monks in the community.' The *Historia* goes on to extol his virtues and what he did for the abbey noting in particular that he had obtained from William I and his two sons, William Rufus and Henry I, as well as from many nobles 'freedoms, lands, liberties and confirmations of the grants to the abbey made by their several patents.' Among these freedoms and liberties was exemption from military service. Dom David Knowles in noting that Gloucester's abbey was never held by military service, i.e. under obligation to provide knights like other feudal tenants, suggests the reason could have been that 'when Serlo became abbot in 1072 the abbey had only a handful of monks, and William who visited the town each year for one of his solomn gatherings of magnates may have been unwilling to burden the new abbot and his struggling family'.[5]

Serlo left a flourishing community of a hundred monks, a great abbey church well on its way to completion, claustral buildings marked out round the great cloister some probably already built. But his greatest achievement lay not in his building works, or in the great increase in the abbey's income, but in the discipline and dedication of the community he had built up and led for so long. His younger contemporary, William of

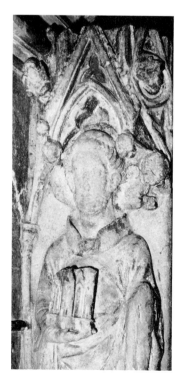

Abbot Serlo (?). Detail of thirteenth-century effigy on south side of
the presbytery. (See plate 6)

Malmesbury, at the time of the abbot's death wrote of him '. . . and that England may not be supposed lacking in virtue, who can pass by Serlo, abbot of Gloucester? All England is acquainted with the considerate observance of the Rule professed at Gloucester, which the weak may undertake to follow and the strong cannot despise.' His firm and wise leadership had 'raised that place from meanness and insignificance to eminence and splendour.'

Abbot Serlo's achievements are summed up by a present-day historian, 'Under the rule of the able and energetic Abbot Serlo from 1072, Gloucester Abbey became one of the leading Benedictine houses of England. Its alienated property was recovered and additional gifts attracted, the church was rebuilt, and the community was much enlarged.'[6] And Harcourt Williams has written:

> Serlo stands out as the foremost figure in the history of St Peter's Abbey. Other abbots were celebrated for their piety, their organizing ability, or for the additions which they made to the abbey church, but it was Serlo who transformed a small declining community into the great and prosperous monastery which his successors could further enlarge and enrich. He began the building of the magnificent Norman church, he greatly increased the number of monks under his direction, and he obtained sufficient endowments to place the abbey in a secure position and to ensure that the fine buildings and large numbers could be sustained in the centuries that followed his abbacy.[7]

It is not known where Serlo was buried, and there is no contemporary effigy of him or memorial to him. As the builder of the great church of the abbey he may have been interred, originally, between two Norman piers on the north side of the high altar. Prior to the destruction of the Norman apse in the mid-fourteenth century this would have meant the position now occupied by the shrine of King Edward II, but there was never any suggestion that the king's burial necessitated the relocation of the abbot's tomb. The position occupied by the memorial to Prince Osric on the north side of the high altar was only created when the existing square termination of the building was constructed. The thirteenth century effigy of an abbot lying on a bracket, attached to the Perpendicular screening, on the south side of the presbytery may well have been part of Serlo's tomb. Leland on his visit to the church in c. 1541 noted 'Serlo, Abbot of Gloucester, lyeth under a faire marble tombe on the south syde of the presbiterye.' He may have been mistaken or misinformed, but he reported that he had seen the fair marble tomb 'on the south [sic] side of the presbytery' which he was told contained the body of the first Norman abbot.

Serlo was, therefore, probably buried on the south side of the presbytery, between the Norman piers, or in the ambulatory, and at the time of the remodelling of the choir, following the burial of Edward II, the rest of the tomb was removed but the effigy was preserved by being set against the Perpendicular panelling. The figure, base and canopy are all carved from one piece of local stone, and must originally have formed the lid of the coffin. The figure of the abbot is life-size and vested as a priest with a pastoral staff. The top of the staff has been broken off. The figure is bareheaded and tonsured; the face, which is rather flat, has a beard and large prominent ears. The head rests on a cushion, and he is wearing pointed shoes or sandals on his feet. At his feet there are two figures with hoods and long robes. In his right hand and resting on his breast is a model of an Early English church with pointed gabled roofs, narrow lower lights and trefoils. The figure lies on a slab beneath a triple canopy. The canopy is cinquefoiled, and supported

by shafts and capitals. There are considerable fragments of medieval paint on the canopy and on the figure, blue, green and yellow. The top of the canopy has been hacked about as has also the bracket. The reason for this damage is puzzling; Bazeley noted 'the top of the slab with part of the canopy is said to have been cut off to make room for the older bishop's throne, now in the nave'.

Apart from this medieval effigy, Abbot Serlo has his memorial in the great Romanesque church which he planned and began building, and which survives, in large part, as the core of the present building, enlarged and enriched by the work of later centuries. What is enscribed on the memorial to Sir Christopher Wren in St Paul's Cathedral applies equally to Serlo:

Si monumentum requiris, circumspice

His great church stands after nine hundred years as a memorial to his energy and devotion, and to the skills of his monks and craftsmen.

CHAPTER THREE

THE ABBEY CHURCH
1089–1100

'The Vale of Gloucester is productive throughout of corn and fruits . . .
You may see the high roads bedecked by fruit trees . . .
No country in England has more or richer vineyards.
Here are innumerable towns, handsome churches and villages without number.'
William of Malmesbury, c. 1125

Norman influence was growing in England for some years before William the Conqueror landed near Hastings in 1066. Edward the Confessor (1042–66) had spent the first twenty-five years of his life in exile in the Duchy. During that time the Normans became the dominant power in Europe through their crusades and conquest of Sicily and southern Italy. In 1042, following the death of Cnut, Edward was invited by Earl Godwine and the Saxon witan to accept the Crown. On arriving in the country he found the English Church in urgent need of reform, and brought clergy from Normandy and Lower Lorraine to fill high office, a policy which his successor, William the Conqueror, was to apply with characteristic thoroughness. When Edward came to build his great abbey church at Westminster he built it in the style and on the scale of the churches which were being built in Normandy. It was said to be very similar in design to the abbey church of Jumieges which was nearing completion at the time, and whose majestic ruins can be seen today.

Soon after the Conquest, in the 1070s and 1080s, cathedrals and abbey churches of similar monumental proportions were begun at Canterbury, Winchester and Lincoln, and at St Albans, Ely and Worcester. These were followed before the end of the century by others at Durham, Norwich, Tewkesbury, Gloucester and elsewhere. Buildings on such a scale must have been overwhelming to the native population of the country in the early years of Norman rule. By comparison Anglo-Saxon churches were small and of simple construction, though full of artistic treasures. Examples of Anglo-Saxon church building may be seen at Bradford on Avon in Wiltshire, and at Deerhurst near Gloucester. But as Kidson notes 'it seems fairly safe to say that . . . the Normans had such a poor opinion of the buildings they found in England when they arrived that they

set about replacing them with buildings of a quality to which they were accustomed as soon as possible. The contempt which they felt for English Church buildings was only a part of their wider contempt for almost everything connected with the religious life of the country.'[1] As soon as was practically possible newly-appointed Norman abbots began thinking about the provision of spacious and carefully planned monastic buildings and offices, together with a large church. In Knowles' words these Norman abbots 'coming as they did from a land which had recently witnessed an extraordinary efflorescence of ecclesiastical architecture and from monasteries complete with all the buildings necessary for the common life of a large body of men, the small proportions and irregular arrangements of the monastic buildings in England must have seemed to them to foster a corresponding irregularity and mediocrity of life.'[2]

At Gloucester, Serlo had to put up with 'the small proportions and irregular arrangements' of the monastic buildings for some years. But in the years between his appointment as abbot and starting work on the abbey church in 1089, he would have been planning the entire complex in detail. The plan was to build across the north-west corner of the old Roman town, the abbey having acquired additional lands on the north and west sides of the monastic precincts. This would have left some of the buildings from late Saxon times still standing, and possibly the church which Bishop Aeldred had recently built for the monastery. These would have been used to house the growing community before larger and more adequate claustral buildings could be built around a cloister, laid out on the north side of the proposed abbey church.

In 1088 some of the barons rebelled against the new king, William Rufus (1087–1100), the Conqueror's middle son. As the abbey chronicle records 'In this year by reason of war between the nobles of England, Gloucester was destroyed and the church of St Peter.' Apparently the town and the abbey were razed to the ground as a result of being caught up in the fighting. The extent of the damage to monastic property is not known, but the fire enabled Serlo to clear sufficient ground to make a start on a new church. Early in 1089 he assembled the materials needed, including stone from quarries near Painswick and timber from nearby abbey estates. The site was marked out, and the foundations of the crypt prepared.

THE CRYPT

Steps lead down to the crypt from the east side of the south transept. At the foot of the stairs a broad ambulatory extends round the apsidal east end passing three chapels on one side, and vistas of the central chamber on the other. A narrow passage from the ambulatory on the north side leads through to another chapel with access up steps to the eastern slype. There is another chapel in the corresponding position on the south side. The crypt extends under the entire presbytery, its ambulatory and chapels. It is only in the crypt that the original apsidal plan of the east end survives intact. The outer walls of the crypt like those of the rest of the original building are typical of the 'thick wall' construction employed by the Normans, being some 2.5 m (8 ft) thick. Set into the walls of both the ambulatory and the chapels are deeply splayed round-headed windows, but several of them have been enlarged. The floor of the ambulatory is about 2.5 m (8 ft) below the level of the ground outside.

The Different Phases of Work

There would appear to be three different phases of work in the crypt, though this, and its exact dating, are matters of debate among architectural historians. First, there is the work in the central chamber which antiquarians of the last century and others more recently have argued pre-dates Serlo's work.[3] Dean Spence-Jones expressed the conviction that the central area is 'different in character' to the rest of Serlo's crypt: 'The double row of columns in the central area belongs without doubt to an earlier period than any of Serlo's work.' Whether the columns and other material in the central chamber are, in fact, part of Aeldred's church, destroyed by fire in 1088 but still *in situ* raises many questions. Serlo might have been expected to have repaired it so that it could continue to serve the needs of the community at least until the east end of his own great church was completed. Dr R. Gem writes of Edward the Confessor's church at Westminster: 'The foundations of the new church were laid out some distance to the east of the old buildings [the latter being presumably somewhere in the region of the west end of the present nave] and were planned so that the east end of the new building – which was most needed for the liturgy – could be completed and brought into use before it was necessary to demolish the old church.'[4] On the other hand, Serlo may have demolished Aeldred's church in 1089, building the crypt on the site of the late-Saxon church and using some of its stone-work in the central space.

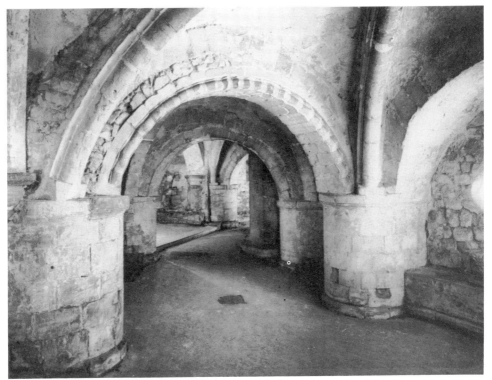

The crypt: from outside the axial chapel looking towards the south-east chapel showing strengthening ribs and arch with chevron

Secondly, there is the more substantial work around the outside of the central chamber, which is all-of-a-piece with the original work in the ambulatory and in the chapels, and certainly dating from Serlo's first phase of building. The distinctive character of the work can be seen, for example, at the entrance to the central chamber on the south side, and in the chapels. Thirdly, there is the strengthening work in the ambulatory consisting of arches built under the original transverse arches, additional ribs applied to the groin vaulting, and the casing of the attached columns against the arcade and outer walls. The two layers in the arcade walls are well illustrated in a drawing by F.S. Waller showing how the casing built round and enclosing the earlier smaller pier corresponds with the encasing of the small attached column against the outer wall. (See illustration on p. 36.) Here and there the corners of the abaci of the original attached columns protrude from this later strengthening work. The strengthening arches, springing from the enlarged columns, are of plain rectangular section, though at the entrance of the south-east chapel the ribs are of one broad half-roll with two smaller quarter hollows. Outside the north-east chapel they incorporate chevron set against the underside of the arch.

The Date of the Strengthening Work

It was thought that this use of chevron precludes a date for the strengthening work earlier than *c.*1120. Chapman argued that chevron, one of the most popular enrichments of the Romanesque period, first appeared in England about 1110, predating any examples in Normandy. But more recent research suggests that chevron was known and already popular in Normandy by 1090. There is therefore no reason why it may not have been used sporadically in this country in the late eleventh century. But whether such a labour-intensive decoration would have been used in the apparently urgent strengthening work in the crypt is another matter. The stones had probably been cut for use in the nave, currently being built, but had been discarded and so were available for use in the reinforcement of the crypt. This would support Dr C. Wilson's conclusion that the strengthening of the foundations of the eastern arm was done 'early in the 12th century.' Others, however, have argued that the work was done some years earlier. 'This strengthening work was rendered necessary owing to earthquake shocks which occurred [August 1089] and possibly from the fact that the originally defective foundations on the south side of the crypt caused a slight settlement.' (Masse 1899). The work was done 'very shortly after the completion of the ambulatory' (Metcalffe). The way the original transverse arches of the south ambulatory have begun to give way, either under pressure from the building above or as a result of some early settlement in the foundations, suggests that something had to be done fairly quickly to stabilize the building. It would seem safe to say that the strengthening work was put in 'before the completion of the superstructure' (Thurlby).

 The date of the strengthening work is related to the question whether Serlo intended to construct a high vault over the choir. He may, originally, have intended to span the choir with a wooden roof and ceiling; and only later, during construction, decided to build a high (stone) vault. This meant the foundations in the crypt had to be

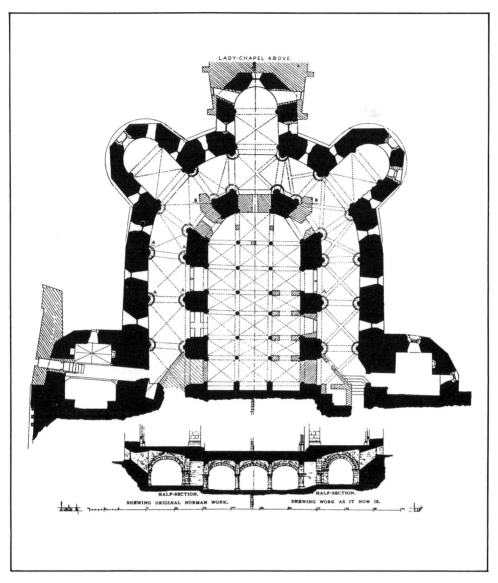

LADY-CHAPEL ABOVE.

HALF-SECTION.
SHEWING ORIGINAL NORMAN WORK.

HALF-SECTION.
SHEWING WORK AS IT NOW IS.

Plan of the crypt. F.S. Waller, 1856

strengthened to take the additional weight and a quadrant vault used in the tribune gallery. The strengthening work in the crypt shows every sign of having been hurriedly put in. The supporting arches and ribs rest awkwardly on the enlarged capitals often protruding in a rough and unfinished way. The strengthening ribs of the vault consist of one complete arch abutted by two half arches! In the tribune gallery the quadrant vault appears to have been designed to serve as internal buttressing to the inside wall or arcade of the choir transfering the lateral thrust of the high vault to the outer walls.

The Main Features of the Work

Other features in the crypt should be noted. The original floor-level of the central chamber, estimated from the base of the columns of the arcade, was about 0.7 m (27 in) lower that that of the surrounding ambulatory. A close examination of the stonework of the outer arcade wall shows that originally the bays of the central chamber were alternately open and closed to the ambulatory. In the central chamber volute capitals are mixed with cushion capitals, and the surrounding wall shafts have twin-scalloped capitals. The columns of the two arcades are further apart on the north–south axis than on the east–west axis. Semicircular arches span the main arcades east–west, but over the central aisle a series of three-centred arches had to be constructed to keep the level of the vault uniform. Though only supporting the floor of the presbytery these arches seem to be dangerously depressed. Wilson comments: 'Faced with such a severe limit on height, less unpredictable designers might have been content to copy Worcester's subdivision of the central space into four aisles covered by vaults of small span and elevation. However, the Gloucester master opted for three broad aisles and covered them with vaults of a daringly shallow profile.'[5]

Two of the volute capitals on the north side of the central chamber have acanthus leaves carved on them, and on another capital is a mask-like face. This face closely resembles the faces of King Harold's men in the Bayeux Tapestry, with their 'handlebar' moustaches. It is also similar to a face, found during excavations in 1945–55, on a

(A) Mask on capital of pier in north arcade of the crypt. (B) Acanthus decoration on adjoining capitals

damaged capital at Rouen Cathedral dated *c.* 1063. Dr Maylis Bayle comments on the Rouen face:

> Such capitals with crudely carved masks and prominent volutes in the upper register and with a lower row of plain leaves, are very common in Romanesque Normandy especially between 1050–1080. The nearest parallels to the Rouen capital are found in the crypt of Bayeux Cathedral (*c.* 1050), in Thaon old church (*c.* 1060), in the nave of the Trinity abbey church in Caen (*c.* 1070) and in St Etienne, Caen. Although this type did not spread as widely in England as in Normandy, it may be found, with some differences, in Gloucester Cathedral crypt (*c.* 1089), in Blyth Priory Church (*c.* 1080) and elsewhere.[6]

The Subsequent Alterations and Use of the Crypt

That there are no remaining traces of liturgical use in the central chamber is probably because the rising water-table led to the area being abandoned for worship early on. Professor R. Willis, speaking in 1860 after F.S. Waller had cleared an accumulation of

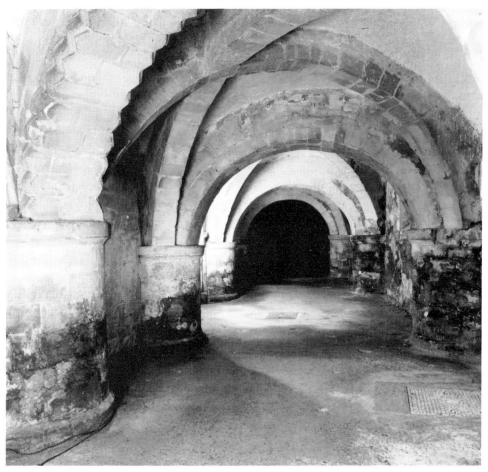

The crypt: north ambulatory looking west

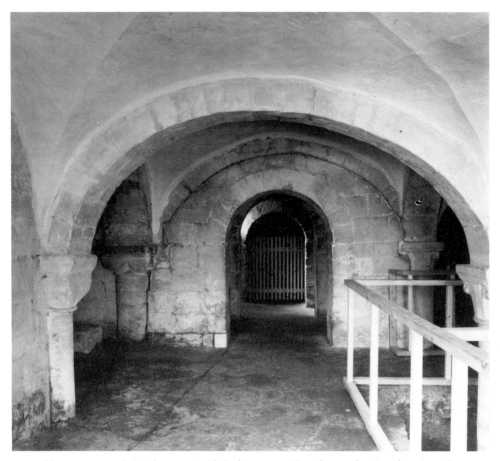

The crypt: central chamber, south side looking west. Note depressed arch and groin vault

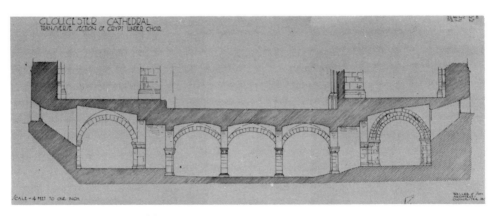

The crypt: transverse section (F.W. Waller)

bones and debris from the crypt, commented; 'the cathedral is built on a quicksand, and there was formerly much water in the crypt but it has now been drained.' There is still 'much water' around the base of the central columns when the water-table rises. More recently excavations around the eastern piers confirmed that there was no made up floor level in the central chamber, suggesting that flooding was always a problem. But there is ample evidence that the chapels off the ambulatory were in use well into the thirteenth century and probably into the fourteenth. The first chapel on the right at the foot of the stairs contains a double piscina with a shelf in good preservation. There are remains of hinge-posts (two sets) and the holes for the movable bar with which the doors could be fastened. The south-east chapel contains a wall-arcade of five plain arches with ornament above and with the remains of a sedilia beneath. The moulding on these arches should be compared with the fragment of wall-arcading at the north-east corner of the base of the tower. In this chapel there is also a double piscina with a shelf. A large stone slab has been set up to serve as an altar. It has no consecration crosses on it, in contrast to the two stone slabs set into the floor of the bridge chapel. On either side of the entrance are fragments of a stone screen.

The axial chapel which is under the vestibule of the lady chapel contains a font designed by Sir Gilbert Scott and some relaid medieval tiles. The alterations to the side windows and the blocking up of the east window is thought to be evidence that the Early English lady chapel (1226) was an adaption and extention of the Norman axial

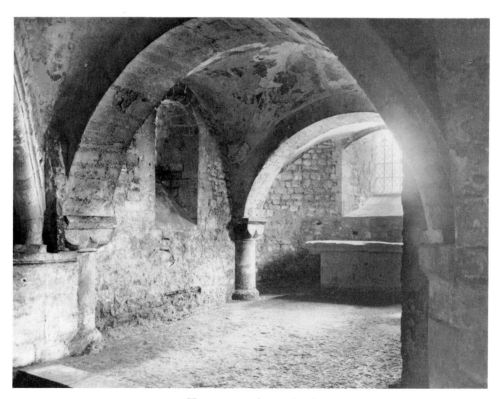

The crypt: south-east chapel

chapel at ground level. The north-east chapel, which is whitewashed, contains nothing of note apart from a partially blocked up doorway which was opened in the eighteenth century to give access from the Grove. The chapel in the north-west corner of the crypt is thought by some to have been the preserve of the abbot who had access to it through the eastern slype. But why the abbot required a chapel in the crypt is not clear. It is far more likely to have been used as a mortuary chapel, and to have been adapted and enriched for this purpose in the thirteenth century. The recess where the altar stood has vaulting and decoration of the thirteenth century, now much decayed, and at the side a very mutilated piscina of the same date. On the north side of the altar recess is a blocked up opening which apparently provided a squint-like view of the chapel from outside the building before the slype was extended eastwards. If a mortuary chapel, the body of a deceased member of the community would have rested in the main recess of the chapel before being taken up the steps and out to the monks' burial ground. The daily procession of monks through the eastern slype to the burial ground, to pray for their departed brethren, passed the crypt door which led down to the mortuary chapel.

For many years the crypt was a charnel house. In an engraving of 1829 skeletons, skulls and bones are piled high in the central chamber. But these remains were removed in 1851 to the south-west chapel of the crypt (as explained in the Latin inscription above the entrance) and then buried in the monks' burial ground on the north side of the lady chapel. At the same time the crypt was drained and concreted, the windows were glazed with clear glass, and outside a vast quantity of earth was removed from the side of the walls. Fragments of medieval glass were saved, and eventually used in the reglazing of the west window above the liturgical choir.

Encased attached shaft supporting strengthening rib
and arch. F.S. Waller drawing, 1856

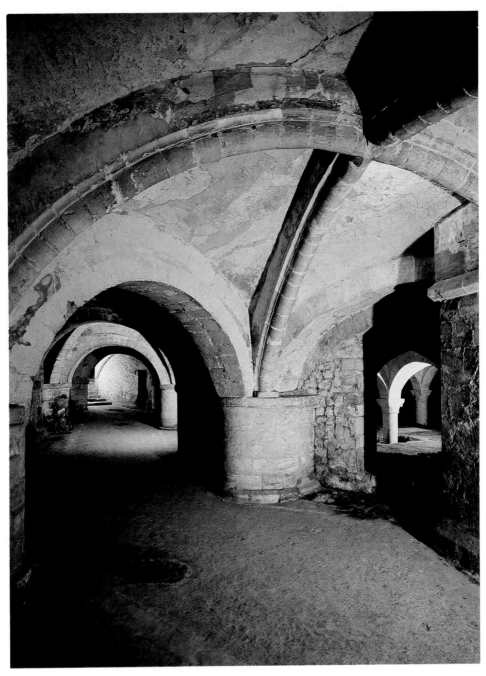

Plate 1
The crypt ambulatory, towards the south transept entrance and into the central chamber. (Pitkin
Pictorials)

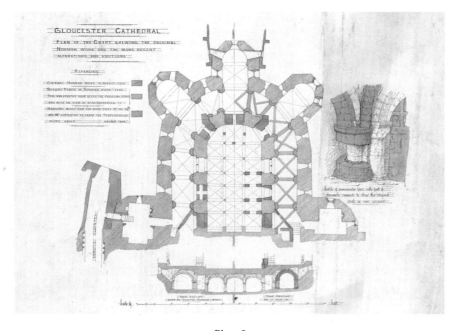

Plate 2
Top: Page of the *Historia*, or *Chronicle of the Abbey*, recording Serlo's appointment. Bottom:
Plan of the crypt, showing the strengthening work in blue, and the later work, mostly
fourteenth century, in red

Plate 3
Grant of Liberties by Henry II. Note the initial, with the king presenting the grant to a kneeling monk. (Public Record Office, London)

[Medieval Latin manuscript text in Gothic hand — Royal MS 13 A III f 41v, with marginal annotations including "Wigorn..." / "Glocestria" / "Petrus Ap..." and a marginal drawing of the skyline of Gloucester.]

Plate 4
Royal MS 13 A III f 41v. Note the margin drawing of the sky-line of Gloucester in the thirteenth century. (British Library, London)

THE AMBULATORY

The north and south aisles of the ambulatory present a superb vista of early English Romanesque. At the west end of both aisles the original Norman entrance to the ambulatory from the transepts remain intact behind the later Perpendicular screen. Twin attached shafts rise to capitals with a shared abacus from which springs a broad transverse arch of plain rectangular section. Such an arrangement originally spanned the four sides of the crossing, but all that remains now are the twin half-shafts on the inner face of the piers beneath the arches on the north and south sides.

In spite of the fourteenth-century reconstruction of the east end, the apsidal plan of the Norman choir can still be seen in the crypt and traced above at ground level through fragments of the original construction that remain *in situ*. F.S. Waller's plan of the crypt shows that the five-sided foundation of the outer wall was matched by a three-side arcaded apse. The same construction was repeated at ground level and in the tribune gallery, all of which was taken down when the great east window was built. But when the ground beneath the high altar was being excavated in 1872 for the erection of the reredos the foundations of the two Norman piers of the apse could be clearly seen. These piers were not circular but ovoid. Wilson observes 'These strange ovoid piers were necessitated by the use of wide archivolts in the arches of the main arcades and galleries.' The springing of the Norman arches which spanned this apsidal section of the ambulatory can still be seen rising from the capitals of the most easterly Norman piers, and opposite on the outer wall, either side of the entrance to the lady chapel, are the responds or corresponding wall-shafts complete with their capitals.

Behind Perpendicular screens the apsidal chapels have survived virtually intact apart from later tracery in the windows. In each chapel the wall behind the altar is semicircular on plan but outside the chapel the wall is three sided. The two transverse arches of the vault spring from cushion capitals; between the arches the vault over the main space is groined. In the south-east chapel there is dog-tooth moulding at the base of the wall-shafts. Against the wall on either side there is a narrow bench or *sedilia*, and above it a slightly pointed wall arch. There are also the remains of the bases of two small

South ambulatory of the choir, looking east

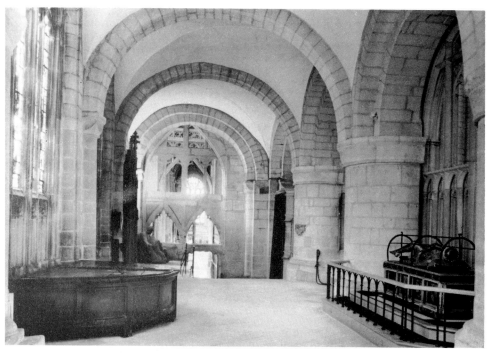

South ambulatory of the choir, looking west (Farley Photography)

Paired attached shafts, with capitals and a single abacus, at the west end of north and south choir ambulatories. Originally there was a similar arrangement on the north and south crossing piers

columns which supported a stone altar. The circular stone set in the tiled pavement on the south side is puzzling. It may have been the base of a pedestal piscina.

THE TRIBUNE GALLERY

Although not complete, the tribune gallery is 'perhaps the finest in existence' (Masse). It is exceptionally broad and originally extended round the apsidal east end of the Norman church. As in the crypt there were three chapels off the apse, and as below at ground level two remain intact. F.S. Waller's isometric drawing of the remains of the Norman building shows that later (in the course of the mid-fourteenth-century reconstruction of the choir) the apsidal section of the tribune gallery and the axial chapel were taken down. Originally access to the axial chapel at this level was from the demolished apsidal section of the tribune. But when this section was removed it was no longer possible to

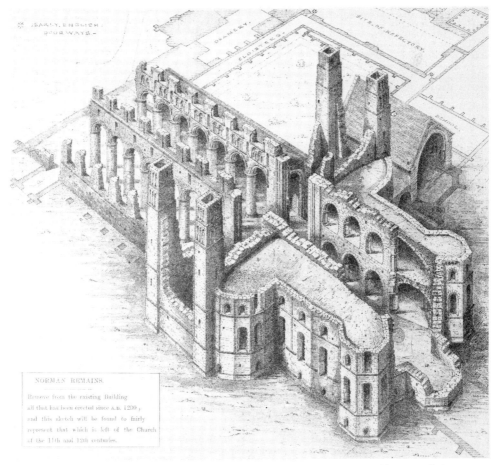

Isometric drawing showing the remaining Norman work, with all post-1200 additions and alterations removed. F.S. Waller drawing, 1855

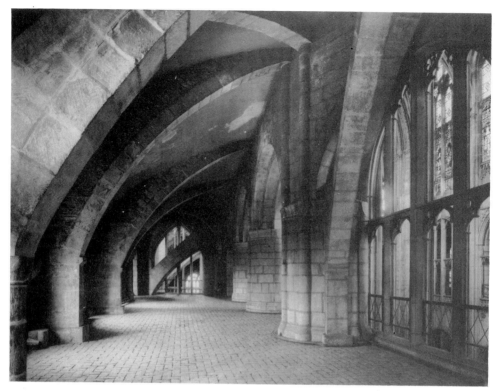

The tribune gallery, south side looking west

get from one side of the gallery to the other at the east end. To restore access an enclosed passage-way was built outside the great east window. The passage is carried on segmental arches and is constructed mainly of reused Norman stonework. The passage also gives access to the so-called bridge chapel, a small chapel which was later redesigned to form a 'gallery-chapel' at the west end of the lady chapel. In the chapel is a Norman stone altar with three or four consecration crosses inscribed on it, and in the tile-pavement beneath it the bases of two supporting colonettes. There are two more stone altars set in the floor by the entrance.

The most significant feature of the tribune gallery is the quadrant vault. This contrasts with the groined vaulting of the crypt and the choir ambulatory. The ribs, which are more massive when seen from the roof-space, abut the choir arcade and were intended, as already noted, to strengthen it to withstand the lateral thrust of a high vault. Bernard Bevan in his *History of Spanish Architecture*, comparing the Romanesque churches of St Sernin and Santiago de Compostella, observed 'In both churches the *triforia* (tribunes) are real galleries, capable of accommodating large congregations, and like the *triforia* at Gloucester, they are covered with demi-berceau or quadrant vaults which buttress great semicircular barrel vaults.' During the major reconstruction of the choir in the mid-fourteenth century everything above the first few courses of ashlar over the arcade arches was taken down thus destroying all evidence of a possible clerestory

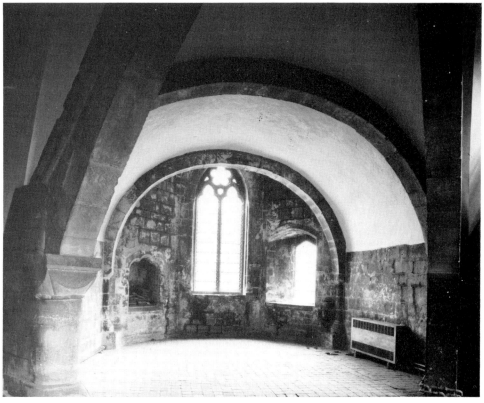

The tribune gallery, north-east chapel

level and springing of a stone vault. Some have argued that while the quadrant vault pre-supposes the *intention* to construct a high vault it was not built until *c.* 1130 when the crypt was strengthened to take the additional weight. If this were the case the presbytery would have been covered originally with a high pitched wooden roof possibly with a painted ceiling below it. But, in contrast with the nave where the evidence of burning roof-timbers can be seen in the calcination of the great circular columns, there is no evidence in the eastern arm of the building of any such fire damage.

THE CHOIR ELEVATION

Since no description or drawing of the Norman choir has survived, antiquarians of the last century and present-day architectural historians have turned to Romanesque churches in Normandy, Burgundy and elsewhere for some indication as to its original elevation. Such comparisons, however, have led scholars to widely differing conclusions, particularly as to whether the choir had a two, three or even four storey elevation; and whether the high vault, assuming there was one, was a barrel vault or groin vault. Most believe that it was within the competence of Norman builders in the last decade of the

eleventh century to span a space the width of Gloucester's choir with a high vault, even
if, in particular instances, they still preferred a wooden roof and painted ceiling. As long
ago as 1934 Sir Alfred Clapham, in his *English Romanesque Architecture after the Conquest*,
argued for a high vault over the choir, and assumed a three storey elevation. This he
believed consisted of a clerestorey above the present gallery arches, and a barrel vault
over the choir with a half-dome over the apse.

THE ALTERNATIVE INTERPRETATIONS OF THE EVIDENCE

In more recent years attention has been focused on certain Norman features in the choir
itself and in the transepts which, it is argued, point to various possibilities.

1. At the north-east angle of the base of the tower there is a fragment of one and a half
bays of Romanesque blind arcading. (See illustration on p. 46.) Is this fragment part of a
band of decorative arcading which ran round the external wall of the choir in the way a
similar band runs along the exterior wall of the nave of Tewkesbury Abbey? If so, does
this fragment indicate the level of the presbytery wall plate on which the Norman roof
rested? The steep pitch of the roof over the tribune gallery meant that the wall above the
tribune arcade arches must have extended to a considerable height, as high as the
transoms of the fourteenth-century clerestory windows. Was there a triforium, with or
without a wall passage, in the height of this wall?

2. On the north side of the presbytery, on the inner surface of the last Norman pier
before the great east window, there is a small attached shaft protruding through the
Perpendicular tracery. Did this shaft, which is just to the east of centre in the Norman
pier, relate to the original vaulting of the demi-dome of the apse?

3. In the Norman staircases in the transepts there are blocked up doorways which led
across the end walls to the tribune gallery. In the staircase in the north-west corner of
the north transept there are two such blocked doorways, the lower of the two is on the
level of the tribune gallery and led across a wall-passage to the gallery; but did the

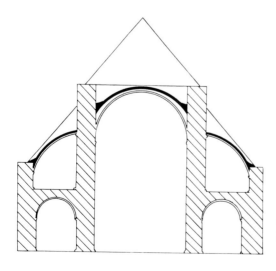

The tribule gallery, hypothetical cross-section of
barrel-vaulted Romanesque choir. Thurlby,
1981

higher of the two lead across to a clerestory passage on the east side of the transept and then continue along the north side of the choir? Indeed did it continue round the apse, and along the south side of the presbytery to link up with a wall-passage in the end wall of the south transept? (See illustration on p. 47.)

How are these three features to be interpreted in relation to the elevation and vaulting of the choir? Thurlby has proposed a two storey elevation consisting of the present choir arcade and tribune gallery, with a high barrel vault. He does not consider the blocked doorways in the north transept turret stair or the fragment of decorative arcading on the exterior angle of the tower relate to a choir triforium. Instead he relates Gloucester's choir elevation to the great pilgrimage church of Saint-Sernin, Toulouse, which had the two storey scheme comprising main arcade and gallery, and a quadrant vault over the galleries to take the lateral strain of a high vault. The nook shaft protruding from the easternmost Norman pier on the north side of the choir, being to the east of centre, relates not to a transverse arch or rib of the main vault, but to a quadripartite rib vault in the apse.[7] He finds the pattern for this vault in the quadripartite groin vaults in the north-east and south-east ambulatory chapels. The line of the web of these groin vaults suggests the line of the ribs in the vault of the choir apse. A similar, though scaled down, version of such a rib vault may be seen at the Romanesque priory church of St Michael at Ewenny, a daughter house of St Peter's, Gloucester built between 1116 and 1126.[8]

Wilson, on the other hand, believes the evidence points to a three-storey elevation, a clerestory level and a groin vault. When the Perpendicular panelling was placed over the piers and arches of the tribune 'the gallery arches lost an arch order like the four which remain, and the segment cut from the piers must have included a shaft matching the three survivors.' He goes on 'the shafts facing the main vessel must have performed some function, and it need hardly be doubted that they resembled the shafts towards the gallery in being prolonged upwards to receive the transverse arches of the high vault.'[8]

THE EVIDENCE OF REUSED ROMANESQUE WORK

In the past few years attention has been given to the identification and original location of a considerable amount of reused Norman masonry in the eastern arm of the building. This reused material can be readily identified and by comparing it with *in situ* Romanesque work it is possible to determine its original location. For example, it has long been recognized that the foundations, in the crypt, of the two easternmost vaulting shafts of the presbytery are made up of reused Norman masonry. The stones have Norman tooling and masons' marks, and the nook-shafts and the angle to which some of the ashlar is cut identifies it as having come from one of the axial chapels.

Again, stones from the two huge ovoid columns which supported the main arches of the Romanesque apse were used in *c.* 1340 to raise the level of the south wall of the tribune gallery so that the pitch of the roof over the quadrant vault could be lowered. In the roof space there are two courses of stones with curved surfaces. A template taken of the curved surfaces shows the stones to have come from these demolished apsidal piers. Other reused Romanesque work can be identified in the tribune gallery itself. The strengthening west jamb of the south ambulatory chapel is made up of reused material

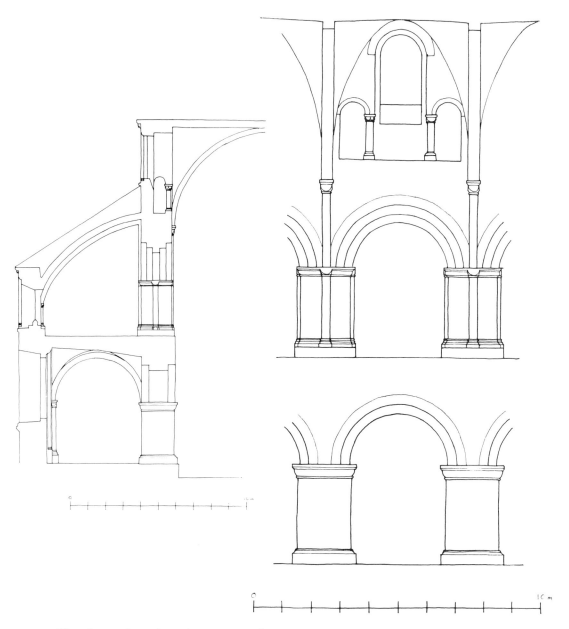

The tribune gallery, alternative reconstructed section through the north side of the choir, with the corresponding reconstructed interior elevation. Wilson, 1981

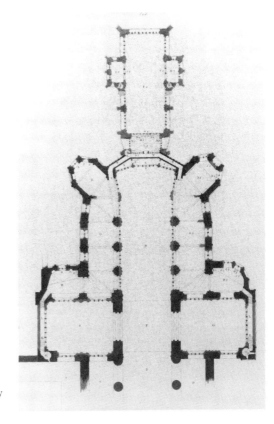

Plan at tribune gallery level, with the lady
chapel. John Carter, 1809

consisting of a base, shaft and capital. Two of the three courses of masonry which make
up the shaft bear familiar Norman masons' marks. In the corresponding position on the
north side, on the west jamb of the north-east chapel, there are two large scallop capitals
one used as a capital and the other as a base of a shaft which is made up of three courses of
masonry. That this is reused Norman material is confirmed by the fact that the tooling
changes from diagonal on the flat surfaces to vertical on the rounded surfaces. Existing
Romanesque work shows that the large single scallop capitals came from wall responds
in the destroyed eastern section of the ambulatory.

It is not so easy to identify the original location of other reused material. In the
tribune gallery, on the south side, at the south-west angle of the exterior wall,
diagonally opposite the south-east crossing pier, the respond under the inserted rib
consists of a reused base, shaft and capital. They probably came from the same location
since their dimensions indicate they belong together. Another instance of reused
Romanesque material is opposite, on the other side of the gallery at the north-west
angle, diagonally opposite the north-east crossing pier. Here there is a pair of shafts
serving as a respond, each consisting of two monolithic sections, one about 0.9 m (3 ft)
high and the other 0.48 m (1 ft 7 in). Each of these composite shafts has a separate
capital, one being a single scallop, the other a double scallop. The base profile is similar
to that found under the reused shaft at the south-west angle opposite, on the south side
of the gallery.

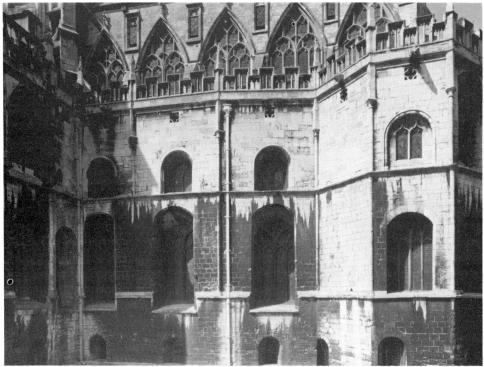

The choir, external view of the south elevation. Note, enlarged Norman windows of the ambulatory rise higher in the wall, and the lowered sills break string course

Fragment of Norman blind arcade at north-east angle of the base of the tower

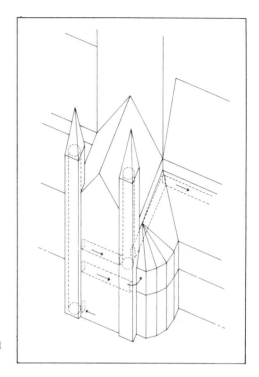

Diagrammatic reconstruction of Romanesque wall
passages in the south transept. C. Wilson, 1981

It is assumed that this material came from the demolished east end of the choir, and
was used by the builders to strengthen the gallery at these particular points. But, as
McAleer points out, the pieces of monolithic shafts, their single or double scallop
capitals and distinctive bases at the north-east and south-east angles of the gallery are
difficult to place. The shafts and capitals are clearly free-standing. There is nothing
remotely like them in the existing Romanesque work in the tribune gallery. He
therefore believes that this material came from a third storey in the elevation, above the
existing tribune gallery. The choir then, as built by Abbot Serlo, had a three storey
elevation, and a clerestory which included a wall-passage. He argues that the twin shafts
at the angle of the north gallery with the transepts, and similarly the capital, shaft and
base at the junction with the south transept must have come from the destroyed
clerestory. A band of arcading between string courses ran round the exterior wall of the
presbytery, and this and the blocked doorway in the Norman staircase relate to a wall
passage. 'There was a ground stage formed by the heavy arches springing from the round
piers of the choir aisles and ambulatory; a second stage, the tribune, with equally heavy
arches on shorter round piers, and a third stage, very likely a wall passage open to the
choir through pairs of arches utilizing monolithic central shafts, forming a narrow
horizontal band under a barrel vault.'[9] This is an attractive reconstruction, but with
such differing interpretations of the evidence the original elevation of the choir must
remain an open question.

THE CROSSING AND THE TRANSEPTS

The present Perpendicular tower rests on the original Norman crossing piers. The huge piers are closer together on the east–west axis than on the north–south axis, but on all four sides of the crossing the piers originally supported semicircular arches probably of single square section similar to those surviving at the entrances to the choir ambulatory. On each side of the crossing a pair of attached shafts rose to cushion capitals united by a single abacus. The springing point of the arch spanning the crossing piers on the east side is marked by an inscribed stone in the south face of the north-east pier. Due probably to settlement the two eastern piers are leaning outwards so that when the masons came to put up the Perpendicular panelling, for example, in the south transept (1331–6), in order to ensure that the new panelling was truly vertical they cut back into the stone of the crossing pier quite severely.

Nothing is known about the date or decoration of the Norman tower. But it was probably built after the completion of the nave, and judging by Norman towers which have survived elsewhere, for example at Tewkesbury, Norwich, Winchester, Southwell and Durham, the tower at Gloucester would have been a low massive structure, richly ornamented on all four sides with arcading, pierced by small windows and belfry openings, and surmounted by a low wooden spire.

Because of the alterations to the south transept in the time of Abbot Wygmore (1329–37) the details of the original Norman design, the form of vaulting, the fenestration and the reticulation of the walls, are all matters of conjecture. F.S. Waller's isometric drawing shows the extent of the destruction of the Norman work caused by

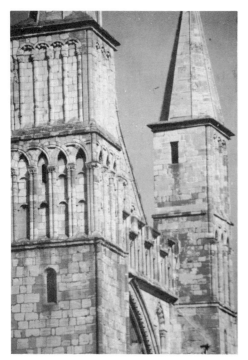

Left: South transept exterior: detail of twelfth-century Norman work. Below: Stone marking the place in the north-east crossing pier where the Norman arch on the east side of the crossing sprang

later building operations. On the east and west walls of the transept a certain amount of the original Norman masonry remains undisturbed though a large part of the wall around the windows had to be rebuilt when the early Perpendicular panelling was put up. The end wall was taken down to within 4.5 m (15 ft) of the ground when the great Perpendicular window was inserted in 1335/6, with the consequent destruction of the Norman windows and wall passages. On the outside the arch of the fourteenth-century window contains a band of continuous chevron which includes some Norman worked stones as well as some copies dating from the erection of the window. If chevron decorated the original windows in the end wall of the transepts, as it did the windows of the nave and the transept was completed by 1100, this would be a remarkably early instance of the use of this form of Romanesque decoration. Verey comments 'It looks as if the work of 1089–1100 went as far as the lower parts of the transept. In the upper parts chevron has arrived, as it has in the nave.' However, the chevron surrounding the existing terminal window may have come from the south aisle of the nave, which had been reconstructed a few years earlier, the chevron being replaced by ball-flower decoration. The unwanted but valuable Norman stones may have been stored with a view to their being used in some future rebuilding work. If this were the case the original Norman windows, in the end wall of the transept, may have been without decoration and like those in the crypt and ambulatories, simple round-headed openings splayed on the inside and out.

Tewkesbury Abbey: note the tower decoration and the blind arcading beneath the eaves. Early nineteenth-century etching

Norman vaulting, east end of the north aisle; reconstruction of original design, Wilson, 1978

The north transept is also largely Norman work though much altered and encased in fine Perpendicular panelling by Abbot Horton between 1368 and 1373. In the north-west corner is the Norman newel stair giving access to the tribune gallery. The transept had a high pitch roof as indicated by the gable end which like that on the south side retains Norman decoration. All evidence of the Norman vaulting was removed during the fourteenth-century reconstruction of the transept. There is nothing at present on the transept wall-plates to indicate whether there was a high vault. Nor are there any signs of calcination on the walls to indicate that an open wooden roof burned down during the fire of 1122 which damaged the nave so severely; nevertheless the Norman transept was probably covered with an open wooden roof or with a wooden ceiling.

The chapel of St Paul on the east side of the transept retains its Romanesque form, though somewhat altered in detail. Behind the Perpendicular panelling the twin responds, with single scallop capitals, and groin vault are typical of the first phase of building (1089–1100). The webbing of the vault in this chapel is of particular interest. Wilson points out that Gloucester 'seems to be the only 11th century church whose lesser apses at ground-floor level all contain groin vaults rather than traditional semidomes. Just one earlier Romanesque apsidal groin vault has survived, that in the south transept chapel of St Nicholas in Caen.' The entrance to the transept chapel is considerably wider than the entrance to the choir ambulatory. This would have added importance to the chapel. The doorway on the north side of the chapel was opened up to give access to the room over the eastern slype, built in the thirteenth century. The wall arch over this door is not a blocked window, but an example of a decorative feature of the early Romanesque work occuring elsewhere in the eastern arm of the building. In the transept itself the thirteenth-century screen or *reliquary* beneath the terminal window obscures the lower part of the Norman wall, and on the west side of the transept the large Perpendicular window has destroyed all traces of the Norman windows and wall reticulation.

THE DEDICATION OF THE CHURCH 1100

It is usually assumed for structural and liturgical reasons that the first two or three bays of the nave were more or less completed by 1100. Certainly the lower courses of the tower must have been rising above the roof-levels otherwise the community would not have been able to use the liturgical choir below. Wilson observes that:

> . . . in many Norman and Anglo-Norman monastic churches a major pause occurred in the work as soon as enough of the fabric had been completed to enable the monks to use the presbytery and liturgical choir. At Gloucester the eastern arm and transept could not have been put into service before the building of the stair turrets at the outer west angles which give access to the clerestories and galleries. Equally, the stair turrets could not have been built independently of the west walls of the transepts. The choir stalls stand, as they have always stood, under the crossing tower, and it is the adjoining part of the nave, the easternmost bay, which preserves evidence for a protracted cessation of work, followed by a radical revision of the design.[10]

The evidence to which Wilson refers is at the east end of the aisles of the nave, where the vault abuts the Perpendicular panelling of the transepts. In the north aisle the

Norman vault survives, but at the east end there are the remains of an earlier plan for the vaulting. As built, sometime before 1100, the arch between the north aisle and the north transept was a quadrant, springing from a pair of shafts on the north side, and meeting the crossing pier above a matching pair of shafts. The quadrant itself has gone, but the plain cushion capitals from which it sprang remain against the north wall. On the crossing pier opposite the paired shafts disappear through the webbing of the vault but in the roof space above the vault they reappear. In a careful examination of the evidence, Wilson suggests the intention may have been to vault the nave aisle with a series of quadrants as in the tribune gallery, and leaving the space between them open to the wooden roof. Thurlby interprets the evidence as 'demonstrating the designer's indecision' about the nave vaulting, adding 'the intention must have been to vault the aisles with quadrants springing from above the aisle windows and rising to immediately above the triforium rear enclosing arches, in fact at exactly the same height as the quadrant vaults in the choir gallery. This scheme, however, was soon abandoned and the vault as preserved in the north aisle constructed.' Wilson believes that when work was resumed rib vaulting was introduced into the aisle as part of a design to introduce rib vaulting throughout the nave.

There appears therefore to have been two distinct building programmes, the first from 1089 to the dedication of the church in 1100. In the last year of the reign of William Rufus, on Sunday, 15 July 1100, as Florence of Worcester recorded 'the church which Abbot Serlo, of revered memory, had built from the foundations at Gloucester, was dedicated with great pomp by Samson, Bishop of Worcester; Gundulf, Bishop of Rochester; Gerard, Bishop of Hereford and Herveas, Bishop of Bangor.' The second phase of building began sometime between 1100 and 1110 and continued until the completion of the whole building *c.* 1126, apart from the tower. Thus, though there is some doubt as to how much of the building was completed by the day of dedication in 1100, in all probability most of the nave, the upper part and turrets of the transepts and the tower belong to the second phase of building, after Serlo's death in 1104.

COMPLETING THE CHURCH
1100–1126

'Lucis onus Virtutis opus.'
Gloucester Candlestick, 1105

During the early years of the twelfth century Anglo-Saxon and Norman families set aside old antagonisms, and began to seek ways of living and working together. A new generation was emerging which had no personal recollection of the harsh subjugation of the country by the Normans. Intermarriage was becoming increasingly common. The king (Henry I) had himself married Edith, or Matilda as the Normans renamed her, sister to the King of Scots, who through her mother was descended from the royal house of Wessex. English thegns and yeomen began to christen their children with Norman names, while Anglo-Normans began to learn English and to draw apart from their kindred across the channel in the duchy. By the mid-twelfth century the two had become so intermingled that it was said by a contemporary writer that no man could say that he was either Norman or English.

THE CROWN AND THE MONASTIC COMMUNITY

In spite of the more eirenic spirit at large in the country the repercussions of the quarrel between William Rufus and Archbishop Anselm continued in the time of his successor, Henry I (1100–35), but on a different issue. When the archbishop returned from exile he refused to take the usual oath of homage and to be reinvested in his see by the new king. He argued that as a spiritual person he owed fealty to God alone and received all his power and authority from God, and not from the king. Henry could only reply that, though the archbishop was a spiritual person, he was also a great tenant-in-chief holding vast estates, and that for them he must do homage to the Crown like any other feudal landowner. Anselm refused, and there the matter stood for a while as neither would yield. Anselm even went into exile again. But in 1106 he and the king met at Bec in

Normandy and agreed a compromise which was to apply not only in Anselm's case but in all future investitures of bishops. The newly elected prelate was to do homage as a feudal tenant for the estates of his see; but he would not receive the symbols of his spiritual authority from the king but take up his ring and crozier from the high altar of his cathedral as direct gifts from God.

This, however, was not the end of the matter for this and related issues were to arise again and again in the uneasy and often tense relationship between the Crown and the Church in medieval times. Though applying primarily to the position and privileges of the bishops, the principle agreed between Henry I and his archbishop also applied to others in the Church such as abbots who also enjoyed the revenue from vast land-holdings by virtue of their office. In appointing whom he pleased as bishops and abbots William the Conqueror behaved not only in a characteristically high-handed way, but in the case of the monasteries contrary to established tradition. According to the *Rule of St Benedict*, abbots were to be elected by their communities. Admittedly, in 1072 there was not much of a community at St Peter's when the Conqueror appointed Serlo abbot. But on Serlo's death in 1104 the now thriving community of over a hundred monks elected one of their own number abbot. Peter, who had been prior for eleven years, would have taken over the responsibilities of his office immediately on his election (5 August 1104), though Knowles gives the date of the start of his abbacy as 1107. This was the date, according to *The Annals of Winchester*, when he 'received the abbey' i.e., the ceremony of benediction which confirmed his election.

The circumstances in which the abbots of St Peter's received their office were to vary considerably though, according to the *Historia*, there were very few occasions when the

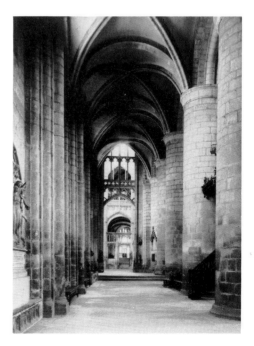

The nave, north aisle looking east: original Norman
vaulting, columnar piers and responds

Crown did more than approve the community's nomination. Abbot Peter (1104–13) is said to have 'taken over' ruling the house (*suscepit regimen*); and William, his successor is said simply to have 'succeeded' (*successit*) him. William Godeman nominated his successor, Walter de Lacy, though as the *Historia* states *Walterum nomine, consensu fratrum pro se abbatem elegit.* When Walter de Lacy died the community had to accept a stranger as their abbot, a monk from the great Benedictine abbey of Cluny in Burgundy. 'Two brothers were sent to the community at Cluny to inform them we have chosen Lord Gilbert as Abbot, to whom King Stephen, when he heard of the fame of his very great uprightness, at the petition of Milo his Constable, granted the Gloucester prelacy at his court in London.'[1] In Hart's edition of the *Cartularium Monasterii S Petri Gloucestriae* there is a document, reproduced as a frontispiece, which is a grant of liberties by Henry II (1154–89). The initial letter is formed by an illumination in which the king is represented crowned, vested in a scarlet robe, and seated on his throne. Before him is a Benedictine monk, kneeling, and receiving a charter from the royal hands. This beautifully painted initial well expresses the understanding between the king and the Benedictine community that though the abbot's authority was spiritual the temporal and material benefits enjoyed by the monastery were derived from their land-holdings and so ultimately from royal favour.[2]

RESURGENCE OF INTEREST IN ANGLO-SAXON ART

The growing *rapprochement* between the second and third generations of Norman and Anglo-Saxon families was to have an affect on many aspects of everyday life during the

The nave, west end of north aisle

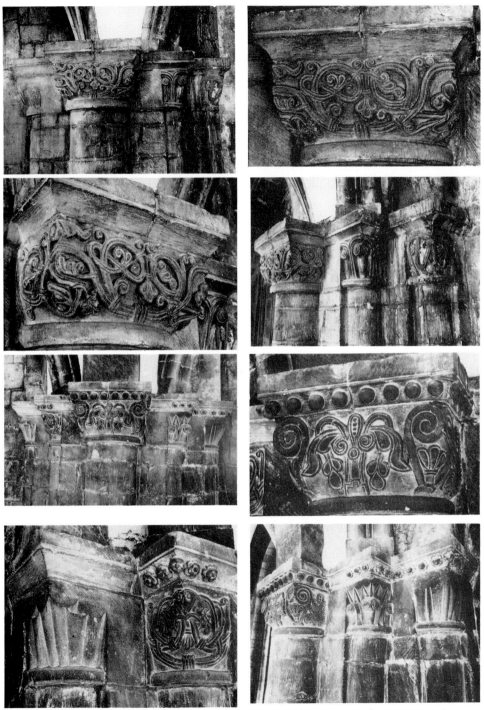

The nave, north aisle, towards west end, capitals on neighbouring responds, *c.* 1125 (Farley Photography)

twelfth century, not least on language and literature, art and architecture. For example, the revival of interest in Anglo-Saxon art was not only permitted but now positively encouraged by the Norman overlords. Even before the Conquest, through the work of the Winchester School the Normans were familiar with and admired Anglo-Saxon book-painting with its whole-page scenes framed within rich borders of acanthus leaves. After their victory in 1066, the Normans found themselves, in Zarnecki's words, 'the sole patrons of the arts in England, and heirs to a complex artistic tradition.'

As the Normans had pulled down old Saxon buildings to make way for their own massive works it may have seemed that native art, particularly stone carving, was being discouraged if not suppressed. In the early phase of building at St Peter's Abbey the Norman masons used very little decoration of any sort. But when work was resumed on the nave, after the dedication of the church in 1100, the builders began using a variety of decorative motifs particularly on windows and arcade arches. Even so, compared with some contemporary Romanesque work their use of such motifs was restrained. Their fairly restricted repertoire consisted mostly of the geometric patterns popular in Normandy at the time, zig-zag and star ornament, billet and lozenge, cable moulding and bead decoration, and of course chevron which had first been applied to arches in Normandy in the late eleventh century.

When the building of the nave was nearing completion, there was a mason at Gloucester familiar with pre-Conquest work and in sympathy with the revival of late-Saxon designs. Superb examples of his work can be seen on the two most westerly

 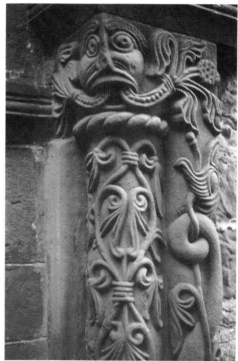

Kilpeck Church, Herefordshire, the porch (left) and detail of the right jamb (right)

capitals of the responds of the north aisle of the nave. Some have seen Viking influence in the design and possibly influence from contemporary metal work. On stylistic grounds these capitals have been dated *c.* 1130 which accords well with the probable date of the completion of the nave. The appearance of such work towards the west end makes one wonder what decorative work was lost as a result of Abbot Morwent's rebuilding. With the revival of interest in old Saxon and Viking designs and with such a gifted stone carver at Gloucester there could have been some exquisite carving on the western façade. But nothing has survived, unless this was the original location of the late Saxon or Anglo-Norman 'Christus' displayed in the Gallery Exhibition. Another example of considerable interest is the beak-head on one of the arches of the north arcade. This is very reminiscent of the Hereford school of sculpture in the eleventh and twelfth centuries, and the remarkable series of beak-heads around the eves of Kilpeck Church in Herefordshire, a church given to St Peter's Abbey in the 1130s. 'The grotesque heads on the arches at the west end are said to represent the mummeries of the Anglo-Saxon gleemen' (Masse).

ABBOT PETER AND THE GLOUCESTER CANDLESTICK

According to the *Historia*, Serlo's successor, Abbot Peter (1104–13) was remembered in the community for three things. Firstly, for having provided the monks with a valuable collection of books – *Petrus secundus abbas post Conquestum claustrum copia librorum ditavit.* Secondly, for having surrounded the abbey precincts with a high stone wall, and thirdly, for having acquired many further donations of lands. But he also provided the monastery with a candlestick of quite exceptional quality and beauty for liturgical use. It is one of the great masterpieces of Anglo-Norman metal work, and a very early and rare type of altar candlestick. It can be seen in the metal-work department of the Victoria and Albert Museum in London. Inscribed around the stem are the words: *ABBATIS PETRI GREGIS ET DEVOTIO MITIS ME DEDIT ECCLESIE SANCTI PETRI GLOUCESTRE*, which may be translated 'The gentle devotion of Abbot Peter and his flock gave me to the church of St Peter at Gloucester.' The candlestick is 51 cm (20 in) high, excluding the pricket, and made of an alloy of copper, zinc, silver and a very little iron. The percentage of silver is high, almost twenty-five per cent in the base. It is not made, as used to be thought, of bell-metal since it contains virtually no tin.[3] It was cast by the lost wax process in three sections; the foot to the lowest node, the stem to the middle node, and the greasepan with the upper node. The three sections are held together by an iron rod which also forms the pricket.

There are two further inscriptions on the candlestick. Round the greasepan are the words *LUCIS ON{US} VIRTUTIS OPUS DOCTRINA REFULGENS / PREDICAT UT VICIO NON TENEBRETUR HOMO.* Though the general sense is clear, a precise translation is difficult. Oman suggested 'The debt of light is the practice of virtue. The glorious teaching of the Gospel preaches that man be not benighted by vice.' Borg has offered a more literal translation 'The burden of light is the work of virtue. Shining doctrine teaching that man be not shadowed by vice.'[4] Both Oman and Harris,[5] comparing the style of its decoration with illuminations in manuscripts of the period, considered it to be English work. Borg agrees: 'the decoration of the candlestick fits securely into the late 11th early

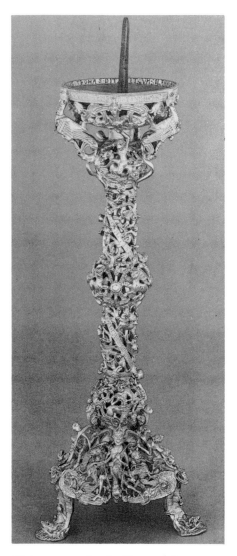

The Gloucester candlestick, 1110, (Victoria and Albert Museum)

12th century Anglo-Norman Romanesque style.' He believes it could have been made in Gloucester though Harris has put forward evidence that it was commissioned from a Canterbury workshop. In either case, as Borg comments:

> . . . we can have no doubt that the person who designed it was intimately familiar with the styles then current for embellishing the books that found their way into major cathedral and monastic libraries. In this context, the note in the *Historia* that Abbot Peter gave a large number of books to the monastery at Gloucester, may be significant. However, it may be doubted whether an artist of the calibre of the maker of the candlestick would need to resort to illuminations for his ideas ; he may just as well have worked from a pattern book of his own or from a memorized repertoire of decoration.

For many years it was thought that the candlestick was one of a pair, but more recent research makes it 'safer to assume there was only one.' It has long been compared with a

pair of candlesticks, at Hildesheim in Germany. These are of the same basic design, with a tall three-noded shaft and with a base with three feet, but in detail there are many differences. On the Gloucester candlestick, for example, dragons' wings provide the triangular borders of the base, and their tails are looped back over the shoulders of little crouching men. On the Hildesheim candlesticks there are also three dragons, but they are all on the base proper, facing the shaft, and each has a figure riding on its back. The spaces between the dragons are filled with twining tendrils. The Gloucester candlestick, on the other hand, is more complex in its design having additional dragons in conflict with human figures, and this theme is continued on the lowest node, which shows a man riding a dragon and a winged centaur. The lower stem of the Gloucester candlestick is also more warlike than the Hildesheim pair, having an ape-man fighting a dragon among foliage.

The central nodes also differ, with the symbols of the Evangelists on the Gloucester candlestick, and another more complex foliage pattern on the Hildesheim pair. The upper shaft of the Gloucester candlestick continues the theme of the lower shaft, though in a subtly different form. On the Hildesheim pair there is a repetition of the foliage growth, without clambering figures but with the addition of birds. The upper node on the Hildesheim pair has three human masks, while the Gloucester candlestick returns to the theme of the dragon conflict and mythological monsters. In both, the greasepans are supported by creatures which are clearly dragons on the Gloucester candlestick but less clearly identifiable on the Hildesheim pair.

The Hildesheim candlesticks are usually dated *c.* 1000, but whether there is a direct relationship or a relationship through some common factor with the Gloucester candlestick is still an unresolved question. But, as Borg points out, the two wealthiest

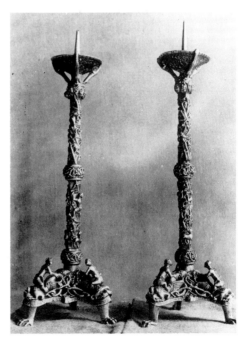

The Hildesheim candlesticks *c.* 1000. (Kunstgre-schichtlichen Institut der Philipps-Universitat, Marburg)

metal workers in England after the Conquest were Otto and Theodoric, both German names. According to the Domesday Book they had considerable land holdings. The former made the cast bronze tomb for William the Conqueror at St Etienne, Caen. This suggests there may well have been German or Ottonian influence on English Romanesque metal work in the early years of the twelfth century. A suggestion which is further supported by the fact that in the second half of the eleventh century a number of west of England bishops, Hereford, Exeter, Wells and Sherborne/Ramsbury came from or had connections with this part of Europe.

It is said that mythical or fantastic creatures in medieval art are for purely decorative purposes and have no iconographical meaning. While this may be so in many instances it is not always the case. Borg takes seriously the possibility of an iconographical interpretation of the Gloucester candlestick. He suggests the general theme is set out in the inscription on the greasepan. The candlestick supports the light which is Christ, with the base showing a confusion of evil in the form of monsters and dragons. In some later candlesticks the combat of 'Virtues' and 'Vices' is represented with the shaft and top of the candlestick denoting a ladder of tribulation in the gradual ascent towards God. But on the Gloucester candlestick the light is reached through the medium of the Gospels represented by the Evangelists' symbols on the central node. If these features indicate the general theme some of the details of the design have obvious conotations. The dragons, for example, are seen as manifestations of evil. There is also a significant difference between the clambering figure on the stem below the node and that above the node. On the lower shaft a human form bearing a beast's head drives a sword into the throat of a small winged dragon ; but on the upper part of the stem, above the level of the life and teaching of Christ as represented by the Evangelists' symbols, another human figure attempts to ascend to the light by climbing through tangled scrollwork.

The candlestick was lost to St Peter's Abbey soon after it was made since an inscription on the greasepan reveals it was given to the cathedral at Le Mans in the late twelfth or early thirteenth centuries by a certain Thomas de Poche or de Poce (*Pociensis*). Subsequently it belonged to the Marquis d' Espaulart of Le Mans, and was then sold for about £800 to Prince Soltykoof. It was bought from his collection for £680 for the Victoria and Albert Museum in 1861.

ABBOT WILLIAM GODEMAN 1113–1131

After Abbot Peter's death in 1113, William Godeman was elected the 'third abbot of St Peter's after the Conquest' (*Historia*). Two events of particular interest took place at St Peter's during Godeman's abbacy. First, the *Historia* notes: 'It was at that time that the Solemnity of the Conception of the Blessed Mother Mary was first begun to be celebrated among us in England.' The Feast celebrating Mary's conception was brought to the western Church from the east by monks fleeing the iconoclastic persecutions of the ninth century, and soon began to be observed in Rome, Italy and Sicily. It may have been observed in England before the Conquest, but certainly shortly after Anselm arrived at Canterbury he either instituted or revived it, and promoted the observance of the feast day throughout the country. But whether or not the conception of the Virgin was immaculate continued to be a much debated subject in the western Church in the

early part of the twelfth century.[6] The introduction, however, of the Feast of the Conception was a significant development in the growth in the medieval church of what Marina Warner calls 'the myth and cult of the Virgin Mary.'

Secondly, the *Anglo-Saxon Chronicle* records that in 1122 'on the 8th day of the Ides of March', while the monks were singing mass, and the deacon had begun the Gospel 'Jesus passing by . . . lightning set fire to the steeple [sic] and the whole monastery and all its treasures were burned, except for a few books and three mass vestments.' While the *Historia* notes the fire, it gives no indication of its extent. But another chronicler confirms that the damage was considerable, 'the city and part of the monastery were burned.' If the fire was caused by lightning striking the spire, that is the conical roof of the tower, it must have spread rapidly across a path of wooden buildings to the town itself. F.S. Waller believed it was this fire which destroyed the wooden roof of the nave, the burning timbers causing the calcination of the lower part of the nave columns. The town and abbey were both to suffer considerably from further outbreaks of fire during the twelfth and early thirteenth centuries. With most of the houses and shops in the town being built of timber and crowded together such conflagrations and destruction were inevitable from time to time.

THE COMPLETION OF THE NAVE

Work on the nave of the abbey church continued through the abbacies of Peter, and his successor, Abbot William (1113–30). Much of the Norman nave survives. It is dominated by huge cylindrical columns which have narrow, round, convex capitals similar to those at Tewkesbury (consecrated 1121). The arcades are made up of seven of these immense piers, each over 9.1 m (30 ft) high, with a circumference of more than 6.4 m (21 ft), and placed approximately 3.8 m (12 ft 6 in) apart. Some Victorian

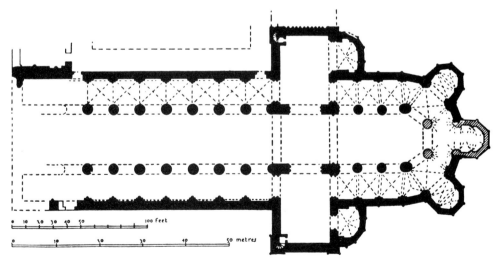

Plan of the Romanesque church from A.W. Clapham's *English Romanesque Architecture after the Conquest* (Oxford, 1934)

etchings show them with square bases, but the two most easterly columns, adjoining the choir screen, have octagonal bases. Hollar in his drawing of the nave (1644), before the bases were hidden by the eighteenth-century paving, depicts them with octagonal bases. Before the reconstruction of the west end there were probably nine in each arcade. The seven bays which have survived have round Norman arches of three contrasting orders, a pair of strong soffit rolls, a straight edge, and chevron at right angles to the wall. The arches are not wide, as the columns are comparatively close together. Above the arches is a string course with a variety of Norman decorative motifs, including billet and cable moulding.

The Elevation of the Nave

Above the arches the huge columns reduced the triforium to a narrow band of decorative work. But as Kidson notes 'the elevation has the characteristic French disposition, a comparatively narrow triforium, with a high arcade and a high clerestory on either side.' The extent of Norman influence in the design can be seen by comparing Gloucester, for example, with La Trinité, Caen and the Church of Mont St Michel. Each bay of the triforium consists of an over-arch with chevron decoration, and two twin openings with short columnar piers and responds, scallop capitals and chevron set at right angles to the wall. The main arches were built originally open to the roof space above the aisles, but they were later filled in leaving only a small opening from the roof space in each bay. There is no wall passage through the triforium.

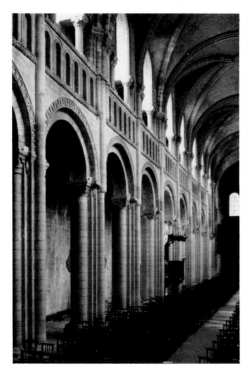

Caen, Eglise de la Trinite, eleventh/twelfth centuries. The elevation of the nave

Only traces of the original Norman clerestory have survived. Either side of most of the present clerestory windows chevron can be seen set at right angles to the walls, which in some bays turns over in an arch form. But much of the original clerestory was destroyed when the Early English vault was constructed, and later when the present window tracery was inserted. Thurlby points out that 'in the nave, the Romanesque main arcade and triforium remain untouched while the clerestory retains its original wall passage with sufficient detail to permit the reconstruction of a regular A:B:A rhythm with a central round headed window.' In the light of comparisons with clerestories in contemporary Romanesque churches in this country and in France, Wilson has drawn a reconstruction of the original elevation at Gloucester, at triforium and clerestorey level, bearing in mind what remains of the Norman work.[7] (See illustration on p. 66.)

It has been assumed for a long time that the nave originally had a high-pitched wooden roof either open or boarded across. It was this wooden roof which is thought to have been burnt down or seriously damaged in 1122 and/or in 1190. Masse (1899) unable to decide which fire caused the damage to the nave, wrote: 'Possibly in the fire of 1122 the nave roof was destroyed, and of this fire the piers in the nave show traces.' But later he states ' . . . the roof, which was made of wood, was destroyed by fire in 1190. Of this fire the piers certainly show the traces to this day, all have become reddened and slightly calcined'. The *Historia* does not specifically mention the nave roof burning on either occasion. Of the 1122 fire it records that 'once more the city and its principal monastery were ablaze with fire'; and in 1190 'a fire in the city burned down most of the town and almost all the workshops attached to the abbey . . .'

There are, however, features of the elevation which suggests the main span of the nave, like the aisles, was originally vaulted in stone. Thurlby refers to the construction of the present nave vault in 1242, and points to the extent to which the Norman masonry was taken down on either side of the springing. This, he suggests, is far more extensive than would have been necessary if the nave had been covered with a wooden roof and ceiling. The point Thurlby makes is well illustrated around the springing of the vault at the east end of the nave, on the north side, where vertical masonry lines on each side of the thirteenth-century springing show the extent of the dismantling of the Norman wall:

> The indications are that there was a stone vault over the nave from the outset. The evidence points in favour of quadripartite rib vaults over single bays. Above each main arcade pier at the triforium string course stand the present vaulting shafts. To the left and right of the shafts and continuing up to the ribs there is considerable 13th century infill before reaching the Romanesque ashlar. Had the 1242 vault shafts simply been introduced onto plain Romanesque walling then there would have been no need for the expanse of new masonry to either side. On the other hand if Romanesque vault shafts had to be removed before the 13th century work could be commenced then the infill would be explained.

But if such a vault was in place 'from the outset', it is difficult to explain the calcination on the nave piers caused, it is said, by falling timbers during the blaze which engulfed the nave in 1122. It is possible that after the original wooden roof was burned down, a stone vault was constructed to ensure that a similar disaster would never happen again. This vault, built between 1122 and the end of the decade, would have spanned the nave until it was replaced by the present vault in 1242. The fact that the vaults of Durham Cathedral have survived from the twelfth century should not obscure the fact

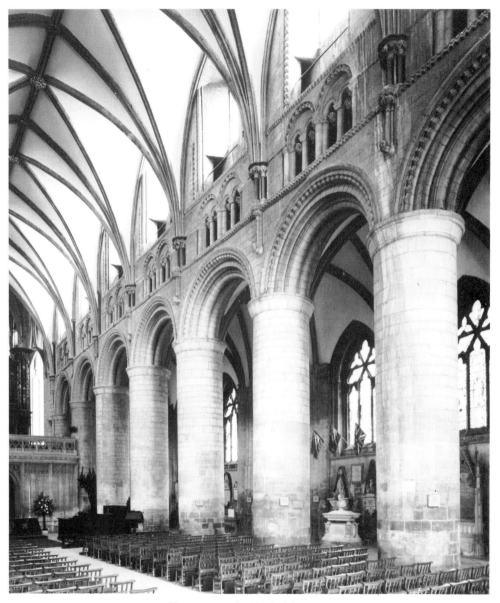

The nave, south side, looking east

that many Norman vaults, especially those spanning a wide area, collapsed or for other reasons were replaced in the thirteenth and fourteenth centuries. Thurlby, therefore, proposes the construction in the nave of grouped shafts similar to those over the minor piers in the choir of Durham Cathedral where, he notes, 'one detects exactly the same setback at the string course above the main arcade as at Gloucester.' But at Gloucester the springing was probably more analogous to the responds in the north aisle, which

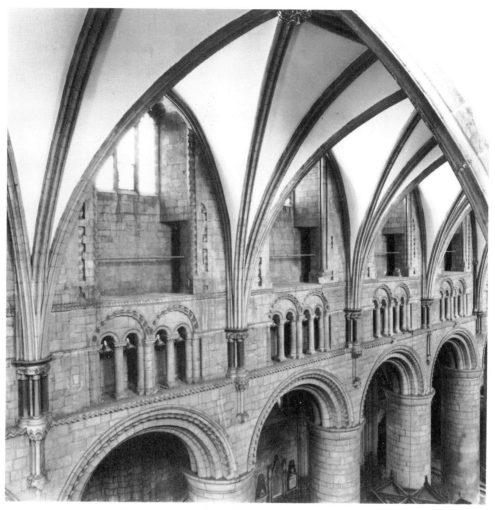

The nave, north side, triforium and clerestory passage

consist of a central half-shaft for the transverse arch, two nook shafts for the diagonal ribs and two nook shafts for the wall arches.[8]

The Origin of the Huge Cylindrical Columns

The origin of the design of the huge cylindrical columns has been discussed by antiquarians and architectural historians for many years. Were they invented by the Gloucester (or Tewkesbury) masons? They were used in at least five great churches, all roughly of the same date, in the Severn valley area. Or did they or their Norman masters derive the idea from elsewhere?

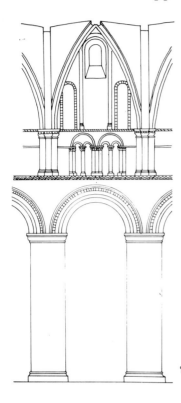

The nave, reconstruction of a bay of the Roman-
esque north elevation, Wilson, 1978

1. Some have argued that since many features of the Romanesque style are derived from Classical, and in particular Roman architecture, in constructing these huge columns the Norman masons were simply copying, utilizing the design of, Roman columns. Near St Peter's Abbey in the Westgate Street area there stood the baths of the Roman town, with the great exercise hall supported by columns over 9 m (30 ft) high. A fragment of one of these, found in 1971, can be seen in the foyer of the City Museum. One or more of these columns may have been standing or lying about in pieces in the eleventh century and, though of lesser diameter than the columns in the nave, the Norman masons realizing their structural possibilities may have decided to use the design. They could be used not only to provide height and stability to the nave, but having reduced the triforium to a band of decorative arcading they would make it possible to light the nave on the north side by a series of aisle windows above the level of the roof of the adjoining cloister walk.

However, another writer argues that 'it is highly improbable that any Roman columns stood to such a height in late 11th century Britain to give a direct prototype.' The piers are 9.3 m (30 ft 7 in) high, and were originally 9.6 m (31 ft 6 in) before they were effectively shortened at least 25 cm (10 in) by the concealment of their plinths in the pavement laid down in 1740. But would the abbot and his master mason need to have seen an actual column to recognize the advantages of using them? Kidson believes the designer of the similar series of columns at Tewkesbury knew the description of the Roman writer Vitruvius of his basilica at Fanum which employed similar columns, and

that the nave at Tewkesbury (and by implication, Gloucester) was a conscious eleventh-century revival of a Roman basilica.[9]

2. Others have argued that the origin of the huge columns lies in Burgundy, and that knowledge of the style came to this country via Lorraine and, more immediately, from a chapel which, according to William of Malmesbury, Robert of Lorraine built at Hereford when he became bishop (1079–95). The chapel no longer exists but a drawing of it has survived and Jean Bony, the French architectural historian, suggested it could well have been completed by the time Gloucester's nave was begun.[10] The upper chapel of Bishop Robert's building at Hereford is seen as remarkably similar to the narthex of the Church of St Philibert at Tournus in Burgundy, a church with which Robert as a monk of Cluny, would have been familiar.[11] St Philibert is a remarkable building belonging to the 'First Romanesque' period of Burgundian architecture centred on Cluny II in the early eleventh century. The tall cylindrical columns of the nave are made of far smaller blocks of ashlar and the diameter of the columns is half that of Gloucester's, though in the narthex the columns are sturdier. But it is not only on stylistic grounds that a link with this Burgundian church has been suggested. William of Malmesbury records, as does the *Historia*, that Bishop Robert laid the foundation stone of the abbey church at Gloucester in 1089, and not the diocesan bishop, Wulfstan, Bishop of Worcester. Bishop Robert may have drawn Serlo's attention to the advantages of the immensely tall columns used at Tournus and at other churches in Burgundy such as St Germain, Auxerre.

3. Another possibility is that pre-1100 Romanesque churches in the Normandy–Loire region of France supply as close examples of the use of giant columns as any churches in Burgundy, particularly in their chevets.[12] But whether these are parallel developments rather than possible sources of Gloucester's great columns is a matter of debate. It is argued that there is no need to go further afield nor to go beyond eleventh-century Anglo-Norman architecture for columns of similar girth, and that those in the nave at Gloucester are no more than a natural development of a process that had been going on for some time in Romanesque architecture. St Augustine's Abbey at Canterbury, according to Gem had 'uniform slender columnar piers (of no more than 3 ft 6 in diameter) in the apse hemicycle and in the straight bays of the choir.'[13] He also argues that Worcester Cathedral, begun in 1084, originally had the same arrangement. Shrewsbury Abbey (founded 1083), Great Malvern Priory (begun 1085) and Tewkesbury, like Gloucester, simply used columnar piers of larger diameter. But even if they are seen as part of a progression, in diameter and height, they are the earliest columns of such height and girth, and confined to the great churches of the Severn valley at Gloucester, Tewkesbury, Pershore, Evesham and Worcester.

The North and South Aisles

As already noted, there is evidence at the east end of the aisles which suggests Serlo intended to build a quadrant vault over the nave aisles, with a high-pitched wooden roof open from the ground and extending to a point above the triforium arches. Such a plan was abandoned, however, as work on the nave continued after the dedication of the church in 1100. The aisle now retains its original Norman rib vault with ribs of two

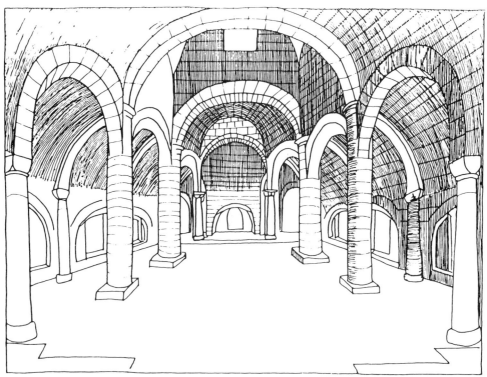

The bishop's chapel at Hereford, upper chapel looking east (after W. Stukeley). (Oxford, Bodleian Library MS top.gen. d.13)

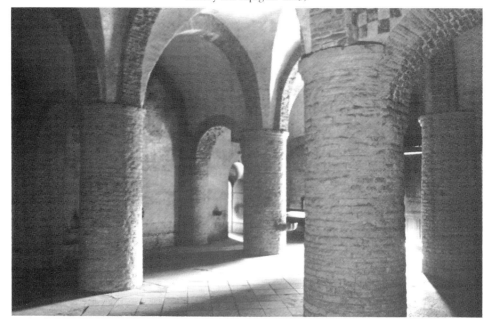

Tournus, Saone-et-Loire, France, Eglise S. Philibert tenth/eleventh centuries. The narthex

rolls and a spur between. The impressive series of responds are composed of five parts, a central half-shaft for the transverse arch, two nook shafts for the diagonal ribs, and two nook-shafts for the wall arches. The capitals vary in design, but those at the east end are without decoration, whereas the last two at the west end on the north side are richly carved.

The windows in each bay of the aisle have been considerably enlarged and contain Perpendicular tracery, but the jambs and heads are original Norman work. Even the original small, round-headed windows would have ensured that the nave was comparatively well lit for Norman times. With the stone work of the window frames cut well back it is impossible to know whether the Norman openings were glazed or shuttered. They would certainly have been glazed early on if not originally. At the west end of the aisle the window above the processional door was later half blocked up. The south aisle of the nave was vaulted in the same way as the north aisle, but by the early years of the fourteenth century the south wall was leaning out to such an extent that the vault had began to collapse or was in danger of doing so. The whole of the Norman vault was taken down and the existing vault built. At the east end of the aisle fragments of the original springing of the wall arches can be seen.

The West End of the Nave

The two (or three) most westerly bays of the Norman nave were taken down by Abbot Morwent (1421–37) together with the corresponding portions of the aisles. Little is known about the plan or the elevation of the Norman west end apart from the fact that it had two flanking towers, one of which collapsed in the latter part of the twelfth century. Consequently, a number of questions arise. Was the Norman nave longer than the present nave? Why did Abbot Morwent rebuild the west end at all? Did he rebuild using the original foundations?

Some have thought that he shortened the Norman nave by one bay. In the absence of archaeological evidence which could settle the issue, evidence centres on alterations to adjoining Norman buildings and the likely spacing out of the piers of the Norman arcade at the west end. Adjoining the north wall of the nave at the west end is a Norman slype or passage leading from the outer court into the great cloister. It has been suggested that this has been shortened by a bay at the west end. According to this hypothesis the passage, as originally constructed, would have extended well beyond the present line of the west end of the nave. The thirteenth-century entrance corridor of the abbot's house, adjoining the slype on the north side, apparently extended southwards to the entrance of the slype, and above formed a corridor-room to the abbot's chapel. But when the present west front of the slype and the chapel were built, both were shortened, and an awkward connection created between the corridor-room and the abbot's chapel. If the extended slype represents the original building line at the west end, and assuming that the slype and abbot's chapel shared the same frontage with the nave, then there can be little doubt that Abbot Morwent shortened the Norman nave. This was St John Hope's conclusion.

The second consideration is the probable position of the most westerly piers; the

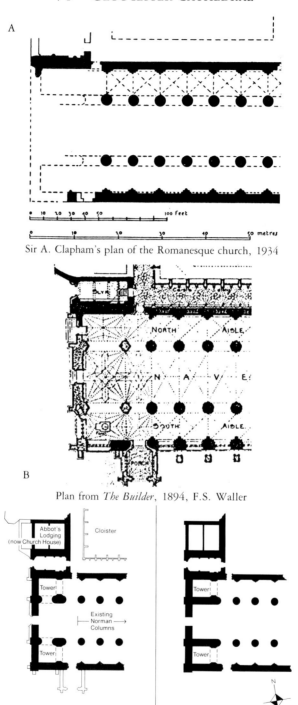

A

Sir A. Clapham's plan of the Romanesque church, 1934

B

Plan from *The Builder*, 1894, F.S. Waller

C

Alternative reconstruction of Romanesque west end, Bryant, 1990

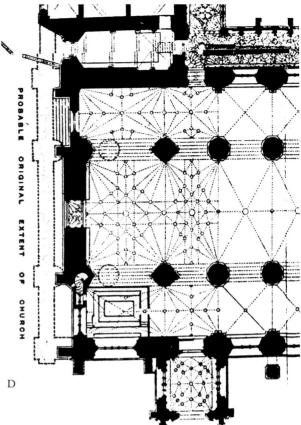

PROBABLE ORIGINAL EXTENT OF CHURCH

D

Plan of the west end of the nave from
Gloucester Cathedral Records

fluted columns were almost certainly raised on the foundations of Norman piers. But the greater span between the fluted columns and the terminal wall raises more complex questions than Masse suggested when he observed that 'anyone who will take the trouble to space out with a compass the distance between the centre of the piers in the nave on a plan will be inclined to fall in with St John Hope's suggestion.' There is no record of bases of Norman piers having been found beneath the paving, or of projecting walls as marked on Sir A. Clapham's plan (A). In order to narrow the span to that which

The sky-line of Gloucester from the west in the early fourteenth century. (Royal MS 13A III f 82)

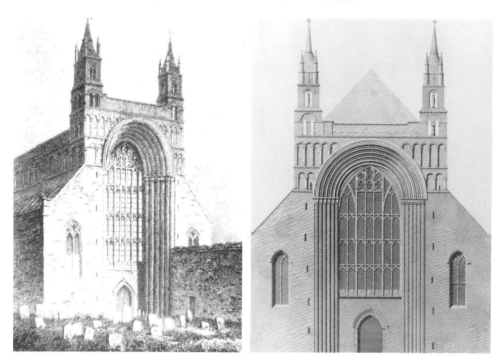

Left: Tewkesbury Abbey. Right: detail of west end from nineteenth-century drawing, John Carter, 1807

separates the columns in the main arcades, it is necessary to suppose that the projecting walls extended, on the line of the arcade, either to the required distance, or that they extend still further to become one with the Norman columns replaced by the existing fluted piers (C). The purpose of these projections, possibly involving ovoid or elongated piers, would have been to provide support for the corners of the western turrets or towers not resting on the main walls of the building.

But a third consideration is the point at which the early fifteenth-century work joins the walls of the Norman nave. The 1894 plan in *The Builder* and Sir A. Clapham's plan indicate that at the north-west angle the Norman stonework of the nave walls continues a metre or so into the terminal wall. If there is evidence in the disturbed masonry in this area to support this, the west end would seem to have been rebuilt on the Norman foundations. In which case Abbot Morwent did not shorten the nave, but remodelled it, taking down the western towers and their foundation walls within the building. But does the evidence in the stonework of the west end support this? There is certainly reused Norman ashlar in the terminal wall, but the whole construction as well as the design is of the fifteenth century. Or did Abbot Morwent remodel the exterior and reface the external wall?

While doubts remain, there are certain features which strongly support St John Hope's contention that the Norman west end extended a further bay to the west (D).

1. Above the over-restored thirteenth-century façade of the Norman abbot's lodging (Church House) there is a gable end resting on what appears to be Norman

masonry, and containing stepped blind arcading similar to that on the gables of the north and south transepts. If, in spite of later rebuilding or remodelling, this Norman gable is *in situ* it probably marks the western building line not only of the abbot's lodging but of the extended western slype and the west end of the church. It would be unusual for these buildings not to share the same alignment.

2. If the distance between the Norman piers is taken as 3.8 m (12 ft 6 in), a further bay, with projections from the terminal wall to provide bases for the towers, would extend the nave to roughly the same alignment as that indicated by the gable end and extended western slype. There can be little doubt that the slype and the chapel above it have been shortened by at least one bay at some time. Restoring these bays, would bring the building line of this range well forward of the present west end.

3. The evidence in the wall at the west end of the north aisle is not easy to interpret, but measurements seem to confirm that the vertical masonry line which curves round to the east higher up, is on the line of a Norman wall arch reaching up into the vault of the bay. With the Norman respond removed on the west side of this arch, large stepped blocks of ashlar were set into the curve where once there was a wall arch as in the bays further east. The respond which has been removed would have provided for a further bay to the west.

4. The masonry of the north west corner and, in particular, the small attached vaulting-shaft and its base set into the corner, are part of Abbot Morwent's rebuilding work and not, as suggested by Waller and Clapham, *in situ* Norman work. The point at which Abbot Morwent's work abuts the Norman work in this area is in the north aisle wall, a metre or so from the corner and not in the terminal wall. It would seem, therefore, that the entire west wall of the nave was built in the early fifteenth century on new foundations east of the original Norman terminal wall, and abutting the Norman work at the west end of the north aisle.

If a further bay of the Norman nave is projected westward, then the pier to the west of the fifteenth-century fluted pier would stand too far to the east to correspond with the scar of the Romanesque vault wall arch on the north wall. It is necessary, therefore, to suppose that the fifteenth-century fluted column replaced a Romanesque pier of larger dimensions than the rest of the piers in the nave arcade. This seems to confirm that the original Norman pier was probably ovoid.

But it also suggests a further possibility. Was there at Gloucester a large central western tower, as at Hereford (commenced in the twelfth century though not completed until the fourteenth), and no more than comparatively small turrets on either side? The ovoid piers would then have supported transverse arches in various directions, as in the eastern apse, including an arch or series of arches across the main span of the nave which would have supported the projected central tower on the east side. The documentary evidence which refers to twin west towers could be taken as alluding to small turrets similar to those adjoining the terminal walls of the transepts. As Thurlby has pointed out 'this would make it easier to explain the long time between the fall and rebuilding of a tower at the west end. The fall of a tower would almost certainly have damaged the south west corner of the building, whereas the fall of a turret could have left the building below largely untouched.'

The only documentary evidence of the elevation of the west end is a rough drawing in

the margin of a thirteenth-century manuscript in the British Library. At the foot of f.82v of Royal MS 13 A III there is a drawing of the skyline of Gloucester from the west, showing the west end of the abbey church. (See illustration on p. 71.) Unfortunately the left-hand side of the picture, showing the north-west corner of the nave is smudged and worn, and partly covered by a building in the foreground, possibly St Mary's Gateway. The most noticeable feature is the tall spire. What is probably one of the south transept towers, Ashwell took to be the south-west tower. At the west end there is clearly a large thirteenth-century window, judging by the tracery, set within a recessed arch. This seems to suggest that the west end of the nave may have been similar to the west end of Tewkesbury Abbey which was being built at roughly the same time. In that case between the twin western towers there would have been a triumphal arch composed of receding orders and with a small central doorway.[14] If the great door in the south porch came originally from the doorway in the Norman west front, the west door must have been round-headed, and therefore without a tympanum.

Thus, while much of the Norman nave survives, much has been lost through later rebuilding. The north aisle has survived almost intact except for the enlarged window openings and the reconstruction of the two or three most westerly bays. Again, apart from the rebuilding of the west end, the majestic central space retains much of its original Norman work. The series of massive columns either side and the arches linking them down the full length of the nave, surmounted by the diminutive triforium and clerestory passage, presents a fine vista of Romanesque work. The clerestory windows retain fragments of Norman work in the surrounding stonework. The vault, however, does not sit comfortably on the Norman arcades, though in itself it is a good example of Early English work. The south aisle has lost its round-headed windows and original vault, but the Norman responds survive, propped up by large external buttresses. The abbey chronicle does not give the date of the completion of the nave; it could not have been much later than 1130.

The External Aspects of the Norman Church

The church was built on a low ridge sloping down to the River Severn. This partly explains the rising levels within the building. The west end is raised several steps above the ground outside, and inside there are steps up to the transepts, and to the liturgical choir. There are further steps up to the presbytery and still further steps to the high altar. From the transepts there is a considerable flight of steps up to the side entrance to the presbytery, and more steps to the ambulatory. This rise in the ground towards the east end is also evident outside the building. The substantial buttresses against the south aisle of the nave, and the buttressing of the tower are evidence of settlement in the building largely due to the fact that part of the south side of the building was raised over a Roman ditch. Heighway points out that excavations in the 1970s established that the base of the Roman wall crosses the nave, diagonally from north-east to south-west, at the first bay of the nave from the crossing. This means that the second to fifth bays are over the Roman ditch.

There are no surviving features of the Romanesque church at the west end. On the south side of the nave the only Norman features to survive are the buttresses between the

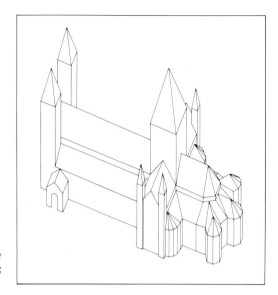

Axonometric reconstruction of the Romanesque abbey church of St Peter, Gloucester (crossing tower turrets omitted). C. Wilson, 1981

clerestory windows. But on the north side the frames of the north aisle windows are still in place though somewhat altered. At clerestory level, as on the south side, the shallow buttresses remain *in situ* between the windows. Around the base of the tower some Norman work can be identified, including the fragment of blind arcading at the north-east angle. The most noticeable external feature of the Romanesque building are the twin towers of the north and south transepts. Though much restored these retain their Norman wall decoration consisting of bands of tall round-headed arches and interlacing arcading, and rebuilt pyramidal roofs.

At the east end, the ambulatories and chapels are obviously Norman work, with thick mortar joints and characteristic tooling, horizontal on a flat surface and vertical on a rounded surface. Though some of the windows have been enlarged and filled with later tracery, a number retain their original form. The arch over some of the windows has been raised, though the position and line of the original arch can still be seen in the stonework either side of the window. A break in an original string-course is sufficient to confirm that some of the Norman windows have had their sills lowered. Other windows have been blocked up, for one reason or another, while some have been partially obscured by a reredos. The north-east and south-east chapel roofs have been raised, the remains of a corbel table indicating the original level. Wilson's axonometric reconstruction of the Romanesque church from the south-east, in which the crossing tower turrets are omitted, gives a striking impression of the external aspect and general proportions of the original abbey church.

CHAPTER FIVE

FOUR ABBOTS
1131–1205

'St Peter' monastery in Gloucester administered
this church in peace and tranquility.'
Geraldus Cambrensis on Llanbadarn Fawr Church

There were only four abbots of St Peter's between the years 1130–1205. In recounting the events of their abbacies the *Historia* makes no mention of any building work. This is not surprising since work on the church was more or less completed; and though work on the claustral buildings must have continued for some time it was of no great interest or importance from Abbot Froucester's perspective. The Norman refectory and monks' dormitory had both long since been pulled down and rebuilt, and other twelfth-century work had been remodelled or replaced. In selecting his material Froucester was more concerned with the past achievements of the abbey, and with its present eminent position among the religious houses of England. He therefore dwelt on his predecessors' reputation for holiness or learning, their influence in the wider life of the church, their acquisition of property and privileges for the monastery and their part in the enrichment of the abbey church. The one event affecting the fabric of the church, the collapse of a tower, is recorded in graphic detail. Otherwise the *Historia*'s account of these years (1131–1205) is confined almost entirely to various domestic matters with occasional references to the national scene, to the turbulent events of the reigns of Stephen (1135–54) and Henry II (1154–89).

ABBOT WALTER DE LACY 1131–1139

Abbot William Godeman, before he left to go into retirement, appointed Walter de Lacy abbot 'without asking the agreement of his chapter'. Walter had been his chaplain for eleven years, and had been in the monastery since the age of seven. It is noted that 'his parents offered him to God and St Peter at the very tender age of about seven years

because of their devotion to religion and the monastic way of life; and he acquired much wealth for the church from his father as well as from his mother Emma.' The practice of boys being admitted to a monastery was provided for in the *Rule of St Benedict*. It was common practice, particularly among noble families, for parents to give a younger son to the monastic life and to take the vows on the child's behalf. A group of boys of seven and upwards had formed a normal part of the life of Benedictine communities from early times. The boys were placed in the charge of a master who was responsible, under the abbot, for teaching them and disciplining them. They were fully integrated into the community and were normally expected to be present in the choir for all the offices.

The motives of parents in giving their children to the monastic life were, of course, mixed. If, as was almost invariably the case, they were younger sons who would not inherit the estates, life in a monastery provided for their future. They would be with others of an aristocratic background and if religiously and intellectually inclined would be able to pass their days pursuing their particular interests. With increasing numbers of servants employed by Benedictine houses to carry out more menial tasks, they would be well provided for and live out their days in security and comparative comfort. But the parents also hoped for spiritual benefits from the donation of estates which were expected to be made with the child-oblate for his future support and the support of the whole community. The community for its part would pledge itself to pray for the soul of such benefactors, here and hereafter.

In his *Medieval Monasticism* Lawrence notes that:

> In the complex medieval penitential system, the goodwill of such a community was vital for peace of mind. The Penitentials laid down a graduated scale of satisfactory penances appropriate for every sin. Fornication, for example, with a virgin involved a year's penance, during which time the penitent was required to fast on bread, salt and water, to abstain from the sacraments, and if married from conjugal intercourse. Moralists of the twelfth century declared that the balance of satisfaction still outstanding at death had to be made up in purgatory. The best hope, therefore, lay in the possibility of commutation or substitution.[1]

In this way periods of canonical penance might be served by others, or commuted to alms-giving, pilgrimage or other good works. The gift of a child or an estate to a monastery was in itself a meritorious act which might remit a long period of penance.

William Godeman had a reputation for holiness, and in particular for gentleness in his dealings with others. Nevertheless, the *Historia* gives details of a number of disputes which developed between St Peter's and neighbouring or dependent houses. Such conflicts were usually about property and were, in fact, commonplace in medieval times particularly between religious houses and dioceses. In many cases those in dispute would resort to fabricating documents to prove their case. There are thought to be a number of such documents among the charters and leases of St Peter's Abbey now held in the cathedral library. During Walter de Lacy's abbacy there was a dispute between the Bishop and Chapter of Hereford and the abbot and monks of St Peter's concerning the latter's right to St Peter's, Hereford. But in the same year, 1134, there was no such dispute when 'Hugo, the son of William, the son of a Norman, gave to God and to St Peter and the monks of Gloucester the church of St David at Kilpeck, with the chapel of St Mary de Castello, and all the chapels and lands which belong to them.' The church of Kilpeck in Herefordshire was to remain in the possession of St Peter's until the Dissolution. The

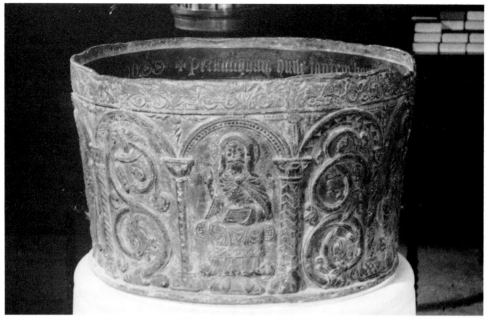

The Lancaut Font *c.* 1140

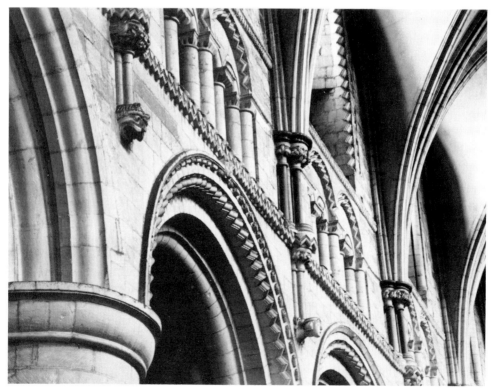

Romanesque decorative work on the north elevation of the nave

interest of Kilpeck Church today lies in its exceptionally fine Romanesque carving of the Hereford School. The carved head at the top of the arch at the west end of the north arcade of the nave at Gloucester is very similar to the beak-heads at Kilpeck. (See p. 56.)

At this time the abbeys of Tewkesbury and Gloucester played a significant part in establishing monasticism in South Wales, and in particular in Glamorgan. St Peter's Abbey established a dependent house, the Priory of St Michael the Archangel, at Ewenny in *c*. 1130, and St Michael's, Colwinston was granted to the abbey in 1141 eventually forming part of the endowments of Ewenny Priory. In the *List of Donations* in the Gloucester cartulary it is recorded that Robert, Earl of Gloucester, made the Priory of Ewenny free of toll throughout all his lands during the abbacy of Walter de Lacy. The donation required that 'there shall be therein a convent of at least thirteen monks of the order of Gloucester.' There are still tiles in the presbytery of the church bearing the arms of St Peter's Abbey (the crossed keys of St Peter and the sword of St Paul) and of William Parker, the last Abbot of Gloucester and the arms of benefactors of the priory.

The Lancaut Romanesque Font

At about this time (1130–40) in the small church of St James at Lancaut in the Wye valley, now a ruin standing a short distance from the banks of the river, a new lead font was being installed. It was one of a number made by a highly skilled craftsman probably working in the Bristol area. Six of the fonts have survived, all made from the same mould. The lead was cast in flat strips, and then welded together to form a cylinder, the bottom of the font being cast last. The block which was used consisted of four arcades, two enclosing seated figures, probably intended to represent Apostles, and two with foliage, the figure and foliage arcades alternating. Of those which have survived four are decorated with twelve arcades, one with eleven. The font from Lancaut is the smallest with only ten. The fonts have a strip of delicate palmettes at the top and bottom, though the bottom strip is missing on the Lancaut font. The bases, the colonettes, the capitals, the arches and the spandrels are richly decorated.

Zarnecki notes that 'the scrolls within the arcades resemble designs in manuscripts, for example the Winchcombe Psalter *c*. 1130, while the linear and decorative treatment of the figures resemble the Anglo-Saxon figure style in, for example, the *Troper* though the chip-carved band across the robe of one figure is a typically Romanesque device. The

Initial drawing of a Benedictine abbot

font is a fine example of the continuing popularity of pre-Conquest styles in the 12th century.'[2] England was one of the principal producers of lead in the Middle Ages. In many ways it was an ideal material for fonts, being used from Roman times for water pipes and cisterns. In all, thirty lead fonts have survived in this country of which sixteen are Romanesque. A few are to be found in France. The Lancaut font was removed from the church in the Wye valley in 1890 and restored by the Marling family of Stroud – as recorded on an inscription inside the rim of the font. It was given to the cathedral by the family in 1940, and set on its podium in the lady chapel in 1987.

The Robert of Normandy Connection

During Walter de Lacy's abbacy, 'in the year of our Lord 1134, Robert Curthose, Duke of Normandy, the son of William the Conqueror died in Cardiff Castle on 3rd February. But he was buried with due honour in the church of St Peter at Gloucester before the high altar.'[3] William the Conqueror had left three sons; to Robert, the eldest he bequeathed not the English Crown but his own inheritance of Normandy. To the second son, William Rufus, who had long been his father's loyal helper, he gave the throne of England, and to Henry, the youngest son, he left only a legacy of £5,000. On his father's death at Caen, William Rufus hurried over to England and was duly crowned by Lanfranc, Archbishop of Canterbury.

As King William II of England (1087–1100), he fought his elder brother Robert who harried him at every opportunity. In 1096, however, Robert 'seized by a sudden access of piety and a spirit of wandering and unrest' went off on the First Crusade, mortgaging his entire dukedom to his younger brother for £6,666 in order to raise and equip a large army. In the attempt to deliver the Holy Sepulchre from the Turks and set up a Christian kingdom the duke fought courageously. Late in 1099 he made his way homeward, only to find on his arrival in Normandy that William Rufus had been killed in a hunting accident in the New Forest on 2 August 1100 and his youngest brother, Henry, had had himself crowned King of England.

Robert, having once more taken possession of his duchy, planned to cross to England to support the barons who had taken up arms against Henry in support of his claim to the English Crown. But Henry bought him off with £3,000, an irresistible temptation to the impecunious duke. That, however, was not the end of the matter for after a long period of aggravation and bitter hostility Henry invaded Normandy and defeated his brother, capturing him at Tinchebrai in 1106. He sent Robert into strict confinement in Cardiff Castle, and kept him there for the rest of his life. As the *Historia* noted he died in 1134, and at his own request was buried in the abbey church of St Peter at Gloucester 'with due honour' before the high altar.

The tradition that Duke Robert was buried 'before (*coram*) the high altar' goes back, therefore, at least to the time of Abbot Froucester (1381–1412). Of course Froucester in his *Historia* used material preserved in the abbey, and while the account of Walter de Lacy's death may well be contemporary, the note about Duke Robert probably represents a later tradition. What is certain, however, is that at the end of the fourteenth century the community believed the duke was buried in the presbytery in front of the high altar. For this reason Gilbert Scott, in laying down the tile pavement in the

Romanesque decoration on fragment of arch, possibly from the Norman cloister, in Church House

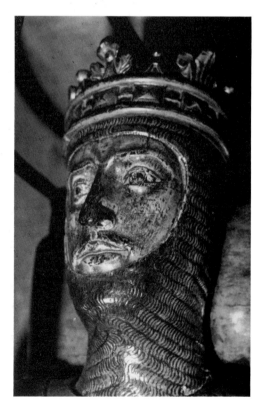

Detail of effigy of Robert, Duke of Normandy
c. 1134. Effigy *c.* 1240

presbytery in 1871, marked Duke Robert's traditional burial site with plain tiles. But as far as is known, no excavations took place at the time to establish whether there was a burial of any sort in that area. Some, such as Masse, have argued that there is not sufficient depth of earth for an interment. According to F.S. Waller's sectional drawing of the crypt there is at least 0.6 m (2 ft) of earth above the vault of the crypt. This would provide sufficient depth for a burial since it was common practice in medieval times to set stone coffins only inches below floor level, sealing them with a ledger. The alternative place for the burial, if the evidence of the *Historia* is set aside, is the chapter house where Duke Robert's name is written in Lombardic script in the wall arcade along with other early donors to the abbey. The inscription runs, *Hic jecat Robertus Curtus*. In the thirteenth century a painted wooden effigy of the duke was made. Where it was placed originally is not known. At the end of the sixteenth century it rested on a mortuary box in the centre of the presbytery 'before the high altar' (See plate 6).

The Death of Abbot Walter de Lacy

The *Historia*'s account of the death of Abbot Walter, which is clearly contemporary, is of particular interest for the insight it gives into the way a monastic community in medieval times was affected by such an event, and the attitude of the monks to suffering and death:

> And now, Walter de Lacy, in ripe old age, that he might be worthy of the life to come, was blessedly touched by the divine chastisement, so that, as we believe, he was being purified beforehand. Thus after he grew old, from the time he entered the service of God in all that concerns the religious life, he was stricken in his eyes about two years this side of his life's end. So when he had greatly rejoiced for a while in this chastisement, as we heard from his own mouth, on 11th December he was happily with the monks singing the psalms of the Saturday liturgy, chanting with the psalm-singers. He left out not a single verse. He went to bed and stayed there for a short time. And soon returning very early in the morning to the church, he was devoutly present at the mass being celebrated in honour of Mary the Mother of God. And when, having performed the sacred mysteries, he with his whole body prostrated was to sing the seven Penitential Psalms with the hymn *Jesu nostra Redemptio* and adore the divine

Label stop, showing face protruding from gaws

sacramental species, suddenly he was stricken with a paralytic illness. The Mass ended he was carried off to his bed, and fortified by partaking of the Body and Blood of Christ, he remained some days totally incapacitated in body.

Then having recovered somewhat his bodily strength and speech, as long as he survived he continued tireless in prayer, in confessing his sins, in almsgiving, in making satisfaction, so far as he could to his God and to men. When therefore the festival of the Lord's Nativity was completed and the Purification of the Holy Mother Blessed Mary herself was upon us the same venerable father Walter recovered enough to celebrate the said festival himself joyfully praising God. Soon after dawn, while the brothers sang together and rejoiced, he again confessed his sins and devoutly received Holy Communion. When Vespers was over his own most personal blessing having been again requested and received with Absolution and the Kiss of Holy Blessedness, he was again stricken with paralysis and deprived of the use of all his members. He suffered for six days and nights. When they were over, nine and a half years after he became prelate, about the third hour of the day, he sent forth his spirit. He was buried by the venerable Abbots Reynald of Evesham and Roger of Tewkesbury on 8th February and in the year of our Lord 1139, and the fifth year of the reign of King Stephen.[4]

ABBOT GILBERT FOLIOT 1139–1148

The death of Henry I on 1 December 1135 marked the beginning of a long period of great unrest in the country, with civil war breaking out between supporters of Stephen of Blois, a nephew of Henry, who had been crowned king with the support of the Great Council and Henry's daughter Matilda whom he had wanted to succeed him. Milo, or Miles who was Constable of Gloucester Castle and sheriff of the county at first supported Stephen as king, and in 1138 received him at Gloucester. But the following year when Matilda landed in Sussex, Miles with a considerable proportion of the baronage

Label stop in Chapter House, resembling owls

transferred his allegiance to her. In the autumn of 1139 Miles accompanied Matilda to Gloucester, became her liege man, and began campaigning for her. In a pitched battle near Lincoln in 1141, Stephen was captured and brought to Gloucester Castle, but then transferred to Bristol. Matilda, who had been staying at Gloucester, set off to London but one reverse after another followed. At Oxford she bestowed on Miles the earldom of Hereford but, forced to release Stephen in exchange for her half-brother Robert, Earl of Gloucester, she lost ground steadily, being beseiged first at Winchester and then at Oxford. She managed to escape, it is said, by being let down by a rope at night from the castle keep, to thread her way through the hostile outposts and then on foot through the snow to Gloucester. Miles, who had supported her loyally and fought bravely, died in December 1143, accidently shot in a hunting accident. A controversy broke out between St Peter's Abbey and the canons of Llanthony Priory, just south of the town, as to who should have his body for burial. Both claimed the honour but in spite of Abbot Foliot's vigorous arguments he was buried at his own foundation, Llanthony. His son, Roger, inherited the earldom but forfeited it shortly afterwards through a rebellion, which was suppressed in 1155.

The *Historia* states that 'after Walter de Lacy was buried, two brothers were sent to the community at Cluny to inform them we have chosen Lord Gilbert as Abbot.' However, it was not the community that had chosen Gilbert Foliot as their new abbot. The initiative came from Milo, Earl of Hereford, his kinsman. The suggestion received the approval of King Stephen when he heard of Foliot's reputation as *vir eximiae facundiae et sapientiae*, a man of very great resourcefulness and wisdom. Nevertheless, Foliot was welcomed by the monks of St Peter's:

> . . . with great rejoicing and singing of praise on the Festival of Pentecost which that year was celebrated on 11th June. And on the following day after he was enthroned with the approbation of many of both orders and with joy and exultation as befitted such a man in the Lord who acquired as much wealth within for the same church as beyond its walls for the priories outside. Moreover he obtained for the said church many and varied privileges, both from the pope and the bishops.

As far as the *Historia* is concerned, the story of Gilbert Foliot ends with his appointment nine years later as Bishop of Hereford:

> In the year of our Lord 1148 Robert de Bethune, beloved of God and men, bishop of Hereford, went to the Council of Reims, and was taken ill there. He departed this life on 16th April, the Friday in Easter

Damaged Norman capital, original location unknown

Week, having been confessed and absolved by the Apostolic Legate and many other archbishops and bishops. The venerable Abbot of Gloucester succeeded him in the bishopric. He was consecrated with great pomp by Archbishop Theobald at St Omer in Flanders with the approval of the Lord Pope on 5th September in the tenth year of his prelacy as abbot.

It is said that he obtained the bishopric through the influence of Thomas á Becket, but it was Theobald, Archbishop of Canterbury, who managed to get his friend Gilbert to accompany him to the Council at Reims where the opportunity of preferment occurred. Gilbert wanted to retain his abbey in plurality, as Henry of Winchester had done in similar circumstances, but he was 'defeated in his purpose by the monks of St Peter.'[5]

Gilbert Foliot was the son of a Norman family which, though not of the highest rank, was improving its position in the twelfth century. He passed at a comparatively early age from a career in the academic world to the monastic life at Cluny. There he was remembered with respect and admiration even though he was one among many rich young noblemen of promise in the days of Peter the Venerable. In his short stay at Cluny he rose to become one of the priors, going on to become Prior of Abbeville before coming to Gloucester. He was undoubtedly one of the most outstanding of all the abbots of St Peter's. But as John of Salisbury put it he had an unfortunate habit of always annoying his superiors. When he was a monk he used to attack the priors, when a prior, the abbots, when an abbot, the bishops. Barlow says of him 'He was of noble birth, a former clerk and master, and then monk and prior of Cluny, a good scholar and theologian, and an ascetic of the purest morals, indeed insufferably righteous.'[6] He was also a man of great ambition, known in high places and with wide connections in the western Church. Another historian has described him as 'an ascetic monk and abbot, something of a scholar, a capable bishop, an inspiring preacher; he was also a harsh controversialist, was involved in forgery and practised unashamed nepotism.' He was successively Abbot of Gloucester (1139–48), Bishop of Hereford (1148–63) and Bishop of London (1163–87). As abbot he was an open defender of the claims of the Empress Matilda to the English throne; as bishop he was Thomas á Becket's most forceful opponent among the clergy, and Henry II's loyal supporter.[7] His interest to the historian, however, lies not so much in the variety of his activities as in the complexity of his character.

The three most serious charges made by historians against Foliot's integrity and good character are that as Abbot of Gloucester he connived at forgery; that when Becket went to Canterbury and Foliot to London disappointed ambition drove him to chicanery in his dealings with the archbishop; and that his relations with Becket showed him to be arrogant, cold and pharisaical. On the forgery charge, Morey and Brooke note that:

> . . . it has long been known that Gloucester abbey, in common with many other religious houses, dabbled .n forgery. It has recently been argued that forgery was perpetrated there precisely when Gilbert Foliot was abbot, in all probability in his last year of office in or shortly before 1148. If it is established that forgery was committed at Gloucester while he was abbot . . . one can hardly acquit Gilbert of being accessory to the crime.[8]

As already noted, forgery was commonly practiced among monastic houses in medieval times, and it is difficult to apportion guilt or to determine how much the abbot really knew about it. Nevertheless, it was recognized to be a crime, and it is difficult to acquit

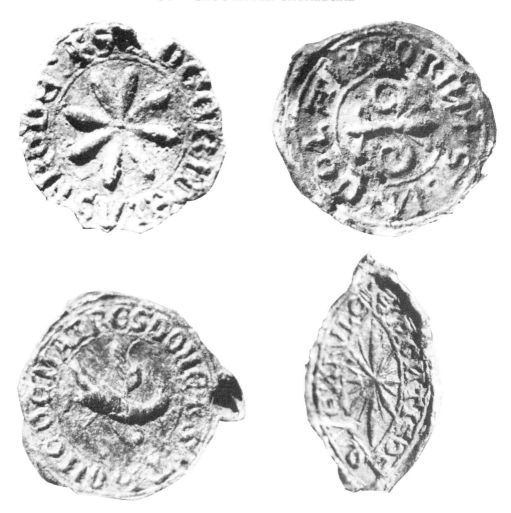

Miscellaneous seals from documents now lost (Gloucester Cathedral library)

Gilbert of complicity in a scheme which depended for its success on his good name with the Bishop of Worcester and the Archbishop of Canterbury. Whatever the truth of the matter it did not sully the reputation Foliot enjoyed when at Gloucester. The brief account of his abbacy in the *Historia* glows with his praise.

ABBOT HAMELINE 1148–1179

In the second half of the twelfth century the abbey was in the hands of two abbots, Hameline and Carbonel, about whom little is known. On Foliot's move to Hereford, Hameline, who was sub-prior, 'having been elected unanimously according to the Rule' was made abbot on 26 September and blessed by Symone, Bishop of Worcester, on

Grotesque, twelfth century

5 December. Apart from recording that 'he obtained much land and property, rents and churches for the church and its priories' the *Historia* relates only the ending of the dispute with York over the alienation of the manors of Northleach, Standish and the Barton. The archbishop laid claim to the manors alienated by Aldred, but which had been restored by Thomas, his successor. Hameline pursued the matter vigorously going to Rome to try to settle the issue once and for all:

> After various arguings about it all, both in the Papal Curia and in provincial synods, the case was settled thus; that the monks conceded to the Archbishop of York, who then was Roger, the following – Oddington, Condicote and Shurdington, 1,196 acres; and the Archbishop himself in his own general synod retracted any item concerning a false accusation or legal right in the matter of the previously mentioned manors which Hameline asked to be restored to his own church.

Thus the abbey retained the manors of Northleach, Standish and the Barton, though at a price. But in 1155, as if by way of compensation, the canons of Bromfield gave 'their church and themselves' to St Peter's Abbey by the hand of Gilbert, Bishop of Hereford, with the authority of Theobald, Archbishop of Canterbury and of the Apostolic Legate.

The Abbey's Scholastic Reputation

St Peter's Abbey had been gaining a high reputation as a place of learning since the time of Abbot Serlo when it attracted boys such as Walter de Lacy from wealthy and powerful Norman families. Through the twelfth century its reputation was enhanced by several

Grotesques at west end of nave arcade, early twelfth century

scholarly monks who attracted pupils from near and far. For example, Geraldus Cambrensis (*c.* 1146–1223) who had received his early education from his uncle, David Fitzgerald, Bishop of St David's, was sent to the abbey for some years, followed by ten years further education in Paris. One of the monks, Osborn, was 'the most elegant Latinist of his age' (Leland). He added several works of divinity to the conventual library, but these together with many others were later removed by order of Henry VIII to his own Royal Library. Osborn's *Panormia*, according to Fosbrooke (1819) inscribed by Abbot Hameline, was the only work to survive the Dissolution. Another monk of the house, Reginald, also gained a reputation for learning; he went on to become Abbot of Evesham.

Geraldus Cambrensis (Gerald of Wales) was not, however, uncritical of life at St Peter's during the years he spent at the abbey. Lewis Thorpe, who has edited Geraldus' works, comments 'As soon as he, Geraldus, was old enough to leave his home at Manorbier, he was sent to the Benedictine Abbey of St Peter at Gloucester where a Frenchman, Amelin, was abbot and where his teacher was a monk called Haimo. He approved of the instruction which he received at St Peter's and he later described his teacher there as "that most learned scholar Master Haimo", but looking back down the years he was critical of the wealth and worldliness of the monks of Gloucester, more perhaps of Llanthony Secunda than of St Peter's.'[9] Nevertheless it was at St Peter's that he began to acquire his mastery of medieval Latin and his extensive knowledge of classical and later Latin authors.

The Abbey's Liturgical Calendar

An antiphonal with other liturgical texts dating from *c.* 1170–1200 which once belonged to St Peter's Abbey is in the possession of Jesus College, Oxford. (See plate 5.) The calendar contained in the manuscript (Jesus College MS 10) is earlier than the rest of the volume, and many 'Hereford additions' made in the thirteenth or early fourteenth century suggests the manuscript passed from the parent house, St Peter's Abbey, to the daughter house of St Guthlac, Hereford. The calendar was probably used at the abbey early in the twelfth century for there are several entries which show the influence of the abbey of Mont St Michel, the monastery of which Serlo was a monk. There are also a number of saints in the list who were patron saints of rectories appropriated to St Peter's

Abbey at the time when the calendar was drawn up in its final form. On 4 February Aldatus, bishop *c*. 577 is remembered. There was a church dedicated to St Aldate in Gloucester at the time. Later, he was included among the figures of saints and martyrs in the reredos of the lady chapel. On 1 March David, episcopus is remembered, a later addition possibly reflecting the Kilpeck connection. Similarly Gundleius, confessor, is included because his church at Newport in Monmouthshire was granted to the abbey by William II in 1093. Among others in the calendar with a Gloucester connection are: Guthlacus, confessor (11 April), Kineburga, virgo of Gloucester (25 June), Arildis, virgo et martyr of Kington (20 July). Arildis or Arilda is the patroness of the Church of Oldbury-on-the-Hill, Gloucestershire. Her body seems to have been translated at an early date to St Peter's Abbey. Very little is known about her, but Leland in his *Itinerary* states: 'Santa Arilda, virgin, martyred at Kington by Thornbury, translated to this monastery, hath done many miracles . . . A certain Muncius, a tirant is said to have cut off hir heade because she would not consent to lye withe hym.' She and Kineburga both had small figures placed in their honour in the reredos of the lady chapel. (See Appendix VIII.)

The Abbey's Relationship with the Jewish Community

The *Historia* at this point relates a story about a Christian boy who was alleged to have been tortured by Jews and flung into the River Severn. The boy, named Harald, was 'enticed away secretly by Jews' and at 9 a.m. on 18 March 1168 the boy's body was dragged from the river by fishermen. The body was seen by 'many clergy and common people' and the following day:

> . . . towards sunset the boy's body was carried away to the church of St Peter of Gloucester, accompanied by an innumerable throng of people with the Lord Abbot Hameline and the whole community going before. With the larger bells tolling he was borne aloft and carried away the same night to a more private place with lights kindled all around. He was viewed by the brothers and carefully laid out and washed. And so on the morrow he was buried with great reverence before the altar of the Holy Confessors, Archbishop Edmund and King Edward, in the northern part of the church.

The boy was regarded as a martyr. It was alleged that the Jews had tortured him; a number of citizens as well as the monks of St Peter's had examined the scars and burns. Apparently thorns had been fastened to his head and under his armpits, liquid wax poured in his eyes and on his face. They had tied him between two fires severely burning both sides of his body, his back and buttocks, his knees, hands and feet. They poured hot dripping over him 'as we do when basting a roast.' What lay behind the story, and why the *Historia* records it in such detail and with such deep emotion is not altogether clear but it may be an attempt to justify the ferocity of the anger and spite expressed later in anti-Jewish riots elsewhere in the country. At all events the boy's cruel murder did not fade in the memory of the community; a small figure or statue of the young martyr was included among those to local saints in the reredos of the fifteenth-century lady chapel.

Henry II (1154–89) had given peace and protection to the Jewish community and, as

a result, their numbers had grown rapidly. Yet they were hated by their neighbours, partly because they envied their success in trade and partly because of their money-lending. But they were hated most of all on the grounds of their race and religion. Nevertheless, they had settled in the country under the king's protection and, in return for the heavy tribute which they paid him, obtained security for their life and goods. They were often called the 'king's property' because he kept the right of taxing and managing them entirely in his own hand. When Henry II died and Richard I (1189–99) was being crowned a deputation of Jewish elders came to bring him a gift. They were set upon by the king's foreign servants and severely beaten. The news spread fast and, on a false rumour that the king approved the action, a London mob rose and sacked the Jewish quarter. Worse was to follow for the pent-up feeling against the Jews erupted in Norwich, Stamford, Lincoln, York and other places where riots led to the death of many Jews. At York all the Jews took refuge in the castle and when they were beset by a howling mob crying for their blood, fearing the worst, they killed their wives and children and then set fire to the castle and burned themselves rather than fall into the hands of the mob. No adequate punishment was ever meted out for the suffering and death the riots caused; at York no more than a fine was imposed on the town.

How the Jewish community in Gloucester was affected by the riots in other parts of the country is not known. Herbert notes that a prominent member of the community in the 1170s was Moses le Riche, whose heir owed the Crown 300 marks in 1192 for the right to have Strongbow's debts:

> In the early years of the 13th century Gloucester Jews were financing local magnates, such as Henry de Bohun, Earl of Hereford, and Roger de Berkeley, and their activities among the burgess community at the same period are revealed by sales of property to pay off debts owed to the Jews or to redeem mortgages. The Jews of Gloucester had a grant of royal protection in 1218 and were placed in the custody of 24 burgesses.[10]

The Collapse of one of the Western Towers

The *Historia* records that at some time between 1163 and 1179, when Roger, Bishop of Worcester, was celebrating Mass before the high altar of St Peter's:

> . . . the large and high tower of the church, by defect of its foundations, fell down suddenly just as he was concluding. And though the crash and shock of the earth was so terrible as was never before seen or heard, so that only a very few monks remained in the choir, few ministers stood at the altar nearly all fleeing seeking hiding places and expecting nothing but the certain ruin of the whole church, the bishop intense at his devotion and looking upwards remained unmoved at the high altar.

It has long been assumed that 'the large and high tower' which collapsed was the southern turret-tower at the west end. Fosbrooke imagined the nave crowded with men and women listening to the Mass, and at the time of the calamity moving forward nearer to the nave altar for the principal benediction so avoiding injury from the falling masonry at the west end. The reason given in the *Historia* for the collapse of the tower viz. 'by defect of its foundations' is probably correct since the foundations of the south-west tower were near the *fossa* of the old Roman town wall.

Abbot Hameline died on 10 March 1179 having ruled the abbey for thirty-one years 'amid greatly increasing disturbances in the world.' This must be an allusion to the period leading up to the murder of Thomas à Becket, Archbishop of Canterbury, in 1170 in which the former abbot, Gilbert Foliot, now Bishop of London, was so deeply involved, and also to the unrest during the later years of the reign of Henry II, brought on by the rebellion of his sons.

ABBOT THOMAS CARBONEL 1179–1205

The seventh abbot of the monastery 'after the Conquest' was Thomas Carbonel, described as Prior of Hereford, that is of St Guthlac's Priory near Hereford, one of the abbey's dependent houses. He was elected 'according to canon law by the whole chapter' and was received 'and enthroned with honour on 17th September [1179] with a great procession and a crowd of the common people.'

The brief account, in the *Historia,* of events at the abbey during his abbacy includes references to the imprisonment of Richard I by the Duke of Austria and the ransom paid for his release; and also to the 'plunderings and fires as well as robberies' which marked the end of Richard's reign. King Richard had left the country shortly after his coronation in December 1189 to take part in the Third Crusade. The crusaders captured Acre in 1191, and the king went on, without much support, to attempt to capture Jerusalem. But he stopped short of the holy city, and on his return was captured and held first by Leopold of Austria, and then by Emperor Henry VI in Germany for over a year. Henry demanded a ransom of 150,000 marks for his release. This was an enormous sum for the country to raise especially since it was in the grip of a civil war. A crushing tax was imposed to raise the money, 'one fourth on all movable goods, and twenty shillings on every knight's fee.'

By the spring of 1194 the king was released, and returned home. Within months he was off again to France to try to recover his lost possessions leaving Hubert Walter, Archbishop of Canterbury and Justiciar, to rule the country. At the Great Council of 1198 Hugh, Bishop of Lincoln, led a revolt against further exorbitant taxes demanded by the king for his French campaign, and in the same year there was a popular revolt in London. In the following year, however, Richard, still fighting, received a wound in his shoulder from a crossbow bolt and died shortly afterwards. The *Historia* describes the effect of these events on the monastery:

> In the year of our Lord 1193, Richard the first king of that name after the Conquest, when he returned from Jerusalem was imprisoned in harsh conditions by the duke of Austria, it is said for three months and almost fifteen days. He was then ransomed by the Emperor of Germany and held by him for a while. Meanwhile, all over England there were disturbances caused by general lawlessness, plundering, fires and robberies, and to make matters worse a tax was levied on clergy and laity alike to raise the ransom to free the king. Whatever treasure was held in any church in chalices or other silver vessels was forcibly removed.

Two other matters are mentioned in the *Historia*; the first concerns Hubert Walter, Archbishop of Canterbury and at the time Justiciar of all England who in 1195 deposed Robert, Abbot of Tournay, and ordered him to be kept in St Peter's Abbey, Gloucester.

He was to be held for eighteen months and fettered. Such references as these led some writers in the eighteenth century to suggest the Early English screen in the north transept was once a place of confinement and punishment. Others have suggested 'cells' in the crypt were used for this purpose. The erring abbot would not, however, have been held in the church at all, but in some secure place in the claustral buildings. The second matter concerned a fire in the city in 1190 which 'burned down most of the town, and almost all the workshops (*curiales officinas*) attached to the abbey. It also set on fire two churches, St Mary in front of the abbey gate, and St Oswald's adjoining the wall.'

Abbot Thomas Carbonel died in 1205, and after a few years the abbey found itself, unexpectedly, the venue for the coronation of the young king, Henry III (1216–72), and facing a long period of extensive rebuilding.

EARLY ABBEY CHARTERS

The first two charters illustrated here have the principal seal of the abbey, one is a good representation of the face and the other a reasonable image of the smaller counter-seal. The other two charters have private seals. The ten volumes of medieval deeds, from the cathedral library, from which these are taken are currently (1990) being microfilmed in preparation for an edition by Prof R.B. Patterson of those in the period before 1265, to be published by the Bristol and Gloucestershire Archaeological Society in its *Gloucestershire Record Series*. The notes on the charters and their seals are by David J.H. Smith, County and Diocesan Archivist.

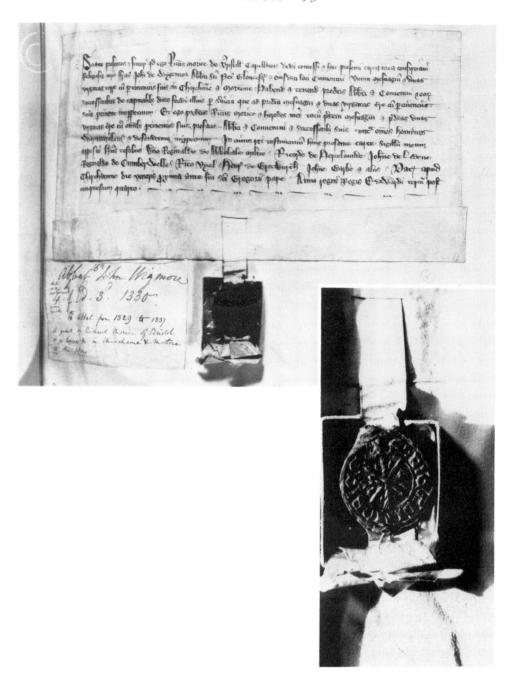

Grant by Richard Morice of Bristol, chaplain, to the Abbot [John of Wygemore] and Convent of St Peter's, Gloucester, of a messuage and two virgates of land in Churcham and Moreton (9 March 1330). Seal of Richard Morice: circular, green, about 25 mm, four sprigs of a plant in the angles of a cross saltire; inscription: * S. RICARDI MORICE

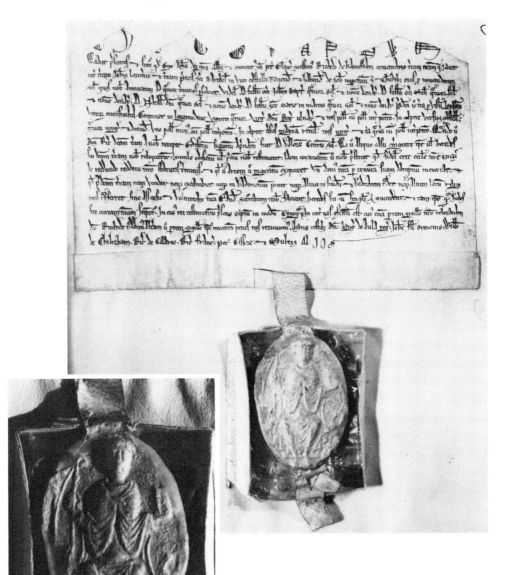

Grant of Abbot John and the Convent of St Peter's, Gloucester to Richard of Kamesham mason of all their land which lies between the land of John Lorimur and the land of the prior of St Bartholomew in Castle Lane [Gloucester] for 19 s. per annum n.d. (1243–63). Abbey seal (face): pointed oval, cream-coloured, about 57 mm × 40 mm. St Peter with pastoral staff and open book seated on a cushioned throne. The edge has crumbled away taking with it the inscription. On the dorse: counterseal about 45 mm × 30 mm, indecipherable (apparently identical to seal on p. 96).

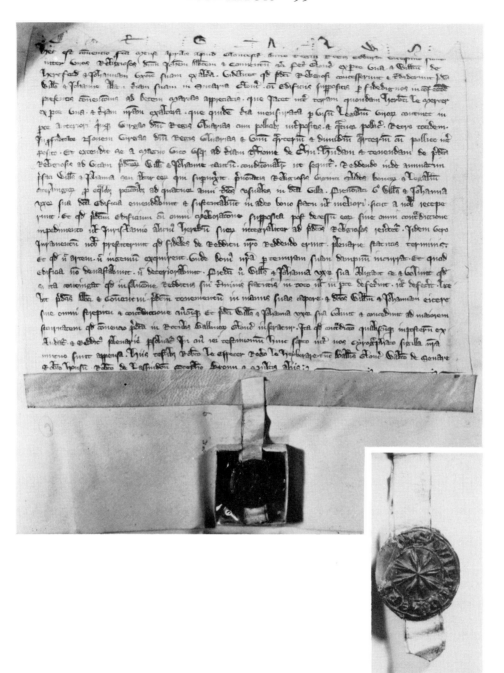

Grant from John the Abbot and Convent of St Peter's, Gloucester, to William of Hereford and Joan his wife of their land in Cordwainers Row [in Northgate St.] Gloucester, April 1301. Seal of William of Hereford: circular, bronze-coloured, about 23 mm eight three- pointed forks arranged as spokes, their stems meeting at the centre; inscription: *S. WILLI DE HEREF . . .

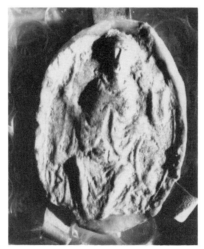

Grant of Abbot Henry and the Convent of St Peter's, Gloucester to William le Lorimer of our land in Castle Lane which lies between the land of Thomas of Guesham and the land of Sibilla our tenant for 4 s. 4 d. per annum n.d. (early thirteenth century). Abbey seal (face) (as described for grant of Abbot John). On reverse: pointed oval counterseal about 45 mm × 30 mm – figure of a saint standing on a triangular base, details and inscription indecipherable.

REBUILDING AND REFURBISHING
1222–1242

*'How sublime is this humility, which is incapable
of yielding to the weight of honours, or of being
rendered proud by them! The Mother of God is
chosen, and she declares herself His handmaid.'*
St Bernard of Clairvaux, 1090–1153

The *Historia* in recounting events at St Peter's Abbey in the early decades of the thirteenth century again refers to the national scene. King John (1205–16) having lost his continental possessions had returned to England and before long had become involved in a quarrel with the papacy. It concerned the appointment of the Archbishop of Canterbury following the death of Hubert Walter in 1205. In normal times the king would have nominated and the monks of Canterbury would have elected the archbishop, but Pope Innocent III insisted on stepping in and settled the quarrel between the king and the monks by forcing his own nominee on the Church, a learned English cardinal who was living in Rome, Stephen Langton.

John was driven to fury over the Pope's action. He refused to accept the nomination, or to allow Langton to enter the country. In retaliation Pope Innocent laid an Interdict on the country suspending on his own authority the celebration of the mass, closing the churches, and even prohibiting the burial of the dead in consecrated ground. The majority of bishops published the Interdict and the clergy had no option but to follow their directives. This made the king as furious with the clergy as he was with the monks of Canterbury, whom he sent into exile. He proceeded to seize the estates and revenues of those bishops who had taken refuge overseas, and declared all clergy to be outside the pale of the law. No one who molested them was to be punished. For five years the struggle between the power of the Pope and that of the king tore the country apart. Meanwhile the king filled his coffers with church money, and scorned the Interdict.

However, in 1213 there was the threat that Philip, the French king, might take advantage of the situation and invade the country. Faced with this possibility John was

forced to submit. Not only did he agree to acknowledge Langton as archbishop and to restore all the lands and revenues he had taken from the church, but he stooped to win Innocent's favour by doing homage to him, and declaring the Kingdom of England a fief of the Holy See. When this became known the barons and people were as disgusted by the king's submission as they had been by his extortion.

The *Historia* states that the abbey submitted to the directives of the general Interdict (1207). The monks refused to allow their vicars to perform Sunday duties. Three years later, when King John made a 'cursed tollage upon all the churches of England', he took 500 marks from St Peter's Abbey, and one hundred waggons with eight horses each for carrying his baggage. In 1214 the interdict was relaxed 'to the great joy of all the people', and the clergy were able to get back to their duties.

THE CORONATION OF HENRY III

One of Langton's first acts on becoming archbishop was to call a great assembly in St Paul's Cathedral in London at which he proposed to the baronage that King John should be asked to ratify and re-issue the charter that his great-grandfather, Henry I, had granted to the English people, binding himself to abstain from all vexatious and oppressive customs, and to abide by the ancient customs of the realm. The proposal was accepted at once by the great majority of the barons as the best and most constitutional means of bringing pressure on the king. At first the king resisted the demand but eventually, aware that he had little support among the barons and the people, he was

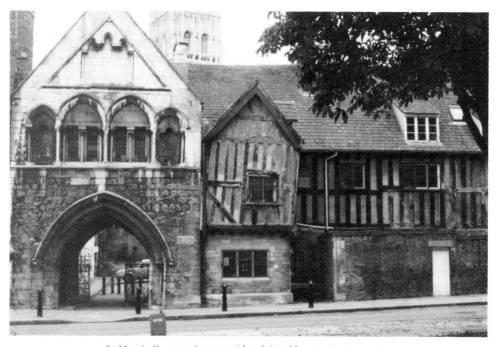

St Mary's Gate on the west side of the abbey precincts *c*. 1200

forced into acceptance at Runnymede. So occurred the famous meeting between the king and his barons, headed by the archbishop, at which the king solemnly swore to grant all the provisions of the Great Charter (Magna Carta) which had been drawn up by Langton for his signature. However, in spite of signing, the king began to disregard its provisions and civil war broke out. This led eventually to the king's death at Newark Castle in October 1216 and the hurried crowning of his eldest son, Henry, a boy of nine, at the abbey church of St Peter at Gloucester.

Henry Blunt (1205–24) was abbot at the time of the coronation. The supporters of the Crown were anxious to see the young king crowned as early as possible after the interment of King John at Worcester. There was no time to send to London for the crown (much of the royal regalia had been lost, in any case, in the fens of Lincolnshire), so Henry was crowned with a golden bracelet taken from his mother's arm. The coronation of the young king brought renewed hope for peace, and for the people of Gloucester great excitement. The *Historia* records that:

> King John's son, Henry. who had been named his heir since he was a boy of ten [sic] succeeded him and was crowned at Gloucester in the church of the Blessed Peter the Apostle on 28th October by Lord Peter de Roches, bishop of Winchester by authority of Cardinal Gwalo, titular priest of St Martin and Legate of the Apostolic See, being present himself with certain bishops and many noblemen.

The scene is depicted in a window by Clayton and Bell (s ix 1860) in the south aisle of the nave.[1]

Herbert notes that though 'John was a fairly frequent visitor to the town in the later years of his reign, his son, whose first coronation, in 1216, took place at Gloucester, was perhaps the medieval king who had the closest connection with the town.'[2] In the atmosphere of renewed hope at the beginning of the long reign of the young king, Henry III (1216–72), the abbey planned an extensive rebuilding programme. Work began in the latter years of the abbacy of Henry Blunt, and continued through the abbacies of Thomas Bredon (1224–8) and Henry Foliot (1228–43) culminating in the rededication of the church in 1239. The programme was far more extensive than appears from the modest amount of thirteenth-century work that has survived in the building.

THE EARLY ENGLISH GOTHIC STYLE

The work was carried out in the architectural style known, since Thomas Rickman (1817), as Early English. The terms Rickman used in describing the developing styles of English church architecture continue to be widely used. But one style tended to merge into another, giving transitional periods in which features of the old were mixed with anticipations of the new. The move away from Romanesque came considerably earlier on the Continent than in England. This may have been partly due to the influence of the Cistercians who wanted to build their churches in a way that would reflect the simplicity and austerity required by the *Rule of St Benedict.* But there were more practical reasons for the emergence of the new style. Experience had revealed the limitations of Romanesque. For example, the round-headed arch imposed severe limitations in the construction of vaults. If the space to be vaulted was square, as in the compartments of the north aisle of

the nave, all was well; but if the space was rectangular then there were problems to overcome. One solution was to use three or four centred arches as in the rectangular compartments of the central chamber of the crypt. This solution to the problem is a notable example of the ingenuity of the Gloucester masons, and the risks they were prepared to take. But they came to see that the pointed arch and the rib vault together with the flying buttress – the main features of the new Gothic style – opened up new possibilities. These features first appeared in the Ile de France, in buildings like Amiens Cathedral and the Abbey Church of St Denis built between 1135 and 1145. In Kidson's words, 'here were the first tentative expressions of Gothic'. In combining these features an entirely new structure and style was created, and within a few years the full possibilities of the style were being exploited in Notre Dame Cathedral in Paris, begun *c.* 1163, and in Laon Cathedral, begun in 1170. Because of the practical advantages and the aesthetic enrichment of the new style, it spread in no time throughout western Europe.

While particular features of the Gothic style such as the pointed arch appeared early on, even in Anglo-Norman work, the fully integrated style first arrived in this country through the influence of French patrons and architects such as Roger de Pont l'Eveque, Archbishop of York. The archbishop built Ripon Minster in *c.* 1179, a building which displays all the marks of Gothic work. At Canterbury after a disasterous fire in 1174 the French architect William of Sens rebuilt the choir on the Norman foundations but entirely in the Gothic style. Coinciding as it did with the murder of Thomas à Becket and the beginning of pilgrimages to his shrine this building was to have an immediate

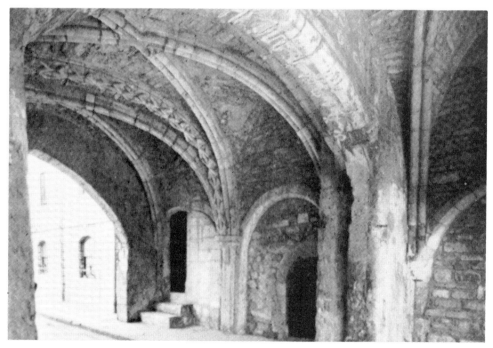

St Mary's Gate, interior

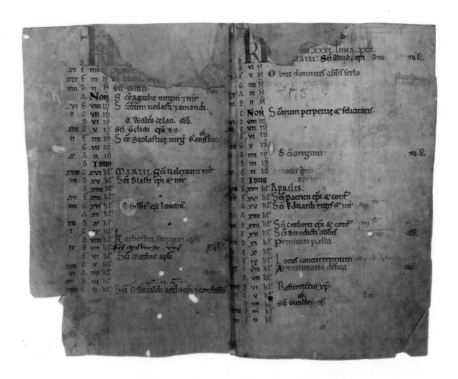

Plate 5
Pages of the thirteenth-century *Gloucester Calender*. (Jesus College, Oxford MS 10)

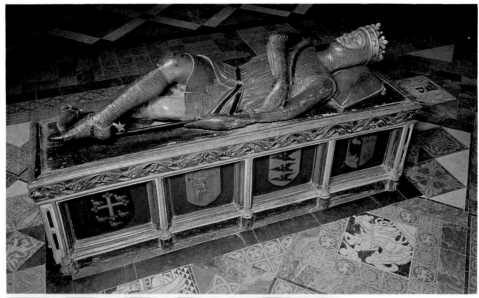

A

C

B

Plate 6
(A) Wooden effigy of Robert, Duke of Normandy, thir-
teenth century (Pitkin Pictorials). (B & C) Thirteenth-
century effigy of Serlo, showing detail of canopy, and traces
of medieval paintwork

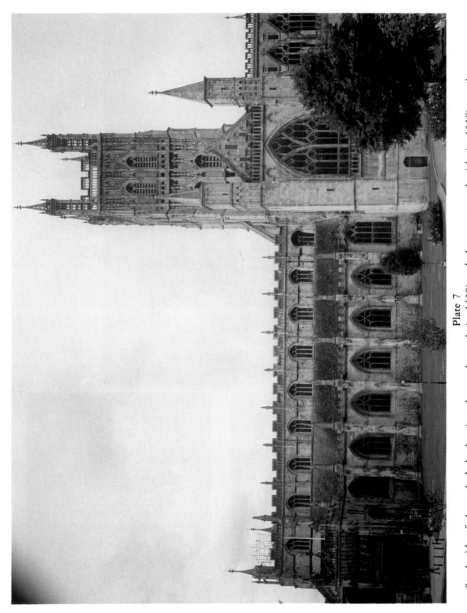

Plate 7

South side of the cathedral, showing the south porch (c. 1430) and clerestory, south aisle (c. 1318), south transept (terminal window 1335), and tower (1450–60). (Pitkin Pictorials)

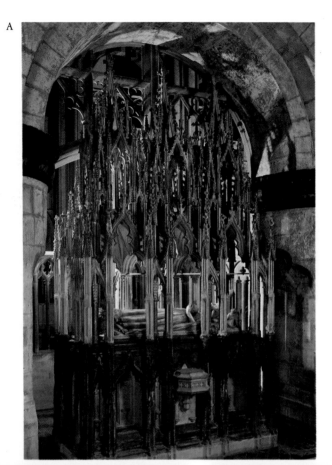

A

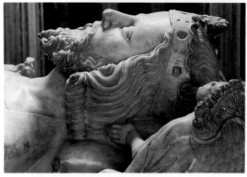

B

C

Plate 8
(A) Tomb of Edward II, King of England 1307–27. (B) Detail of alabaster effigy of Edward II
(Woodmansterne slides). (C) Detail of stained glass (1335) in east window of south transept

St Mary's Gate, detail of vaulting

and widespread influence. As Kidson puts it 'The importance of Canterbury was not that it represented this or that kind of Gothic, but that it was Gothic and not Anglo-Norman. It marks the point at which the higher English clergy abandoned their conservative attachment to the old style and set out to bring themselves up to date.'[3] In the West Country, Abbey Dore in Herefordshire, built in the 1170s, represents a clear move away from Romanesque and in the nave of Malmesbury (*c*.1165) Anglo-Norman masons went over to pointed arches for their main arcades. The same thing happened in the two bays at the west end of the nave of Worcester Cathedral. But the slowness of patrons and architects in England to adopt and exploit the possibilities of Gothic is dramatically illustrated by comparing Wells Cathedral with Chartres, which were built at about the same time.

At Gloucester the only surviving example of Early English Gothic, on any scale, is the nave vault (1242), together with the screen in the north transept and St Mary's Gateway on the west side of the precincts. The nave vault incorporates the main features of the new style – the pointed arch and rib vault, the cluster of Purbeck shafts, stiff leaf decoration and fine carved bosses. A feature which shows the divergence of Early English Gothic from work on the Continent is the use of ridge ribs, and the use of Purbeck is another particularly noticeable feature. Because it can be 'polished' it is often referred to as marble. Gervase of Canterbury in writing an account of the progress of the building of the choir at Canterbury noted the architect's liberal use of Purbeck, commenting 'there used to be no marble shafts, while here they are numberless.' What Watkin calls 'this festive treatment of the interior' in the choir at Canterbury set a fashion which was

widely imitated in the thirteenth century in this country but which has no precedent on the Continent. He describes Canterbury's choir as 'a rich polyphony of French Gothic and Anglo-Norman themes bound brightly together with a new decorative system of polished Purbeck marble shafts and string-courses, contrasting in colour and texture with the lighter-coloured stone background.'[4] At Gloucester the nave vault and the screen in the north transept are later and modest examples of this 'festive treatment' of a Romanesque interior.

THE BUILDING WORKS OF HELIAS THE SACRIST

Little is said in the *Historia* about any building work during the abbacy of Henry Blunt except that in 1222 'the great eastern tower of Gloucester church was built with the help of Helias the sacrist.' Helias was probably responsible not only for the new tower but for much of the other work carried out between 1222 and 1237, the year of his death.

The Central Tower

Fire broke out in the city on 31 July 1222. 'The whole parish of St Mary before the abbey gate was burned, and part of the bakehouse and brewhouse and the house between the gate and the stable, both sides of the main street from St Nicholas to the bridge, together with all the little streets to our own Barton.' (*Historia*) The following year there was another fire:

> On Sunday night 21st May fire attacked from the street leading to the castle to the Lichgate of the abbey. And on the following Thursday, after the first bell for Matins, a fire started from the Great Cross of Gloucester and enveloped the entire street of the cobblers and drapers and the church of St Mary of Graselove, part of Holy Trinity Church, together with both sides of the main street as far as the place where the earlier fire burned itself out.

These accounts are so vivid and detailed that they must have come from someone who was in Gloucester at the time. The two fires caused widespread devastation in the town, and some damage to buildings in the abbey precincts.

It was at this time (1222) that 'the great eastern tower of the Gloucester church was built with the help of Helias the sacrist.' Some writers have assumed that Helias rebuilt the south-west tower which had collapsed so dramatically in the days of Abbot Hameline. But it is specifically stated in the *Historia* that repairs to this tower were begun in 1242, and completed some time during the abbacy of John de Felda (1243–63). The statement that Helias 'erected the tower of the abbey of Gloucester . . .' can only refer to the central tower. It is most unlikely, however, that he pulled down the Norman tower and built a completely new tower.

When W.J. Carpenter-Turner, architect to the Dean and Chapter of Winchester Cathedral towards the end of the nineteenth century, was studying a manuscript in the British Library he noticed a sketch of Gloucester in the margin. The manuscript was Royal MS 13A III, f.82 (or f.41v), a thirteenth-century copy of the *Historia Regum Britannie* of Geoffrey of Monmouth. (See plate 4.) An article about the drawing appeared

shortly afterwards in the *British Archaeological Association Journal* (1898) by Caesar Caine. The sketch is of Gloucester's skyline in *c*. 1300 as seen from the west, from the water meadows or Over Bridge. It shows Blackfriars in the centre next to the castle, and then, on the left, the abbey church of St Peter. The most noticeable feature in the sketch of the abbey church is the very tall spire. The drawing strongly suggests that Helias the sacrist remodelled the upper stages of the existing tower adding corner turrets and a tall spire. The spire (*turris*) would have been constructed of oak and covered with lead. It appears to have been a very distinctive structure and in the Early English style.

The rest of the drawing is not easy to interpret, but the turret on the right of the tower, the south side, is probably the south-west turret of the south transept. The roof line and the windows below appear to join it to the tower and crossing, and not to the west end of the nave. There is no sign of the south-west turret which formed part of the west end of the building, and which had collapsed in the late thirteenth century. There appears to be a large window, partially obscured by another building, at the west end beneath the high gable of the roof of the nave. This, of course, predates the present west end which is the work of Abbot Morwent (1421–37). With the construction of the new vault over the nave in 1242, it may have been decided to take down the central part of the terminal wall and build a great west window. The proportions of the window are impressive, and the tracery clearly Early English.

The Monks' Choir Stalls

Helias is also credited with constructing new choir stalls. A fragment of one of the stalls was preserved by F.S. Waller, architect to the Dean and Chapter in the nineteenth century, behind the canopy over the vice-dean's stall. At the same time (*c*. 1872) other fragments of woodwork were deposited in the south-east chapel of the tribune gallery. These fragments are now displayed in the Gallery Exhibition. Helias' stalls appear to have had canopies consisting of a simple three-sided pyramid of crocketed shafts and, attached to the boarded screen behind the seats, a moulding comprising a round-headed arch supported by slender attached shafts on either side. No fragments of the seats have survived.

The stalls were probably the first permanent stalls to be placed in the choir. In earlier centuries monks stood around the choir, though they were allowed to sit for the readings during the offices. Benches (*scamna*) were placed on a slightly raised platform backing onto the choir screen. Judging from the remains of early stalls, Dom D. Van Humbeeck doubted whether they had always had stools or desks attached to them. The monks may have had no more than hassocks (*formae*). The advantage of this arrangement was that the *formae* could be taken into the presbytery and grouped round the high altar for the celebration of the conventual Mass, enabling the brethren to kneel there in greater comfort. Even when stalls were set up in choirs in the late twelfth and early thirteenth centuries and *formae* became part of the stall, they were retained for those occupying the benches in front of the stalls. The moving of the *formae* was discontinued in the thirteenth century.[5]

When *formae* were incorporated in the design of stalls and simple supports were provided for the arms there were still no desks at which to kneel and on which to rest

books. The offices were recited from memory, and in any case the use of books would have been impossible at certain times such as Matins which was usually conducted in darkness up to the Te Deum. But the use of *antiphonaries,* sanctioned in England at the General Chapter of the Benedictines in 1217, introduced the custom of putting detachable desks above the *formae.* The children were given the job of putting them in place before the office. But gradually desks were included in the design of more permanent stalls. It may well have been this development that prompted the community to ask Helias to design and to erect stalls in the choir at Gloucester.

Much earlier, in the eighth and ninth centuries, bishops and abbots on the Continent asked their clergy not to use staffs in church because at times they were used in an offensive way. But the more aged and infirm monks found this ruling hard to accept since during the long hours of standing in the choir they were accustomed to use their staffs to lean on. In the eleventh and twelfth centuries the monks at St Peter's probably had no more than a bench to sit on, and had to stand without misericords or book rests on which to lean. On the Continent misericords began to appear in the late eleventh century and by the twelfth century they were widely used. Helias' stalls probably had misericords though none have survived. These would have allowed the monks to take the weight off their feet while appearing to stand. After the General Chapter of the English Benedictines in 1278, stalls with arm rests, misericords and desks became an accepted part of the furnishings of the choir. After this their design was not so much a matter of liturgical requirement as of architectural and ornamental development.

The Improved Water Supply

Thirdly, Helias is credited with improving the monastery's water supply. Henry I either granted, or confirmed an earlier grant by William I which allowed the monks to lead or draw the water from the Fullbrook. Like other religious houses, St Peter's needed two water supplies, one for drinking, washing and general domestic purposes, and the other for keeping the drains clear and for turning the mill. Up to this time the supply of water was dependent on the well in the garth (cloister garden) and on the Fullbrook which passed into the town near the Northgate and entered the monastic precincts by the kitchen quarters.

Fullbrook-Leggatt, on the basis of excavations (1964) traced the course of the Fullbrook:

> It divided into two channels within the precincts, one of which led under the dorter to the lavatorium in the Great Cloister, and the other was split into two just east of the infirmary (under which one channel passed), then supplied the abbot's lodging and then fed the abbey mill. The other channel went to the Little Cloister (water still flows here at a depth of about 14 feet), then passed the cellarer's checker and there forked, one arm going to the mill,and the other by the kitchen into the prior's lodging. Here it joined the water from the Great Cloister and close by the Inner Gate the water from the mill whence the re-united stream left the abbey precincts just north of the St Mary's Gate.[6]

Helias' concern was to improve the supply of fresh or 'living water' (*Historia*) which at the time must have been insufficient or unsatisfactory. He built a conduit and constructed a reservoir outside the *lavatorium* in the cloister garth. This reservoir, which

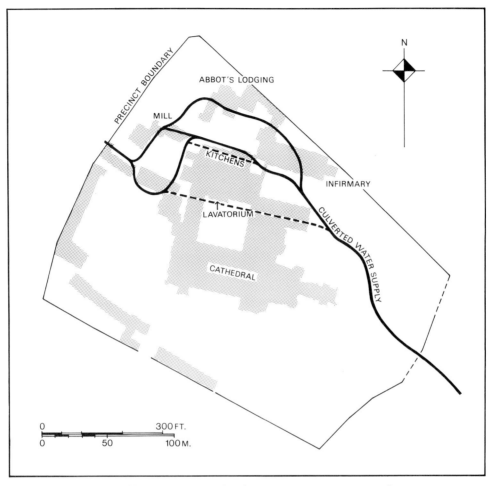

St Peter's Abbey: water supply (based on St John Hope's plan revised 1990)

later became a drain, was rediscovered and excavated in 1888. In Edward II's time the monks of St Peter's obtain a fresh supply of water from Mattesdune (Robinswood Hill) about 2 miles to the south-east of the abbey, and the reservoir in the garth was converted into a drain.

The Chapel of Blessed Mary

It is probable that Helias was also involved in the construction of the lady chapel, completed during the abbacy of Thomas de Bredon. Though there were chapels dedicated to the Blessed Virgin earlier than the thirteenth century, for example at Glastonbury (begun in 1184 and completed in 1186), many chapels were built and endowed in her honour at this time. Popular devotion to the Virgin was reaching new

Detail from the 'Coronation of the Blessed Virgin Mary' in the great east window *c*. 1350

heights. The place accorded to her in the theology and devotion of the western Church arose from the realization of her unique place in the divine plan for man's redemption. She was honoured as the one chosen by God to be the mother of our Lord. The account in the Gospels about her relationship with our Lord and her part in the early years of the Church in Jerusalem, recounted in the *Acts of the Apostles*, were elaborated in the second century. The apocryphal *Book of James* gave details of her parentage and birth, her early years, her betrothal and marriage and the circumstances of her death. In later centuries, as a result of theological reflection on the growing traditions about her, she was honoured with a variety of titles, such as Mother of God, with its implicit Christological affirmation and, in the later medieval period, the Mediatrix of All Grace, because of her maternal intercession. Later still, she was given the title Queen of Heaven, expressing widespread belief in her Assumption and her Coronation in heaven. In the fourteenth century the abbey was to enshrine this medieval doctrine in the stained glass of the Great East Window.

In 1224 Ralph de Wylington and his wife Olympias provided the funds for establishing a chapel in honour of the Blessed Virgin at St Peter's Abbey. *The Historia* states 'The chapel of Blessed Mary in the cemetery was completed at the expense of Ralph de Wylington who gave rents with which to maintain in perpetuity two priests there to say masses for the dead.' The Wylingtons also gave yearly rentals to provide for

The Norman abbot's lodging, detail of gable of the west front, thirteenth century

lights to burn before the altar of St Petronilla in the chapel of St Mary during mass, and all day long and all night on the festivals of St Mary and on the vigil of St Petronilla. There is a document in Abbot Froucester's Register B (one of a number relating to this earlier lady chapel) in which Abbot Henry Foliot (1228–43) pledged that he and his successors would carry out for ever the wishes of the founders.[7] He fixed the salary of the chaplains of St Mary's Chapel and their assistant at $2\frac{3}{4}$ marks annually and allotted to them from the abbey pantry their daily portion of cheese, candles, bread, meat and beer. He also ordained an annual commemoration of the pious benefactors on the anniversary of Ralph de Wylington's death.

But where was the lady chapel built? Usually at this time and later, in the fourteenth and fifteenth centuries, lady chapels were built on at the east end of the church. If this were the case at St Peter's Abbey, the foundations of Ralph de Wylington's chapel would be beneath the entrance of the present lady chapel which was built in the second half of the fifteenth century. But the *Historia* states that the chapel of St Mary was built *in cimiterio*, in the cemetery. The monks' cemetery lay on the east side of the abbey church.

1. Dean Sieriol Evans argued, in an unpublished paper, that the de Wylington chapel was a completely detached building on the north side of the present lady chapel. 'It is referred to as being *juxta magnam ecclesiam*, which means near to, not attached to, the existing building.' He pointed out that free-standing chapels were not uncommon at the time. At Worcester the thirteenth-century lady chapel was detached on the east side of the Norman cathedral to which it was joined only after the reconstruction of the eastern

arm. At Ely the fourteenth-century lady chapel stands on the north-east side of the choir linked to the cathedral by a covered way:

> The lady chapel as a separate building reflects the religious attitude of the thirteenth and fourteenth centuries in which our Lady coming second only to her glorious Son should have a shrine of her own not merely an altar in His church, an independent establishment with her own worship and her own ministers. Hence it was endowed with priests to serve at its altars, independently financed by lands allocated to them, though of course housed and provided for in the community.

The chapel, the dean argued, was built *juxta magnam ecclesiam* and *in cimiterio*, that is in the area to the east of the slype and slightly away from the projecting Chapel of St Edmund, with access to it from the east cloister walk via the eastern slype.[8] There is, however, as yet no firm archaeological evidence of such a building in this area.

2. More generally, it is thought that the de Wylington chapel was either an adaption or an extention of the Norman axial chapel. F.S. Waller wrote 'The chapel was probably not a new building, but simply an alteration of the old east apsidal chapels on each floor to suit the "Early English" times. The inserted windows of this date in the crypt seem to confirm this view.' Waller believed that the axial chapel in the crypt and the two chapels above it were extended out *into the cemetery*. The blocked up east window and the remodelled side windows of the axial chapel in the crypt are certainly of this date, and externally the chapel has been squared off. This would have provided the extended Norman chapel above with foundations for a square termination in the Early English style. But if the crypt axial chapel and the chapel above it off the choir ambulatory were extended eastwards, the axial chapel at tribune level was probably also extended providing a single roof over the three-storey extention. There is evidence in what remains of the tribune chapel, and in particular in its vault, to suggest that this was the case. Only excavations in the lady chapel could provide evidence of how far eastward the building extended. The floor, however, has been so disturbed by interments that little of the thirteenth-century east wall remains intact.

3. The de Wylington lady chapel may not have involved any structural work at all, but only the adapting and refurnishing of the existing Norman axial chapel, and rededicating it in honour of the Blessed Virgin. If, as suggested earlier, material from the two upper axial chapels was used in the crypt to provide foundations for the two eastern piers of the choir, these Norman axial chapels must have remained undisturbed until the reconstruction of the east end in the mid-fourteenth century. In which case, the blocking up of the thirteenth-century east window and the external squaring off of the crypt axial chapel must date from the building of the present lady chapel in the late fifteenth century.

OTHER THIRTEENTH-CENTURY WORK

In the course of these rebuilding works, the masons were busy refurbishing the chapels, providing them with new *piscinæ* and new windows in the Early English style. In the chapels in the crypt and tribune gallery there are several windows which were inserted at

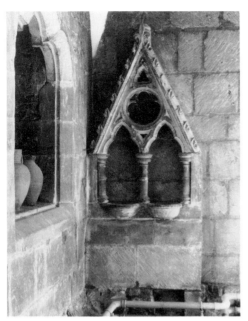

Early English *piscina*, in the north-west chapel on the tribune gallery

Early English doorway into the undercroft storage area on the north side of the refectory

this time, and also several *piscinæ*. A particularly fine *piscina* survives in the north-west chapel in the gallery, but there are others, somewhat mutilated, in the south-east and north-west chapels of the crypt. Two or three are twin *piscina*, which is further evidence of their dating to this period. In this type of *piscina* one of the basins was intended for the washing of the priest's hands, and the other for the washing of the communion vessels. The shelf was for the cruets, and the drains connected directly with the earth. The north-west chapel in the crypt was further enriched at this time with vaulting ribs and bosses with stiff-leaf ornament.

Other work undertaken during the thirteenth century is more difficult to date with any exactness. This includes the rebuilding of the *dark cloister*, the passage from the north-east corner of the great cloister to the little cloister and infirmary. This was probably constructed at about the same time as the infirmary, having one or two lancet windows, originally, on the eastern side. To what extent the great cloister was remodelled is not known, but there are two doorways one at either end of the north walk that date from this period. The doorway at the west end led up to the refectory which was completely rebuilt later in the thirteenth century, and that at the east end, hidden behind later Perpendicular panelling, formed the entrance to the dark cloister. These doorways may be the only surviving parts of a far more extensive rebuilding of the cloister in the thirteenth century. On the other hand, they may relate only to the building of the new refectory and the new passage-way leading to the new infirmary.

The Treasury Screen

The screen in front of the entrance to the Treasury in the north transept is an exceptionally fine piece of Early English work. It appears to be a screen of some sort which has been altered and adapted to fit into its present position. There is no reference to it in the *Historia,* but it may date from the period of rebuilding and refurnishing associated with the name of Helias. It is divided into three compartments, that in the middle forming a doorway. On either side of the doorway are arched openings, with beautifully carved foliage decoration. Purbeck marble shafts are placed at the angles, and corbel heads at the springing of the arches, except on the east side where the work appears very unfinished. But curiously there are also some unworked blocks of stone by the springing of the arches. Some of the figures on the outside are mutilated, but inside the screen there is a well-constructed vault with bosses one of which, in the central compartment, is a particularly delicate and beautiful piece of work. There are also several small carved heads notably that of a mitred ecclesiastic at the top of the moulding at the angle on the left-hand side.

The unfinished appearance of the screen where it abuts the east wall of the transept may be due to the stone work having been dislodged when the Perpendicular panelling was laid onto the transept walls in the fourteenth century. If this was the case it is strange that no one ever made good the damage caused to the screen. The scars in the stonework above each of the arched openings are probably due to the removal of tall crocketed gables which originally stood over each compartment. Presumably these gables were removed when the wall-passage was constructed behind the screen; the castellation on the top of the screen being added in their place. But this raises other questions as to the original purpose of the screen and whether it was designed to stand in its present position. Various theories have been put forward:

1. 'The beautiful structure in the north transept, sometimes called a reliquary, is part of the de Wylington chapel.' Bazeley believed the de Wylington lady chapel was an extension of the Norman axial chapel and that this structure served as a screen or entrance to the chapel. Ashwell measured the screen to see if it would fit across the entrance to the Norman chapel when the apsidal east end was still in place, and concluded that it would. When the Norman east end was dismantled in the mid-fourteenth century to make room for the great east window, the screen in front of the de Wylington chapel was taken down and re-erected in the north transept to serve some other purpose.[10] But there are difficulties with this theory. If the crocketed gables which surmounted the screen were in place when it stood in front of the Norman axial chapel would they have fitted beneath the Norman vault outside the chapel? Again, in this position the screen would have fitted against the responds of the Norman vault and severely restricted movement around the apsidal east end.

2. It looks more like a choir screen than anything else, but if so it cannot be in its original position. It is not wide enough to fit exactly between the piers at the east end of the nave. But with its crocketed pinnacles rising to more than 6 m (20 ft) from the steps on which it would have been raised, and set beneath the new Early English vault (1242), its Purbeck decoration matching the shafts of the nave vault, it would have made an impressive entrance to the liturgical choir. It was quite common after refurnishing a choir to erect a new screen. Following the installation of Helias' new

The reliquary: detail of carving over east opening

The reliquary: detail of west opening (note the minute mitred head to left of damaged capital), Purbeck shafts and foliate capitals

choir furniture a new screen could have been erected. If this were the case, the Early English screen would have remained *in situ* until the mid-fourteenth century when Abbot Wygmore's screen replaced it (1329–37). It would then have been moved to the north transept to be used for some other purpose, possibly as a reliquary.

3. The screen was designed to stand in its present position, and to serve as a reliquary. The masonry on the right-hand side was disturbed when the Perpendicular panelling was put up in the 1360s. Before this the structure would have abutted the Norman wall at the side of the chapel entrance, and the right-hand side of the screen would have been as the left-hand side, properly finished and completing the balance of the design.[11] The screen, which was certainly in this position in 1360s when the north transept was remodelled, was installed here at about the time the church was rededicated *c.* 1242. 'It cannot be dated earlier than the late 1240s.' (Dr P. Tudor Craig). Everything inside the structure, the vault with its finely carved bosses and that part of the terminal wall which is enclosed seem to confirm the view that it dates from this period and was designed to stand in this position.

It was almost certainly designed as a reliquary, though Heighway found no reliquary fittings in the stonework when the entrance was made into the treasury in 1976. There has been endless speculation about its original purpose. Some have thought it was an Easter sepulchre, a chapel in which a figure of Christ was laid with solemn ceremony for Good Friday until the dawn of Easter Day. Others have thought it was a penitentiary. They noted that, as in Britton's engraving (1829), there were iron bars across the

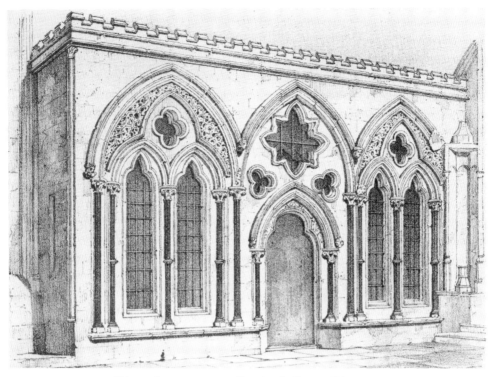

Thirteenth-century screen. Drawing J. Carter, 1807

openings in the screen. There are still ferramenta in the octofoil opening above the central doorway. It must therefore have been a place where recalcitrant monks were kept! Clarke, however, pointed out that the 'iron bars' were in fact made of wood (1850), and in any case they were not medieval. Others believe it was a secure place to keep valuables. In the *Calendar of Close Rolls* (Edward III, 1346), transcribed by Hockaday (*Extracts* 207), it is stated that the king ordered the Abbot of St Peter's to deliver to the collectors of the subsidy in Gloucestershire 'a good and strong house in that abbey where they may safely deposit the money.' Whether this extract has any relevance to the treasury screen is doubtful. The hooks for a strong door were still in place in the structure, the most likely purpose of which is to secure the abbey's relics and treasures.

The Infirmary

There is no reference in the *Historia* to the building of the infirmary. It must have been a large and impressive structure, and judging from the six arches of the south arcade which have survived it was probably built a little after Helias' time. At the Dissolution the infirmary was unroofed and partly demolished as being no longer required. The west entrance and the ruined arches of the arcade were preserved by being incorporated in sixteenth-century tenements which were built around and adjoining them and known

later as Babylon. These tenements were taken down in *c*. 1860 revealing what was once a fine building. At the east end of the infirmary were the infirmarer's lodging and a chapel dedicated to St Bridget. The chapel of St Bridget is often referred to in abbey deeds, and described as a cell for infirm monks. Writing before the demolition of Babylon, Britton (1829) surmised that the chapel 'probably stood between the prebendal house, near the gate of the infirmary, and the entrance to the small cloister, as appears from vestages of early English arches, on the outside of the building occupied as tenements, opposite the house of the organist.' Thirty years later, with the pulling down of the tenements, the extent of the infirmary was revealed, and the probable position of St Briget's Chapel confirmed. The main entrance to the infirmary hall at the west end was probably covered with a pentise or porch.

At the infirmary the sick were cared for, those who had undergone blood-letting rested for a day or two, and those members of the community who were too aged or infirm to continue in the rigours of the daily routine of monastic life ended their days. The main hall resembled the nave of a church, with beds in the aisles either side. Within easy reach were the chapel and the little cloister, and the kitchen which provided a special diet, including meat, in the adjoining *misericord* or dining room.

THE EFFIGY OF ROBERT, DUKE OF NORMANDY

At about this time the abbey acquired an effigy of Robert, Duke of Normany, the eldest son of William the Conqueror (see plate 6). Presumably it was placed in the middle of the presbytery where, according to the tradition current in the monastery at the end of the fourteenth century, the duke was buried. Whether it was part of an altar tomb or attached to some other structure is not known. From the late sixteenth century it is depicted or described as resting on its present mortuary box. A possible motive for the abbey having the effigy made at this time (if indeed it was the community's initiative) and placing it in the presbytery may have been to match the burial of King John in the choir at Worcester. At times the relationship between the diocesan church and St Peter's Abbey seems to have been one of rivalry. With the approaching re-dedication of the abbey church this visual assertion of the community's close association with the Conqueror would not have seemed out of place. But the exact date of the effigy is not known. It cannot be later than 1300, and some have put it much earlier, even 'within sixty years of Robert's death.' There is now, however, a consensus of scholarly opinion which would date the effigy to the mid-thirteenth century. It should therefore be studied in the context of this period, and possibly in the context of the rebuilding programme which culminated in the rededication of the abbey church in 1239.

The effigy is made of Irish bog oak. The torso is hollowed out. The figure is lying down and the crowned head rests on a pillow. The bent legs are crossed. The feet must originally have rested on a foot support of some kind and, given Robert's royal connections, this would probably have been a lion. The right hip is raised so that the body is in large part supported on the left hip. A black strap extends across the chest, stopping abruptly at the edge of the tunic's arm hole. Judith Hurtig thinks that the strap indicates that a shield was attached to it on the left side of the body as on a similar stone effigy of roughly the same date at Dorchester, Oxon.[12] Duke Robert is depicted

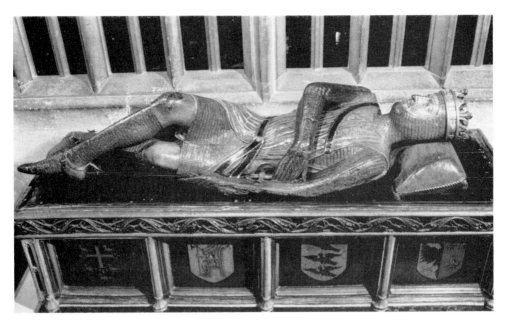

Top: Effigy of Robert, Duke of Normandy (Jones Photography). Bottom: The Dorchester effigy
c. 1260 (Conway Library, Courtauld Institute of Art)

withdrawing his sword from its scabbard. The armour and the style of the smooth,
flattened, curvilinear folds of the tunic are very similar to the Dorchester tomb. Hurtig
believes the present position of the hands is incorrect and must be the result of
restoration. Certainly if there was a shield attached to the left side of the body the
present posture and gesture would be impossible. In her view 'close inspection reveals
that the hand and lower part of the arm are not original.' Further, on the crossed legs,
she doubts whether the usual interpretation of this pose as indicating that the knight

fought in or died during a Crusade to the Holy Land can be sustained. The pose was adopted in sculpture, in wood and stone, in about 1250 which is 'well after the great period of European crusading.' A study of tombs of knights in England up to about 1350 shows that most of them have crossed legs, and 'one simply cannot accept the possibility that as late as the middle of the fourteenth century all these men went on Crusades.'

The adoption of the pose coincided with the adoption of recumbency for such figures. The cross-legged pose would have little meaning in a standing figure, whereas it is natural in a seated or recumbent position. Further, the adoption of the pose coincides with the beginning of the development of the gesture of withdrawing the sword from its scabbard. In the case of the effigy of Duke Robert the crossed legs are particularly emphasized and at the same time the gesture of withdrawing the sword is boldly depicted. In a way the figure is shown as relaxed with head on a cushion (and legs resting on a lion or dog), but also as alert, ready to draw his sword from its scabbard. Might not such a pose simply depict the knight 'at rest', and yet as in life vigilant, a virtue much extolled by medieval knights and poets?

Philip J. Lankester, in an important article in *Oxoniensia* (vol. LII, 1987), also compares the effigy with the limestone figure at Dorchester. The Dorchester effigy has been dated as early as 1230 but also as late as 1310, and was attributed by Lawrence Stone to the Abingdon workshops. Lankester, however, questions this, pointing out the similarities with the wooden effigy of Robert Curthose, which he notes has been dated variously between *c.* 1240 and *c.* 1290. He comments that 'there are sufficient similarities bewtween the two effigies to assign both to the same workshop and to make it probable that they were executed by, or under the close supervision of, the same sculptor who was clearly an artist of considerable talent and technical skill.'

Lankester could find no obvious event in the thirteenth century which might explain the commissioning of an effigy of Robert of Normandy, but he notes that Dr Pamela Tudor Craig has suggested that it may have been made in support of Henry III's claim to the duchy, sometime before 1259 when he relinquished his claim on sealing the Treaty of Paris. There is also the effigy in Purbeck stone of his father, King John, in Worcester Cathedral normally dated somewhat later than his death in 1216, perhaps *c.* 1232, which he must also have commissioned. Lankester wonders whether there may not be a connection with the Fontevraud royal effigies. If so, this would suggest a date for the Gloucester figure of *c.* 1255–65. But whether Henry III commissioned it, or what occasion gave rise to it being commissioned, remains a matter for scholarly speculation.

The effigy has been repaired at different times. According to Atkyns it was broken to pieces by Cromwell's soldiers, 'but Sir Humphrey Tracy of Stanway bought them and laid them up until the Restoration of King Charles the Second, and then caused the monument to be repaired and beautified at his own charges.' Bonnor writing in 1798 added that Sir Humphrey 'had wire-work made to protect it and placed it above the choir, where it remained until Dean Chetwood removed it to the north east ambulatory chapel.' The iron-work refers to the protective cradle, which being made *c.* 1662 did not originally form part of the mortuary chest. This is confirmed in two early drawings which show the effigy lying on the chest but without the cradle. The earlier drawing is dated 1569 and is by Robert Cooke. It is headed 'the manor of the tombe of Robert

Carthoyse, Duke of Normandy (sonne of K: Wm Conqueror) in the same church in the middle of the quyer.' This shows that the effigy and the chest were married up before 1569, i.e. thirty years after the Dissolution. This is also confirmed by Leland's observation (1540/1) that the tomb of Robert Curthose 'lyeth in the middle of the presiterie. There is on his tombe an image of wood peinted, made longe since his death.' If there is an implied contrast between the wooden effigy and a surviving stone 'tombe' then Leland does not refer to the mortuary chest; but if there is no such implied contrast the effigy and the chest were as one at the end of the monastic period (1539). It should be noted that, unless Cooke's drawing is very inaccurate, the right arm is shown in its present position and there is no sign of a shield.

The second sketch is by Nicholas Charles, Lancaster Herald *c.* 1610, and is chiefly concerned with the heraldry on the chest. On the figure itself the spurs are of the rowel type and again there is no shield. Around the chest are a series of ten shields bearing coats of arms, nine of which were originally intended to commemorate the nine worthies of the world. On the right side are: Hector, Julius Caesar, King David of Israel, King Arthur. On the left side are: Edward the Confessor, Alexander the Great, Judas Maccabaeus, Charlemange. At the ends are Godfrey of Bouillon and the Arms of England and France quarterly. The blazoning of the last suggests the chest is later than the time of Henry IV (1399–1413). Sir William Guise remarked to the Gloucester Cathedral Society in 1883, 'I am disposed to assign to the effigy a date not very remote from the period at which the duke lived. The hauberk of chain-mail and the long surcote ceased to be worn after the thirteenth century. But the mortuary chest on which the figure rests is no earlier than the fifteenth century.'

At the time of the Restoration (1660) a gifted local painter, John Campion, received payment 'for gildinge and paintinge of Duke Robert his tome and about the quire', and

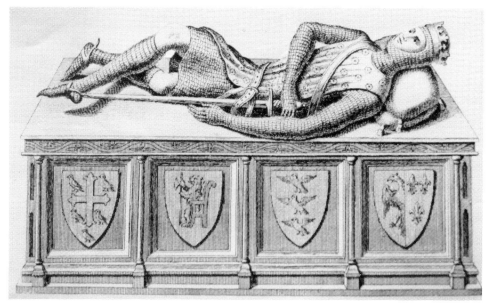

Effigy of Robert, Duke of Normandy, resting on mortuary chest decorated with heraldry. Nicholas Charles' drawing of 1610

a certain Mr Smith was paid £1 3 s. 6 d. 'for the wyer about Duke Robert', presumably work done at the request of Sir Humphrey Tracy. In 1791 the tomb-chest was recoloured. Anna Hulbert examining the painting in 1981 found extensive indications of a medieval paint layer. Apparently, the plinth and corners were scarlet, the hollow above the plinth, now white, were probably green. At the head-end there was shown to be a good patch of gold, and gold also on the foliage beading. 'I suspect the gold on the effigy is more recent than the 18th century. However, it is clear that if the present 1791 layer were removed anything underneath would be fragmentary.' (Hulbert).

When originally polychromed the effigy was gessoed. Much of the gesso has disappeared taking the colour with it. But the straps of the spurs were once red, possibly the mail was simulated in tin or silver leaf, either of these would have turned to black or grey, and this would account for the grey repainting. Hulbert identified three layers, the thirteenth-century layer, another when the effigy was placed on the mortuary box in the late fifteenth century, and the eighteenth-century layer, together with subsequent touching up:

> It has been suggested that Duke Robert's nose may be a repair. The closest possible examination by the naked eye with a good light gives every indication that it is an integral part of the original sculpture. An X-ray should quickly confirm this. In view of the hollowness of the structure it might well be possible to take an X-ray of the chest which would give a reasonable reading of the paint. This would probably be the easiest way to ascertain whether the leopards of England were ever 'embroidered' on the gown (Hulbert).

In the 1980s the effigy and the chest were exhibited in London, at the Public Record Office, in celebration of Domesday Book 1086; and at the Royal Academy of Arts' exhibition 'The Age of Chivalry' in 1986/7. Cracks in the torso and around the neck were filled with wax, and other minor repairs carried out in order to stabilize the effigy for removal to London.

The Nave Vault Completed 1242

The nave vault may well have been under construction at the time of the dedication of the church in 1239. It was completed in 1242. It was a formidable undertaking and must have been regarded as the consummation of two decades of continuous building work. Work on the vault began at the west end and progressed towards the tower crossing. This would have necessitated the repair of the south-west tower. One or two bays of the old vault would have been taken down as the new vault was constructed. Work probably went on beneath the timber roof which was left in place to provide protection from the weather. This may be the reason why the vault was built rather lower than might have seemed desirable. Though a typical example of Early English Gothic and a simple and graceful construction in itself, it sits rather awkwardly on the wall of the Norman arcade. As Verey commented 'The vault can be criticised as being too low.' Masse more bluntly wrote 'it effectively spoiled the nave'.

As work proceeded a considerable amount of the clerestory wall had to be taken down in order to secure a sure footing for the springing of the new vault. Either side of the springing a vertical masonry line reveals the extent of the disturbance particularly at the

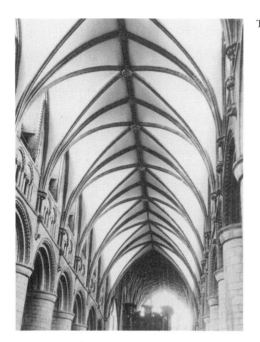

The nave vault, completed 1242

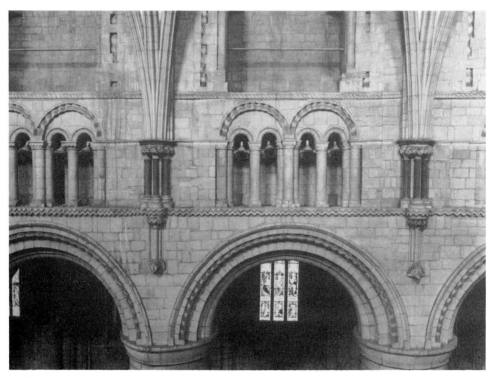

The nave vault springing, a cluster of Purbeck shafts with stiff leaf capitals. Note the vertical masonry line on either side of the springing

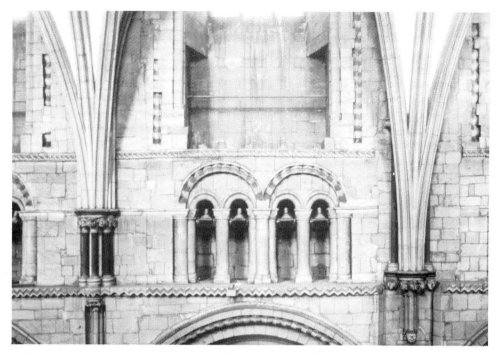

The nave vault springing at the east end of the nave. Note single tall Purbeck shafts on either side of the springing

east end. In the first four surviving bays from the west end the vault springs from a cluster of short Purbeck shafts, standing on the floor of the triforium which is divided from the arcade below by a string course with chevron moulding. Below the string course are extension vaulting shafts which descend between the arches of the arcade and end in a corbel head. But in the three eastern bays the springing of the vault is dropped several feet down to the level of the triforium floor and there are no clusters of Purbeck shafts. Instead on either side of the springing there is a single, tall shaft. The clerestory wall arches in these bays are kinked on the east side apparently to narrow each bay in the approach to the tower crossing. The ridge rib which, from the west, is fairly broad is greatly reduced in width in the eastern bays. There is also a steady rise in the apex of the vault from west to east amounting to 0.4 m (1 ft 6 in).

The explanation of these changes in design may lie in the statement in the *Historia*: 'In the year of our Lord 1242 the new vault was completed in the nave of the church not with the help of craftsmen as at first but by the ardent devotion of the monks who were in that place.' *Completa est nova volta in navi ecclesiae, non auxilio fabrorum ut primo, sed animosa virtute monachorum item in ipso loco existentium.* In other words, the monks finished the work themselves without the help of the craftsmen they had employed at the beginning. When they came to the last three bays, at the east end of the nave, the monks for some reason lost, or had to dispense with, the help of their masons and had to finish the work themselves, as best they could. They seem to have stilted the vault from a lower position in order to make up for an earlier error in calculations. This meant

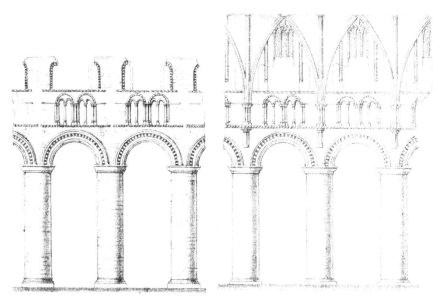

F.S. Waller's drawing of the remains of the Norman clerestory, with later additions

abandoning the uniformity of the earlier bays and putting an unsightly kink on one side of the wall arches.

Abbot Foliot died in 1243, a year after the nave vault was completed. Some have thought the effigy on a bracket on the south side of the presbytery is Foliot's. The effigy certainly dates from the middle or latter part of the thirteenth century. Masse noted 'It is said by some to be Aldred's, by others to be Serlo's monument. The date of the monument is later than either. The mutilated effigy bears a model of a church in his left hand, and this points to its being the monument of a founder. It is more probable that it is to the memory of Abbot Henry Foliot, in whose time the church was re-dedicated.' In this Masse was following Haines in his *Guide to Gloucester Cathedral* and Matthew Bloxham.[13] But Bazeley is surely right in commenting:

> It is ridiculous to suppose that the monks in the time of Edward I would have carved an effigy of Abbot Foliot as a founder of the abbey because some sixty years before their time during his rule the abbey was re-dedicated, or because the vaulting of the nave was completed. Nor is it likely that for these reasons the gifted Perpendicular builders of the time of Edward III would have altered the construction of the south wall of the presbytery and have given Foliot such a place of honour as the figure now occupied.[14]

Yet, carved in the manner of the thirteenth century and depicting an abbot of the time fully vested, the effigy gives a fair impression of the abbot in whose time (1228–43) such a major refurbishing and rebuilding programme was carried through.

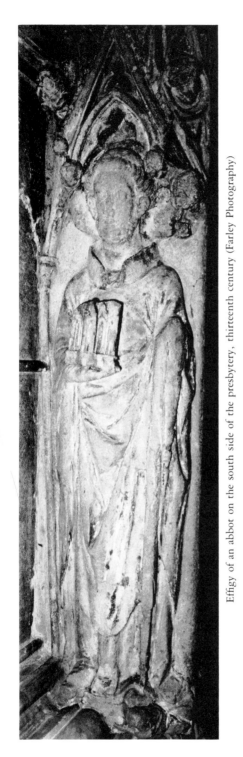

Effigy of an abbot on the south side of the presbytery, thirteenth century (Farley Photography)

The nave: some medieval faces (*c.* 1242)

The Re-dedication of the Church 1239

Henry Foliot, Prior of Bromfield, had been elected abbot in 1228 with the 'unanimous agreement of all the brothers.' It proved a wise choice, for during his abbacy the new chapel in honour of the Blessed Virgin had been completed, and 'foreign priests' provided under the terms of the Wylington's bequest. Helias, the sacrist, had carried through an extensive rebuilding programme. Helias died in 1237, just two years before the rededication of the church. The fact that the church was rededicated at all is clear evidence of the extent of the work which had been carried out. In the words of the *Historia*:

> In the year 1239 on September 18th the church of the abbey of Gloucester was dedicated by Walter de Cantilupe, bishop of Worcester in honour of the chief of the apostles, the Apostle Peter. Accompanying him were the venerable fathers the abbots of Evesham and Tewkesbury, of Pershore and Cirencester and other noble gentlemen with a huge crowd of the common people. The bishop granted forty days holiday to the church and granted that the anniversary of the dedication be celebrated by all in the city of Gloucester as if it were a Sunday and that the holiday should last fifteen days.

This occasion of rejoicing over the near-completion of such a major programme of rebuilding and refurnishing was doubtless sustained by an ample supply of food and wine. One of the abbey vineyards was in the north-west corner of the precincts. The vineyards of Gloucestershire were well-known, William of Malmesbury writing in the twelfth century: 'This county is planted thicker with vineyards than any other in England, more plentiful in crops, and more pleasant in flavour. For the wines do not offend the mouth with sharpness, since they do not yield to the French wines in sweetness.' The vineyards of Gloucestershire survived as late as 1701, and happily in recent years vine growing has been revived with excellent results. The curious terraces or step-markings on the Cotswolds in various places, locally called 'litchets' or 'lyches' are thought to be the sites of old vineyards. In 1230 Abbot Foliot had appropriated the annual rent of 20 marks from the church of Newburgh in Monmouthshire *ad caritates conventus de vino Gallico*. This was to provide an even more generous amount of wine for the convent to drink in commemoration of its founders and benefactors.

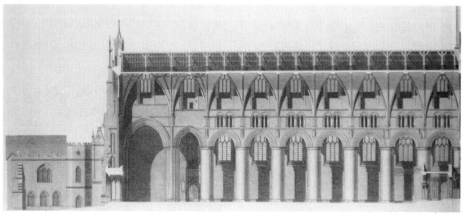

The nave elevation, Carter, 1807

THE THIRTEENTH-CENTURY ABBEY
1243–1306

*'The Statute of Mortmain laid down that thenceforth
none might give, sell, bequeath or exchange
or otherwise assign to religious persons lands,
feudal holdings or rents without the king's permission.'*
Historia

When Abbot Henry Foliot died in 1243, the prior, Walter de St John, was elected abbot. As prior he had begun the rebuilding of the south-west tower of the nave which had collapsed *c.* 1170. Presumably the tower was patched up at the time, but with the building of the new vault in the nave, a large west window was probably inserted and the western tower rebuilt. If the tall turret tower shown in the drawing in the margin of the thirteenth-century copy of *Historia Regum Britannie* in the British Library is the south-west turret tower of the south transept, there is no sign of a similar tower adjoining the window at the west end of the nave. Though elected, Walter de St John never became abbot. He died on the day on which he was to have been installed. John de Felda, the precentor, was elected in his place, and 'put in authority by the choice of all the brothers.' He guided the fortunes of the monastery for the following twenty years (1243–63). The *Historia* says 'he was gentle in manner, tall of stature and with a countenance commanding respect.' He was generous, and lavish in his entertaining. He ordered that on the anniversary of his death the monks should be given increased allocations 'from all the produce of the mill and the vineyard' and special provision made for the poor at the gate. He is said to have built the mill at Over 'from its foundations' and opened talks with John de Fretone about the levy on fishing in the Severn, a dispute which had eventually to be settled before the London bench. The abbey's rights over fishing in the river produced a valuable source of revenue and of fish supplies for the abbey. He completed the work on the south-west tower of the nave, and in 1246 pulled down the old Norman *frater*. Work began at once on a new and slightly larger dining hall.

FINANCIAL MISMANAGEMENT

The abbot's love of entertaining and his generosity to the community and to the poor, together with the extensive and continuous rebuilding work which had gone on over the previous twenty years led the abbey into serious debt. By 1251 it owed 3,000 marks. The abbot appealed to the Bishop of Worcester who promptly 'forbade the reception of strangers and severely restricted the hospitality of the abbey.' With the death of John de Felda in 1263, his chaplain Reginald de Homme was installed as abbot. He found the monastery 1,500 marks in debt due, it was said, 'to losses and misfortunes'. He appealed to the king, and again in 1272 when the situation had got even worse, the newly-crowned Edward I took the abbey into his protection. The king appointed a commissioner to be responsible for the administration of his grant and 'to keep all persons from damaging or molesting the abbey.'

The abbey derived most of its wealth from the vast estates it owned, and in particular from the thirty or more manors scattered throughout Gloucestershire. A series of detailed surveys of the abbey's estates compiled in the 1260s, during the abbacy of Reginald de Homme, set out the basis of the financial support of the community. By means of the labour of their numerous tenants the monks cultivated extensive demesne or home farms on the manors, and transported much of the produce to Gloucester to be consumed at the abbey or sold in the market. Owning estates in different areas of the county was a particular advantage. On the Cotswold manors sheep-farming was already an important feature by the 1260s, while the manors in the Severn vale provided facilities for wintering the flocks as well as meadowland for hay and for pasturing dairy cattle. The Severnside estates included fishing-weirs for salmon and lamprey, and those bordering the Forest of Dean supplied timber for building and for firewood. Several of the manors in the more sheltered areas had vineyards. Yet in spite of this landed wealth the history of the abbey is marked by periodic financial crises caused mainly by extravagance and the mismanagement of its resources.

ABBOT JOHN DE GAMAGES 1284–1306

John de Gamages who took over as abbot in 1284 had been prior of St Guthlac in Hereford. He was a man of substance, described in the *Annals of Worcester* as 'that most noble man, in the elegance of his manners and splendour of his birth'. The *Historia* states he was *vir nobilis et discretus*. In spite of the debt he inherited on becoming abbot in 1284, one of John de Gamages' first acts was to gather the community, on the Sunday next before the Feast of St Peter, 'before the abbot's throne' and grant the monks 'of mere goodwill and under no coersion' generous allocations for 'their provisions and comforts.' They were to have special grants of food for 'the second course' in the refectory on various festivals and anniversaries. There was to be 'good freshly caught fish and salted sea fish, not full of spawn' and a generous allowance of it. There were to be eggs and 'good fish' for everyone. And on the two festivals of the sacristan and precentor, i.e., on their name-days, they were to have 'a good cask of wine'.

The monastery entertained on a lavish scale during John de Gamages' abbacy. This is evident from a note about the 'solemn and sumptuous festival in the great hall by the

courtyard of the abbey' given by the abbot on the occasion of a Court of Justice held in the year 1305 around the Feast of St Hilary. There were about seventy present at the festival, thirty knights, the Priors of Llanthony and St Oswalds and other ecclesiastics. 'And they all assembled in the hall and behaved quietly according to their feudal rank, and were summoned in very great numbers to take the oaths with no commotion nor any absent. Whether judges or other barons, present at this festival, they said at their summoning that they had never seen such a festal gathering and such honour in those parts for many years past.'

John de Gamages is praised in the *Historia* for having obtained many privileges for the abbey. One was a charter whereby during every vacancy in the abbacy, the prior and convent were appointed keepers of the abbey until the abbot-elect received the temporalities. The abbey had to pay 200 marks to the king for the first four months of the vacancy, and if the vacancy was not filled a further sum of 200 marks for every four months thereafter. As a result of astute management Abbot John was able to pay off the abbey's debt of 1,000 marks which he had inherited in 1284, and put the abbey's affairs on a sound financial footing. This was done mainly through increasing the abbey's stock of sheep on its estates to 10,000, which were said to have produced forty-six sacks of wool for sale in one year. He not only developed sheep-farming but carried out an ambitious programme of building on the abbey's estates of which the great barn at Frocester is a remarkable survival. There is evidence too that at this period and during the early years of the fourteenth century several of the parish churches in which the abbey had rights as rector were enlarged and enriched.

It is small wonder that the entire community mourned the death of their redoubtable and generous abbot. A detailed and probably contemporary account of his death is given in the *Historia*. He had lived sixty-two years in the monastery of which he had been abbot for twenty-three years. He died in May 1306 (or, according to the *Annals of Worcester*, 1307) and was buried near his brother Sir Nicholas Gamages 'without the choir, near the gate to the cloisters'. Britton has a footnote that states 'when workmen were erecting Bishop Benson's screen in 1741 they found a stone coffin containing a sword, a little pewter chalice, a staff.' This coffin was thought to be that of Abbot Gamages, 'as the chalice and staff denote an ecclesiastic, and the sword a knight, probably his brother.'

The Statute of Mortmain

The financial position of the abbey could not have been helped by the *Statute of Mortmain*. Edward I came to the throne in 1272 on the death of his father, Henry III. Throughout his reign King Edward sought to strengthen the Crown by restricting the rights of both the Church and the baronage. The first clash with the Church came in 1279 when Archbishop Peckham made an attempt to reassert some of Becket's old doctrines as to the independence and scope of the church's jurisdiction. When Peckham summoned a national council of clergy at Reading in that same year, and issued certain 'canons in support of the independence of Church courts' the king replied not merely by compelling him to withdraw the document, but by passing the celebrated *Statute of Mortmain*. This measure was intended to prevent the further accumulation of estates in the dead hand, in *mortua manu,* of the Church.

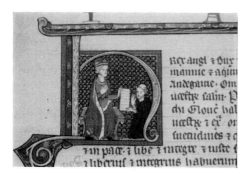

King bestowing grant of liberties to a kneeling monk. (Detail of plate 3)

The statute is referred to in the *Historia*: 'In the year of our Lord 1278 and the sixth year of the reign of the first King Edward after the Conquest, King Edward and his magnates published the *Statute of Mortmain,* which laid down that thenceforth none might give, sell, bequeath or exchange or otherwise assign to religious persons land, feudal holdings, rents without the king's permission.' Among the medieval deeds in the library of Gloucester Cathedral there is a document, dated 1283, a royal licence to alienate *in mortmain,* giving permission to a certain John Thormerton to convey land to the Abbey of St Peter. Because such a gift of property to monastic houses 'in free alms' deprived the Crown also of military and other feudal services, Edward I forbade it by the Statute. In future a special licence was necessary to convey land *in mortmain,* and for this a suitable sum had to be paid which proved, of course, a useful device for further increasing Crown revenues.

Yet there was justification for the king's action. By the late thirteenth century about a quarter of the country was already in the possession of the Church, and this land no longer contributed its fair proportion of the taxes of the realm. A large share of the king's revenue came from death-duties and resumption of lands to which there was no heir; but as a monastery or bishopric never died, the king got neither reliefs nor escheats from them. The *Statute of Mortmain* therefore prevented the alienation of land to the monasteries, and expressly forbade the fraudulent practice of ostensibly making gifts to the Church and receiving them back. Landholders had sometimes pretended to make over their estates to a monastery, in order to escape the taxation due on feudal fiefs, while in reality by a corrupt agreement with the monks they kept the property in their own power, and enjoyed it tax-free. For the future land rarely fell into the 'dead hand' of the church since it could not be given away without the king's consent. As a result, very few new monasteries were built or endowed after the passing of the statute. But the Crown frequently relaxed the rule in favour of the colleges of the Universities at Oxford and Cambridge which were then being established and generously endowed.

Gloucester Hall, Oxford

Oxford in the late thirteenth century was a market town dominated by a castle and enclosed by new stone walls, situated on rising ground above the confluence of the rivers Isis and Cherwell. Within the walls were the halls and lodging-houses from which the

Pembroke College (Gloucester Hall), Oxford, row of medieval lodgings

university was to develop. Ever since the General Chapter of the Benedictine Order held in 1247 it had been the declared policy of the Order to encourage study and education in a further effort to return to a stricter interpretation of the *Rule of St Benedict*. As a result the Presidents of the Chapter at Reading in 1277 decided to found a house of study at Oxford. The first Benedictine establishment in Oxford was, in fact, the cell founded by the Abbey of St Peter, Gloucester in 1283 on a site next to the Carmelites and opposite Beaumont Palace.

Sir John Gifford of Brimpsfield in Gloucestershire purchased this site belonging to the Hospitallers of St John intending to found, for the good of his soul, a small priory for thirteen monks of St Peter's Abbey. The *Historia* describes the original initiative:

> In 1283, on St John the Evangelist's Day, John Gifford, Baron of Brimpsfield being present himself in St Peter's Abbey at Gloucester, the venerable Father, Abbot Reginald de Homme presiding, founded Gloucester College *extra muros Oxoniae* as a house for thirteen monks of the abbey, and appropriated for their support the revenues of the church of Chipping Norton in Oxfordshire.

Each monk was allowed 15 marks per annum. The original cell founded in 1283 remained in being, but eventually it was transferred to the control of Malmesbury Abbey where Gifford died in 1299. The abbot of that house became ground landlord and, at the same time, the prior was to be a Malmesbury monk. L.E. Gordon in his *Paris and Oxford Universities in the 13th and 14th Centuries* (New York, 1975) sums up the Gloucester connection with the Oxford college:

After protracted negotiations it was opened in 1298–9 to Benedictines from convents through the province of Canterbury, and the connection with St Peter's in Gloucester was broken. It was not, like other colleges, a corporate body, being under the dual control of the abbots of Malmesbury and the presidents of the college. In 1336 this control became even more amorphous when Benedict XII, as part of his monastic reforms. united the provinces of Canterbury and York into one, thereby making the college accessible to monks from over the whole of England.

However, for many years the name of the college was to bear witness to the fact that it was founded as a result of the generousity of a Gloucestershire man, with the encouragement and support of St Peter's Abbey, and for the benefit of its members.

Pope Benedict XII's reforming *Constitution for the Benedictines* in 1336 made the sending of student monks, one out of every twenty in the monastery, to the university a legal obligation. A *prior studentium* at Gloucester College was put in charge of the Benedictines at Oxford, who were as far as possible to live not dispersed around the town, but in groups of not less than ten. Ideally all student monks sent to Gloucester College were to be under the *prior studentium* and tutored by the monastic doctor of theology. The thirteen student monks sent to Oxford from St Peter's Abbey were 'chosen out of the convent to be improved in learning . . .' After that the abbey maintained three or four of their monks at the college for some considerable time. This link with the university must have provided increasing intellectual stimulus to the community and introduced the monks to the new learning which emerged in Oxford in the following century.

St Peter's Abbey had been highly regarded as a place of learning from Serlo's time,

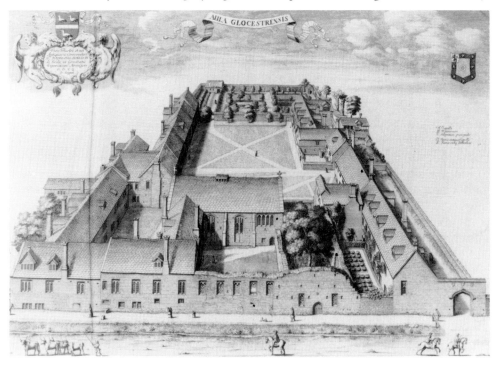

Gloucester Hall, Oxford: from a drawing by David Loggan *c.* 1675

when sons of noblemen were sent to the monastery for their schooling. The intellectual life of the place had been given fresh stimulus during the abbacy of Gilbert Foliot (1139–48) who brought to the office all the learning and asceticism that were later to make him, as Bishop of London, such a formidable opponent of Archbishop Thomas á Becket. While at Gloucester he set aside a regular income for the provision of ink and parchment to increase the number of volumes in the library. The scholastic reputation of the monks had been growing for some considerable time. It was now to be maintained and enhanced by their attendance at the Benedictine college at Oxford.

There is evidence to suggest that some of the monks on their return to the monastery engaged in preaching, not only to their brethren in the community but more generally in the diocese. It has long been accepted that by the age of Wycliffe all the great names in the history of monastic eloquence had disappeared. Certainly there is a dearth of new monastic sermons in the fifteenth century, in contrast to the numerous texts associated with the friars, probably because of the traditional reluctance of the monastic orders to become involved in *cura animarum.* But P.J. Horner in a discussion of a manuscript, containing monastic sermons, which originated in St Peter's Abbey (MS Laud misc 706, Bodleian Library, Oxford), has pointed out that:

> . . . with the university training of many monks, spurred on by Benedict XII's reforms of 1336, the growing participation of the monasteries in the preparation of candidates for ordination, the opportunity to carry out pastoral duties in churches in the gift of the monastery, the need to supplement the ranks of the secular clergy badly depleted by the Black Death [1346] – the Benedictines of the late 14th century undertook a larger role in pastoral matters.

The General Chapters issued specific instructions that student monks at Oxford should be well trained to preach in the vernacular as well as in Latin. The Laud manuscript 706 provides evidence that Lent courses of sermons were given by Benedictines to ordinary congregations. The manuscript, which contains fifteen sermons, was *ex libris* (f. 188v) John Paunteley, a monk of St Peter's Abbey and a *sacre pagine professor* at Oxford in 1410. The volume contains the sermon which the learned monk preached at the funeral of Abbot Walter Froucester (Abbot of St Peter's 1381–1412) whom he described as *sanctissimus pater benedictus*

It was a source of great satisfaction to the community that a monk of St Peter's Abbey, William de Brok, was the first Benedictine to obtain the degree of doctor of divinity at the university. The *Historia* records the day of his *inceptio* with obvious pride:

> In the year of the Lord 1298, on the day after Saint Bernard's day, brother William de Brok, a monk of this place, was admitted as a student in Sacred Theology at Oxford under Master Richard de Clyve, Chancellor of the University. He was the first of the Order of the black monks of St Benedict to make a name for himself in the subject. Towards Vespers on that day at his examination his companion Laurence Honsom, a monk graduate in the same subject, and from this place, conducted a public dialogue with him. At his admission were present the abbot of this place with his own monks, priors, inferior officers, people living in the monastery, clergy, squires and other noble persons up to one hundred mounted men. Also present were the abbots of Westminster, Reading, Abingdon, Evesham and Malmesbury, many priors and other monks, who all generously supported the admission with various gifts and contributions of produce. And all the other prelates of our Order in almost the whole Province of Canterbury sent various contributions by their representatives, and thus his admission was completed to the honour of this house and our whole Order.

Three years later William de Brok, Doctor of Divinity of the University of Oxford, became Prior of St Peter's Abbey.

At the Dissolution the college buildings were sold, but in 1560 they were acquired by William Doddington who, in turn, sold them to Sir Thomas White, the founder of St John's College. The first principals of Gloucester Hall were Fellows of St John's. Loggan's engraving of 1675 gives an idea of the Hall at that time. In 1714 Gloucester College ceased to exist and was replaced by Worcester College, founded by Sir Thomas Cockes. The fifteenth-century *camerae,* or tenements, occupied by the monks remain on the south side of Worcester College. Some of the *camerae* are still identifiable from shields over their entrances; for example, there remain those of Glastonbury, St Augustine's Abbey, Canterbury and Malmesbury. Furney in his *Extracts* (*c.* 1720) noted:

> Other monasteries of Benedictines afterwards partook of the benefit of this house; and their lodgings were called agreeable to their names. That part called Gloucester lodgings (as appears by the arms of the Abbey at the entrance thereof) still remains, and in the habitation of the Provost of this house, which has lately changed its name of Gloucester College, afterwards of Gloucester Hall, into Worcester College.

The quarters used by the monks of St Peter's were demolished to make way for the New North Range and Provost's Lodging (1753–73). Gloucester's name survives only in Gloucester Green opposite Worcester College, now the site of the Oxford coach station.

The New Dormitory 1313

In 1300 another major fire severely damaged abbey property. The *Historia* states that the fire broke out 'on the day of the Epiphany towards the time of the High Mass' and started in one of the timber buildings in the great courtyard. It spread to 'many buildings all through the abbey' destroying or badly damaging the small bell-tower, the great hall and the cloister. 'But after many folk ran together from all sides and many prayed, the entire fire was soon brought under control, so that this may be ascribed more to a miracle than to the great help we received.' A south-westerly breeze must have caused the fire to spread across from the domestic and stable buildings on the west side of the outer court to the great hall, a thirteenth-century building on the south side of the inner court, and on to the *parvum campanile,* a small bell tower near the north-west corner of the cloister used to call the community to meals in the refectory. Masse states that 'in this same fire the Norman dorter or dormitory suffered considerable damage.' Certainly the dormitory was pulled down three years later, and a new *dorter* was built. It took ten years to complete, but in 1313 it was ready for occupation. 'All the monks left their cells with their own beds and transfered themselves to the new dormitory.' (*Historia*). On the Feast of All Saints that same year it was blessed and sprinkled with holy water by Lord David Martyn, Bishop of St David's.

The dormitory was pulled down at the Dissolution as being no longer required, and all that now remains to mark its site is part of a window jamb with a fragment of ball-flower ornament on it at the north-east angle of the chapter house. The building lay on the north side of the chapter house extending from the east cloister walk at first floor level. In many Benedictine monasteries the dormitory ran the whole length of the east

side of the cloister with the chapter house and rere-dorter below. This enabled a night-stair to be built leading directly down from the dormitory to the transept giving direct access to the choir. In the ideal scheme of a monastic layout known as the St Gall plan, dating from the ninth century, the dormitory is shown in this position, with a series of rooms in the undercroft beneath. However, the St Gall plan marks no special chapter house, but indicates that the north walk of the cloister was to be used for this purpose. The desire for a chapter house of appropriate size and splendour soon became stronger than any tradition as to the correct or convenient placing of the dormitory. Thus, at Canterbury and Winchester, as well as at St Peter's Abbey, the chapter house, with its high vault, cut off the dormitory from the transept of the church, the monks having to go down to the east walk of the cloister, and so to the choir for the night office.

Webb points out that:

> . . . in most examples of the 12th century where height and splendour were required, the direct communication of the dormitory with the transept was preserved by a compromise whereby the chapter-house was entered through a vestibule which occupied the undercroft of the dormitory, the chapter-house proper being built out to its full height to the east. This provided an opportunity for very effective dramatic contrast between the vestibule, low and broken up with columns supporting a vault in small bays, and the hall itself which was lofty and covered with a single unbroken span. Good examples are at Bristol, Hexham and Chester. Some of the greater chapter houses of the 12th century had vaults of up to a 35 ft span, as at Durham, Reading and at Gloucester.[1]

This raises the question whether, before the construction of the chapter house vault in the mid-twelfth century, there may not have been a low vestibule at the west end, and a passage over it connecting the dormitory to the transept. The west end, above a few courses over the entrance, is evidently later work required by the building of the vault. The passage, it is argued, may have passed across the west end of the chapter house, and continued over the *locutorium,* or eastern slype, to the newel stair leading down to the transept. Here there is a vertical masonry line in the newel stair, possibly indicating the position of a doorway, at roughly the right height and facing the right direction to link up with such a passage.

ABBOT JOHN THOKEY 1306–1329

Work on the dormitory was still in progress at the time of Abbot John de Gamages' death in 1306. John Thokey, the sub-prior, was elected abbot on St Philip and St James' Day and confirmed and blessed at Hartlebury by the Bishop of Worcester. He was installed with due honour on the following Feast of St Peter and St Paul. The *Historia* states 'he conferred and obtained many benefits for the monastery as much in buildings as in other ecclesiastical ornaments.' There is no mention of his inheriting any great debt, as his immediate predecessors had done, so presumably the king's agents had brought the financial affairs of the abbey under control. The situation had been helped by the increasing prosperity of the country as a whole, and of the wool trade in particular.[2] Even so, it should be noted that the two major building works undertaken in the early years of the fourteenth century, the new dormitory and the reconstruction of

the south aisle of the nave, were both forced on the abbey. The first was as a result of fire damage, and the second through the collapse or threatened collapse of a Norman vault. Judging from the quality of the work in the south aisle the abbey was well past its period of chronic debt. The decorative work on the exterior was almost ostentatious. The *Historia* speaks of 'very great expenditure on many items . . .' Clearly it was designed to impress those approaching the abbey from Westgate Street through King Edward's Gate. This gateway which had been built by Edward I in the late thirteenth century spanned the narrow approach road leading to the south side of the church.

The Decorated Style

Though only a fragment remains to indicate the style in which the new dormitory was built there is no mistaking the style of the work in the south aisle. As Early English Gothic spread though the country, developing regional variations, the influence of northern France continued to be felt mainly through rebuilding work at Westminster Abbey and later on at Old St Paul's, London. Lancets and geometric forms, circles, trefoils and quatrefoils, so characteristic of the Early English style gradually gave way to more complex and flowing designs. These included pointed trefoils and ogee curves, shapes like daggers and *vesica piscis*. The main distinctive features and motifs of the new style were much in evidence by the end of the thirteenth century or the early years of the fourteenth century. The ogee double-curved arch, for example, became a common feature from *c.* 1290. It was used in window tracery and on wall panelling, and it took a three dimensional form in the nodding ogee canopy, early examples of which may be seen at Exeter Cathedral in the bishop's throne (*c.* 1315) and the sedilia (*c.* 1320), on the Percy tomb at Beverley, and at Gloucester in the magnificent tomb of King Edward II and in the canopies of the choir stalls.

Another distinctive feature was the lierne rib which was introduced into vaults. These short ribs do not spring from either the main springers or from the central boss, they are purely decorative serving no structural purpose. One of the most impressive lierne vaults in the country is that which spans Gloucester's choir (*c.* 1345). Another feature was the graceful, flowing tracery, sometimes involving interlacing ogees, which was introduced into windows. Windows were becoming larger and larger presenting stained glass workers with enormous opportunities for showing off their skills. The Bishop's Eye window in the transept of Lincoln Cathedral is a notable example. A more modest but very beautiful and delicate example of Decorated tracery is in the west window in the south transept (*c.* 1332). Another noticeable feature of so-called Decorated work, particularly in the West Country, is ball-flower ornament. This was used in great profusion in the rebuilding of the south aisle of the nave (*c.* 1318).

But do all these new forms and shapes, some of which were inspired by work seen by pilgrims and crusaders in the Middle East, amount to a new distinctive style? Or was this a period of innovation and experimentation leading eventually to the establishment of Perpendicular? Kidson writes:

> The half century from 1285 to 1335 witnessed the most brilliant display of sheer inventiveness in the whole history of English medieval architecture. Sometimes the works of this period are grouped

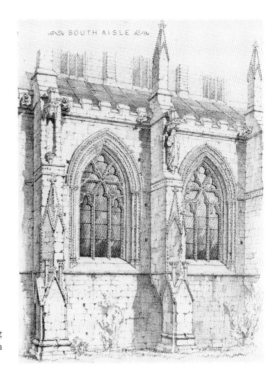

The nave, south aisle exterior, showing buttresses and windows of the early fourteenth century. (See plate 7)

together under the label 'Decorated Style'. But quite apart from the fact that this is a singularly inept term by which to distinguish one set of English medieval buildings from the rest, it is doubtful whether the notion of stylistic unity which it implies will stand up to analysis. The name decorated was first used to distinguish windows with elaborate patterns of tracery from the simple lancets which preceded them and the Perpendicular panelled windows by which they were followed. It is easy enough to extend the meaning of the word to include the new kind of vaulting which was invented *c.* 1290 to which the name 'lierne' is given; but whether we can go farther and speak of Decorated buildings, as well as Decorated tracery and vaults, is another matter. By comparison with the impressive similarities between early Gothic buildings on the one hand, and Perpendicular buildings on the other, it is the variety – one might almost say the experimental character of the so-called Decorated designs – that is the salient fact about them. One gets a better insight into the great buildings of this period by regarding them as so many essays in the quest for a new style. One of these avenues of research led directly to Perpendicular and the kind of solution which Perpendicular offered sheds a good deal of light upon the general problem with which the discarded alternative were concerned as well.[3]

The South Aisle of the Nave c. 1318

The *Historia* notes that in 1318 the Feast of Corpus Christi 'began to be generally observed through the English Church' and adds that 'at the same time the south aisle in the nave of the church was built . . . with very great expenditure on many items.' It was indeed an extensive and expensive rebuild. Only the lower part of the south wall and the responds of the Norman aisle were left intact. The 'very great expenditure on many

items' refers to the profusion of ball-flower ornament on the windows and ribs of the vault, and outside to the great buttresses which were also richly decorated with ball-flower and figures in niches. Only three of the main niches retain fragments of the original sculptures which though weathered retain sufficient detail to show the quality of the work. The figure on the easternmost buttress is thought to represent Prince Osric; the neighbouring figure was given a new head when the whole buttress was restored in the nineteenth century. These three are all that remain of a once impressive array of figures of tutelary saints and benefactors which, as battered niches and canopies show, once enriched much of the exterior of the building and not only the south aisle of the nave. The rebuilding extended from the angle of the south transept to the west end of the nave, the full length of the south aisle, with an ornamental frieze in the entablature. A section of this frieze is preserved in pristine condition *in situ* in the room over the porch (see plate 7).

In 1851 there were six statues in the niches, and in sufficiently good condition for C.R. Cockerell to describe the original iconography. 'Here were displayed to the public eye, in the true spirit of an age so attached to the evidences, titles and rights established by historical records and authorities, those illustrious founders and benefactors of whom the abbey and indeed the city might be so justly proud.' The two easternmost, he observed, were the most perfect: 'they are royal personages; they hold churches in their hands and tread upon pigs, thus quaintly signifying the exaltation of Christianity over idolatry, which kept mankind in a swineish degraded state.' He adds that 'one of these was lately moulded by the sculptors of the new Parliament Houses in London.' He considered they might represent Wulfere and Ethelred. 'The following three are unfortunately too much defaced to distinquish their characters, but they appear to be female statues and may represent the royal abbesses, Kyneburga, Eadburga and Eva. The sixth is a king and probably intended to be King Canute.' Those further to the west, the seventh and eighth statues, were lost with the building of the south porch (1421–37). Even before the fifteenth-century porch was added with its own array of figures and the entrance flanked probably by St Peter and St Paul, the south face of the aisle must have been an impressive sight.

The south aisle had been vaulted in the same way as the north aisle. But early settlement on the south side of the building destabilized the aisle wall threatening the collapse of the vault. This settlement may have been related to the infilling of the ditch of the old Roman wall which lies diagonally under the nave from south-west to north-east. Another contributory factor may have been lateral thrust from the nave vault causing the south aisle wall to lean outwards. In the central section the wall leans as much as 0.3 m (11 in) out of vertical which could well have caused a bay or two of the Norman vault to collapse. But the vault remained intact at the east end due to the buttressing effect of the south transept. In the eastern bays the first stones of the springing of the wall arches still rest on the capitals of the responds. Towards the west end of the aisle the Norman responds, between the fifth and seventh bays, are still vertical. This probably means that there was an earlier porch, on the site of the present porch, affording support to the wall at the west end of the aisle.

Abbot Thokey decided to place buttresses up against the Norman responds with the bases of the buttresses detached from the wall, and to take down the rest of the wall to about 3 m (12 ft) above ground level. He then inserted large decorative windows, with

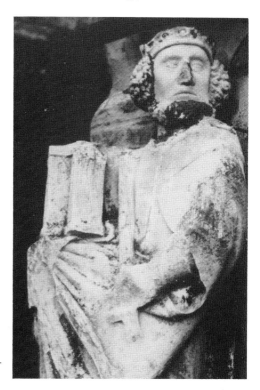

A figure in niche of eastern buttress, nineteenth-
century head

'butterfly' tracery festooned with ball-flower ornament both inside and out. Masse supposed that Thokey, for reasons of economy, first tried to preserve the Norman vaulting by buttressing the wall, and when this failed (in some cases the buttresses themselves lean 10–12 cm (4–5 in) out of the vertical) he was forced to take the vault down and to built an entirely new one. This may have been so.[4] Clearly, the wall had to be buttressed first, and the windows inserted before work on a new vault could begin. The work then began at the east end of the aisle, and each bay was constructed with little regard to cost. The lavish care that was expended on the work can be seen not only in the extremely labour-intensive ball-flower decoration, but also in the finely constructed vaulting in which the webbing is precisely defined. Yet, this was not to continue after the first three bays. The design was considerably modified as the work progressed along the aisle; with the ball-flower decoration and the careful webbing of the vault being dropped, as work on the aisle was hurriedly completed.

Originally the first bay (from the east end of the aisle) had a window like the rest in the series, but in *c.* 1400 it was remodelled. The window was heightened and given a four-centred arch, but ball-flower decoration was retained. The arch voussoirs of the original two-centred arch seem to have been modified and re-used. As Morris points out their profile is the same as the other windows except for the omission of the outer hollow moulding:

To accommodate the higher arch, the ball-flower jambs of the frame had to be extended which seems to have been effected by adding in stones of the same design from the disused frame of the interior. The

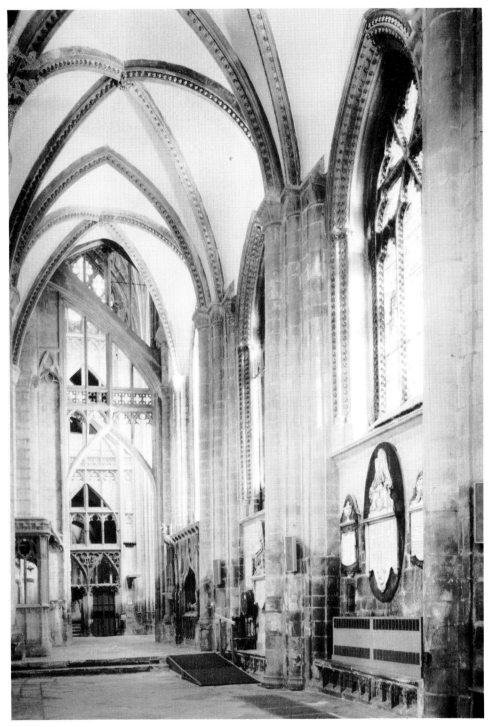

The nave, south aisle looking east (Farley Photography)

same apparent care to blend older work with the new is shown in the tracery, in which the use of a transom in combination with the ogee in the head of each pair of lights harks back to the adjoining south transept windows of the early 1330s.[5]

The date *c.* 1400 for this work accords well with the style of the effigies of the so-called Brydges tomb in the recess beneath the window. Presumably the enlargement of the window and the insertion of new glass was part of the memorial.

The next bay to the west contains a number of interesting features. This is now the first of the series of three-light windows with 'butterfly' tracery which originally ran the full length of the aisle. Around a centre boss there are five wing-like tracery lights, the first, third and fourth, in clock-wise order, are of similar design, as are the second and fifth. Alternatively, the tracery may be seen as a St Andrew's Cross intersected by a horizontal line. The east window of the chancel at Badgeworth, near Gloucester (*c.* 1315) is very similar. St Michael's-at-the-Cross in Gloucester, now demolished except for the tower, had two such windows in the south chapel though without ball-flower. This type of tracery was also common in Herefordshire around 1300, with examples at Much Marcle and Ledbury, and at Hartpury near Gloucester, which was a possession of St Peter's Abbey.

In contrast to the first bay where the webbing of the vault is well defined (the segment facing east related to the high arch of the entrance to the transept), in the next two bays the webbing though equally clearly defined relates to the line of the old Norman windows and cross to the centre of the main arcade. As already noted, in these bays the first stones of the wall arches have been left resting on the capitals of the Norman responds, whereas further along the aisle where the responds lean outwards they are missing. In the roof space above these three eastern bays there are rough buttresses, but there are none in the bays further west. The ribs of the vault in these bays are festooned with ball-flower which peters out further to the west. It is perhaps significant that where the ball-flower peters out the webbing of the vault ceases to be defined.

The nave, south aisle roof space, looking west

Ball-flower Decoration

Why these changes were made is a matter of speculation. It would have been understandable, but is most unlikely, that the medieval masons went on strike refusing the make any more ball-flowers. They are certainly the most noticeable feature of the south aisle. They cover the window surrounds, the tracery, some vaulting ribs and the external buttresses in great profusion. It is said that a horizontal line drawn just above the springing of the window arch cuts across no less than thirty ball-flowers. This form of decoration was in use in the Gloucester area before work began on the south aisle. Morris argues that a mason from Wells who had worked on the chapter house there went

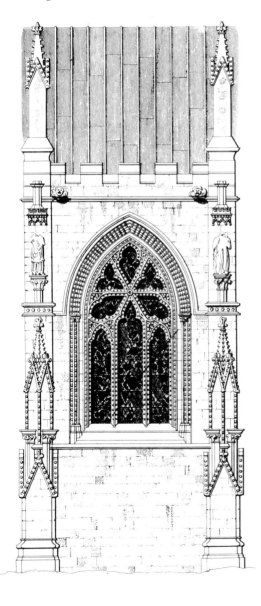

The nave, south aisle: detail of elevation of one compartment, H. Ansted, 1827

on to Hereford around 1310, and then came to work at Gloucester. He bases this mainly on the design and use of ball-flower in the three centres where the ornament was fashionable for twenty or more years, with the same master-mason responsible for its use. A number of parish churches in the neighbourhood incorporate the ornament probably deriving its form from the Gloucester workshop. These include Bishops Cleeve, Brockworth, Cheltenham, Newent, Teddington and Withington; the most notable examples of its use being the north chapel of Badgeworth and the sacristy of Tewkesbury.

Morris estimates that each mason might have made five ball-flowers per working day. Each window contains about 1,400, so that with seven windows plus the ribs of the vault the total for the work which has survived is about 11,000 ball-flowers. 'This produces the daunting figure of 2,200 extra work days to carve the ornament alone.' With a work force of say thirty masons working through the day the south aisle could have been finished in one working year, provided the campaign was well planned and co-ordinated. But Morris doubts whether the aisle was completed so rapidly. The reason for the modifications in the design of the work may have been due to funds running out. It was an ambitious project. Having completed the external work to a high standard, and having begun work on the vault at the east end to a similar standard, it was decided to complete the rest of the vault more simply.

While a lack of funds may be one reason why the work was simplified, there is another possible explanation. If, as there is reason to believe, work on the south aisle was not begun until *c.* 1325 it would still have been in progress when the abbey was caught up in the funeral of Edward II and all that followed from it. The *Historia*, noting that the Feast of Corpus Christi 'began to be observed by the English Church in 1318' adds that it was 'at this time' that the south aisle of the nave was built. The Cottonian manuscript of the *Historia* states that the monks' dormitory was not completed until 1325. This leads Morris to wonder whether the south aisle was not completed until somewhat later than 1318. Could it have been hurriedly finished as the community tried to cope with the influx of pilgrims and eventually with the London-directed' proto-Perpendicular work round the corner in the south transept?

At St Peter's Abbey ball-flowers were not confined to the south aisle. They were used in remodelling three chapels, the north-east and south-west gallery chapels and the south-west chapel of the crypt. The work in the south-west gallery chapel is particularly fine, both externally and internally. The centrepiece is a two light ogee reticulated window thickly encrusted with ball-flower, complemented internally by an elaborate rerearch with open work cusping and by several canopies and brackets for images. As Morris points out 'an unusual feature is the treatment of the arch of each of the window lights as a canopy terminating in a finial, a sculptured embellishment of the tracery probably derived from knowledge of work in the Thames valley (e.g. the east windows of Merton College, Oxford).'

It has been assumed, since St John Hope pointed out the fragment of ball-flower on the jamb of a window of the monks' dormitory, that this form of decoration must have been profusely used on that building as well (1303–13).[6] Morris questions this assumption. He writes 'modern research suggests that this is rather too early for ball-flower work. In fact the mouldings on the surviving window jamb indicate that the true date is likely to be in the decade 1320–30, which means that it must represent a

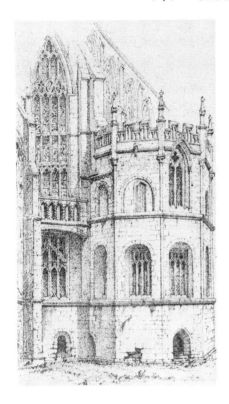

The tribune gallery, north-east chapel exterior (F.S. Waller), showing *c.* 1320 window, top left, with ball-flower ornament

later modification to the dormitory range, perhaps for a private chamber, or that the date usually accepted for the dormitory rebuilding is suspect.' The date, of course, comes from Hart's edition of the *Historia,* but his edition derives from two manuscripts of which he regarded that at Queen's College, Oxford as the more reliable. Bigland, however, preferred the alternative version, the British Museum's *Cottonian Manuscript Domitan viii* which attributes the dormitory to the time of Abbot Wygmore (1329–37). On the basis of this, and of the profiles of the jamb of the tracery, Morris concludes 'a date in the 1320s is possible but not earlier.'

On 20 September 1327 Edward II, after being held captive in appalling conditions at Berekeley Castle for some months, was brutally murdered. This event was to have unforeseen consequences for the Abbey of St Peter as three months later the king's body was brought to the abbey to be interred on the north side of the presbytery. His burial marked a turning point in the fortunes of the abbey, and in particular in the architectural history of the abbey church.

CHAPTER EIGHT

KING EDWARD II
1307–1327

'A king who altogether refused to trouble himself
about the governance of the realm.'
Sir Charles Oman

Historians have been harsh in their judgement of Edward II (1307–27) and with some justification. During his father's life time he showed himself to be incorrigibly idle and apathetic in refusing to bear his share of the burdens of state, and instead wasted his time with worthless favourites. On becoming king he persisted in his idle, obstinate and thriftless ways as the country was drawn into conflict, first with the Scots and then with the Irish. His confidant Piers Gaveston gained the ascendency, only to be replaced after the king's ignominious defeat at Bannockburn by Thomas, Earl of Lancaster, and then by the Despensers. Meanwhile in France his wife, Queen Isabella, and her lover the exiled Marcher baron, Roger Mortimer, were determined to bring about the downfall of the Despensers and to have the king deposed in favour of his son, a boy of fourteen who was with them. When the queen crossed to England, Edward and the Despensers fled towards Wales, but they were captured, the elder Despenser was promptly hanged, and Hugh Despenser executed three weeks later. The king was eventually confined to Berkeley Castle, some 12 miles south of Gloucester. The queen summoned a parliament in the name of her son, Prince Edward and the king was pronounced unfit to reign and deposed. Their fourteen year old son was elected to take his place, but power rested with Queen Isabella and Roger Mortimer.

THE MURDER AND BURIAL OF KING EDWARD II

At Berkeley the king was treated with great cruelty, and neglected in the hope that the foul conditions would hasten his death. However, when his constitution proved strong enough to resist all privations, his keepers secretly put him to death. He suffered the

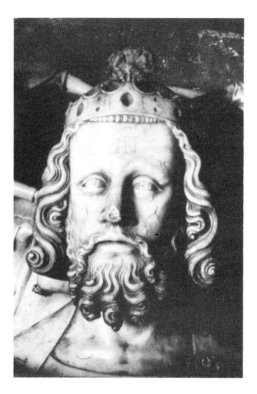

King Edward II, detail of the effigy on his tomb
c. 1330

barbarity of a red-hot poker being driven through his anus to his heart in order that his body should show no evident signs of violence. That was on 20 September 1327, but it was three months later that his body was brought to St Peter's Abbey for burial. The *Historia* explains the delay: 'After his death certain neighbouring monasteries, namely St Augustine's of Bristol, St Mary's of Kingswood and St Aldhelm's of Malmesbury were afraid to accept his venerable body for fear of Roger de Mortimer and Queen Isabella and others involved.' Wilson, however, maintains 'there is no truth in the story fabricated by the Gloucester monks that the king's body was refused burial by several neighbouring abbeys fearful of reprisals from Mortimer's faction.'

Whether or not this was the cause of the delay, time had to be given for the royal regalia to be brought from London. The queen and the young king were present at the funeral; the circumstances in which the king died not being generally known at the time. The accounts of William Aside, the receiver of the castle, give details of the preparations and costs of the funeral. Canvas had to be dyed black to cover the carriage, and cords, collars for the horses, traces and other harness had to be made. Other expenses were a silver vessel for the king's heart and the cost of oblations 'at severall times in the chapple of the Castle of Berkeley for the king's soule.' There was also an agreed allowance of £5 for every day the body remained at Berkeley.

Then, as the *Historia* records, Abbot Thokey:

. . . brought him with honour from Berkeley Castle in his own carriage painted with the arms of the same church, and it was taken to the monastery at Gloucester. The abbot and the whole community

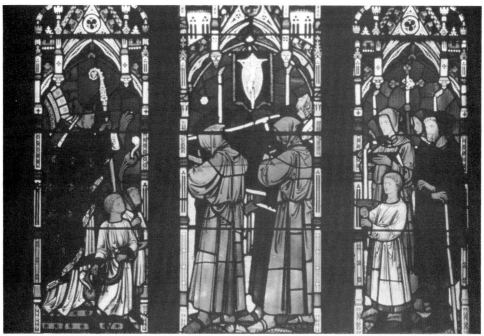

Abbot Thokey receiving the body of Edward II for
burial. Clayton and Bell window, 1859, in south aisle
of the nave (s vii)

Tomb of Edward II. Carter, 1807

being in solemn vestments attended a procession consisting of the entire town (*totius civitatis*) received the king's body with honour, and bore it to burial in the northern part near the great altar.

There is a window, by Clayton and Bell (1859) in the south aisle of the nave depicting the scene as Abbot Thokey received the body of the king outside the abbey church, but as Masse pointed out 'it bristles with anachronisms'.

The *Historia* recalls an incident in earlier and happier days when Edward II, visited the Abbey of St Peter:

> The abbot and community received him with honour. And sitting at table in the abbot's hall and seeing there paintings of the kings, his predecessors, he jokingly asked the abbot whether he had a painting of himself among them or not. The abbot replied, prophesying rather than making it up, that he hoped he would have him in a more honourable place than there. And thus it happened.

Though Abbot Thokey probably had no choice in the matter, having been ordered by the Court to give the body of the king a decent burial, nevertheless in the circumstances it was an act of courage which brought unforeseen advantages to the abbey. The gifts of the pilgrims who came to the king's shrine together with the donations of the royal house enabled the community to carry through a programme of reconstruction which was to transform the choir and presbytery of the Norman abbey.

The Pilgrims and their Offerings

The king's body was buried on the north side of the altar, between two Norman piers adjoining the apse. Eventually, on instructions from the Court, a magnificent shrine was erected over the burial place. Herbert notes that 'the burial of Edward II in Gloucester Abbey secured the favour of the new king for the town as well as the abbey'. While visiting the town in December 1328 Edward confirmed the borough charters 'in honour of the body of our father which lies buried at Gloucester.' However, for the first few years of the new reign Gloucester was secured for Mortimer's party; the castle was granted for life to Queen Isabella in 1327, and held by her until 1330. But on reaching the age of eighteen in October 1330 the young king freed himself from the tutelage of his mother and Roger Mortimer. The latter he tried and executed, and the queen was sent into seclusion in Castle Rising in Norfolk.

By erecting a magnificent tomb, clad in Purbeck marble and with an alabaster effigy of the murdered king lying on it, the young Edward III intended not only to honour the memory of his father but also to provide a shrine at which members of the Court and the common people alike might come to think of his father as a quasi-saint. The fact that the memory of so ineffective a monarch stirred such widespread popular feeling was partly due to the cruel fate that had befallen him. But though pilgrims came, it was said in great numbers, to his shrine and made their offerings, the murdered king was never canonized. Later, miracles were said to have taken place at the shrine, which encouraged his great-grandson, Richard II, to try hard to secure his canonization, but to no avail. It was probably on the occasion of Richard's visit to the tomb in 1379 that the capitals of the piers on either side of the shrine were painted a rusty red and decorated with the emblem of the white hart. In 1391 Richard granted the advowson of Holy Trinity in

Effigy of Edward II, Carter, 1807

Westgate Street to St Peter's Abbey, with licence to appropriate the church for 'the maintenance of lights and ornaments around the tomb of Edward II.'

There was an atmosphere of mystery and an aura of sanctity surrounding the tomb of Edward II in the mid-fourteenth century. After entering the church through the west door, and being ushered along the south aisle of the nave, the pilgrim would be taken through the small doorway beside the aisle altar and across the south transept. Approaching the shrine from the south side meant the community could come and go from the choir undisturbed. The significance of the hallowing angels over the entrance to the south ambulatory would not have been lost on the pilgrims as they went up the steps and made their way round the east end to the shrine itself. The shrine would have been surrounded with colour, and bedecked with costly ornaments. Flickering lights would have cast an unearthly shaddow on the dormant figure of the king. Whether or not the people considered Edward a saint, they came with the sense that here lay the remains of a king, at whose shrine miracles were said to have happened. The power of kingly figures and of holy men were closely associated in the medieval mind with their tombs, or with parts of their bodies kept as relics. Even the representations of saints in effigies and frescoes, in statues and in stained glass encouraged popular belief in the efficacy of such objects to convey grace and healing power. In spite of the Judaic prohibition on the making and worshipping of graven images, the influence of the

Tomb of Edward II, detail of the canopy

Greek and Roman traditions of symbolic art had prevailed in the medieval church. Representations of Christ and the saints had become common features of religious devotion. In fact, the importance of art in religion was never greater than in the fourteenth century. Churches were filled with sacred objects, reliquaries, rood screens, statues, crucifixes, wall paintings and stained glass. The combined historical and spiritual elements of the Christian religion were celebrated in all kinds of artistic work as popular piety was allowed full rein. Away from monastic churches and cathedral foundations, the increasing wealth of the towns and the continued growth of a money economy gave laymen the means of endowing devotional works in their own parish churches.

Every means would have been employed to encourage pilgrimage to the shrine, for this was in the interest of both the abbey and the townspeople. According to the *Historia*:

> . . . the offerings of the faithful and the devotion which the people showed for King Edward, who had been buried in the church, were such that the city of Gloucester could scarcely hold the multitude of people flowing together there from the cities, towns, villages and hamlets of England. As a result out of the offerings made there in the first six years of Abbot Wygmore's prelacy the St Andrew's Aisle [the south transept] was completed to the last detail, as may now be seen.

Some have thought that the chronicler exaggerated the numbers who came, the distance they travelled and the amount they gave, but from the local point of view it may well have seemed that as crowds thronged the narrow streets that they had come from all over the country. The town certainly found it difficult to accommodate them all, though it welcomed the increase in trade which they brought.

The *Historia* may have exaggerated the amount the pilgrims donated to the abbey. It states that the oblations presented at the shrine were so great that had they been

Tomb of Edward II, detail of Purbeck-clad tomb

expended upon the church it could have been completely rebuilt. As Verey commented 'If they were pilgrims of the common sort, they would not have had much money.' It was undoubtedly the privileges which the king granted the abbey, and the gifts and donations he, his family and nobles made for the work that mainly financed the building programme over the next twenty years. In consideration of the expenses incurred at the funeral, the king granted the abbey a number of privileges, one of the first, made in 1328, was to reduce the payment to the Crown during each interregnum in the abbacy, fixing the rate at £100 a year. Among the royal donations the Black Prince was said to have contributed a gold cross to the abbey, the Queen of Scots a valuable necklace containing a ruby, and Queen Philippa a heart and ear of gold. Thus, while the offerings of the pilgrims may have amounted to a considerable sum, initially contributing substantially to the remodelling of the south transept, this experimental work and the extremely costly programme of work in the choir must have been carried out under the direction of royal craftsmen and under royal patronage.

The Shrine and Royal Patronage

The effigy of the king is carved in alabaster and is probably London work of *c.* 1330. (See plate 8.) It is one of the earliest and finest examples of work of this kind in the country. Masse commented 'It may be, judging from the expression of the face, that there had been some attempt at portraiture'. Recent research suggests, however, that until the mid-fourteenth century memorial effigies were fairly uniform and stylized, so that if there was an attempt at portraiture in the effigy of Edward II it is a very early example. Some have suggested the sculptor used a death-mask, though this is now generally discounted. The king is depicted crowned holding in one hand an orb and in the other his staff, at his feet is a lion. His head rests on a single cushion, supported by censer-angels. Like the rest of the effigy these are beautifully sculpted; the folds of the

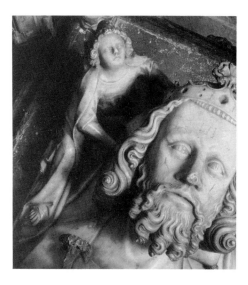

Effigy of Edward II, detail of head and censing angel

cloth, the hands and feet show them to be the work of a master. Evidently there were jewels set into the crown and elsewhere. At one time the whole shrine was a blaze of colour, though illuminated only by votive candles and flickering lamps. In such light the pale fleshlike hue of the alabaster face must have taken on an awesome, deathly quality.

The figure rests on a tomb of fine grained oolitic limestone clad in Purbeck marble, with ogee-arched recesses, cinquefoiled with crocketed heads. The weepers, or angels in mourning, have long since disappeared from the recesses. Originally there were twenty-eight of them standing on corbelled pedestals and secured by dowells. There are traces of colour at the back of some of the niches, mostly red ochre. Wilson notes that 'the only traces of the short-lived cult of Edward II are crosses cut by "pilgrims" into the surrounding stonework and the bracket inserted into the side of the tomb chest to carry a golden ship which Edward III presented after his deliverance from a dangerous sea crossing.' The tomb is set on a tiled pavement which was laid down at the time and probably extended beyond the immediate area of the tomb. The Norman piers at either end of the tomb have been cut away to form large ogee-arched niches. The capitals were painted brown or rusty red with the white hart emblem of Richard II to mark the visit of the king to the tomb in 1378. On the presbytery side there was a screen of slender circular columns and rounded arches, of which only the east and west end sections remain. The main section of the screen was erected considerably later. Its similarity to that surrounding the neighbouring chantry of Abbot Parker suggests that, with the adjoining doorway into the choir, it was erected during his abbacy (1514–39).

The canopy is also of fine grained oolitic limestone quarried locally. For all its richness it has a lightness and elegance that is quite remarkable for this period. Biver and others compare the canopy with that which surmounted the tomb of John of Eltham, in Westminster Abbey. The canopy over the Eltham tomb was destroyed by the Dean and Chapter of Westminster in 1760, but a drawing of it has survived which shows it to have been very similar to the Gloucester canopy though somewhat simpler. Wilson comments:

Edward II's monument belongs to a genre more highly developed in England that elsewhere in the late Middle Ages, the architecturally ambitious tomb. However, compared to tomb canopies of the previous generation, for example that of Crouchback at Westminster, it is singleminded in its emphasis on tabernacles of complex plan. This eschewal of Decorated luxuriance foreshadows the remodelling of the south transept at Gloucester, begun *c.* 1331, and there can be little doubt that both are the work of one architect. As in the transept, the detailing indicates a close knowledge of London and Canterbury work consonant with an attribution to Thomas of Canterbury, architect of St Stephen's Chapel from 1320 to 1336.[2]

The canopy consists of two stages of ogee-headed arches, with close cusping at the sides of the arches and ogee foils, surmounted by finials with buttresses placed diagonally and terminating in pinnacles. It is exquisite work, and the over-all effect is most impressive. A number of the carved crocketed finials were replaced by plaster ones in restoration work carried out in the eighteenth century (in 1737, 1789 and 1798) by Oriel College, Oxford, in honour of Edward II who was the founder of the college. The shaft and finial at the north-east of the canopy is even more recent work. The small iron hooks attached to the stone work of the canopy, slightly above the effigy on the far side from the ambulatory, have aroused curiosity. Their purpose remains something of a mystery. They may have been for securing figures such as censing angels or for attaching lamps to illuminate the effigy, or as some would have it for fixing painted boards or

Effigy of Edward II, detail of lion at foot of the figure

some other form of ornament. It has been suggested that the 'lofty and intricate canopy was added later in the same century.'[3] This seems to be based partly on stylistic grounds, and partly on the way the canopy is bedded on the tomb. The Purbeck-clad tomb and alabaster effigy would certainly have been put in place first; the canopy may have been erected some time later. This would allay Metcalffe's anxiety as to how the canopy was protected during the remodelling of the choir.[4]

Whether it can be assumed that the body of the king lies buried beneath this impressive memorial has been questioned by some historians. G.P. Cuttino and T.W. Lyman argued, in 1978 in *Speculum*, that the body buried below the tomb was, in fact, that of one of the servants at Berkeley Castle. The king made his escape, dressed as a monk, and fleeing abroad ended his days in Italy. It is an intriguing story, based on a reported confession, but few have been convinced by the evidence. Though it proved nothing the tomb was opened in October 1855 in the presence of Dr Jeune, the canon-in-residence. The sub-sacrist was also present and made a note of what was found:

> On the 2nd October 1855, in the presence of Dr Jeune, the canon-in-residence, Mr Waller, the cathedral architect, Allen, the sub-sacrist, and Henry Clifford, the master mason, the tomb of Edward II in the cathedral was opened, by removing the floor on the south side of the tomb; only just below the flooring, immediately under the tomb. We came first to a wood coffin, quite sound, and after removing a portion of this, we came to a leaden one, containing the remains of the king; the wood, although light as cork, was still very perfect, and the lead one quite entire, and made with a very thick sheet of lead, its shape very peculiar, being square at bottom, and rising on each side like an arch, and so turned over the body in an oval or arched form, and made to set nearly down upon the body. The tomb was never known to have been opened before this. It remained open but the space of two hours, and was then closed again, without the slightest injury being done to the tomb. The fact of his interment being now five hundred and twenty-eight years since, it was considered to be in a wonderful state of preservation.

THE REMODELLING OF THE SOUTH TRANSEPT 1331–1336

Abbot Thokey was forced to resign through ill-health in 1329, and the prior, John Wygmore (1329–37), was elected to take his place. He was a practical man, with artistic gifts. The *Historia* states that he 'took much delight in working with his own hands, both in mechanical arts as well as in embroidery in which he was highly proficient.' He had been involved in building work at the abbey for some time. As prior he was responsible for building the new Abbot's Lodgings *cum parva aula sibi annexa et capella ibidem perfecit* on the north side of the precincts near the infirmary garden. He was the first abbot to live there and the old Norman *camera* with its thirteenth-century additions on the north side of the west end of the church now became the prior's lodgings. He was also responsible for building the Grange at Highnam and, most importantly, for remodelling St Andrew's Aisle (the south transept) between 1331 and 1336.

The work in the transept stands out in marked contrast to that only recently completed in the adjoining south aisle of the nave. Indeed, the change of style was so sudden and so complete that there must be some impelling reason why the abbey turned away from the use of the so-called Decorated style in the south aisle and elsewhere in the 1320s and adopted, so whole-heartedly, a new style less than ten years later for work in

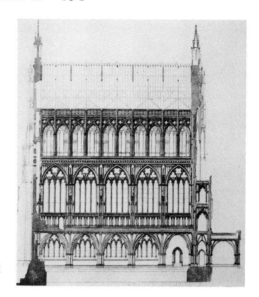

St Stephen's Chapel, Westminster, longitudinal
section

the south transept. It was a style which had not been seen outside London. The explanation for the change can only lie in the murder of Edward II at Berkeley Castle, and his interment at St Peter's Abbey on 20 December 1327.

Though documentary evidence is fragmentary, there can be little doubt that the initiative to erect a shrine to the murdered king and to remodel the choir came from the young Edward III. The work, which was to transform the dark interior of the Romanesque choir, was carried out in a style which had recently been adopted for royal works in the capital, and which Edward II had favoured. It was the Court style of the early decades of the fourteenth century, a style which could be seen in two London churches, St Stephen's Chapel in the Palace of Westminster (of which only the crypt survives today), and the cloister and chapter house of Old St Paul's. The main features of this new London style (later to be known as Perpendicular) suddenly appeared in the south transept of an abbey church a hundred miles or more away. But it must have seemed entirely appropriate to carry out, the work in the south transept first, and then the main remodelling of the choir in a style which had been adopted for royal works by Edward II.

Work on St Stephen's, Westminster had begun in 1292, and continued in the 1320s under royal patronage. The work involved the extensive use of panelling on the walls, extending as tracery through the windows. This was, apparently, the first time tracery was used in this way in England. St Stephen's was destroyed in 1834, and the chapter house of Old St Paul's was irreparably damaged in the Great Fire of 1666. As a result the south transept at Gloucester contains the 'first adequate impression of what could be done with this new type of decoration.'[5] This is rather different from saying, as was often done in the nineteenth century, that the south transept was 'the birth-place of Perpendicular architecture.' In Kidson's words 'it used to be said that the Perpendicular style was created in Gloucester out of the proceeds of the cult of Edward II . . . but we now see the Gloucester style of 1330 onwards as that of London and the court brought to

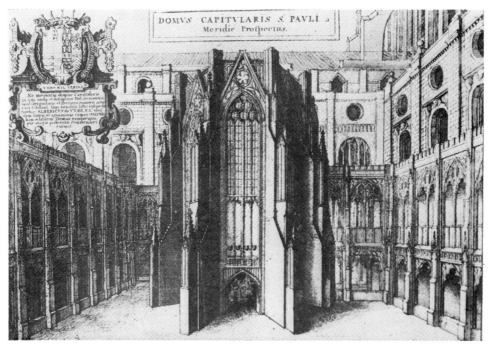

Old St Paul's, London, W. Hollar

the West Country under the auspices of the new King's filial piety.' The origin of this use of wall decoration goes back to La Sainte Chapelle in Paris. Again, as Kidson points out:

> . . . when tracery was invented in France it spread with a sort of natural inevitability from the actual window openings to the adjacent masonry. It soon became apparent that remarkably homogeneous effects could be achieved by this means, and during the second half of the thirteenth century the whole aspect of Gothic churches both inside and out was transformed as the possibilities of tracery were exploited. By 1300 the ubiquitous shafts of early Gothic had largely disappeared, and tracery had taken their place as the principal decorative element in church design.

In 1331, barely four years after the interment of Edward II, and in the same year that the young Edward III seized the reins of power, work began in the south transept. Buttresses were built to support the south crossing piers which were rebated to ensure that the panelling laid onto the adjoining walls was truly vertical. Above the tribune gallery on the east side two clerestory windows were added, and on the west side a large and a smaller window containing graceful flowing tracery. There is nothing 'Perpendicular' about the tracery in these windows. On the south side, the Norman wall between the two turrets was taken down to within 4.6 m (15 ft) of the ground, and a large window inserted involving the rebuilding of the terminal wall from the gable down to the base of the new window. It is possible to see the full extent of this work only by looking up at the external elevation. In the gable there is a group of stepped, round-headed blank arches profusely decorated with zig-zag ornament similar to that in

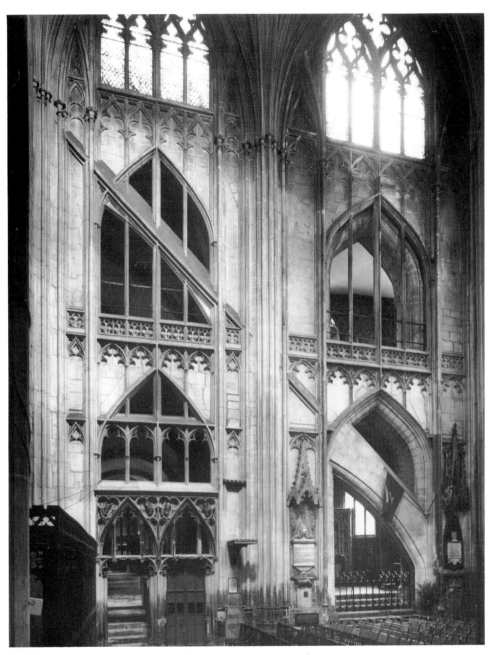

The south transept, east side

the gable of the prior's lodgings (the present Church House). Below these in the spandrels of the great arch of the window are zig-zag blind arches slightly pointed with attached colonette and capitals. These seem to be cut away by the frame of the great window, but they must be reset work. However, the vertical line of chevron on either side of the window is *in situ* Norman work forming part of the turrets. In the window arch itself Norman chevron was reused, though newly cut stones had to be added to make up the numbers required. The additional chevron, like that added in the nineteenth century, contain two or more dags, in contrast to the Norman chevron which has only one dag on each stone.

During restoration work on the transept between 1979–83, Bernard Ashwell, architect to the Dean and Chapter, reported that:

> . . . a great deal of the work in the 14th century was done with the Norman roof still in place. It was the west and east walls which were tackled first and the design of the clerestory windows, with not a vestige of Perpendicular in them, bears this out. Against the south-west turret on its north side a strong buttress of re-used Norman stones was erected in reconstructing the west wall. The work then started on the south front and here on each internal side of the turrets further strong buttresses were erected, again with re-used Norman stones. But what about the manifestly Norman designed and built gable end above the great south window? Clearly this would have been an enormous weight to carry while the new window was being constructed below and it would have been very unstable in a high wind.

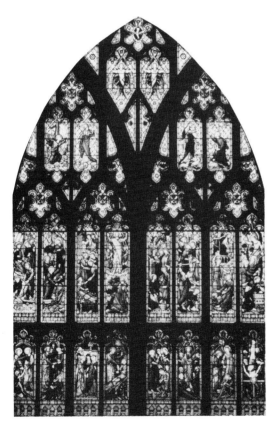

The south transept, terminal window *c.* 1335

Ashwell believed the gable end was taken down and re-erected later with fourteenth century modification at the apex. Once the terminal window was completed the masons could then proceed with the stonework above it, including the two blind arches, the pierced balustrade and re-erected the Norman gable with new fourteenth-century copings and curved apex.

Internally, the tracery of this window is all-of-a-piece with the wall panelling, its vertical members rising from floor-level through the wall passage, up the wall to the window and then as mullions to the arch of the window. This is, by definition, a Perpendicular window, and the earliest example since it can be dated fairly accurately to 1335/6. But whether the insertion of the window marked the point at which the king's master mason, William Ramsey, came on the scene is another question. The tracery, however, is very similar to that in windows designed by Ramsey in 1332 for the chapter house of Old St Paul's in London. It may be no mere coincidence that the Gloucester window was completed in the same year (1335/6) in which William Ramsay became Surveyor of the King's Works. Though documentary evidence is lacking (which is not surprising since no fabric rolls have survived) it is probable that Edward III sent masons, who had earlier been employed on work in London, to Gloucester to advise and direct the work there. The initial work in the south transept must have been seen as experimental and preparatory to the major reconstruction and remodelling of the Norman choir and presbytery. The intention was to transform the dark interior of the monastic choir into a 'royal chapel', a kind of Sainte Chapelle, so that it would be a fitting place for the shrine of an English king.

The Main Features of the South Transept

There are a number of interesting features in the south transept. In the Norman stair in the south-west angle of the transept are two blocked up doorways which originally led onto wall passages, the lower leading to the tribune gallery and the higher to a passage over the tribune.[6] With the construction of the great window these two wall passages were removed along with the rest of the terminal wall. The higher of the two had to go with the insertion of clerestory windows in both the transept and the presbytery, but access was still required to the tribune gallery. A wall passage was therefore constructed below the great window, entered from the Norman newel stair and leading up steps, on the east side, to the gallery.

In the south wall, near the entrance to the Norman staircase, is a small doorway with side pieces coming forward in a graceful curve, rather like the arms of a throne. On the arms are beautifully carved, though now badly damaged, figures of angels. It is still possible to appreciate the quality of the work from their posture and the treatment of the draperies. Carter, writing in 1807 noted 'The arch of the opening, in its head, has four turns concentrated by a flower. About the head is an ogee architrave rising from small columns, which bend forward on each hand, forming open arms or fences on each side of the steps of the doorway. On the arms recline statues, angels, acting as guardians to the doorway. Their attitudes are well conceived and pleasingly varied.' Fosbrooke (1819) observed: 'It is rare for the statuary of the Middle Ages to assimilate the grace and expression of classical sculpture, yet Guido, the great painter of angels, would not have

The frontispiece from Carter's plans and elevations, 1807

The south transept, south door

disdained the celestial ease and sweetness of these fine figures. The countenances even breathe of divine inspiration, the contour is youthfully round, without muscle, and the drapery falls in the most tasteful folds.' Sadly, the heads are now missing.

It would be extraordinary for such a beautifully sculptured doorway merely to lead out of the building. It must have led into a room adjoining the south transept. In Carter's plan of the building (1807) there is marked in this position a 'Sacristry' but the only evidence of the existence of such a building seems to be the small recess in the exterior wall near the doorway. Excavations south of the transept wall in the last century (1867) revealed part of a Roman tesselated pavement, but not the foundations of a medieval building. In Haines's *Handbook to Gloucester Cathedral* (1865) it is called the Confessional. A drawing by Jewitt of the same date shows the doorway blocked up, as do all nineteenth-century drawings, photographs and etchings. If, in medieval times, it was not a doorway into an adjoining sacristy, its purpose is something of a mystery.

The double doorway which gives access to the crypt and the south ambulatory is

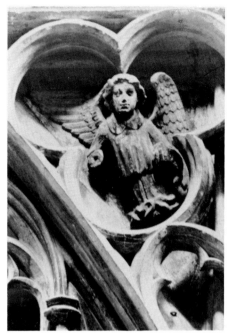

The south transept, decorative details, from the double doorway on the east side, and the doorway in the south-east corner

Double doorway to crypt and south ambulatory

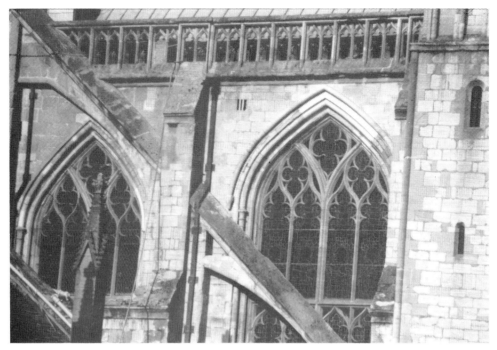

The south transept, external view of west side, showing flowing window tracery and buttress

exceptionally fine, with its ogee arches and intricate curves on two planes, and angels hovering in the screen work. It appears to be an intregal part of the remodelling of the transept, copied later in the north transept at the entrance to the north ambulatory, and much later at the outside entrance to the western slype. At the side of this twin doorway is a carved stone wall-bracket. It has dowel holes in its upper surface suggesting a figure once stood on it, perhaps of St Barbara. Masons and carpenters often sought her prayers for protection against thunderstorms and fire which were a constant hazard in building work. The bracket is L-shaped like the medieval equivalent of the architect's T square. This has led some to suppose it was the gift of a master mason, or more probably in view of the carving on the underside of the bracket, a memorial to a mason or mason's apprentice who died after falling from scaffolding, possibly during work on the south transept. The carving depicts an old mason sitting with the tools of his trade on his lap, looking thoroughly distraught; in front of him is the splayed out body of another workman, perhaps an apprentice, lying on an exact miniature of the transept vault.

The vault is an early example of lierne vaulting, short ribs connecting the main ribs together. The simple net-like pattern has no bosses to cover up inexact joins. Though attractive in its simplicity, Pevsner considered it 'aesthetically disappointing'. But Willis (1860) remarked: 'There is a peculiarity in this type of vault, that it demands great skill in the art of stone cutting, so that the joints may lie truly together, without which all would fall to the ground. It shows that the builders were most skillful masons.'

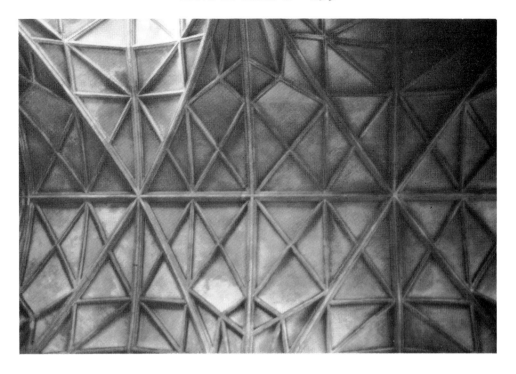

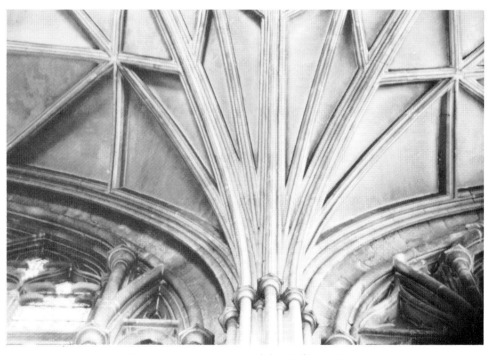

The south transept vault, and detail of its springing

The clerestory windows on the east side contain glass from the original glazing programme (1331–6). In the tracery are vine leaves and grapes on a ruby ground, and below are plain line-edged quarries set within a simple border (see plate 8). Though these windows were restored by Hardman in the nineteenth century a considerable amount of the original glass remains.[7] There is glass of a similar design and date in the windows on the north side of the apse at Tewkesbury Abbey, almost certainly the work of the same glazier.

Abbot Wygmore's Pulpitum

Abbot Wygmore lived to see the south transept transformed, but he died on 28 February 1337 before the work on the choir got under way. He was buried 'before the Salutation of Blessed Mary at the entrance to the choir on the south side'; the *Historia* adds '. . . which he himself had built together with a *pulpitum* there, as may be seen now.' This choir screen or *pulpitum* built by Wygmore is described by St John Hope.[8] There were two screens:

> The first consisted of two stone walls – the one at the west end of the quire, against which the stalls were returned, and the other west of it between the first pair of pillars. The western wall was broader than the other, and had in the thickness of its southern half an ascending stair to a loft or gallery above, which extended over the whole area between the two walls. This loft was called in Latin *pulpitum*.

A *pulpitum* sometimes contained an altar, as apparently it did at Gloucester, or a 'pair of organs' and sometimes both. From it on the principal feasts the Epistle was read and the Gospel solemnly sung at a great eagle desk. At ground level, on either side of the *pulpitum* door, there was probably an altar. Wygmore's screen or *pulpitum* was adorned with figures, set in tabernacles, by Abbot Thomas Horton (1351–77). In 1987 a drawing by W. Hollar, dated 1644, showing Abbot Wygmore's choir screen came into the possession of Gloucester City Museum and Art Gallery. This magnificent screen survived *in situ* until Bishop Benson (Bishop of Gloucester 1734–52) replaced it by a screen designed by Kent. The bishop not only removed the medieval screen, but from Bonnor's plan and description (*Itinerary* 1796) it is clear he also removed those portions of it and of the rood-screen which extended across the nave aisles forming eastern chapels.

St John Hope also described the second screen:

> . . . all traces of which have long since disappeared. It stood between the second pair of piers, that is a bay west of the *pulpitum*. It was a lofty stone wall, against which stood the altar of the holy cross, or rood-altar, as it was more commonly called, and upon it was a gallery called the rood-loft, for it contained the great rood and its attendant images. The rood usually stood on the parapet or front rail of the loft, but sometimes on a rood-beam crossing the church at some height above the loft.

Such an arrangement seems to have existed at Gloucester, for in the sixth course from the top a stone has been inserted in both piers exactly on the line where the ends of the rood beam would have fitted into or rested on corbels in the piers.

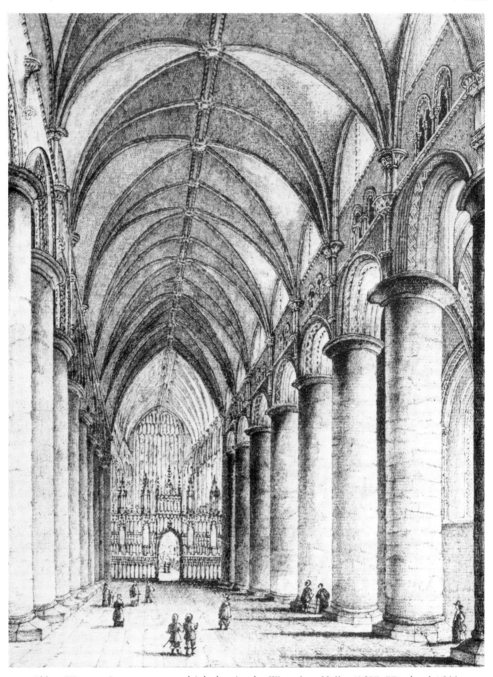

Abbot Wygmore's screen; pen-and-ink drawing by Wencelaus Hollar (1607–77), dated 1644
(Gloucester City Museum cat. no. Art 1851)

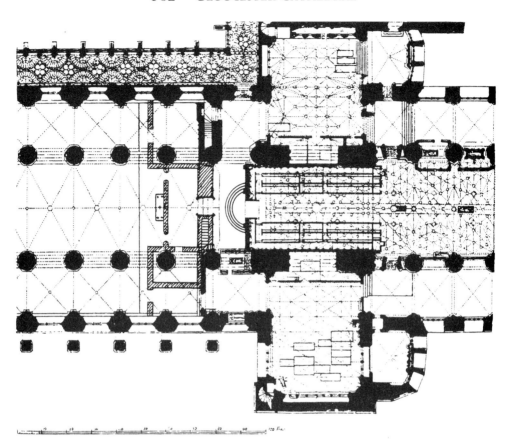

Plan showing the position of medieval choir screens (after John Carter and Browne Willis)

On either side of the rood altar the screen was pierced by a doorway for processions and the altar itself was protected by a fence-screen a little farther west. The eastern of the two doorways between the nave and the cloister was shut off by the screen and reredos of a chapel adjoining it on the west. The monks could therefore freely pass through the cloister door without being interrupted by strangers. This east door was not only the ordinary entrance from the cloister but through it passed the Sunday and other processions that included the circuit of the cloisters and the buildings accessed from it. This procession always returned into the church by the west cloister door, and after making a station before the great rood, passed through the rood doors in single file, and entered the choir through the *pulpitum* or choir door.

The Death of Abbot Wygmore 1337

While working on paving at the east end of the nave in 1787 workmen came upon a stone coffin. A certain John Cooke, a local surgeon, was asked to examine the remains in the coffin, and wrote to a friend, Charles Marsh, describing what he found. The coffin:

> . . . which lay so near the surface that it had no other covering but the old pavement. It contained a body in a robe, or gown, as of serge and leathern boots, the leather still retaining a degree of firmness,

Abbot Wygmore's remains and coffin, and the head
of his pastoral staff: drawing by John Cooke, 1789

nor had it totally lost its elastic quality. The robe was decayed, and though it had in some places the
appearance of folds, on touching it, turned to dust. The bones were not injured. In the hand of the
deceased was a crosier neatly adorned with silver, which had been gilt and burnished. It was chiefly of
wood, and the staff perfectly hard and sound. The cavity of the coffin which was of one stone measured
six feet six inches in length.

It was generally supposed to have been the mortal remains of Abbot John Wygmore,
who was buried 'on the south side near the entrance of the choir.' Workmen had come
across the coffin earlier, in 1741, when excavating at the entrance of the choir to lay the
foundations for the Kent screen. John Cooke alleged that the crosier had been removed
'by some person in 1741, when it was first discovered, but the pious bishop, who
considered the remains of his predecessor as sacred, ordered that it should be
immediately replaced, and commanded that no further liberties be taken with anything
appertaining to the deceased.' But the bishop's orders were not strictly observed because
'it was known that one of the sextons had a remnant of this robe in his pocket for many
years!'[9]

Though Wygmore lived to see the work on the south transept completed and his great
screen erected in front of the choir, it was his successor, Adam de Staunton, elected
abbot in 1337, who carried out the remodelling of the monastic choir. But when
Staunton died in 1351 the work was still not quite completed. It was left to his
successor, Thomas Horton (1351–77) to finish it. But by *c.* 1355 the work was done,
the work of transforming the choir of the old Norman abbey church into a 'royal chapel',
the magnificent Perpendicular choir we know today.

REMODELLING THE CHOIR

1337–1367

'Then give me of your gold to make our cloister Said he . . .
As yet we've hardly finished the foundation.
There's not a tile as yet or tesselation
Upon the pavement that we hope to own
And forty pounds is owing still for stone.'
Chaucer, 'The Summoner's Tale', Canterbury Tales)

The thirty years between 1337 and 1367 saw the gradual transformation of the eastern arm of the abbey church. Already the south transept had been opened up, and light and colour flooded in through large expanses of clear and stained glass. The plain ashlar walls of the Norman building had been cased with panelling, and a large terminal window inserted. This work, carried out between 1331 and 1336, must have made the community conscious of how dated and dark was their Norman choir and presbytery. Though it would involve them in years of building work, and deprive them of the use of the choir for some considerable time, they must have welcomed the prospect of extending what had been done in the south transept to the choir, and eventually to the north transept as well. Nothing less than this could have been envisaged as the next stage of the work began in 1337.

THE TWO ABBOTS RESPONSIBLE FOR THE WORK

After the death of John Wygmore in 1337, the prior, Adam de Staunton, was elected abbot. It was at this time that the work of reconstruction in the choir began in earnest. Presumably the experimental work in the south transept had been approved by the abbey's royal patron before work of a similar character began under the direction of a new architect. Edward III visited Gloucester on five occasions before 1330, and again in 1334

when the work in the south transept was well under way. After that he appears to have visited the town very little; there was a flying visit on 31 August 1349, when he issued a chancery writ and a letter under the secret seal from Gloucester. On this visit, if he had time to visit the abbey, he would have found the work in the choir well advanced, indeed nearing completion. There is no doubt that he took a continuing interest in the work, and in keeping alive the memory of his father. The Bishops of Llandaff and Worcester, together with the Abbot of Evesham, were excused from attending parliament because they agreed to hold services at Gloucester to commemorate Edward II's death. These services were held as late as 1375; Richard II continued them.

Though documentary evidence is lacking there is sufficient dissimilarity between the early Perpendicular work in the south transept and the work in the choir to suggest that it was carried out to the designs and under the direction of another architect. There is such a remarkable unity of style in the work in the choir, from the basic conception of the rectangular space to such design details as the cusping of the windows, to leave little doubt that it was the work of a single mind, an architect of genius. The *Historia* indicates that most of the reconstruction was completed during the abbacy of Staunton. He is said to have built 'the great vault at vast expense, with the stalls there on the prior's side . . .' Though no mention is made of the clerestory windows, the wall panelling, the removal of the apse, the construction of the square termination and the great east window, it is difficult to see how the vault could have been constructed unless this work had also been carried out.

In the vineyard on the north side of the monastery, Staunton also 'built the Abbot's Lodging there and surrounded part of it with a wall, but his successor completed the work.' At the end of Staunton's abbacy there were thirty-six monks in the community and 1,000 marks in the treasury. Staunton died in 1351, and was buried 'before the altar of St Thomas the Martyr' which had been built or refurbished by his half-brother, John de Staunton. St John Hope thought this altar was at the east end of the north aisle of the nave, backing onto the screen which extended across the nave from wall to wall.

Staunton was succeeded by Thomas Horton, the sacrist, though his election was

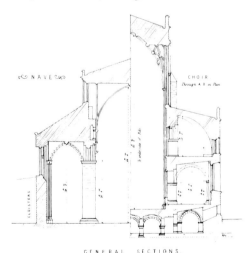

Central section showing the relative levels of the
nave and choir. F.S. Waller, 1852

per viam compromissi. He ruled the monastery for more than twenty-five years (1351–77) and is credited with having acquired numerous possessions and adorned the church with a variety of costly books, vestments and silver vessels. According to the *Historia* he 'built the abbot's chapel near the garden of the infirmary, the covered chamber of the monks' guesthouse and the great hall in the courtyard where later the King held his Parliament.' As far as work on the church was concerned he 'finished the work in the choir, comprising the high altar with the presbytery, the stalls on the abbot's side or south side of the choir' (Masse). This seems to confirm the impression that the major part of the reconstruction work was completed by the end of Staunton's abbacy, for the work in the choir credited to Horton could amount to little more than completing the panelling of the presbytery, furnishing the sanctuary with, for example, an altar, reredos and sedilia, and completing the choir stalls. He also had tabernacle work and figures made at the entrance of the choir on the north side. When the work in the choir was completed, he remodelled the north transept along the lines of the earlier work in the south transept, inserting a large terminal window and side windows, and building a fine, richly embossed vault (1368–74). He defrayed the greater part of the cost himself. He also began work on the great cloister. He resigned on 8 November 1377 because of increasing infirmity and died four months later. He was buried 'under the flat stone in the north transept.' Thus, during the abbacies of Staunton and Horton not only was the choir completely remodelled, but the north transept was treated in a similar way. The rebuilding of the great cloister was begun, and a considerable amount of work was carried out in the precincts.

Towards the end of Staunton's abbacy two events occurred which materially affected the work going on in the choir. First, a wave of euphoria swept across the country with the news of the success of the French campaign. Edward III had invaded Normandy in 1345 landing at Cherbourg with 4,000 men-at-arms, 10,000 bowmen and 5,000 infantrymen. On 26 August the following year he was confronted by a vast army under Philip VI near Crecy. Though greatly outnumbered, Edward won a notable victory mainly through the speed and accuracy with which his bowmen released their arrows into the French ranks. The Prince of Wales, though only fifteen years old, so distinguished himself that his father knighted him on the field of battle. They went on to capture Calais after a long siege, and returned home laden with glory and the spoils of war. It was a time of great national rejoicing. The impressive array of shields in the lowest tier of the great east window, borne by some of the chief commanders who fought at Crecy, may well have been inspired by these celebrations.

The euphoria, however, engendered by the success of the French campaign (1345–7) was soon to be dissipated by an outbreak of the plague, the Black Death, in 1349. It spread to Gloucester in the spring of that year and was at its height during the summer months. The first symptoms were great boils breaking out in the groin or under the armpits, culminating in a sudden fever and violent retching; the victim usually dying within forty-eight hours. A third of the population of the country perished. Manor rolls and bishops' registers bear out what contemporary chroniclers wrote about the effect of the outbreak, though strangely there is no reference to it in the *Historia*. Nevertheless, the abbey is thought to have lost about a quarter of its complement of monks and probably an equal proportion of servants and craftsmen.[1] The building work and refurnishing going on at the time in the choir would certainly have been affected.

The Tower Crossing

Some nineteenth-century writers imply that work in the choir began with the dismantling of the Norman apse and proceeded by stages towards the tower crossing. Structurally work must have begun with the reconstruction of the tower crossing and the building of the western bays of the vault. Wilson writes 'The work was done in three distinct phases: the south transept (*c.* 1331–6), the choir, begun with the liturgical choir in the crossing under Abbot Staunton and continued into the presbytery under Abbot Horton; and the north transept (1368–73).' The inference here is that the work proceeded bay by bay from the tower crossing, so that Horton, rather than Staunton, was responsible for completing the eastern bays of the vault, removing the Norman apse, constructing the square termination, building the great east window and inserting the glass. This would give a *terminus ad quem* for the work of 1355–60, with the glass being inserted some ten years after the victory it is thought to commemorate. This could be so.

Waller's isometric drawing indicates the extent of the Norman work which had to be dismantled. The original Norman crossing would have been very similar to that which has survived at Tewkesbury Abbey. At Gloucester the great round-headed arches on each side of the crossing had now to come down and, on the north and south sides of the crossing, pointed arches put up in their place. Springing from slender spans of stone 'suspended' below these transept arches, the first bay of the new vault was then constructed. These graceful spans, four-centred arches, are so depressed and so slight that it is a wonder they can bear their own weight. In designing them the architect may

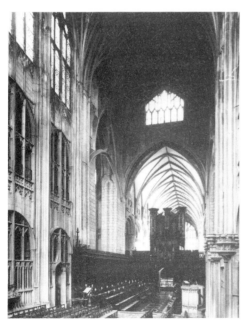

West bays of the presbytery and the crossing, looking west

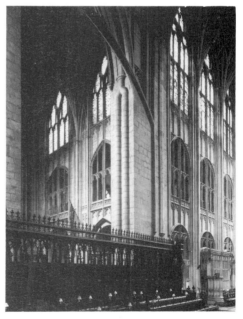

The crossing and west bays of the presbytery, looking north-east into the north transept

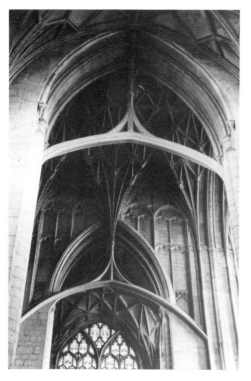

Flying spans below the north and south crossing
arches, looking north

have been influenced by the design of wooden structures, but to attempt to reproduce such a design in stone and at such a height is a remarkable achievement. If the Norman arches had not been removed the vault could have sprung from the wall above the arch, but in order to keep the springing of the vault at a uniform height a point had now to be found within the new arch from which the westernmost bay could spring. On the not very pronounced apex of each of the spans was placed a vertical mullion, and on either side counter-curves. The result is a stone ogee arch which seems to hang in mid-air, and from which rise the seven ribs of the vault. This is a remarkable invention, or in Willis' words 'an ingenious mode of treating a difficulty . . . the alternative would have been a capital hanging down and resting on nothing, an absurdity!' Verey calls it 'a very original stylistic conceit which by contrast emphasizes the spatial unity of the choir and presbytery, and isolates the transepts.'

If there was a vault at the crossing in the Norman building, it would have been higher and quite separate from that over the presbytery. The purpose now was to unify the choir and presbytery by erecting a vault of uniform design and at the same height over the entire area. A west facing window was inserted to cast light over the vault above the liturgical choir. This became possible not only because of the height of the new vault, but also because of the lowering of the pitch of the nave roof. Was all this achieved without disturbing the stability of Helias' tower and the tall spire that rose above it?[2] The inner faces of the two east crossing piers were modified to bring them into harmony with the rest of the remodelling. The twin half-shafts

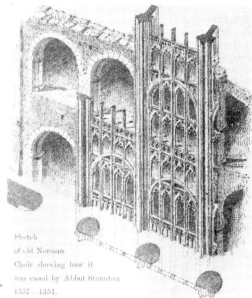

Sketch
of old Norman
Choir showing how it
was cased by Abbot Staunton.
1337—1351.

The casing of the Norman presbytery,
F.S. Waller, 1852

attached to the crossing piers on the north and south sides of the choir were retained. However, they were brought together at the top of the crossing piers in a most curious way and merged into the soffit mouldings of the new arches. Willis commented that: 'The architect having two Norman shafts on the face of the piers of the tower, discordant to the new design, made them run into one at the top, like as they sometimes saw water pipes.' But it was 'an escape from a difficulty which he, Willis, could not commend!'

The Rectangular Panelling

Viewed from the entrance, beneath the organ, the choir appears to be Perpendicular work, but on closer examination much of the original Norman building can be seen behind the screen of vertical panelling. The huge piers and round arches of the tribune arcade, and the quadrant vaulting are all still there. But in the remodelling work the piers and arches had to be cut back to give a flat surface to which the Perpendicular panelling could be secured. A drawing by F.S. Waller shows how the piers and their capitals were cut back to a depth equivalent to the outer order of the Norman arches. The hood-mouldings had to go and the wall surface had to be prepared before the veneer or lattice work of panelling could be securely bonded to the Norman piers and walls. The panelling was made to completely cover the walls of the north and south elevations from the floor of the presbytery, over the arched openings of the ambulatory and tribune gallery, up the wall surface and, as tracery, through the clerestory windows to the vault. Where the panelling overlays Norman arches it matches them in being semicircular, but where it has no such backing, at ground floor level in the easternmost bays, the arches are pointed. The panelling was continued westwards across the spandrels of the north

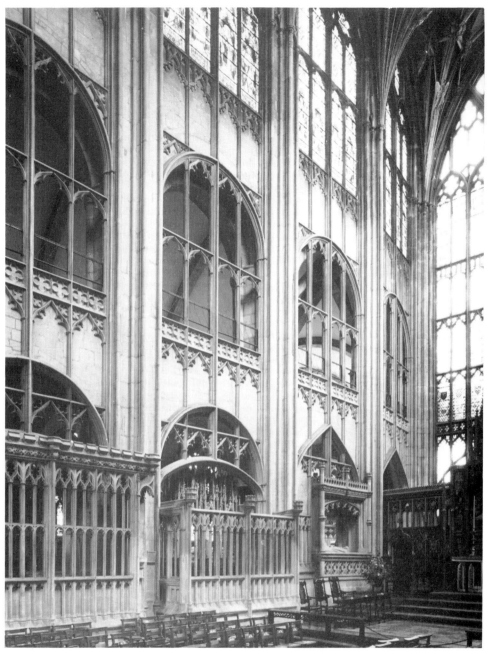

The choir (presbytery), north side, showing perpendicular panelling, and splayed eastern bay

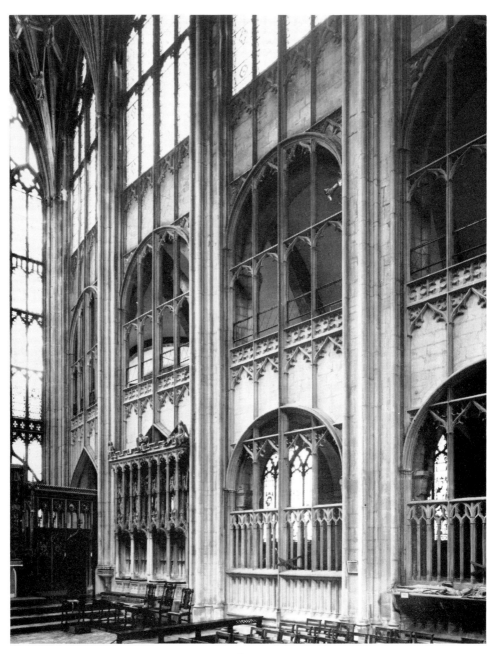

The choir (presbytery), south side

and south crossing arches. Here instead of being applied to the walls, the panels were worked out of the old Norman masonry. The old stone work was sunk back from the original surfaces leaving part of the stone standing out in the form of panels. 'Parts of the choir are nothing but the ancient Norman work cut down and shaped; this shows the skill and economy of the builders' (Willis).

Kidson sees in the use of rectangular panels the source of the homogeneity in the over-all design of the choir:

> Unlike luxuriant patterns of decorated tracery, those at Gloucester are simple and spare. The motive on which the design was based is a rectangular panel with an arched and cusped head. The only virtue of these panels is that they can be repeated endlessly, and applied to any kind of surface, or indeed to no surface at all. Some are occupied by glass; others are backed by solid masonry; and still others pass over the openings of the old Norman walls. The biggest aperture of all is at the east end. This is completely filled with glazed panels to form the first of the great English Perpendicular windows. In fact, the window is slightly wider than the choir – the walls of which have been splayed out to contain it. It is also slightly bevelled. The usual impression of a window as a hole in a wall has been completely eliminated here. Instead the choir seems to terminate directly against a glass screen; and the whole structure takes on the character of a fragile glasshouse with parts of the windows blocked in or otherwise obscured.[3]

Wilson sees the choir elevation as a development from those of the south transept, where tiers of upright arch-enclosing rectangles have not yet 'become the *leitmotiv* of the design.' It is much clearer there than in the choir that this 'panel' motif develops from the version of the French Rayonnant triforium used to mask the remodelled openings of the gallery. The moulding which frames these openings is only the:

> . . . most important of several correspondences which prove that the immediate source of the idea of the masking was the exterior of St Stephen's Chapel in Westminster Palace. The screening of the south choir aisle from the transept has already taken on the panelled aspect adumbrated in the framework of the timber screens traditionally used in such a position, but only in the choir are its closely spaced horizontals extended to the whole height of the elevation. The result of this change is to give the choir much greater rhythmic and textural consistency. But the increase in the number of horizontals is offset by making them slighter in gauge than the mullions. Verticality is further stressed by eliminating all horizontals from the immediate vicinity of the vault responds and by extending the clerestory far above the level of the Romanesque wall-head still adhered to in the south transept.[4]

In other words, in the presbytery itself the series of immensely tall vaulting shafts, whose strong lines are unbroken by any horizontal moulding, intensifies the impression of soaring height.

The Lierne Vault

The vault, with its myriad of liernes and with bosses placed at the intersections of the ribs, extends from west of the crossing to the great east window. As the points of intersection increase, so do the bosses. They thus intensify the impression of texture, appearing to be heads of nails fixing a net to the vault. There is such a multiplication of liernes and tricerons that they must be regarded as far more textual than structural. The vault has a longitudinal ridge-rib with two parallel ribs, a feature apparently invented at

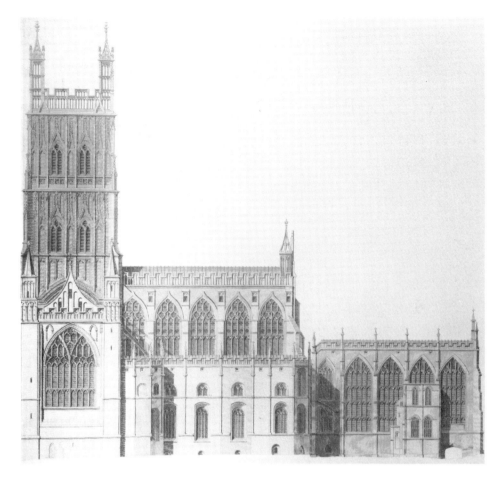

Section of the choir, south side from west to east, with the lady chapel and crypt, J. Carter, 1807

Gloucester and later copied in the north transept, at the west end of the nave (*c.* 1430) and in the lady chapel (*c.* 1475). The bosses at the east end, over the high altar, represent a choir of angels playing various musical instruments. In the centre the figure of our Lord in glory has his hand raised in blessing.

The vault, in itself a *tour de force*, in relation to the design of the rest of the choir leaves much to be desired. Kidson feels that:

> . . . the vaults at Gloucester strike the only discordant note in the whole composition. The vaults have what is undoubtedly the most involved lierne pattern ever devised in England. There are no less than three parallel ridge ribs, and several basic rib systems – e.g. quadripartite, sexpartite etc – can be detected superimposed on one another even before the liernes are taken into account. Yet few people would acclaim the result as something visually satisfying. It is evident that the intense congestion was an attempt to match and complete the all-over patterns on the walls and windows below. But whereas lierne vaults accord well with Decorated window tracery, their irregular compartments merely look untidy when they surmount tier upon tier of rectangular panels. There is another factor which

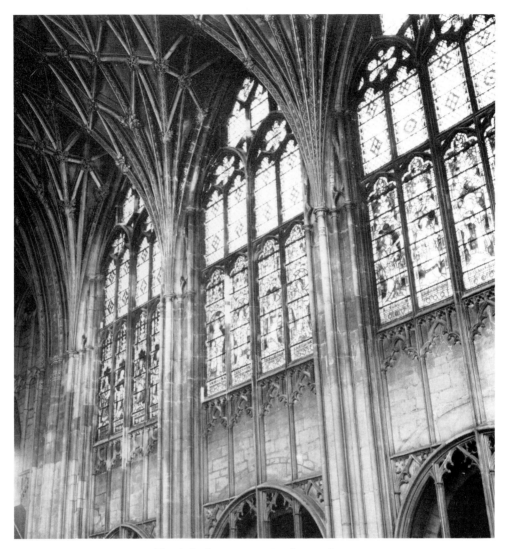

The choir clerestory, north side, west bays

interferes with the coherence between vaults and walls. The vault pattern is still conceived in terms of ribs. This is an awkward residue, and there is no doubt that it was felt as such, even though it took a surprising length of time before a satisfactory solution was worked out. It is not hard to see the crux of the problem. If walls and windows were covered with tracery panels a completely homogeneous interior required that the vaults should be treated in the same manner. But how to apply tracery to a vault. . .?[5]

The solution, of course, is to be found in the cloisters in the form of fan-vaulting, where series of identical panels make up the vaulting cones. It is for this reason that fan-vaulting is the most harmonious and aesthetically satisfying form of vaulting with Perpendicular architecture.

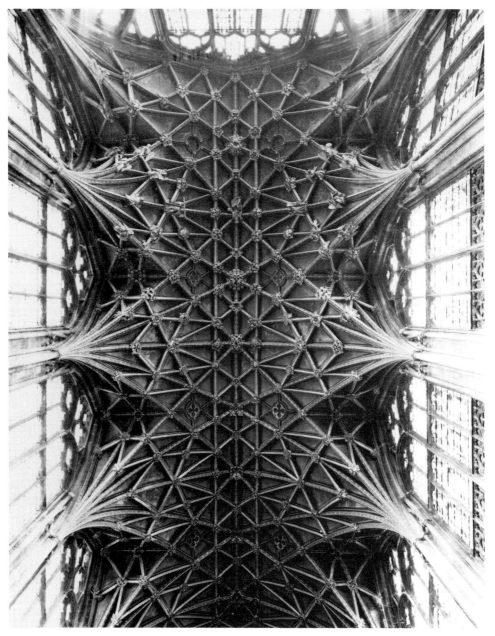

The complex lierne vault over the choir *c.* 1350. A study in architectural geometry

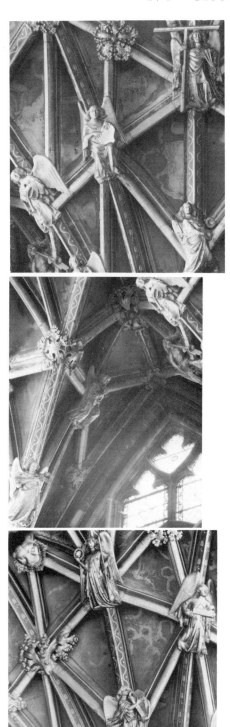

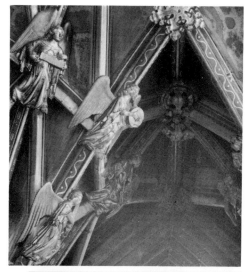

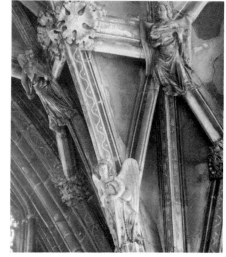

The angel choir. Details of the vault and angel choir
over the high altar

The Square Termination

Before the vault could be completed the Norman apse had to be taken down and the great east window erected within a new rectangular east end. This was a massive undertaking involving the removal of the semi-dome, a section of the tribune gallery, at least part of the axial chapels and the two central piers of the Norman apse. The foundations of these ovoid piers were revealed when the ground was being prepared for the erection of Gilbert Scott's reredos in 1872. Stones from them were used to raise the external walls of the tribune gallery so that the pitch of the roof over the gallery could be lowered and still clear the quadrant vault. Material from the axial chapels was used to form foundations in the crypt for the additional vaulting shafts on either side at the east end of the presbytery. Unlike the other vaulting shafts in the presbytery these do not back onto Norman piers. To the east of them, the last bay of the presbytery is splayed outwards so as to encompass the great east window. Even with the canted window-frame bedded securely on the apsidal east end in the crypt, it was felt necessary to buttress the two principal mullions of the window to give it added stability against wind pressure. The resulting structure is a most ingenious way of achieving a square termination to the choir, while leaving the apsidal east end of the Romanesque crypt practically unaltered. In Wilson's words:

> . . . the main vessel of the presbytery was lengthened by demolishing the Romanesque apse and the central section of the ambulatory. The exigencies of building on top of the outer wall of the crypt-level ambulatory explain the main peculiarity of the easternmost bay: the way that its side walls swing outwards before joining the east wall. The consequences of this improvisation are breathtaking: an immense window-wall, the largest in medieval Europe, which appears from most viewpoints as if floating unattached to the side walls.[6]

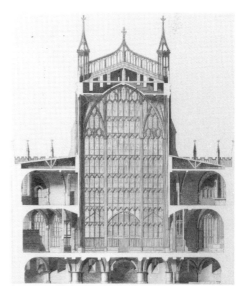

Section of the east end of the choir. J. Carter, 1807

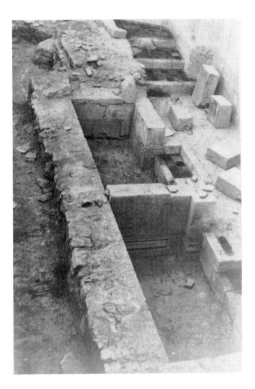

Excavations (1872) below the high altar revealed the
medieval chamber for relics or treasures

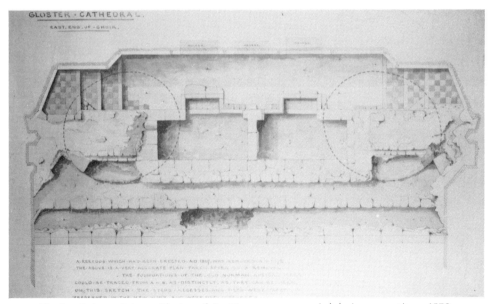

The foundations of the ovoid piers of the Norman apse, revealed during excavations, 1872

The destruction of the Norman apse, with its broad ambulatory at tribune level (the scars of which can still be seen), meant that there was no connection between the north and south sides of the tribune gallery at the east end. But eventually a passage was built linking the two sides, passing around outside the great window. If, as is commonly assumed, this 'bridge' was not constructed until the fifteenth century, how were the north and south sides of the tribune connected at the east end? Were they left without any link for a hundred years, that is from *c.* 1355 until 1450? Presumably, when the great east window was completed the de Wylington lady chapel was still *in situ* at the east end? If the thirteenth-century chapel was an extension of the Norman axial chapel how could it have been unaffected by the construction of the great east window?

The enclosed passage passes by a small chapel which was incorporated into the design of the lady chapel in the mid-fifteenth century. The bridge which carries the weight of the passage and the passage itself are constructed largely from reused Norman masonry. From the seventeenth century the passage, and sometimes the whole of the tribune gallery, was described as 'the Whispering Place' because the passage conveys the slightest whisper from one side of the gallery to the other. Storey, in 1814, called it 'the great and singular curiosity of this edifice.'

The Design Intention

A detailed study of the remodelled choir shows that it was the work of an architect with a flare for finding unusual solutions to difficult problems, and with a daring that led him to constructions which the more cautious would have thought impossible. More than anything else, it is the sense of spacial unity that is so arresting. This was achieved in a variety of ways. First, two distinct compartments of the Romanesque building, the liturgical choir and the presbytery, were unified by the removal of the crossing arches and the construction of a vault extending over the entire space. Secondly, the 'flying spans' on the north and south sides of the crossing with the high backing of the choir stalls, have the effect of isolating the transepts, enclosing and unifying the choir. Thirdly, the stone panelling wraps the entire choir and presbytery into one, covering even the spandrels of the crossing arches and extending eastwards over the entire north and south elevations. At the east end the same panelling becomes tracery in the great east window. Lastly, the glazing adds still further to the sense of unity in the whole design. Tier upon tier of full length figures set in architectural niches and against alternating backgrounds of blue and ruby glass, filled the great window, and continued along the north and south elevations filling the clerestory windows as well. In these windows was a series of royal figures, probably drawn from biblical times and later history also set in niches against a background of alternating ruby and blue glass.

Though the choir was, above all, the centre of the life of a monastic community, it was also designed to reflect the patronage, prestige and power of the Crown in a place which had seen the coronation of one English king, and was now the burial place of another. What had been created within the shell of the Norman choir and presbytery was to prove the prototype of the English royal chapel. It was many years before St George's

Reused Norman material, to strengthen the tribune gallery at the time of the reconstruction of the Choir. (A) North gallery, looking east. (B) South gallery, looking east (1980). (C) North gallery, east end, detail. (D) South gallery, east end, detail. (E) North gallery, looking north. (F) South gallery, looking south

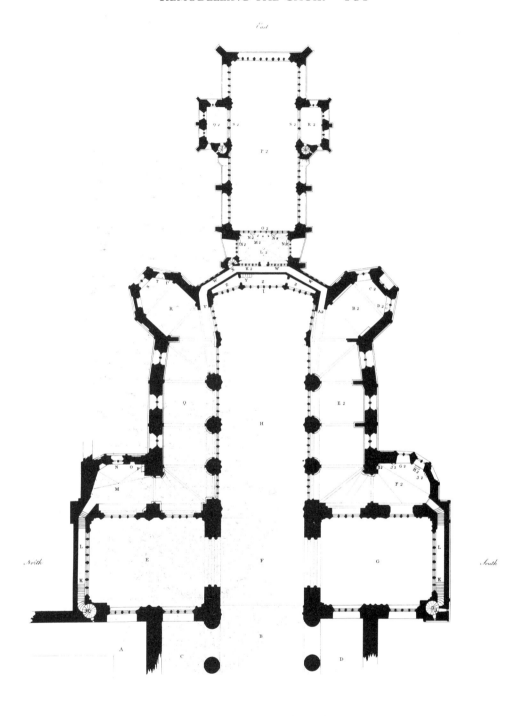

Plan of the east end of the choir, showing reconstruction of 1340–55, and the 'Whispering Gallery' connecting the north and south sides of the tribune at the east end. J. Carter 1807

Chapel at Windsor was built, King's College at Cambridge, but when they were built they were constructed to the same basic design as the fourteenth-century choir of Gloucester Abbey.

The High Altar

In the remodelled choir, the high altar occupied the same site as it does today, except that in the nineteenth century the altar was raised one step higher. Behind the reredos there was a narrow space containing cupboards for the principal jewels, and beneath the altar two large recesses for the safe keeping of the relics. Part of these recesses is still visible from the feretory which is still paved with mid-fourteenth-century tiles. No description of Abbot Horton's altar and reredos survives but during excavations in the area in 1872 the footing of the altar, and the feretory were revealed. From F.S. Waller's drawing of the excavations, it is clear provision was made for keeping relics or treasures in the space between the back wall and the reredos proper.

Abbot Horton set up a new altar and reredos, and also provided the vestments and vessels required for the celebration of the Mass. According to the *Historia* he:

. . . adorned the church prudently and from his own funds, and by his hard work, with ornaments of many kinds, books, different kinds of vestments, silver vessels . . . He obtained the silver vessels from which the community is served in the refectory, and also four basins of silver for the high altar in the church, that is to say two big ones for the use of the abbot and two other small ones for a priest

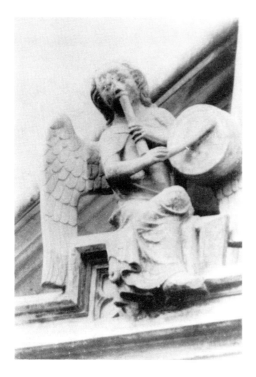

High altar sedilia, detail of angel making music on
the embattled cornice

celebrating there. Also, two candlesticks of silver for the same altar, and one chalice of gold for the same. A silver bowl for holy water with a silver sprinkler and a cross of silver and gilt to place on the altar while the abbot celebrated there . . .

Abbot Horton's completion of the choir stalls and his new altar and reredos are a reminder that what mattered to the monks in the remodelling of the choir was that they had a new arena for their daily offering of worship. Their corporate life centred on the choir and in the offices of the *Opus Dei*, and on the large open space in front of the high altar where they knelt for the daily offering of the Mass. The great window towering up behind the altar lifted the eye through tiers of holy men and women, saints and martyrs, to the apostles and to our Lord and the Blessed Virgin seated in glory, and to the angelic host of heaven. It must have seemed to the monks like some giant triptych, in which rank upon rank of figures, set in painted architectural niches, were alive and joining with them in worship. The architectural setting of their worship, however inspiring, was subordinate to their shared religious experience which was evoked more by the movement of the liturgy and the furnishings of the choir than by the splendour of the structure itself. As Nicola Coldstream has said of Chartres: 'In a building such as Chartres Cathedral, where the stained glass and sculpture survive, it is obvious that the architecture is the background to the figurative arts, that the architecture is designed to support and exhibit the vast *summa* of Christian history represented on the doorways and in the windows.'

In Coldstream's words:

. . . the church building, poised symbolically between everyday life and the life to come, was the place where earthbound sinners could glimpse the Heavenly Kingdom . . . enter the cloudy region between reality and symbolism when in the ceremony of the Eucharist the bread and wine became the body and blood of Christ. Much medieval literature explores the relation of inner states of being to the outer world, and it came naturally to medieval people to see individual objects in the world as symbols or representations. Saints and prophets on the church walls were the Church Triumphant made actual; these divine beings were seen to be intercessors, offering a path to individual salvation amid the warnings of judgement, and they were an essential part of the experience of being in the church building . . . At Gloucester the path to salvation was displayed in the east window, with the Coronation of the Virgin, attended by saints, angels, kings and founders of the abbey. Again, the iconography is modified to suit the circumstances . . . The choir is a closed world, fenced in a very literal sense by the net of tracery which covers it in; an angelic orchestra plays in the roof bosses over the high altar, and the stage is set.[7]

SOME MEDIEVAL CRAFTS

'Bazalel was filled with the divine spirit,
making him skillful and ingenious, expert in
every craft, and a master of design, whether
in gold, silver or copper, or cutting precious stones
for setting, or carving wood in every kind of design.'
Exodus 35

'Their prayer is in the practice of their trade.'
Ecclesiasticus

The remodelling of the choir and presbytery, completed by about 1355, involved more than the work of masons. They showed enormous skill and daring in executing the ambitious plans of the architect, but many others, such as tilers, glaziers, carpenters, embroiderers, metal workers and silver smiths, painters and carvers in stone and wood had work to do as well. The reconstructed choir was furnished with new stalls, and the sanctuary enriched and equipped with all that was needed for the monastic community's daily round of prayer and worship. Much of the contribution made by these skilled craftsmen was integral to the actual construction of the building. One of the first groups to be involved would have been the sculptors, shaping out of rough stone a myriad of bosses for the vault.

SCULPTORS – THE ANGEL CHOIR

There were various grades and skills among those who worked with stone, but the sculptors were given increasing recognition as the interior and exterior of churches became more elaborately decorated. Some of the most gifted were employed on the statuary that filled the west fronts of cathedrals such as Wells and Lincoln. Many others were involved in adorning the interior of churches with decorative motifs on screen and

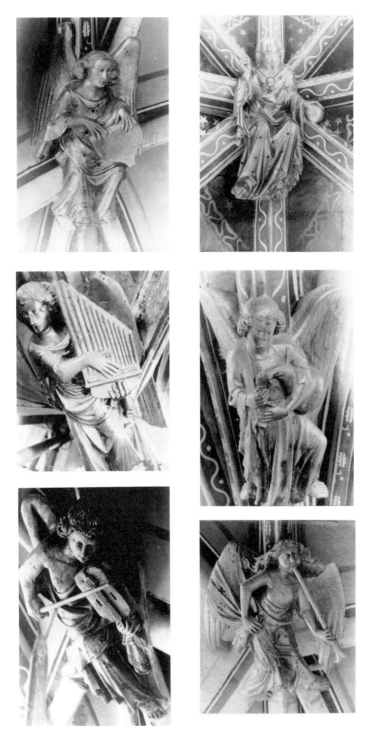

The angel choir, details of figures in the vault over the high altar

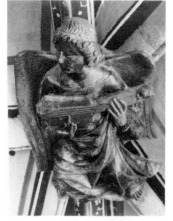

spandrel, and with sculpted figures in niche and reredos. The complex design of the choir vault at Gloucester, with its great number of bosses and, at the east end, an angel choir would have involved sculptors and other stone carvers in years of work.

There are well over four hundred bosses, mostly with naturalistic foliage, set into the choir vault; but there are also a number with small heads, mostly of beasts, scattered about. With ribs seeming to run in all directions, the seven main ribs some spanning two compartments of the vault, the ridge rib and the two parallel ribs, and numerous liernes, there are carved bosses at almost every junction. The result is a density of decorative detail that is altogether too extensive. The hundreds of foliate-bosses hardly create an impression of the star-studied vault of heaven, if that was the intention. The complexity of the design weighs too heavily on the light and ordered panelling of the structure below. 'Christ in Majesty' and the angel choir, in spite of the considerable size of the figures, are almost lost among the liernes and in the foliage of the bosses. Nevertheless, it is the finest and most extensive lierne vault in the country, and a great achievement.

Angel choirs had been a feature of English church decoration since the late thirteenth century. They are found in stained glass windows, occasionally an entire choir though more often today fragmented, an angel or two here and there. But there are more complete examples, at Malvern Priory in Worcestershire and in the Beauchamp Chapel at Warwick. At Malvern the angel choir is associated, as it is at Gloucester though in a different medium, with a scene depicting the Coronation of the Virgin. Angels with instruments are also found carved in wood on choir screens and stalls, including misericords, and carved in stone on doorways and as decorative details on sedilia as in the choir at Gloucester. They are found on the spandrels of choir arcades and on west fronts. Their iconographical importance varies according to their position in the building. In some instances they appear to be purely decorative, but in other contexts, for example in choirs, they have a musical and liturgical significance. Such is the case with the Gloucester angel choir over the high altar.

However, there may be another reason for an angel choir being incorporated among the bosses of the vault. Glenn in her study of *The Sculpture of the Angel Choir at Lincoln* suggests that at Lincoln 'there may have been a connection between angels as a common reliquary ornament and their extension to the actual architecture of the building designed to house the shrine.' She notes that there is support for such a notion in the decoration of La Sainte Chapelle in Paris. 'The Lincoln scheme was equally well suited for the purpose of ornamenting a pilgrimage chapel which was designed as a final abode for the relics of a major saint.'[1] The angel choir at Gloucester may, therefore, be related to the tomb of Edward II on the north side of the choir; a choir which was reconstructed and refurnished in his honour, and in the hope that it would promote pilgrimage to his shrine and popularize the conception of the king as a saint. It should be noted, however, that whereas the Lincoln Choir has features associated with the Last Judgement, appropriate to its connection with the relics of a major English saint, there is no suggestion in the Gloucester angel choir of anything except the continuous adoration of 'Christ in Majesty'. The three angels with emblems of the Passion symbolize the reason for the other sixteen being engaged in continuous praise: 'Worthy is the lamb that was slain to receive all honour . . .' This inclusion in an angel choir of some who are carrying instruments of the Passion, such as spear and sponge and crown of thorns, is not

uncommon in this country, in France or elsewhere. In the great west doorway of Bourges (1250–60) angels with the instruments of the Passion appear on either side of the enthroned Christ in the apex of the tympanum. The predominant theme in such compositions is that of praise, the offering of an endless *Te Deum* in honour of Christ who is represented not displaying the wounds of the Passion, but enthroned in glory.

Christ, seated in majesty and surrounded by heavenly musicians, is depicted bareheaded and with no nimbus. He has long hair falling over his shoulders, and a long beard. He is wearing a robe with very full sleeves, fastened with a large circular clasp on his chest. In the shrine below, the hand of Edward II holds an orb symbolizing his kingly power; in the vault the Christ holds an orb in his left hand, expressing his universal sovereignty, and his right hand is raised in blessing. The angels are also bareheaded and with long hair hanging down in curls to the shoulders. They all wear an undergarment with close-fitting sleeves and a loose cloak over it fastened with a diamond shaped clasp on the chest. The upper part of the wings is bare with primary feathers showing; other feathers are shown on only two of the angels. The features of the figures and details of the instruments have suffered somewhat with the passing of time, but sufficient remains to reveal the quality of the work. The entire group was probably the work of one master-sculptor for there is a remarkable consistency in style and quality. (See Appendix VI.)

There are a number of other examples of medieval stone carving and sculptures in the building from the superb effigy in alabaster of King Edward II to the delightful series of faces and grotesques below the nave triforium.

GLAZIERS – THE GREAT EAST WINDOW

As described earlier, during the reconstruction of the east end of the choir the Norman apse had to be dismantled and foundations prepared in the crypt before the great east window could be erected. Using material from the demolished Norman axial chapels foundations were built for the two additional vaulting shafts at the east end. The last bay, east of these shafts, was then splayed out so as to abut the great shafts on either side of the window. The window itself, resting on the outer wall of the crypt, had to be canted, and the two central mullions strengthened by being buttressed to more than two-thirds of their height.

Structure

The buttressed mullions divide the window into three parts, a central section of six lights, and wings of four lights each making a composition of 4–6–4. There are three transoms in the wings, and five in the centre, which rises above the wings into the tracery of the arch. The tracery of the window is similar in design to the panelling which encases the entire choir. However, the window tracery, its heads and cusps, as seen from inside is not always repeated outside. Outside on some tiers plain transoms only cross the light. This means the glazing of these lights is rectangular, the upper part of the light being obscured by the internal cusping. This practice was repeated in the great

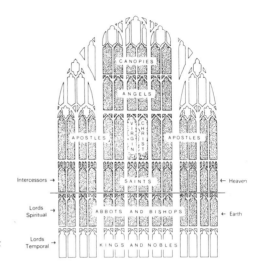

The divisions and iconography of the great east
window (Jill Kerr)

west window and in other windows. 'Apart from the later east window of Exeter
Cathedral this phenomenon has not been observed elsewhere' (Kerr). Again, outside, the
hood mould turns into an ogee shape and rises to the perforated parapet of the gable,
flanked on either side by pierced pinnacles. The late fifteenth-century lady chapel was
built practically detached from the main building in order to allow the maximum
amount of light through to the choir.

The window, particularly when viewed from the ambulatory below, is massive. It is
21.9 m (72 ft) high and 11.6 m (38 ft) wide, which, at the time, made it the largest
window in the country. The east window of York Minster, with which it is often
compared in size, is 23.8 m (78 ft) high and 10.1 m (33 ft) wide, but this was not
completed until 1405. This gives Gloucester's east window an area of 254 sq m (2,734
sq ft) and York's 240 sq m (2,583 sq ft). The York window was to have a larger area of
glass because at Gloucester the two lowest tiers of the central section form the entrance
to the lady chapel. But such comparisons apart, to have constructed a window of this
size at all on the foundation of the abbey's apsidal crypt is a most daring and magnificent
achievement.

Style

Though the tracery of the window is Perpendicular the glass itself, in Winston's words,
is a 'pure example of the Decorated period.' For him it presents no feature which would
indicate the great change of style which was imminent at the time. The window is a
striking example of the way a change in the architectural framework usually preceded by
a few years changes in the style and technique of painted glass. For example, the
extensive use of white translucent glass, the alternating of ruby red and blue glass as
background, the architectural niches painted on clear glass and the rows of almost
sculptured figures are all features of glass of the Decorated period. Again, the style of

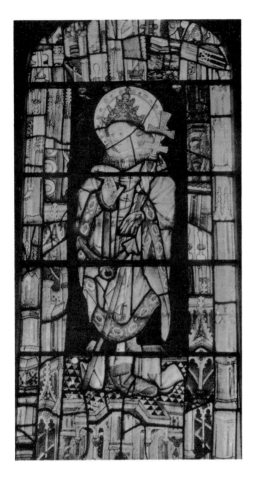

The great east window, detail of (?) Clement of
Rome at the apex of the window

painting using 'smear' shading and the form of human features, especially the eyes and
nose, are all characteristic of the earlier period yet they are set within a frame of early
Perpendicular stonework.

Yet, as Richard Marks points out, other features seem to anticipate developments:

The style of figures and canopies is fully in the Decorated spirit, but in other respects the glass points
the way to the achievements of the fifteenth century . . . The creation of a new architectural aesthetic,
with walls consisting merely of a translucent screen, demanded in its turn much less heavy colouring
and a reduction of ornament, not just with white glass dominating but also a lightening in tone of
coloured glass. In this respect the glazing of Gloucester's east window points the way to the future.
Compared with the comparatively dark tones of Tewkesbury, which creates an enclosure and a denial of
external matter, the Gloucester glazing opens up and transmits the outside world to the interior
through a transparent screen. Similarly, in its tiers of figures Gloucester anticipates the most common
glazing scheme of the fifteenth and early sixteenth centuries. The Gloucester glass was indeed
anticipatory, for it was to be almost half a century before its aesthetic innovations took root in English
glass-making.[2]

Design

The window was designed to be viewed from a distance (see plate 9). 'There is no doubt', as Kerr has said 'that the painter has taken the distanced viewpoint of his audience into account in the simplification of the painting techniques.' It was designed to form a gigantic triptych of tiers of canopied figures with the central section rising higher 'into the heavens' than the wings. The figures are set against vertical columns of alternating ruby red and blue glass. These two main colours are pot metal as is a certain amount of the yellow though there is also some yellow stain. A small amount of glass of other colours is introduced here and there mainly for decorative detail. The canopy work and the figures are painted in dark brown with subtle shading, and the rest, nearly fifty per cent of the total area of the window, is a vast expanse of white glass. This contains a myriad of tiny bubbles which refract the light and so create a brilliant, translucent silvery effect. In the tracery lights the quarries of clear glass are ornamented with edge-lines and delicate star-like designs, with a narrow band of the same glass forming a border. The two lowest tiers, either side of the entrance to the lady chapel, are treated in the same way though the borders are broader and enriched. Prominence is given to the two central columns by the double width of ruby red glass as a background, and also to the top tier of lights, extending across the entire width of the window, by the blue glass being delicately diapered. In this position and against this enriched background are the figures of our Lord with the Virgin Mary at his side, both crowned. and either side of them the apostles St Peter and St Paul.

The painted architectural shrine work seems to stand free of the mullions and transoms of the window. The whole elaborate 'structure' is conceived as resting on a base across the bottom of the lowest tier of figures. On this tier the figures do not stand on pedestals, as they do in the tiers above, but on a tile pavement. This forms the foundation of the entire 'structure' which rises, tier upon tier, with the painted canopies occupying more and more space until, above the angels, they extend into and fill an entire tier. The niches consist of side jambs which support a flat-fronted arched hood which is surmounted by a tall crocketed pediment terminating, within the light, in a finial. The side jambs do not terminate within the light, but continue into the next tier being cut through, as it were, by the transom, and so on until they terminate in finials in the topmost tier. Similarly, behind each of the pediments there appears to be a shaft which continues up, through the cusping and transom, into the light above, here to form a bracket which serves as a pedestal for the figure in the upper light.

This preponderance of architectural detail is integral to the design. In Kerr's words:

> . . . close examination of the painting techniques reveal that the effect of the entire window is quite deliberately directed to achieve the visual impression of sculpted figures in niches. The depth and perspective of the architectures is carefully designed and articulated with the use of extensive monochrome contour washes to define the third dimension. The niches are three-quarters angled to reveal simple vaulting heavily painted to create shadow depth, the ribs and decorative bosses picked out of matt wash. The placement of the figures in the niches against the colour backgrounds emphasises the sculptural effect; the feet are firmly and formally placed on the pedestals and the postures plausibly arranged to enhance the sculpture-in-niche effect by the incursion of parts of the figures and attributes in front of the side shafts.[3]

A B

Photographs taken after Charles Winston's restoration of the window: (A) St Peter, (B)
St Paul, (C) An apostle, (D) St George, (E) A saint, (F) A bishop, (G) Fragments arranged as
King Edward II, (H) A king

Of the painting of the faces she writes 'This is superb. Once the observer has gazed into
these strikingly cadaverous physiognomies with the lugubrious deep set eyes and
formalised hair and beards, their powerful dignity is never forgotten.'

Subject

The subject of the window has long been thought to be the 'Coronation of the Blessed
Virgin Mary'. This had been a popular subject for some time in medieval Europe with

C

D

representations not only in stained glass, but in sculptures in wood and alabaster, in ivory carvings and in mural and panel paintings. With the development of the cult of the Virgin in the thirteenth and fourteenth centuries and with the widespread building of chapels in her honour it became a favourite subject for the decorated west fronts of great churches, for example, at Wells in this country and Rheims in France. Similarly in the great east window at Gloucester central place and prominence is given to our Lord and the Blessed Virgin. The fourteen lights on this tier provided for them to be central and for the twelve apostles to flank them on either side. Yet it is also true that little else is done to enhance their position. In the window as a whole they are lost among the other figures. Their importance is not emphasized by the size of their niches or height of their

E F

canopies, by their proportions or by decorative detail. But other features do distinquish
them from the other figures in the window. The lower part of the figure of Christ is lost,
and has been replaced by the lower half of a standing figure, but like the Virgin he was
probably seated. All the other figures are standing. Both figures are crowned, the Virgin
has her hands crossed over her breast, and our Lord has his right hand raised in blessing.
They are half turned towards each other. The fact that originally the six apostles on
either side of them were all turned towards the two central figures makes it plain that
they were the focus of attention. But on the lower tiers the figures are not looking up at
the Coronation scene but, arranged in pairs, they are turned towards each other. Apart
from their position on the tier below there is nothing to indicate that these figures relate
in any way to the central figures of Christ and the Blessed Virgin (see plates 10 and 11).

G

H

All this suggests an alternative interpretation of the window. Clearly, the window reflects the hierarchical structure of medieval society, and also of the Church's understanding of the structure of the Divine Order. The heavenly sphere was represented by three flaming stars in the apex of the window, signifying the presence, power and authority of the Triune God over his Church and all creation. The central star is missing, and has been replaced by fifteenth-century glass which depicts St Clement of Rome. Perhaps a restorer thought the figure of St Clement with his triple tiara might suitably represent God the Father. In depicting our Lord and the Virgin seated beside each other in glory, surrounded by the apostles, there is the realization of Christ's majesty and of the Church's devotion to his Virgin Mother. On the tier below are the saints and martyrs through whose intercession sinful men made their requests known, and were assured of God's mercy and compassion. This vision of the heavenly sphere is related and rooted in local history and the monks' own experience by the figures of the abbots and bishops of the church, holy men with whom the community could identify and whom they regularly commemorated. Below, represented by their armorial bearings, are the lords temporal reminding the community of those through whose patronage and generousity their choir had been transformed and richly furnished.

Looking up at this array of figures the community would have lost all sense of the distinction between the earthly and the heavenly spheres as saints of bygone centuries mingle and merge, in their intercessory role, with those of the heavenly order. In every office and in their daily conventual mass they pleaded the intercessory prayers of the saints and martyrs in seeking divine mercy and protection. The tonsured and mitred figures were also part of the monks everyday experience for in their prayers and intercessions they were constantly reminded of those of their community who lay buried beneath ledger stones in the church or out in the monks' cemetery. They went there regularly in procession to pray for the departed. They were also frequently reminded of their debt to founders, patrons and donors, some of whom were represented in this great throng. In fact, they lived out their days aware of this hierarchy of holy men and women, and of the heavenly order expressed in the tier upon tier of figures. For them the two orders indeed merged into one as the earthly was taken up into the heavenly, the temporal into the eternal. In other words, it is the liturgical context of the glass in the choir of a Benedictine monastery that provides the clue to its interpretation. It expresses something profound about that community, its faith and worship, its attitudes and way of life. In Kerr's words, for the monastic community the window was 'effectively a gigantic didactic glass reredos.'

Description

Considering all the vagaries and vicissitudes of history the window is in remarkably good condition. This is largely due to the work of Charles Winston in the last century. However, closer examination of the window reveals that it is far from complete and undamaged. As already noted, at the apex of the window between two flaming stars there is a fifteenth-century insertion. Below tall canopies were six angels, drawn and painted from two cartoons used alternately, but the second angel from the left is missing

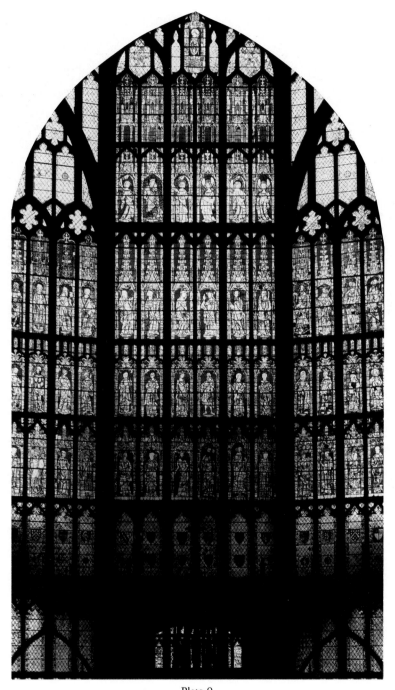

Plate 9
The great east window. The shadow is cast by the lady chapel and whispering
gallery. (Pitkin Pictorials)

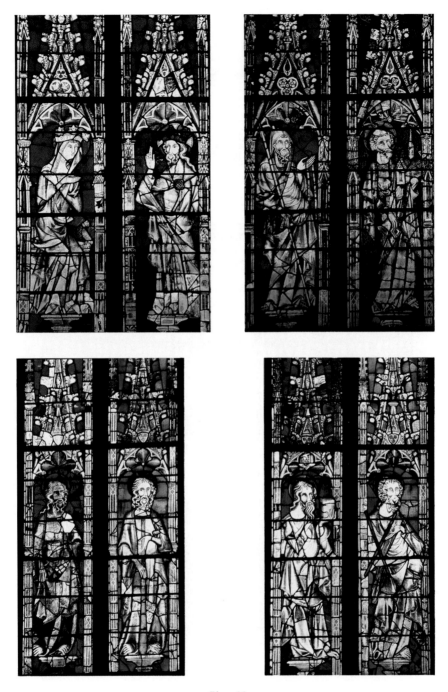

Plate 10
Top left: Blessed Virgin Mary and our Lord. Top right: St Thomas and St Peter. Bottom left: an
Apostle and St James the Less. Bottom right: an Apostle and St Andrew

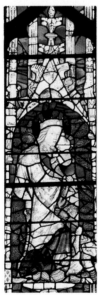
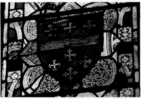

Plate 11
Top left: St Cecilia and St George. Top right: St Margaret and St Lawrence. Bottom left: Virgin and Child, fifteenth-century insertion. Bottom right: arms of Warwick and Talbot, and the 'Golfer'

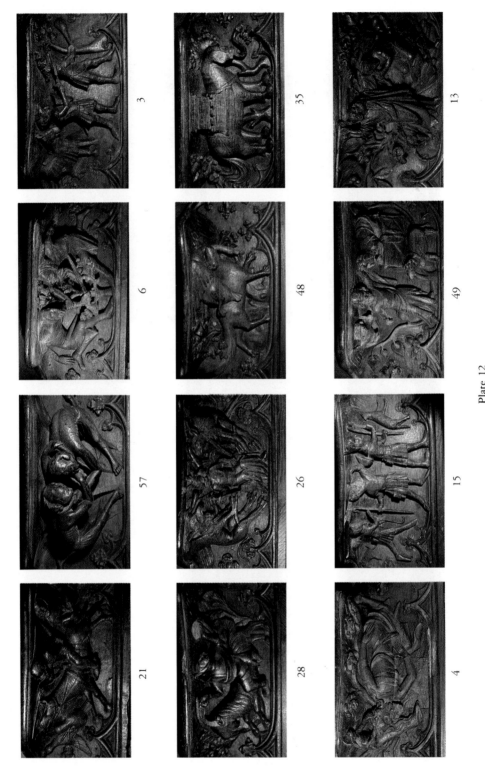

Plate 12
Misericord carvings in the monks' stalls in the choir (J. Farley). See Appendix IV

and in its place is a beautiful 'Madonna and Child' of the mid-fifteenth century. On the tier below, on either side of our Lord and the Blessed Virgin, there were originally six apostles all identifiable by their attributes. Thus, St Peter in whose honour the abbey church was dedicated is seen holding a church in one hand and the keys of the kingdom in the other, and beside him is St Thomas holding a spear in one hand and the girdle thrown down by the Virgin at her Assumption in the other. James the Less is nimbed, like the others, and holds a club in his hand, and St Andrew can be identified by his saltire cross. On the right, the south side of the window, is St Paul set against a background of blue foliate rinceau and holding a sword in his hand. His face is lost, and on his left are not other apostles but fragments of kings, larger in scale than the *in situ* figures, and coming originally, so Winston suggested, from the clerestory windows. The glass is of the same date and of the same glazing programme but originally these figures formed part of an impressive series of kings of biblical times and English history which filled the larger lights in the clerestory.

On the tier below are figures of saints and martyrs of the church. Some are nimbed, but most are not. Only five of them are identifiable by their emblems. On the extreme left, for example, is St Cecilia not with her more usual attribute of a musical instrument but with a wreath of roses on her head and a book in her right hand, paired with St George in his armour. Evidently the original arrangement of this tier was to group in pairs a female and male saint looking across a narrow mullion at each other, and framed, as it were, within the stronger mullions and transoms. In the centre are St Catherine and John the Baptist. On the right among the more damaged figures is St James the Great who has a particularly fine face and who, as an apostle, should be on the tier above. In his pilgrim's hat where a shell (of Santiago de Compostela) might be expected, is a small, framed face of Christ. The identity of others on this tier is not certain.[4]

The next tier contains abbots, some of them, no doubt, former abbots of St Peter's. There had been sixteen or seventeen 'after the Conquest', but none of those in the window is now identifiable. With them are bishops, presumably of Worcester and archbishops of Canterbury. These are also in pairs, a tonsured abbot and mitred bishop, looking across at each other. St Peter's was not a mitred abbey until the time of Froucester *c.* 1380. On the lowest tier are armorial bearings, fourteen in all, some in cusped quatrefoils, others set directly in later quarries. They include the arms of the king, Edward III, with those of his father, Edward II, his son the Black Prince, and a number of his nobles who fought with him in the French Campaign of 1345–7. Five of the six in the central section were reset in tinted quarries either at the time of the Restoration of Charles II (1660), or during Winston's restoration of the window (1860). There are fourteen decorative roundels in the window, most are about 20 cm (8 in) in diameter and contain monochrome geometric or floral decoration. But there is one on the lowest tier, among the shields, that is rather different, larger in diameter and containing coloured glass, depicting a small figure which has long been thought to represent a golfer. There is reason to believe the 'golfer' is, in fact, a boy playing bandy-ball, a popular medieval ball game, and not golf which dates back no further than the early decades of the fifteenth century.[5]

Date

For many years the window has been known as the 'Crecy Window' on the assumption that it commemorates some of the commanders who fought, and some who lost their lives, at the Battle of Crecy in August 1346, or at the siege of Calais in the following year. It is true that the *Crecy Roll* contains all but two of the names of those whose shields originally appeared in the window, and these two, Lancaster and Pembroke, were at the siege of Calais. Thus the connection with the French Campaign of 1345–7 is strong. Kerr, however, points out that 'apart from participation in the French Campaign all those whose shields survive in the window were also participants in the Scottish Campaign.'

As no glazing accounts have survived, the date of the glass cannot be determined with complete accuracy, but a date *c.* 1350 is indicated by the character of the glass itself and by its architectural setting. The stone frame-work of the window may have been nearing completion, and details of the design of the glass still under consideration at the time of Crecy. If this were the case, the design may have been modified, and the work then put in hand shortly after 1347, that is during the period of general euphoria following the king's return to England when, among other celebrations, he instituted the Order of the Garter at Windsor on St George's Day 1348. However, it is clear that the subject and design of the glass determined the pattern of the tracery in the window, and not vice versa, and so the general *schema* of the design would not have allowed much last minute alteration. In any case work on the window may have been held up for a while during the Black Death (1349) when the number of experienced glass-painters and glaziers must have been seriously depleted.

Thomas, Lord Bradeston, is thought to have given the glass in memory of his close friend and neighbour, Sir Maurice Berkeley. His arms are in the so-called donor position at the bottom right-hand corner of the window. He was Berkeley's feudal tenant for the manors of Bradeston and Stinchcombe, as such Kerr doubts whether Bradeston would have been in a position to have given such a large and expensive window. 'In the absense of documentary evidence it is more plausible to suggest that the expense of glazing such a large area would have been defrayed by more than one donor.'

CARPENTERS – CHOIR STALLS

In addition to the skilled work of stone-masons and glaziers, the work of carpenters and wood-carvers was vital in the erection and furnishing of a medieval building. Stone is the material that attracts most attention, but it could not have been built without wood. Wood provided the scaffolding for the walls and the centring for the arches and vaults. The templates, the trestles and the cranes which handled the stone were all made of wood. Great timber roofs, hidden masterpieces of medieval engineering, were raised above the stone vaults. Indeed, the great carpenters of the medieval period were engineers, as well as designers, architects and craftsmen. Many of the fitments and furnishings in wood have been lost – screens, rood-lofts, pulpits, lecterns, chests and cupboards. But much has survived. At Gloucester, in the south porch, is a massive Norman oak door dating back to the twelfth century banded in iron on the front and of

Fourteenth-century cope chests, in the south ambulatory

cross-battened construction on the back. The Chapel of St John in the south transept has a late fifteenth-century parclose screen. In the south ambulatory is the wooden effigy of Robert, Duke of Normandy, a reminder that medieval woodwork was often painted and gilded.

Also in the south ambulatory are two rare and massive cope chests. These were kept in earlier times in the room over the eastern slype (the choir vestry). The cope was originally simply a cape (Latin *cappa*), and was worn over a cassock and surplice as a processional vestment, its long and voluminous shape providing warmth for the clergy. It was often ornamented with a broad band, or orphrey, along the two front edges, and was fastened by a large clasp, or morse, on the chest. When it was laid flat the cope was semicircular, but it would have been folded when put away in a chest. Hewett describes the Gloucester cope chests in detail. They were designed as quarter-circles. Both have straight sides measuring about 2.3 m (7 ft 5 in), and one is 0.8 m (2 ft 9 in) high, the other not so high:

> They have four legs, one at each corner and one in the middle of the curved side. Along with the bottom rails they were mortised and tenoned and grooved, then offered together, fitted and pegged. Half way between each pair of legs are stiles. The eight fielded panels were then slid into the grooves in the stiles. The top rail, consisting of three lengths already pegged together, with mitred corners and having a hollow chamfer underneath, was fitted. Lastly, the legs and rails were chamfered, and the chests painted in red and blue.

The carpentry is an early example of fielded panels. The boards have skewed and square edge butt joints, edge-to-edge, a complicated and expensive task. The ironwork is undecorated and undateable. The chest may be associated with the work in the north transept and cloisters under Robert Lesyngham from *c.* 1368.

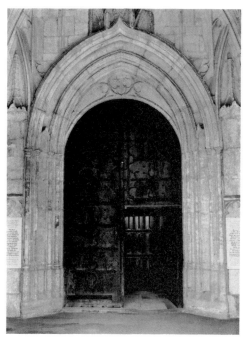

The twelfth-century door in the south porch

West door to the great cloister, detail of its construction (Cecil A. Hewett)

Design

The glory of Gloucester's woodwork is the set of mid-fourteenth-century choir stalls. While the great east window was being inserted new stalls were being constructed for the choir. Those on the north side were completed during the abbacy of Adam de Staunton, and those on the south side during Thomas Horton's abbacy. If there was a break in completing the work, it was probably due to the Black Death. But since Horton had been sacrist for some years before he became abbot in 1351, he would have been able to continue supervising the project. This would account for the furniture being so homogeneous. It is confusing to give the dates for the work on each side of the choir as '*c*. 1340' and '*c*. 1360' since this suggests as much as twenty years may have separated the two phases of work. The most that can be said from the dating given in the *Historia* is that the north side was completed before 1351, and the south side was not begun before that date. This could means that there was a break of no more than a year or two.

Tracey believes the design of the stalls 'came from the pen of a metropolitan carpenter or mason-architect.' But he wonders about 'the extent to which the carvers responsible for its embellishment, and the joiners who built it, carried out the letter as well as the spirit of the original blueprint.' Noticing a number of features which are very similar to contemporary furnishings at Exeter, he suggests 'the Gloucester stalls may well have derived from the blueprint of a "London" designer, such as William Hurley or William Herland, but the execution bears the signature of West Country craftsmanship.' The

The library, details of corbels, wood carvings (Jones Photography). Crowned heads probably fifteenth-century; the others of the late fourteenth century. The type of hat common in medieval period; rolled back knitted or felt

seats, however, cannot be paralleled anywhere else. 'The shape of the standards is archaic, with the rectangular lower section and the elbow projecting well out from the top of the capping. The unusual treatment of the base of the leading edge of the standard is not paralleled in any surviving stalls in the country.' The seating was thoroughly and well restored by Gilbert Scott, and in every case a piece of new wood was let into the standards below the arm rest. This, as Tracey says, 'tends to give the impression that the standards have been deepened, but this is not so because otherwise the panel at the bottom with its inset trefoil would be correspondingly narrower.' He adds 'it is admittedly difficult to envisage the problem that necessitated this particular method of repair.'

Canopies

At first glance the earlier stalls on the north side look the same as those on the south, but closer examination reveals a number of differences. The wedge-shaped trefoil leaf and the rosette are common to both sides, but certain variations of detail suggest the work was done in two phases, or that half-way through the work there was a reassessment of the design and lay-out of the canopies. For example, the nodding ogee canopies are flanked throughout by finialled buttresses, but some of these have gablets in the middle section,

The choir, detail of two designs of canopy (Jones Photography)

others have plain inset panels and the arches are double rather than single cusped. On the north side there is no consistent pattern in the arrangement of the stalls with these different motifs, but on the return stalls and on the south side they alternate regularly. Similarly, the cusps of the tracery panels behind the canopies are, on the north side, a mixture of plain circles and rosettes, but on the south side they consist entirely of circles. All these motifs are typical of the period and all-of-a-piece with the work going on at the time in the transept and choir. The quatrefoil tracery in the cresting, the various tracery patterns used in the spandrels of the canopies, and the lierne vaulting over the seats can all be found in the south transept.

The design of the prior's seat, on the north side of the entrance to the choir, is similar to the rest except that the canopy is taller and projects much further forward. The abbot's stall, on the south side, is even more impressive, and though containing the same basic motifs, structurally it is different from the standard canopy. The tower at the back of the standard canopy is triangular and tied into the cornice on the stall backing, but on the abbot's stall it is square and free-standing on three sides. Again, the spandrel of the front arch is rather flat, hardly nodding forward at all, and instead of the two finials on the standard canopy, it would have had originally no fewer than twelve. The stall is exceptionally wide; the four stalls beside it are of standard width. Over the south-west corner there is a standard canopy instead of the type especially designed for that position on the north side. Even so, it does not fit properly and the result is unsatisfactory. In spite of these variations and modifications in design, the stalls come together to give the impression of a completely homogeneous design, forming a beautifully proportioned monastic choir.

WOOD CARVERS – MISERICORDS

The word *misericord* comes from the Latin *misericordia* meaning pity or mercy. The misericord seats in a monastic choir were therefore seen as a concession to human frailty, since by tipping the hinged seats up, the older monks could half-sit or squat on the narrow ledge. Being raised above the normal seat level, they would appear to be standing, as they were officially required to do. When such stalls were introduced into monastic choirs in the late thirteenth and fourteenth centuries it became a common practice to allow woodcarvers to display their skills on the underside of the seats. There is rarely a consistent iconographical scheme in their work, indicating that the individual carvers were free to choose their own subject-matter, though at times this may have been restricted by the availability of patterns. A series such as that in the choir at Gloucester reflects many aspects of medieval life. Only a small proportion of the misericords have specifically religious or biblical subjects. It has been estimated that of the 8,600 medieval misericords surviving in England today less than five per cent have religious subjects, and only one and a half per cent have biblical subjects. It may have been felt that such subjects were not entirely appropriate for such a position, hidden away under a seat where few would ever see them. However, medieval craftsmen were not averse from carrying out work for obscure corners of the building. Perhaps, as Kraus puts it 'clerics were delicate about allowing the lower body to be in contact with effigies of Christ, Mary or the Apostles!'[7] (See plate 12 and Appendix IV.)

Sources

There are fifty-eight misericords in the choir, fourteen of which are Victorian copies dating from the restoration of the choir under Gilbert Scott in 1872–3. Laird wondered whether the surprisingly high proportion of biblical and specifically religious subjects among the Gloucester misericords may not have been the result of a sombre attitude engendered by the plague of 1349. 'Could this reflect renewed personal preoccupation with things religious among those carvers still active after the pandemic that killed more than a quarter of England's population?'[8] While it is true that there is an unusually high proportion of religious subjects compared with the national average, the proportion on the north side does not differ significantly from the proportion, among the medieval misericords, on the south side. There are only three on the north side (pre-Black Death) and nine on the south side (post-Black Death), but only one of those on the north side is a nineteenth-century replacement, whereas no less than six of those on the south side are Victorian. Since there was no attempt to match the subject of the Victorian copies with the originals, the higher proportion of religious subjects on the south side merely reflects the personal preference of the cathedral clergy in the 1870s for biblical subjects.

The monsters depicted in the Gloucester carvings are exactly those whose use St Bernard had condemned in 1125, fearing their power to distract from holy thoughts; monkeys, lions, fighting knights, hunters, monstrous centaurs, half-humans, several bodies with one head or many heads with one body. The animals carved are generally of mythical and symbolic meaning, a lion fighting a dragon, symbolizing Good fighting Evil. Favourite subjects were: the pelican feeding its young with its own blood, as Christ shed his blood on the cross for the salvation of man; or the unicorn which could only be caught when it laid its head on the lap of a virgin, symbolic of Christ, born of a virgin and crucified. The elephant is usually depicted as a war-machine with a tower or howdah on its back. Matthew Paris made a drawing of the African elephant which Louis IX of France gave to Henry III in 1255. Many watched in amazement as the animal made its way from Sandwich on the coast to London; but many others had never seen one, including many wood carvers who had to rely on hear say or copying from a Bestiary.

The wood carvers used much the same material as the friars who illustrated their sermons with references to everyday life, fables, legends and romances. The fox, for example, was regarded as a cunning deceiver who, by his wit and guile, lures his prey into his grasp. The fox is depicted in panel and wall paintings, as well as in misericords, making off with a goose, often with a woman with her distaff in hot pursuit. The fox is also depicted preaching to a cock and hens, disguised in a monk's cowl. Another popular story was the medieval romance of the Flight of Alexander the Great, being lifted high between two griffins so that he could survey his conquered lands. A mermaid is often to be seen with her comb and mirror, symbols of vanity, and bent on seduction or with fish in her grasp, representing the successful catch of a Christian soul. Other subjects depicted are wrestling, bear-baiting, ball games and hunting, and also hard work in fields, orchards and forest.

In the Gloucester misericords the centrepiece of the carving is framed not by supporters but by exuberant cusped foliage decoration. This is most unusual since supporters, a uniquely English feature, were almost invariably added. But as Christa Grossinger writes of the Gloucester carvings, this 'enables the figures to move in sweeping style across the whole width of the misericord.'[9]

14

9

5

44

38

33

Misericords (See Appendix IV)

Subjects

The variety of subjects may be set out as follows: (Vic. indicates a Victorian carving). (See Appendix IV.)

1. *Biblical and other religious subjects*: Sampson and Delilah – Delilah cuts off Sampson's long flowing hair with a pair of shears (4). The coronation of the Virgin Mary (7 Vic.). The sacrifice of Isaac – Abraham with a sword-like knife held over the head of his son, an angel restrains him (13 Vic., 49 medieval). The Three Shepherds following the star to Bethlehem (15). Moses with the Commandments addresses the Israelites

(20 Vic.). The presentation in the Temple (46 Vic.). Angel playing musical instruments (23 Vic.). Balaam and his ass (29). Adam and Eve (39 Vic.).

2. *Legends*: The Flight of Alexander (8, 26, 22 Vic.). The Pelican in her Piety (16). Queen Disa, a Norse folk-tale (18). Fox carrying off a goose (48). Man riding a goat, facing backwards and blowing a hunting horn (19 Vic., 28 medieval).

3. *Rural and domestic scenes*: Lady in a garden, with birds in the trees and dog at her feet (10). Hawking, a rider on horseback, with beater and hawk, pinning a duck (21 Vic., 27 medieval). Pigs eating acorns under an oak tree (30). Two youths playing with dice (32). Two youths running and playing with a ball (33). Horseman riding at full speed (38). The Vintage, gathering grapes beneath a vine (51). Deer stalking, hunter with a long bow fells a deer (54). Tree felling in a forest, with deer standing at a distance (56). The Wrestlers (57). Bear baiting, a ferocious dog attacks a chained bear, while the bear's keeper with a stick stands by (5).

4. *Animals and birds*: Owl sitting on a branch is mocked by other birds (9). An elephant with a howdah (35). Eagle striking at an animal, possibly a fox (36). Monkey riding on a cart horse (40). Lion traps a fox up a tree (41). Two dogs trap a fox up a tree (44).

5. *Men in conflict and at rest*: A man running at another thrusting a sword into his stomach (6). A knight in armour, riding his charger and attacking a dragon, possibly St George (12). The tournament, two knights on their chargers meet in combat (52 Vic.). Crowned king reclining (25). Man dressed in costume of Chaucer's period reclining (42). Man holding a stave reclining (47 & 53 Vic.). Reclining figure with hands held in attitude of prayer, holding a book and with a scroll across his body, possibly an angel (55)

6. *Monsters and Dragons*: Male and female human faces with dragons' body (11). Mermaid with fish in both hands (14). Monster swallowing a man, possibly Jonah and the whale (17 Vic.). Two dragons joined at the neck, sharing the face of a jester with asses' ears (24). Two monsters fighting (31). Lion confronting a dragon (34). Winged human figure thrusting a spear into a dragon's mouth (37, 45). Lion fighting a dragon (43). Dragon (50). Lion fighting a winged dragon (58 Vic.).

Some of the figures and scenes are not easy to identify, and others are open to more than one interpretation. Some may be catagorized under different headings. Another heading might be 'Humour'. Medieval carvers enjoyed depicting humorous situations from everyday life, and from fables, proverbs and romances.

PANEL PAINTING – FOX AND GEESE

From ancient times stories including animals have been told to point some moral or to make some satirical point, endowing them with human characteristics. There are, for example, Aesop's *Fables* and Aristotle's *Animal Tales*. In the medieval *Bestiaries* many creatures were endowed with moral significance and given symbolic attributes. Among these was the fox called Reynard whose exploits were told and retold often in extremely bawdy detail. The fox was the personification of every kind of evil, theft, deceit, lying, treachery, cunning and fornication. He was regarded as a kind of crafty hero–villain who variously embarrassed and outwitted stronger animals like the wolf, bear and lion.

The Epic

Varty has shown that the epic of Reynard originated in about 1150, and rapidly proliferated throughout western Europe. Most people were unable to read or write, but a good story well told lived on in their minds. The most popular and vividly remembered episodes were set down by illiterate people for illiterate people in stone sculptures and wood carvings, in painted and stained glass, in drawings and sketches. Most of the sculptures and drawings were produced in monasteries and churches, and usually by or under the supervison of men in holy orders, consequently they often had a religious or moral purpose. With telling and retelling, the story of Reynard took different forms, but the representations of the epic in stone and wood, in panel painting and stained glass make it possible to determine the form the story had taken at different times and in different parts of western Europe.[10]

The first reference to the Reynard story in English literature is in the Nun's Priest's Tale in Chaucer's *Canterbury Tales c.* 1390. Long before that it was being represented on misericords, capitals, stained glass and portals. At Wells Cathedral there is an early example on a capital (*c.* 1190), in which the farmer's wife seeing the fox making off with a cock, calls to the farm hands to go after it. The cock often features in the story, along with other farmyard animals. The fox once caught, is brought before Noble the lion, with Brun the bear, Tibert the cat, and Grimbert the badger and others standing around. There are five misericords at Bristol Cathedral which depict the story.

In other examples the fox is shown preaching to farm animals. He preaches and they fall asleep, and then he pounces. Misericords at Wells depict the scene *c.* 1180, at Ely

The fox and geese legend in medieval literature

c. 1338 and Lincoln *c*. 1370. In the fourteenth century the preaching fox was usually an itinerant friar preaching by the way side, but in the fifteenth and sixteenth centuries he was more often depicted indoors, preaching from a pulpit. He is vested like a priest or abbot. A popular board game, 'Fox and Geese', was played by novices in the north walk of the great cloister at Gloucester where, still incised in the wall-bench, is the 'board' on which they played. The purpose was to move the 'geese' across the board in such a way as to trap the 'fox' in the corner; the player doing so won (see plate 13).

The Setting

On the panels at the back of four of the stalls on the north side of the choir are paintings of St Margaret of Antioch and St Anthony of Egypt, and a series of eight miniature paintings of the fox and geese legend. Clive Rouse describes how they were found:

> In 1972 I was asked by Seiriol Evans, the dean of Gloucester, to inspect and report on some paintings . . . in the Dean's Vestry in the north transept. Little was known of these paintings beyond a vague reference in Keyser to 'portraits of saints', and the surviving ones had not been identified. It is likely that there were at least six figures in this area, but only two survive with indications of a third. Those now cleaned and conserved represent St Margaret of Antioch emerging from a dragon, and St Anthony with his attributes of pig, bell and rosary, and carrying his tau-headed cross or staff. These figures are on the tall, upright panels forming the back of that part of the stalls between the back of the seats and the stall canopies. Each panel is framed by a black and white quatrefoil border.

The back of the north choir stalls, the panels on which the fox and geese paintings were discovered

Below these tall panels are four smaller ones, covering the back of the seats of the stalls. They were covered by a crude ornamental painting of brocade patterns with trees, foliage, a vase of flowers and other motifs probably of the sixteenth century. On close examination it was found that on the small panels were clear indications of painting underneath. It was decided to remove a small area of the upper design to establish whether this was so. At once animal figures and other features began to emerge, and it became clear to Rouse and his assistant, Ann Ballantyne, that these were part of a set of scenes connected with Reynard the Fox. Following further examination the two panels containing eight scenes were fully exposed and restored. But they were not over-restored by Ballantyne. Her purpose was to expose the beauty and detail of the original work.

The Paintings

The paintings, dated *c.* 1375, are in cartoon form, the top row reading from left to right, and then the lower row, also from left to right. The first scene depicts the fox running off with a goose in its mouth and flung over its back. The second shows the fox arrested and brought before Ysengrin the Wolf. The third shows Reynard being dragged by three yoked geese to execution, and the fourth depicts him hauled up by the goat, hare and goose, and hanging from a gibbet. On the lower tier, in the fifth scene the stag and hind begin to sing the burial service, and the sixth, which is not very clear, probably shows the animals celebrating the death of Reynard. The seventh scene shows

Reynard and the farmyard animals. See plate 13

Reynard being lifted off the bier for burial while the service is read, Baucent the Boar and Courtois the hound assisting with 'bell, book and candle'. Lastly, Noble the lion holds a celebration feast, with Fiere, Brun, the Goat and Monkey. (See plates 13 and 14.)

The series of life-size figures of saints, St Margaret and St Anthony among them, along the back of this section of the choir stalls, would have fitted well into the furnishings and decoration of the small chapel which then occupied the space between the north crossing piers. The chapel was known as the Chapel of St Anthony. How the animal paintings fitted into this arrangement is not so clear, but what is clear is that they were the work of a very gifted artist who may well have been a member of the community. What is so striking about these miniatures, and the carvings on the misericord, when compared with the formality and stylized character of the figures in the great east window, is their life-like quality. The stained-glass painters were confined by the traditions of their craft, and a reverential attitude towards their subjects imposed by their ecclesiastical patrons.

TILERS – DECORATED TILES

Another craft of growing importance in the century before the remodelling and refurnishing of the choir was that of the tile-maker. He would set up his kiln where there was suitable clay freely available, and transport the finished tiles to the site where the floor was to be laid. There was a well-known group of tile-makers at Malvern, where many of the tiles purchased by the abbey were manufactured.

Method

All the decorated tiles dating from the medieval period are two-colour tiles and all but a few late examples have the design in white clay on a background of the red body of the tile. When the tiles were glazed and fired the decoration appeared yellow on a brown ground. Such two-colour tiles were probably first made in England in the second quarter of the thirteenth century. The decoration was inlaid with white clay in a plastic state, pressed into cavities stamped in the surface of leather-hard tiles with a wooden stamp on which the decorative design had been left upstanding. Examples decorated by this method with lions, birds and heraldic shields are to be found in the apse of the south-east chapel of the tribune gallery.

After inlaying the clay the tiler consolidated the surface with a bat and then cut away surplus white clay and brought up the outline of the decoration. When this was done carefully it produced a sharply defined decoration, but it was difficult to get red and white clays that shrank equally, and if the white clay shrank more than the red, cracks appeared round the edges of the inlay and sometimes it would fall out. During the last decades of the thirteenth century tilers began to introduce the white clay in a liquid instead of a plastic state. Several methods seem to have been used. White clay introduced as slip never shrank away from the edges or fell out but it rarely filled the cavities to the level of the surface of the tile and sometimes did not even cover the bottom, although at

The Seabroke pavement, tile with royal arms (right) and the *Maria* motif (left)

other times it spilt over the edge of the cavity on to the surface. Such faults, of course, rendered the design less clear.

After the white decoration had been applied, whatever method was used, the tile was glazed with a lead glaze. This was usually applied as an ash of lead oxide mixed with a liquid and brushed on. The edges of the tile were then trimmed generally with a bevel towards the base. When enough tiles were ready they were stacked in the oven of the kiln in rows standing on edge, each layer at an angle across the layer below. Most kilns were fired with wood and to fuse the glaze the temperature in the oven had to reach 1,000°C. Plain glazed tiles were used with the decorated ones. The dark glazes present on tiles in Gloucester's abbey church were obtained by adding a small proportion of copper or brass filings to the lead ash. Most of the remaining tiles in the church date from the mid-fifteenth to the early sixteenth century. They were probably all decorated by pouring fairly thick slip into shallow cavities. In the judgement of Elizabeth Eames they are some of the most intricately decorated and successful tiles ever made.[11]

Pavements

The finest pavement to have survived from the medieval period is that in the *sacrarium* of the choir, known as the Seabroke pavement. It was quite extensively restored in the nineteenth century. First, the local antiquarian, S. Lysons restored it: taking tiles from

Tiles of the Seabroke pavement *c.*1450 (Anne Kellock)

Detail of the Seabroke pavement

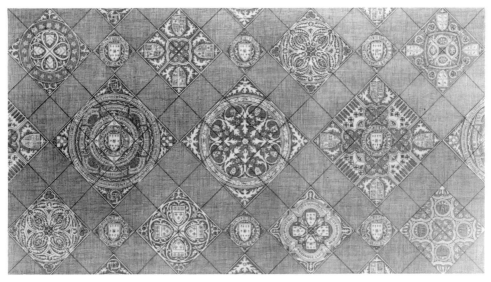

John Carter's drawing (1788) of part of the Seabroke pavement (The Society of Antiquaries of London)

other parts of the building to do so. Storer (1814) wrote that 'many of these tiles have lately been brought from different parts of the church and disposed in the present order by the good taste and skill of S. Lysons Esq'. In the early 1870s Gilbert Scott also restored it, and the part that lay beneath and around the high altar was removed and relaid in the south-east chapel of the tribune gallery. The new altar was then raised a step higher, and the area paved with new tiles. The part of the Seabroke pavement which was removed to the tribune chapel was relaid between strips of dark grey slate. Like the rest of the pavement which remains *in situ* and partly covered with carpet, it consists of nine-tile and four-tile squares set diagonally. The decoration on five of the nine-tile squares in the relaid gallery pavement is the same as that in the pavement below in the sacrarium. All the four-tile squares are filled with the same design, including a circular band with the inscription: *AVE MARIA GRA PLE*. They must all belong to the same mid-fifteenth century Malvern–Gloucester series.

At the same time as part of the Seabroke pavement was relaid in the tribune chapel a number of other tiles, of varying dates and designs, from other parts of the building were preserved by being relaid in the apse of the same chapel. Most of these date from the late thirteenth and fourteeth centuries. Heraldic designs include some known at Cleeve and Glastonbury Abbeys; others, including designs of birds and lions, may have been made in the kiln at Nash Hill, Lacock, excavated in 1972. There are also two complete examples of an eagle displayed within a quatrefoil frame spread over four tiles, and one complete example of the companion lion. There is a single row of Malvern tiles set square, and among the heraldic tiles some designed in the early years of the sixteenth century for Llanthony Priory, which lay a mile to the south of St Peter's Abbey.

The east end of the Prior's Chapel (in Church House) is paved with reset tiles belonging to the group made at an unidentified kiln in the Bristol area at the end of the fifteenth century and the beginning of the sixteenth century. Some of the tiles in the group were designed for St Augustine's, Bristol, and are known as the Canynges–Bristol tiles. The paved area is divided into three strips running from north to south. The east and west strips are filled with plain glazed tiles. The middle strip has decorated tiles except at the north and south ends. The decorated tiles are sixteen-tile and four-tile

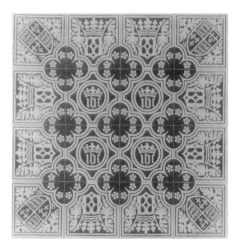

Henry Shaw's detail (1858) of a sixteen-tile pattern of
the Seabroke pavement

squares set diagonally, separated from each other by rows of plain dark glazed tiles. This is the arrangement used in the pavement from Canynges House, Bristol, now in the British Museum, and all the designs in the Prior's Chapel are present in the Canynges Pavement.[12] In the east part of this strip the designs are all correctly laid, but in the west part the sixteen-tile squares are made up of tiles from more than one sixteen-tile design. These tiles are probably the best tiles from a complete pavement, resembling the Canynges Pavement, perhaps originally laid in this chapel or in some other part of the Prior's Lodging.

There are other medieval tiles, in the ambulatory chapels and lady chapel, in the axial chapel in the crypt and in the north-east chapel in the tribune gallery and in many other places about the building. Some are very worn, but others are excellent examples of the tiler's craft from the thirteenth century to the Dissolution. (See Appendix V.)

CHAPTER ELEVEN

THE GREAT CLOISTER
1381–1412

'A right goodly and sumptuous piece of work.'
Leland, 1541

The abbey chronicler credits Abbot Horton with more than the completion of the choir. He was also responsible for a variety of minor works in the precincts including 'the covered *camera* of the monks' hostelry' and 'the abbot's chapel'. The latter is described as being 'near the garden of the infirmary'. St John Hope places the chapel on his plan of the abbey precincts (1891) north of the infirmary on the east side of the abbot's house.[1] Horton also built 'the great hall in the court'. This can only refer to the large hall on the south side of the inner court (Miller's Green), where Horton erected a new timber-framed building on the original thirteenth-century undercroft. In his day this extended westward as far as the vaulted entry to the inner court. It was in this 'great hall' that Richard II held his parliament in 1378. This building, like the addition to the monks' hostelry and the abbot's chapel, no longer exists, though a shortened timber-framed hall still stands on part of the undercroft. Two of Abbot Horton's other building works have survived, the first phase of work on the great cloister and the remodelled north transept.

THE NORTH TRANSEPT

In Horton's time the north transept, known as St Paul's Aisle, still consisted largely of unaltered Norman work. This must have seemed rather austere and uninspiring adjoining the now transformed and sumptuously furnished choir. But it must have been the intention for some time to treat the north transept in a similar way. The construction of the choir vault with the rebuilding of the north crossing arch committed the community to doing something about the north transept. It was therefore a desire to enrich and unify the whole of the eastern arm of the building, the particular preserve of the community, that led Abbot Horton to undertake further major reconstruction work.

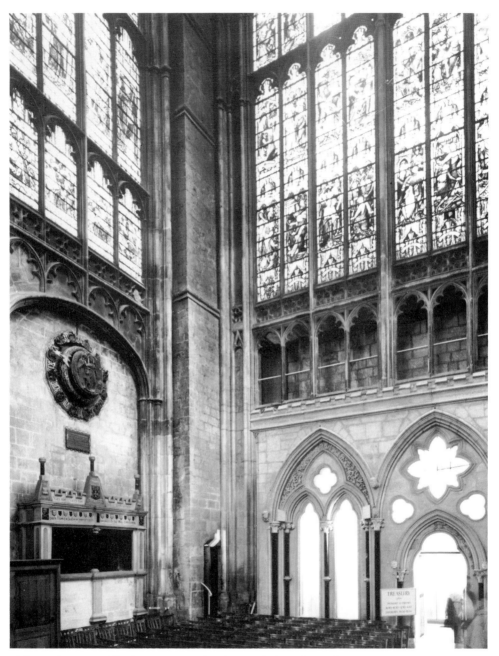

The north transept. North-west corner: showing terminal window and wall passage above thirteenth-century reliquary (treasury) screen

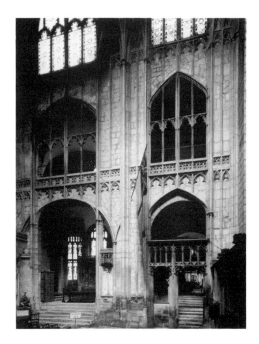

The north transept, east side

The *Historia* gives specific dates for the work in the transept: 'The aisle of St Paul in the monastery of Blessed Peter which was begun the day after the Epiphany of the Lord in the 41st year of King Edward III of that name after the Conquest, was, by the grace of God, fully completed at the Vigil of the Nativity of the Lord in the 47th year of the above-mentioned king.' Thus in six years (1368–74) the work was completed, at a cost of £718 0s. 2d., of which the abbot himself paid £444 0s. 2d., considerably more than half.

The building programme involved taking down much of the west wall, and constructing a large window, with a smaller one over the entrance from the nave aisle. But unlike the corresponding windows in the south transept, the tracery of these windows and of those opposite on the east side of the transept was Perpendicular and very similar to that in the upper part of the great east window. The end-wall was taken down to within 4.6 m (15 ft) of the ground, and a large window constructed with a wall-passage below it to gave access to the tribune gallery and its chapels. Because the base of the new window was lower than the level of the tribune floor, there had to be a stairway at the east end of the wall-passage leading up to the gallery.

The crocketed gables of the thirteenth-century screen or reliquary were removed and replaced by the present castellation. Where the screen abuts the east wall there is a large niche set at an angle, but the masonry around this feature has been disturbed and left unfinished. This was caused when the masons were applying the panelling to the east wall, but it is curious that they never made good the damage done. The earliest drawings of the screen show it in this unfinished state.

The design of the Perpendicular panelling, like the tracery in the windows, is far more developed than that in the south transept. Angular mouldings are used in place of

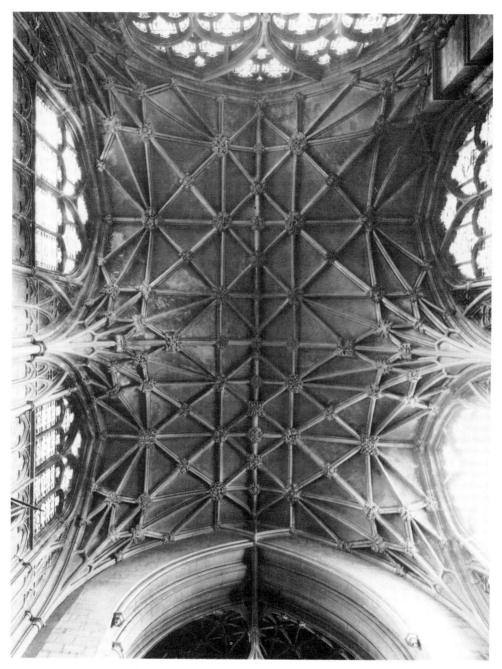

The north transept vault; top the terminal window

round mouldings, and the mullions rise uninterrupted to the vault. The vault too is far more complex than the south transept vault, with well-carved bosses at the junctions of the ribs. The springing has the promise of a fan vault, the junction of the main and transverse ribs being rounded rather than angular as in the choir vault. In fact, the vaulting ribs almost form a conoid, making the vault the precursor of the fan vaulting of the great cloister. The smaller ribs springing from between the larger ones are a little above the union with the capitals and the supporting shafts.

FAN VAULTING AND THE GREAT CLOISTER

Fan vaulting is a form of vaulting that is peculiar to England. In the early phases of its development it was centred in a small area around Hereford, Gloucester and Tewkesbury. It must have begun as a mark of personal style, and spread in the region through the master travelling to different commissions. But Kidson asks:

> Were fan vaults invented at Gloucester? There is something about the complete assurance with which they are handled that suggests that some experiments had been made before; but if so, nothing has survived. In the 1360s at Hereford, we know that the chapter house (now destroyed) was vaulted with fans, and there may have been a complete fan in the centre where thirteenth-century architects would have built a cone of ribs. It needs only a little thought to realise how perfectly the principle of the fan was adapted for this purpose, and we are apt to wonder whether it did not originate in such a context. In essence the cells of a fan vault are generated in the same way as the 'leaves' of thirteenth-century French rose windows – only in two, not three dimensions. The starting point for such designs in England was Westminster Abbey; and this alone is sufficient to connect the idea of fan vaulting with the London milieu in which Perpendicular developed at the beginning of the fourteenth century. But whether or not fan vaulting began as early as this, the circumstance that it was not used in the choir at Gloucester has no bearing on the date of its invention. The mere fact that the earliest fans were small-scale, decorative forms may well imply that they originated in tombs and chantries, rather than in large architectural projects.[2]

Description

Each side of the cloister is divided into ten bays, nine containing a large Perpendicular window of eight lights crossed by a broad transom projecting externally like a shelf as protection from the weather. Evidently the window openings below the transom were not glazed, as the shelf was designed to prevent rain from driving in. The design of the tracery in the windows of the east walk differs from that in the windows of the other walks. The earlier windows of the east walk are divided by two main pointed arches with a horizonal element at springing level made up of interlacing ogee archlets. This produces two pairs of elongated hexagons above, cusped equally top and bottom, with a third pair centrally at the top, all with supermullions and Y tracery. The tracery in the windows of the other walks is less elaborate; the ogees do not interlace, and there is one larger elongated hexagon at the top; there are also simplifications in the fans. But, as in all the walks, the window tracery is repeated as blind tracery on the internal wall. These comparatively minor differences do not effect the harmony of the whole. The design creates a sense of enclosure in a way no other Gothic cloister does.

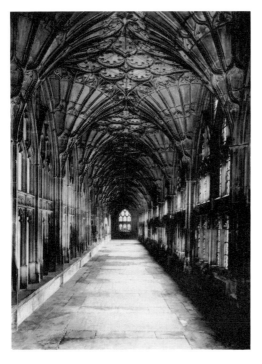

The great cloister, west walk looking north

The cloister forms a quadrangle; the length of each of the four walks varies slightly but they are approximately 44.8 m (147 ft), with a width of 3.8 m (12 ft 6 in) and a height of 5.6 m (18 ft 6 in). The bays of the *lavatorium* are exactly square. The roughly square dimensions of the bays of the main walks indicates that the great cloister was built on the foundations of the original Norman cloister which would have been based on square compartments. This would have simplified the design and construction of the fan vault. As Wilson notes, 'designing and building fan vaults over square bays, as at Gloucester, was comparatively straightforward, but it was far more difficult to adapt them to the rectangular bays normally used in churches. The earliest surviving fan vault over rectangular bays is the timber example at Winchester College Chapel.'[3] Later the Gloucester masons were to construct fan vaults over a number of narrow rectangular spaces, for example, over the entrance at the west end of the nave and from the nave into the cloister, and in the chantries of the lady chapel.

Construction

The fan vaulting of the cloister differed from the ribbed vaulting in current use in a number of ways. Traditional Gothic vaulting was conceived as a series of supports or ribs between which were placed the warped surfaces of the webs. The structural function of the ribs was load bearing, forming a permanent framework for erecting the web. The transverse arches and ribs were placed in position, and then the webs were built up. In

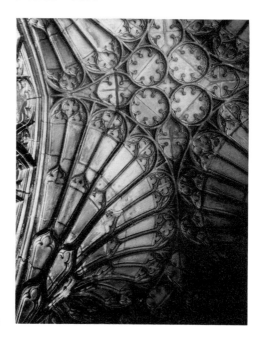

The great cloister, detail of fan vaulting

rare cases the diagonal ribs were not rebated so once the mortar was set, the ribs could be removed and the vault would still be secure. Usually the ribs were rebated to receive the webs and continued to serve a structural as well as aesthetic function. The stress levels in the webs of ribbed vaults were kept low by using a lighter stone such as tufa (which was used in the thirteenth-century nave vault); the diagonal ribs helped to carry the load to the piers. This system had the advantage of concentrating the lateral thrust of the vault as efficiently as possible on one point which could then be buttressed if necessary.

The construction of Gloucester's fan vaulting was, however, somewhat different. As Kidson states, 'the essential point of the original idea was that these vaults are really shells of jointed masonry with a self-developing system of tracery cells cut in relief on their surface.' In other words, the fan vaulting is made up of interlocking masonry, and in each piece there is cut a part of the tracery pattern. As Wilson writes: 'The Gloucester vaults are constructed entirely of jointed ashlar blocks each of which includes part of the tracery and part of the plain surfaces between. Many later vaults which are visually similar to Gloucester revert to traditional rib and infill construction.' The 'ribs' therefore are not functional, but purely aesthetic, the whole structure being held by the heavy, square key stone in the central spandrel of each bay. Though it is not found in the east walk, elsewhere in the cloister there is a standardized jointing system for both the central spandrel and the lower parts of the vault, with the stones of the wall ribs tending to be uniform in shape and size. This would have made for simplicity and speed in construction since the masons could produce the stones by the dozen. The extrados or upper surface of the vault has been plastered over, and in parts, particularly in the northern section of the east walk, the vaulting pockets have been filled in with rubble. This may indicate that this section of the vault once had a room built over it.

The Hereford Connection

It is now thought that a master mason or architect by the name of Thomas de Cantebrugge was responsible for designing and overseeing the early construction of the great cloister, including the fan vaulting. He probably came from the hamlet of Cambridge in Gloucestershire, but he became a citizen of Hereford, and is known to have carried out work there between 1364 and 1370. He was hired to complete the new chapel of St John the Evangelist and St Michael, and to work on the new chapter house. This work was probably begun by John of Evesham who was appointed master mason of Hereford in 1359. The chapter house, which is now in ruins, is thought to have been fan vaulted, though whether John of Evesham or Thomas of Cambridge should be credited with its design is not clear. Harvey thought Thomas may have designed it as early as 1359 while still in charge at Gloucester.[4] The evidence for the chapter house having been fan vaulted rests not so much on fragments that remain on the site as on a drawing by Stukeley dated 1776. The central pillar and the fan vaulting radiating from it appear to have been very similar to the east walk of the cloister at Gloucester, so much so that in the opinion of some architectural historians there can be little doubt that it is the work of the same master.

It is therefore suggested 'as a working hypothesis' that Thomas of Cambridge was in charge at Gloucester for some time before he began work on the chapter house at Hereford in 1364. He supervised the building of the first phase of work in the great

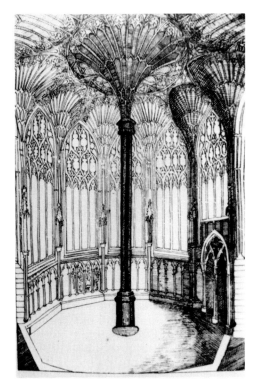

Hereford Chapter House interior, drawing by Stukeley 1776 (Bodleian Library, Oxford)

cloister, the first six bays of the east walk from the door into the church to the chapter house door. He then moved away from Gloucester to take up his important contract at Hereford. On stylistic grounds, it is considered possible that Robert Lesyngham was then appointed master mason at Gloucester where he carried out the remodelling work of the north transept between 1368 and 1374. He is known to have been in Exeter in 1377, but he may have returned to Gloucester Abbey after that to complete the cloister under Abbot Froucester. This suggestion is based on the fact that the style of the north transept is very similar to that of the later cloister walks. If this was the case, the difference between the design of the first six bays of the east walk and that of the rest of the cloister indicates a change of master mason, from Thomas of Cambridge to Robert Lesyngham. Leedy points out, however, that nothing of the vaulting conoids at Hereford survive above the *tas-de-change*, so that the argument about similarity of design rests entirely on the 1776 drawing by Stukeley.[5]

Dr William Stukeley was born in 1687 of a Lincolnshire family. From an early age he visited churches and made sketches of their more interesting features. In 1710 he journeyed round England on horseback with some friends in search of stone circles. He became a medical doctor and vicar of a country parish, but his great passions as an antiquarian were standing stones and ruined buildings. These he would measure and draw in great detail and record any local lore associated with them. Stukeley wrote of his

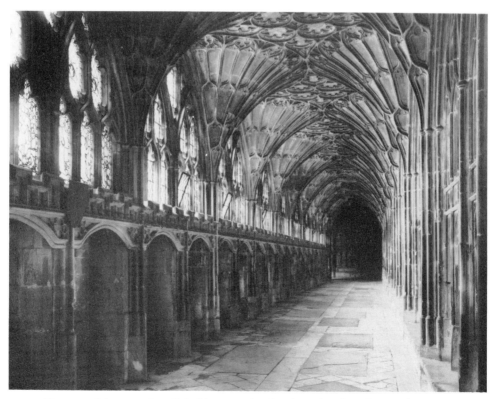

The great cloister, south walk looking east, showing the series of carrels or study recesses

drawing of the chapter house at Hereford: 'I endeavoured to restore the whole in drawing as well as I could . . .' Leedy takes this to mean that the drawing is an imagined reconstruction rather than an accurate drawing based on existing remains. It is known that in Stukeley's day only four walls of the structure were standing, and the only parts of the vault that could have been *in situ* were the wall ribs and the *tas-de-change*. As Leedy points out that at the time 'no part of the central pillar or any parts of the vaulting conoids above the *tas-de-change* remained.' The fragment which can now be seen in the centre of the ruined chapter house is not part of the central conoid but a *tas-de-change* from an angle, and this type of *tas-de-change* does not necessarily imply a fan vault since it is also common with lierne vaults. Thus, though the Hereford chapter house is known to have been built by 1371, whether it was fan-vaulted remains uncertain.

Date

While it is difficult to determine the exact date of the introduction of fan vaulting in the cloister, there seems to be a consensus that work in the east walk began before 1364. The *Historia* gives no indication whether the first phase of the work in the cloister preceded the work in the north transept, or whether it was going on at the same time. If

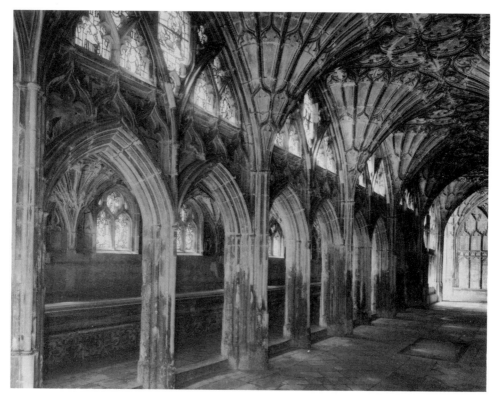

The great cloister, north walk looking west, showing the *lavatorium*

it was not begun before the completion of the remodelling of the north transept in 1374 there would have been little time to make much progress before the retirement of Abbot Horton in 1377. However, if this was the case, the abbot's departure and a worsening financial situation might account for a break in the work until the abbacy of Walter Froucester (1381–1412). The first six bays of the east walk would then have been constructed between 1374 and 1377. But this late date does not fit in with the probable movements of those who are thought to have been in charge of the work in the north transept and in the great cloister. Nor does it take into account the phrase in the *Historia* that it was 'left unfinished for many years . . .' For these reasons it is more likely that these six bays were built during the earlier years of Horton's abbacy, and probably before 1364. This would make the first phase of work the earliest fan vaulting, on any scale, to have survived.

Leedy is inclined to date the work on Gloucester's cloisters almost entirely to the abbacy of Froucester though he concedes that the differences in the design of the east walk and the other walks suggests that there were two distinct phases in the building programme. But he argues that it was the northern part of the east walk, and not the southern bays that were built first. He regards this section as 'more experimental'. These bays were followed by the southern bays which, at first, were not vaulted. This early phase of the work, that is, the bays of the east walk from the chapter house northward, and the unvaulted bays to the south of the chapter house doorway, may have been carried out by Horton, though he notes that Leland and the *Monasticon* give sole credit for building the entire cloister to Froucester. In the 1870s J.T.D. Niblett saw no less than seven representations of the second badge of Richard II, the sprig of broom plant, on the old painted glass in the *lavatorium*.[6] This suggests that glazing was still going on in the 1390s since this badge was first adopted by Richard II in 1393. Yet this does not conflict with the generally accepted view that Abbot Froucester completed the work, begun by Horton in the early 1360s.

Gloucester's cloister is widely regarded as the most beautiful in England. The walks resemble an avenue of trees, their branches meeting overhead. The windows and wall panelling, with their branching tracery, fit perfectly with the spreading pattern of the fan vaulting above. Indeed, the whole design seems to have been conceived and executed simply to impress and to be aesthetically satisfying. In Kidson's words:

> Each cell at the base of the fan bifurcates into two, and each of these into two more and so on. As they grow larger they assume more and more the shape of typical Perpendicular panels; and at all stages there is an element of ordered inevitability which is a perfect foil to the endless repetition of the wall and window tracery. No Perpendicular interior in England can vie with the long vistas of Gloucester's cloister, at least from the point of view of uniformity. Here, if anywhere, the aesthetic ideal of the style finds its fulfilment.[7]

KING RICHARD II'S PARLIAMENT OF 1378

After governing the monastery for twenty-six years, Thomas Horton was forced to resign due to increasing infirmity on 8 November 1377. John Boyfield, the precentor, was elected in his place *per viam compromissi*. His abbacy was brief. He died in January 1381 after little more than three years in office. He was buried 'on the south side of the north

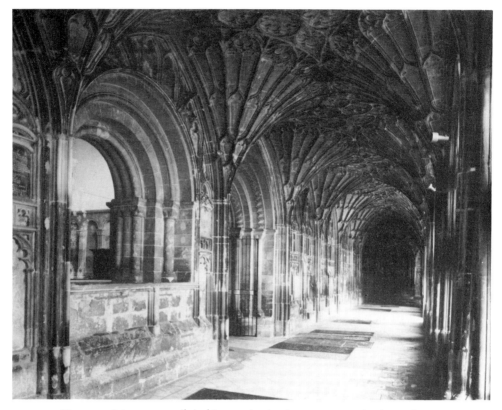

The great cloister, east walk looking south, showing entrance to the chapter house

transept near his predecessor.' He is described in the *Historia* as a man 'of transparent simplicity and mild . . . but during the whole time of his prelacy his rivals were rising up against him. As a result he had hardly any rest, since the bishop of Worcester and very many others troubled him with different vexations and disturbances.'

There was one notable event at the abbey during his time, which from the detailed account given in the *Historia,* appears to have been well remembered by the community. Richard II, a boy of eleven at the time, held his parliament at the abbey in 1378, taking over the entire monastery and the rest of the town for the occasion. It was said to have been called in Gloucester because of the danger of unrest and riot in London in the wake of the imposition of a poll tax earlier in the year which affected everyone from dukes and archbishops to agricultural labourers. The affairs of state were in the hands of a Council of Regency, dominated by the old antagonists John of Gaunt and William of Wykeham. Proceedings began on 2 November and continued for twenty- eight days at enormous cost and inconvenience to the abbey and the townspeople. The king and his entire court were lodged in the monastery, which was so full that it was said 'some of the monks took their meals entirely in the dormitory, and later in the school house.' During the session the martyrology was read in the choir 'without respect to order' for as the chronicler says 'the monastery was so crowded that it was more like a fair than a house of religion, and

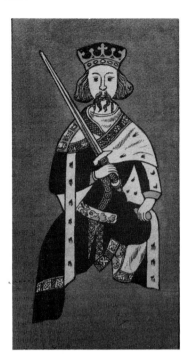

Figure of a king (? Richard II 1377–99) from the lady chapel east
window, engraved by Samuel Lysons, 1792

the grass plat in the cloister was so trampled and [ruined by] ball games that not a
vestige of green grass was to be seen.' All the available rooms and halls of the monastery
were used for the proceedings. Business relating to the law on arms was transacted in the
refectory, the king holding his privy council in the guest chamber; the Council of the
Commons met in the chapter house and the Lords in the great hall. The great hall of the
abbey was the earlier and far larger timber-framed hall which extended on a
thirteenth-century undercroft along the entire south side of the inner court (Miller's
Green).

The parliament was not the only aggravation with which Abbot Boyfield had to
contend; there was the problem of the abbey's worsening financial position. The Bishop
of Worcester unjustly accused the abbot and his monks of 'incontinence', in the sense of a
lack of self-restraint in matters of expenditure, and he procured a bull from the Pope to
secure for himself and his successors the right of visiting the monastery. The expenditure
of the abbey had exceeded its annual income of 1,700 marks for some time, so that
something had to be done. In 1380 there were fifty-four monks in the community,
together with no less than two hundred officers and servants. Besides the abbot there
were three priors, two cellarers, two almoners, three sacrists, two precentors, chamber-
lains, keepers of the refectory, infirmary and hostelry, masters of the churches, chapels
and works, a monk of the vill or town, kitcheners, monks who were *scholares Oxon*
residing at Gloucester College, Oxford, all of whom had their particular lands, rents and
emoluments. The principal officers of the house also had their chaplains, attorneys,
registrars, clerks, stewards, bailiffs, porters, brewers and shepherds amounting to over
one hundred and ten in all. There is no doubt that the monks lived, by the standards of
the times, in considerable comfort. They were also given to extravagant entertaining.

There were mitigating circumstances for in recent years there had been 'inundations' and 'pestilence' in the town, the crippling expense of the four weeks of the king's parliament, and inflation and mounting troubles throughout the country.

MOVEMENTS FOR REFORM IN THE CHURCH

The most significant of these 'mounting troubles' in the long term was the rise of the Lollards, an anti-papal movement associated with the name of John Wycliffe 'the morning star of the Reformation.' The state of the papacy and of the Church generally at the time was utterly scandalous. The Pope was living not at Rome but at Avignon, under the shadow of the French king, and the power of the papacy was being shamelessly misused by the French court. England had never loved papal influence, and she had still less reason to love it when it was employed for the benefit of her political enemies. The stories of simony, corruption, and evil living of the papal court were widely known all over Europe, but provoked even more anger in England than elsewhere, though the English Church itself was far from blameless. There were bishops who were mere statesmen and warriors who neglected their pastoral work; there were secular clergy who were never in their parishes,

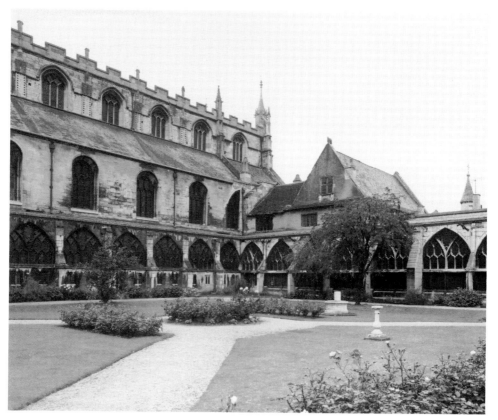

The cloister garth, looking south-west

and monasteries where religion and sound learning were less regarded than wealth and high living. It was especially the great wealth of the monasteries and the seemingly small benefit they brought to the nation which provoked popular comment. Since the days of the *Statute of Mortmain* the spirit of the times had changed, and benefactors who wanted to leave a good work behind for the good of their souls founded and endowed schools and colleges, and not abbeys as had been the custom for so long.

It was John Wycliffe (*c.* 1329–84), Doctor of Divinity of the University of Oxford and sometime Master of Balliol College, who voiced the popular discontent with the state of the Church, and antagonism towards the papacy. He taught that the Pope's claim to be God's vicegerent on earth and to guide the consciences of all men was a blasphemous usurpation, because each individual was responsible to God for his own acts and thoughts. He maintained that 'all men are tenants-in-chief under God, and hold from him all that they are and possess; the pope claims to be our mesne-lord, and to interfere between us and our divine suzerain, and therein he grievously errs.' Wycliffe also believed the church was far too rich, 'her virtue is oppressed by the load of wealth', and advocated a return to apostolic poverty in which the clergy should surrender the greater part of their enormous endowments. Later on he had increasing doubts about the Real Presence and other doctrines of the medieval Church, but it was mainly as a denouncer of the power of the papacy and the riches and luxury of the clergy, secular and religious, that he became widely known. In all this he was expressing resentments and religious convictions which eventually, through the increasing influence of the 'new learning' in the universities and the widespread availability of the Scriptures through the invention of printing, were to shake the foundations of medieval society.

ABBOT WALTER FROUCESTER 1381–1412

On the death of Abbot Boyfield in 1381 the chamberlain of the monastery, Walter Froucester, was elected abbot 'by way of compromise on the Feast of St Anthony.' It was a wise choice for he was a man of many gifts. In the words of the *Historia*: 'Amid the greatly increasing changes of the world he ruled the house with vigour and prudence, and at much expense and effort he himself greatly enriched and built up the church within and without with many kinds of ornaments, books, vestments, various silver vessels . . .' He found the abbey in serious debt but by wise management of its resources he was soon able to recover the position. He made a deliberate policy of appropriating churches. Supported by the king and John of Gaunt he succeeded in his petition to Pope Urban VI for St Mary de Lode, and in 1391 obtained the advowson of Holy Trinity in Gloucester. There was much rebuilding at the abbey's manors, and farms were increasingly well stocked with cattle and sheep. The income of the monastery increased from 1,700 marks to over 2,000 marks in a matter of a few years.

Features of the Great Cloister

As already noted, Abbot Froucester completed the great cloister begun during the abbacy of Thomas Horton. In a reference to the building of the cloister, the name of

Design of window tracery in east walk (top), in contrast to the design used in the other walks

Abbot Horton was erased in the Gloucester copy of the *Historia*. It reads: 'He [Froucester] built the monastery cloisters in fine style at great expense. It was begun in the time of . . . and taken as far as the door of the chapter house and left unfinished at that point for many years.' Why the name was erased is not clear; a later scribe seems to have wanted to give Abbot Froucester credit for the entire work. Furney (*c.* 1807) stated that:

> . . . in some manuscripts now in my custody it is said Abbot Froucester began [sic] the building of a neat cloister, whose ceiling and ornamental workmanship are no where surpassed. All the windows along the south cloister are contrived for writing places . . . and at the west end of the north cloister there are many neat washing places near the refectory for the convenience of the monks before and after their repast.

Yet there can be little doubt that Abbot Horton began the work. When it was resumed during the abbacy of Froucester, he constructed the north walk, adding a *lavatorium* at its west end and an *almery,* a groined recess for towels in the wall opposite. The *lavatorium* was lit by eight two-light windows towards the garth, and by windows at either end. Half of its width was taken up by a stone ledge and trough. The ledge originally supported a lead tank with spigots from which the water flowed into the trough. There was an efficient drainage system, part of which was discovered and unearthed outside in the cloister garth in the last century.

The west walk, though mainly a passage, also has a stone bench along the length of the wall. In the wall is an ogee-arched doorway which provided access to the prior's lodgings and probably to the inner court as well. Another doorway at the south end of the walk opened into the western slype, a fine vaulted entrance and waiting area for visitors to the monastery. Along the south walk Froucester inserted twenty carrels or small study recesses. This walk was probably cut off by a screen or curtains to enable the monks to work without distraction at their writing, transcribing and illuminating. The whole row of carrels was given a rich embattled cornice. From time to time when a number of copies of a particular work were required for liturgical or teaching purposes the south walk would have served as a *scriptorium,* with up to twenty monks writing a text at the dictation of one of their number. The great cloister is much the same today as it was when it was finished by Froucester (*c.* 1400), or when Leland saw it, on his visit to the abbey in 1541, and commented that 'it is a right goodly and sumptuous piece of worke.'

The Games Played in the Cloister

Against the north wall of the cloister walk is a stone bench on which traces of scratchings survive indicating that the novices, who used this walk, played games known as 'Nine Men's Morris' and 'Fox and Geese'. Such markings in stone benches have been found elsewhere in the country, at Norwich, Canterbury, Salisbury, Westminster and Chichester.[8] There is nothing particularly clerical about the games; they were also played in houses and in the fields although visible traces of them seldom remain. They were still played on curbstones and doorsteps in Victorian England using pebbles or fruit stones as 'men' or counters. In the simplest of the games (Fig. 1) the two players each

Incised in stone bench of the north walk of the cloister, a board for playing 'Fox and Geese'

had three counters, and they began by setting them down alternately, the object of each being to get his three 'men' in a row, along the lines marked on Fig. 2, exactly as in 'noughts and crosses'. At Norwich some of the boards for this game have both lines and holes, with the middle hole much larger than the others (Fig. 3).

Boards found at Gloucester and Salisbury are for playing 'Nine Men's Morris'. Each player had nine men, and the board had twenty-four points at intersecting lines or at angles (Fig. 4). The players set their men on the board alternately, each trying to get three of his own in a row. When he had made a three, he was permitted to take off any one of his opponent's men that he chose, except that he was not to break into an already made three if he could obtain his due without doing so. When all the men were on the board the players moved them from point to point along the lines, still trying to make three, until one won by taking all the other's men. Another board found at Gloucester, in the north walk of the cloister (Fig. 6), looks like an unfinished example of the more common Fig. 5. It was used for the game of 'Fox and Geese'. The game is still obtainable and played on a wooden board with holes in it, using pegs. Figure 7 shows how the pieces were set out. The black spot in the middle is the fox, and the seventeen white ones are the geese. The pieces are moved from point to point along the lines, one

Fig 1

Fig 2

Fig 3

Fig 4

Fig 5

Fig 6

Fig 7

Medieval board games, including Fox and Geese

point at a time, except that the fox takes by jumping over a goose next to him if the point beyond is free. The fox's objective is to take all the geese, and the geese try to trap or shut in the fox so that he cannot move, in which case he is beaten.

The Chronicle of the Abbey – *the* Historia

Abbot Froucester also collected and transcribed the abbey records down to the twentieth year of the reign of Edward III. He would, of course, have involved others in the community in collecting and collating the material. The original of the *Historia* has not

survived, but there are several early copies. Manuscript 34 in the cathedral library is one of the earliest and most reliable. It was bought by the Dean and Chapter in 1879 for £150 from Calvary & Co., booksellers in Berlin. Other works are bound up in the one volume, but the texts on the history of the abbey and list of gifts to the abbey agree substantially with the printed text of the *Historia* in the Rolls Series *Historia et Cartularium Monasterii Gloucestriae* edited by W.H. Hart in 1863–7. The abbot also compiled registers, two of which are in the cathedral library, Registers A & B. One contains a collection of charters and other documents relating to churches appropriated to the abbey. These are arranged in sections, detailing the property of ten of the officers of the house, the sacrist, almoner, hosteller, sub-almoner, master of the works, chamberlain, masters of the frater, the farmery, the lady chapel and the precentor. These works, and other medieval deeds and leases, are the essential source material for the study of the history and architectural development of the abbey. The *Historia* itself sketches the history of the monastery from Saxon times, beginning with Osric's foundation, and then gives an account of the contribution of each abbot to the life and buildings of the monastery from the Conquest to Abbot Froucester's own prelacy.

The Monastic Library

There is no documentary evidence to confirm that Abbot Froucester built the room above the eastern slype and muniments room which is thought to have been the monastic library, but this may well be the case.[9] Clearly he was a scholar and the *Historia* does mention books as being among the many ways in which he enriched the abbey. With its long history as a place of education and learning, the monastery must have had a considerable collection of works. In the usual custom of the times these would have been stored in chests or boxes, or on shelves put up for the purpose in the library or monks' writing room. With the building of the carrels in the south walk, there would probably have been cupboards nearby for writing materials and a certain number of manuscripts.

Above the eastern slype a room had been built in the thirteenth century for use as a vestry and for storing records. It ran the width of the transept, with access from the north transept. Above this room, at some time in the fourteenth century, another room was built. A newel stair in the south-west corner of the chapter house was built to provide access to the room from the east walk of the cloister. This room was the monastic library as the arrangement of the windows on the north side makes clear. The windows would have provided light for the series of small study cubicles along the north side of the room. If the door from the cloister was blocked up by the wall-panelling of the first six bays of the cloister, this suggests that the library room was built in Abbot Horton's time. On the other hand, the room was almost certainly built after the remodelling of the north transept and the construction of the terminal window (1368–74).

Abbot Froucester is often said to have been the first abbot of St Peter's to have had the privilege of wearing the mitre, ring, sandals and dalmatic. He obtained the privilege, for himself and his successors, through the support of the Duke of Gloucester. Yet the *Historia* states that 'his predecessor [Thomas Horton] had been the first to obtain the

privileges of the mitre . . . from the Roman pontiff.' Abbot Froucester died in 1412 and was buried in the south-east part of the choir, under the arch of the tower. Furney states (*c.* 1807) that 'there remains his gravestone, which appears to have had his effigy in his mitre on a brass, which are now torn off.' All that remains to mark the burial place of one of St Peter's great abbots is a modest granite stone in the floor of the chapel of St John the Baptist.

THE WEST END AND THE TOWER
1412–1460

'John Gowere who built Campden Church and Glo'ster towre.'
A medieval rhyme

Abbot Froucester was succeeded by Hugh Moreton, about whom little is known. Britton notes that 'he died without having done anything worthy of particular notice.' While this may be so the years of his abbacy (1412–20) were momentous in the affairs of the Church and in the fortunes of the country. Henry V led a series of expeditions to northern France and won a notable victory over a far larger French army at Agincourt in 1415. He gained control of most of the country north of the Loire. At home his piety and love of order and orthodoxy led him to carry on his father's persecution of the Lollards with redoubled severity. Since the parliament of 1394 when those who sympathized with their cause began to agitate for a national declaration against some of the practices and doctrines of the Church, the Lollards had been openly questioning and indeed condemning the veneration of images, the efficacy of pilgrimages, the celibacy of the clergy and the doctrine of the Real Presence in the consecrated elements of the Mass. The writings of John Wycliffe (c. 1329–84) had spread to the Continent, and John Huss, the Bohemian theologian and preacher, had made the doctrines of the Wycliffites popular among his countrymen.

The 'Great Schism' was at its height with the Roman Church presenting the disgraceful spectacle of two rival Popes, one at Rome and another at Avignon, anathematizing each other and preaching a crusade against each other's adherents. With such a state of affairs no one knew who was orthodox and who heretical. John Huss was among those who attended the Council of Constance in 1414. The Council, which lasted until 1417, settled the scandal of the rival popes and brought order to the Church, but not reform. The Council condemned the teaching of Wycliffe and ordered his body to be removed from consecrated ground. John Huss, who had been given safe conduct to the Council by Emperor Sigismund, expressed his criticism of the corruption in the Church and of the errors of her teaching. However, in 1415, when the Council was still in

session he was arrested, tried for heresy and burned to death. The flames only fuelled protest and, in England, strengthened the hands of the Lollards. The increasingly harsh suppression of dissent made a general outbreak of religous ferment inevitable sooner or later.

GLOUCESTER IN THE FIFTEENTH CENTURY

In the first half of the fifteenth century Gloucester entered a period of increasing prosperity. A variety of trades flourished in the town. There was an important down-river trade particularly in corn, fruit and cider from the fertile Severn vale to south Wales and the north Cornish coast. Coal, salt and wood was brought by boat from higher up the river to meet local needs and for export through Bristol. Metal working was still prominent, ore being brought from the Forest of Dean and worked in the Longsmith area of the town. The manufacture of pins became increasingly important. Bell-founding too had been going on for many years. The names of several bell-founders are known, including John of Gloucester who cast bells for Ely Cathedral in 1346. With ample supplies of wool available from the sheep-rearing areas of the Cotswolds, Gloucester and neighbouring towns and villages were established centres of cloth-making. There were considerable numbers employed as weavers, dyers and fullers in mills in the Stroud area, and a growing number of wealthy master-weavers resident in Gloucester. The export of cloth became one of the town's main industries. The knitting of woollen caps, by the increasing number of 'cappers' in the town, contributed significantly to the recovery of Gloucester's economic fortunes towards the end of the fifteenth century. Produce and a wide variety of wares were brought to the markets

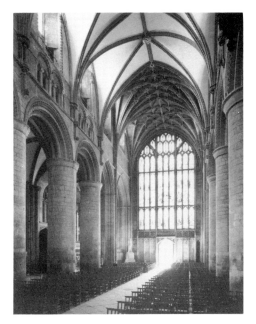

The nave, the west end interior; showing the pointed arches over the reconstructed western bays, the great western window and the lierne vault

which served hamlets and villages for miles around. There was a thriving trade with London, carters with horse-drawn waggons laden with local goods and imported wine went regularly to the capital.[1]

The Mayor and Burgesses

With Gloucester's growing prosperity, the power of the merchant class increased in the town's affairs. Burgesses were responsible for many aspects of communal life, and enjoyed increasing privileges. From their ranks the town officials were chosen, senior among them being the bailiffs and stewards or reeves. These officials were directly answerable to the Exchequer for all debts, and they had the right to hold courts in the town to settle matters of ownership, debt and trespass. On 2 September 1483 Richard III granted the town a Charter which made Gloucester and the neighbouring parishes and hamlets of Dunstone and King's Barton hundred into a separate county, to be known as 'the county of the town of Gloucester.' The Charter gave the town a mayor and aldermen, and incorporated the burgesses under the style of 'the mayor and burgesses of the town and Gloucester.' The mayor was to carry out the duties of clerk of the market, steward and marshall of the king's household and escheator within the new county. He and his fellow aldermen were to have full magisterial powers, the two bailiffs performing the office of sheriffs in the new county. The new body proceeded to form a common council, consisting of forty members, the mayor and his fellow eleven aldermen, the two sheriffs, four stewards and twenty-two other burgesses. They had the right to hold their own court and issue bye-laws, and responsibility for the maintenance of public buildings, paving and cleaning the streets of the town, the water supply, the preservation of public order and regulation of trade. The mayor was to uphold the dignity and honour of the town, and to emphasize the importance of his office a sword was carried before him on ceremonial occasions, as it is to this day.

Towards the end of the fifteenth century Gloucester went into a period of decline, but because of its importance in local administration and trade in the area, due in part to its position at the junction of vital road and river routes, it survived until an up-turn in the town's fortunes in the early sixteenth century. In 1455 there were at least ten inns in the town's main streets, catering for the needs of those who were visiting or travelling through the town. Among them was the New Inn in Northgate Street, recently rebuilt by St Peter's Abbey, and another owned by the abbey in the parish of St Mary de Grace, later known as the Fleece. Furney recorded that 'in or about Abbot Seabroke's time John de Twynning then called a laudable man, and a monk thereof, built from the foundation the great inn called the New Inn in the Upper Northgate Street to the great profit and advantage of the abbey', which according to tradition was intended for the reception of pilgrims. Fosbrooke repeated that the 'intention was, no doubt, to draw visitors to Edward's shrine. The abbey appears to have been remarkable for providing gratuitously the most minute necessities of their visitors.' Herbert, however, pointing out that the tradition was not expressed in writing until the eighteenth century, questions whether this was, in fact, the intention of the abbey in enlarging and rebuilding the inn at this time. 'It may be that the popularity of the cult of Edward II was short-lived.'

Heading of the Charter of Incorporation of Richard III, 1483

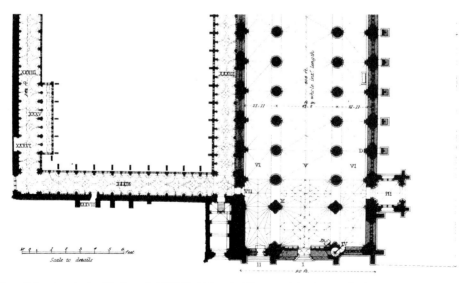

Plan of the church, by H. Ansted 1828 (in Britton's *History and Antiquities of Gloucester Cathedral*, 1829). Note the detail of the reconstructed west end of the building

The Town Council and the Abbey of St Peter

The relationship between the burgesses and later the new Common Council and the Abbey of St Peter was not always harmonious. After the Crown the abbey was the principal landowner in the town, and thus heavily involved in its affairs. The abbey was also a major landlord in the surrounding area, holding manors in the new 'county of Gloucester' and across the River Severn. Inevitably certain matters of dispute arose, such as the meadows to the north-west of the town in which the abbey shared with the burgesses commoning rights. A branch of the River Twyver, known as Fullbrook, which flowed through the abbey precincts was another source of friction. The abbey's fishing rights on the Severn were also disputed from time to time. Herbert notes that:

> . . . in the late 14th century and the early 15th century jurisdiction over abbey personnel and its walled precinct became a major issue between the two communities, apparently because of a more aggressive attitude adopted by the town authorities. The precinct had probably caused difficulties in policing the town from earlier times; in *c*. 1247, for example, a suspected murderer against whom the hue was raised took refuge in the abbey, which closed its gates against his pursuers.

Though, in the town charter of 1398, the abbey had obtained exemption for its tenants and servants from the bailiffs' power in certain offences, the bailiffs challenged the

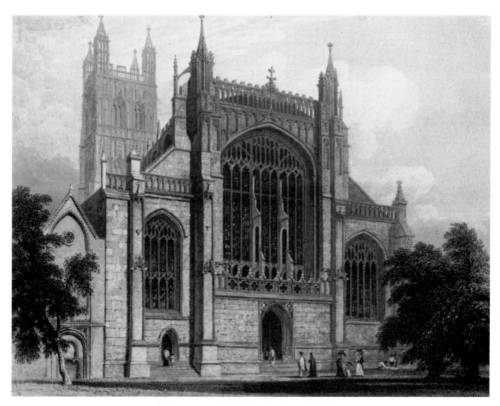

The west end (W.H. Bartlett, 1828)

abbey's right to hold a separate court to try such cases. Officers carrying their maces actually entered the precincts in 1414 to apprehend suspects. In 1447 the abbey accepted that the precincts were part of the town and within the jurisdiction of the town's officers. The officers for their part agreed that their powers of execution were limited to cases of felony and treason and to the holding of coroners' inquests. The monks agreed not to give sanctuary in the precints to fugitives from justice.

At the beginning of the sixteenth century there were violent confrontations between the abbey and the townspeople, supported by the burgesses. Disturbances extended over several weeks following the hay harvest of 1513. Herbert records that armed mobs:

> . . . with the support of the mayor and aldermen, drove off the abbey's cattle from common land on the west side of the town, attacked abbey servants, and dug a ditch across the meadows. But an agreement in 1518 gave the abbey the right to build a new bridge across the Old Severn, guaranteed it access across the meadow to its manors west of the Severn, and confirmed the abbot's right to buy victuals in the town and trade there as a burgess. The power of the townspeople to besiege the monks in their precinct and starve them of supplies had evidently been demonstrated or at least threatened.

It is difficult to say how far such confrontations were caused by particular and genuine grievances, and how far they were expressions of popular feeling against the monks and all their works. A Lollard priest preached in the town in 1383, but as Herbert notes 'there is no further evidence of dissatisfaction with the traditional forms of religion until 1448 when two Gloucester men, William Fuer, a weaver, and William Grainger, renounced their heresy before the Bishop of Worcester.' It would be surprising in the growing ferment of religious controversy in the latter years of the fifteenth century if certain 'heresies' were not embraced and expressed by some in the town. Yet it was not until 1536 that Protestant ideas began to cause widespread dissension in Gloucester. When William Parker was elected abbot in 1514 there were only a few years of comparative tranquility left for the community.

ABBOT JOHN MORWENT 1421–1437

In the early years of the fifteenth century the community at St Peter's Abbey seemed untroubled by the rising tide of resentment against the wealth and power of the Church, and the growing number who were demanding reform. Abbot Moreton was succeeded by John Morwent who is thought to have been chamberlain at the time of his election. During his abbacy (1421–37) an agreement was made between the abbey and the town whereby the lane that ran along beside the south wall of the abbey was granted to the bailiffs and burgesses. At the same time their sergeants were empowered to carry their maces before the bailiffs in the abbey, and the bailiffs with their sergeants were allowed to execute the king's writs and summons within the abbey, except upon the abbot, monks and their domestic servants and counsellors. Morwent is remembered chiefly for his building work. He pulled down the Norman west end of the church, and rebuilt it in the style of his time, adding a fine porch on the south side.

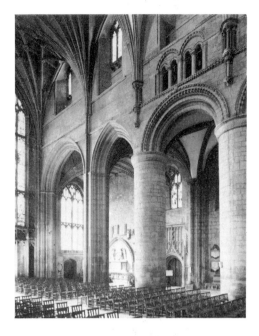

The nave, the north-west, showing the conjunction of the early fifteenth-century work and the Romanesque

The West End of the Nave

The drawing in the margin of the British Library copy of the *Historia Regum Britannie* gives some idea of what the west end of the nave looked like before Abbot Morwent's reconstruction. The drawing is difficult to interpret, but it would appear, judging from the style of the tracery, that in the late thirteenth century a large window had been inserted within the great arch which filled the Norman west end between the two flanking towers. One of the two Norman west towers had collapsed at some time between 1163 and 1179, but it was repaired and eventually rebuilt. The cause of this collapse was said to be faulty foundations. For the same reason it has been supposed that the entire west end was in danger of collapse in the early fifteenth century. Verey, for instance, states that the west end 'was rebuilt by Abbot Morwent in 1420 after the collapse of the Norman west end.'[2] If this was so, Morwent had no choice but to rebuild. There is evidence to suggest that he intended, in any case, not only to rebuild the west end but to remodel the entire nave in the Perpendicular style and so unify the whole interior of the building. There was a tradition to this effect in the abbey itself. When Leland visited Gloucester in 1541 he understood, presumably from his 'auld monk', a former member of the community, that Abbot Morwent intended 'if he had lived to have made the whole body of the church of like worke'. The single vaulting rib springing from the Norman column at the west end of the north aisle seems to indicate that it was the abbot's intention to continue eastward, at least along this aisle. But with his death in 1437 the work was stopped, never to be resumed. Willis wrote that 'we must be glad he did not live to spoil the Norman by his feeble Perpendicular' (1860), and similarly Masse commented 'It is a matter of rejoicing that he was not spared to carry out his intention!'

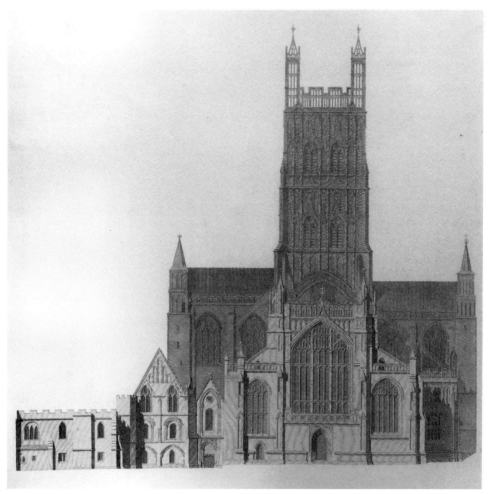

The west end, John Carter's drawing (1807). Note the quatrefoil of the balustrade above the west door, also shown in W.H. Bartlett's drawing, 1828

Whether or not, in rebuilding the west end Morwent shortened the nave, has been discussed in an earlier chapter. The evidence for his having done so lies partly in the north aisle, the adjoining western slype and the frontage of the Norman abbot's lodging (Church House). An examination of the actual stonework of the west end leaves little doubt that it was completely rebuilt in the fifteenth century, and not remodelled from the existing Norman building.[3] The arrangement of the Norman piers at the west end, and whether there were walls projecting from the west end eastward along the line of the arcades cannot be settled without excavation. Ashwell believed there was 'six feet of rubble' beneath the west wall, but the significance of this for the original building line of the Norman nave is unclear.

Compared with other west fronts, Abbot Morwent's design is not very imposing at first sight, but it has an interest of its own especially in its construction. The doorway is

The nave clerestory, the windows on the south side

in front of the plane of the great window, and is comparatively simple, the walls on either side being unadorned. A passage, with an embattled balustrade, crosses at the foot of the window. The design of the balustrade is early Victorian, a modification made by Fulljames and Waller. A number of early nineteenth-century drawings show a balustrade of quatrefoils each surmounted by a miniature of the crocketed balustrade sweeping up to the cross in the gable above. The large Perpendicular window above the balustrade is of nine lights, divided vertically into three sections by two major mullions which are buttressed on the exterior. This is a feature copied from the great east window. Horizontally the window is divided by two plain transoms, plain that is when viewed from the outside, but inside the cusping is elaborate. This is another feature of the great east window. The fact that the transoms are so far apart could indicate that the window originally contained a Tree of Jesse. Fragments of an early fifteenth-century Tree of Jesse are preserved in the three central lights of the lowest tier of the lady chapel window. An alternative subject for the glazing of a window in this position would have been a scene depicting, in vivid reds and yellows, the eternal anguish of the sinful in hell and the joy of the righteous as they are received into heaven. But there are no fragments of such a Doom window preserved either in the lady chapel east window or elsewhere in the building.

Above the window the projecting wall ends in a pierced parapet, and a gable set back on another plane with a crocketed balustrade sweeping up to a central cross.[4] To left and right are two small turrets delicately worked with flying buttresses. These are features of Gloucester's west end which are of considerable interest. The pierced parapet over the doorway is repeated at the top where its horizontal line, coming in front of and

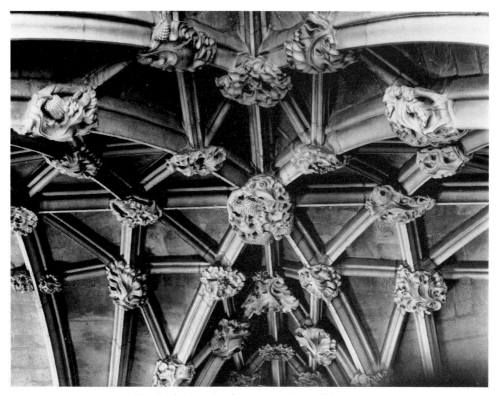

Detail of the vault of the western bays of the nave

concealing the gable end of the roof, is very uncommon. By carrying the outer moulding of the window through this work, and terminating it with enriched crockets and a finial, the architect has shown great ingenuity and originality. Since the clerestory windows at the west end of the nave are clearly part of Morwent's work, the whole series on both the north and south sides probably date from this period even though the design of the tracery would not preclude an earlier date. The original Norman openings were enlarged by removing the splay, but the width of the window frames remain unchanged. Their circular heads have been altered to four-centred arches, and each is divided into three lights. The hood mouldings are continued at the line of the springing forming a horizontal string-course carried round the original Norman buttresses. The latter are, in a most ingenious manner, surmounted by pinnacles mitred into them. The parapet is ornamented with trefoiled panels.

Inside, the new west window and the two flanking windows in the rebuilt aisles brought a flood of light and colour into the nave. Morwent's reconstruction began to do for the nave what the remodelling of the east end had done for the choir. The two western bays, of unequal length, were rebuilt with fluted columns, pointed arches and a lierne vault. Willis spoke of 'the noble Norman piers and the two paltry Perpendicular piers erected by Abbot Morwent.' The vault, left unplastered on the interior face, shows how the web was made up. It has a longitudinal ridge-rib with two parallel subsidiaries

on either side. The same arrangements runs north–south between the clerestory windows forming a cross with the main ribs running east–west. These parallel ridge-ribs are a feature of lierne vaulting at Gloucester, appearing first in the choir and copied by Morwent and later by the architect of the lady chapel.

The bosses also owe much to the choir vault adding still further to the impression that Morwent was intent on rivalling the work in the eastern arm. Most are foliage-bosses, but there are a few figures and heads. The central one in the western bay represents the Coronation of the Virgin, the theme of the great east window. The two figures are seated on a bench; Christ has long flowing hair and beard, and is dressed in an ample cloak fastened on the chest with a quatrefoil clasp. Below the cloak is a close-fitting gown with tight sleeves. The right hand is raised in blessing, and the left holds an orb on the top of which is a large cross patee. Both Christ and the Virgin wear crowns. The Virgin has long flowing hair and she too wears a cloak and close-fitting undergarments. Her hands are held together in prayer. There is also a large oval boss containing leaves and fruit like strawberries, and another of a dragon with long horns surrounded by the same fruits and leaves. Where the vaulting ribs meet above the windows there are two human heads, one on the north side and one on the south. One has very prominent ears, which are not human, and a long lock of hair coming from the side of each temple; similar locks under the chin are apparently intended to come from the head too. The other has very stiff hair that may represent for foliage. The rest of the bosses are of foliage.

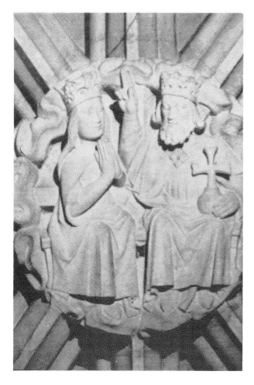

Central boss of Abbot Morwent's vault, the coronation of the Blessed Virgin Mary

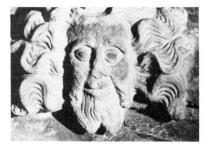
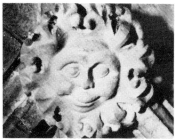

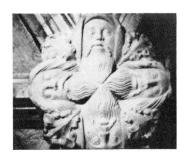
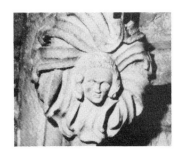

Bosses from Abbot Morwent's work at the west end of the nave

The South Porch

Morwent is also credited, mainly on the evidence of Leland, with having built the south porch. Though there are obvious similarities to the west front, the porch is more elaborately decorated. This reflects the increasing importance accorded to the southern approach of the abbey church from the early years of the fourteenth century. Though Morwent's reconstruction involved the removal of three of the western bays of the south aisle, built only a hundred years earlier, as well as the earlier porch, King Edward's Gateway was now the main public entrance to the abbey precincts. The southern aspect of the nave had, therefore, to be further enhanced. A wall, possibly dating from this period, extended from the west side of the gate-house across to the south-west angle of the nave. This would have left St Mary's Gate as the way into the main courtyard of the abbey, to the stabling and guest-houses and through to the inner court (Miller's Green), the main domestic offices and the abbot's lodgings.

The south porch, similar to the porch of Northleach Church which was built at about the same time (*c*. 1430), is divided into two storeys by a band of quatrefoils. The lower one contains the entrance, formed by a lofty arch with spandrels ornamented with quatrefoils which originally contained the royal and abbey arms. The doorway is flanked by niches of considerable height. These would probably have contained figures of St Peter and St Paul. The upper storey was filled with a range of six canopied niches, and above them was an enriched cornice. The whole elevation is beautifully finished by an elegant pierced parapet terminating in an ogee arch. The open parapet and pinnacles resemble, in miniature, those on the tower. The buttresses supporting the corners are decorated with panels and cusping, and small niches which also contained figures. Even

The south porch. W.H. Bartlett's drawing (1827), showing the niches over the entrance empty. The porch was restored in the nineteenth century and figures, by Redfern, added

without the original figures, long since decayed and replaced with figures by
J.F. Redfern, it is an imposing entrance, both inside and out.

The interior of the porch is panelled. It has windows on its east and west sides set into
the wall panelling, and a lierne vault with appropriate bosses. There are a number of
grotesque heads and faces surrounded by radiating leaves or petals, and in the centre
Christ in glory with cherubim on all four sides. The great wooden door, semicircular at
the top, had to be adapted to fit into the pointed arch of the entrance. It probably came
from the central doorway of the Norman west end. The hinge work with trident-shaped
iron strengtheners dates from the twelfth century. The small room over the entrance
appears to be unfinished. Since access to it is via the south-west turret stair and along a
narrow ledge behind the nave parapet it was probably seldom used except for storage.

Much of the original stonework of the porch had to be replaced during restoration
work in the nineteenth century. This included the tracery of the windows which is
formed by piercing the internal wall-tracery, with the result that while the windows
look somewhat curious inside the porch, outside they seem perfectly normal. At the
same time the front of the porch was restored to what was thought to have been its
original design. Figures were placed in the restored niches: in the centre, St Peter and
St Paul, and on either side the Evangelists; below them, Prince Osric and Abbot Serlo,
and in the small niches in the buttresses St Jerome, St Ambrose, St Augustine and
St Gregory, the great doctors or theologians of the western Church. This was a
reasonable choice of subject.

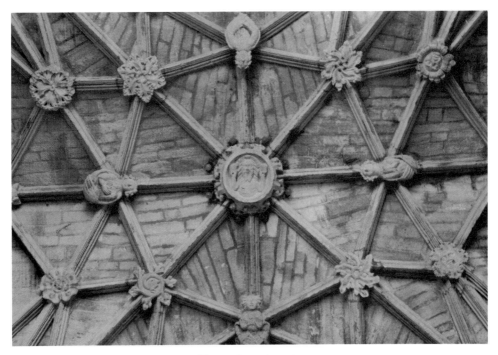

The south porch vault

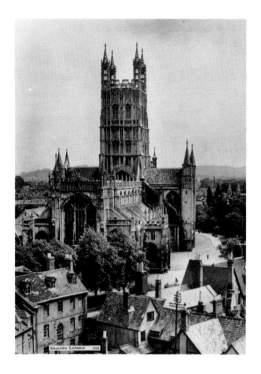

The church from the south-west (1952), showing the central tower rising high above the building and the town

ABBOT BOULERS 1437–1450

On the death of John Morwent in 1437, a monk by the name of Reginald Boulers was elected abbot. He is known in contemporary and later records by a variety of names, Boulers, Boulars, Butler or Boteler. He had attended Gloucester College at Oxford and was a doctor of divinity of the university. In 1440, not long after his appointment, he was offered the bishopric of Llandaff but declined. He seems to have had political ambitions for in 1444 he was appointed ambassador to Rome by Henry VI. Since this meant he would be away from the abbey for some considerable time, the community made him an allowance of £400 per annum. He returned to Gloucester though exactly when is not known. In 1450, Richard, Duke of York, in his opposition to the king, Henry VI, arrested Abbot Boulers and took him prisoner to Ludlow Castle in Herefordshire, but he was not there for long. In the same year he was given the See of Hereford which he held until he accepted preferment to the great diocese of Lichfield. But he did not forget his old community; he left his books to the abbey library.

In the seventeenth and eighteenth centuries, and probably earlier, the north-east ambulatory chapel, the chapel of St Edmund and St Edward, was known as Boteler's Chapel. This association with Abbot Boulers probably means that the screen, reredos and remodelled windows date from his abbacy (1437–50). This accords well with the style and character of the work. The reredos retains many of its original features, including the statuettes, traces of paint on the shields (recently restored) and a *piscina* (now covered with a credence ledge). The enlarged rectangular window openings, set into the Norman round-headed windows, led to the extension of the tracery to cover the

filled-in segments above the lights. Fragments of the original glazing survive in the cusping showing that the windows were glazed with figures of saints set in painted niches against an alternating ruby and blue background. The design of the great east window had a considerable influence on the glazing in other parts of the building. The tiles too date from this period and, though the glaze has worn off most of them, there are a few excellent specimens. The effigy of Robert, Duke of Normandy, rested here for many years making Masse lament (1899): 'It seems a pity that these tiles should be doomed to disappear under the nails of sightseers, who as a rule look at nothing but the effigy of Robert, and go away satisfied when they have proved for themselves that the effigy is of wood!'[5]

ABBOT THOMAS SEABROKE 1450–1457

When Reginald Boulers became Bishop of Hereford in 1450, the community elected Thomas Seabroke as abbot. During his brief abbacy (1450–7) the central tower was taken down and the present tower built. An inscription on the wall below the west window of the choir states that Robert Tully, one of the monks, was responsible for the work. 'This work which you behold constructed and adorned is the result of Tully's labour, at Abbot Seabroke's bidding.' After Seabroke's death in 1457, Tully completed the work before leaving the monastery in 1460 to become Bishop of St David's. During Seabroke's abbacy a tile-pavement was laid down around the high altar. This was repaired and somewhat rearranged during restoration work in the nineteenth century, but it remains substantially intact.

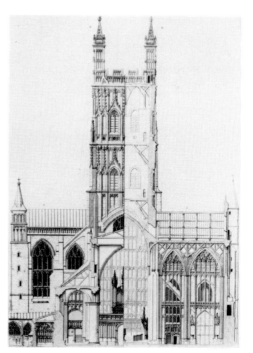

The tower and the south transept, half elevation and half section, by H. Ansted 1827.

The Central Tower

Tully's tower was the third to be constructed at the crossing of the abbey church. The first was begun by Abbot Serlo during the first phase of work on the Norman building, and completed some time after his death. The second was that of Helias, the sacrist, built *c.* 1222. There are no traces of Helias' tower, nor is it known how much of the Norman tower the sacrist dismantled before raising his new tower and spire on the old work. He may have removed no more than the upper courses of the Norman work. Whether his own tower survived the reconstruction of the choir crossing in the mid-fourteenth century is by no means certain. Some have argued that it would not have been technically possible to remove the Norman arches at the crossing and insert pointed arches without taking the tower down. If this were the case, the church may have been without a central tower from *c.* 1350 until Abbot Seabroke raised his great Perpendicular tower a century later. Others point to Norman masonry still *in situ* around and above the mid-fourteenth-century arches of the crossing and between the top of the crossing piers and the lowest courses of the Tully tower, and argue that the earlier tower must have survived the reconstruction.

Ashwell believed that the Early English tower, as depicted in the margin of the thirteenth-century manuscript (Royal MS 13 A III f.41v), was taken down when the present crossing was constructed. 'The first stage of the new (1450) tower was therefore completed *c.* 1350, and John Harvey confirms this view. The Norman tower had to be removed in the 14th century for the crossing arches to be constructed.' Ashwell

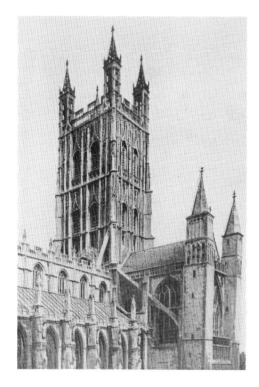

Detail of the tower from the south-west

continued 'The vault, the tower arches (rising much higher than the Norman arches) and the flying arches, were all built in the mid-14th century. When the upper stages were constructed these had to be done from outside, there would have been no question in 1450 of going up through the choir.'

In the time of Abbot Seabroke the tower, or whatever remained of it, was taken down to a level just above the roof-line, and the present tower built. The tower could not have been taken down as far as the Norman piers, as Bazeley maintained, since the mid-fourteenth-century vaulting remained intact. F.S. Waller seems to have been uncertain as to whether Abbot Serlo's tower had been substantially altered before the reconstruction work at the crossing, or whether it remained intact until Seabroke' time. He wrote:

> The original Norman tower was probably somewhat similar to that at Tewkesbury Abbey, and might have been about one square in height above the apex of the then roof of the choir. This tower was taken down, and in the fifteenth century the present tower was erected, of much less thickness of masonry . . . but of at least double the height, as measured from the choir roof, and the whole of it borne on the original twelfth-century foundation, assisted, it is true, by flying buttresses carried skilfully and with great picturesque effect across the openings of the transept walls.[6]

Waller gives no date for the dismantling of the Norman tower, stating only that the present tower was erected in the fifteenth century. His isometric drawing, however,

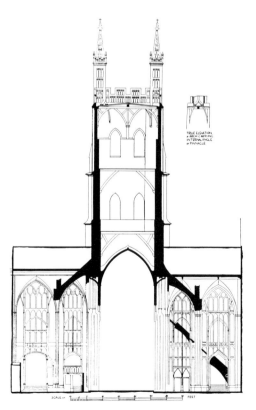

Section through the transepts and tower showing the flying buttresses, F.W. Waller (1906)

shows the Norman tower dismantled to the crossing piers, indicating that, in his judgement, no Norman work remains *in situ* above the four surviving crossing piers.

The two towers in the area with which the tower of St Peter's Abbey is compared are Chipping Campden (*c*. 1450–60) and Worcester Cathedral (completed 1374). Harvey pointed out that the decorative work on the Gloucester tower 'adhered extraordinarily closely to the mouldings and traceries of the previous century.' The ogee arches, in particular, and the design of the canopies at the base reflect the influence of Worcester's central tower. This is not to say that 'the basic design was decided in the second half of the 14th century rather than the second quarter of the 15th century' (Ashwell). The Tully tower was certainly influenced by the tower at Worcester but it was equally, if not more, influenced by the design of the tower of Malvern Priory. Indeed, Harvey considered that they were by the same architect.

High up over the crossing, below the west window, is the inscription which reads:

HOC QUOD DIGESTUM SPECULARIS OPUSQUE POLITUM
TULII HAEC EX ONERE SEABROKE ABBATE JUBENTE

To the purist the couplet, with its main verb missing, it is awkward and ungrammatical. As one writer comments 'If the monkish writer meant it for a puzzling conceit, he has completely succeeded.' But the general sense is clear: 'This work which you see built and adorned, was done by the labour of Tully, at the command of Abbot Seabroke.' Thus, though the tower has long been known as the Seabroke Tower, it was the work of Robert Tully, one of the monks. Exactly how he was involved in the work is not clear. It is thought by some, unlikely that one of the monks would have been able to design such a structure, or oversee its construction. Yet there were some highly intelligent and gifted men among those who became monks in later life, and some with long experience in various trades and crafts. Many of the monks would have been involved in one way or another with maintenance work and with building projects, and some with particular aptitudes and training would have become highly skilled over the years. Even though Harvey includes Tully in his biographical dictionary of *English Medieval Architects*, he says of him: 'He is often stated to have been the architect of the tower of Gloucester Abbey built *c*. 1450–1457, but he was in reality in financial control as "master of the works". There is a tradition that the builder was a certain John Gower.'[7] There was a medieval rhyme which ran: 'John Gowere, who built Campden Church and Glo'ster towre'.

Whatever part Robert Tully and John Gower played in the work, the tower was an immense achievement. It rises over 68.5 m (225 ft) and is crowned with a coronet of open parapet and airy pinnacles. It is patterned on all side with two huge tiers of blank arcading, two louvred openings surmounted with crocketed pinnacles, and a broad band of quatrefoils between the tiers, marking the two main stages. The window openings and surrounding mouldings are deeply recessed. The overall effect is to take the eye ever higher and higher to the culmination of the design in the open work of the pinnacles on the four corners. Lower down at the corners of the tower are diagonal buttresses designed to steady the tower's estimated 6,000 tons of masonry. The whole structure rests, in defiance of accepted architectural wisdom, on foundations which were already over 350 years old.

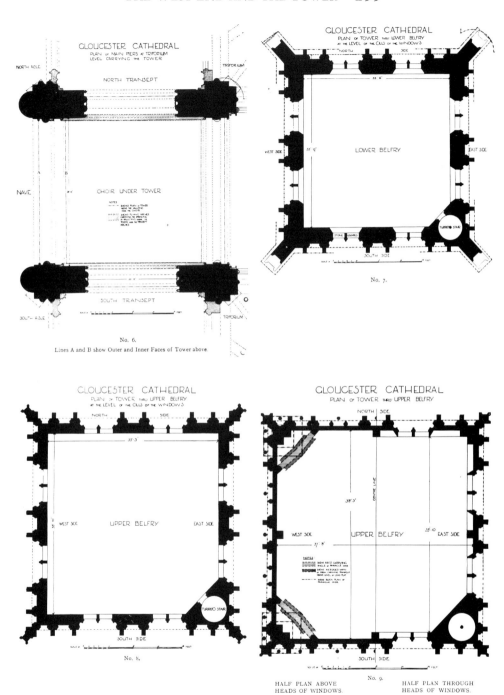

Plan of main piers, and then through lower and upper belfry, at cill and top level, F.W. Waller
(1906)

The tower has always made people stand back in amazement and wax eloquent in describing it. Fosbroke (1807), for example, wrote 'Its peculiar perfection, which immediately strikes the eye, is an exact symmetry of component parts, and the judicious distribution of ornaments.' Earlier, Dallaway wrote of the coronet, the delicate work at the top of the tower: 'The stone is wrought almost to the slenderness of iron-railings, the perforated pinnacles not a little resembling bird-cages.' Clark, in his *Architectural History of Gloucester* commented:

> No drawing, however accurate, can give a perfect idea of the tower of Gloucester Cathedral. It is impossible for the pencil to portray its ever-changing aspects, sometimes when darkened to the colour of pitch by passing shadows, and at others shining out white as marble against the face of the black thunder cloud, or when the setting sun throws over it a rosy lustre. But on a clear moonlight night it is seen to the greatest advantage when the light, falling from the south-east, just catches the faces of each slender buttress and flowing canopy, throwing their sides into shade and the intermediate parts into deep shadow; and illuminates the graceful pinnacles, whose form is so softened by the mellow light – aided by the effect of distance, that they almost seem to form a part of the blue vault above them.[8]

Viewed from any side the ancient abbey church, now the cathedral, had been crowned with one of the most magnificent and finest towers in western Europe.

The Seabroke Pavement

The pavement in front of the high altar, of necessity partly covered by a carpet, is a fine example of mid-fifteenth-century tile work, dating from the abbacy of Thomas

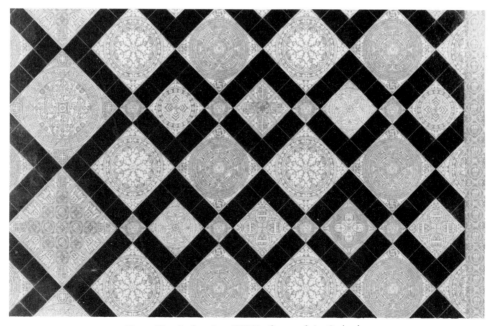

Henry Shaw's drawing (1858) of part of the Seabroke pavement

Seabroke. It consists of an elaborate arrangement of sixteen-tile, nine-tile, four-tile and single-tile squares set diagonally and separated by rows of plain dark glazed tiles. This appears to be their original arrangement. The decoration on one tile includes the coat of arms of Abbot Seabroke (or Sebrok), *ermine a cinquefoil sable*, within a circular band bearing the inscription *DOMINUS THOMAS SEBROK ABBAS*. This is used for the single tile elements in the pavement, and also as the middle tile of a nine-tile design in which the inscriptions on the outer tiles include the date MCCCCLV. It is therefore safe to assume that this pavement was commissioned in 1455 by Abbot Seabroke. (See Chapter 10.)

Analysis of the fabric of these tiles by Alan Vince has shown that they were made of Malvernian clay, probably in the kiln at Great Malvern which was discovered in 1833. Another nine-tile design in the pavement includes a shield with the arms of St Peter's Abbey, the keys of St Peter and the sword of St Paul, and a shield with the arms of Westminster Abbey of which Malvern Priory was a cell. This design would therefore have been appropriate to both Great Malvern and Gloucester. One sixteen-tile design has the arms of England in the corner and at the sides the crowned double M for St Mary the Virgin and St Mary Magdalen also appropriate to Great Malvern. Another has the arms of Westminster Abbey in the corner and may be supposed to have been designed specifically for Great Malvern. In fact most of the designs on the tiles in the pavement, except those with the arms and name of Abbot Seabroke, have also been found in Malvern Priory, but no original pavement now remains in place there. Instead scores of crowned M tiles, rescued from delapidated paved areas, have been inserted in the outer wall behind the high altar reredos.

Other names are associated with Seabroke on a number of tiles. These include R. Brygg, J. Applebi, W. Farlei and Joh Graft[on], the names presumably of certain officers in the house, such as the prior, precentor and chancellor. Part of the pavement, that beneath the raised area around the altar itself, was removed *c*. 1872 to the south-east tribune chapel, and relaid there between strips of dark grey slate. Earlier in the century Lysons had saved a number of tiles from other parts of the building, and relaid them in the sacrarium, which accounts for the presence of a miscellany of tiles particularly on the south side near the sedilia. In this area there are also tiles of William

Henry Shaw's drawing (1858) of a nine-tile pattern in the
Seabroke pavement

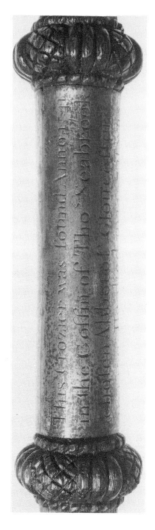

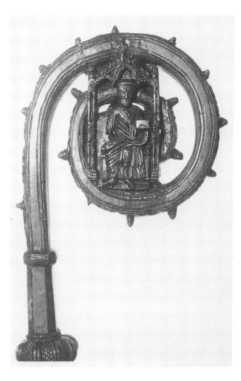

Abbot Seabroke's pastoral staff, and detail

Malvern, alias Parker, the last abbot of St Peter's (1514–39), which should be compared with those remaining around his cenotaph; and others with the arms of the Brydges family: Arg. on a cross sable, a leopard's face, or, differenced by a fire-cone gules. These closely resemble the arms on the armour of the knight in the recess at the east end of the south aisle of the nave. There is also a tile with the words *Croys Crist me spe de* † followed by *A ME* or *A MARIA*. All these tiles had a narrow escape in the eighteenth century, at the time the nave was paved, when an offer was made to pave the presbytery with marble. (See Appendix V.)

The Seabroke Chantry and Tomb

Abbot Seabroke died in 1457 and was buried in a chapel at the south-west end of the choir where an effigy in alabaster was placed on his altar tomb. For centuries this chapel was known as the Chapel of the Salutation of the Blessed Virgin Mary, but for some time now it has it been known as Seabroke's Chapel. The effigy shows the abbot in his alb, stole, tunic, dalmatic, chasuble, amice and mitre with his pastoral staff on his right side. The front horn of the mitre (*mitra pretiosa*) is badly damaged. The alb extends to the feet, and he is wearing a maniple and fringed stole. Over all is a chasuble which is very full and long. The pastoral staff, enveloped in a *vexillum* or banner of the cross, is also damaged. The shoes are plain and very pointed. The hands were folded on the chest, but they have been broken off at the wrists. Under the head are two round cushions, the

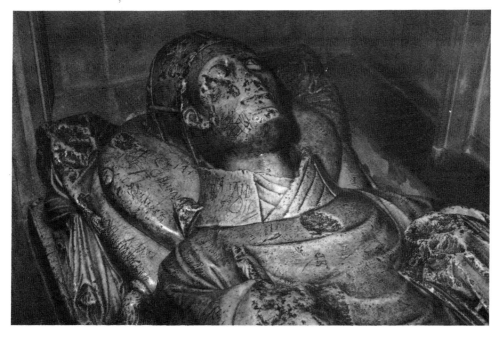

Abbot Seabroke: detail of his effigy, in the Seabroke chapel at the east end of the south aisle of the nave

upper one with buttons and the lower one with tassels. These are supported by angels with long flowing albs fastened on the chest with a diamond *fibula* or brooch. At the feet is a lion. There is no inscription. The recess in which the tomb and effigy are set has a wide arch decorated with cinquefoils, and the walls are panelled. Above the arch are five panels containing sexfoils with spandrels and an enbattled cornice. The mutilated altar and reredos of the chapel have survived, together with five canopied niches for saints and a vaulted ceiling ornamented with sexfoils. On the south side of the altar is a piscina, and above the canopied ceiling of the altar is a frieze with lions and quartrefoil flowers. The *Monasticon* states that when Bishop Benson repaired the choir in 1741, Abbot Seabroke's coffin was opened. A pastoral staff which lay on the remains of the body was removed and given to one of the prebendaries of the cathedral. Eventually it was acquired by the Society of Antiquaries of Newcastle. The Society loaned it to the Cathedral in 1981 for the Gallery Exhibition. The replica now on display in the exhibition was made by Carole Feasey (1981).

Plate 13

Medieval panel paintings (fourteenth century) of the Epic of Reynard the Fox. (A) Reynard makes off
with a goose. (B) Reynard is arrested and brought before Ysengrin, the wolf. (C) Reynard is dragged
by three yoked geese to execution. (D) Reynard is hawled up onto the gibbet by goat, hare and goose.
(E) The stag and hind begin to sing the burial service. (F) The animals celebrate the death of Reynard

Plate 14
(G) The burial service is read while the dead fox is lifted off the bier for burial. (H) Noble, the lion, holds a celebration feast, with Fiere, Brun, the goat and monkey

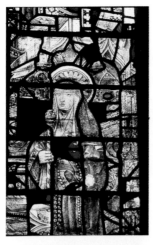

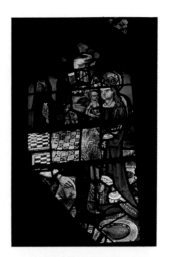

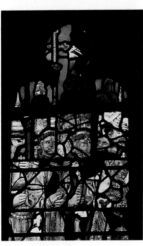
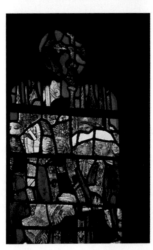
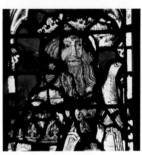

Plate 15
The medieval stained glass of the lady chapel. Top tier: A virgin saint, St Lawrence and fragments of early fifteenth-century glass. Middle tier: monks in procession, and bishops in procession, *in situ* glass. Fragments of a king, reset from choir clerestory. Lowest tier: bishop (note, tower in cusping, poker work and inscription); Christ with aura rising from the mouth of hell, and detail

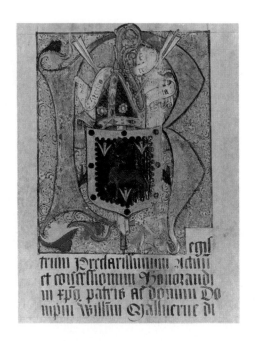

Plate 16
Above: The Arms of Abbot Parker from the abbey register. Below: Heraldic glass in south walk of great cloister (from the abbot's hunting lodge at Prinknash). The arms of Henry VIII, France and England, Abbot Parker's arms, Katherine of Aragon's token, and the attributive arms of King Osric of Northumbria

THE LADY CHAPEL
1468–1482

'Many seke ben here cured by Our Lady's mygthe
Dede agayne revyved of this no dought
Lame made whole and blynded restored to syghte
Lo here the chyef solace agaynst all tribulacyon
To all that be seke bodely or goostly
Callin to Our Lady devoutly.'
Richard Pynson, fifteenth-century ballad

After the death of Abbot Seabroke in 1457, Richard Hanley was elected abbot. His abbacy (1457–72) and that of his successor, William Farley (1472–98) covered the second half of the fifteenth century. The long years of war with France had come to an end in 1453, with England losing the last remnant of the great inheritance of Eleanor of Aquitaine, after it had remained for three hundred years in the hands of the Plantagenets (1154–1453). This was soon followed by the bitter internal feuding of the great Houses of York and Lancaster and their supporters. The Wars of the Roses (1454–85), so called from the white rose which was the badge of York and the red rose which was later assumed as the emblem of Lancaster, was much more than a factional fight between two rival coteries of peers. It began as an attempt to oust an unpopular minister from power by force of arms. But it developed into a long-drawn out power struggle which left the country in a far worse state, from the political and constitutional point of view, than it had known since the days of King John. Finally, in 1471, Edward IV of the House of York, assumed power and through firm government began to restore the country's fortunes. After the brief reign of Richard III (1483–5), notable for Gloucester because the king granted the city a new Charter, Henry VII (1485–1509) came to the throne and led the country to increasing stability and prosperity.

Only a year after his installation in 1457 Abbot Hanley obtained valuable concessions from the Crown. The king, Henry VI, agreed a general pardon for the community for all forfeitures and offences. In 1470 William Nottingham, once the king's attorney general

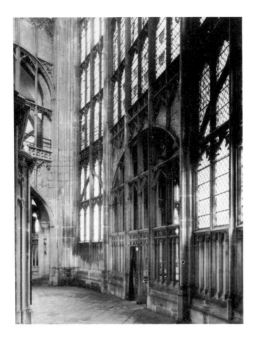

The entrance to the lady chapel from the ambulatory

and later a knight and Chief Baron of the Exchequer, gave lands to the abbey for the 'erection of a chantry' to be served by two of the monks. This may refer to one of the chantries in the lady chapel which was being planned at that time, or to the chapel over the vestibule. Abbot Hanley began the building of the lady chapel, and it was completed by his successor William Farley. It was the last major building work undertaken by the abbey. One of the largest and most beautiful lady chapels in the country, at the time of the Dissolution it was said to be one of the most richly decorated. Judging from fragments of the original glazing, the glass alone would have filled the chapel with dazzling colours. The reredos too, with its three main niches surrounded by many smaller niches, contained carved figures of saints and martyrs richly polychromed. Then there were the niches in the vaulting shafts, some of which retain their medieval paint, which also contained figures of saints. Adding to the sumptuous effect of all this wall decoration and painted sculpture were the resplendent colours of the furnishings and hangings in the *sacrarium*. Overhead the complexity of the lierne vault, with its myriad of bosses, added still further to the rich texture of the building.

SOME CONTEMPORARY BUILDINGS

Kidson points out that the period between 1425 and 1475 was not notable for major building works. Many parish churches were built and others enlarged, but would-be patrons were too preoccupied with the campaigns of the Hundred Years War, and later with the bitter rivalries of the Wars of the Roses to consider providing funds for major projects. However, once Edward IV became King he encouraged the great houses of England to give their patronage to major work. With the resumption of Crown

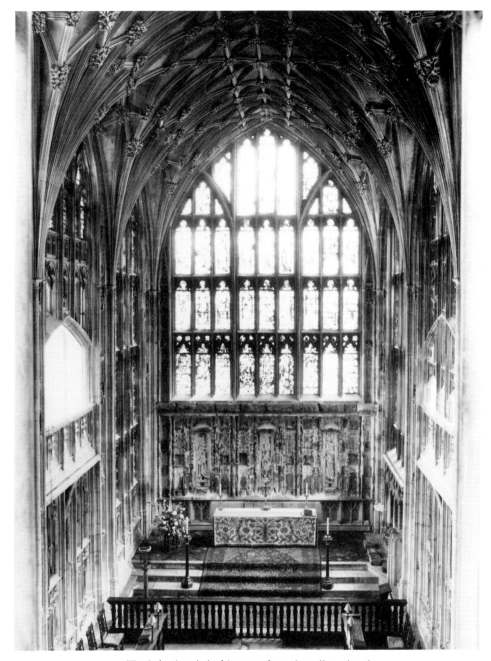

The lady chapel, looking east from the gallery chapel

patronage, St George's Chapel, Windsor was begun in 1474, 'partly in honour of the national saint and partly as a Yorkist dynastic chapel to replace Westminster as a royal burial place.'[1] St George's was followed by King's College Chapel, Cambridge and, during the reign of Henry VII (1485–1509), by the magnificent chapel in Westminster Abbey that bears the king's name. These three buildings formed, in Kidson's words 'a splendid climax to the whole medieval tradition.'

The influence of Gloucester's choir upon these major works was considerable. Kidson, for example, observes that King's College Chapel, Cambridge was modelled, not on previous college chapels, like that of New College, Oxford, but on a cathedral choir. He writes:

> The nearest prototype is, in fact, Gloucester, and of all the Perpendicular buildings in England which were influenced by that precocious design, it is the only one which deliberately takes up the problem of the homogeneous Perpendicular interior at the point where it was left at Gloucester, and finds for it a wholly satisfying solution. Essentially the chapel was conceived as Gloucester choir with all the extraneous masonry removed – that is, with all the panels free to be filled with glass.[2]

It is now generally recognized that the design of these magnificent buildings owes a great deal to the 'royal burial chapel' which Edward III built *within* the old Romanesque choir of St Peter's Abbey nearly a century and a half earlier.

The lady chapel, begun at about the same time as St George's, Windsor, is another building which owes much to the adjoining mid-fourteenth-century choir, both in its basic design and in its detail. The interior of the lady chapel gives the impression that the choir has been lifted out of its supportive framework in the Norman presbytery, and

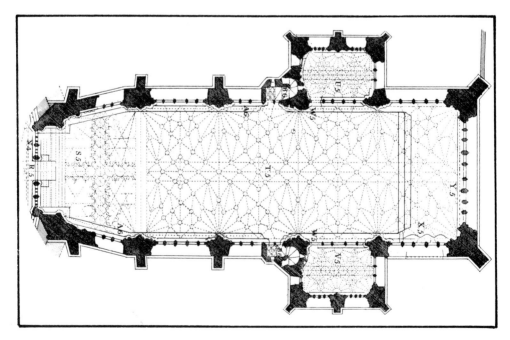

Plan of the lady chapel, J. Carter 1807

joined onto the building at the east end. Though on a smaller scale, the lady chapel has the same rectangular plan, and like the choir the east end is formed by one huge wall of glass. The vault is a replica of that in the choir. The openings in the panelled walls could now be filled with painted glass. It is a free-standing version of the choir on a smaller scale.

THE DATE OF THE LADY CHAPEL

The lady chapel was built during the abbacies of Richard Hanley and William Farley. This dating goes back to Leland (1541) and to his conversation with 'the auld monk'. There is no reason to doubt that the chapel was built at some time during this period of forty years. It was probably begun towards the end of Hanley's abbacy, Abbot Farley overseeing the main work and completing the building before the end of the century. This would suggest the lady chapel was built *c.* 1468–82.

1. There is evidence to support this earlier date in the building itself. In the stained glass there is a profusion of Edward IV's badge, the 'sun in splendour' and the rose 'en soleil' which is found in the cusping of the side windows, in the windows of the south chantry chapel and elsewhere. The Yorkist badge would hardly have been placed so prominently and profusely around the chapel to the exclusion of the Lancastrian and Tudor badges after the accession of Henry VII in 1485.[3] There is also the *rebus* in the east window, concealing the identity of the donor, but revealing that he was a member of the Compton family. It is known that the Compton-Winyates of Warwickshire had a close connection with the town and county of Gloucester at this time. The donor, therefore, was probably Edmund Compton, father of Sir William Compton (1482–1528), a friend of Henry VIII, who became chief steward of the abbey in 1512 and constable of the castle.

2. It is, of course, possible that his son, Sir William, gave the window in memory of his father; in which case, if the significance of the Yorkist badge is discounted, the chapel may not have been completed much before the end of the century. Indeed some stained-glass historians, on the evidence of the fragments of the original glazing which have survived in the east window believe the glass displays continental influence and

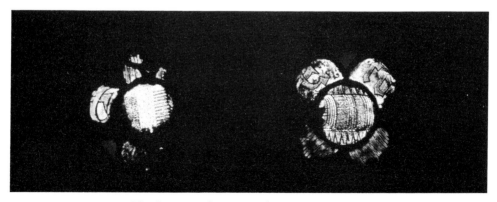

The Compton *rebus* in the lady chapel east window

The lady chapel, niches in the vaulting shafts, one
retaining original paintwork

would therefore date the glazing to the early years of the sixteenth century. This would indicate a rather later date and a much longer building period if the work began in the abbacy of Richard Hanley.

Some writers who have assumed the later date argue that the chapel was never completely finished. The community had 'a premonition of impending dissolution' (Ashwell), which caused them to lose interest in their new building. Thus, though the building work was completed, it was never properly decorated and furnished. There is little or no evidence, however, for such a view. The chapel was probably completed well before the end of the fifteenth century and used by the community for more than fifty years before the monastery was dissolved in 1539. In descriptions of the chapel from the seventeenth century there is evidence of its early splendour and the richness of its furnishings. There is still evidence of its once colourful interior in the medieval paint work which has survived years of neglect, Puritan whitewash and Victorian 'restoration'. The original paint on the reredos and on several niches on the vaulting shafts shows that red, blue, yellow and green predominated. The reredos alone must have been a magnificent sight when all its niches were filled and the whole richly gilded and painted. Sadly nothing is known about the sumptuous furnishings which must once have adorned the altar.

THE CONNECTION WITH MAIN BUILDING

One of the most intractable problems concerning the architectural development of the building lies in the *nexus* between the main structure and whatever building or buildings existed at the east end. Originally in the Norman building there was an apsidal chapel,

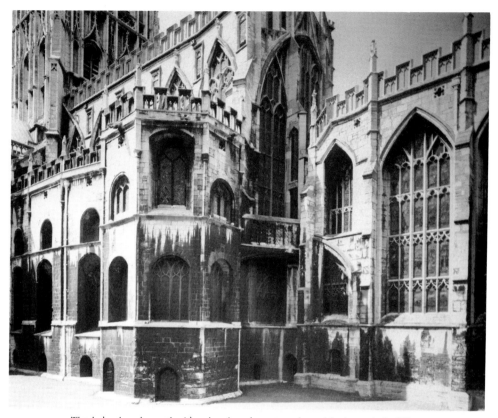

The lady chapel, south side, showing the connection with the main building

built over the axial chapel in the crypt and of similar design. Above this chapel there was another, off the ambulatory around the east end of the tribune gallery. The Norman axial chapel at ground level is thought to have been substantially altered in the thirteenth century, if indeed the de Wylington lady chapel involved the extension of the axial chapel rather than its refurnishing. The blocking up of the east window and the external 'squaring off' of the crypt chapel below seems to support the notion that the chapel at ground level was extended eastward. If so, how was the axial chapel at tribune gallery level affected? Was it left undisturbed, the extension of the chapel below being separately roofed ? Or was it also extended and re-roofed?

Were those axial chapels retained in spite of the reconstructions of the east end in the mid-fourteenth century? F.S. Waller in his isometric drawing of the Romanesque remains of the church indicates that very little of the Norman work of these chapels was left standing. Were the chapels partially demolished when the choir was remodelled ? If this was the case the community would have been deprived of its thirteenth- century lady chapel just at the time when devotion to the Virgin was at its height. The tribune gallery too would have been left without a passage linking the north and south sides at the east end for more than a hundred and twenty years. If, however, the chapels were retained, in some form, until the building of the lady chapel in the late fifteenth

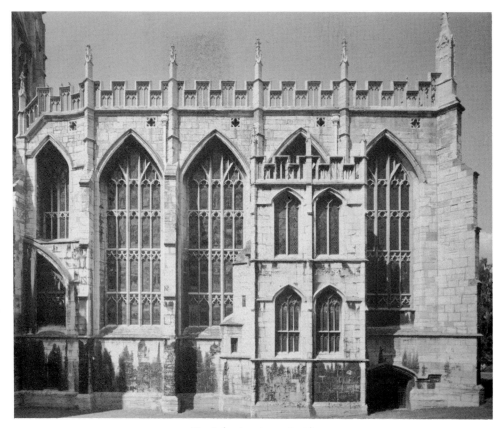

The lady chapel, south side

century, the enclosed passage connecting the two sides of the gallery (commonly called the whispering gallery) could have been built at the same time as the completion of the great east window, or shortly afterwards. There is a considerable amount of reused Norman masonry in the passage. Chevron must have come from some part of the second phrase of the building work (1100–26), but the stones from a nook shaft, used on the underside of the passage, probably came from one of the partially demolished axial chapels.

There are features in the small upper chapel, the chapel over the lady chapel vestibule, which appear to be the remains of the Norman axial chapel at tribune level, modified in the thirteenth and fourteenth centuries. The west window and below it the enclosed passage connecting the chapel with the tribune gallery could all have formed part of the reconstruction of the east end following the fourteenth-century remodelling of the choir. The round-headed side windows, whose tracery shows no particular Perpendicular influence, are set awkwardly within pointed window arches. The tile pavement and the bases of the colonette supporting the altar, which rests on a large piece of tufa, seem to be part of an earlier building. On the east side of the chapel is a very substantial arch which bears the weight of this gallery, and with the arch of the open tracery above it the

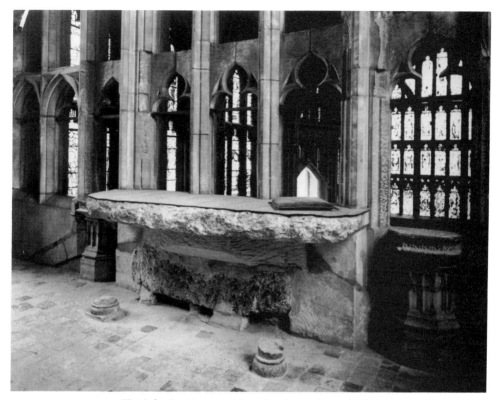

The lady chapel, west gallery chapel over the vestibule

weight of the vault. This arch supports the lady chapel vault on the east side, and on its west side the vault of the gallery chapel. The importance of this arch becomes even clearer when the extrados of the vault is examined in the roof-space. The vault over the gallery chapel is an Early English rib vault and quite distinct from the lady chapel lierne vault. In other words, this upper chapel appears to have been quite distinct from the main structure of the lady chapel although it is incorporated into the lady chapel as a west gallery.

Externally, the crypt wall, west of the first buttress of the lady chapel, rises on each side to form a firm base for one end of the bridges which supports the passage linking each side of the tribune gallery. It would appear that the detachment of any buildings east of the great window had already been effected by the time work on the lady chapel was begun in the late fifteenth century. The de Wylington chapel, at ground level, was therefore probably retained together with the chapel above it when the great east window was constructed. Both would have been extended in the thirteenth century and reconstructed to share the same square termination. After the remodelling of the choir the upper chapel would have been connected with the main building by the enclosed passage from the tribune gallery. Abbot Hanley's builders in the fifteenth century did not, therefore, demolish these buildings, but remodelled them still further, and incorporated them into the design of the new lady chapel. In doing so they reconstructed

the lower windows, inserting Perpendicular tracery of the same design as that used throughout the chapel, and built great arches across them to strengthen the buttresses of the great east window. In this way, the lady chapel was built out at the east end as a semi-detached building, with parts of the reconstructed mid-fourteenth-century axial buildings retained to form a vestibule and a gallery chapel.

THE MAIN STRUCTURE

The vestibule, with its low and beautifully constructed vault, forms an impressive entrance. The vault has ribs running in different directions in its four sections, and pendants forming a cross:

The history of the pendant motif in late medieval English architecture is long and fascinating. It originated in timber work, where there was a certain structural justification for it, although it was

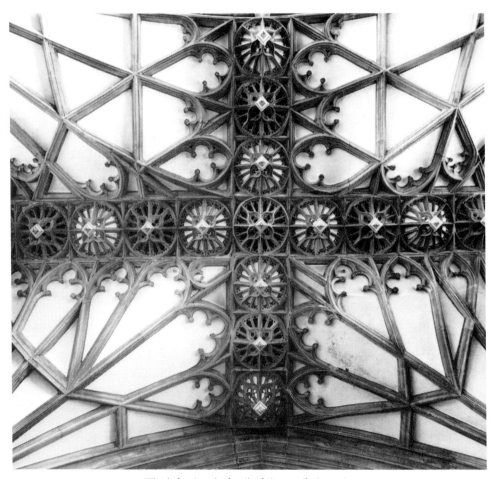

The lady chapel, detail of the vestibule vault

often used as a purely decorative device. It seems to have been adopted by stonemasons at Oxford in the middle of the 15th century. It appears in the vault of the Divinity School there and later in what is now the cathedral, where someone had the idea of threading the pendants on transverse ribs. At Westminster the process was taken a stage further by making the pendants the centres of fan-cones. The result is a series of fans which appear to be suspended in space from transverse ribs. The Westminster fans are smaller than the elegant designs at King's College, and the density of the cells is very much greater.[4]

Interestingly this feature of the three royal chapels also occurs, in a more modest form in the vestibule of Gloucester's lady chapel. In Clarke's words, the pendants are 'not so prominent as those in Henry VII's Chapel in Westminster Abbey, but sufficiently so to shew that the principle of constructing ornament, instead of ornamenting construction, had already begun to work.'[5] This principle of course, had been familiar for quite a while.

The arch at the west end of the lady chapel is deeply moulded, and has a band of thirteen cinquefoils supporting shields which were originally enriched with armorial bearings. Above the arch is a stone screen, reaching to the full height of the roof. It serves as an 'east window' to the gallery chapel, though also as a screen through which, on occasions, those occupying the chapel could participate in, or watch what was going on in the chapel below. The main vessel of the lady chapel is rectangular and divided into four bays with only vaulting shafts separating the large windows on either side. The wall below the windows is panelled with delicate tracery like that in the windows and, because the walls are so low, the sides of the chapel consist mainly of fine tracery and glass. Between the windows the vaulting shafts contain brackets for figures beneath richly carved canopies. Some of these canopies, like the walls, show traces of colour.

At this period one might have expected a fan vault, but instead the master mason went for a replica of the vault over the choir, with its many lierne ribs and bosses, and a ridge rib with parallel ribs on either side. It must have been within his competence to construct a fan vault, though 'it is one thing to put a fan vault over a cloister walk or even over a chapter house, and quite another to construct one over the main vessel of a church perhaps forty feet wide and eighty feet high. To do so required skill of a very high order; but even more it required nerve.'[6] The bosses are superbly carved and exceptionally well preserved, though some were restored in 1896. With six exceptions they are all composed of foliage. But among the foliage are a very grotesque centaur, three fishes arranged in a triangle, a fish curved round so that the tail and head come near together, a dragon coiled up between spreading three-lobed leaves, two dragons fighting head to head, and on another carving a dragon biting the tail of one of the others, and two dragons each biting the tail of the other.

Projecting, as it were, between the buttresses supporting the second bay from the east end are small chantry chapels with oratories or singing galleries above them. The two chapels have fan vaults ingeniously adapted to a fairly narrow rectangular plan. The singing galleries have rib vaults with bosses which have recently been polychromed. Access to the singing galleries is by a small staircase set into the angles of the wall. The galleries are held up by flying ogee arches across open-panelled stone screens, but on the north side there is no panelling across the front of the gallery. In the front of the galleries are stone shelves on which to rest books and music. Cut into the stone of the music rest

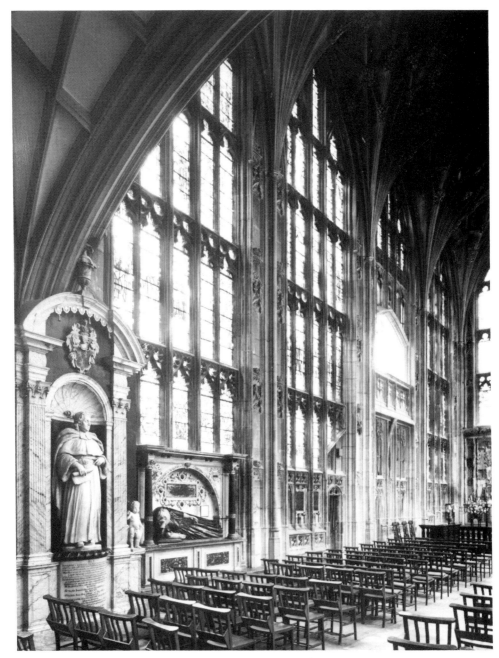

The lady chapel, north side

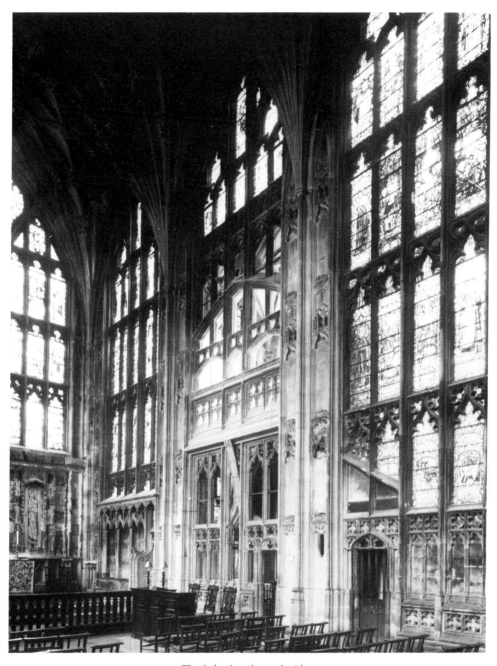

The lady chapel, south side

in the north gallery is a country scene showing a gentleman of the Commonwealth period with his dog, and in the distance a church with a tall spire. There are fragments of medieval glass in the windows of both the chapels and oratories.

THE REREDOS AND ITS ICONOGRAPHY

The reredos, which was badly damaged either shortly after the Dissolution of the monasteries or during the Commonwealth, is divided into three compartments each with a large niche which would have contained the three main figures: St Mary the Virgin in the centre with St Anne, the mother of the Virgin on her left, and probably St Peter, patron saint of the abbey, on her right. Around these figures were clustered, in smaller niches, an array of saints and martyrs. Although the niches have been empty for centuries, the identity of many of those commemorated and their positions in the reredos is known because the master mason incised their names in the stone at the back of the niches. Most of the names are written in the same bold scrawl, although a few are written in small, rather neater handwriting. All were probably written after the reredos

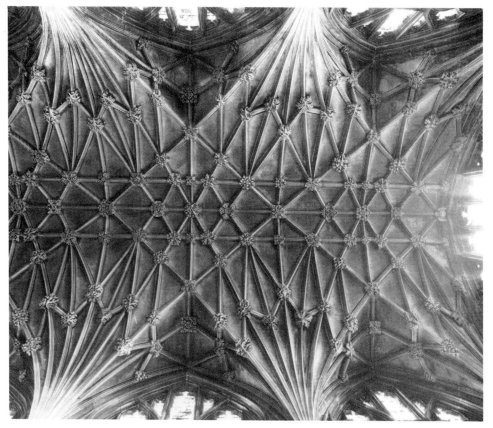

The lady chapel, main vault

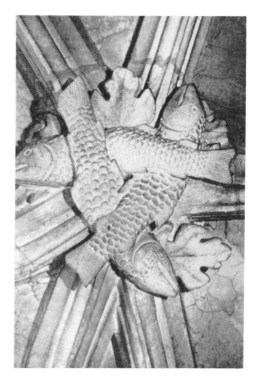

The lady chapel vault, one of the bosses

had been assembled in position because certain letters are scratched on the cement between adjacent stones. Names are found in most of the seventeen vertical compartments of the reredos, though not in the three larger compartments.

Spaced out between the three main compartments (X) are fourteen other vertical compartments, divided from left to right, in the pattern of 3 X 4 X 4 X 3. In the first vertical compartment there are three niches, in the second two, and in the third three. In the next group of four compartments there are three niches in the first, two in the second and third, and three in the fourth. The niches are similarly placed on the right of the central niche. Numbering the vertical compartments from left to right, and the niches in each compartment by letters from the bottom, the names of the saints and martyrs are detailed in Appendix VIII.[7]

Among them were: Arilda (1b) and King Lucius (1c), Keneburga (3a), Dorothy (3b), Bishop Blesius (5a) and St John the Evangelist (8c), Botolph (10a) and Bridget (11a), St Margaret of Antioch (15a) and St Thomas the Apostle (16b). From the full list certain facts emerge about the original iconography. There was a certain symmetry in the arrangement of the saints, and as appropriate in a lady chapel, virgin saints and martyrs predominate. There is a high proportion of Celtic saints; a number of others relate specifically to the history of the abbey itself. Dependent upon the accuracy of the identification of their names, the graffiti provide a valuable example of the iconography of a fifteenth-century reredos. From the spelling of the names the orthography was largely influenced by phonetics. Barbele for Barbara, Bottop for Botolph and Ozold for Oswald. The last example suggests the phonetics could be of local origin.

THE SACRARIUM PAVEMENT AND OTHER TILES

The entire floor of the chapel was paved with encaustic tiles, though seventeenth- and eighteenth-century grave stones have caused the destruction of the pavement in the central area, and years of neglect and treading feet have destroyed the glaze and design on most of the tiles in the vestibule. Before the paved area round the font was laid down the pattern on a number of tiles was still discernible, as was the overall pattern of the pavement. In the sanctuary many of the tiles are in a reasonably good condition, and the paving pattern is clear. Between rows of dark tiles set diagonally to the axis of the building, decorated tiles are laid in groups of four and sixteen. On a pattern of sixteen tiles can be read *Ave Maria gra'ple Dus tecum* [*gratia plena Dominus tecum*].* On others similarly designed are the words *Domine Jhu {Jesu} miserere.*† On others there is simply *Ave Maria gra'ple* and *Dne Jhu miserere.*† There has been considerable patching but sufficient of the original tiles survive *in situ* particularly on the north side of the altar to show how impressive the pavement must have been when it covered the entire floor of the chapel.

There is a group of miscellaneous tiles near the Clint memorial on the south wall, some of which are of great interest. Most of these tiles were taken from different parts of the church, and relaid here in the 1890s, though some are *in situ*. Some in the south chantry chapel could be a job lot from Llanthony Priory. They are inscribed with *Timetib' deu nihil deest {Timentibus deum nihil deest}.*‡ There are others with *Letabor in mia – et sethera* and *Deo Gracias.*§

* Hail, Mary full of grace, the Lord is with you.
† Lord Jesus, have mercy.
‡ Those who fear the Lord lack nothing.
§ Thanks be to God.

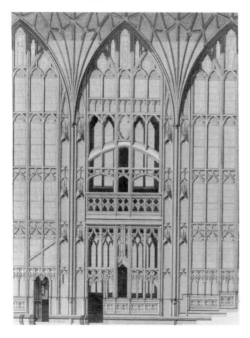

Lady chapel, part of the north elevation, showing the chantry chapel and door to the stair to the singing gallery above, J. Carter, 1807

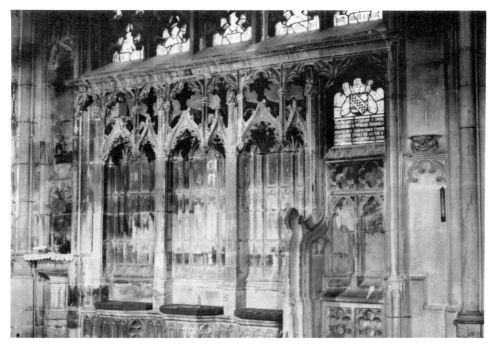

The lady chapel sedilia

THE STAINED GLASS OF THE EAST WINDOW

The glass at present in the east window is in such a chaotic state that at first sight it appears to be 'a mere mass of richly toned fragments'. Most of the glass is of the late fourteenth or fifteenth centuries and came from other windows in the church, but some of the fragments are *in situ*. No description of the medieval window has survived nor of the window before the glass was leaded up in this way, so that the only hope of recovering the original design lies in such glass as has survived *in situ* in the window itself. Two glass historians, Le Couteur (1915) and Rushforth (1921)[8] identified what they believed to be fragments of the original glazing in the small *oculi* and cusping of the windows, and separated out other fragments which came originally from other windows in various parts of the building. As a result Rushforth believed the original design of the lady chapel window consisted of figures in niches alternating with one-light scenes, and that the scenes in each tier were countercharged with those in the tier above and below. He concluded that 'we may accept this as a fundamental element in the original design of the window.' If so, this would combine the then traditional design of figures in architectural niches, with the more pictorial approach which was characteristic of late fifteenth and sixteenth century work. The east window of St Margaret's, Westminster, of roughly the same date, is composed of figures in painted niches along side pictorial scenes. Similarly, in the east window of the lady chapel, in a light on the left-hand side of the top complete tier of lights, there is a group of five monks walking in procession,

one carrying a cross (9), and in a corresponding light on the south side (15) there is a group of bishops also walking in procession with a cross carried in front of them. In the cusping of adjacent lights there are fragments of painted canopy work indicating that these lights contained figures of saints or martyrs. (See plates 14 and 15.)

In its setting in the lady chapel the window must have had at least one important representation of the Blessed Virgin herself. Accordingly in one light (25) there are substantial remains of a Madonna in a deep red mantle with jewelled border standing on the crescent moon surrounded by a glory of gold rays. Her head has gone, and the Child has been replaced by a mass of alien fragments, but at the bottom of the light there is the following inscription *S{an}c{t}a Ma{ria} cel{es}t{i} lumine.* This Madonna probably occupied the central light (4) at the top of the window. In other lights, in glass of the same hue, are traces of female saints (3,4), and elsewhere are fragments of inscriptions (32,33) suggesting, as would have been wholly appropriate in such a window, that the Virgin was accompanied and supported by a number of virgin saints. Rushford conjectures, more speculatively, that the scenes of processing clergy in lights (9) and (15) may depict the translation of the miraculously preserved bodies of two canonized nuns, St Ethelreda of Ely and St Withburga of Durham.

But there is more order in the arrangement of the fragments than has hitherto been recognized. Fragments from other windows in the chapel and from elsewhere in the church were leaded up in this window, in order to preserve them, probably in the early years of the nineteenth century.[8] Whoever did the work, possibly the widow of the cathedral glazier Francis Ursell in 1802, was anxious to keep fragments from the same window together, and to arrange them in the window so as to create some sort of balance of colour and texture. Thus the three central lights at the top of the window (3,4,5) contain remains of several saints set within uniform canopies with leaf backgrounds. The outer figures are vested as deacons. The glass is similar to that in the restored medieval windows in the north aisle of the nave, so these fragments may well have come from one of the other three-light windows in the series there.

Fragments of Christ in His Passion are scattered over several lights. In 1867 in the 'window above the north chapel of the Lady Chapel there was a figure of Christ with crown of thorns and uplifted hands'. This suggests that the windows in the side chapels had as their theme the suffering of Christ, and consequently of his mother, the Blessed Virgin. Again, there are fragments of four soldier-saints painted in a very distinctive style in lights in the middle tier (17,20,22,23), which appear to have been in pairs facing each other with alternately ruby red and blue backgrounds. It is possible that these came from a five-light window, the contents of the middle light being lost. If so, this would suggest that they came from one of the side windows of the lady chapel itself where, for example, in the third bay from the east end on the south side, in the cusping, canopy work is set against alternating red and blue backgrounds. Though these fragments were leaded up in this position in the early 1890s, C.H. Dancey, the glazier, was restoring in this one window the original pattern of glazing in all the windows. Other fragments from the side windows, preserved before and during Whall's monumental work (1898–1905), also suggest that the windows were filled with full-length figures of saints with occasional pictorial scenes.

The glass of the original glazing of the east window and other windows in the lady chapel may have been smashed during the Commonwealth (1649–60) when the reredos

may also have been hacked about. The damage, however, could have been done much earlier, shortly after the Dissolution. Enormous quantities of painted glass were destroyed at that time not only through the action of iconoclasts but in the pulling down of monastic buildings. In the years that followed, Protestant reformers such as John Hooper, Bishop of Gloucester 1550–4, ordered the wholesale destruction of stained glass and other works of art. This continued during the reign of Edward VI, and later during the reign of Elizabeth I in spite of her issuing a proclamation forbidding 'the breaking doune and defacing of any image in glass windows in any church, without consent of the Ordinary . . .'

THE ABBEY BETWEEN 1498 AND 1514

Abbot William Farley presided over the abbey 'with great credit' but at his death the monks were so disorderly and contentious that the king, with the Privy Council, had to direct a mandate to the prior, who was presiding over the affairs of the monastery, commanding him to punish all the offenders and to keep the abbey in order during the vacancy. The cause of the trouble was the election of the new abbot. Abbot Farley died in 1498, and eventually a monk named John Malvern was appointed abbot, but he died within a year. He was succeeded by Thomas Braunche (1500–10), who in turn was succeeded by John Newton, also called Browne (1510–14). Little is known about these two abbots, or indeed about life at St Peter's during these years. It was alleged that there

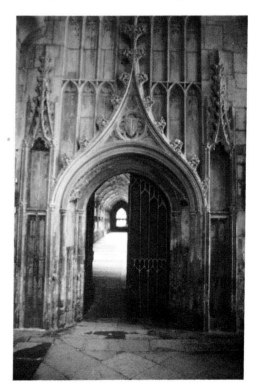

West door to the cloister

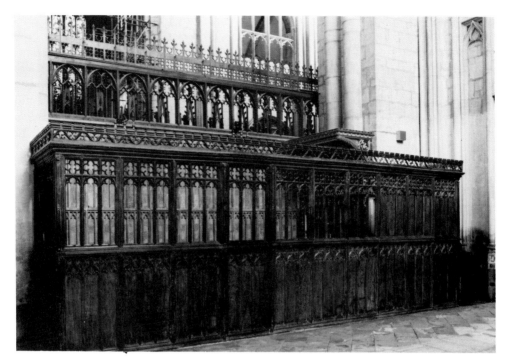

Parclose screen of the chapel of St John the Baptist

were 'many disorders' and 'enormities committed in the abbey'. Such reports may, however, only reflect the growing antagonism towards the monasteries in the country as a whole.

The abbots' registers reveal that the monks put on plays at the two near-by abbatial residences at some time before 1505 and continued doing so until the Dissolution (1539). In 1505 the Prior of St Bartholomew's Hospital, which was not far from the St Peter's Abbey, did homage, for a piece of land, to the abbot in the great parlour at the Vineyard, the abbot's residence on the west side of the River Severn. The entire community had gathered there, along with a number of the local gentry, to see 'the common plays', *communes ludos*. A lease of the manor of Ablode from that same year has as one of its conditions that the lessees should annually maintain 'the common plays' at their own expense as the abbot had been accustomed to do of old, *antiquo . . . usitata ffuit*. New versions of this lease drawn up in 1516 and 1535 repeated this condition. Furthermore the 1516 ordinances establishing a group of beadsmen to be attached to the abbey state that the men were excused from their normal regimen of prayers when the plays were being performed. Unfortunately these records yield no detail about the nature of these plays but they were presumably religious in character, and the careful provision for their support indicates the importance attached to them by the community.

With the lady chapel now completed only minor works were undertaken during this period. One such was the construction of a chapel beneath the south crossing arch against the back of the choir stalls. There had been a chapel here from the twelfth century, as is evident from the recesses of an early reredos behind panelling in the

present reredos. The chapel is thought to have been constructed at some time between 1510 and 1514, though the parclose screen could date from the fifteenth century. The association with Abbot Newton (alias Browne) seems to rest mainly on the observation that the abbot shared the same initials as St John the Baptist to whom the chapel was dedicated. The initials JB are painted in great profusion all over the woodwork.

With William Parker's appointment as abbot in 1514 came the final phase in the life of St Peter's Abbey, and twenty-five years later the Dissolution of the Monasteries brought the passing of an era.

THE END OF AN ERA

1514–1540

'The Middle Ages sleep in alabaster
A delicate fine sleep. They never knew
The irreparable hell of that disaster
That broke with hammers Heaven's fragile blue.'
W.R. Childe, *The Last Abbot of Gloucester*

Henry VIII came to the throne in 1509 at the age of eighteen. All that the nation knew of him was that he was a bright, handsome youth, fond of horses and hounds, but equally fond of his books and his lute. He had from the first an eye to his own popularity, and did all that he could to please the people by shows and pageants which forced him to dig deeply into the funds his father had amassed. He gave an early indication of his future cruelty and ruthlessness by getting rid of his father's trusted but unpopular servants Empson and Dudley, and appointing as his chief minister the able statesman who was for twenty years to be the second most powerful man in the land, Thomas Wolsey, Dean of Lincoln. Wolsey was the son of an Ipswich butcher who had sought advancement in the Church, the easiest career for an able man of low birth. He had served Foxe, Bishop of Winchester, one of Henry VII's chief advisers, and from his service passed into that of the king. He was an active, untiring man, with a great talent for work and organization of every kind. Henry made him Bishop of Tournay, then Archbishop of York, and finally Chancellor. In this office he served for no less than fourteen years, and was the chosen instrument of all his master's schemes. His dignity was increased when, in 1515, the Pope made him a cardinal and appointed him his legate in England. He indulged in the kind of pomp and state associated with the king, never moving about without a sumptuous train of attendants. This arrogance caused him to become much disliked especially by the old nobility, but the king tolerated it so long as he was useful to him. But his ostentatious display of wealth and power, and his unbridled ambition, aiming as he was to become pope, were blamed by the populace for the burden of increasingly heavy taxes, and for the king's tyrannous extortion of funds by means of 'benevolences'. The country became more and more discontented.

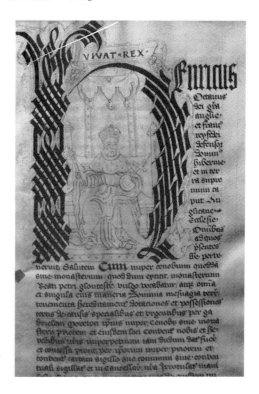

King Henry VIII, initial drawing from the Grant of
Endowment, 1541

THE LAMENTABLE STATE OF THE CHURCH

Religious matters had not been at the centre of English politics since the days of
Wycliffe, but a storm was now at hand far more terrible that that which had swept over
the land in the days of the Lollards. The condition of the western Church had become
more and more deplorable. The worst example was set at Rome, for bad as the Popes of
the fourteenth century had been, those who were contemporary with the Tudors were far
worse. Rome had seen three scandalous popes, the first of whom – Alexander VI, the
celebrated Rodrigo Borgia, was a monster of depravity, a murderer given up to the
practice of the foulest vices; the second – Julius II, was a secular statesman with no
piety, but a decided talent both for intrigue and for hard fighting. The third – Leo X,
was a cultured atheist, of artistic tastes, who used to tell his friends that 'Christianity
was a profitable superstition for Popes.' Under such pontiffs all the abuses of the
medieval Church came to a head. Corruption, open impiety, reckless interference in
secular politics, non-residence, neglect of all spiritual duties and greed for money were
more openly practiced by the clergy than ever before. Even the more high-minded of the
ecclesiastics could see no harm in obvious abuses; Foxe, Bishop of Winchester, a man of
great virtue, absented himself for twenty years from his see, and Wolsey held three sees
at once, and never went near any of them. The lamentable state of the Church would
have provoked murmuring in any period, but in the sixteenth century it led to open
rebellion throughout much of western Europe.

THE CONTINENTAL REFORMERS

The revival of arts and letters, which men were calling the Renaissance, was now at its height and there were many educated laymen who were prepared to criticize the Church and contrast its teaching with its practice. The multiplication of books, owing to the discovery and development of printing, had placed the means of knowledge in everyone's hands, and the revived study of Hebrew and Greek was setting the more scholarly in reading the Scriptures in their original languages. All the elements of violent hostility against the papacy its superstitions and its enormities, were ready to combine and to erupt. In 1517 a German friar, Martin Luther, had first given voice to the universal discontent by opposing the immoral practice of selling 'indulgences' or papal letters remitting penances for sins in return for money. He had followed this up by preaching against many other papal abuses, so that when the Pope, Leo X, replied by excommunicating him, he began to attack the whole system of the medieval church, inveighing against the Pope's spiritual supremacy, the paying of tributes to Rome, the offering of masses for the dead, the invocation of saints, the celibacy of the clergy, the adoption of the monastic life and many other matters. In all this he was supported by his prince, Frederick, Elector of Saxony, and the greater part of Germany at once declared in his favour.

At first England was not much affected by Luther's attack on the papacy. The English Church was probably less corrupt than the church in France or Italy, and though full of

King Henry VIII, by Holbein *c.* 1536

abuses was not nearly as unpopular with the people. It still retained much of the old national spirit which gave it, as in the past, a sturdy independence of the dictates of Rome. Neither the king nor the people as a whole showed any signs of following the lead of the Germans. Indeed King Henry wrote a book in defence of the seven sacrements and received in return from the Pope, Leo X, the title of Defender of the Faith, which has been displayed on the coins of the realm ever since. Wolsey left doctrinal matters well alone, devoting himself to practical reforms. His first measure was to suppress many small and decayed monasteries, and to build with their plunder his great foundation of Cardinal's College in Oxford, afterwards known as Christ Church. It was not until about 1527 that England began to be drawn into the struggle which by then was convulsing continental Europe, and then the cause came initially from the king's private life rather than from any doctrinal controversy. On his accession the king had married Catherine of Aragon, the widow of his brother, Arthur, Prince of Wales. Marriage with a deceased brother's wife being illegal, a papal dispensation had been procured to removed the bar. All the children of the marriage, except one, the Princess Mary, died in infancy. By 1527 Catherine, though only forty-two years old, was a confirmed invalid. Henry wanted a male heir to ensure the succession and so preserve the country from the horrors of civil war. To this end he was determined, somehow, to divorce Catherine and take a younger wife. He became much attracted to Anne Boleyn, a niece of the Duke of Norfolk and one of the maids of honour. Wolsey, realizing the need of a male heir undertook to procure the Pope's consent for the king to set Catherine aside. But the task proved more difficult than he had expected. Thinking the delay was due to Wolsey's bungling or reluctance to act in the matter, the cardinal at the height of his unpopularity with the people, found himself dismissed as chancellor, deprived of all his enormous personal wealth and sent away from Court to live in his archbishopric of York. A year later he died.

THE RISE OF CROMWELL AND CRANMER

The king meanwhile had taken to himself two new councillors. In secular matters he gave his confidence to Thomas Cromwell, whom Wolsey had discovered and brought to court, and in church matters he turned to his chaplain, Thomas Cranmer, one of the few clerics who had been influenced by the continental reformers. Cranmer had suggested a new method of dealing with the divorce issue. It could be argued that marriage with a deceased brother's wife was strictly forbidden in the Scriptures so that the Pope had no authority to sanction it in the first place. The king pursued the idea with vigour, and at the same time made it clear to the clergy that he would stand no opposition from them on the matter. He told the Convocation of the clergy that they had all made themselves liable to the penalties of Praemunire for recognizing Wolsey as papal legate without royal leave. They only obtained pardon by voting the king, as a fine, £118,000 which even for the Church with its accumulated wealth was a very large sum indeed. He also charged Convocation to address him as 'Supreme Head, as far as the law of Christ will allow, of the English Church and clergy' in obvious defiance of the Pope's claim to universal authority, and threatened to cut off the annates or first fruits paid by all benefices when they changed hands, which formed the country's main contribution to

Thomas Cromwell *c.* 1530

Rome. When this did not produce a settlement of the problem of his marriage, Henry took the step which led inexorably to the breach with Rome. He appointed Cranmer Archbishop of Canterbury, and charged him to try the question of the divorce in an English ecclesiastical court, without any further application to Rome.[1] In spite of Catherine's appeal to the Pope, Cranmer proceeded with the trial and declared the marriage to be contrary to the law of God, and pronounced the king free from all his ties and able to marry again. Even before the verdict was announced, Henry had secretly married Anne Boleyn (January 1533), and the moment that the court had given judgment he presented her to the nation as Queen.

The Pope at once declared the new marriage illegal, and threatened Henry with excommunication. This made the king only more defiant than ever. With his refusal to acknowledge the Pope's spiritual authority over England, and the Pope's refusal to acknowledge the validity of the new marriage, the rupture between the Roman See and the English Church was inevitable. Queen Anne soon bore the king a daughter, the future Elizabeth I, and Henry then ordered all his subjects to take an oath repudiating all obedience to papal orders, and to acknowledge the child as rightful heiress of the throne to the prejudice of his elder daughter Mary. Sir Thomas More, Wolsey's successor, and John Fisher, Bishop of Rochester, refused to take the oath and were imprisoned. Henry then obtained from parliament the 'Act of Supremacy' which declared he was 'Supreme Head of the Church of England', and pronounced any one who denied him this title guilty of high treason. As a result More and Fisher were beheaded.

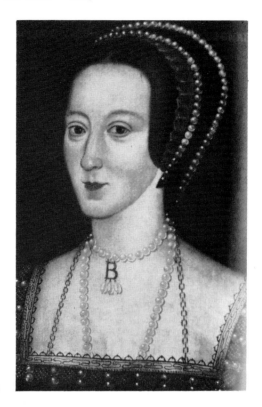

Anne Boleyn, wife of Henry VIII

THE DOCTRINAL DISPUTES

Although all this had been brought about entirely on the king's initiative, the country had acquiesced in it because of the old and long-felt abuses for which the papacy was held responsible. The king and people alike wanted to end the customs by which the pope had profited – his vast gains from the annates of English sees and benefices; his habit of appointing non-resident Italians to the richest English preferments; his power of summoning litigants on ecclesiastical matters before the distant, costly and corrupt church courts at Rome. Yet the English Church had now seceded from the Roman obedience, and organized herself as an independent body with the sovereign as her Supreme Head. Her throwing off the yoke of Rome was sufficient to make it inevitable that the continental reformers would before long begin to exert increasing influence over the minds of the English people.

The German protest against the papacy had taken shape in the declaration that the Bible alone was the rule by which Christian men should order their lives, and that the traditions of the medieval Church, which supplemented the teaching of the Gospels, were dangerous, full of errors and superstitions, and often directly contrary to scriptural precepts. These medieval traditions were the bulwark of the Roman Church, and before long Henry and the bishops began following the German reformers in basing the reform of the English Church on the Bible and the Bible alone. Soon English reformers came to

the fore who could not find in their Bibles any justification for some of the doctrines to which King Henry himself clung most obstinately, most of all the dogma of Transubstantiation. This dogma was developed in the thirteenth century by Aquinas, who argued, in terms of medieval scholastic theology, that the substance of the bread and wine is changed at the consecration into the body and blood of Christ, while the accidents (the outward appearance) remain bread and wine. It was around this dogma that the Roman Church had built up its main claim to be the sole dispenser of divine grace, to rule the souls of men and to determine their destiny.

Further, the doctrine of the 'Sacrifice of the Mass', as commonly understood at this time in the western Church, involved the offering up of the consecrated bread and wine in sacrifice for the sins of the world. The Pope and the priesthood, by their power of granting or refusing the sacrament to the people, stood as the mediators between God and man.[2] The continental Protestants, cut off from the main body of the western Church by the Pope's ban, had formulated doctrines which struck at the roots of the power of the clergy. Some of them, like Zwingli (though not Luther and Calvin) treated the sacrament of Holy Communion as no more than a solemn remembrance of the death of Christ, denying any sacramental character to the rite. In their protesting against the Roman Church's doctrine of the Sacrifice of the Mass, the majority of early English Protestants followed the more extreme continental teaching. However, the king himself clung to the Roman doctrine of the Mass with the result that Roman Catholics who refused to acknowledge the king's power to supersede the Pope's authority were hung as traitors, and Protestants who refused to accept the king's doctrine of the Sacraments were burnt as heretics.

THE DISSOLUTION OF THE MONASTERIES

Meanwhile, Henry proceeded with his reform of abuses in the English Church by attacking the monasteries. The monks had long been unpopular. The early ideal of the monastic life which had been so vigorous in the twelfth and thirteenth centuries had long died away, and ever since the time of Wycliffe people had been asking one another what useful purpose was served by the monasteries. There were no less than six hundred and nineteen of them in England. Some were enormously wealthy, but they did little to justify their existence. Most had long since ceased to be centres of learning or of teaching. The general feeling was that apart from going through the daily round of services, the monks did practically nothing. Their wealth had led to much luxury, both of splendid buildings and of high living. But some argued that the monasteries were worse than useless – they were positively harmful. They had a habit of acquiring rich country livings, drawing all the tithes from them, putting in a vicar to do the work and providing him with a very meagre wage. They extracted vast sums from the people through encouraging devotion to saints and relics. By their indiscriminate doling out of relief and charity they fostered the horde of itinerant beggars who under the name of pilgrims tramped from abbey to abbey all the year round. There was also a considerable amount of immorality in some of the monasteries. Even before the Reformation, Archbishop Warham and Cardinal Wolsey had stormed against the immorality of certain monasteries, asserting that idleness, luxury and high living bred such sins within the

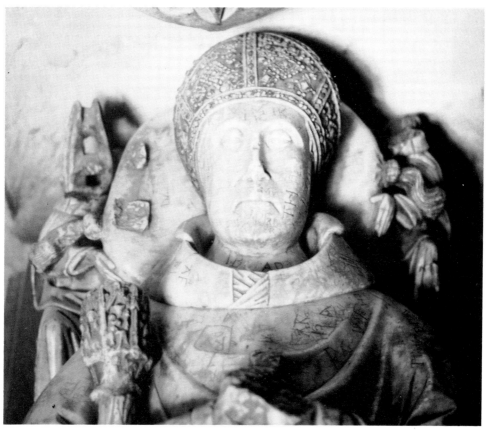

William Parker, last Abbot of St Peter's, Gloucester

seclusion of monastic houses. In public esteem the better houses suffered for the sins of the worse.

Whatever the truth of such allegations, the king determined to suppress this 'papal militia' and to fill his coffers with plunder.[3] Accordingly he sent commissioners round the country to report on the state of the religious houses. These officials, in accordance with the king's wishes, drew up a damning report. They declared they had found nothing but idleness and corruption in the smaller monasteries, and many of the greater houses were no better. No doubt the commissioners grossly exaggerated the blackness of the situation knowing that the king would welcome all possible justification for the action he was contemplating. Yet it is equally certain that in most parts of England the monks were deservedly unpopular and that the commissioners' report only reflected the country's judgement of them. Henry therefore laid the report before parliament in 1536 and obtained their support to suppress the smaller monasteries, those with an income of less than £200 per annum. This was agreed and their goods were confiscated by the Crown.

In the same year Henry, disappointed that Anne had not borne him a son, turned against her accusing her of voluptuous airs and graces, and of displaying a lack of dignity

and decorum among his courtiers. The truth was he had become attracted to another woman, Jane Seymour. On 2 May he sent Anne to the Tower of London, charging her with misconduct with several members of his household. Protesting her innocence and expressing her amazement to the last, she was tried, condemned and executed within the space of less than three weeks from her arrest. In all probability she was guilty of nothing more than unwise levity; her real crime had been that she stood in the way of Henry's wanton desires. With unseemly haste he married Jane Seymour. For a while he was then distracted from his Church reforms by rebellion in Ireland and the North. The 'Ten Articles' of 1536 which he drew up with his own hand, and which were adopted by Convocation, declared that the Bible and the three Creeds were to be regarded as the foundations of Christian belief. Baptism, penance and the Eucharist were declared sacraments, but the validity of the other four was not denied. Auricular confession was declared expedient and necessary, and prayers for the dead were defended. Yet the Articles also declared that all doctrines and ceremonies for which authority could not be found in the Bible were superstitious and erroneous. Consequently the king ordered that a copy of the Bible translated into English was to be placed in every church in the land (1538).

THE INFLUENCE OF THE ENGLISH BIBLE

The translation used was that of William Tyndale, a native of Gloucestershire who had studied at Oxford from 1510–15 and later at Cambridge, but who had been forced to go to Germany in 1525 to continue his translation work. His Bible was printed in 1526, but on its arrival in England it was bitterly attacked by Archbishop Warham and Thomas More. He worked from the original Hebrew and Greek, and not from the Vulgate, the Latin Bible; the style of his English was, for the time, straightforward and vigorous. His translations became the basis of the *Authorized Version* (1611), and so have had a profound influence on both English religion and literature. But in 1535 he was arrested by order of Emperor Charles V, imprisoned near Brussels and the following year strangled and burnt at the stake. Miles Coverdale (1488–1568), a priest who had also been forced to live abroad, was the first to publish a complete Bible in English, but he based his work on the Vulgate, Luther's Bible and Tyndale's Pentateuch and New Testament. It was printed in Zurich, and first appeared in 1535. A first edition of Coverdale's Bible in the library of Gloucester Cathedral bears the title *Biblia the Byble*: that is the holy scrypture of the Olde and New Testament, 'faythfully translated in to Englyshe by M Coverdale . . .' and printed in Cologne by E. Cervicornus and J. Soter. It was presented to the library by Alderman Thomas Pury who had received it in 1648 as a gift from Oliver Cromwell. It evidently came from the royal library as the arms of James I of England are impressed on the cover.

Gloucester's copy is dedicated to King Henry VIII and 'his dearest just Wife and most vertuous Princesse Queen Anne.' At the end of the volume is the notice 'Printed in 1535, and finished the fourth day of October.' The present title page has the date 1536. The copy in the British Library, which is identical with the Gloucester copy in every other respect, is dated a year earlier. The title page of the Gloucester copy is therefore not original, a fact which is confirmed by an inspection of the way the page is attached to

The Arms of the abbey on a tile in Abbot Parker's chantry

the rest of the volume. The explanation of the discrepancy must be that in the months between the completion of the volume, on 4 October 1535 and the 25 April the following year (the day on which the commission for the queen's trial was tested) the king's 'dearest just wife' had fallen out of favour, and so it would have been inappropriate and indeed highly dangerous to couple her name with that of Henry VIII in the dedication. The coronation of the king's third wife, Jane, provided a solution to the difficulty with the alteration of two letters, Anne becomes Jane. The type, thus amended, is found in other copies, for example at Lambeth and Sion College libraries. The date also had to be altered, from 1535 to 1536, hence the confusion on the part of the printer and binder leading in the case of the Gloucester copy to the dedication being to Queen Anne and the date being 1536.[4]

THE LAST YEARS OF KING HENRY VIII

The king aware of how profitable the plundering of the lesser monasteries had been, now determined to act against the greater houses as well. In 1538–40 all were swept away, in many cases the abbots and monks were induced to surrender their estates peaceably in return for pensions or promotion. But where persuasion failed, force was used. The wealthy abbots of Glastonbury, Reading and Colchester all resisted, and were hung. An Act of Parliament was passed bestowing on the king the lands of all the monastic foundations. The king had promised to devote the enormous plunder to ecclesiastical purposes, and had spoken of founding many new churches and schools, and creating twenty new bishoprics. In the end he lavished most of the abbeys' lands on his favourites among the nobility and gentry. The Church only benefited by the endowing of six new bishoprics – Oxford, Chester, Peterborough, Bristol, Gloucester and the short-lived see of Westminster.

In 1539, when St Peter's Abbey at Gloucester was surrendered to the king's commissioners, Henry fuelled the fires of martyrdom by issuing The *Six Articles*

Abbot Parker's badge

Abbot Parker's arms

Katherine of Aragon's
token

Osric as Viceroy
of Wiccia

Henry VIII
and
Katherine of Aragon

Osric of Northumbria

Edward VI
as Prince

France and England

Jane Seymour
with quarterings
and royal augmentation

Dorothy Braye
and Braye (ancient)
with an inescutcheon
of 4 quarterings

Sir Edmund Brydges
quartering Chandos and
Berkeley of Coberley

Sir Edmund Brydges:
impaling Braye quarterly and
ancient, with an inescutcheon of
4 quarterings

Drawn by R. C. Barnfield

The Prinknash heraldic glass in the south walk of the great cloister

Detail from the Prinknash heraldic glass in the south
walk of the great cloister; Abbot Parker's arms

condemning all who should write or speak against certain doctrines of the medieval Church, such as Transubstantiation, the celibacy of the clergy and auricular confession. Meanwhile he had obtained a male heir. In 1537, his third wife, Jane Seymour bore him a son, Prince Edward, although she died at the child's birth. Edward was now declared the sole heir to the throne. Cromwell fell out of favour over his part in the marriage of the king to Anne of Cleves, and eventually he was arrested and executed for having received bribes and for 'dispersing heretical books and secretly releasing heretics from prison.'

In 1540 the king married Catherine Howard, a cousin of Anne Boleyn and a niece of the Duke of Norfolk, giving further encouragement to those whose allegience was still with Rome. Yet within eighteen months she was sent to the block. His sixth wife was a young widow of twenty-six, Catherine Parr, who nursed the king faithfully through the infirmities of his later years. The king was growing grossly corpulent and developing a complication of diseases which racked him during the last five years of his life and partly accounted for his bouts of terrible cruelty. The end came in January 1547. He had ensured a peaceful succession and had preserved the country from civil war. Only a comparatively small number had been executed. The reign proved to be less dangerous for the mass of the people than for those in positions of prominence. Yet he left the church in tension between the Protestant reformers and the supporters of the papacy, and the country suffering from his years of waste on pageants, foreign intrigues and fawning courtiers.

WILLIAM PARKER THE LAST ABBOT OF GLOUCESTER

When Abbot John Newton, alias Browne, died on 4 May 1514, after an abbacy of only four years, William Parker, master of the works, was unanimously elected abbot (1514–39). Considering the importance of the position held by the abbot of one of the great medieval monasteries, it is remarkable that Parker, who was not yet thirty years old and nearly half-way down the list in the community, should have been chosen. He was clearly a man of exceptional ability.

His Life

Parker was also called Malverne, presumably because he was born at Malvern in Worcestershire. He was said to have been of the family of Parker of Hasfield near Gloucester. Nothing is known about his parents except for a solitary reference in Parker's own Register which states that on 'December 11th 1520 the abbot and convent of St Peter's, Gloucester, granted a pension of 40s. to John Cusse, Vicar of South Cerney, that he should pray for the soul and body of William, abbot of Gloucester and for the souls of John and Isabel Parker, the parents of the said William.' This has given rise to the suggestion that Parker's home was in the village of South Cerney in Gloucestershire where there is a tomb reputed to be that of the abbot's parents.

Wherever his early childhood may have been spent, he was almost certainly educated at St Peter's Abbey for he was sent eventually by the monks to Gloucester Hall, Oxford. As a bachelor of civil law he took his DCL on 29 January 1507, and his BD on 1 July 1511. He received his DD on 5 May 1515, a year after he become abbot of St Peter's. It is not known at what stage he returned from Oxford to take his vows, but it was some time before 1510 because at the election of his predecessor, John Newton, he was thirty-fourth in the community which was said to number no less than sixty-five at that time. On 23 November in the year of his election, King Henry VIII issued a writ summoning Parker to meet him in parliament. As St Peter's was a mitred abbey the abbot had a seat in the House of Lords. But Parker did not attend, obtaining proxies to vote for him. In the following year he attended the General Chapter of his Order held at Coventry when various statutes were enacted to reform the monasteries of abuses. These together with other constitutions respecting the proper distribution of the alms of the house, he transcribed into his Register.

His Building Works

As master of the works, before being elected abbot, Parker would have been responsible for building work at the monastery and probably at the abbey's churches and estates. There seems to have been little scope or need for any major rebuilding or new building at St Peter's itself during his abbacy. He is said to have adorned King Edward's Gateway. The refacing on the south side of the surviving tower probably dates from his abbacy. He also repaired the abbot's lodgings, perhaps remodelling the great gallery and putting in the oriel windows which can still be seen overlooking Pitt Street. He built

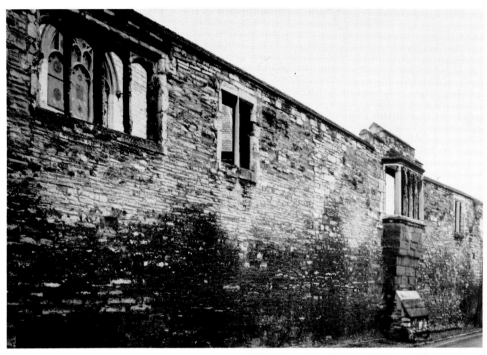

Top: North wall of the abbot's lodging (Pitt
Street). Right: Detail of oriel window
(T. Dorrington)

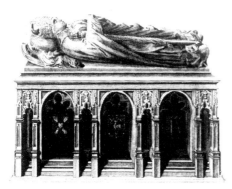

Tomb of Abbot Parker, in his chantry chapel in the
north ambulatory, Bonnor, 1796

part of Barnwood Court, a mile or two from the town centre, and converted the house at
Prinknash from a hunting lodge into an abbatial residence. The date of the work at
St Peter's Lodge at Prinknash is thought to be between 1520 and 1525. A few years
before this, Parker had made his second brother, Humphrey, 'woodward' of Buckholt,
the large beech forest which extended for miles around Prinknash. From that time
Humphrey may well have occupied the Lodge, at least in his brother's absence. Parker
must often have ridden up to his country house to inspect the rebuilding work, and later
to stay there with his relatives, or to hunt in the surrounding woods. From the windows
of the lodge, Parker would have been able to see the tower of his abbey church rising out
of the mists of the vale some five miles away.

Parker built a chantry for himself beside the shrine of King Edward II, and had an
impressive effigy of himself sculpted. On the screen of the chantry is a frieze of
beautifully carved vine leaves, tendrils and grapes. The alabaster effigy of the abbot is
badly defaced, but the chasuble and mitre are sufficiently intact to give the impression of
a prince of the church. Around the base of the tomb are panels, containing the abbot's
arms and the emblems of the Crucfixion of Christ. On the tomb itself are the Tudor rose,
the pomegranate, a lion's head, oak leaves, fleur-de-lys and the initials WM for William
Malverne, alias Parker. At the head, the Norman pier has been cut away and the abbot's
arms surmounted by a mitre placed on the wall over the head of the effigy. At the foot is
a cross composed of a tree with its branches growing into the shape of a cross. In the
pavement around the tomb are some very good tiles with the arms of the abbey, and
some other specimens with an excellent greenish glaze on them. Some of the large 0.2 m
(7 in) tiles with the abbot's own arms are particularly well made and well preserved. The
poet W.R. Childe refers to this tomb in his lines on *The Last Abbot of Gloucester*:

> The Middle Ages sleep in alabaster
> A delicate fine sleep. They never knew
> The irreparable hell of that disaster
> That broke with hammers Heaven's fragile blue
> Yea, crowned and robed and silent he abides
> Last of the Romans . . .

It has often been stated that 'after the Dissolution he was not buried here, instead a
Marian and an Elizabethan bishop lie below' (Verey).

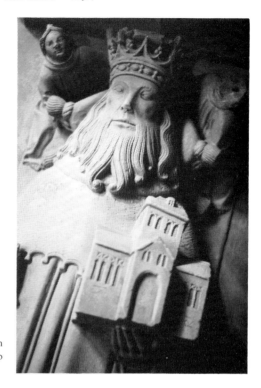

Prince Osric, founder of the first monastic house in
Gloucester: detail from the effigy on his Tudor tomb
in the north ambulatory

Parker also built a 'fayre tombe', as Leland called it, to the founder of the first
monastic house on the site, Prince Osric of Mercia. With the fourteenth-century
squaring off of the east end another place of honour had been created on the north side of
the altar. No one knows whether there was a tomb in this position prior to Parker's
time. Some have suggested it was occupied by the thirteenth-century tomb of Serlo, but
this seems unlikely. All that remains of Serlo's tomb is the effigy of him, if indeed it is,
which now lies on a bracket on the south side of the presbytery. Leland, however, states
that when he visited the building in 1541 Serlo's tomb [sic] was on the south [sic] side
of the presbytery. In any case, Abbot Parker sought to enhance the standing of his abbey
by building a new tomb as a memorial to its Saxon founder, and placing his own arms in
the spandrels of the canopy. The other coats of arms are those of the abbey and of Osric
as King of Northumbria. Though not nearly as fine a structure as the abbot's own
chantry, Osric's tomb is interesting in that the effigy itself is curiously carved as though
in a deliberate attempt to make it appear older than it is. Osric is represented crowned
and sceptred, clad in a tunic, a laced mantle and a fur hood or collar, holding a model of
a church in his left hand. The Norman pier at the head is cut away to make room for the
tomb, and at the feet is the inscription *Osric Rex primus fundator hui Monasterii 681* [King
Osric, first founder of this monastery 681]. Leland records that 'Osric, founder of
Gloucester Abbey, first laye in St Petronell's Chapel, thence removed with our Lady
Chapel, and thence removed of late dayes, and layd under a fayre tombe of stone on the
north syde of the high aulter'

His Attitude to Reform

Parker's various grandiose schemes seem in keeping with the self-aggrandisment of the Cardinal Archbishop of York, Thomas Wolsey, and the example he set the rest of the heirarchy. After Wolsey's fall from favour in 1529 the sober truth about Henry's intentions began to dawn upon the church, and particularly on the monasteries. In 1534 Abbot Parker complied with the king's demands and subscribed, together with thirty-four of his monks, to the king's supremacy. This took place on 31 August when Dr Richard Gwent, Archbishop Cranmer's commissary administered the oath to the abbot and the community in the chapter house. In addition to the oath, Gwent had brought with him a mandate to the sheriffs and magistrates of the county to take into custody and imprison any who refused to take the oath. It is known that Parker took part in the meetings of parliament and convocation at which the king's divorce was approved, and papal authority repudiated; at the same time legal effect was given to the king's wishes concerning the dissolution of the smaller monasteries. But what the abbot's attitude was towards all this is not known. The *Dictionary of National Biography* states that Malverne 'is said to have been opposed to Henry VIII's ecclesiastical policy'. This may be true. Yet while the abbot may have disliked taking the oath, he would have realized that there was no alternative, except imprisonment and possibly death. So he complied, presumably easing his conscience with the fact that practically everyone else was doing the same.

Fragmented glass in the lady chapel east window, depicting monks in procession

Little is known about Parker's personal dealings with the king. He entertained him and his party at the abbey in 1535. Henry visited the town with Anne Boleyn in their royal progress through the western and southern counties, staying at castles and great monastic houses on the way. They came to Gloucester via the abbeys of Winchcomb and Tewkesbury, arriving in the town on Saturday 31 July. Sir Thomas More had been beheaded a few weeks earlier, on 7 July, an event which must have been in the minds of those receiving the king at St Peter's Abbey. An old book of ordinances records that the king's party was met outside the town by the mayor, the sheriffs and aldermen all clothed in scarlet robes and accompanied by a hundred burgesses all on horseback. Later, joined by the town's clergy in full vestments, they proceeded to the abbey where they were received in great state by Abbot Parker and his brethren. The king spent a week in Gloucester, passing the Monday and Tuesday hunting in the vicinity of Prinknash, and the Wednesday hunting at Miserden. When the king eventually left the abbey and the town to continue his progress to Bristol all concerned must have heaved a sigh of relief. Just four years later the history of the Abbey of St Peter's came to an end.

The end must have been foreseen by Abbot Parker. With the dissolution of the smaller houses in 1536, including those in Gloucester, he must have realised that it was only a matter of time before the greater houses shared the same fate. He attended the Parliament which opened on 28 April 1539, but when the abbey was surrendered to the King's commissioners on the 4 January 1540 there is no mention of him; the task fell to the prior, Gabriel Morton, and thirteen monks. Parker's absense on this momentous occasion has given rise to much speculation. Gasquet in his *Henry VIII and the English Monasteries* quoting Willis, asserted that 'Abbot Malvern of St Peter's Gloucester unable to avert the doom of his house, could never be brought to sign the fatal surrender.' The inference is that he left the monastery a few months earlier to live in retirement with one of his nephews, passing the rest of his days in obscurity. However, a letter from Gabriel Morton, the prior, to Cromwell, dated 9 June 1539, states that owing to the death of their late abbot, the community desired Cromwell's advice as to the election of a new abbot. The reason for his absence from the abbey on the day of its surrender was, therefore, that he had died early in June 1539. Herbert comments that 'the tradition that he was not buried in the tomb apparently derives from the mistaken belief that at the dissolution of the abbey in 1540 he was still living and was contumacious.'[5]

There is no record, however, that he was buried in the abbey church, though this is hardly surprising in view of the confusion of the time and the loss of so many of the medieval records. If he had died at the abbey early in June 1539, months before the surrender of the monastery, he would surely have been buried in the chantry he had prepared for himself. Yet Fosbrooke and other historians since have stated that the abbot was not buried in his chantry. This seems to be confirmed by Colonel N.H. Waller's account, writing to Dom Michael Hanbury, OSB in 1928, of the opening of the tomb in 1919. 'The tomb which was made by Abbot Parker for himself was opened in 1919 owing to the floor giving way and a repair having to be made to it. I saw the tomb when opened and it contained two coffins, in one was an elderly man and in the other a younger man, and in the former coffin there was a small carved burial crosier in oak, a replica of which was made and original put back.' He had been advised (by Dr Henry Gee, Dean of Gloucester 1917–38) that the two coffins were probably those of two bishops of Gloucester, namely James Brookes (1554–8), a zealous papist, delegated by

the Pope for the examination and trial of Bishops Cranmer, Ridley and Latimer, and Bishop Cheney (1561–79) the first Elizabethan bishop. Yet if the abbot is not buried in his chantry where is he buried? Bazeley thought that Parker, unwilling or afraid of facing up to the surrender of the monastery, went to London and died there, probably at the White Hart Inn in Holborn which was owned by the abbey. If he died of the plague his body would have been buried hastily, and away from Gloucester. However, all this is pure speculation.

His Character

There is scarcely enough evidence to form a judgment of the character of the last abbot. Such evidence as there is, mainly that of his own works and writings, suggests that he was a man of his time, a proud and ambitious prelate. As a Roman Catholic writer comments, 'the failing was sadly common among ecclesiastics at the time, both secular and regular, and its prevalence would, apart from other causes, suffice to account for the Reformation.' Like others, he was lavish in the way he used his position to benefit his relations. Both his brothers, Thomas a cleric and Humphrey, a farmer, and also his nephews, are often mentioned in the abbot's Register as grantees of abbey lands and as officers of the abbey. His brother, Thomas, for example, was Chancellor of the Diocese of Worcester from 1521–32, and among other grants made by Parker to Thomas were the vicarage of Hartbury, the rectory of Buckland and a messuage elsewhere, all in 1515. Thomas died in 1538 when he was also cellarer of St Peter's Abbey.

Knowles in his cameos of monks and abbots at the time of the Dissolution regards them as men of their age. He writes of William More, Prior of Worcester, that 'he possessed neither holiness of life nor intellectual or practical ability', and that his

A weather beaten crucifix, from the east gable of the lady chapel, lying on the ground

The alabaster effigy of Abbot Parker, *c.* 1539

inclusion in a gallery of portraits was due primarily to the aptness with which his career at all points illustrates the trend of the age. Parker was also a man of his time, enjoying his position and all the privileges and prestige that went with it. He displayed his wealth and power in typically Tudor style by indulging in grandiose schemes for personal aggrandisment. But they were not to last. Knowles, writing of Durham, takes comfort from the fact that though so much was swept away 'the beauty of the setting remained' and at least some 'of the treasures of artists and craftsmen that the centuries had accumulated.'[8]

Hart's lament on the last days of the abbey of St Peter at Gloucester reflects the rather romantic and idealized notion of medieval monasticism current in certain circles in mid-Victorian England, but the lyricism of his words strikes an echo of sadness in the heart:

> At the Dissolution the Abbey which had existed for more than eight centuries under different forms, in poverty and in wealth, in meanness and in magnificence, in misfortune and success, finally succumbed to the royal will. The day came, and that a drear winter day, when its last mass was sung, its last censer waved, its last congregation bent in rapt and lowly adoration before the altar there; and doubtless as the last tones of that day's evensong died away in the vaulted roof, there were not wanting those who lingered in the solemn stillness of the old massive pile, and who, as the lights disappeared one by one, felt that there was a void which could never be filled, because their old abbey, with its beautiful services, its frequent means of grace, its hospitality to strangers, and its loving care for God's poor, had passed away like a morning dream, and was gone for ever.[9]

THE MONASTIC PRECINCTS

'The Common room . . . "a fyre was keapt in yt all wynter,
for the Monnckes to cume and warme them at,
being allowed no fyre but that only, except
the Masters and Officers of the House, who had there severall fyres . . ."'
The Rites of Durham

The Saxon monastery founded by Osric, Prince of Mercia, in *c.* 681 was probably built in the north-west corner of the town, inside the Roman walls. When the Norman church was built, or possibly a little earlier, the precincts were extended on the north and west sides to take in land belonging to St Oswald's Priory. Abbot Peter (1104–10) built a wall around the extended precincts. Shortly before 1218 the abbey precincts were again extended taking in land owned by St Oswald's, and a new stretch of wall was built. But after this the area of land enclosed within the precinct walls remained much the same until the Dissolution.

THE PLAN AND BUILDINGS OF THE PRECINCTS

Sir William St John Hope in his *Notes on the Benedictine Abbey of St Peter at Gloucester* points out that the buildings around the precincts were laid out 'very nearly according to the normal plan.'[1] The area west of the church and filling the whole of the south-west quarter of the site was the *curia*, the outer or great court. In it stood the hospitate buildings, consisting of the halls and chambers for the entertainment of guests, and near the great gate-house (St Mary's Gate) were the eleemosynary buildings for the relief of the poor. On the north side of the outer court was a range of buildings with a gate-house in the centre, rebuilt in the fourteenth century, through which access was gained to the inner court. In this smaller, inner court there was the mill, driven by the Fullbrook, the bakehouse, the kitchen to the north-east adjoining the west end of the refectory and other service buildings.

On the north side of the precincts, from the fourteenth century, was the abbot's

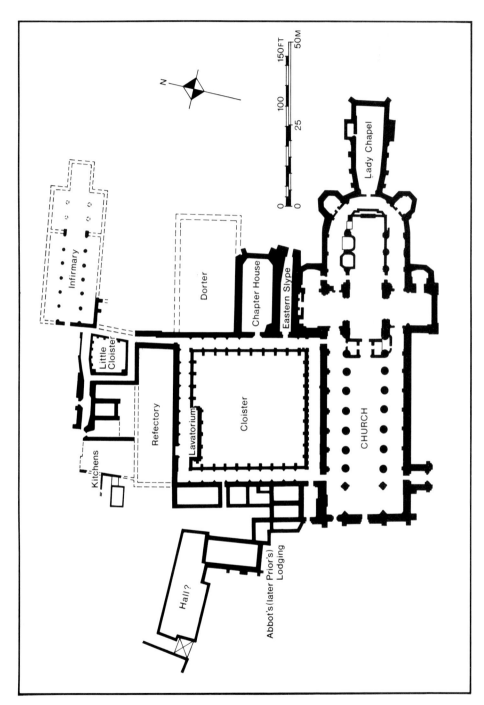

Plan of the claustral buildings of St Peter's Abbey. Richard Bryant 1990 after St John Hope (1891)

Four of the abbey gates, F.S. Waller 1852 as follows: (1) St Mary's Gate. (2) King Edward's Gate
(3) St Michael's Gate. (4) Gate to Inner Court.

lodging and also the infirmary, both of which were connected by covered ways with the main monastic buildings. The north wall had no gateway in it since it formed part of the town's defences. In 1447 a condition of the settlement of a dispute between the abbey and the town was that no breaches should be made in it. Near the infirmary, and extending southwards, beside the little cloister and on the east side of the dark cloister, were other buildings. Around the east end of the church there was a garden, partly used as the monks' cemetery. From *c.* 1460 the monks' cemetery appears to have been bounded on the east by a wall adjoining the east end of the lady chapel and occupying land on both the north and south sides of the chapel. The northern part would have been entered from the cloister via the eastern slype, and the southern part through the passage beneath the *sacrarium* of the lady chapel. The line of the outer wall to the east ran close by St Lucy's Garden and St John's Church. This land was probably partly an orchard and partly cultivated. A wall extended south from the corner of the south transept, dividing the area on the south side of the church into the inner or monks' cemetery, lying on the east side of the wall, and the lay cemetery on the west side of the wall. A similar arrangement existed at Canterbury.

The Abbey Gates

The wall, built by Abbot Peter, had a gate-house in the middle of its west side, and there was a second gate-house (the lyche-gate) in the middle of the south side. A third and smaller gate, a little to the east of the lyche-gate, gave access to the outer or lay cemetery. The great gate on the west side, St Mary's Gateway, is first recorded in 1190. The vault dates from this time, but the superstructure appears to be early thirteenth century. It has a gate-porch entered by a wide but low pointed arch, with an inner arch where the doors were hung. The entire entrance area known as the gatehall also had doors towards the court. In its south wall are two recesses, and on the north side a doorway leading to the upper story of the building. In 1892 St John Hope described the façade, before the later restoration of the building: 'The upper story has an arcade of four arches on the street-side. The outer pair each have a trefoiled niche or panel in the back. The other two arches are larger and are both pierced with two square-headed lights, also of the 13th century, with dividing mullions. In the gable, within a large triangular panel, is a niche of three arches carried by detached shafts.'

The gateway on the south side, at the end of College Street, has been almost entirely destroyed. There was an earlier gate, known as the lych-gate, first recorded in 1223. Only a fragment of the west side of the later entrance remains. It was built by King Edward I *qui portam illam hujus monasterii ejus nomine insignen construxit*. It was later 'restored and beautified' by Abbot Parker. The remaining turret of the gate is probably Parker's work. In a niche on its south face are the attributed arms of Prince Osric, as King of Northumbria. The stone bearing these arms was dug up *c.* 1828 and placed in this position. The small cemetery gate further to the east, at the end of College Court, dates from the end of the fifteenth century, but possibly even later, from Abbot Parker's time. It was known as St Michael's Gate in the seventeenth century. It consists of a flattened archway with canopied niches on either side. The fourteenth-century gateway

from the outer court to the inner court (Miller's Green) has a lierne vault and a blocked doorway in its west side which may have led to the almoner's lodging, on the site of the present Community House.

The Abbot's Lodging

The hospitate buildings, those devoted to the reception of guests, were generally arranged in three groups. The abbot's group, where the king, distinguished churchmen and the nobility were entertained, was situated on the west side of the cloister, at the north-west corner of the church. In the fourteenth century a new lodging for the abbot was built on the north side of the precincts and his first lodging was handed over to the prior. The second group, in charge of the cellarer, stood somewhere in the great court. Here merchants, franklins and other visitors of middle rank would be entertained. The third group, where the lower orders, pilgrims and paupers were housed stood in the immediate vicinity of the great gate-house. With the closure of the monasteries in the 1530s it was this kind of accommodation which was most missed, leading to the passing of the Poor Law of Queen Elizabeth I (1601). All attempts to cope with pauperism by voluntary charity having failed, it was finally resolved to make the maintenance of the aged and invalid poor a statutory responsibility of the parishes. The new law directed that the able-bodied vagrant should be forced to work, but if he refused, he should be imprisoned. The genuinely weak and deserving were to be fed and housed, a rate being levied on the parish for their support.

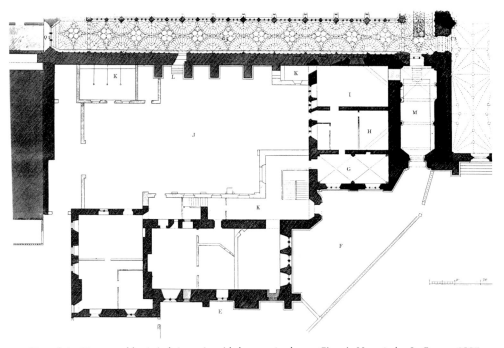

Plan of the Norman abbot's lodging, the old deanery (and now Church House), by J. Carter, 1807

The original lodging for the abbot (now part of Church House) is described by Herbert as 'an early 12th-century tower, about 35 feet square. The tower was separated from the north side of the nave by a vaulted ground-floor passage above which an abbot's chapel was built *c.* 1130. The guest range was possibly destroyed by a fire which damaged the domestic buildings in 1190, and the abbot's lodging was given a western lobby behind an elaborate new front *c.* 1200.' It consisted of two main blocks, built on two sides of a court; the one to the south in the angle formed by the cloister and the west end of the church, and the other to the west with a court between it and the cloister. The southern block, which contained the private apartments of the abbot, consisted of three large square Norman chambers, one above the other, with their original windows enriched within and without with zigzag mouldings. Each chamber had also, in the north-east corner, a doorway into a garderobe tower shown in Carter's plan (1807) but long since destroyed. The two lowest chambers have their southern corners crossed by stone arches, moulded or covered with zigzag ornament.

The ground floor was entered from a vaulted lobby or antechamber. The first floor had a similar antechamber, as had the second floor originally, but this has been altered. These are the early thirteenth-century lobbies described by Herbert. Both the outer parlour (the western slype) and the chapel above it were once 2.8 m (9 ft) longer than they are now. They were probably shortened and their west ends rebuilt with old masonry at the time the west front of the nave was rebuilt, and also shortened by a bay, in the fifteenth century. The first floor of this part of the house contained the abbot's private apartments, namely his dining room, bedroom, solar and chapel. The second

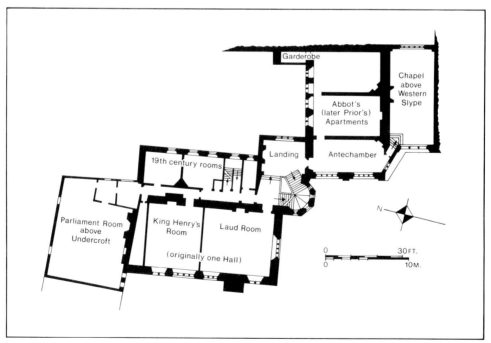

Plan of the Norman abbot's lodging (adjoining the west end of the church). Richard Bryant after N.H. Waller (1950)

floor was devoted to his own special guests, while the ground floor contained a reception room and probably accommodation for one or more servants.

At the north-west corner of this southern block is a semi-octagonal turret staircase leading to the antechambers on the first and second floor. This is part of the nineteenth-century reconstruction of the building. The much earlier entrance tower it replaced was nearly square and of the same date as the antechambers. A medieval lanthorn is preserved on the upper staircase. The western block of buildings, which was connected with the southern block by the turret and landings, was so altered in the fifteenth century and further modernized and enlarged in the nineteenth century that it is difficult to make out the original arrangement. The southern half is two stories high, with a large hall on the upper floor. St John Hope thought that this fourteenth-century hall may have been the great guest hall built by Thomas Horton, and used for the sittings of the Commons when parliament was held in the abbey in 1378. The hall was later divided into two rooms, one being lined with good Jacobean panelling (Laud Room) with the fifteenth-century roof underdrawn by a plaster ceiling.[2] The ceiling of the other room (Henry Room) was taken down in 1959–60 revealing the structure of the roof and motley coloured timbers.

At the north end of this hall is another two-story building. The lower part, or undercroft, is of stone and dates from the thirteenth century. It is now the cathedral

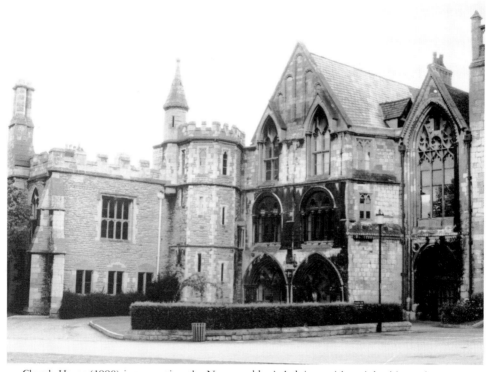

Church House (1990) incorporating the Norman abbot's lodging, with mainly thirteenth-century front; extended in the late sixteenth and seventeenth centuries, and the whole altered substantially in the nineteenth century

restaurant, but originally it formed part of a building of considerable architectural importance, as may be seen from the jamb of an elaborate Early English window at the north-west corner. From its position it was probably the abbot's hall, and extended westward to the inner gate. It was here that the famous dialogue between Edward II and Abbot Thokey took place. But at some time in the fifteenth century this hall was taken down and an upper storey of wood built on the thirteenth-century undercroft, of which only the east end survives (Parliament Room). When, from 1541, it was occupied as part of the deanery there was still attached to it, at the west end, an empty, ruinous range extending to the inner gate, and known as the old workhouse and old school house. It was evidently known *c.* 1600 as the 'long workhouse'. It was an ancient part of the abbey where, according to Dugdale, early kings held their councils and parliaments. The house that replaced it in 1667–70 was known as the Parliament House (7 Miller's Green).

The court of the abbot's house may have been enclosed by covered walk-ways on the west and north sides enabling the abbot to go into the cloister under cover. The small ogee-arched door in the west walk of the cloister originally led to the abbot's house via these covered ways. In the nineteenth century a block of additional rooms was built on the west side of the court against the medieval hall to provide the dean and his family with increased accommodation. In the late 1970s a passage, with lavatories and a small shop, was built to link the cloister walk with the Undercroft Restaurant, so that a small enclosed patio is all that now remains of the abbot's court. Excavations carried out at that time revealed Saxon burials and even earlier strata. In the north-east corner of the patio is all that remains of the garderobe, but the Norman decoration round the doorways is of interest.

As already noted, during the first half of the fourteenth century the abbot moved from these rooms to a new lodging on the north side of the precincts, and the former abbot's *camera* was occupied by the prior. Between 1316 and 1329, while John Wygmore was prior, 'he built a new *camera*, apartments, for the abbot beside the infirmary garden.' *Dum prior ejusdem monasterii extiterat cameram abbatis juxta gardinum infirmarie construxit.* Later, Abbot Horton built 'the abbot's chapel beside the infirmary garden.' *In edificiis tam extra quam infra multum ampliavit ut capellam abbatis juxta ortum infirmarie.*[3] The camera built by Wygmore and first occupied by him was a hall with a group of chambers and domestic quarters attached to it.

Drawings (1856) of the plans of the old building made by F.S. Waller before its demolition together with the description given in Henry VIII's charter make it possible to reconstruct the fourteenth-century abbot's *camera* in some detail. Based on the references in the *Historia*, the house is thought to have originated in a chamber built next to the infirmary garden shortly before 1329. Later a hall with private apartments were added at the west end, and in the mid-fourteenth century Abbot Horton built the adjoining chapel. The house, therefore, consisted of a great hall with the abbot's own *camera* on the east side, and the servants' quarters and lodgings for guests on the west. From the abbot's appartments, where he also entertained special guests, a gallery led eastward to another *camera* close to the infirmary, containing a hall, pantry, kitchen, chapel and bedrooms, which were the abbot's private apartments. All these buildings had cellars and domestic offices beneath them. On the east of the abbot's lodging lay the infirmary garden, and on the south the abbot's garden. The north side was bounded by a

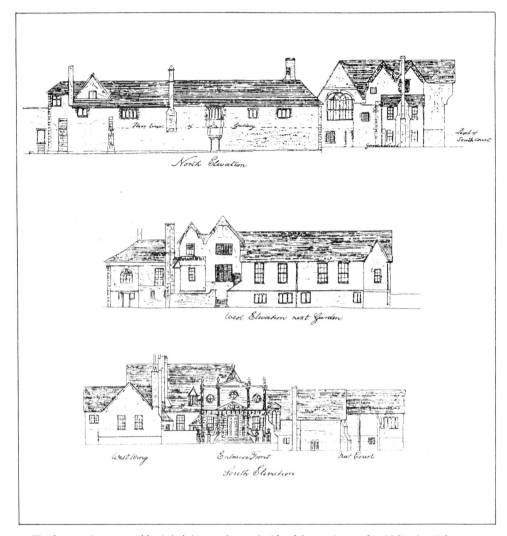

The fourteenth-century abbot's lodging on the north side of the precincts, after 1541 when it became
the bishop's palace

street (Pitt Street). As noted earlier, the eastern *camera* was built, beside the infirmary
garden, by Wygmore while he was still prior. The great hall was probably also
Wygmore's work, to which Abbot Horton added the apartments on the east and a small
hall for the servants on the west.

The letters patent of Henry VIII founding the bishopric of Gloucester in 1541
granted to the bishop for his residence the whole of the premises known as the abbot's
lodging.[4] This ancient residence of the abbots of St Peter's and later the bishops of
Gloucester survived substantially intact and considerably enlarged until it was pulled
down to make way for the Bishop's Palace (built 1857–62) which is now the main
building of the King's School.

The Great Guesten Hall

There are few remains of the cellarer's range of buildings from which to reconstruct their plans and arrangements. The first reference in the *Historia* to buildings in the outer court is of their being burnt down in the fire that destroyed a large part of the town in 1190. Then in 1300, on the feast of the Epiphany, a fire broke out in a timbered house in the great courtyard, from which it spread to the small bell-tower, the great *camera* and the cloister. The *camera* referred to was probably part of the abbot's house (Church House), that is, the great hall attached to it (Parliament Room). In 1305 the king's judges were entertained by the abbot at a sumptuous feast 'in the great hall in the court of the abbey.' This may have been the abbot's own hall (Laud and Henry Rooms), but more probably the great guest hall under the charge of the cellarer. St John Hope believed that this hall, and other buildings for the accommodation of guests, stood in the south-west part of the outer court, where some old remains still exist in houses there (8 and 9 College Green). Incorporated in these two properties is a large room with an open roof and a fireplace of medieval date.

The *Historia* states that Abbot Horton built 'the covered *camera* of the monks' hostelry and the great hall in the court where King Richard II afterwards held his parliament.' This parliament sat from 22 October to 16 November 1378 in the *aula hospitum* or

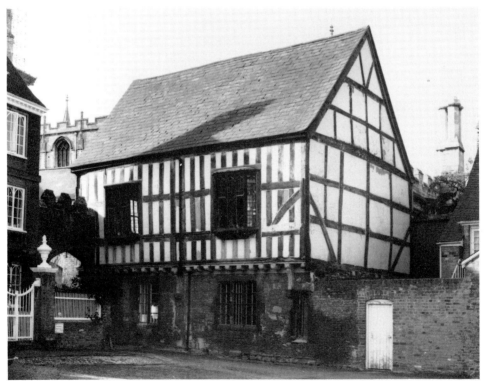

Part of the great hall on the north side of the Norman abbot's lodging, now known as the Parliament Room

guesten hall, so that the *magna aula* and the *aula hospitum* would appear to be one and the same building. Adjoining it was a guest's chamber, *camera hospicii,* where the privy council met, 'which was anciently called the king's chamber on account of its beauty.'

The accommodation for such as pilgrims and paupers was probably contained in the long range of buildings extending southwards from the abbey gate, along the west side of the great courtyard (10–14 College Green). The house adjoining St Mary' Gate. is partly of timber-frame construction resting on stone walls of the ground floor. Its 'original function is not known' (Herbert). The almonry buildings were probably between the great gate and the inner court (Community House). There is evidence to suggest that in addition to the hostelry accommodation, along the west side of the great court, there was stabling. This would have adjoined the walled miskin, or dungheap, in the south-west corner (College Yard).

The Inner Court

The inner gate gave access to the inner court (Miller's Green) where, as already noted, the bakehouse, boulting house, brewhouse, additional stables, mill and other domestic buildings stood. Later, it was also the way to the abbot's lodging. The existing gateway dates from the fourteenth century. In its west side is a blocked doorway, perhaps communicating with the almonry range. The building on the site (Community House) has medieval work in the basement. Little is known about the buildings around the inner court. St John Hope believed the bakehouse stood in the corner near the great gate, because a settlement made in 1218 with St Oswald's priory mentions a boundary line descending in a direct line from the garden through the frater, larder and bakehouse as far as the new wall next to St Oswald's. The brewhouse was probably next to it and another building, since a fire in 1223 that destroyed all St Mary's parish 'before the abbey gate', also burned 'part of the bake house and brewhouse, and a house between the gate and the stable.' But this house and the stable may have been in the outer court (College Green). The mill stood on the north side of the inner court (Miller's Green). The mill was leased as a working corn mill until the mid-eighteenth century. There is a millstone in the cellar of the house now standing on the site (1 Miller's Green).

THE MAIN CLAUSTRAL BUILDINGS

The medieval monastic cloister (*claustrum*) was a square of open ground at the centre of the complex of buildings in which the monks lived and worked. It was surrounded on all four sides by a covered-way which gave access to the main buildings of the monastery. The church was on one side, and the main domestic buildings of the monastery on the other three sides. The covered ways were open to the garth, or square open space, which was usually a grass plat. The covered ways, or cloister walks, were also, on occasions, processional ways and, with stone benches along the wall, places of work and study. The idea of laying out the main monastic buildings around an enclosed garden goes back to the Roman *villa rustica*, which was designed to provide well-to-do Greek and Roman families with fresh air while protecting them from the glare of the Mediterranean sun.

Much the same plan was adopted by Roman settlers in Britain, though more for protection against the vagaries of a northern climate. St Benedict used the word *claustrum* for an enclosure, but in the sense of the whole area in which the monks were enclosed rather than in the narrower sense of the cloister garth.

Until the ninth century a claustral plan was not widely used in monastic establishments. The plan of early monasteries in the west, such as Wearmouth and Jarrow, contain nothing that resembles a cloister; the various buildings were far more haphazardly arranged. But in the ninth century the famous St Gall Plan was devised setting out the perfect cloister for a Benedictine community. This intriguing drawing was to have a considerable influence on the planning of claustral buildings and the way they were arranged within the monastic precincts. In the tenth and eleventh centuries in

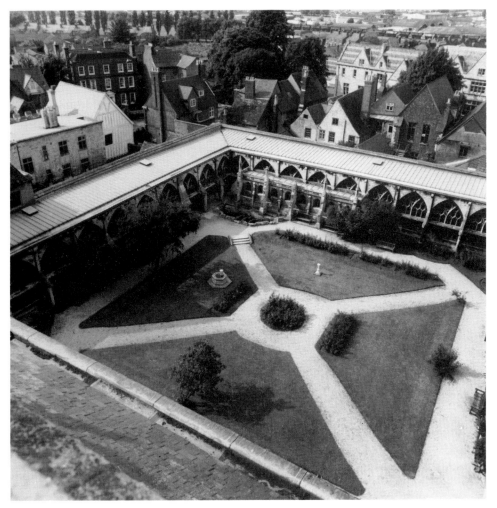

The great cloister, looking north-west

such centres as Cluny the cloister became established as the ideal way of grouping the buildings and providing access to them. By the time the Benedictines built their great abbeys in Britain following the Norman Conquest they had adopted the now established plan for the lay-out of their buildings. Any deviations from it were generally due to the peculiarities or exigencies of the site.

Christopher Brooke reflects that:

> . . . these complexes were built in the 12th and 13th centuries when no such patterns could be found in castles and palaces; no other group of buildings so complex or so uniform as monasteries seem to have existed in the central middle ages. They belong to an age and a monastic world which took community living for granted; there are virtually no private cells outside the hermit orders, just as there was virtually no privacy in a castle or a palace at this time . . . Their relationship, the articulation of church, cloister and domestic buildings, was evidently appropriate to a life of ritual – for worship in the church, for processions in the cloister, for sleeping in common, eating in common, and in the *lavatoria* often finely adorned, for washing in common. The great custumals of the 11th–13th centuries emphasise at every turn that the monastic life was a life of ritual; and for that the cloister formed a happy and appropriate centre.[5]

Somewhat unusually, at Gloucester, the great cloister is on the north side of the church, but *mutatis mutandis* the arrangement of the claustral buildings follows the usual pattern. The monks would have used the eastern door when entering the church. They could pass freely through to the choir without being interrupted by strangers because the nave was shut off by the screen and reredos of a chapel on the west side of the doorway. The Sunday and other processions, which included the circuit of the cloister and buildings opening out of it, passed from the choir through

A water spout in the great cloister, in the form of a servant holding a ewer, *c*. 1400

this east cloister door, the procession always returning into the church by the west cloister door. Then, after making a station before the great Rood, the monks passed through the rood doors in single files and entered the choir again through the *pulpitum* or choir entrance.

The east walk was a passage way between the church and the infirmary and the later abbot's lodging. It provided access to the parlour or *locutorium,* chapter house and the dormitory. The side to the garth is divided into twin bays, each containing a large window of eight lights crossed by a broad transom projecting externally like a shelf. Below this shelf the window openings were not glazed. The shelf formed a kind of awning or protection from the weather, and ensured that rain-water from the roof was thrown well clear of the unglazed openings below. It was noted in the nineteenth century that on the cloister side of the southern half of the second bay of this walk, and of the northern half of the fourth bay there were small cupboards or closets. These may have been store cupboards for books for the use of the monks when they were working round the corner in the south walk.

The south walk was shut off at the east end, and probably also at the west end, by a screen. It had ten windows facing towards the garth, each of six lights, and below the transom the lights are replaced by twenty small recesses or carrels, two to each window. Each carrel was lighted by a small two-light window and surmounted by a rich embattled cornice. There was a similar arrangement at Durham, where *Rites* describes how 'everyone of the old Monks had his carrell, severall by himselfe, that, when they had dyned, they dyd resorte to that place of the Cloister and there studied upon there books, every one in his carrell, all the afternonne unto evensong tyme. This was there exercise every daie.'[6] There is no evidence of fittings for the storage of books on the wall opposite the carrels, but the easternmost carrell may have been fitted up as a book cupboard.

The west walk, though used mainly as a passage, has a stone bench along the wall. At the north end was the frater door, and at the south end the processional door into the church. In the west wall are two doorways. The smaller, nearer the northern end, led to the court of the abbot's, later the prior's house; and the larger, at the southern end of the

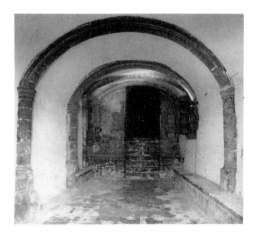

The outer parlour, or western slype, leading from
the outer court to the west walk of the great cloister

walk, opened into a vaulted passage of Norman date extending under part of the abbot's house. This was the main entrance into the cloister from the outer court. A blocked doorway in the north wall, at the east end of the passage, led into the abbot's lodging. The passage, or slype, was always carefully guarded to prevent intrusion by strangers or unauthorized persons. It served as an outer parlour, where the monks talked with strangers and visitors, and where merchants showed their wares.

The north walk was closed at both ends by screens, and must therefore have had some special use. From analogy with the arrangements at Durham there can be little doubt that this walk was where the novices gathered and were taught. At Durham the master of the novices had 'a pretty seat of wainscott . . . over against the stall where the Novices sate. And there he taught the said Novices both fore noon and after noon. No strangers or other persons were suffered to molest or trouble the said Novices, or Monks in their carrels while they were at their books within the Cloister.' On the stone bench against the wall there are scratched (now somewhat erased) the diagrams, or 'boards' of games played by the novices in their more idle moments.[7] They included 'Nine Men's Morris' and 'Fox and Geese'. See Chapter 11.

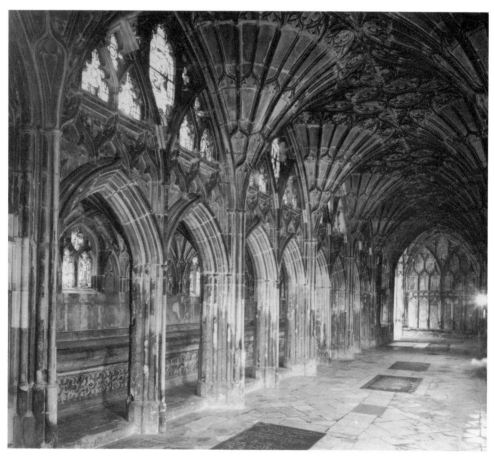

The north walk of the cloister, looking west, showing the *lavatorium* on the left

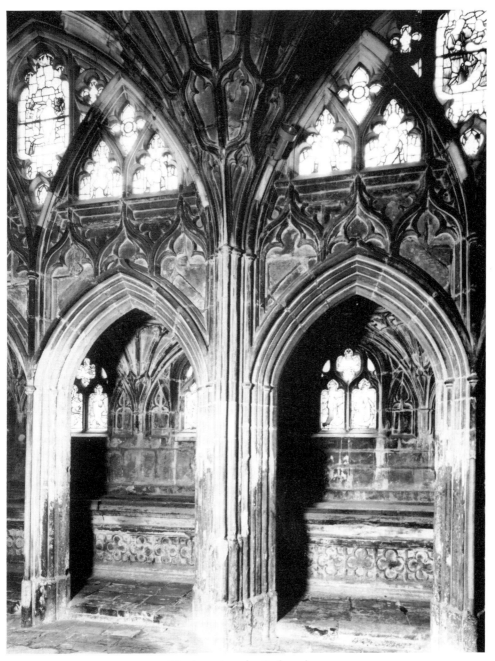

The *lavatorium*, detail of two bays

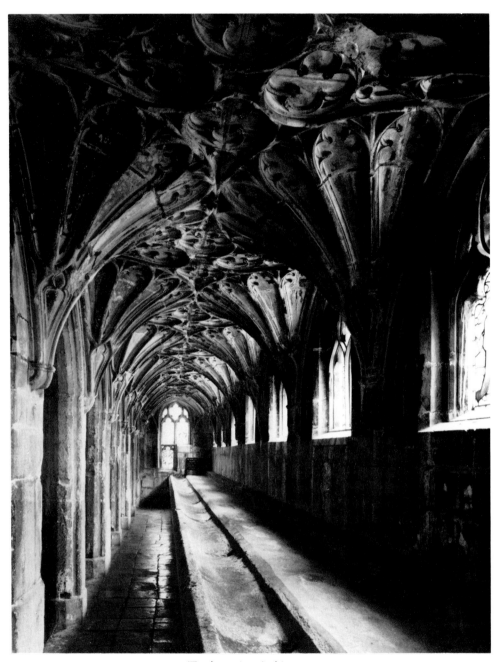

The *lavatorium*, looking east

At the west end of the north walk, occupying four bays, is a very beautiful *lavatorium*, or washing place one of the most perfect of its date to have been preserved. It projects 2.4 m (8 ft) into the garth, and is entered from the cloister walk by eight tall arches with glazed traceried openings above. Internally it is 14.3 m (47 ft) long and 2 m (6 ft 6 in) wide, and has eight two-light windows towards the garth, and similar windows at each end. One light of the east window has a small square opening below, perhaps for the water supply. Half the width of the *lavatorium* is taken up by a broad, flat ledge or platform against the wall, on which stood a lead cistern or laver with a row of taps, and in front a shallow trough originally lined with lead at which the monks washed their hands and faces. From this the waste water ran away, though outlets, to the drain in the garth outside.

Opposite the *lavatorium* is a groined recess or almery where the towels were hung. On the west side of the *lavatorium* is a curious opening in the lower part of the window, occupying two lights, with a square chase in the head, carried up vertically on the outside. It had a transom at half its height, now broken away together with the sill. If it was not connected with the supply of water to the *lavatorium*, it probably had something to do with a bell which hung in the vicinity of the frater to call the brethren to meals.

The Parlour, Vestry and Library

Entering the great cloister from the church through the eastern door the first building, on the right, is a wide barrel-vaulted passage (now housing the Treasury). The entrance to this passage from the east walk of the cloister was blocked up when the panelling was applied to the walls in the second half of the fourteenth century. A small doorway was built in the wall in 1873, but this is kept locked. Access to the passage, the eastern slype, is now through the screen in the north transept. The passage is chiefly of early Norman date, and originally of the same length as the width of the transept against which it is built. It had a wall arcade on each side of fifteen arches on the north but only eleven on the south, the space between the transept turrets did not allow more than that number. Two of the eleven arches were removed when the entrance from the transept was constructed in 1978. In the south-west corner is a hollowed bracket, or cresset stone, in which a wick floating in tallow was kept to light the passage when necessary. This is now between the security screen and the cloister door.

The towel cupboard opposite the *lavatorium* in the north walk

The drain (thirteenth century) outside the *lavatorium*

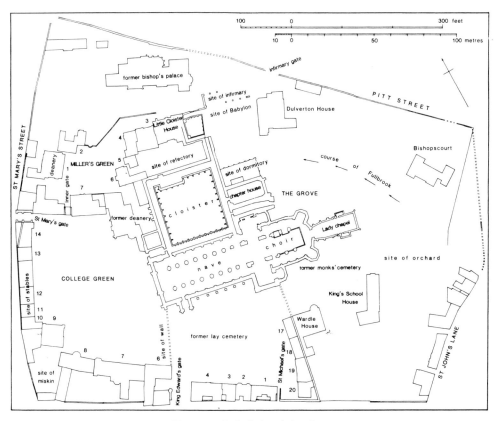

Gloucester Cathedral and the close

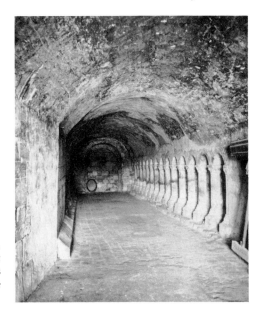

The *locutorium*, or eastern slype, looking west, *c*. 1865, before opening the doorway from the east walk of the cloisters. Since 1978 it has been used as the treasury, with an entrance opening from the north transept

In the fourteenth century it was necessary to enlarge the vestry and library which had been constructed over this passage. This entailed taking down the east end of the passage and extending it to double its former length. At the same time a vice or circular stair was built at the north-east angle to give access to the library. To prevent the new stair encroaching too much on the apse of the chapter house, the addition to the passage was deflected a little to the south instead of being carried on in a straight line. The vault of the added part is a simple barrel in keeping with the early Norman work. The use of the passage was twofold. First, it was a place where conversation was permitted. Hence its name *locutorium* or, in English, the parlour. There was a general rule of silence in the cloister itself. Secondly, it was the way the monks went out to the cemetery, as they did at Durham where:

> . . . the Monnkes was accustomed every daie, aftere thei dyned, to goe thorowgh the Cloister . . . and streight into the Scentorie garth, wher all the Monnks was buried, and thei did stand all bair-heade, a certain longe space, praieing amongs the toumbes and throwghes for there brethren soules being buryed there, and, when they hadd done there prayers, then did they returne to the Cloyster, and there did studie there bookes, until iij of the clocke that they went to evensong. This was their dalie exercise and studie, every day after they had dyned.[8]

But when the present cloister was built the original use of the slype seems to have passed away, and in the new works the arched entrance was blocked up and covered by the new panelling.

The vestry, built over the eastern slype, was entered from a stairway from the chapel on the east side of the north transept, as it still is. But before the Dissolution it was

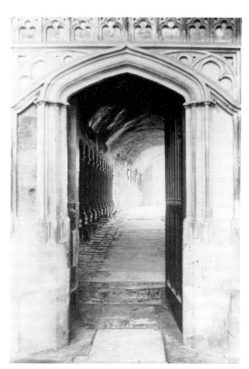

The *locutorium* through the nineteenth-century
doorway, looking east

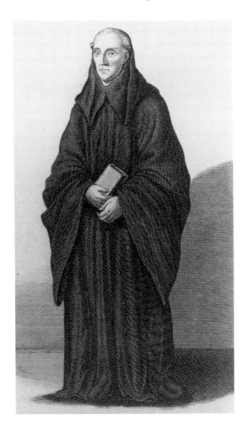

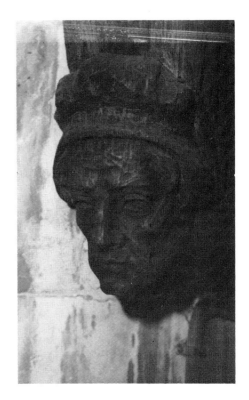

Top left: A Benedictine monk. Drawing by J. Coney in Dugdale's *Monasticon*. Top right: A wooden corbel, from the fifteenth-century roof of the library. Bottom: Abbey Register C, showing its original binding, and impress made by Anglo-Saxon leaves used as packing on the inside front cover

probably one large room where the many vestments and ornaments were kept, but all the old fittings have gone. Carter's plan shows that there were two cope chests in it. These are now in the south ambulatory. The room is now divided up by partitions.

The library, built in the fourteenth century over the vestry, retains much of its original open roof. The north side has eleven windows, each of two square-headed lights and perfectly plain, which were designed to light the bays or studies. The large end windows are late Perpendicular, each of seven lights with a transom. There are beautiful

wooden corbels from which the roof springs, which are probably contemporary with the work of the cloisters when the western stair to the library was built and the room altered. There can be no doubt that this was the library. It corresponds in position exactly with that at Durham, which is described in *Rites* as 'standinge betwixt the Chapter house and the Te Deum wyndowe, being well replenished with ould written Docters and other histories and ecclesiasticall writers.'[9]

The Chapter House and Dormitory

The next building along the east walk is the *capitulum* or chapter house. It has three bays, and originally terminated, as at Durham, Reading and Norwich, in a semicircular apse which was replaced by the present polygonal apse in the fifteenth century. The roof is a lofty barrel vault carried by three pointed arches. The vault of the apse is an ordinary lierne vault. Along the side walls, which are arcaded, may be traced the line of the stone bench on which the monks sat in chapter. The president's seat in the new apse seems to have stood on a low dais. The west end is arranged in the usual Benedictine fashion with a central door flanked originally by two large unglazed window openings, with three windows above. The lower part of this wall is the early Norman work of Serlo, and its stonework is reddened by the flames that destroyed the wooden cloister (and perhaps a temporary roof on the chapter house) in the fire of 1102. The upper part of the west end, and all the side walls and roof belong to later work, when the chapter house contained no wooden fittings to burn, for they show no signs of fire. Only one of the windows

Stone lectern at the entrance to the north ambulatory. Its purpose is uncertain, but it is probably something to do with the monks attendance in the choir rather than pilgrim's offerings at the nearby shrine of Edward II

The twelfth-century chapter house, looking west

flanking the doorway can now be seen, the other having been partly destroyed and covered by Perpendicular panelling when the new library stair was built in the south-west corner of the room.

In the normal Benedictine plan there extended from the chapter house, parallel with the cloister, a large two-storied building. The ground floor contained the common house, the treasury and other offices; but the upper floor was the great dormitory, or *dorter* as it was more commonly called, in which the monks and novices slept. At Gloucester, probably because of the contracted space on the north-east, and the proximity of the infirmary buildings, the early fourteenth-century dorter did not occupy the normal position, but was built along the north side of the chapter house. The Norman dormitory, however, may have extended northward from the chapter house, forming a second storey over the north end of the east walk of the cloister. In 1303, probably because the dorter was damaged in the fire that burned the great cloister in 1300, the Norman dorter was taken down and a new one begun. A larger dormitory was planned, and so the new building was oriented east–west along the north side of the chapter house where there was space to extend eastward. It extended some way beyond the east end of the chapter house and incorporated, on the ground floor, the reredorter or lavatory block. This has yet to be confirmed through excavations. The reredorter or, in Latin, *necessarium*, was generally built over the great drain of the monastery. At Gloucester it was probably at the east end of the dorter, or at the north-east corner of the dorter where it might also have served the infirmary. The new dormitory range took exactly ten years to build and, as the *Historia* relates, on All Saints' Day 1313, after it

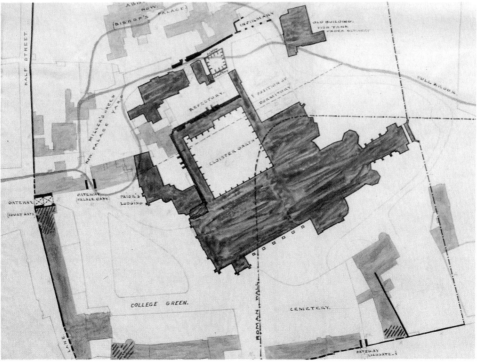

Plate 17
Top: View of the north side of the precincts from the tower (1980). Bottom: Plan of the monastic precincts, *c.* 1850

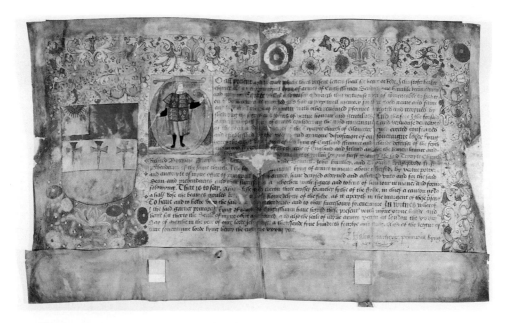

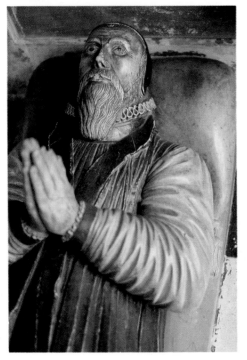

Plate 18

Top: Grant of Arms to the Dean and Chapter of Gloucester 1542. Bottom left: Godfrey Goldsborough, Bishop of Gloucester 1598–1604. Detail of effigy in north chantry chapel of the lady chapel. Bottom right: Thomas Machen, wife and family, memorial 1614

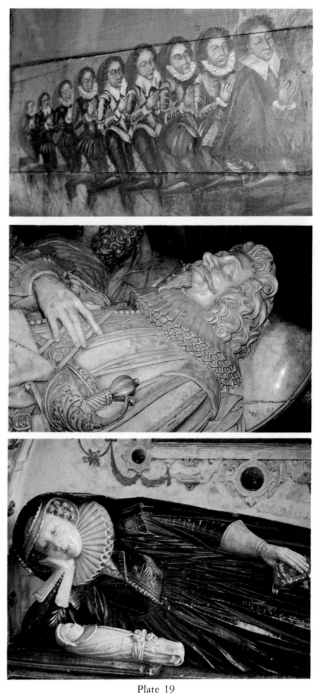

Plate 19
Top: The nine sons of John and Anne Bower (1613), south transept memorial. Middle: William
Blackleech, detail, monument in south transept. Bottom: Elizabeth Williams memorial in lady
chapel, detail

A

B

C

Plate 20
(A) The Restoration organ case, 1662. (B) The cathedral's Restoration Holy Communion plate, in the treasury. (C) Dr Abraham Gregory, Prebendary of Gloucester 1671–90

had been blessed and sprinkled with holy water by the Bishop of St David's, the monks carried their beds into it.

While reroofing the east walk of the cloister in 1964/5 it was noticed that the cones of the fan vault in the northern section were filled with rubble, indicating that this half of the cloister walk may have had a second storey 'which might have linked the monks' dormitory with the abbey buildings to the north, possibly the refectory' (Ashwell). At high level near the west end of the south wall of the dorter a blocked doorway was found and:

> . . . hidden under the chapter house roof are the remains of a stone staircase now consisting of only three steps running southwards over the top of the dorter/chapter house wall. It would seem that in addition to the main flight of stairs from ground level to the dorter floor, an additional flight ran from the dorter level to a higher level still. This flight was probably constructed after the cloister was rebuilt in order to give access to the upper storey which was located over the northern half of the east walk (Ashwell).

Later, during restoration work in 1967–8, Ashwell noticed on the east face of the east walk of the cloister the remains of a 'flat two ring arch (of 6.7 m (22 ft) span) built of fine pointed ashlar stonework.' St John Hope thought this arch was of Norman date, but Ashwell reported: 'A close examination of the masonry seems to indicate that it might be of the 14th century. . . . It is therefore possible that this arch is contemporary with the dorter.' If so, and if it relates to the width of the fourteenth-century dorter, the building was somewhat narrower and smaller than had previously been thought.

The dorter and its undercroft were destroyed shortly after the Dissolution, as being no longer required, so the plan and extent of the building are uncertain. St John Hope was unable to find any definite remains of the eastern limits of the building during his excavations in the 1870s. However, he noticed the one small fragment of the building which has survived, the window jamb with ball-flower ornament at the north-east corner of the chapter house. This was in position before the Norman apse of the chapter house was removed, for the later apse, which is square externally, has the corner cut off so as not to block the window. A decorated string course also remains along the chapter house wall, and on the west is a large blocked recess of Norman date against the cloister wall. The dorter seems to have had only one door from the cloister, at the south-west angle. As there was no other doorway north of it, this door probably opened into a sort of lobby from which a flight of stairs led up to the dorter, and other doors opened into the rooms on the ground floor. It was usual in most monasteries for a passage to go direct from the dorter to the church, to enable the monks to go to matins at midnight without going down into the cloister. But such an arrangement was not universal, and at Gloucester and Reading, both of them large abbeys, it seems the monks had to come down into the cloister to get to the church.

At Durham the dormitory still exists, a great room more than 60 m (200 ft) long and 15 m (50 ft) wide, with the remains of the *reredorter* to the west of it. Here, according to *Rites of Durham*:

> . . . all the monnks and the Novices did lye, every Monnche having a little chamber of wainscott, verie close, severall, by themselves, and ther wyndowes towardes the Cloister, every windowe servinge for one Chambre, by reasonne the particion betwixt every chamber was close wainscotted one from

another, and in every of there wyndowes a deske to supporte there bookes for there studdie . . . In either end of the Dorter was a four square stone, wherein was a dozen cressets wrought in either stone, being ever filled and supplied with the cooke as they needed, to give light to the Monks and Novices, when they rose to theire mattins at midnight, and for their other necessarye uses . . . And the mydest of the said Dorter was all paved with fyne tyled stone, from th'one end to th'other. Also the said Supprior's chamber was the first chambre in the Dorter, for seinge of good order keapt.

Under the dorter was the warming room, where a fire was kept burning through the winter. At Durham the room was also used for 'a sollemne banquett', given by the prior 'betixt Martinmes and Christinmes', and consisting of 'figs and reysinges, aile and caikes, and therof no superflwitie or excesse, but a scholasticall and moderat congratulacion amonges themselves.'

The Refectory and Cellars

In the north walk of the cloister are two Early English doors, one at the east end leading to the infirmary and abbot's lodging, and the other at the west end. The first is refaced with Perpendicular work, and the second is filled with a nineteenth-century window. This west doorway was the entrance to the great dining hall of the monks, known as *refectorium*, or in English, the frater. The frater, which was begun in 1246 on the site of the Norman refectory which was destroyed to make room for it, was a great hall nearly 40 m (130 ft) long and more than 12 m (40 ft) wide. The earlier twelfth-century refectory it replaced was 1.8 m (6 ft) narrower. As at Canterbury, Worcester and elsewhere it stood over an extensive range of cellars, formed by a central row of piers. It was reached by a broad flight of steps from the cloister and, passing up through the frater door, ended in a vestibule screened off from the rest of the hall and covered by a loft or gallery. Into this vestibule would also open the service doors from the kitchen and buttery. At the north-west corner of the refectory there was a small hall, built on a similarly vaulted undercroft, both of which survive in the range now used by the King's School Junior School (Little Cloister House), which may then have been the misericord, or dining room used by the infirm and sick in the infirmary.

During restoration work in Little Cloister House in *c.* 1967 it was found that the original roof timbers, of a simple braced-collar type of construction, were still in place in the central range. This range consisted of a vaulted undercroft, with a hall, solar and garderobe on the first floor. At the north end of the first floor hall, the *Majestas* now at the west end of the Parliament Room, was discovered. Above the present Victorian ceiling was the original ceiling of the medieval hall elaborately painted to represent stone vaulting with painted ribs, bosses and angels. The ceiling was dated by Clive Rouse to the late fifteenth century. But it was so damaged that it could not be restored and exposed. This hall was almost certainly the misericord. Ashwell reported in 1969 that it had been possible to show from fragments remaining, nearly the whole decorative scheme. 'The elaborate ceiling combined with the *Majestas* at the north end and perhaps painted walls as well must have made a very imposing room.'

Just after the Dissolution the refectory was severely damaged by fire, with 'most parte of the leade consumed.' The west end and practically all the north side was pulled down in the early years of the seventeenth century, together with the undercroft, but the south

wall, being common to the cloister, remained up to the height of its window sills. These still exist under the coping on top of the cloister north walk wall. The east end still stands to the same height. St John Hope noted that it has 'its width nearly filled by the lower parts of five broad panels (of which the central was slightly wider than the others) separated originally by detached marble shafts, and in which higher up were probably as many windows.' At the east end, then, of this great dining hall were five Early English windows, in steps down either side of the central light, filling the high gable end of the building, and along the south side, looking out over the north cloister walk, a series of similar but smaller windows. Much of the stonework of the east and south walls is reddened by the fire that extensively damaged the frater in 1540.

At the east end of the refectory at Durham, according to *Rites of Durham*:

. . . stoode a fair table with a decent skrene of wainscott over it . . . having a convenyent place at the southe end of the hie table with in a faire glasse wyndowe, invyroned with iron, and certaine steppes of stone with iron rayles of th'one syde to goe up to it, and to support an iron deske there placed, upon which laie the Holie Bible, where one of the Novicies elected by the master was appointed to read a chapter of the Old or New Testament in Latten as aforesaid in tyme of dynner . . . Ther was also at the west end of the Frater-house, hard within the Frater-house door, another door, at which the old Monks or Convent went in, and so up a greese, with an iron rail to hold them by, into a Loft which was at the west end of the Frater-house, above the Cellar, where the said Convent and Monks dined and supp'd together. The Sub-Prior sate at the end of the table as chief; and at the greese-foot there was another door that went into the great Cellar or Buttery, where all the drink stood that did serve the Prior and the whole Convent of Monks, having their meat served them in at a dresser window from the Great Kitchen through the Frater-house, into the Loft, over the Cellar. [10]

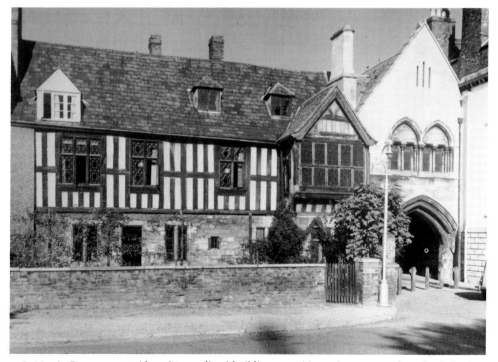

St Mary's Gateway, east side, a late medieval building on a thirteenth-century undercroft adjoins it

Gloucester probably had the same arrangement.

The stores were kept in the great cellar (or series of cellars) under the frater. During the excavations in the 1870s, it was established that the cellar, as first built, was Norman work. It was about 3 m (10 ft) high, and divided down the middle into two alleys by a row of square Norman piers, upon which rested a plain vault. There was a series of corresponding pilasters along the side and end walls. One of the responds on the south side retained its square chamfered abacus and a fragment of the springing of the vault. 'From the positions of the responds uncovered it seems that both the cellar and the Norman frater above originally included the space now occupied by the entry to the little cloister (the so-called dark cloister), part of whose wall is of Norman date. The new gable of the frater was, however, set further west, and so necessitated a re-construction of this end of the cellar' (St John Hope). The north wall of the thirteenth-century frater, on the little cloister side, has two blocked openings. The larger is an archway 3.7 m (12 ft) wide and nearly as high as originally built, through which large barrels and other bulky stores could be brought in. The smaller opening, just to the east, was a narrow doorway which opened into a passage in the thickness of the wall with three steps down at the end. At the bottom an archway on the east opened into a passage about 5.2 m (17 ft) long and over 1.8 m (6 ft) wide, which led under the entry to the little cloister to a building on the other side now destroyed. On the west of these openings are the remains of a large window.

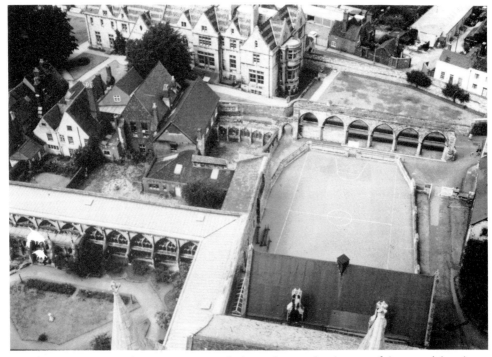

The precincts, looking from the tower towards the north-west, showing part of the great cloister in the foreground; the little cloister in the centre, and the infirmary and arches of the south arcade on the right. The nineteenth-century bishop's palace, now the King's School, is at the top of the picture

Of the buttery, pantry, kitchen and other domestic offices that served the frater no definite remains exist, nor are their exact sites known. The small stone house in Miller's Green may have formed part of, or adjoined, the kitchen at the south-west angle of the frater. Such kitchens were usually large and lofty buildings, surmounted by a pyramidal roof, as in the case of the monastic kitchens at Ely and Durham, each about 10.7 m (35 ft) square, and the splendid abbot's kitchen at Glastonbury which is of the same area. At Gloucester one of the buildings west of the frater was a larder, as is evident from an agreement made in 1318 with St Oswald's Priory.

THE CATHEDRAL CLOSE

The old walls of the abbey remained intact at the Dissolution. They were first breached on the east side, near St John's Church, in 1626 when one of the tenants, Abraham Blackleech, was given permission to make a gateway 'through that parte of the Collidge walle that is towards St Johns Church.' The Dean and Chapter were nervous about this breach, and stipulated in the agreement that if 'there shall appeare any inconvenience, detriment, or scandall, to the said Cathedral Church by means of the openinge of that passage' it shall be closed up again. A new entrance, with a wicket gate, known as the infirmary gate was made in the north wall, east of the bishop's palace, by 1673. The room over King Edward's gate in College Street was leased as a dwelling until it was demolished in 1805/6. The east side of the gateway, attached to 5 College Green, was taken down in 1892, together with the adjoining house, so that College Street could be widened. Only the west side of the gateway survives. St Mary's Gateway was leased to the Chapter Clerk in 1600, and used in part as a dwelling, but also as an office 'for the expeditinge and dispach of the business of the church, And for the safe keeping of the Records, evidences and ledger-books of the same.'

The bishop was given the abbot's lodging on the north side of the precincts, and the dean the prior's lodging (Church House). Other buildings were assigned to the six prebendaries, the minor canons, the choristers and the master of the college school. Housing was also provided for the almsmen and other servants of the cathedral. The houses had to be adapted for domestic occupation. Medieval halls were divided into two floors, staircases built and windows enlarged. There are fragments of medieval buildings incorporated into a number of the properties around the precincts. For example, part of the infirmarer's lodging, or St Bridget's Chapel, is incorporated into Dulverton House, and remains of the abbey kitchen, which survived into the eighteenth century, were incorporated into 3 Miller's Green. As already noted, a substantial part of the *misericord* lies between 3 Miller's Green and the house on the west side of Little Cloister. The latter, as well as Dulverton House, were occupied by two of the prebendaries, the other four residing in the great court, in properties on the site of Community House, and Nos 14, 7 and 8 College Green.

Properties built for tenants included houses on the site of, and now incorporated into, the King's School House in the late sixteenth century, and along the west side of St John's Lane, begun by 1649. The upper churchyard was still used for burials and remained rough ground until 1616 when building began. By 1649 houses had been built along the east wall (from the south transept to St Michael's gate), and along the

south side between the two gates. The great court (the lower churchyard) had two prebendal houses on the south side which were remodelled in the early seventeenth century and again altered in the late nineteenth century. In the late seventeenth century new brick houses were built including Parliament House (7 Miller's Green) in *c.* 1670 on the site of the old workhouse and school room, and Cathedral House (Wardle House) on the east side of the Upper Churchyard *c.* 1690. Another house which dates from this period is 6 Miller's Green, with its fine façade, and a little later one of the most imposing houses in the precincts, 9 College Green, was built *c.* 1707. But this is to anticipate the changes which were to take place not only in College Green (the Close) but also in the cathedral in the following centuries.

CONTINUITY AND CHANGE
1540–1616

> *'Except Westminster Abbey no convent escaped*
> *the Reformation so well.'*
> John Loveday of Caversham, 1736

The long history of the Abbey of St Peter, Gloucester came to an end with the surrender of the monastery to Henry VIII's commissioners on 3 January 1540. The Charter creating the new diocese of Gloucester alludes to the abuses which led the king to close the monastery:

> Whereas the great convent or monastery, which, whilst still in being, was called the monastery of St Peter of Gloucester . . . and all and singular its manors . . . and possessions, for certain special and urgent causes were, by Gabriel Morton, Prior of the said abbey or monastery and the convent thereof, lately given and granted to us and our heirs for ever . . . We, being influenced by divine goodness, and desiring above all things that true religion, and the true worship of God may not only not be abolished, but entirely restored to the primitive and genuine rule of simplicity; and that all those enormities may be corrected into which the lives and profession of the monks for a long time had deplorably lapsed, have, as far as human frailty will permit, endeavoured to the utmost that for the future the pure word of God may be taught in that place, good discipline preserved . . .

The king also explained his reasons for deciding to save the ancient abbey from almost certain ruin while leaving other monasteries in the area to become quarries for building material. He considered the former abbey church a 'very fit and proper place' to be preserved 'considering the state of the said late monastery in which many [sic] famous monuments of our renowned ancestors, Kings of England, are erected . . .' Since the only monument in the church to one of Henry's 'renowned ancestors, Kings of England' is that of Edward II, whoever drafted the Charter was either ill-informed, or he included the crowned head of Osric, Prince of Mercia, and even Duke Robert of Normandy among the king's illustrious ancestors. But he may have used the term monument for 'anything that by its very survival commemorates a person, action, period or event.' The

Left: Indulgence of St James of Compostella, probably printed at Burgos in 1503. Above: A fragment of an English Indulgence printed by Wynkyn de Worde, probably in 1511

word was so used as early as 1530, according to the *Shorter Oxford Dictionary*, and therefore could be applied more widely to include, for example, the array of kings in the clerestory windows of the choir. At all events the decision in 1541 to establish a new diocese of Gloucester preserved the abbey church and a good many of its claustral and precinct buildings from destruction. The abbeys of Winchcombe, Evesham, Hailes and Cirencester were not so fortunate for they were left to the same fate as so many monasteries all over the country. Even so some of the old monastic buildings at St Peter's, such as the monks' dormitory, were pulled down as being no longer required.

In place of the abbot and prior, the *Henrician Statutes*, dated 5 July 1544, provided for a dean and six prebendaries.[1] In the words of the Charter: 'We also will and ordain that the said Dean and Prebendaries and their successors, shall for ever hereafter be called the Dean and Chapter of the Holy and Individed Trinity of Gloucester.' The dean and prebendaries were appointed by the Crown and given responsibility for the worship of the cathedral church, and for ensuring the proper repair and maintenance of the cathedral and precinct buildings. The first dean was William Jennings, one of the king's chaplains and the last prior of the nearby Augustinian priory of St Oswald. The priory had been dissolved in 1536 when there were only seven canons and eight servants remaining in the house. The church itself was in a ruinous state, but the living quarters were in good condition. The former prior held his new office of *decanus* or dean in

plurality with five other livings (i.e. parishes), and remained in office for twenty-three years through some of the most turbulent years of English history. It was said he 'changed his opinions with the circumstances.' His name appears with three of the prebendaries, Richard Browne, Edward Bennet and John Huntley, on the Grant of Arms by the king to the cathedral church in 1542. This document with its coat of arms drawn by Christopher Barker, Garter King of Arms of England, is kept in the cathedral library. Jennings died in 1565 and was buried 'before the choir door'.

A DECADE OF CHANGE 1539–1549

The first bishop of the new diocese was John Wakeman, the last Abbot of Tewkesbury. He remained in office until his death in 1549. One of the duties of the new bishop was to carry out a Visitation of the cathedral every three years.[2] His Visitation in May 1542 gives a fascinating insight into the problems that arose during the transition from monastic life to the new cathedral order. Since all concerned, the bishop, dean and prebendaries shared a monastic background, it was a matter of their adapting to the new regime. The prebendaries (or canons) who were present at the Visitation were Thomas Kingeswood, Henry Wyllys, Richard Browne, and John Huntley. They were asked whether 'the divine services were duly observed according to mode and form as they ought to be.' One of their number replied that 'Prime and other hours are not sung canonically.' Another confirmed that 'Prime, terce, sext and none are wanting.' They complained that a shortage of certain books, antiphonals and processionals, was causing difficulties. Many of the old service books would have been removed and others burnt, and as yet there was no authorized alternative. Apart from the monastic *Hours*, there were no rites or forms of service for them to use. It was not until 1549, ten years after

John Wakeman, last Abbot of Tewkesbury, first Bishop of
Gloucester 1541–9

the monastery was dissolved, that the first *English Prayer Book* was issued attached to an Act of Uniformity requiring the clergy to use the new book from 1 November of that year. In the meantime, with many of their old service books removed, they had no idea what forms to follow. Asked whether the stipendaries performed their duty in a proper manner, and whether they 'go into the choir with a modest demeanour', Prebendary Kingswood replied 'No, for as much as they come in too wanton and dissolute a dress [*habitu*], with daggers, even long ones, quarrelling and chiding with one another.'

Other questions concerned the responsibilities of the clergy for teaching and preaching, and the furnishings of the church. The parochial as well as the cathedral clergy were to stress the 'abolishment of the pretensed power of the Bishop of Rome, and the diligence of all persons and at all times in the year in their sermons to declare the same. And that the king's majesty's power in his realms and dominions is the highest power in earth under God.' They were to ensure that 'All persons . . . have one sermon every quarter of the year at the least . . . purely and sincerely declaring the words of God dissuading their hearers to credit any fantacies devised by man's tradition.' Sermons were now to be an essential part of the Communion Service. 'After the Crede ended, shall folowe the Sermon or Homely, or some portion of one of the Homelyes, as their shalbe herafter dericted' (1549). 'After the Crede, if there be no sermon, shal follow one of the homelies already set forth, or hereafter to be set forth by commune aucthoritie' (1552). If the clergy could not preach themselves they were to use a homily from the *Book of Homilies*, which contained twelve homilies, and was first agreed by Convocation in 1542 and published in 1547.

They were to see that 'all persons . . . every holyday when they have no sermon immediately after the Gospel openly recite to their parishioners in the pulpit the *Pater noster*, the *Credo*, and the Ten Commandments in English, exhorting all householders to teach their children and servants the same.' They were to ensure that 'there be now in every church one book of the Bible in English of the largest volume commodiously set in some part of the church, and whether there be any that have denied, interrupted or letted the quiet and sober reading thereof.' And further that 'all images, shrines and the like things misused in time past by the which superstition and hypocrisy crept in diverse men's hearts be clean abolished.' They were asked whether 'there be any lights used in the church as set before any image or in any place thereof other than two lights upon the high altar before the sacrament.'

Appointments and Duties

Bishop Wakeman's Visitations revealed the need for more specific instructions about the duties and responsibilities of the clergy. In 1544 by command of the king, there were issued *Statutes and Orders for the better Rule and Government of the Cathedral Church*. These laid down that the dean was to be of good life and reputation, not only learned and skilful in sciences, but holding a degree of doctor of divinity, bachelor of divinity or doctor of law. He was to rule and govern the cathedral church 'according to the statutes and ordinances of the same, so far as they agree with God's word, and the laws of this realm.' He was to preserve and keep all the goods, lands and tenements belonging to the church. He was to ensure that 'divine services be performed with all decency, that

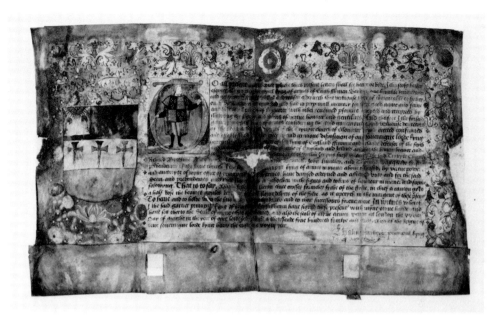

The Grant of Arms to Gloucester Cathedral, 1542

sermons be preached upon days appointed, and that children be profitably instructed, that alms to the poor be distributed and that all persons do faithfully discharge those duties wherein they are entrusted.' Further, he was to keep and preserve the treasure and ornaments of the church, the vestments, charters, muniments, court-rolls etc belonging to the church. He was to visit once every year and thoroughly inspect 'the manors, lands, tenements, houses, edificies, groves, woods and underwoods' belonging to the cathedral church. He was to see that where necessary rebuilding work and repairs were carried out so that there was no deminution of income from the property. Within eight days of his return from his travels he was to 'lay all these things before the other canons then present, and to give up his account in writing.' For this Visitation he was allowed 4s. a day for expenses. The dean could be absent from the cathedral only for royal or parliamentary or convocation duties, though under the Statutes he was given leave to be absent for one hundred days a year to 'mind his parochial concerns and other benefices if he hath any, and to dispatch his own other private business.'

Similarly, canons or prebendaries were to be 'of good name, not only learned and skilful in the scriptures, but dignified with some title of learning, either a professor of divinity, or a bachelor of divinity, a doctor of law or a master of arts, or at least a bachelor of law.' They too were excused residence only for royal duties, or for cathedral business, though they were allowed to be absent for eighty days a year 'to visit their cures or other benefices, if they have any, and to mind their own private concerns.' They were charged to preach regularly, especially in the cathedral church (though also further

afield without loss of emoluments). Between them they were to ensure that 'almost no one Lord's Day in the whole year shall be without a sermon.' The dean was to preach 'in the English tongue' every year at Easter, upon Corpus Christi and at Christmas.

The *Statutes and Orders* cover every aspect of the qualifications and appointment, duties and responsibilities of all involved in the life of the cathedral:

> We decree and ordain that there be for ever in the said church one dean, six canons, six minor canons, whereof one shall be sacrist, another deacon, another sub-deacon; six lay-clerks, one master of the choristers, eight choristers, two masters to instruct the children in their grammar, whereof one shall be the head master, the other under-master; four poor people to be maintained at the charges of the said church, two under-sacrists, two door-deepers, who shall also be virgers; one butler, one cook and one under-cook.

Communal Living

This reference to a cook and undercook is of particular interest in relation to what the *Statutes and Orders* lay down concerning the Common Table.[3] 'We ordain and will that all the resident canons shall live apart with their several families, and shall so dispose of their revenues which they shall receive by our liberality to good purposes, that they may not seem to have sought shifts and excuses for their covetousness . . .' But if a canon was of 'very limited means (£40 of constant yearly rent, beside the salary of our church, all his payments being deducted), he need not maintain his family apart', but 'go to the table of the dean, or some canon or minor-canon within the circuit of our church.' For those who, as monks, had always been accustomed to living in community and eating their meals together, this would have seemed the natural and right thing to do. If one of the brethren had not the means of supporting a separate establishment, then he was the care of the others. However, 'if there be more canons in this circumstance they may maintain a common table of their own. All who thus living together at a common table shall be esteemed but as one resident, and shall receive out of the common dividends, but so much as one of them who maintain their families apart.' For some time after the Dissolution there was a certain amount of sharing accommodation and communal living, though most members of the College, that is of the cathedral foundation, lived in parts of former monastic properties around the precincts, which were divided up and adapted for their use.

The *Statutes and Orders* provided for the possibility of communal living for all members of the College: 'those who live together and praise God together in the choir, may also eat together and praise God together at table, We ordain and will that as well as the minor canons and officers in the choir as the teachers of the grammar scholars, and all other inferior officers in our church, and the children who learn to sing, shall feed together in the common hall, if it may be conveniently done.' To this end it was further ordered that 'the dean do make choice of, and admit as butler, or manciple, an industrious man, who at seasonable hours, shall supply with bread and drink those who eat at the common table. The dean shall also chose a cook and an under-cook who shall diligently provide the meat and drink for the table of those who eat together.' For this reason the old monastic refectory, with the adjoining kitchens, was not pulled down at the Dissolution but left for communal use until the building became unsafe in the early

The Communion.

The priest standyng humbly afore the middes of the Altar, shall saie the Lordes prayer, with this Collect.

ALmightie GOD, vnto whom all heartes bee open, and all desyres knowen, and from whom no secretes are hid: clense the thoughtes of our heartes by the inspiracion of thy holy spirite: that we may perfectly loue thee, and worthely magnifie thy holy name: Through Christ our Lord. Amen.

Then shall he saye a psalme appointed for the introite: whiche psalme ended, the priest shall saye, or els the Clearkes shal syng.

iij. Lorde haue mercie vpon vs.
iij. Christ haue mercie vpon vs.
iij. Lorde haue mercie vpon vs.

Then the Priest standyng at Goddes borde shall begin.

Glory be to God on high.

The Clearkes.

And in yearth peace, good will towardes men.

We praise thee, we blesse thee, we worship thee, we glorifie thee, wee geue thankes to thee for thy greate glory, O Lorde GOD heauenly kyng, God the father almightie.

O Lorde the onely begotten sonne Jesu Christ, O Lord GOD, Lambe of GOD, sonne of the father, that takest awaye the synnes of the worlde, haue mercie vpon vs: thou that takest awaye the synnes of the worlde, receyue our praier.

Thou that sittest at the right hande of GOD the father, haue mercie vpon vs: For thou onely art holy, thou onely art the Lorde. Thou onely (O Christ) with the holy Ghoste, art moste high in the glory of God the father. Amen.

Then the priest shall turne hym to the people and saye.

The Lorde be with you.

The aunswere.

And with thy spirite.

The

The Communion. Fol. cci.

The Priest.

Let vs praie.

Then shall folowe the Collect of the daie, with one of these two Collectes folowyng, for the kyng.

ALmightie God, whose kingdom is euerlasting, and power infinite, haue mercie vpon the whole congregatiō, and so rule the heart of thy chosen seruaũt Edward the sixt, our kyng and gouernour: that he (knowyng whose minister he is) maye aboue all thinges, seke thy honour & glory, and that we his subiectes (duely consydering whose auctoritie he hath) maie faithfully serue, honour, & humbly obeye hym, in thee, and for thee, accordyng to thy blessed word, and ordinaunce: Through Jesus Christe oure Lorde, who with thee, and the holy ghost, liueth, and reigneth, euer one God, worlde without ende. Amen.

ALmightie and euerlasting GOD, wee bee taught by thy holy worde, that the heartes of Kynges are in thy rule and gouernaunce, and that thou doest dispose, and turne them as it semeth best to thy godly wisedom: we humbly beseche thee, so to dispose and gouerne, the heart of Edward the sixt, thy seruaunt, our kyng and gouernour, that in all his thoughtes, wordes, and workes, he maye euer seke thy honour and glory, and study to preserue thy people, committed to his charge, in wealth, peace, and Godlynes: Graunt this, O mercifull father, for thy dere sonnes sake, Jesus Christ our Lorde. Amen.

The Collectes ended, the priest, or he that is appointed, shall reade the Epistle, in a place assigned for the purpose, saying.

The Epistle of sainct Paule written in the Chapiter of to the.

The Minister then shall reade the pistle. Immediatly after the Epistle ended, the priest, or one appointed to reade the Gospel, shall saye.

The holy Gospell written in the Chapiter of. The

The Prayer Book of 1549

seventeenth century. It was used for some time as a communal eating place for the school, by both masters and boys, and by unmarried or impoverished members of the College, by singing men and minor canons.

Liturgical Changes

Since they were no longer monks the cathedral clergy were under no obligation to rise early for the offices of the *Opus Dei*. Gradually a new pattern of daily worship was established containing elements of the monastic offices, which were enshrined and enforced upon the clergy with the issuing of the 1549 *English Prayer Book*. The record of Bishop Wakeman's Visitations, particularly in 1548 to the parishes of the diocese, reveals the full extent of the changes which were taking place throughout the country as a result of Archbishop Cranmer's directives. He had made it clear that there were to be no more than two lights on the high altar, and that the ringing of bells at the words of consecration in the Mass was to cease. Chantries were suppressed, private Masses and prayers for the dead discontinued, and most church ornaments, such as lamps, censers, candlesticks, bells, crosses and vestments, prohibited. All images were to be removed and wall paintings erased. All this was in accord with the *Injunctions of Edward VI* of

1547 when parish authorities had been ordered to 'take away, utterly extinct and destroy all shrines, coverings of shrines, all tables, candlesticks, trindles or rolls of wax, pictures, paintings and all other monuments of feigned miracles, pilgrimages, idolatry and superstition; so that there remain no memory of the same in walls, glass windows, or elsewhere within their churches or houses.' As a result in some churches stained glass was destroyed and replaced with clear glass, in others windows were taken out and kept for possible reinstatement or for use in repairs. Wall paintings were destroyed by scrapping the pigment from the stone or plastering over them, and countless medieval carved figures of the saints were taken out of their niches and smashed.

With the issuing of such radical orders, there can be little doubt that considerable damage was done to the fabric and furnishings of the cathedral, particularly during the episcopate of John Hooper. What was far more difficult to 'order' was a change of heart and mind as to what the priest believed he was doing, for example, when he celebrated the Mass. These were years of confusion and uncertainty as the old beliefs, attitudes and convictions were replaced by what was called the 'new thinking'. This is reflected in the answers to questions in Bishop Wakeman's Visitations in 1548. The canons of the cathedral informed on each other, as they had been encouraged to do in monastic days, as to each other's intention when consecrating the sacred elements of the Eucharist. Richard Browne, the sub-dean, complained that 'at the instigation of Roger Tilar . . . the mode and order of the consecration of the Eucharist are changed . . .' Browne doubted 'whether Tilar has intention of consecration.' Another member of the cathedral chapter complained about the theological convictions and behaviour of Roger Tilar who

Thomas Cranmer (1489–1556), Archbishop of Canterbury

'by his own rash authority does not observe the due form and mode and order specified . . . as regards the consecration of the Eucharist, and similarly we have the canonical hours in use otherwise than we are accustomed.' But other more cautious and charitable members of the Chapter, in response to similar questioning, commented that there had been 'certain alterations as regards divine offices . . . the instigator is unknown.'

While, in many respects, there was continuity in the faith and worship of the church during this time, profound changes were on the way. These were to prove as radical and rapid as the Church in England had ever faced. Much that had been so familiar for so long was swept away almost overnight. Cranmer's purpose was to simplify the forms of worship; the old services had become so complex with rules and rubrics that even the clergy found difficulty in following what was proscribed. He also wanted to give the people a liturgy in their own language. If the people were to take an intelligent part in the services they could no longer be in Latin. Cranmer was also determined to restore the primitive practice of administering the Holy Communion in both 'kinds', that is of giving the faithful the consecrated bread and wine, which had been withheld from them for so long. The Eucharist was to become the people's thanksgiving for the benefits of the death and resurrection of Christ, and their participation in the act of remembrance which he ordained. And, with the Bible now translated into English and set up in churches throughout the land, Cranmer realized the importance of encouraging the people to read the Bible for themselves, and to listen to expository sermons.

A REFORMING BISHOP 1550–1554

When John Wakeman, the first Bishop of Gloucester died in 1549, there was an interregnum until Archbishop Cranmer consecrated John Hooper at Lambeth in 1551. Hooper was a former Cistercian monk at Cleeve in his native Somerset. At the Dissolution he went to London where he read the works of Zwingli and Bullinger, and becoming convinced of the truth of their reformed doctrine, he returned to Oxford. But he was forced to leave the country, and went first to Paris, and then to Strasbourg and Zurich where he made many friends among the reformers, notably Bucer and Laski. Soon after the accession of Edward VI in 1549 he returned to England and became chaplain to the Protector Somerset. His preaching drew large congregations and provoked considerable controversy. In July 1550 he was offered the see of Gloucester, but his consecration was delayed by Hooper's refusal to take the oath with its reference to saints and angels, and by his refusal to wear vestments. For refusing the rochet he was committed to Fleet prison in London in January 1551. But he gave way and two months later he was consecrated by Cranmer at Lambeth, the London home of the Archbishops of Canterbury.

Hooper worked tirelessly to establish reformed doctrine and practice in the diocese. He preached three or four times a day, and kept open house for the poor. He drew up fifty-two *Articles of Religion* to which he required the clergy to submit, and later issued thirty-one *Injunctions*. He ordered stone altars to be taken down and 'an honest table decently covered' to be erected 'in such place as shall be thought most meet.' He forbade the use of lights 'on the Lord's board', the elevation of the host, the ringing of sacring, or sanctus bells, worship of the saints, and prayers for the dead. He instructed the clergy

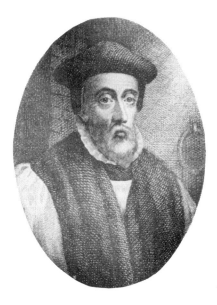

John Hooper, Bishop of Gloucester *c.* 1555

to urge their people to come frequently to Holy Communion and to receive both the bread and the wine. He ordered the clergy to preach every Sunday and on festival days, and to catechize the children in the afternoon. He made it clear that the marriage of the clergy was 'holy and agreeable to the Word of God.' He ordered that all rood lofts, screens, tabernacles and sepulchres should be removed, all images painted on the walls be defaced, and when glass needed to be repaired or replaced no saint should be portrayed. When he examined the clergy he found that 168 were unable to repeat the Ten Commandments, 31 were unable to find them in the Bible and 41 were unable to say where the Lord's Prayer could be found, and of these 31 did not know the Lord was the author of the *Pater noster*. He charged the clergy to spend more time in reading and studying, and less in hunting and hawking.

Early in 1552 Hooper was translated to Worcester on the understanding that he could hold the see of Gloucester *in commendam*. For a while the diocese of Gloucester became merely an archdeaconry within the diocese of Worcester, the income of the see being appropriated by the Crown. Hooper found greater resistance to his reforming zeal in Worcester where he was strongly opposed by two of the cathedral canons. He longed to return to Gloucester and to continue his work among the clergy of the diocese which he had begun with such enthusiasm. But following Edward VI's premature death, and the accession of Mary, Hooper was deprived of his see (20 March 1554), and after a year of imprisonment was condemned as an obstinate heretic and sent to Gloucester to be burnt. He died outside St Mary's Gate on 9 February 1555 'for the example and terror of others such as he hath there seduced and mistaught.'

One of the few indications of the attitude of the Dean and Chapter to these events and to the reforming zeal of the bishop lies in a citation dated 25 February 1553 requiring them to appear in the Consistory Court to 'allege the cause or causes why they had not certified nor caused to be certified, with regard to their execution of the mandate of the bishop or rather in truth that of the king, respecting the appearances of the Chapter in

The burning of John Hooper, 9 February 1555, outside St Mary's Gate. From Fox's *Book of Martyrs*, 1563

the convocation of the clergy . . .' As a result of their not appearing on this occasion they were pronounced by the judge, Chancellor Williams, 'contumacious and suspended from the execution of any office which should be performed by them, and their suspension is to be made known in the convocation.' Even before the death of Hooper, Queen Mary had appointed James Brookes, formerly chaplain or almoner to Bishop Gardiner and a zealous papist, to the see of Gloucester. He was to act as the papal delegate at the examination and trial of Cranmer, Ridley and Latimer. Latimer, Bishop of Worcester, and Ridley, Bishop of London, were burnt together under the walls of Oxford on 7 September 1555. As they stood together, bound to the stake, Latimer said to Ridley: 'Play the man, Master Ridley, for we shall this day light such a candle in England, as by the grace of God shall never be put out.' Archbishop Cranmer was forced to witness the burning; six months later he suffered the same fate.

 Changes of a different kind now took place in the diocese. Between 16 May 1554 and 19 April 1555 fifty-four of the clergy were deprived of their livings, probably because they had married. Some left their wives and were reconciled to the Church, but none of them suffered death during the Marian persecutions. Though Brookes was a prominent Catholic he showed little zeal in administering the statutes against heretics. As a result there were few victims in Gloucestershire as compared with other parts of the country.

Queen Mary I, born 1516, Queen of England, 1553–8.
Portrait by Hans Eworth, 1554

However, a Gloucester bricklayer and a blind boy were burnt to death in 1555, but no more than a handful of others in the south of the diocese. Elsewhere the burnings, which had begun with Hooper and Prebendary Rogers of St Paul's Cathedral, went steadily on at a rate of about ten a month until the queen's death in November 1558. The persecution was at its fiercest in London, the see of the rough and harsh Bishop Bonner, and in Canterbury where Pole had succeeded Cranmer.

THE ELIZABETHAN SETTLEMENT 1558–1603

When Mary died she was succeeded by her sister Elizabeth who had spent the previous five years in almost continual peril of her life. She was the daughter of Henry VIII and Anne Boleyn, and a young women of twenty-five when she inherited all the problems of a bitterly divided country. The Catholic party was still in power, and the large majority of the people were professing 'the old religion'. But she knew her sister had made the name of Rome odious, and that there was a powerful and active body of Protestants, some in exile and some at home who were ready to rush in and reverse, if not avenge, all that Mary had done if she gave them any encouragement. On the other hand any sudden and radical alteration of the status quo with all its tensions and dangers, might produce serious reaction from Philip of Spain, the late queen's husband, who had profited

considerably from her alliance for four years. Elizabeth's personal predelictions, like those of her father, were in favour neither of Romanism nor of Protestantism. She did not intend being a slave of the Pope, nor the tool of the zealots who had embraced, during their exile on the Continent, the doctrines of the Swiss and German reformers. At the same time she wished to offend neither Catholic nor Protestant, but to lead them both into the *via media* of an English Church which would be both orthodox and independent. She was not a woman of any depth of personal piety or fervent zeal, and she hoped that it might be possible to make others conform, without much difficulty, to the Church which offered the happy mean between the two extremes.

But the task was not to prove as easy as she thought. Antagonism and convictions on both sides were deep as well as mistrust and suspicion. Matthew Parker, the new Archbishop of Canterbury, proved a wise and godly man who did his best to guide the Church of England through the crisis. In the short term Elizabeth's attempts to dampen controversy served their purpose, but by the middle years of her reign they led to a weakening of the Church which simultaneously earned it the contempt of idealists and aroused hopes of anti-clerical victory on the part of those elements in society which were either covetous of ecclesiastical endowments or resentful of ecclesiastical authority. The 'quiet men' whom Elizabeth chose as bishops in her earlier years, like Richard Cheyney at Gloucester (1561–79), proved incapable of maintaining discipline in their dioceses, and with indiscipline came corruption, scandal and sometimes violence. Belatedly the Crown recognized the need for tougher men and tougher policies, and under James I and Charles I the effort to re-establish ecclesiastical authority both among the clergy and over the laity came to be personified by William Laud, whose decisions and attitude while Dean of Gloucester (1616–21) foreshadowed the policies which he pursued as Archbishop of Canterbury after 1633, and which led to the overthrow of episcopacy in the Civil War.

On Elizabeth's accession the see of Gloucester was vacant, and remained vacant until 19 April 1562 when Richard Cheyney was consecrated bishop. The reason for the long interregnum was that in 1558, on the death of Bishop Brookes, John Bourchier alias Bowser the last Abbot of Leicester, was nominated as Bishop of Gloucester but he failed to obtain possession of the see before the death of Queen Mary. The Patent Roll of 1558 styles him as *episcopus nominatus*. Meanwhile in the summer of 1561 there was a Metropolitan Visitation of the Dean and Chapter, Matthew Parker being Archbishop of Canterbury. Though records of the Visitation have survived they throw little light on the affairs of the Dean and Chapter at the time, or the condition of the cathedral church. The Episcopal Visitation of 1565 noted that the dean, William Jennings, was excused from attending 'on account of the infirmity of his limbs'. He died on 4 November 1565. But records of later Visitations, notably in 1576, 1580, 1594 and 1595, reflect the general state of laxity and lawlessness which prevailed in many of the dioceses during the middle and later years of Elizabeth's reign.

The account of Bishop Cheyney's Visitation in 1576 paints a vivid picture of life in College Green, as the Close at Gloucester came to be called. Laurence Humphrey was the dean. Like his predecessors he occupied the Prior's House adjoining the west end of the cathedral which was still being adapted and extended to provide more adequate accommodation for the dean and his family. Thomas Perry was the sub-dean, and Arthur Sawle, John Angell and William Shingleton prebendaries. Tobias Samforde was

the schoolmaster, and Francis Peerson the usher; David Walter, John Henbury, John Warde and Richard Jones clerks and minor canons. The singing men are also named; Robert Draper, Robert Hollande, Thomas Woodcocke and Henry Hinston, and the almsmen Robert Elliotts and Thomas Coston. Brian Fairefax was one of the sacristans and John Prycharde one of the janitors. Thomas Harvey was the butler and John Taylor 'sub-cook'. The old monastic kitchens and the monks' refectory were still in use providing meals for members of the school and single members of the College. This was by no means the full complement of the members of the College, or the full list of servants of the Dean and Chapter. Some had houses allocated to them in the precincts, but many of the poorer families and single men lived in tenements formed in what had survived of the old monastic infirmary.

Robert Lichfelde (or, Lichfield) was master of the choristers and organist. He was the first organist whose name is recorded, and he appears to have been appointed c. 1562. The earliest reference to him is probably the entry of his marriage in St Nicholas Church on 10 December 1579. He lived in a property in Westgate Street rented from the Dean and Chapter. When he died on 6 January 1583 he left his musical instruments, books and other goods to his wife and two daughters, and 6s. 8d. to 'the company of the quoire' and a similar sum to the bellringers. He was buried in the south transept of the cathedral, at the angle of the south aisle, where a small inscribed stone marks the place. The original mutilated stone was removed to the Gallery Exhibition in 1981. It reads 'Here lyeth under this marbel stone, Robart Leichfi . . . Organist and Maister of the Choresters of this Cathedral Church 20 years. He dyed the 6 of January 1582.' A 'pair of organs' and other musical instruments were in use in late monastic times and probably in the years immediately after the Dissolution, but it is not known whether these were

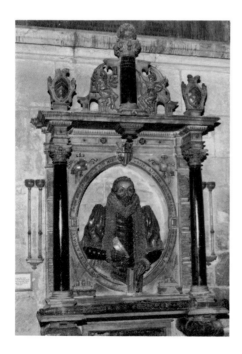

Memorial to John Jones, registrar to the bishops of
Gloucester, c. 1630

all that Robert Lichfield had to accompany the choir. The smaller 'Chaire' organ on the east side of the great organ may date from as early as 1579, but this is by no means certain.

Conflict and Contumacy

Dr Laurence Humphrey had been appointed Dean of Gloucester in 1570. At the time he was the Regius Professor of Divinity in the University of Oxford. During the years of Mary's reign he had gone abroad, living chiefly at Zurich where he joined the English reformers. On returning to Oxford he became widely known for his strong Calvinistic leanings, and was said to be one of the most persuasive and eloquent preachers of his day. In 1580 an archipiscopal Visitation revealed a scandalous state of affairs at Gloucester, presumably due to the dean's constant absence. There was great slackness, absenteeism, inefficiency and even dishonesty in the financial affairs of the Chapter. But in the same year (1580) the dean was offered and accepted the deanery of Winchester. This preferment was surprising since he, with most of the prebendaries, had refused 'on account of the reverence due to his dignity' to appear before Archbishop Grindal's commissary at the archipiscopal Visitation (1580). They were all 'pronounced contumacious and suspended from all benefits of this church until they should duly fulfil due obedience to the said reverend Father.' Still refusing to appear, the dean was 'referred to the High Commissioners to be punished.' But Dr Humphrey was at Oxford at the time attended by one of the cathedral almsmen. He had no intention of travelling the 50 miles to Gloucester to appear before some petty official even if he was acting for the archbishop.

On the preferment of Anthony Rudd, Dean of Gloucester 1585–94, to the bishopric of St David's, Dr Lewis Griffith was appointed dean and remained at Gloucester until his death in 1607. Soon after his arrival he was summoned, together with the prebendaries, to an episcopal Visitation by Dr John Bullingham, Bishop of Gloucester (1581–98). At the first session on 10 July 1594 the Vicar-General, William Blackleach, presided and John Jones, the public notary, took the minutes, but the dean failed to appear. Even at the session the following November when the bishop was present in person, only two prebendaries turned up to answer questions. On 4 March 1595, after a summons had been affixed to the dean's stall in the choir, he came with the prebendaries and a bitter wrangle ensued about the Statutes. The dean acknowledged that he possessed a copy of the Statutes, and had 'undergone an oath to fulfil the said Statutes.' But other members of the Chapter, William Shingleton, sub-dean, Thomas Pury, treasurer, and Laurence Bridger questioned the legality of the Statutes since they had not been confirmed 'by the king's great seal of England'. The Chapter, they said, had been waiting for twelve years for such confirmation. However, in the end, all promised to observe the Statutes as they stood, and the servants of the Dean and Chapter, the schoolmaster and usher, the minor canons and organist, the almsmen and bell-ringer's deputy all agreed to carry out their duties faithfully. But just two years later, at another Visitation, Bishop Bullingham insisted that the Dean and Chapter swear 'truly, faithfully and effectually to fulfil and observe the statutes of the cathedral church.'

His successor, Godfrey Goldsborough (1598–1604) held an extended Visitation,

meeting first in July 1599 in the chapter house and later at Le Wyneyard, a house near Over Bridge, formerly used by the Abbot of St Peter's, and now by the Bishops of Gloucester. The Chapter was 'monished to repair the said chapter house' and, at later sessions which continued well into the following year, Prebendary Pury was ordered 'to pull down a certain seat [*sedile*], erected in the cathedral church, before Wednesday next.' Why this seat so offended the bishop is not clear. Two accounts of this Visitation survive. The bishop was determined to exercise his right to see that the dean and prebendaries carried out their duties under the Statutes. The long list of questions covered every aspect of life in the precincts and worship in the cathedral, and required all members of the College and all those employed by the Chapter to devote themselves without distraction to their duties. But there was still a problem in getting everyone to attend when summoned. William Blackleech, the Vicar-General, was instructed to 'affix to the stalls of the dean, the archdeacon and six prebendaries the several mandates . . .' summoning them to appear at the next session of the Visitation. But in spite of the bishop 'admonishing all to appear . . .' only Prebendary Pury and one other did so. In consequence the other prebendaries were informed that 'if they did not appear at the next session they would be denounced as excommunicate . . .' Accordingly when one of them, Prebendary Peter Coxe, did not appear at the session in November 1602 he was 'suspended for his contumacy . . . and suspended from the execution of his ministerial office.' Later, when he explained the reason for his absense, he was absolved.

Accounts of bishops' Visitations in the second half of the sixteenth century reveal considerable laxity and indeed lawlessness among deans and prebendaries, partly due to their attending to other responsibilities. Most of them held several offices 'in plurality'. They also reveal considerable tension and, at times, deep antagonism between the bishop and the dean, who was sometimes, but by no means always, supported in his attitude or contentions by the prebendaries. Such antagonism continued for some years at Gloucester in the case of William Laud (dean 1616–21) and Miles Smith (Bishop of Gloucester 1612–24). The roots of such tensions were complex. At times they arose from differences of temperament, or of theological outlook, and at other times it was a determination on the part of the Dean and Chapter to preserve the independence of the cathedral from what was seen as episcopal interference. It could also be due, as at Gloucester in the late sixteenth century, to academic pride verses political influence. The dean was often a distinquished academic holding an important university appointment at Oxford, while the bishop was more often involved in the social and political life of London. But whatever the cause in particular instances, the tension between the bishop on the one hand and the dean and prebendaries on the other persisted, with the dean determined to do as he willed within the precincts and cathedral, and the bishop equally determined to 'interfere' and if necessary to 'reform' the ways of the Dean and Chapter. Bishop Goldsborough's Visitations clearly indicate that at the turn of the century the bishop was gaining the upper hand and the Dean and Chapter were coming to realize that a bishop had important responsibilities under the Statutes.

PERSONALITIES OF THE PRECINCTS

The name of John Jones first appears in the records of the 1576 episcopal Visitation. He is described as a 'public notary' and as such took the minutes of the proceedings. He was to continue with that duty for many years. He was clearly an able and meticulous clerk. According to Bigland he went on to become mayor of the city three times (1597, 1618, and 1625), a member of parliament for the city (1603–14), which included the time of the Gunpowder Plot, and registrar to no less than eight bishops. If Bigland is right, Jones served every bishop from Richard Cheyney to Godfrey Goodman. In the account of a Visitation in 1616, he is described as 'the discreet John Jones, notary public, principal registrar of the said reverend Father (Bishop Miles Smith).' He died on 1 June 1630 and was buried at the west end of the nave beneath a marked gravestone, and on the wall near the Consistory Court a memorial was erected to him. The memorial was moved later to its present position on the west wall of the south aisle. It shows Jones resplendent in his robes, with piles of dated legal records on either side, and with the tools of his profession and insignia of his honours. He is said to have had the memorial erected during his lifetime. It does not give the date of his death. The story was told (reiterated by Bigland) that when the monument was almost finished he came to see it in place and disliking the over-redness of the face asked that it be toned down while he took a walk around the church. On returning he was well satisfied and asking whether the memorial was now finished remarked, 'And so have I.' Thereupon he gave the workmen some money for ale, and asked the master mason to go home with him to be paid off. This was on a Saturday; on the following Monday he died. For many years Jones had dealings with William Blackleech, the Vicar-General of the Diocese of Gloucester. For twenty-four years, Blackleech presided over the Bishop's Visitations. He died on 24 March 1616 and was also buried in the cathedral. He was the father of Abraham Blackleech whose tomb is in the south transept.

During his brief episcopate Bishop Godfrey Goldsborough tried to curb abuses and instill a greater sense of discipline in the clergy of the diocese. He had been Archdeacon of Worcester and of Salop, and a prebendary of St Paul's Cathedral and of Hereford and Worcester, the last appointment he held *in commendam* with the see of Gloucester from 1598. He died on 26 May 1604 and was buried in the lady chapel. On his tomb, now in

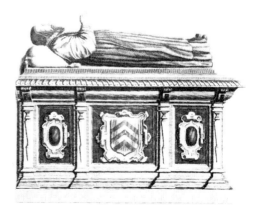

The tomb of Godfrey Goldsborough (Bishop of Gloucester 1598–1604) in the north chantry of the lady chapel

the north chantry chapel, is a life-size recumbent figure, in painted oolite, in the robes of an Elizabethan bishop with rochet over a chimere with lawn sleeves fastened at the wrist with black ribbon. A scarf round the neck falls to within 9 in of the feet. He wears a ruff with a band, and on his head a skull-cap with flaps over the ears. The face is covered with a full beard, with side whiskers and moustache. The shoes have square toes and thick soles. Under the head is a cushion with four tassels. The figure rests on an altar-tomb, about 1.1 m (3 ft 6 in) high and divided into three panels on each side and one at the end. Each panel is ornamented with scroll-work, the central panel on either side and at the foot also contains a shield. At the back of the head on the wall is a finely ornamented monumental tablet. In 1904 Bazeley recorded that 'the effigy lies in the chapel of St Petronilla on the south [sic] side of the lady chapel below the minstrel's gallery.'

Damage and Neglect

Before the Dissolution there had been hundreds of figures of saints in niches in and around the abbey church. Not only in the lady chapel where the reredos and walls were filled with figures, but throughout the eastern arm of the building the smaller chapels

A view of Gloucester *c*. 1610, from Speed's map, 1610, with fortifications based on Hall & Pinnell's map, and published in Fosbrooke, 1807

and their altar pieces, the ambulatories and transepts were all filled with images of the saints. And outside the building the buttresses and the south face of the porch were enriched with statuary. Only empty niches, solitary bases or canopies survive today to mark the places where once finely carved figures adorned the interior and exterior. Apart from the great east window, which miraculously escaped destruction at the hands of iconoclasts, there are few complete figures of saints in the medieval stained glass, though there are many fragments, particularly in the east window of the lady chapel. In view of Bishop Hooper's instructions to the clergy of the diocese to destroy all images of the saints and to smash all stained glass in which they were depicted, it is likely that some, if not most, of the damage done to such objects in and around the cathedral occurred during the reign of Edward VI.

There is very little evidence, otherwise, about the condition of the fabric of the building between the years 1542 and 1616. Certain monastic buildings were pulled down, providing valuable building material for the repair of the church and the adaption and extension of buildings in the precincts. There were no further major alterations or additions to the church itself. The great rood screen across the east end of the nave was removed though part of the extensions across the north and south aisles were left. The north aisle chapel, though bereft of its altar, was left practically intact. Eventually the chapel was filled with memorials, notably to the Machen family (1615) and to Abraham Blackleech and his wife (1639). The magnificent fourteenth-century choir screen, deprived of its statuary, survived at least until the Commonwealth and probably well into the eighteenth century. But other relics of monastic times were removed, smashed or defaced including mural paintings.

Bishop Cheyney in his Visitation of 1576 hinted that the building was being sorely neglected and extensive repairs were urgently needed. 'In 1576 the fabric seems to have been in want of considerable repair' (Masse), but no details of the work needing to be done have survived. In any case very limited funds would have been available for repairs. The priority would have been to furnish the choir for daily services, and to adapt precinct buildings for domestic use. The old monastic workshops were probably run down if not disbanded leaving essential work to local jobbing-builders. Most skilled craftsmen had turned to other patrons for employment, such as the landed and merchant classes who were building fine town houses and country seats for themselves.[8] Benefactors were no longer concerned to save their souls through giving lands or funds to the Church, but to provide a name for themselves by founding and endowing schools, or colleges at Oxford or Cambridge. It comes therefore as no surprise to learn that when William Laud became Dean of Gloucester in 1616 'there was scarcely a church in England so much in decay.'

ROYALISTS AND PURITANS
1605–1660

'There was scarce ever a church in England so ill-governed
and so much out of order.'
Reported comment of James I, 1616

'The great ornament of the city.'
John Dorney, town clerk of Gloucester, 1657

The seventeenth century witnessed the long struggle in the Church between those who, like Archbishop William Laud, valued the Prayer Book and emphasized the role of tradition and reason as well as the Bible in Christian faith, and the Puritans such as William Prynne and John Milton who called for the continuation of the Reformation with the abolition of the episcopate and reliance on the Bible alone. The high churchmen supported the king, Charles I, while the Puritans sought to strengthen the hand of parliament. At the centre of the controversy for many years was William Laud, Dean of Gloucester from 1616 to 1621. The policies he adopted while at Gloucester, particularly with regard to stricter discipline and greater order in worship, foreshadowed the policies he later pursued as Archbishop of Canterbury from 1633, which led not only to his own execution but to the overthrow of episcopacy in the Civil War (1642–51).

THE CATHEDRAL BEFORE DEAN LAUD 1605–1616

On the death of Bishop Godfrey Goldsborough in 1604, Dr Thomas Ravis, Dean of Christ Church, Oxford and one of the translators of the Authorized Version of the Bible (1611), became bishop. He carried out improvements to the Bishop's Palace, and to the Vineyard, the episcopal house at Over across the River Severn. The endowments of the see were not adequate to maintain the two residences. By the end of the sixteenth century the palace was 'a very vaste, mellancollick, decaied and ruinous howse'. But

The Holy Bible, 'conteyning the Old Testament, and the New: newly translated . . . London: by Robert Barker, 1611.' The King James' Bible, the 'Authorized Version. Miles Smith, who wrote the Preface, later became Bishop of Gloucester

Bishop Ravis paid for the repair of both properties, and restored the water conduits at the Palace. He was translated to London in 1607. He was succeeded by Dr Henry Parry, but he too was translated after only three years, becoming Bishop of Worcester. Fosbrooke says he made 'the pulpit in the body of the church at his own charge.' Dr Giles Thompson, another translator of the King James' Version of the Bible, succeeded Dr Parry but he died within months of his appointment. Dr Miles Smith then

became bishop. He was 'a learned Orientalist' who had also been involved in the translation of the Authorized Version. He translated the four major and the twelve minor prophets, and probably wrote the Preface. By nature a quiet, scholarly man, he confessed he was 'covetous of nothing but books.' But as bishop of the diocese throughout Laud's tenure of office as dean, Miles Smith's strong Puritan views inevitably brought him into conflict with Laud.

Bishop Ravis' Visitation in 1605 and Bishop Miles Smith's Visitation in 1613 give some indication of the condition of the cathedral before Laud became dean. In 1613, for example, it was stated that 'the Cathedrall Church by reason of former neglect is not so sufficiently repaired as it were fit it should be, but that much is spent everie yeare in reparations.' The period of 'former neglect' when, as the bishop was told, nothing had been provided 'for the reparation of our church' could refer to the whole period since the Dissolution, some eighty years. But in the absence of any cathedral accounts prior to 1624, how much or how little was spent on repairs during this period is not known. At Laud's second meeting with the Chapter it was reported that 'the fabricke of this Church is verry ruinous and in great decay in many places, so that if speedy care and dew prevention be not used . . . soe goodly an edifice is eyther likely to come to lamentable Ruine or else the poore estate of this Church to be overcharged with the . . . burthen of so greate coste and expence which will fall on it at once.' This was probably not an exaggeration.

There are, however, a few references to repair work in the documents which have survived from these years. In Bishop Goldsborough's time it was thought the Old Hall, the monastic *refectorium,* might collapse damaging adjoining property including the north walk of the cloister. The *refectorium* had been damaged by fire at the time of the Dissolution, but for a long time it had been in use as a dining hall. In 1605 Bishop Ravis offered to repair the building provided the Dean and Chapter acknowledged that it belonged to the see. But apparently nothing was done, and within a few years the Old Hall was demolished. Also in 1605 Bishop Ravis ordered Thomas Field, the *aquaeductor* to repair the lead pipes carrying water from Robinswood Hill to 'the Comon Laver within the greate Cloister.' Evidently the monastic *lavatorium* in the north walk of the cloister was still used, probably for washing clothes, with the waste water flushing the drains of houses in Miller's Green.

Two notable memorials were erected in the cathedral at this time. The first, at the east end of the north aisle of the nave, against the wall, is to Thomas and Christian Machen 1514–1615 (see plate 19). They are depicted kneeling facing each other on either side of a reading desk on which are two books. Above them is a horizontal canopy supported by two Corinthian pillars, and between two semicircular headed arches stands the figure of Time with broken scythe and hour-glass. Below the figures are four adult sons, kneeling on cushions, with doublets and breeches similar to their father's, with swords, cloaks and ruffs. There are three infant sons with ruffs. There are four adult daughters in similar costumes to their mother's, except that they have no caps. Two infant daughters with caps and straight gowns complete the family. Thomas Machen is wearing his robes of office, as Mayor of Gloucester, and his wife is wearing a black gown. The inscription states:

Here lie buried the bodies of Thomas Machen Esq, late Alderman of this City of Gloucester, thrice Mayor of the same, who departed this life the 18 day of October 1614 in the 74th yeare of his age, and

of Christian his wife with whom he lived in the estate of marriage 50 yeares and had issue 7 sonnes and 6 daughters. She departed this life June 29, 1615 in the 70th yeare of her age. *Res pedit huc morimur Mors ultima linea verum.*

A most unusual memorial was erected in the north transept, against the west wall, at about this time. It was to John and Anne Bower and is dated 1615. It consists of a painting on wood panelling, set in a recess. There are two large figures, kneeling at a table with an open book between them; behind the two is a niche with pillars on which are their arms: *Sable, a cross patee arg.* The man has a ruff round his neck, and is wearing a cloak with a fur border hanging down the entire length of it. His wife wears a black dress, tight to the waist and flowing in folds to her feet. She is also wearing a cap and a broad-brimmed black hat, and frills of the same material at the wrists. Behind the father are nine sons, all kneeling; the first appears to be in clerical dress, but others are wearing part-armour, and the youngest knee breeches. The daughters, kneeling behind their mother are wearing dresses similar to hers. William Bazeley thought the name Bower was an alias of the Robins family, remarking that 'nothing is known of this branch of it.' But John Bower seems to have been a member of a 'substantial family of that name who were in Newent for a good number of years. He was probably born around 1540–50, and followed the profession of an apothecary. In December 1572 he was elected surgeon (or *chirurgion* as it was then known) to St Bartholomew's Hospital. At the time a surgeon and a physician lived in accommodation in the hospital or almshouse. He was there until in his death in 1615/6' (Brian Frith).

The bishop's Visitations prior to Laud's arrival in Gloucester provides further information about the cathedral community at the time. Clearly all was not well. The lay-clerks or singing men were often taken to task for their violent behaviour and general lack of discipline. In 1613 Richard Brodgate, a singing-man, was accused of 'laying violent hands on Richard Sandy at the choire dore.' In 1618 another of their number, Richard White, was cautioned 'for frequentinge of Alehouses and slouthfulnesse in performing his service and other unseemely courses not befitting this Church.' Another was reproved 'for his often departinge from devine service before they are ended and allso for his overmuch noyse in talkinge and ianglinge in time of divine prayers.' And another for being 'drunk in the church in the time of Devine prayers.'

WILLIAM LAUD, DEAN 1616–1621

William Laud was already a well-known and controversial figure when, in November 1616, he accepted the deanery of Gloucester. For some years he had been involved in the academic life and politics of Oxford as a Fellow of St John's College, and then as president of the college. As Hugh Trevor-Roper wrote 'Laud received his portion in the Arminian advance in the form of a prebend of Lincoln Cathedral in 1614, and next year he added the archdeaconry of Huntingdon.' As a royal chaplain he preached before the king in 1615 and in the following year he was offered the deanery of Gloucester. He later recalled a conversation with the king during which his Majesty 'was pleased to say he had given me nothing but Gloucester, which he well knew was a shell without a kernel.'[1]

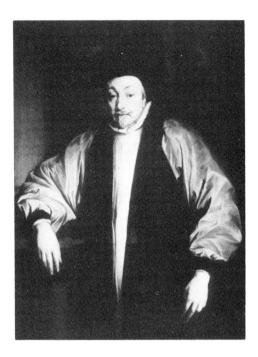

William Laud, Dean of Gloucester 1616–21, as
Archbishop of Canterbury

Liturgical Reordering

Laud was installed as dean by proxy on 20 December 1616. He came in person to make
his declaration on 25 January 1617. He did not take the *Juramentum Decani*, as
prescribed in the Statutes, possibly because his relationship with the bishop, Dr Miles
Smith, had been soured even before his appointment to Gloucester.[2] The bishop was
certainly angered when the new dean at his first meeting with the Chapter had the
communion table removed from its place in the body of the church and set altar-wise at
the east end. But the prebendaries present on the occasion, Thomas Prior, Henry Aisgill
and Elias Wrench had agreed with the dean that 'the Communion Table should be
placed altar-wise at the upper ende of the quier close under the walls upon the
uppermost greese or steppes.' Some have argued that Laud was only bringing Gloucester
into line with the *Injunctions* of Elizabeth I (1559) and the practice of royal chapels and
most cathedral churches at the time.

This is only partially true since Elizabeth discreetly avoided committing herself on
the doctrinal issue, and left the whole question as a mere matter of procedure 'in the
ordering whereof, saving for an uniformity, there seemeth no matter of great moment,
so the sacrament be duly and reverently administered'. She appealed throughout her
Injunctions to the principle of convenience, that is to the practical advantages of
uniformity, audibility and accessibility. Thus she recommended that the altar-table be
kept in the east end when not in use, and moved down at the time of a service. In a city
where Puritan doctrines had already taken hold, Laud's liturgical reordering had
profound theological implications. His action smacked of popery and immediately

Extract from the Chapter Act Book, 1616, ordering the removal of the altar to the east end of the choir

evoked cries of protest. The bishop, a staunch Puritan, was particularly incensed and swore he would not enter the cathedral again so long as Laud remained dean.

Shortly after the chapter meeting, Laud wrote to the bishop to explain his action. He pointed out that the king had been 'graciously pleased to tell me he was informed that there was scarce ever a church in England so ill-governed and so much out of order; and withal required me in general to reform and set in order what I found there amiss.' Believing he had the king's support for his reforms he proceeded to direct that the prebendaries, the quire-men, choristers and the under-officers of the church should bow towards the holy table on entering the choir, 'making their humble reverence to Almighty God, not only at their first entrance into the quire, but at their approaches towards the holy Table.' The altar was to be railed off, and the people encouraged to kneel to receive Holy Communion. The altar-rail placed in front of the high altar was later removed to the lady chapel where it is still in use. The proportions of the design and the quality of the carving mark it out as a fine example of the joiners and woodcarvers' craft in the early seventeenth century.

Laud's purpose in these reforms was to restore a sense of reverence and much-needed order to the church's worship. To the Puritan mind, however, the action he took was tantamount to reverting to the ways of the Roman Church and as such was deeply offensive. The use of vestments was seen not as witnessing to the continuity of the worship of the English Church, but as implying the Romish doctrine of the Mass. In his concern to raise the standard of worship at the cathedral Laud also turned his attention to the choir and the organ. He was far from satisfied with the musical abilities of the

lay-clerks and their general behaviour, and the organ or organs 'were very mean and very far decayed.' At the time the organ loft was on the south side of the choir between the crossing piers. From all accounts the organ was a poor instrument and in urgent need of a complete overhaul. Mr Dallam, a well-known organ builder, came to see it, and on his advice it was decided to follow the example of Worcester Cathedral and appeal for funds for a new organ. A letter of appeal, dated 12 March 1618, was sent to the titled and landed gentry of the county but what it achieved is unknown. The Puritans regarded all such matters as appealing merely to the outward, the aesthetic and the emotional, rather than to the inner, sober and personal side of true religion.

Repairing the Fabric

Less controversially, noting that the fabric of the church was 'very ruinous and in great decay in many places', Laud proposed to Chapter that the more urgent repairs, as identified by the supervisor of the works, be put in hand without delay, and a sum set aside annually to be spent on restoration work. Accordingly the treasurer was instructed to allocate 'yearly upon the reparations of this church the sum of three score pounds.' Because the accounts for the years 1616–21 have not survived there is no way of knowing what work was put in hand as a result of this Act of Chapter. Laud may have restored and enlarged the Deanery (Church House), though the panelling in the drawing room, now known as the Laud Room, is thought to date from at least twenty years later.

Since the earliest extant *Chapter Act Book* begins with Laud's appointment as dean, he probably began the custom of keeping a record of the decisions taken at meetings of the Chapter. He also instructed the prebendaries, as a matter of urgency, to go through existing records, accounts, court-rolls, rentals and inventories and arrange them according to date. They were to work in the treasury, the room over the eastern slype, and to store the documents in chests and cupboards there. Records had been kept 'anciently' in the room over St Mary's Gateway, which was also to be used. In 1635

The Laudian communion rail, originally at the high altar, now in the lady chapel

following his Metropolitan Visitation, Laud ordered the chapter clerk to make a catalogue of the material, and to have boxes and shelves made in St Mary's archway room to house it.

Laud initiated many changes during his years as dean, which is remarkable since he was often away involved in other responsibilities, at Oxford and attending the king on his travels. The king even amended the Statutes of the cathedral to enable him to carry out these duties. When in Gloucester he met with the prebendaries and took action over matters to which they drew his attention, or about which he was otherwise informed. There does not appear to have been any formal Episcopal Visitation during his years as dean, probably because of the strained relationship between himself and the bishop. Dr Miles Smith had carried out a Visitation in 1616, before Laud's arrival in Gloucester, and in 1619 there is the following note in the account of the bishop's Visitation to the diocese: 'to visit the Dean and Chapter upon Friday 4th June.' If this was to be a formal Visitation there is no record of it having taken place.

In 1621 Laud accepted the bishopric of St David's. When Charles I came to the throne in 1625 Laud's influence increased. He was translated to Bath and Wells in 1626, and in 1628 to London. He continued to oppose the Calvinist theology of the Puritans, and to restore aspects of pre-Reformation liturgical practice to the Church of England. In 1629 he became Chancellor of the University of Oxford where he carried through many necessary and permanent reforms. In 1633 he was again translated, becoming Archbishop of Canterbury. His Metropolitan Visitation of Gloucester two years later shows his continuing concern for the cathedral and diocese.

He was not allowed to forget his decision to move the communion table to the east end of the choir for it was to form part of the inditment at his trial. In 1641 he was imprisoned in the Tower of London. His trial in 1644 is generally held to have been conducted without regard for the demands of justice, the Commons imposing their will on the Lords by force. He was executed on Tower Hill on 30 January 1645 after repudiating the accusation of 'popery' and declaring his adherence to the Protestant Church of England. His apparent failure arose from his inability to understand the popular leaning towards Puritanism and the hatred aroused by his violent measures against all who did not share his own views on ritual. In doctrinal matters he showed himself broad-minded and conciliatory. He delighted in the material aggrandizement of the national Church and its prelates, but thereby promoted its identification with a particular political party, and with the king and his supporters.[3]

BISHOP MILES SMITH 1612–1624

Laud was succeeded as dean by Richard Senhouse (1621–4) who in turn was succeeded by Thomas Wynniffe (1624–31) and briefly by George Warburton. In 1631 Accepted Frewen became dean (1631–44). Dr Miles Smith continued as bishop until his death in October 1624. But no sooner had the 'tribulation' of the Laud years passed than he suffered the loss through child-birth of two of his daughters, first Elizabeth at the age of seventeen in 1622 and then Margery in April the following year. Both daughters were buried in the lady chapel, as was their father later.

The memorial to Elizabeth (Williams) against the north wall of the lady chapel, shows

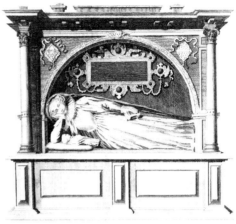

Above: Memorial to Elizabeth Williams, née Smith, in the lady chapel. Left: Miles Smith, Bishop of Gloucester 1612–24

her reclining on her right side, resting her head on her hand. The elbow rests on a cushion. In her left hand she has a book with broken straps. At her side, lying on a cushion, is an infant in swaddling clothes tied round with a ribbon fastened in a bow. The effigy is life-size, and shows her clothing in extraordinary detail – a frilled cap, tight-fitting bodice buttoned down the front, a lace choker, the skirt gathered at the waste by a cord, a scarf round the neck hangs down both sides and a cloak covering the back of her neck and cap, and falling down her back in folds. She lies in a recess, beneath a cornice supported by black marble pillars. In the spandrels are, on the right-hand side, 'or, a chevron cotised sable, between three sprigs with roses and leaves proper'; and on the left-hand side, 'ermine a fess sable, a crescent for difference' (see plate 19).

Her sister's memorial on the wall opposite is far smaller. Margery is shown about a quarter life-size. Her head is supported by her right arm resting on a cushion on a table, on the side of which is an hour-glass. Her costume is similar to that of her sister. She too has curly hair showing at the sides under a frilled cap. She wears a tight-fitting bodice buttoned down the front. Her skirt is full, and she wears a belt and a cloak. In her left hand is a handkerchief with gold edging. The monument consists of a semicircular arch with cornice, above which within a wreath is a lozenge 'or, a chevron cotised sable between three roses leaved and stalked gules'. On each side of the figure are two Corinthian pillars surmounted by obelisks. Below the figure are three panels; on the central one on black marble is the inscription. Both memorials are excellent, and indeed moving, examples of local monumental work of the period.

The year after his second daughter's death, Bishop Miles Smith himself died, worn out, it was said, by controversy and personal grief. He was buried in the lady chapel between the two memorials. A simple ledger marks the place.

MOUNTING CONFLICT 1625–1645

Miles Smith was succeeded by Godfrey Goodman (Bishop of Gloucester 1624–40) who was a high churchman and said to be the only bishop of an English diocese since the Reformation who died a Roman Catholic. The Puritan-minded citizens of Gloucester must have viewed his appointment with some misgiving if not apprehension. His enthronement took place *in absentia* on 4 April 1625, a week after Charles I succeeded to the throne. The dean at the time was Thomas Wynniffe (1624–31), a man of Puritan sympathies, so that the situation in Laud's days when Gloucester had a high church dean and Puritan bishop was reversed, at least until Accepted Frewen became dean in 1631. Frewen was an Arminian, a close friend of Laud, and at the time President of Magdalen College, Oxford. At Oxford he had 'changed the communion table into an altar, the first that was set up in the university since the Reformation.'[4]

Refurbishing the Choir

Suzanne Eward in her book *No Fine but a Glass of Wine* describes life in the cathedral and precincts at Gloucester during the seventeenth century, giving a particularly detailed and vivid account of the years leading up to the Civil War. They were years of growing unrest and mounting tension as the trial of strength between the Royalists and the Puritans was felt all over the country. In Gloucester Puritan influence had been increasing steadily year by year, but at the cathedral things were moving in the opposite direction. Laudian reforms remained in place, and various enrichments and sumptuous furnishings were being introduced which were deeply disturbing to the Puritan conscience. Abraham Blackleech, among others, had given cloth for making vestments and hangings, including a hanging behind the high altar. The accounts contain references to painting parts of the interior of the church with 'several colours' as well as renewing the whitening. An inventory of 1637 lists the 'ornaments' in the possession of the Dean and Chapter; these included a gilt bason and a gilt cup with a cover, a gilt flagon and a Communion cup with cover, and other items of silver or pewter.

In spite of Puritan opposition to the use of music and musical instruments in worship, new settings of the canticles and motets of increasing complexity were being written for the Chapel Royal, cathedrals and college chapels.[5] The cathedral accounts show that music was being purchased for the choir throughout the 1630s, with the result that lay-clerks and choristers were challenged to strive to attain an ever higher standard. But the organ was constantly causing problems, and by 1637 it was considered beyond repair. Other instruments were introduced to accompany the choir, including sackbuts and cornets. In April 1640 a new master of the choristers was appointed, John Okeover, who had been the organist of Wells Cathedral, and work began on a new organ. Robert Dallam was commissioned to build it, with advice from Thomas Tomkins, the organist of Worcester Cathedral. It was erected in a new-organ loft between the piers on the south side of the crossing. Eward notes that 'the case of the little Chaire organ in the Cathedral today may well be the case of Dallam's organ built in 1640. That the style is of an earlier date can be explained by the fact that when it was built the makers would have copied the style of an earlier generation.'[6]

Much time and effort were spent during the 1630s in refurbishing the choir, largely through private donations, but other necessary repairs were also carried out. Earlier, a considerable sum had been spent on repairing the *lavatorium*, and the accounts show frequent payments to glaziers for repairing windows, particularly those on the north side of the choir and lady chapel where the boys of the school had their playground. Very full details of the building of the organ-loft are given in the accounts of 1639–40. A hurricane which swept across the country in March 1630 caused severe damage in Gloucester, and work had to be 'done uppon the Battlements on the Southside of the topp of the Tower beinge shaken with the tempest'; the lead roof also had to be repaired.

Preaching in the Nave

With the growing popularity of the sermon, the Dean and Chapter felt obliged to provide increased seating, at first in the choir and later in the nave. For some time the sermon had been part of the morning service in the choir, but it was then transferred to the afternoon and to the nave. The city's leading citizens were allowed to occupy the Dean and Chapter's seating. Later, the medieval chapel at the east end of the north aisle was fitted out as 'The Mayor's Chapel'. A memorial to Richard Pates, founder of the Pates Grammar School in Cheltenham and builder of Matson House near Gloucester, had been erected in the chapel in *c*. 1588, and another memorial to alderman and thrice mayor of Gloucester, Thomas Machen, and his wife Christian had been erected against the north wall in 1616. It must therefore have seemed appropriate to provide seating there for the mayoral party when they attended the cathedral on Sunday afternoon to listen to the sermon. Seats were also provided between the Norman piers of the nave for other leading families. Sir Nathaniel Brent seems to have noted the popularity of this occasion when he was carrying out the Metropolitan Visitation of 1635 for he wrote of 'much solemnity, many orations, and great entertainment.'

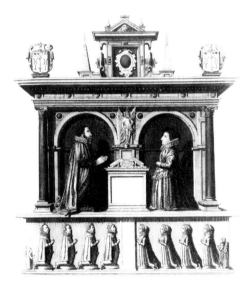

The Machen monument in the north aisle, 1615.
An early-nineteenth-century drawing

But such seating as had been erected by 1635 was ordered to be removed by Archbishop Laud in the eighth of his *Injunctions* following Sir Nathaniel's visit. 'The bodyes of Cathedrall Churches should not be pestered wth standinge seates contrary to the custom in cathedrals and the dignity of those goodly piles of Building.' Thus:

> . . . all standing & fixt seates aws well those where the Mayors & Aldermans wives use to sitt as others betweene the Pillars, be taken downe & other moveable ones fitted into their roomes according to such directions as we gave to the Deane by our late letters written to him. Butt the seate where the Mayor & Prebends used to sitt in Sermon time Because to our owne knowledge they are wthout all blemish to the Church & more convenient then they can any where else be placed We doe hereby require that they be left standinge to the use aforesaid.

The City Corporation paid rent for these seats and regarded them as their own property. Thus, in December 1639, the Corporation ordered that 'The Stewards shall cause the womans seates in the Colledge to bee made fittinge and railed in that straungers other than the wives of the Mayor, Aldermen, Town Clarke and Common Councell may not press in there.' Nevertheless they appear to have been moveable seats for a certain William Mason was paid £3 pa 'for setting the seates & removeing them.'

One of the principal benefactors of the cathedral in the early decades of the seventeenth century was the Blackleech family. In 1597 William Blackleech and his wife Mary had obtained a lease of the 'greate garden or orchard' at the east end of the lady chapel where a house had been recently built. William, who was Chancellor of the diocese (legal officer to the Bishop of Gloucester) for twenty-four years, died in March 1616. His son, Abraham, took over the lease of the property and the enlarged house in 1623. In 1626 he was granted permission to make a door and passage from his garden 'through that parte of the Collidge walle that is towards St John's Church'. The Chapter allowed it on condition that if 'there shall appeare any inconvenience, detriment, or scandall to the said Cathedral Church' it should be closed up again. Blackleech contributed generously towards the refurbishing of the choir in the 1630s. He died on 30 November 1639, and his wife, Gertrude, erected the memorial to him which was placed on the east wall of the 'Mayor's Chapel', the remains of the medieval chapel at the east end of the north aisle of the nave. This was later moved, together with their tomb, to the south transept. The inscription records that Abraham was 'a man not onely generally beloved in his Life but deservedly endeared to Posteritie by rare example of seldome attained piety expressed in his bounty to St Paule's in London, to this Church, to the high wayes about and the poore of this Citie . . .' The alabaster figures on the tomb are exceptionally fine. Sir Horace Walpole wrote of them: 'They are very gracefully designed by Vandyke and well executed.' But there is no indication on the memorial or the effigies as to the designer or sculptor (see plate 19).

The pen-and-ink sketch of the nave by Wenceslaus Hollar (1607–77), dated 1644, shows no seating nor is there a pulpit. This is surprising since Bishop Goodman after his Visitation in 1634 and again in 1640 had ordered that there shall be 'a convenient seat for the minister to read the service' and 'a comely pulpit'. The aisles, of course, are not visible because of the breadth of the Norman piers. But what remained of the old chapel at the east end of the north aisle is shown in Brown Willis' *Survey of Gloucester Cathedral* 1727. The Machin memorial is against the north wall and the Blackleech memorial set where the medieval altar would have been. A note records that 'in a chapel on the north

side of the nave, near the cross aisle, [there is] a handsome marble monument.' It also shows the stone floor of the nave is at its original level, and the octagonal bases of the Norman columns. Most importantly it shows the magnificent medieval screen erected by Abbot Horton still in place at the east end of the nave, though without the figures which originally filled its many niches.

Puritans Gain the Upper Hand

The conflict between the Royalists and the Puritans was leading the country into ever deeper division and confusion. In 1640 Bishop Goodman was arrested, tried and imprisoned by Archbishop Laud. But he was released in 1642, and ordered to return to his diocese. The following year the episcopal palace was sacked and the bishop fled. Anti-clerical feeling was running high in the city and indeed throughout the county. Laud himself had been impeached in December 1641 and sent to the Tower where he lingered for two years. Parliament, now composed mainly of Puritans, was set on revenge against the Church for the tyranny which Laud and the Court of High Commission had exercised over them. In the famous 'Root and Branch' debate during the summer of 1641 the MP for Gloucester, Thomas Pury, argued strongly for the abolition of deans and chapters. Eward recalls the occasion:

Reading aloud that part of Henry VIII's statutes for Gloucester Cathedral which ordained that the Dean and Chapter were to keep residence, feed the poor and distribute alms, preach the word of God, have the youth profitably taught and keep a common table where the canons, scholars, choristers, and under-officers could eat together, Pury proclaimed:

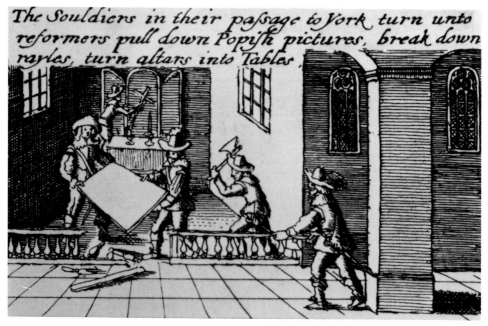

Cromwell's soldiers as 'reformers', a seventeenth-century drawing

'. . . it is notoriously knowne to the city of Gloucester and country there abouts, That not one of the said Statutes before mentioned, are, or ever were, during my remembrance, kept, or the matters contained in any of them performed by any of the Deanes, or Prebends of the said Cathedrall.'

He went on to propose that the Dean and Prebendaries should become preaching ministers, and the revenues and rents received from their properties in the city of Gloucester used for repairing the highways and bridges, and for alms for the poor. The Cathedral, he suggested, should become a parish church, and the rent received from the Chapter's manors should be spent on a stipend for a preaching minister at the cathedral, for two assistants, and for repairing the Cathedral church.[7]

Pury's proposals reflected the feelings of many local people, and of a growing number in parliament. In 1642 parliament ordered that:

. . . in these times of public danger and calamity . . . such part of the Common Prayer and service as is performed by singing men, choristers, and organs in the Cathedral church be wholly forborne and omitted, and the same be done in a reverent, humble and decent manner without singing or using the organs.

Such an order signalled more than the end of the established ways of worship at the cathedral; it marked the end of the authority of the Dean and Chapter to order worship at the cathedral and to direct the work of members of the cathedral foundation. The Dean and Chapter appears to have ceased to function as a corporate body from 1641. Eward believes that the clergy were forced out before the end of 1641 or early in 1642. Yet in August 1643, at the height of the siege of Gloucester, William Brough was nominated as dean, though not installed until 20 November the following year. At least one of the prebendaries, Gilbert Osborne, was present on the occasion which suggests one or two of the clergy continued to live in the Green or to visit Gloucester from time to time from their Oxford colleges or country livings. Meanwhile, in many parts of the country, Puritans and their sympathizers took the law into their own hand, and destroyed communion rails, removed candlesticks and other 'scandalous' objects such as crucifixes, crosses and images, and defaced wall-paintings and smashed medieval glass.

Conditions During the Commonwealth

In the struggle between the king and parliament during the reign of Charles I (1625–49) Gloucester strongly supported the Parliamentary cause. When civil war broke out, Parliamentary forces suffered early reverses, with the loss in the West Country of Exeter and Bristol in 1643 to the Royalists. However, at Gloucester they held out alone against the king, impeding his advance for several crucial weeks. In August a strong force of Royalists, commanded by Charles I, laid siege to the city. Though the walls were nearly in ruins in places, the citizens and a greatly outnumbered garrison, under the leadership of Colonel Massey, put up a vigorous defence, suffering many hardships and adversities. Parliament in London, aware of the crucial importance of Gloucester's stand sent the Earl of Essex in command of Parliamentary forces to raise the seige. They arrived within sight of the city on 5 September. The Royalist army immediately withdrew without risking a fight. The tide of war now turned in favour of the

Parliamentarians. After the Siege of Gloucester in August and early September 1643 the struggle between the king's forces and Cromwell's army went on until, after a series of defeats and being besieged in Oxford, the king escaped to Newark, where he surrendered in April 1646. He was finally brought to trial, and sentenced to death on 26 January 1649. Four days later he was led to execution on a scaffold placed in front of the windows of Whitehall Palace. He died with calm dignity, declaring he died a Christian according to the profession of the Church of England which he had always striven to maintain.

Back in August 1644, the Common Council of the city, in accordance with the policy set out in Thomas Pury's 'Root and Branch' speech in 1641, ordered that from the property rents of the Dean and Chapter the sum of £100 pa be paid to an 'orthodox divine' to preach each week in the cathedral, and a further £50 to another divine to preach in one of the parish churches of the city. With the official abolition of Deans and Chapters in September 1648, the precinct and other properties were used to house the Puritan preachers, and notably Help-on-High Fox who occupied 8 College Green, and later James Forbes (1629–1712). The preaching of James Forbes drew large numbers to the nave of the cathedral. Other properties were leased out, for example, to Thomas Pury junior, son of the alderman, who occupied the deanery (Church House), while other properties were sold.

The cathedral seems to have escaped major damage during the Civil War. Some damage was done by Cromwell's soldiers to stained glass in the cloister where, for a short time, they stabled their horses. The soldiers responsible for the damage were probably those from the Earl of Leven's army which marched through the city in 1645. It was alleged that the great cross which stood in the middle of the churchyard in the Upper Green was taken down and used as building material. The bishop's house at Over had been reduced to 'nothing . . . but a few ruinous stone walls', and the palace had become 'very ruinous and not habitable soe that nobody will rent itt of us butt att a very low rate.' At one stage it was suggested that the cathedral itself should be demolished. A number of people had 'agreed among themselves for their several proportions of the plunder expected out of it.' They began to pull down the little cloister, taking the roof off the north and east walks, and to demolish the lady chapel; tackle was brought up to take the tower down as well.

But they were restrained, and in 1656 the building was made over, to the mayor and burgesses at their own request. John Dorney, the town clerk, appealed to the city council urging them to: 'join your shoulders to hold up the stately fabric of the College church, the great ornament of the city which some do say is now in danger of falling.' At the same time the cloisters, library and 'free-school' together with the residencies of the schoolmaster and his assistant were also granted, by Act of Parliament, to the mayor and burgesses.

Public Library in the Chapter House

Apart from the cathedral records and accounts, there must have been some sort of collection of books at the cathedral prior to the Commonwealth. Most of the abbey's books and manuscripts had been removed at the Dissolution, though some old monastic

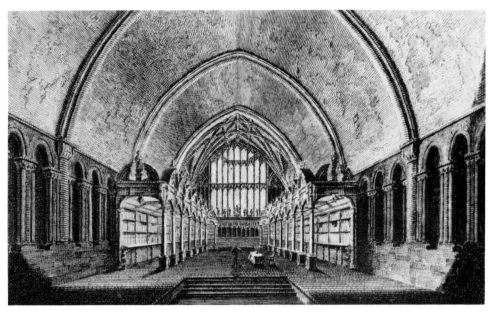

The College Library, in the old chapter house. T. Bonnor, 1796

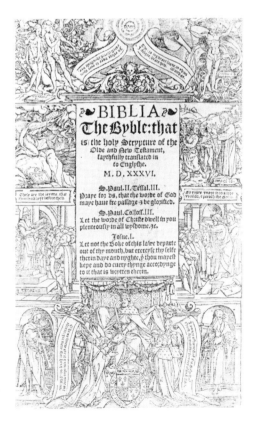

The frontispiece of the *Coverdale Bible* 1535/6 presented to the College Library by Thomas Pury who received it as a gift from Oliver Cromwell

Library donor's book, 1658–87

Printed book (the writings of C. Crispus Sallustius), Paris, 1521, bound in leather with two blind stamped panels of St Barbara and St John the Evangelist on both covers (GCL H.2.5)

records remained and were stored in chests in the treasury. There were also more recent works donated to the library set up by Bishop Goodman for the clergy and the laity of the diocese. These were probably housed somewhere in the cathedral precincts, possibly in the old chapter house. But during the Civil War the mayor and burgesses petitioned parliament to 'Grant the use of the Chapter House in or belonging to the Colledge of Gloucr as a fitt & Convenient place to be imployed as a Publique Library.' This was granted, and Thomas Pury junior spent a considerable sum in fitting out the old chapter house as a library. He had magnificent book cases made, with much-admired carved scroll-work, and encouraged his friends to donate books. The book cases are depicted in a drawing by Thomas Bonnor (1796). He had his coat-of-arms painted on a shield on the north side of the east window. The 'Lieger booke' or benefactors' book lists the names of those who gave books and money for the library. Pury's father gave a number of books including a Coverdale Bible, given to him by Oliver Cromwell, and which, judging from the royal arms embossed on the cover, was originally in the Royal Library.

According to Atkyns, the effigy of Robert, Duke of Normandy, was smashed to pieces by Cromwell's soldiers. Sir Humphrey Tracy of Stanway bought the pieces, laid them up until the Restoration of the monarchy (1660), and then had the effigy 'repaired and beautified at his own charge' and returned to the cathedral. The diarist John Evelyn who visited the cathedral on 31 July 1654 noted that King Stephen [sic] lies 'buried under a monument of Irish oak, not ill carved considering its age.' Clearly, he had seen the effigy of Duke Robert in its traditional place in the centre of the presbytery, even though he mistook it for an effigy of King Stephen. The effigy must therefore have been damaged at some time between 1654 and 1660. The repair work was carried out with great skill, and the figure was polychromed by John Campion, a gifted local artist and craftsman in 1662. He was paid £9 5s. for 'gildinge and paintinge of Duke Robert his Tome and about the Quire.'

The Restoration of the Monarchy 1660

In the summer of 1658 Cromwell was taken ill, and on 3 September he died. As soon as he died, the whole order he had sought to establish began to break up. In six months it had virtually disappeared, and there was a general feeling throughout the country that the only way out of anarchy was the restoration of the old constitution, with king, lords and commons. Calvinistic fervour had worked itself out. Within eighteen months the country was once again ruled by a Stuart king. In Eward's words 'Charles II was restored to his throne in May 1660 amidst scenes of wild rejoicing throughout a country now weary of its Puritan rulers and their military despotism.' With the Restoration of the monarchy the city suffered for its earlier stubborn resistance of the Royalist forces. Charles ordered the walls, gates and castle of Gloucester to be demolished. But the cathedral remained intact, and with the reinstatment of the Dean and Chapter and the restoration of the Elizabethan Settlement, the life and worship of the cathedral was re-established.

AFTER THE RESTORATION
1660–1702

'The Cathedrall or minster is Large, Lofty and very neate,
the Quire pretty. Here are very good Cloisters finely
adorned with ffretwork.'
Celia Feinnes, 1695

In 1660 Charles Stuart, a young man of thirty, returned from the Continent where for fourteen years he had lived in exile, the penniless guest of many unwilling hosts in Holland, France and Germany. He was continental in his manners, thought and life. He had picked up his personal morals at the French court, and his political instincts from the group of intriguing exiles who had formed his wandering and impecunious court. It was said: 'He laughed at purity in women and honesty in men.' Yet parliament welcomed him back, not having discovered his true character, and in a flush of royalist sympathy provided liberally for him. They disbanded the old Cromwellian army, and granted the king an annual income of £1,200,000 for life to be raised from customs and excise. In return old feudal dues of the Crown were abolished. An amnesty was offered to all who had fought against the king in the Civil War, with the exception of those who had sat in the so-called High Court of Justice in 1649 and had been concerned with the execution of Charles I. The bodies of Cromwell, Bradshaw and Ireton were ordered to be disinterred and gibbeted.

Meanwhile many of the parochial clergy who had been ejected from their livings and dignitaries who had been deprived of their appointments were pressing to be reinstated. But some of those lawfully ordained in the Church of England before the Civil War had modified their views and retained their cures. How could the claims of both be reconciled? In broader terms, was the Church to be restored in all its ancient organization and become once again Anglican and Episcopal, or was it to be a far broader based Church including all manner of seemingly contrary view-points? Parliament included many who were for 'comprehension' and many who were pledged to a rigid restoration of the old order. Charles II decided to hold a conference made up of equal

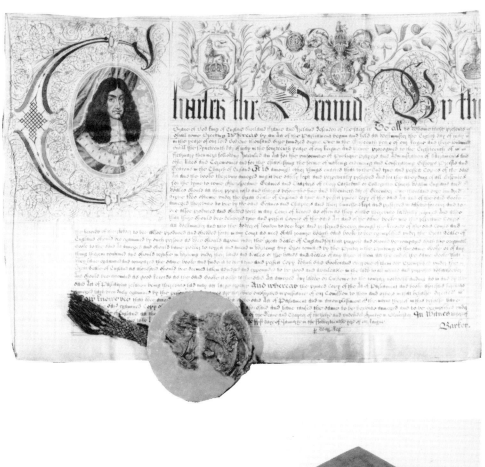

The Book of Common Prayer, 1662. Gloucester's 'sealed' copy, signed and sealed by six commissioners. At the front is Charles II's charter with royal seal attached. The title page is engraved by David Loggan. 'Pd. him [the Dean] for the Common Prayer Booke & the Great Seal bit, by Act of Parliament, to be archives £9. 10. 00.' Account Book f. 354

numbers of Presbyterian and Episcopal divines with the object of arriving at a compromise. But their meeting, in the Savoy Conference of 1661, came to nothing with the divines of the old Church and the Presbyterian ministers refusing to move from their positions.

Parliament then proceeded to pass the Act of Uniformity (1662), which forced the Puritans either to conform or leave the Church. *The Book of Common Prayer*, slightly revised, and the Thirty-Nine Articles were to be the rules of faith, and every minister was ordered to use and abide by them. Every incumbent was to declare his assent to them by 24 August 1662 or vacate his benefice. A similar fate awaited those who refused to accept Episcopal ordination. This left the Puritan ministers three months to choose between conformity and expulsion. The large majority of them conformed and accepted Episcopacy and the *Book of Common Prayer* but about 2,000 refused to do so and were expelled from their livings on St Bartholomew's Day 1662. Those clergy who refused to conform and their followers became known as 'Non-Conformists' or 'Dissenters'. But the position of the established Church was further strengthened with the order that no university professor and no schoolmaster was to be allowed to teach unless he had a certificate of orthodoxy from his bishop.

The king did not wait for these matters to be thrashed out before appointing or reinstating bishops, deans and prebendaries. Within months of his Restoration in May 1660 Charles II had reinstated William Brough, as Dean of Gloucester. Brough had been nominated by Charles I in August 1643, and installed in November 1644, so his appointment had only to be confirmed. He took up residence in August 1660, and before the year was out all six prebendaries had been appointed. However, though the cathedral was once more in the hands of a lawfully appointed Dean and Chapter, the diocese did not receive its new bishop, Dr William Nicholson, until the following year. He was consecrated at Westminster Abbey on 6 January 1661 by Gilbert Sheldon and Accepted Frewen, the former Dean of Gloucester who was now Archbishop of York.

RESTORATION WORK

An enormous amount of restoration work awaited the Dean and Chapter on taking office in the autumn of 1660. They received practical encouragement and welcome financial assistance from the Crown. Charles II wrote to say the Dean and Chapter could keep the Crown's portion of the rents from cathedral properties and apply it to the cost of repair work. In a letter, dated 24 October 1660, the king stated that he had been:

> . . . informed that the Cathedral Church of Gloucester is become very ruinous in the late ill times and beinge desirous to contribute what may lye in us towards a worke of so great Piety as the reparcon & preservacon of that ancient Structure We are gratiouly pleased to assigne ye improved Rents of all Impropriacons belonginge to ye said Church wch were made payable to us the 29th of September last past towards the repairinge of that ffabrick.[1]

The cathedral accounts for the years immediately following the Restoration give some indication of the extent of the work which was now put in hand. Early in 1661 masons, carpenters, glaziers and pavers were all hard at work restoring the fabric and

Charles R

Whereas formerly due care hath not been taken by you or your Predecessors to provide sufficient maintenance for the Vicars or Curates which Officiate in the parochiall Churches appropriated to the Dean and Chapter of that Church Our will is that forthwith provision be made for the Augmentation of all such Vicaridges and Cures where the Tythes and profitts are appropriated to you or your Successors in such manner that they who immediately attend upon the performance of Ministeriall Offices in every parish may have a competent portion out of Every Rectory impropriated to your Use . And to this end Our further Will is that no lease be granted of any Rectories or Parsonages belonging to Your Corporation ~~belonging~~ by you or your Successors untill you shall provide that the respective Vicaridges or Curates placed (where are no Vicaridges endowed) have so much revenue in Glebe, Tythes or other Emoluments as commonly will amount to 80th per Annum or more if it will beare it , and in good forme of law established upon them and their Successors And where the Rectories are of small value and cannot admitt of such portion to the Vicar or Curate Our Will is that one half of the profitts of such Rectory be reserved for the maintenance of the Vicar or Curate , And if any leases or Grants of such fore named Rectories have been made by you since the first day of June last past, and you did not Ordain Competent Augmentations of the Vicaridges or Cures in the respective places, Our Will is that out of the ~~rents~~ fynes which you have received or are to receive you do adde such increase to the Vicars and Curates as is agreeable to the rates and proportions above mentioned. And Wee do Declare Our Will and pleasure in all the particulers fore-recited to be that if you or yor Successors or any Person holding any Dignity, office Benifice or Prebend in that Our Church doe or shall refuse or omitt to observe this our Comands We shall judge them unworthy of our future favour whensoever any preferrment Ecclesiasticall may be expected by them from Us. Given at Our Court at Whitehall this 9th of August 1660 in the twelfe yeare of Our Reigne /

To Our trusty and welbeloved the Deane and Chapter of Our Cathedrall Church of Gloucester and to their Successors /

By his Maty Comand

[signature]

King Charles II's Letter, dated 24 october 1660(GCL)

refurbishing the interior. This activity was seen by a Dutch artist, Willem Schellinks, who in his travels in England in 1662 visited Gloucester. He arrived in the city on 10 July and went to stay at the Bell, 'a very good inn'. The following morning he visited the cathedral. 'This is a very beautiful church, large, with a high vaulting of stone without any timber; it is in bad repair due to its age and the recent war, but is now being assiduously repaired and rebuilt.' He noted in particular that the cloister was 'a fine vaulted building . . . but this is now in disrepair because of the war.' He could not have failed to notice such damage as had been caused during the Civil War and the general neglect of the fabric over many years, but what impressed him was that the cathedral was 'now being assiduously repaired and rebuilt.'[2]

Glazing and Paving

A bundle of glaziers' estimates and accounts for the period from September 1660 to June 1662 give details of work carried out on the windows. The workmen involved were William Lane, an Evesham glazier, William Croft, Robert Wager and John Painter. These accounts show that practically every window in the cathedral and cloisters required attention. No less than £250 was paid in 1661 alone to the firm supplying glass. The accounts usually indicate the amount of (a) new glass required, (b) old glass releaded, (c) old glass repaired, and (d) the number of new quarries used. It is therefore

Glazier's estimates dated 15 September 1660

Glazier's account, 1660

possible to estimate the proportion of medieval glass still surviving in many of the windows. For example, in the chantry chapel on the north side of the lady chapel 16.6 m (54 ft) of 'old glass' needed to be releaded, and 31.6 m (103 ft) of new glass used to complete the window. In the east window of the lady chapel 92.3 m (300 ft) of old glass was releaded. No less than 201.5 m (655 ft) of new glass was supplied for the windows on the north and south sides of the lady chapel. In the choir, the clerestory windows were reglazed, and in the great east window an account records: 'old glass now leaded sixty-two pains in measure 345 ft and a half in quarries 17 dozen' (July 1661). It was probably at this time that five of the six shields in the central lights of the lowest tier were reset in tinted glass.

In the tribune gallery all the windows were reglazed with plain quarries, and a new brick floor was laid. An account has survived for no less than 8,900 'Worster Bricks brought by William Perkes delivered at the Keay in Glocester for the use of the Dean and Chapter' (17 November 1668). In 1675 a considerable sum was paid to a certain Richard Hands, a mason, for 'laying ye pavement in ye body of ye Church', and in 1678 to Francis Reeve for new paving on the north side of the nave. In the cloister the upper lights of the windows were glazed with plain glass. Some years later, in 1679, one of the prebendaries, Abraham Gregory, noted that the 'Scotch souldiers (yt did much mischiefe to ye windows in ye Church and Cloysters) during ye late wars.' The cloister windows seem to have been particularly badly damaged at this time, though some of the

Brick paving in the tribune gallery; the pattern of the mortar bed was discovered in 1935

medieval glass was saved, including a section containing a rhyming account of the abbey's history. The lower lights of the cloister windows were bricked up either at the same time or a little later. Overall the reglazing programme of the early 1660s was extensive and costly, but obviously the work had to be carried out. The scrappy evidence of the glaziers' estimate and accounts, however, leave many questions unanswered.[3]

Choir and Organ

Another urgent task for the Dean and Chapter on resuming office was to re-establish the cathedral's choral tradition. The singing-men and organist had been laid-off during the Commonwealth, and had to be brought together again. Choristers had to be enlisted and their voices trained. Fortunately there were some like Robert Muddin, William Jennings, John Tyler, Roger Adams and Richard Elliot who had been in the choir as lay-clerks or choristers before the Commonwealth, and were still available to form the nucleus of the choir. It was not therefore a matter of starting from scratch. John Okeover, the former organist had also survived the Puritan years, and was able to resume his duties, though for only two years. At the Bishop's Visitation in 1663 it was reported that there was no organist, John Okeover having 'lately gone away.' The lay-clerks, giving evidence at the same Visitation, said that for 'two whole yeares . . . according to

Restoration organ case, 1662 G. Gilbert Scott, 1872

custome theire ought to be two sackbutts & two Cornetts for the use of our Singinge Service & anthems', but instead they had to rely on an organ which was constantly giving trouble. The Dean and Chapter had acquired the 1640 Dallam organ for £80 from a Mr Yates who had bought it during the Commonwealth. In the end the organ proved to be so unreliable and inadequate by Restoration standards that it was decided to replace it.

In the autumn of 1662 the Dean and Chapter appealed for donations towards the cost of the new organ, and Thomas Harris, a well-known organ builder, was commissioned to design and build it. The cathedral accounts give the names of those who contributed a total of over £395, between 1663 and 1666, but though this was about the sum paid to Harris for the new instrument, it was not enough to meet the total cost of all the work involved. Timber from the Chapter's woods at Woolridge had to be felled and sold to make up the deficit. The organ case was made by the cathedral carpenters, and John Campion, a gifted local painter, polychromed and gilded the pipes with floral patterns and figures, and the case with coats-of-arms, including those of Charles II and the royal monogram CR *(Carolus Rex)*. There were also the arms of James, Duke of York, whose wife contributed £100 to the appeal, Edward, Earl of Clarendon, the Dean and Chapter of Gloucester, the See of Gloucester, and the personal coats-of-arms of the Dean, William Brough, and of the six prebendaries, Richard Harwood, Thomas Vyner, Anthony Andrewes, Henry Savage, Thomas Washbourne and Hugh Naish. The present west front of the organ was, of course, the back when the organ stood under the south crossing arch. It has painting almost *trompe l'oeil* in style instead of carving.

The Chapter Act Book order recording the appointment of Thomas Low as organist, 1665

The chaire organ case was skilfully incorporated with that of the great organ. In contrast with the Restoration case, the Chaire organ case is beautifully carved and constructed and obviously dates from an earlier period, possibly as early as 1580.[4] Gillingham comments 'organ-builders in this country have always been conservative in their habits – often building cases in the style of a generation before.' While this is so, organ builders also used earlier cases particularly where funds were limited, as they clearly were at Gloucester. The chaire organ case, therefore, probably dates from *c*. 1630 and, if so, it was probably the case of the Dallam organ.

An organ loft had been constructed in 1639–40 between the south crossing piers. Repairs to the stone-work of the piers show where the main supports were held. Below, within the parclose screen of a one-time chapel, were the bellows, storage space and a staircase which led up to the organ console. A tracing by F.S. Waller of a mid-eighteenth-century painting of the choir (now lost) shows the new organ in this position and also Kent's magnificent reredos (1740). It should be noted that the towers of the organ case are surmounted by Gothic pinnacles. These pinnacles are also shown on nineteenth-century drawings of the organ. They were not part of the original design, but were probably added in the mid-eighteenth century, part of William Kent's Gothic embellishments.

Furnishing and Ornaments

The Dean and Chapter was not only concerned with the restoration of the fabric of the building, urgent as this was, but also with the refurnishing, particularly of the choir, and providing all that was necessary for worship. The Act of Uniformity of Publick Prayers (1662) ordered that before 24 August that year every dean, canon and prebendary of every cathedral or collegiate church was to subscribe to the declaration laid down; and that before 25 December 1662 all Deans and Chapters:

> . . . shall at their proper costs and charges . . . obtain under the Great Seal of England a true and perfect Copy of this Act, and of the said Book annexed hereunto, to be by the said Dean and Chapters and their Successours kept and preserved in safety for ever.

The Chapter duly obtained their copy at a cost of £9 10 s. This is now lodged in the library. Desk copies were also obtained for the stalls.

For the celebration of the Holy Communion new plate was needed, and an inventory, dated May 1673, lists the following items: 'two silver guilt candlesticks, one large silver guilt dish, two silver guilt fflagons, two silver guilt cupps with covers and one silver guilt plate for bread . . .' The silver gilt Communion vessels are typical examples of Restoration church plate.[5] Each piece has a hallmark of either 1660 or 1661, and each is inscribed with a biblical quotation. In 1661 the Dean and Chapter paid £69 s. 6 d. for 'the Vergers Rodd', a silver verge with the royal coat-of-arms engraved on it which the head verger was charged to carry before the chapter or individual members of the chapter at divine service and on ceremonial occasions. In 1673 they paid a further £ 5 10 s. to 'Mr Cosly Goldsmith for ye new mace [or verge].' In 1682, Mr Cosly was paid 5 s. for putting a plate with the arms of the Dean and Chapter engraved on it, presumably, on the verge he had supplied earlier. These verges are still in daily use in the cathedral.

Among the new furnishings for the choir were two brass candlesticks (1663) and altar hangings (1663–4). John Campion was employed to carry out ornamental painting behind the altar. Celia Feinnes visiting the cathedral in 1695 commented on this work: 'At the alter the painting is soe ffine that ye tapistry and pillars and ffigure of Moses and Aaron soe much to the Life you would at Least think it Carv'd.' Campion brought further colour into the choir with his painting of the repaired effigy of Robert, Duke of Normandy, which stood in the centre of the presbytery. He was paid £9 5 s. for 'gildinge and paintinge of Duke Robert his Tome and about the Quire' (1662), and further payments were made 'for paintinge and gildinge the ffont and other work in the

Head of verge, 1661, showing the royal arms (Charles II)

The north transept, showing the Restoration font in St Paul's Chapel, T. Bonnor, 1796

Quire' (1663). A dozen new cushions were provided for the stalls, and a certain amount of restoration work carried out on the canopies. A joiner, Henry Elliot, was paid £5 16s. 8d. in 1669 'for the Carven Canopy over the Deanes seate in the quire.' The payment of such a sum suggests fairly major restoration of the medieval canopy.

Within a few years of the Restoration the choir had been transformed with brilliant ornamental paint-work on the case and organ pipes dominating the choir on the south side, the reglazed clerestory windows above, the great east window cleaned and restored, with rich furnishings and ornamental work and painting around the high altar,

Occasional Offices

In 1661 the bishop ordered that there should be a stone font in every parish church in the diocese. Though the order did not apply to the cathedral church, the Dean and Chapter decided to install a font, or at least to have a portable font available for occasional baptisms. The new font which cost £5 was put in place in 1663. An eighteenth-century plan of the cathedral shows a font between the two most westerly Norman piers on the south side of the nave. But later in the century it was no longer there, and the same or another font is shown in St Paul's Chapel. The fact that a leather cover was made for it suggests that the font shown in T. Bonnor's engraving (1796) standing in St Paul's Chapel was, in fact, the Restoration font. It was a free-standing pedestal font, spherical in shape and made of wood though it probably contained a marble bowl. The upper half, forming the font cover, was painted by John Campion in 1663. When the font was not in use, the protective leather cover would have been laid

over it. The font was sold by auction in the early 1870s, and replaced by a large granite font designed by Gilbert Scott which was placed at the west end of the south aisle of the nave. It is now stored in the crypt (1990).

The marriage register for the years 1677–1700 shows that marriages were usually conducted by the minor canons. The cathedral precincts, described in the Statutes as an 'extra-parochial district', meant that the cathedral was used, in the main, for the marriages of those living in the close or of members of the College and their families. At least one of the families concerned was associated in this way with the Cathedral Foundation, or worked for the Dean and Chapter. As for funerals, interments continued in the upper part of College Green, and in the church itself with the permission of the Chapter and for an additional fee. Regulations and a scale of fees was agreed and introduced. As time passed, the Dean and Chapter came so to rely on burial fees to carry out urgent restoration work that permission was given too freely to those who were able to pay. The many ledgers in the cloister walks date mainly from the eighteenth century. The highest fees were levied on burials in the lady chapel where a study of the ledgers, shows that it was a favoured place for the interment of distinquished citizens and certain county families. But the cost to posterity of such a policy and of all the ledgers and vault covers in the lady chapel was the virtual destruction of a fine medieval tile floor.

PERSONALITIES OF THE PRECINCTS

There were many colourful characters in the city and in the cathedral close during the second half of the seventeenth century. Bishop Nicholson, who had been a 'fearless champion of the Church' during the Commonwealth, was bishop of the diocese from January 1661. In his 1664 Visitation articles he tried to enforce uniformity in worship throughout the diocese, and to reform abuses in the parochial system. He insisted, for example, on the residence of the clergy. He enquired about the repair of the fabric, particularly of towers and bells, the provision of a stone font and cover, a communion table and vessels such as paten, chalice and flagon. The bishop died on 5 February 1671 and was buried in the south chantry chapel of the lady chapel. His grandson, Owen Brigstock, erected a memorial to him, with an epitaph by his old friend Dr George Bull who had been one of the prebendaries and was later Bishop of St David's. The memorial, on the wall beside the entrance lobby, is a fine example of memorial sculpture of the period.

Dr Abraham Gregory, Prebendary of Gloucester from 1671 until his death on 29 July 1690, was another much respected member of the cathedral community who exercised considerable influence in Chapter over many years. He was a high churchman opposed alike to Dissenters and Roman Catholics. As Treasurer he kept a Register of Leases with meticulous care, and he noted down his personal comments on Chapter matters. Seiriol Evans and Suzanne Eward in their study of this *Seventeenth-Century Prebendary of Gloucester Cathedral* describe the career and character of the man who challenged the legality and propriorty of many Chapter decisions, and especially of Prebendary Fowler's impetuous action in destroying the medieval glass in the west window of the choir.[6] Gregory was appointed usher, assistant master, at the College School at the age of seventeen, and after his ordination became incumbent of two Gloucestershire parishes, Vicar of

Memorial to William Nicholson, Bishop of
Gloucester, 1660–71

Robert Frampton, Dean of Gloucester, 1673,
and Bishop of Gloucester, 1680–90

Sandhurst (1664) and Rector of Cowley (1670), before becoming prebendary of the second stall in 1671. In Eward's words 'He was precise and rather aggressive, with a keen legalistic mind. A loyal and ardent supporter of his monarch and his Church. He was a stickler for constitutional procedure, pernickety and contentious over what he thought were his rights, and an aggressive opponent to those whose political and relTgous opinions were contrary to his own'. (See plate 20.)

Dr Robert Frampton was another colourful character in Gloucester at this time. Simpson Evans in his *Life of Robert Frampton* describes his adventurous early years, as a schoolmaster, as a chaplain on a naval vessel, and for twelve years chaplain to a company of merchantmen trading to Aleppo. He returned home to become domestic chaplain to Robert, Earl of Aylesbury. He married into the family, and then sailed back to Aleppo for four more years. But in 1673 he was made Dean of Gloucester, and preferred to the bishopric in 1681. From all accounts he proved a good and faithful bishop, preaching frequently in all parts of the diocese, requiring the use of the *Book of Common Prayer* by all, encouraging Dissenters to return to the Church, exercising great care in examining candidates for ordination and firmly opposing the measures of James II.

When the king ordered the second *Declaration of Indulgence*, giving liberty to Roman Catholics and Dissenters, to be read in all parish churches throughout the country he stood by Archbishop Sancroft and six other bishops in their plea to the king not to force the clergy to do what was contrary to law. He instructed the clergy of his own diocese not to read the document. When the vast majority of clergy in the country refused, the

king committed the seven bishops to the Tower pending trial. Frampton who had not been a party to the bishops' plea but who nevertheless supported their action visited them frequently during their imprisonment. They were acquitted on 30 June to the relief and delight of the vast majority of people. However, when James II's reign came to an end in the 'Glorious Revolution' of 1688 and the Protestant William of Orange and his wife Mary were invited to become joint sovereigns, Frampton refused to take the oath of allegience, and was deprived of his bishopric. He retired to the living of Standish, near Gloucester, which he had held *in commendam*. He died there in 1708 and was buried in the chancel of the church.

In spite of his strong disapproval of the king's profession of the Roman Catholic Faith, Bishop Frampton, received James II graciously on his visit to the city on 22 August 1687. A contemporary local chronicler, Abel Wantner, in an unpublished manuscript, described the occasion:

In the second yeare of the Reigne of King James the Second . . . his Majesty . . . in his Royal Progress came to Gloucester, where he was most Magnificently received by ye Mayor, Aldermen, Sheriffs, and Council on Horseback, in their formalities. The chiefest streets, and lanes of ye City, being covered with Gravell, and Sand & all beset with Green Boughs & Branches, and strawd with variety of fflowers, all ye way he rod thro ye City Even to King Edwards Gate, wch giveth Entrance into ye Upper Colledg-Church-yard, where ye Deane, and Prebendaries of the Cathedral Met his Majestie in their vestments, and on their Knees received himn And from thence Attended him to the Deanerie, where he resided. And the next Morning his Majestie went to see the Cathedral and ye Whistering place, and that Afternoon he was Graciously please to Stroak, and Touch several Persons that had ye Disease called the Struma, or the King's Evill, in ye Ladies-Chappel of ye said Cathedral, and gave to each of them, a Meddal of Gold to Hang about their Necks.[7]

Edward Fowler was another colourful and controversial figure at the cathedral at this time. He become a Prebendary of Gloucester in 1675. His high-handed action, following a meeting of the Chapter in 1679, in smashing the stained glass in the west window of the choir, brought him into sharp controversy with Abraham Gregory. The

Edward Fowler, Bishop of Gloucester, 1691–1714

two men could hardly have been more different in temperament and in their religious and political convictions. Fowler later became incumbant of St Giles, Cripplegate in London, but in 1685 after a row with his parishioners he was suspended. After the Revolution and the ousting of James II, with the accession of William and Mary, he was rewarded for his resolute Protestant convictions by being appointed Bishop of Gloucester (1691). Meanwhile his old antagonist, Abraham Gregory, had stayed on in Gloucester and sworn allegience to the Roman Catholic James II (April 1685), adopting an attitude of non-resistance. Mercifully for both men, Gregory died some months before Edward Fowler returned as bishop. Fowler was bishop of the diocese for twenty-three years, until his death in 1714. In spite of his disruptive earlier years, the *Dictionary of National Biography* describes him as 'one of the most distinguished Whig prelates of his age.' (See plate 20.)

DESTRUCTION OF A MEDIEVAL WINDOW

The controversy surrounding the smashing of a medieval window by Prebendary Fowler provides evidence of the tensions which existed at this time in the Chapter, as indeed throughout the Church. It involved a bitter confrontation between Fowler, a low churchman of Whig sympathies and Abraham Gregory, a high churchman of strong

The Chapter Act Book order for the removal of the stained glass from the west window of the choir, 1679

Tory convictions. At a meeting of the Chapter on 23 June 1679, when he was in residence, Prebendary Edward Fowler obtained permission, or so he thought, to remove the glass from the west window of the choir. As he explained later, in August 1681, he had excluded the chapter clerk and his assistants from the Chapter meeting 'because I would have the matter carried as privately as might be.' But instead of giving orders to a glazier to remove the glass, which was the intention of the Chapter, Fowler went up onto the roof and with a long pole smashed out the 'scandalous' glass himself. In the words of Prebendary Abraham 'Mr ffowler . . . hee it was yt with a long pole dasht it to peices, in ye sight of many, and some strangers of quality yn in ye church . . .'

This six-light window still contained its medieval glass. In 1681 Fowler described it as depicting 'the old Popish Picture of the Trinity: God the Father represented by an Old man with a very long Grey Beard, and a huge beam of Light above his head: God the Son, by a Crucifix between his knees: and God the Holy Ghost, by a Dove with spread wings, under his beard.' From this description it would appear that the picture depicted in the window was very similar to a medieval painting discovered in 1947 in Little Cloister House, and now hanging in the Parliament Room. At all events, Prebendary Fowler, with his strong Puritan sympathies, found it deeply offensive. He defended his action in a sermon in the cathedral on 7 August 1681: 'The destroying of an Idol, that even moderate Papists have condemned, and some of the better sort of Heathens also: to wit a Corporeal Representation of the Great God, and which one would wonder should have any Patrons . . .'

Dr Frampton, the dean, who had not been present at the chapter meeting, was furious when he heard what had happened, but no more so than Dr Abraham Gregory who, though present, had not agreed to the proposal. In the absence of the chapter clerk, one of the prebendaries entered in the Chapter Act Book that: 'it was ordered by a Majority. . . . That a certain scandalous picture of ye holy Trinity being in ye West Window of ye Quire of ye sd Church, should be removed, & other glasse put in to ye place.' But later the words after 'a Majority . . .' were crossed out with such thoroughness that they are quite indecypherable. Abraham Gregory, however, determined to put the record straight and wrote a note in the *Register of Leases* stating that the erased words read 'every one consenting yn present {Dr Gregory only excepted]'. Gregory insisted that the memorandum or minute of the Chapter:

> . . . was not entred till long after ye thine done, and till Mr ffowler earnestly by leter upon leter prest it, doubting his being questioned, and at last was entred by Mr Hodges, Mr Lamb ye Chapt Clarke absolutely refusing it, as against his oath and duty. Whereas Chapter acts are always written down in ye Chapter house by ye Chapter Clarke as soon as they are made.

As Treasurer Gregory had been asked by the Chapter to instruct a glazier to remove the glass, but had refused to give any such undertaking. It had been agreed that: 'ye Treasurer should remove it, but because hee would not promise to do it, Mr ffowler said, I will go and do it presently my selfe, and so did . . .', 'the glass was immediately broken down by a violent hand, which was not ordered.' What angered Gregory particularly was the way James Forbes, the Presbyterian preacher, made capital out of the incident in a sermon the following Sunday. 'The next Sunday ye Conventicle preacher urgd, yt now it was evident ye establisht church needed a more thorough reformation, since its own members confest the dreggs of popery were remaining in it.'

Gregory objected not only to the way Fowler had dealt with the matter in Chapter and afterwards in smashing the glass himself; he objected to the removal of the glass under any circumstances. He argued that the glass 'had stood ye reformation of ye Church of England and of ye Church of Scotland; yt is and neither any of their predecessors in yt Church since H. ye 8th nor any of ye Scotch souldiers (yt did much mischiefe to ye windowes in ye Church and Cloysters) during ye late wars, had been angry at or scandalis'd with it . . .' Furthermore he for one could see nothing offensive in the glass. 'If any private person would interpret it according to his own fancy, ye fault was in him, not in ye window.' In any case he pointed out that the glass was 'up so high, and stood in so private a place, yt not one in a thousand yt came into ye Church either did, nor easily could, see it . . .' And lastly, the representation of the Trinity was '. . . ye very same with ye common seal of ye said Cathedrall Church; yt if in conscience they thought themselves bound to break ye window, they must bee bound to break their seal also . . .' Fowler, however, would not have been persuaded by such arguments.

THE COLLEGE SCHOOL

Maurice Wheeler, Master of the College School from 1684 until 1712, was another remarkable member of the cathedral community at this time. After his student days at Oxford he was ordained and stayed on as chaplain of Christ Church. From 1670 he was Rector of St Ebbe's, Oxford. He showed keen interest in a variety of intellectual pursuits from Coptic typefaces to editing *The Oxford Almanac* in 1673. He also developed an interest in architecture. He was admitted *archididascalus* or Master of the College School on 11 September 1684, and lived with his wife and children at the Schoolmaster's House in Miller's Green. He proved a strict disciplinarian, setting high standards and expecting the boys to strive to achieve them. He encouraged a spirit of enquiry in his pupils, and inculcated a love of learning. He consulted the boys on many matters, trusting them and giving them responsibility. His own lively mind and infectious enthusiasm won the boys' hearts and spurred them on to ever higher attainment. In many respects his approach to teaching was well ahead of his time, and some of his educational methods quite alien to contemporary practice.

He involved the boys in practical projects such as clearing the derelict garden on the north-east side of the cathedral known as the Grove. This provided opportunities for the

The College School. T. Bonnor, 1796

study of elementary botany and developing gardening skills. This particular project was also a challenge to the boys' imagination and aspiration. Bonner (1796) describes in some detail Wheeler's intention in laying the garden out in the way he did:

> He formed a mount; the path to the summit of which was narrow and steep, requiring great exertion to climb, and meant as an emblem of the road to happiness. An *arbor vitae* at the top of it, by its perpetual verdure, was typical of the immortality of the future state, as the reward of virtuous exertion and perseverance. Two cypress trees at the bottomm, were the emblems of death, through which all must pass on their road to immortality. He planted a birch tree with a vine twining up it, as allusive to good and evil; and he distinguished the walks by the appellations of the orators' walk, the poets', the historians', the moral etc. according to the classes of the upper school. The narrow walks within, were termed the reciters' walks; and that which formed the entrance to the grove, was called the rudimentarians' or novitiates in grammar.[9]

Wheeler began a *Census Book of the King's School, Gloucester*, or register of pupils. After his time the Register was continued, with a few gaps, until 1923. This may be the first time the 'College School' was referred to as the 'King's School', after its founder Henry VIII. The list shows that an increasing number of boys from more well-to-do families in the city and county were sent to the school. These included children of the Selwyns of Matson and the Lysons of Hempsted, the Guise, Hayward and Hyett families, the Scudamores and Bathursts. The names of many others associated with the

Page of Maurice Wheeler's school library *Benefactors' Book*

school are given in the school library *Benefactors' Book*. He enlarged the library, again involving the boys to do so (1686):

> It was customary for each scholar at Lent, to give sixpence for the master; one half of this collection he kept as his fair and allowed perquisite, and with the other half he bought cakes for the boys. Mr Wheeler proposed to apply his share of the cake-money to the buying books for the school library, if they would consent to do the same; and thus the purchase of books began. Considerable additions were made by Mr Wheeler, and at different times by his acquaintences, in compliment to him; as likewise by several of the young gentlemen on retiring from the school.

Bishop Frampton and Dean Jane as well as the prebendaries were among the first benefactors of the library, together with many parents and friends of the school and old boys. The *Benefactors' Book*, in Wheeler's own hand-writing, and what remains of the library he built up, are still kept in the old School Room, the present cathedral library. The fire which badly damaged the school room in 1849 destroyed the greater part of Wheeler's original collection. Only fifty of the works he listed remain today in the 'Wheeler library'. In 1709 the Dean and Chapter asked Wheeler to take their own library in the Old Chapter House into his care as Cathedral Librarian. But a few years later, in 1712, Wheeler retired and left Gloucester. He lived on for another fifteen years serving in small parishes, and died at Thorp Mandeville on 6 October 1727. Bonnor's drawing (1796) probably gives a fair impression of the schoolroom in Wheeler's time even though it was sketched a century later. See Appendix XI.

CONTEMPORARY DESCRIPTIONS

Several descriptions of the cathedral interior and of the precincts by visitors to Gloucester at this time have survived. There is the rather earlier (1662) but confused account of Willem Schellinks, a Dutch artist. Whoever showed him round the cathedral took him all over the building and enthralled him by the story he told. Not always accurate in its historical references or in its description of the building, it contains some interesting and amusing detail:

> It has a very beautiful choir with a Lady's Chapel behind. The services are held in the lower choir, in the upper part one sees the tomb of Robert of Artois, the son of William the Conqueror; around the choir are some more ancient tombs, that of Osric the last Saxon king, the founder of this church, and of King Edward the second, murdered by his wife at Berkeley Castle, and carried to Gloucester on a cart drawn by twenty-four harts, who are depicted on a pillar next to the tomb, but this picture has almost disappeared over the years. Further one sees the tombe of Parker, the last abbot of Gloucester, that of Hugh Crawford, general of the Scottish army, and that of abbot Seabroke, Great Keeper of the College. Then the tomb of the Count or Baron, 2nd High Councillor and Constable of England and his wife, with his helmet under his head with its open end towards the outside; if one puts one's ear to this one can hear a sound like the noise of a boiling pot.
> Round the choir are twelve beautiful chapels, and above their vaulting is a wide gallery. On the tomb of bishop Gouldbron in the upper end of the Lady's Chapel used to stand three old statues, which King Henry VIII had broken up and sold for 15,000 pound stirling in gold. [In the gallery] one can go from either side through a narrow stone passage to a chapel behind. This passage is called the whispering gallery, its length in its half-circle is 26 English yards . . . The working of this gallery is like this: if on each side of the narrow passage stands a person, and to locate himself, holds a finger in a

The old bridge over the River Severn and the West Gate, Gloucester. T. Bonnor *c.* 1800

certain little hole and speaks very softly, the person on the other end can hear him and answer him, while none of the other persons nearby can hear anything.

Under the church or the choir a very large number of human bones are shown.

Then we saw the library, a very fine, large building, but due to the war, with very few books and empty shelves.

The church has a very high tower, which we climbed, and saw the large bell which had fallen down. From the top we had a beautiful view. Adjoining the church is the monastry or cloisters, a fine vaulted building, which used to have a water supply or conduit for the use of the monks, but this is now in disrepair because of the war.

Then there is Abel Wantner's list of 'ten things'. Wanter lived in Minchinhampton but frequently visited Gloucester. In 1686 he invited subscriptions for his work which he entitled *Antiquities and other Remarkable Observations of his Native City and County . . . a large and true History of the City and County of Gloucester in one folio.* Unfortunately he did not win the support of the gentry of the area for his work. Their attitude was probably reflected in a remark of Bishop Nicholson (1660–71) that this ambitious commoner should meet with 'those discouragements that were suitable to the man's busie medling in things beyond his station.' Similarly, Archdeacon Furney writing to Browne Willis on 12 January 1719 refered to 'Abel Wantner, late Parish Clark of St John Baptist Church in Gloucester, appear'd to me to be a person very little qualified for this work.' Nevertheless, Wantner's 'ten things' are of considerable interest:

There is no one Cathedral in England . . . that can compare with Gloucester Cathedral for ten things. As *first*, For a library. I spake not of books! but for the variety of imagery and carved work. *Secondly*, For a noble quadrant or cloister. *Thirdly*, For a lofty quire and tresagick roof. *Fourthly*, For a spacious and

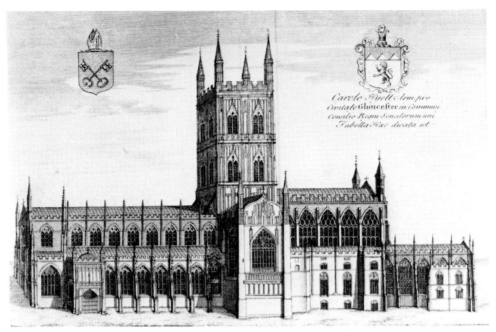

Carolo Fuett Arm pro
Civitate Gloucester in Communi
Consilio Regni Senatorum uni
Tabella Hæc dicata est

The cathedral from the south in the late seventeenth century

curious chappell. *Fifthly*, For an East windowframe and glass. *Sixthly*, For a whispering place. *Seventhly*, For a magnificent tower, or minster. *Eighthly*, For eight sweet tunable bells and chime. *Ninthly*, For a mighty great Sermon-bell, which weigheth three tun and 500 lb. whose noise have been heard down the river of Severn as far as Lidney, which is near fifteen miles below Gloucester. *Tenthly and lastly*, For a sweet and costly organ, whose sound hath been heard as far as the Vineyard Hill beyond Over's Bridge, which is above a mile. [10]

Celia Feinnes during her travels through the country on horseback, came to Gloucester in 1695, and left the following account of her visit:

The Cathedrall or minster is Large, Lofty and very neate, the Quire pretty. At ye Entrance there is a seate over head for ye Bishop to sit in to hear the sermon preached in ye body of ye Church, and therefore the organ is in the Quire on one side wch used to be at ye Entrance. There was a tomb stone in ye middle wth a statue of Duke Roberts, second son to William the Conquerours son [sic], wth his legs across as is the manner of all those that went to the holy warre; this is painted and resembles marble tho' it is but wood and soe Light as by one ffinger you may move it up, there is an jron Grate over it. At ye alter the painting is soe ffine that ye tapistry and pillars and ffigure of Moses and Aaron soe much to the Life you would at Least think it Carv'd. There are 12 Chappells all stone finely carv'd on ye walls and rooffs, the windows are pretty, Large and high wth very good painting, There is a Large window just over ye alter but between it and ye altar is a hollow walled in on each side wch is a Whispering place; speake never so Low just in the Wall at one End the person at ye other End shall heare it plaine tho' those wch stand by you shall not heare you speake – its ye Wall Carrys ye voyce . . . the tower was 203 stepps, the Large bell I stood upright in but it was not so bigg as ye great Tom of Lincoln, this bell at Gloucester is raised by ten and rung by 6 men. On the tower Leads you have a prospect of ye whole town, gardens and buildings and grounds beyond and ye river Severn in its twistings and windings. Here are ye fine Lambrys taken in great quantetys in their season, of wch they make pyes and potts and

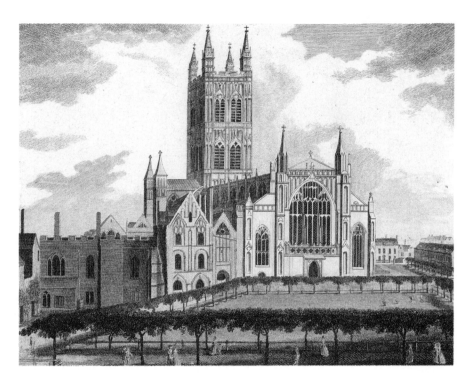

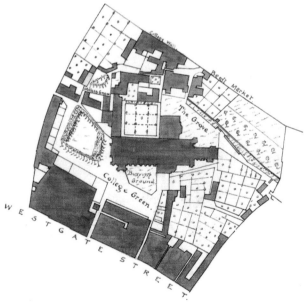

Plate 21
Top: View of the cathedral from the west side of the precincts *c.* 1740. Bottom: Tracing
from Hall and Pinnell's map of Gloucester 1780, showing the precincts

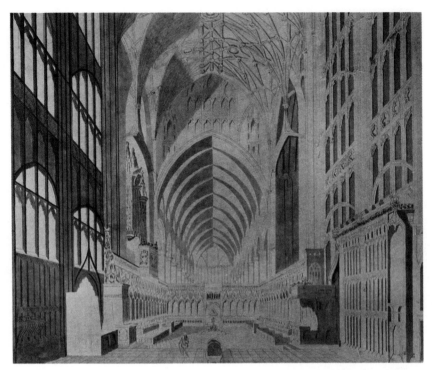

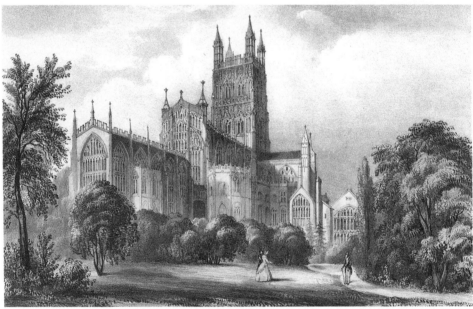

Plate 22
Top: Unfinished sketch or architectural drawing of the choir, looking west; with organ in pre-1718 position, and the early eighteenth-century bishop's throne on the south side; opposite the mayor's seat. Bottom: The cathedral from the north-east, the Grove in the foreground

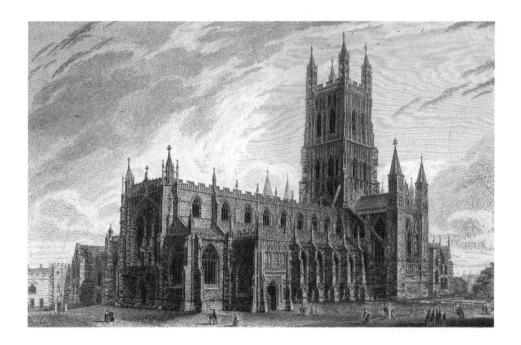

Plate 23
Top: The cathedral from the south-west, 1795. Bottom: College School boys at play, before the building of the new school room and demolition of Babylon

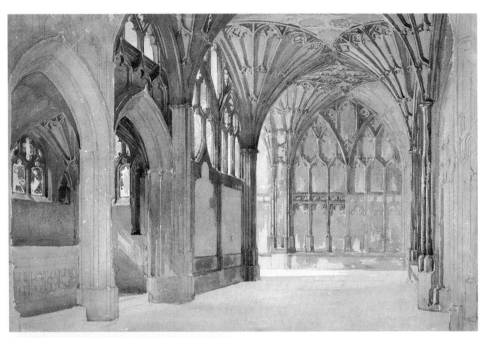

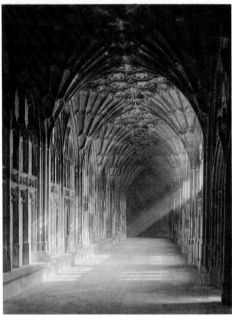

Plate 24

Top: An unfinished watercolour by William Collingwood (Smith) RWS 1819–1903: the north-west corner of the great cloister, exhibited at the Royal Academy 1839–60. Mostly known for his Alpine subjects, Ruskin praised his watercolour *Jungfrau at Sunset*. Most of his professional life was spent in Liverpool, but he died in Bristol. Bottom: *The Novices' Cloister* by Sydney Pitcher, FRPS. From the early years of the century until his death in 1950, Sydney Pitcher (of College Court) produced and exhibited many outstanding studies of the cathedral including this atmospheric study of the north walk of the cloister

Convey them to London or Else where, such a present being fitt for a king; this and ye Charr fish are Equally rare and valuable. Here are very good Cloysters finely adorn'd with ffretwork, here is the Colledge and Library but not stored wth many books I think this is all the remarkable in Glocester.[11]

Early in the eighteenth century there were some major alterations in the internal arrangement and furnishings of the cathedral. The pulpit set up by Dr Henry Parry in 1609 stood against the third pier from the east end, on the north side. It was regularly used for the Sunday sermon, with people gathering at the east end of the nave in front of the great medieval *pulpitum*. In the north and south aisles, at the east end by the second pier, were small chapels enclosed by wooden screens and containing seats; those on the north side were occupied by the city corporation, and those on the south by the cathedral clergy. The medieval screen, adjoining the first piers of the arcade, crossed the full width of the nave. In 1717–18 Dr Knightly Chetwood, refitted the choir for hearing sermons, placing new box pews in front of the medieval stalls, and providing a portable pulpit. As part of the same refurnishing of the choir, a wooden altarpiece in classical style carved by Michael Bysaak, was been installed in 1716. But this is to anticipate a new chapter in the ever-changing internal arrangements of the cathedral.

THE EARLY GEORGIAN CATHEDRAL
1702–1752

*'The man of taste must regret that the good bishop
Benson, distinguished by Pope for his "manners and candour"
should have wasted his munificence upon ill-conceived and
unappropriate ornaments . . .'*
James Dallaway c. 1780

The eighteenth century saw the passionate convictions of the previous two hundred years replaced by a genteel faith based on morality. Reason was dominant. Churchmen such as Berkeley and Paley busied themselves with the intellectual justification of a Christianity suitable for a reasonable man. Revelation was reduced to the limits of the rational. The church reflected the secular political attitudes. The Whig government appointed Whig bishops, while in the countryside Tory parson and Tory squire presided together over village life. Church and State were seen as two pillars of the existing social order. The clergy happily accepted their place in such a society and encouraged their congregations to do the same. But before the middle of the century was reached the status quo was to be disturbed. John Wesley's conversion in 1738 led to the growth of the Methodist movement. Its leaders were John Wesley, his brother Charles, and Gloucester-born George Whitfield. They sought to revitalize religion and free it from the bonds of social convention. They went out to the people with whom the Church had lost touch. Although denounced by Church leaders suspicious of 'Methodist' enthusiasm, John Wesley always hoped that his followers would be able to remain within the Church of England. Unfortunately, however, this did not prove possible and the Methodist set up their own independent church organization.

EIGHTEENTH-CENTURY GLOUCESTER

Gloucester at this time was a busy, bustling city with much of its industry centred round its west side, close to the River Severn.[1] It was widely known for its pin

The Cross at Gloucester, demolished in the eighteenth century

manufacturing but there were other trades contributing to the city's prosperity such as glass-making, sugar refining, brick and soap making. Iron ore and timber from the Forest of Dean continued to provide the raw material for iron-workers and smiths as it had from medieval times and earlier. Another industry which had been carried on in Gloucester for centuries was bell founding. The Rudhall family made bells in the city for generations, it is said that half the belfries of England contain one or more bells cast in Gloucester. The names of members of the Rudhall family, especially those of the eighteenth century, constantly crop up in the records of the Dean and Chapter. There are family memorials on the wall by the west cloister door, appropriately incorporating bells.

The markets continued to attract people from the surrounding area, and trade on the River Severn and along its wharfs was brisk. With increasing prosperity came such amenities as the publication of a local newspaper in 1722, and the building of the Royal Infirmary in 1788. A new county gaol, built on the site of the old Castle, was opened in 1791. The annual Music Meeting combining the cathedral choirs of Gloucester, Worcester and Hereford attracted increasing acclaim. The relationship between the city authorities and the cathedral had its ups and downs. For some time the Mayor and Corporation abandoned their traditional attendance at cathedral services and transferred their support to St Nicholas', a few hundred yards away from the cathedral. But when Dr Knightley Chetwood was dean (1707–20) they returned to the cathedral and were provided with special seating in the refurbished choir (1717).

LIFE IN THE PRECINCTS

At the turn of the century Edward Fowler was still bishop, though because of increasing infirmity he was not greatly involved in the affairs of either the cathedral or diocese in his last ten years. He died at Chelsea in August 1714 aged eighty-two. The dean was William Jane, Regius Professor of Divinity at Christ Church, Oxford and Prebendary of Exeter; but he died at Oxford in February 1707, and was succeeded by Knightley Chetwood. Chetwood has never received the credit due to him for his work at Gloucester. It was during his years as dean that the organ was moved from beneath the south crossing arch to a gallery over the west entrance to the choir, and the choir itself was extensively refurbished. Chetwood's three successors did not hold the appointment for long, Dr John Waugh (1720–3) leaving to become Bishop of Carlisle after only three years, Dr John Frankland (1723–9) to become Dean of Ely and Master of Sidney College, Cambridge, and Dr Peter Alix after only a year in office succeeded Dr Frankland as Dean of Ely. Dr Daniel Newcomb was then appointed and remained in Gloucester for twenty-eight years (1730–58); he was dean throughout Bishop Martin Benson's episcopate. Newcomb was succeeded by Josiah Tucker, one of the most distinguished economists of his day. Bishop Benson (1734–52) and then Dean Tucker (1758–99) were the two dominant influences in the life of the cathedral to the end of the century.

BUILDING IN THE PRECINCTS

From the middle years of the seventeenth century there had been modest housing developments the precincts, especially in the Upper Churchyard and in Miller's Green, involving encroachment on what had long been common land. Some idea of the extent of the developments can be seen by comparing Kip's view of the precincts in Sir Robert Atkyns's *The Ancient and Present State of Gloucestershire* published in 1712, with that of John Speed, published in 1611. In Laud's time *c.* 1616, the Upper Green was still a churchyard with tomb-stones scattered about and interments taking place from time to time. But by the outbreak of the Civil War there were houses along the east wall, and along the south wall between St Michael's Gate and King Edward's Gate. Later, in the lower or western end of College Green, the prebendal houses on the south side were remodelled (7 and 8 College Green) and a number of new houses built. These included Parliament House (7 Miller's Green) in *c.* 1670 on the site of the old workhouse and schoolhouse. A mid-eighteenth-century painting shows its original frontage facing College Green. A little later, *c.* 1680, other houses were built, including the 'Queen Anne' house in Miller's Green (No. 6) and another on the east side of the Upper Churchyard, Cathedral House (Wardle House). At the lower end of the Green, in the south-west corner, an imposing house (9 College Green) of three storeys and five bays, with a central pediment and angle pilasters was built in 1707.

In the eighteenth century Gloucester's new-found wealth from trade, led to the building of fine houses in various parts of the city, the most favoured areas being Spa Road, which had some impressive Regency houses including one particularly fine example of the period until recently used as the Judge's Lodging, and St Mary's Square and College Green in the cathedral precincts. A number of the houses in these areas date

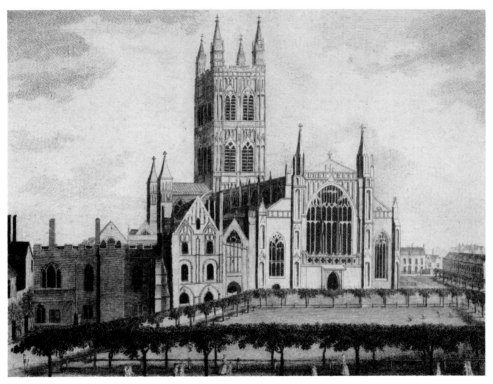

The cathedral from the west side of the precincts in the eighteenth century

from the latter half of the eighteenth century when Gloucester was promoted as a spa. In the precincts a row of four houses was built (*c.* 1735) along the west wall of College Green on the site of the old monastic stabling, which had provided stabling for the bishop and dean's horses. Herbert notes that 'No. 12 includes a ground-floor assembly room with tall sash windows which in the time of the first tenant, Alderman Benjamin Saunders, former landlord of the King's Head Inn, was used for concerts and social gatherings.'[2] The tall house in the north-west corner of Miller's Green (No. 1) was built before 1741. The row of houses on the south side of the Upper Churchyard was rebuilt *c.* 1750–60; and the house on the north side of St Mary's Gateway (later Monument House) *c.* 1774 facing onto St Mary's Square. The former sexton's house, backing onto the abbey wall on the west side of King Edward's gate (No. 6 College Green), was enlarged in 1813. Spacious Georgian rooms were added to the Jacobean extension of what was originally a timber-framed medieval lodging. A cleverly contrived late Georgian frontage brought the disparate parts of the enlarged house into a deceptive unity.

Chapter Matters

The Chapter usually met about three or four times a year in a room at the east end of the present choir vestry, not in the Norman chapter house which was the library and

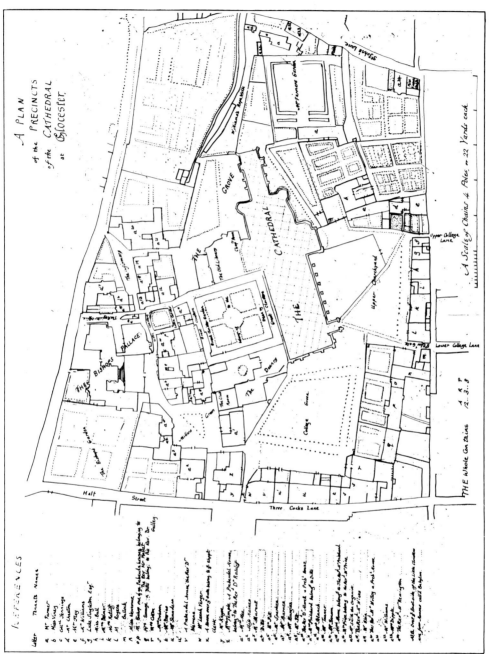

Plan of the precincts c. 1761–4

otherwise known as the Old Chapter House. In the late sixteenth century this long room over the eastern slype was divided into an audit room, a robing room, containing two medieval cope cases (now in the south ambulatory) and, at the east end, the Chapter Room. The well-worn medieval tiled floor of the Chapter Room was boarded over and the room suitably furnished. In 1986 the yellow and dark brown glazed tiles were exposed during repairs to the floor. It was noticed that they were laid diagonally to the axis of the building, and stopped short of the east wall leaving a strip of untiled floor measuring approximately a metre wide.

The Chapter Act Books, in which the clerk recorded the Acts or decisions of Chapter, indicate the broad range of matters with which the Dean and Prebendaries had to deal.[3] Certain legal documents were transcribed into the Act Book, such as the notification of a vacancy in the see, the election of a new bishop and his installation in the cathedral. The appointment of cathedral servants, porters, almsmen etc, the admission of singing men and choristers, the election of officers such as the sacrist and librarian, the appointment of the organist and master of the choristers, the master of the College School and his assistant, and of the minor canons were all formally recorded. Matters relating to property belonging to parishes of which the Dean and Chapter were patrons, and the revenues from the Dean and Chapter's own estates came up for discussion and occasionally for legal action. The management of the estates took up a considerable amount of the Chapter's time even though agents were employed to deal with routine matters.

At Michaelmas each year the Chapter recorded the prebendaries' months of residence for the following year. The six were required, under the Statutes, to be 'in residence' for two months. They chose their months according to seniority of appointment. During these months they were expected to reside at their prebendal house in the close, and to be responsible for all that went on in and around the cathedral. Because the prebendaries often held other appointments, parochial and academic, some of them had to be away for long periods at a time. This was true particularly of the dean who was away for months on end. Dr Knightly Chetwood was dean from 1707 until 1720. He had been chaplain to Lord Dartmouth, the Princess of Denmark and King James II; he was also a Prebendary of Wells, Rector of Broad Rissington, Gloucestershire and Archdeacon of York. On becoming Dean of Gloucester he continued to hold these last appointments, in plurality, to provide himself with an adequate income. He also frequently visited Tempsford in Bedfordshire where he had a family estate.

Another member of the chapter who was only occasionally in Gloucester, apart from his periods of close residence was the holder of the fifth prebendal stall. This was incorporated with the Mastership of Pembroke College, Oxford on 11 November 1718. For well over two hundred years the Master of Pembroke was *ipso facto* and *ex officio* a canon of Gloucester, with a house in the precincts. At first the house adjoining the inner gate, on the west side (on the site of the present Monument House) was assigned to him, but from the nineteenth century he occupied the house now known as King's School House. This house had grown from a small dwelling built *c.* 1590 on a parcel of ground in the Common Orchard leased from the Dean and Chapter by the Blackleach family. By 1623 the house had been enlarged, and in the eighteenth century it was further enlarged and given its present Georgian façade. The Master of Pembroke came to Gloucester to be 'in residence' during July, August or September, i.e. during the summer vacation. This

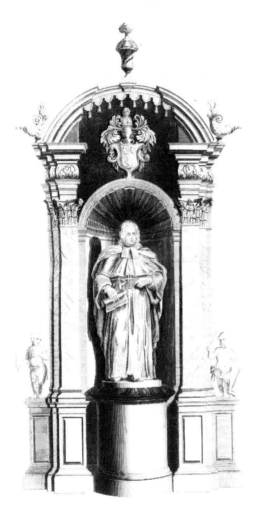

Memorial to Sir John Powell, by Thomas Green of
Camberwell, 1713 (in the lady chapel)

arrangment was to the great advantage not only of the holder, in providing him with a
summer 'seat' conveniently near Oxford, but also to the cathedral. Even though most
members of the chapter were men 'with title to academic distinction' they benefited
enormously by having the Master of Pembroke with them in chapter, and in residence
during the summer. The Pembroke canon was usually asked to inspect the College
School and to report to the chapter. His visits ensured academic standards were
maintained, and his interest in individual boys proved much to their advantage when
seeking entry to the university. Many who held the canonry, such men as Dr Jeune who
became vice-chancellor of the university and later Bishop of Peterborough, developed a
deep affection for the cathedral and made a valuable contribution to its life and work.
The link between the canonry and the college was eventually broken on 31 December
1937.

From time to time the Chapter was in trouble with the judges over the Assize
Services. The judges who attended did not approve of the dean or one of the prebendaries

asking a minor canon, or some other 'inferior clergyman', to preach on this occasion. In November 1713, the Chapter agreed that 'the Dean or Prebendary whose turn it is to preach before the Judges at every Assize does it in person or procure one of the Body [i.e. the Chapter] to preach for him or he shall forfeit his Quarter Salary for neglecting thereof to the rest of the Body.' The enormous size of the forfeit indicates the seriousness with which the Chapter viewed the matter. But this was only one of the unfortunate consequences of the frequent absence of the dean and sometimes of the prebendary in residence. In 1738, in the time of Dean Newcome, and probably as a result of words from Bishop Benson, regulations regarding residence were tightened up considerably. The dean was to be in residence for at least ninety days, and the prebendaries for at least forty-two days, otherwise a forfeit of £40 in the case of the dean and £20 in the case of prebendaries was to be deducted by the treasurer from their income.

There is a fine marble monument to a judge of the period in the lady chapel. Sir John Powell was one of the judges who tried the seven bishops (1688) and joined in the declaration against the king's dispensing power. For this James II deprived him of his office on 2 July 1688; but William III created him first a Baron of the Exchequer, then a judge in the Common Pleas, and on 18 June 1702, advanced him to the King's Bench where he sat until his death on 14 June 1713. From 1685 he represented his native city of Gloucester in parliament. He is depicted standing, a custom which gradually crept into monumental statuary in the latter half of the seventeenth century, but which became more common in the eighteenth century. He is shown in his judicial robes, the gown, academic hood, and mantle faced with fur or miniver. On his head he is wearing the coil, and under his chin are plain bands, which, after the Restoration, replaced the ruff. The cuffs on the sleeves of the gown are furred and in his right hand he is holding a scroll. The figure is standing on a circular pedestal set in a semicircular escalloped recess, surmounted by a segmental-shaped pediment and supported on each side by a Corinthian pilaster, with architrave, frieze and cornice. The moulded arch of the gallery chapel had to be cut back to accommodate the funeral urn at the top. On each side of the fluted pillars is a boy weeping. One of the boys is holding the handle of a torch inverted in his right hand, and the other the handle of a torch upright, resting his left hand on a broken pillar.

Stephen Jefferies — Organist

The Chapter continued to have trouble with the singing men, but this was as nothing compared with the trouble caused by Stephen Jefferies, organist from 1682 until his death in January 1712.[4] He had been a chorister at the cathedral, and after a short time as assistant organist at Salisbury was appointed organist at Gloucester at the age of twenty. He appeared before the Chapter for his 'first monition to depart this church . . .' within months of his arrival, and again in November 1688:

> . . . for that upon Thursday last in the morning (being the Thanksgiving day) immediately after the Sermon ended and ye blessing given he did play over upon the organ a common ballad in the hearing of fiftene hundred or two thousand people to the great scandall of Religion, prophanation of the Church and greivous offence of all good Christians. And ffarther because tho Dr Gregory [the senior prebend of this Church] did immediately express his great detestation of the same to Mr Deighton, then Chanter

of this Church, and Mr John Tyler the senior singingman of the Quire, informing them of the unspeakable scandall that universally was taken at it, and that they imediately acquainted ye said Stephen Jefferies, in direct despite to Religion and affront to ye said Dr Gregory, did after Evening Prayer as soon as the last Amen was ended, in the presence and hearring of all the Congregation fall upon the same straine and on the organ plaid over the same comon ballad again, in so much that the young gentlewomen invited one another to dance; the strangers cryed it were better that the organs were pull'd downe than that they should be so used, and all sorts declared that ye D and Chapter could never remove the scandall if they did not imediately turne away so insolent and prophane a person out of the Church.

Jefferies remained as organist, however, and survived a number of further 'monitions' from the Dean and Chapter. In 1699 he was warned about 'his frequent Absenses especially on Sunday Morninges, but more perticulerly for his not educating the Choristers in the Grounds of Musick which may prove very prejudiciall for the future if not speedily remedied.' Brian Frith relates two further stories about Jefferies from Hawkins' *History of Music*. Jefferies was addicted to staying out late in taverns. In an attempt to cure him of the habit his wife dressed a man in a white sheet with a lantern and candle, and stationed him near the cloisters in order to intercept the organist on his way home. Jefferies, however, on seeing the 'apparition' merely said, 'I thought all you spirits had been abed before this time.' On another occasion when a singer from outside the area with a particularly good voice was asked to sing a solo anthem in the cathedral, he did so standing by the elbow of the organist in the organ loft. Unfortunately he faltered in his singing, and Jefferies, instead of helping him, promptly rose from his seat and leaning over the gallery called out to the choir and congregation 'He can't sing it!' Though continuing to receive his salary, Jefferies does not seem to have functioned much after 1707; from that year his successor, Mr William Hine, is referred to in the *Chapter Act Book* as *huius Ecclesiae Organista*.

Three Choirs Annual Music Meeting

Hine was in full charge of the music at the cathedral from 1712 until his death in 1730. He was highly regarded, and soon after his appointment was given an increase in salary 'in consideration of his musical skill and gentlemanly qualities.' This sounds as though the Chapter was heartily thankful to be rid of the eccentric behaviour of his predecessor. It was during Hine's time that the Annual Music Meetings of the Three Choirs of Gloucester, Worcester and Hereford Cathedrals was inaugurated. Although not named as participating, there is little doubt that Hine was closely connected with the occasion in its early years. Daniel Lyson's *History of the Music Meeting* (1812) notes that the first Annual Music Meeting to be advertised in the *Gloucester Journal* was in 1723, though in all probability the three choirs had been meeting annually for some time before that.[5] In 1718 Hine had to organize the removal of the organ from beneath the south crossing arch to its central position over the west entrance of the choir. This was a bold and imaginative move which evoked considerable controversy at the time, and indeed has since. Some of Hine's works were published after his death. There is a folio in the cathedral library entitled: '*Harmonia Sacra Glocestrensis* or Select Anthems for 1, 2 & 3 voices and a *Te Deum* and *Jubilate* together with a Voluntary for the Organ, Compos'd by

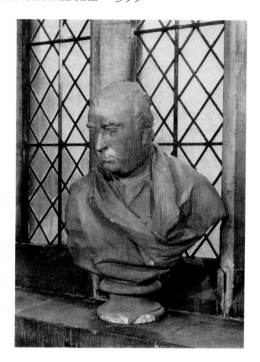

Bust of Handel, from a sculpture by Louis François
Roubiliac. GCL

Mr William Hine, late Organist of the Cathedral Church at Gloucester.' Hine brought a
new professionalism to the musical life and choral tradition of the cathedral and
established new standards of excellence. The rough-and-ready amateurish approach of
the seventeenth century was no longer acceptable. In particular the Annual Music
Meeting provoked a certain amount of rivalry between the three cathedral choirs, and
challenged their organists and choirs to increasingly high standards.

The works of Handel were often included in the programme of the Annual Music
Meeting. A collection of his works in the cathedral library, edited by Samuel Arnold,
and published by Arnold 1789, includes his *'Judas Macchabaeus; a sacred drama'*
performed at the Gloucester Music Meeting in 1772, and the *'Messiah'*, first performed
in 1742, and at one time frequently on the programme of the Music Meeting. There is
also in the library a plaster cast of a bust of Handel attributed to Louis François
Roubiliac (1702/5–62). It is the only portrayal of him, other than the Westminster
Abbey monument, to show the composer bare-headed, with neither wig nor cap. Jacob
Simon notes: 'From its close similarities to the monument, and more especially to
Handel's death mask it would seem that the bust was made late in his life, or more
probably, shortly after his death.'[6]

WORK IN THE CATHEDRAL

Turning from aspects of life in the cathedral close in the first half of the eighteenth
century, to the cathedral itself and to what was being done to restore and refurbish it
during these years (1702–52), there were two periods of activity, the first associated

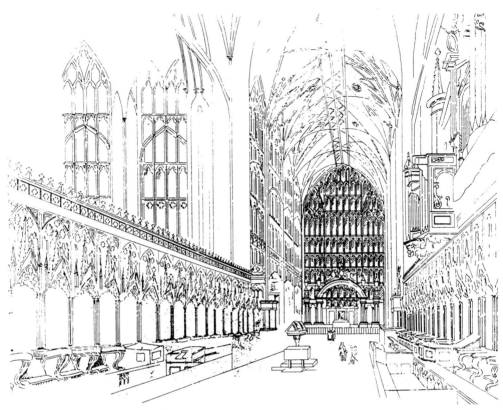

Drawing or tracing of the choir, by F.S. Waller from a lost painting, looking east, showing the classical
reredos and the organ on the south side

with Dr Knightley Chetwood, dean, 1707–20, and concentrated in the choir; and the
second associated with Dr Martin Benson, bishop, 1735–52, mainly involving work at
the bishop's palace, in the nave and lady chapel of the cathedral. Between these two
periods of refurnishing and enrichment the first detailed plan and description of the
building, the work of Brown Willis, was published (1727–30).

Refurbishing the Choir

In 1701, Francis Reeves, a mason, was paid £19 6s.7d. for paving the choir, and the
following year a carpenter was paid a considerable sum 'for work in ye Choyre.' There
were also payments for 'scouring & new dying ye purples' and for 'guilt leather & work'.
In 1707–8 others received payment 'for repayring beautifying & adorning the Choire',
and similar payments continued to be made until 1713 when the first steps were taken
to provide a new reredos for the high altar. In that year it was ordered that 'the Woods
belonging to this Church be surveyed and as much cutt as is Consistent with good
husbandry and one hundred pounds worth thereof Applyed for & towards the Building a
new Alterpeise.'

Inventory of cathedral furnishings and plate, 1697

A thorough refurbishing of the choir was carried out between 1701 and 1718. John Loveday of Caversham wrote in his diary in 1736 that his friend Browne Willis had told him that the choir had 'at great expense been lately beautified.'[7] In summary, new sub-stalls of excellent design and workmanship were erected, the organ was moved to the west end of the choir from beneath the south crossing arch, and a fine new reredos was set up. The whole choir was enriched with new paint work and sumptuously provided with embroidered hangings, cushions and new service books. Browne Willis' plan of the cathedral (1728) shows details of the reordering, and the drawing by T. Bonnor (1796), though sketched many years later, probably gives an accurate impression of the work. Dr Martin Benson, Bishop of Gloucester (1734–52), who expended so much of his personal wealth and his energy in carrying out work in the cathedral did little by way of improvements in the choir, presumably because he was content with its recent restoration.

Michael Bysaak was commissioned to make the new reredos, which was completed and in position by 1716 to the great satisfaction of the Dean and Chapter. So much so that at their November meeting the Chapter agreed that since Bysaak 'hath very well performed and Compleated his work and Articles about the Altar peice and that He hath done much more work than his Articles obliged him to do and will be a great Looser by the same unless this Chapter consider him for itt' the Chapter would award him £20 as a free gift above and beyond his account. Bysaak's reredos remained in position until it

was sold to Cheltenham Parish Church in 1807. Norman's *History of Cheltenham* (1863) describes it *in situ* there: 'The classic carved altar piece and communion table below have only occupied their present position during the past half century. They were removed from Gloucester Cathedral in 1807 . . . The carved altar piece is in the Elizabethian [sic] style, and until the last few years was surmounted with figures and devices, life size . . .' Evidently the Rector, the formidible Francis Close, later Dean of Carlisle, took exception to Bysaak's beautifully carved figures and had them removed. When the reredos was returned to the cathedral parts of it were stored in the south-east chapel in the tribune gallery.

The city authorities warmly approved the work undertaken in the choir. In September 1717 the City Corporation voted that since the dean, Dr Knightly Chetwood, had:

> undertaken a Work of a Large Expense by Beautifying & Enlarging the choir Cheifly Intended for the Better Accommodation of the Corporacon & Inhabitants of this City, to Assemble together In Gods service. To shew how highly we Approve of the Same, we Chearfully present to the said Dean for the better Enabling him to Compleat So Good & Pious a work (So much to the Honour of God, and the Reputation of the City) the sume of ffifty pownds to be paid . . . upon ffinishing the same & Removing the Organ over the Doore & having convenient Seats Intire for the Mayor & corporacon.

A small gallery with seating was constructed on the south side of the crossing where the organ had been, and the reference to 'beautifying and enlarging' the choir must refer to the increased seating capacity provided by the new oak stalls put in between 1707–12. These stalls were removed from the choir in *c.* 1872 to make room for the present sub-stalls designed by Gilbert Scott. Sections of the stalls were adapted to provide seating for the choir in the nave.

The mayor and corporation were even more delighted when, in July 1738, the Chapter ordered that:

> A New Seat be erected in the Choir just above the Archdeacon's Stall for the Use of the Mayor of Gloucester when the Archdeacon shall thinke fitt to sitt in his owne Stall (which is used by the Mayor in his absence) and that the said seat be made just like the Seat opposite to it and that there be a Moveable Canopy provided for it to be made as like to that over the Archdeacon's Stall as conveniently may be, which is to be putt up whenever the Mayor shall sitt in the said seat.

It was this proposal that brought the Mayor and Corporation back to the cathedral from attendance at St Nicholas Church in Westgate Street: 'for a composure of the difference that hath lately happen'd betweene the said Deane & Chapter & this Corporation . . . the former vote touching this Body's going to Church to St Nicholas in this City be & is hereby Repealed.'

In the eighteenth century the wealthy and those with influence seem to have been able to persuade the Dean and Chapter to do almost anything for their convenience or pleasure. When Dr John Waugh was dean (1720–3) the Chapter agreed several Orders which had to be repealed later. For example, on 29 November 1720 permission was given to 'John Cocks of the City of Gloucester Esq to make away or passage from the bottom stairs leading up to a little chapel on the south side of the Ladies Chapel belonging to this Church into a walk leading to the house of the said John Cocks for the use and convenience of him, the said John Cocks and his family to come to Divine Service in this Cathedral.' Part of the outer wall of the stairway was therefore taken out,

The blocked doorway (1720) leading into the lady chapel; note the masonry lines around the small window

close to ground level, and a doorway built so that the Cocks family, living nearby in what is now King's School House, could go more directly to the choir on Sunday mornings. However, when John Cocks died in 1737, and the house was leased to another member of the family, Sir Robert Cocks of Dumbleton, the Dean and Chapter repealed the Order, pointing out 'whereas the said Act of Chapter . . . was illegal . . . it is therefore repealed and made void and that the said way or passage be forthwith stopped up.' A vertical masonry line marks the position of the door.

Browne Willis Survey 1727–1730

Browne Willis (1682–1760) was an eccentric antiquary who spent much of his life and fortune on building and restoring churches. In the course of his work he travelled widely, and as a result produced, *inter alia*, his Surveys of the cathedrals of York, Durham, Carlisle, Chester, Man, Lichfield, Hereford, Worcester, Gloucester and Bristol . . . which were published 1727–30. In his *Survey of Gloucester*, he included a plan of the cathedral and adjoining buildings and this provides valuable information about the internal arrangements of the cathedral at the time.

In the nave the Consistory Court occupied the bay at the west end of the south aisle. The burial place of one who served in the Court for many years, John Jones, was marked by a ledger in the floor close by, and his memorial was on the wall above it. The memorial was moved to its present position on the west wall of the south aisle when the

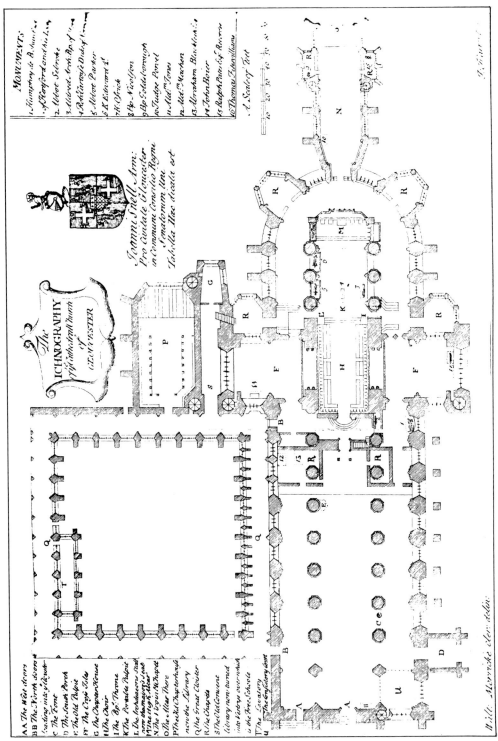

Plan of the cathedral, 1727, from Willis' *Survey of Cathedrals*, vol. 2. Engraved by T. Harris

Court itself was removed in the last century. A font is shown between the two most westerly Norman piers on the south side of the nave. Since no font is shown in the north transept chapel where it stood at a later date, the Restoration font must have occupied this position. What is described as 'the old pulpit' abuts a Norman pier on the north side towards the east end of the nave. The pulpit was provided by Bishop Henry Parry in 1609.

At the east end of the north aisle was a chapel dating back to medieval times. It contained two memorials; that to Alderman Machen, against the north wall of the chapel, and that to Abraham Blackleech and his wife, backing onto the east wall. The remains of another medieval chapel, enclosing a Norman pier, are marked on the south side. Adjacent to this, by the next pier to the east, is the entrance to the Seabroke Chapel and a stairway up to the screen. According to Fosbrooke, writing in 1817, the organ was moved to its present position over the west door of the choir in 1718. At the same time, if Abbot Wigmore's *pulpitum* had survived to this date, the central section would have been taken down, or partially removed, to form an organ loft. Browne Willis' plan, therefore, shows the arrangement of the east end of the nave after the removal of the medieval screen and the erection of the organ over the entrance to the choir but, of course, before the Kent screen (1741) was in position.

The tomb in the thickness of the wall on the right entering the south transept from the nave, is said by Browne Willis to be that of Humphrey de Bohun, Earl of Hereford, and his wife. The earl died in 1367. In the south transept the memorial to Ralph Pates is shown in its present position beneath the terminal window. But 'the effigies of a man in a lawyer's gown and of a woman, with a boy kneeling behind the man and three girls behind the women' were already missing from the monument. The entrance, of course, to the chapel on the east side of the transept had not been blocked up by the memorial to Bishop Benson. The new seating is shown in the choir, and there is a pulpit just to the east of the presbytery steps. A bishop's throne, the throne at present in the nave, occupies its traditional position east of the choir stalls on the south side. Opposite on the north side of the choir is a stall described as 'the Archdeacon's stall, now the mayor's seat.' The thirteenth-century effigy on a bracket is shown against the south wall of the presbytery, and the wooden effigy of Robert, Duke of Normandy, in the middle of the presbytery east of the pulpit stairs.

In the north transept, Browne Willis's comments on the use of the eastern slype and the room above it are of particular interest. The room is described as 'the old convent library now turned into vestrys over which is the Free Schoole'. Apparently he thought this room was once the old monastic library and not the room above it, occupied at the time by the Free School (College School). His comments confirm that the present practice room was known at this time as the Chapter House or Chapter Room. In the cloisters iron railings are shown in front of the *lavatorium*, with an entrance only at the east end. His plan of the chapter house shows the library fittings in the two bays at the west end, whereas in Bonnor's engraving, published seventy years later (1799), they are shown in the two eastern bays. In 1743 the library was dismantled and all the books removed to 'the aisle on the south side of the choir'. Twenty years later the chapter decided to move the bookcases and the books back to the Old Chapter House when, presumably, the bookcases were reassembled at the east end.

John Loveday's, Diary 1736

The picture of the cathedral and its furnishings which Browne Willis drew in 1728 is confirmed by a visitor to Gloucester in 1736. John Loveday who lived at Caversham undertook a number of journeys, mainly on horseback, between 1729 and 1765. He knew Browne Willis and admired his work. He first visited Gloucester in 1730 but did not stay long, returning in March 1736 when he described his visit to the cathedral in some detail. He found the nave 'paved with stone' but 'unequal in beauty to the choir.' As Browne Willis had said in 1727 the choir 'is a very noble room, which at great expence had been lately beautified'. He noticed, as he had been told by Browne Willis, that over each of the choir stalls was written 'Allelujah'. He also noticed the 'freestone effigy on a shelf-tomb for Aldred, Bishop of York and Worcester . . . he crowned the Conqueror. The model of the church is in his right hand. He died in 1069.' Evidently he was told that the effigy on the south side of the presbytery was that of Aldred, the late eleventh century Bishop of Worcester who became Archbishop of York.

More importantly, he noticed in the choir that 'the pavement is of stone, till the ascent to the altar, which begins from the throne, there it is chiefly of painted brick.' Presumably, the remains of the much-repaired medieval pavement between the choir stalls had been removed during the repaving of the choir *c.* 1701. Looking down from the tribune gallery he saw that 'from this story you perceive that the pavement of painted-brick [tiles] is very regularly disposed.' It seems that the medieval tile floor, though patched, had survived in the presbytery as well as in the sanctuary. If medieval tiles from the floor between the choir stalls had been used to repair the presbytery

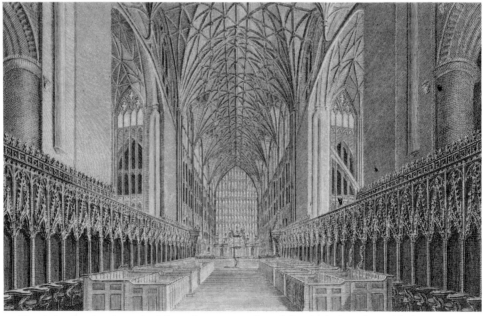

The choir, showing the early-eighteenth-century stalls and the classical reredos, with the organ no longer on the south side. T. Bonnor, 1795

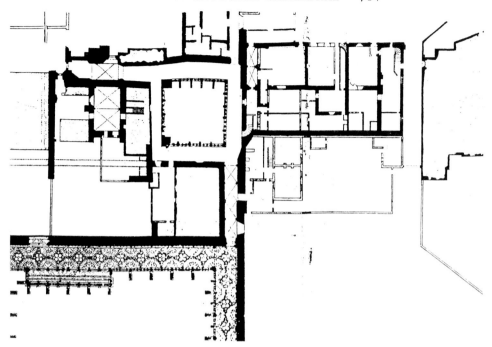

Plan of the apartments in and around the monastic infirmary on the north side of the cathedral.
J. Carter 1807)

Seabroke pavement, 1450; medieval tile floor

pavement, the presbytery floor as well as the *sacrarium* pavement may well have been 'very regularly disposed.' The bishop's throne was 'no old thing'. It had been made at the same time as the new stalls and altar-piece. He enthused about the reredos with its 'segment of a good large circle bending in the middle' through which it was possible to see the stained glass of the east window of the lady chapel. The arched member of Bysaak's reredos followed the line of the stone arch over the entrance to the lady chapel.

The lady chapel he described as a 'long but proportionable room entered under the great window . . . The handsome east window of this chapel is of painted glass, and part of this is the window that is seen in the choir through the segment of the circle above mentioned.' He noted that 'though there is an altar in the chapel yet it is never used.' The chapel was used only for the early morning Prayers. The 'large old Chapter House, now the library is well fitted-up, though as yet it has no very large collection of books; tis paved with painted bricks. No inscriptions appear on the walls of this place, nor on the wall of the north isle in the nave, as in Leland's time.' The inscriptions in Lombardic script on the walls of the chapter house had been covered over with limewash, and were only revealed again and restored in the nineteenth century. He commented: 'The bishop's palace makes no figure at all on the outside, but has very good appartments.' Bishop Benson was to give it a more imposing exterior a few years later. 'The infirmary now belongs to the minor canons', that is, the minor canons, among others, lived in the tenements which had been built around and within the remains of the old monastic infirmary. Loveday's guide on his visit was the Revd John Newton, one of the minor canons, so presumably he was well-informed. 'He afforded us his good company, shewing us the place and we breakfasted with him.'

BISHOP MARTIN BENSON 1734–1753

Dr Martin Benson was nominated to the See of Gloucester by the Crown in 1733, and duly elected by the dean (Dr Daniel Newcombe) and prebendaries on 1 January 1734. He

Dr Martin Benson, Bishop of Gloucester, 1734–52

was installed on 21 February. On becoming bishop he resigned all his other appointments, except his Durham prebend, and declared he would accept no higher preferment. He was as good as his word for he stayed at Gloucester until his death in 1753, even though Gloucester was one of the poorest bishoprics. He proved to be a 'vigilant and active Prelate' and 'wherever he went he carried Cheerfulness and Improvement along with him'. As T.H. Cocke writes:

> His closest friends were the other pre-eminent figures of the early Georgian episcopate, the philosophers, Bishop Butler and Bishop Berkeley, and the witty Bishop Rundle. His brother-in-law was Archbishop Secker, a Dissenter by birth who rose to the highest ranks of the Church. Alexander Pope linked them together in a verse:
>
> > Ev'n in a Bishop I can spy Desert
> > Secker is decent, Rundle has a heart
> > Manners with candour are to Benson giv'n
> > To Berkeley ev'ry virtue under Heav'n[8]

Benson, a cousin of Browne Willis, had been involved in church restoration for some time before arriving in Gloucester. The two had worked together on repairing Bletchley parish church of which Willis was patron and Benson a one time incumbent. Thus, it was not long before Benson had identified several projects which were to absorb his interest and on which he was to spend very considerable sums of money. These included improvements to the palace with the addition of a Palladian frontispiece to the hall (1741), the repaving of the nave, the building of a new choir screen, the erection of a 'radiance' behind the lady chapel altar and adorning the exterior with crocketed pinnacles. There are no references in the Chapter Act Books or the Treasurers' Accounts to this work so presumably the bishop obtained the tacit and informal agreement of the dean and prebendaries and met the total cost of the work himself.

Improvements to the Bishop's Palace

Benson turned to the most distinguished architect-designer of his day, William Kent, for advice on his major projects. Benson already had a link with him through one of Kent's major patrons, Frederick, Prince of Wales, to whom Benson had been appointed a chaplain in 1726. In any case, Benson would have known of his reputation and his work in various fields. Kent had been responsible for an astonishing variety of work, as architect, painter, decorator, interior designer, furniture designer, illustrator and even gardener. In his early years he had become an enthusiastic exponent of Palladian principles. This was partly the result of securing the support and friendship of Richard Boyle, 3rd Earl of Burlington, whose qualifications as a patron were impeccable being extremely rich and much in demand at the new Whig court of George I. He was commissioned to design the interiors and furniture for Houghton Hall, a new Palladian mansion in Norfolk, and he had a considerable influence on the design of another Norfolk mansion, Holkham Hall. When Benson approached Kent he wanted him first of all to carry out improvements at the bishop's palace, and in particular to design a new portico in the Palladian style.

Fortunately, before the medieval building was pulled down in the nineteenth century

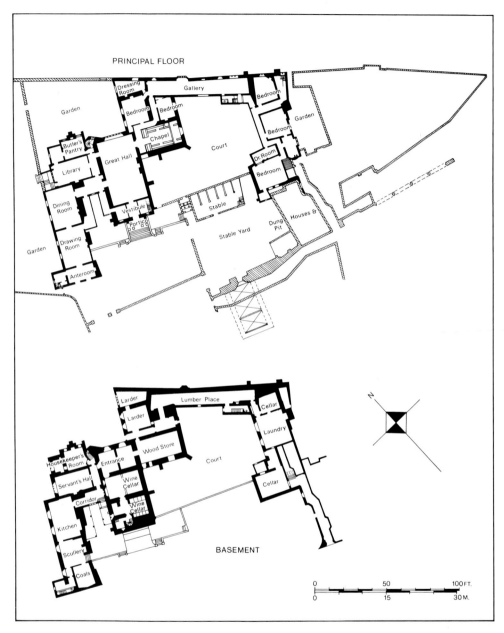

PRINCIPAL FLOOR

Garden

Dressing Room

Gallery

Bedroom

Bedroom

Bedroom

Bedroom

Garden

Butler's Pantry

Chapel

Court

Library

Great Hall

Dr. Room

Bedroom

Dining Room

Vestibule

Stable

Garden

Portico

Drawing Room

Stable Yard

Dung Pit

Houses &

Anteroom

BASEMENT

Larder

Lumber Place

Cellar

Larder

Laundry

Wood Store

Housekeeper's Room

Entrance

Court

Servant's Hall

Wine Cellar

Cellar

Corridor

Wine Cellar

Kitchen

Scullery

Coals

0 50 100 FT.
0 15 30 M.

Plans of the bishop's palace, from a drawing by F.S. Waller, 1856; before its demolition and redrawn by Richard Bryant, 1990

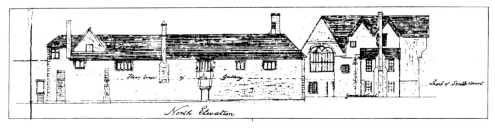

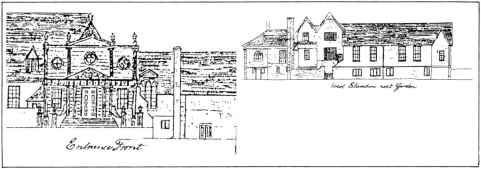

Drawings by F.S. Waller (1856) of the bishop's palace, showing the impressive portico which Bishop Benson added, the chapel and the Pitt Street wall with oriel window

to make way for the Victorian bishop's palace (now the King's School), F.S. Waller made detailed drawings of the plans of the building and of its elevations. The fine Palladian portico which Kent designed in *c.* 1740 is seen on the south elevation. This imposing entrance to the palace faced the courtyard on the south side of the house since it was from this direction, through Palace Yard (Miller's Green), that carriages approached the house.

Kent's Choir Screen 1741

At the time, Kent had carried out little ecclesiastical work, apart from some monuments, but the bishop would have known of his monumental screens erected at the south end of Westminster Hall in 1738/9 to enclose the Courts of Chancery and the King's Bench. Clearly, he thought a similar screen would look well at the east end of the nave, and introduce a new style of architecture into the great Norman nave. Some years before Benson arrived in Gloucester considerable alterations and improvements had been carried out in the 'sermon place', that is in front of the choir screen. The medieval choir screens, at the east end of the nave, consisted of a pulpitum closing off the choir, substantial enough to support an organ, and a rood screen a bay to the west.[9] Kent's new screen was designed to replace the western wall of the *pulpitum*, and like its predecessor it had to support the organ loft. As Browne Willis' plan shows, the space below remained unobstructed by cross walls. Two blind niches were added on the far wall either side of the entrance to the choir. One of these, on the south side, can be seen in the Verger's Checker.

Cocke describes Kent's design for the screen as:

William Kent's choir screen, drawing from *Some designs of Mr Inigo Jones and Mr Wm. Kent*, published by John Vardy in 1744

. . . typical of the way he created a contemporary Gothic by expressing classical forms of architecture in conventionalized, loosely medieval details. He was not concerned with archaeological accuracy. These shafts carried three wide ogee arches covered with wavy crockets. The parapet above was adorned across the front with decorative panels, probably painted, and crowned by a bizarre cresting of pineapples and pinnacles.

A drawing of the screen erected in the nave in 1741 was published by John Vardy, one of Kent's draughtsmen, in 1744. The screen looks very flimsy abstracted from its setting, but Vardy and Kent were careful to point out the setting by a unique graphic device, hatching in at the bottom left and right corners of the print the relatively huge girth of the pillars abutting the new screen:

Clearly the object of Kent and Bishop Benson, whose name was prominently inscribed in the central panel of the attic, was to induce an effect of the 'lightness' which Walpole had found so pleasing in the west front of the cathedral. The screen at Gloucester is a lighter, more open version of the design for the alterations Kent had proposed for Westminster Hall in 1739, and that his solutions met with a considerable degree of acceptance in the 1740s is demonstrated by the publication of these designs in the form of prints.[10]

Benson's intention in introducing such an architectural embellishment was to offset what many at the time regarded as the depressing effect of medieval buildings. John Evelyn the diarist, for example, had expressed the feeling of others when he wrote that the cathedrals of the Middle Ages were 'congestions of heavy, dark, melancholy;

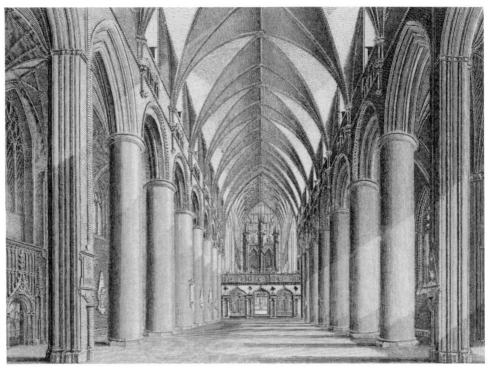

The nave, showing Kent's screen, 1741 drawing by T. Bonnor, 1796). Note the memorials on the Norman piers

monkish piles without any just proportion, use or beauty.' Ever since Inigo Jones had grasped the significance of the Renaissance for architecture, and Sir Christopher Wren (1632–1723) had adopted the formal Italian school, interest in all things Classical had become widespread. Wren's younger contemporaries, Hawksmoor, Vanbrugh and Gibbs were all using the stock features of the Classical revival to good effect. Yet, at the same time, a revival of interest in Gothic design and Gothic features was developing, epitomized in Sir Horace Walpole's Gothic villa, Strawberry Hill in Middlesex, which was begun in 1747. Bishop Benson hoped Kent's screen, with its neo-Classical form and Gothic features, would enrich and 'lighten' the medieval interior of the cathedral.

According to Dallaway, Kent suggested to Bishop Benson that the Norman piers in the nave should be fluted. But on finding they were not solid but filled with rubble the project was abandoned. Such a conversion of the Norman pillars to classical columns would have been tragic, but the suggestion provides some kind of justification for the design of the screen. Though this in no way condones the notion, it does draw attention to Kent's larger architectural intention. If his recommendation could have been carried out, the screen would have had a context that was sympathetic with its design. But fortunately the plan could not be carried out life-long.

Benson's interest in architecture and design is reflected in the small but choice collection of books he left to the cathedral library. These are mainly of Roman

antiquities, views of Versailles and the like. Though his additions to the nave and lady chapel were approved by his friends at the time, before long there was critical comment. 'Kent, who was praised in his day for what he little understood, designed the screen . . .'[11] The antiquary Dallaway wrote: 'The man of taste must regret that the good Bishop Benson, distinguished by Pope for his "manners and candour" should have wasted his munificence upon ill-conceived and unappropriate ornaments, upon works which are neither Gothic nor Chinese.'

Somewhat later T. Bonnor, in his *Itinerary* (1796), commented that the screen combined the characteristics of the various orders of architecture without any of their good points. Even so the screen remained in place until 1819 when the present screen was erected. F.S. Waller, writing in 1890, observed:

> Forty years ago everything not 'Gothic' [the fashion of the day] was destroyed; but were it possible now to reinstate the Chapter House book-cases, the Renaissance Reredos of the Choir, Wygmore's pulpit, the aisle screens, the remains of the rood loft, and the choir fittings, and to put them all back – odd mixture as they would be – to the positions they occupied in 1727, few would be found to object.

But the story of cathedral interiors is one of constant replacement of the old by the new, with the consequent loss of items of unmatched quality and unique character. Yet, as Masse commented in 1899 *Tempora mutantur* and *nos et mutamur in illis*.

The College Library

In November 1743 the Chapter ordered that the books be removed from the Old Chapter House 'on the north [sic] side of the Great Cloister' because the room was damp and unfit for people to study there:

> The dampness of the said Room being prejudiciall to the Health of persons using and Studying in the said Library and having likewise unbound and otherwise impaired many of the Books, which inconveniences are not sufficiently remedied by the Chimney lately built in the said Room for that end. It is therefore ordered and agreed by this Chapter that the Books shall be removed into the Isle on the south side of the Choir and that the said Isle be immediately converted into a Library and fitted up for the recepcon of the said Books, And that the Shelves and all things necessary for receiving the said Books which are now in the old Library be removed from thence into the said Isle, And that the expence thereof be defrayed out of the money appointed for providing Books for the Library and the sale of timber . . .

The 'Old Library' (Chapter House) was left as a store-room for a while; in 1750 the Chapter ordered that it be cleared of rubbish, the floor repaired and the windows mended. Then, in 1764, the Chapter ordered that the library, the books and the bookcases, be moved back again to the Old Chapter House. In 1796 T. Bonner published his drawing of the 'College Library' as set up again in the old Chapter House.

Bishop Benson's Other Works

Kent carried out other work for Bishop Benson. At the Palace he built the fine Palladian frontispiece to the hall, and carried out some alterations to the principal apartments.[12] In the cathedral he is said to have designed the stucco facing in front of the mutilated medieval reredos of the lady chapel. Fosbrooke quoted Dallaway's reaction to 'Kent's Radiance'.[13] He wrote 'The interior of the lady chapel is uncommonly elegant, though it loses much effect by concealing the altar of the finest tabernacle-work which was covered over some years ago by a raw white stucco, representing a radiation.' Benson, in the theological fashion of the time, would have considered it a wholly appropriate symbol of the deity, as it was also a symbol of the Age of Enlightenment. Here was an explosion of light, of divine glory breaking out of the darkness of the past. Perhaps it was not an inappropriate focus for the early morning prayers, which were conducted by a minor canon in the lady chapel each weekday morning at 6 o'clock, and attended by the boys of the College School.

Apart from the more constroversial additions to the cathedral interior, Bishop Benson was responsible for other and more lasting improvements to the building. These were carried out as a result of his Visitation of the Cathedral and Articles of Enquiry 1739–40. The Injuctions he issued following the Visitation concerned *inter alia* the proposal that the £20 set aside each year for the repair of 'ways and bridges' (an ancient responsibility which was no longer applicable) now should be spent 'on some publich work for the service and honour of the church, and in particular in making and keeping all the pavements and ways in the church and cloisters and about the church and within all the precincts in good and decent repair and order.' Together with the fines for

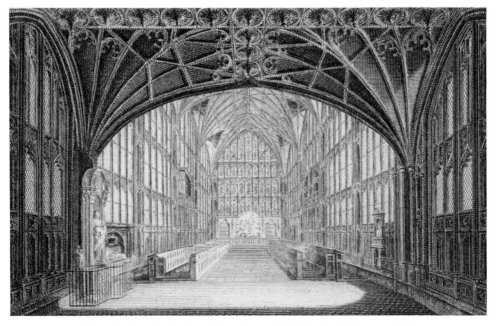

The lady chapel, showing Bishop Benson's 'Radiance'. T. Bonnor, 1796

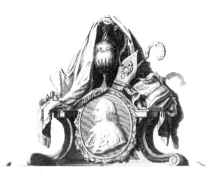

Part of Bishop Benson's memorial, an early nineteenth-
century drawing

non-residence this provided part of the funds required for the repaving of the cathedral and cloisters. In 1742 the *Chapter Act Book* recorded that for failing to keep residence the treasurer was ordered to 'lay out the money of the prebendary's forfeit to defraying the cost of new paving in some part of the body of the church and cloisters, provided for in the last audit.' In 1743 the forfeits were to be laid out in defraying the cost of 'cleaning the roof and sides of the lady chapel, painting the choir and repairing the pinnacles on the south and west end of the church.' In the following years forfeits provided funds 'for new pavement in the choir and the new steps and pavement in the north aisle, and to the steps and pavement leading to the chapter house.' The porch and south aisle were paved in 1746, and other parts paved or repaired, ending with the north ambulatory in 1752. The paving of the cathedral was therefore not entirely Benson's work. It was funded partly out of forfeits for non-residence and the application of the ancient 'ways and bridges' allocation.

The 'good Bishop Benson' died at the palace on 30 August 1752, much lamented by the diocese and missed by the cathedral community. Bishop Porteous of London wrote of him: 'His purity, though awfully strict, was inexpressibly amiable.' Britton wrote of him: 'This worthy divine was not only zealous in the discharge of his episcopal duties, but generously expended much of his income in the repairs and adornment of his palace and the Cathedral.' A large memorial was erected against the east wall of the south transept which involved the blocking up of the eastern chapel. Another memorial was placed at the west end of the nave. When the transept chapel was opened up during restoration work in the nineteenth century, the medallion of Bishop Benson and other features of the memorial were removed to the south tribune gallery.

THE LATE GEORGIAN CATHEDRAL
1752–1838

*'Whose unremitting Attentions to the Preservation, and whose Judgment
and Taste, displayed in numerous Improvements of this magnificent
Structure and its Appendages, have excited the Admiration of the
present Age, and will command that of the Future'.*
T. Bonnor on Dean Josiah Tucker, 1796

By the middle of the eighteenth century Gloucester was becoming, in a modest way, a fashionable place to live. The wealthy were attracted by the growing cultural life of the place, with a winter season of music and drama, and every third year in the summer the Music Meeting of the three cathedral choirs of Gloucester, Worcester and Hereford. Yet, in spite of an attempt to promote itself as a spa Gloucester never rivalled Cheltenham or Malvern as a fashionable watering hole. Nevertheless, in the early years of the century some elegant houses had been built in the centre of town, such as Bearland House, and Ladybellgate House where the Raikes family lived and where Robert, founder of the Sunday school movement, was born. Robert Raikes' father had begun the local newspaper *The Gloucester Journal* in 1722, and when Robert took over its production he used it as a means of raising public awareness of the plight of the poor, the harsh treatment of prisoners and the need for proper schooling for children. With the Revd Thomas Stock he started Sunday schools not only to impart religious knowledge and inculcate Christian values, but to teach children to read and write. George Whitfield, another local man, born in 1714 at the Bell Inn in Southgate Street and educated at the College School, was ordained by Bishop Benson at Gloucester Cathedral and preached his first sermon at St Mary de Crypt.

John Howard in his report *The State of the Prisons* (1777) drew attention to the appalling conditions in the city's gaols. Prisoners of all ages were kept in insanitary and overcrowded conditions, with no exercise area except the flat roofs. In the County Gaol, the old castle, there was one courtyard and one day room, into which all prisoners were herded indiscriminately. Howard described the degrading conditions and the

The old county gaol, part of the old castle (T. Bonnor, from a sketch shortly before it was demolished)

licentiousness of the prisoners. 'Many prisoners died of infectious diseases like smallpox or "gaol fever" [typhus] which was spread by lice. There was no bath and only one sewer. The prison was so dilapidated that prisoners had to be chained up at night.'[1] Through the efforts of Sir George Onesiphorus Paul (1746–1820), the son of a successful cloth manufacturer from Woodchester in Gloucestershire, the treatment of prisoners and their conditions of imprisonment improved. He believed prisons should care for their inmates, so that they were not only punished by their imprisonment but given encouragement to amend their ways. A new County Gaol was built on the site of the old one to house 207 men and women in separate accommodation. Prisoners were made to work to 'dispose them to the habits of industry' even if this amounted at times to working the treadmill which pumped water into a storage tank. In 1782 a new city gaol was built outside the South Gate and the old gaol at the North Gate was pulled down. The inscription on Onesiphorus Paul's memorial, by Servier, in the south aisle of the nave, speaks of him as having 'first reduced to practice the principles which have immortalized the memory of Howard.' As a result 'this county has become the example and model of the best system of criminal discipline in which provident regulation has banished the use of fetters and health have been substituted for contagion, thus happily reconciling humanity with punishment, and the prevention of crime with individual reform.'

JOSIAH TUCKER, DEAN 1758–1799

The *Dictionary of National Biography* describes Tucker as 'an economist and divine.' His earlier years were spent in Bristol as Rector of St Stephens from 1749, and later as a

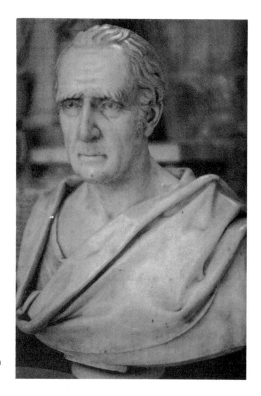

Sir George Onesiphorus Paul. From the memorial in
the south aisle of the nave

prebend of the cathedral. His parish included the water-front of the harbour area and the hall and residences of many of the Merchant Venturers. As a result he was well known in the city's mercantile community, and took a great interest in local politics and trade in the port. He became a prolific writer on economic matters, publishing in 1755 his *Principles of Commerce*. This was written for the benefit of the young Prince George, later George III. When Tucker became Dean of Gloucester in 1758 he kept in close touch with Bristol and occasionally wrote pamphlets on political and economic issues. He was an advocate of canals and the extensive use of machinery as well as home industries, taxes on bachelors and dogs, the independence of the American colonies and the naturalization of the Huguenots (French Protestants settled in Britain). He attacked trading monopolies and opposed press gangs and slavery in the plantations. He also predicted the rise of American power and prosperity. 'The American Continent will be the principal seat of all these valuable possessions and make a most distinguished figure among the nations of the earth and in the history of the world.'[2]

During the early years of Tucker's tenure of the deanery the bishop was Dr William Warburton. Tucker had seen something of him during his Bristol days when Warburton was dean of the cathedral. He was appointed Bishop of Gloucester in 1759, a year after Tucker was installed as dean. Both were forceful characters and distinguished in their fields, Bishop Warburton being a friend of Pope and editor of his works. They developed an intense dislike of each other. The bishop used to say the dean 'had made a religion of his trade, and a trade of his religion.' Warburton died in 1779 at the age of eighty and

was buried in the cathedral. On the marble monument erected to his memory by his friend Dr Hurd, Bishop of Worcester, there is a long and laudatory inscription.

Mrs Cotton's Pew

The dean may have found it equally difficult to get on with some of the ladies of College Green. Mrs Cotton, an elderly and wealthy widow who lived in one of the finest houses in the precincts (9 College Green), was an eccentric. Sir Horace Walpole in a letter following a visit to the cathedral in 1753 wrote:

> Here is a modernity which beats all antiquities for curiosity: just by the high altar is a small pew hung with green damask, with curtains of the same; a small corner-cupboard, painted, carved and gilt for books in one corner, and two troughs of a bird-cage, with food and water. If any mayoress on earth was small enough to enclose herself in this tabernacle, or abstemious enough to feed on rape and canary, I should have sworn that it was the shrine of the Queen of the Aldermen. It belongs to a Mrs Cotton who, having lost a favourite daughter, is convinced her soul is transmigrated into a robin red breast; for which reason she passes her life in making an aviary of the cathedral of Gloucester. The chapter indulge this whim as she contributes abundantly to glaze, whitewash and ornament in the church.

Just before Tucker arrived in Gloucester the Dean and Chapter had ordered that 'the screen before King Edward the Second and Abbot Parker be removed backward on the

The house in the precincts (9 College Green) occupied by Mrs Cotton

line with the choir wall, and that proper provision be made there for a seat for the use of Mrs Cotton.'³ This order was probably never carried out so that no 'proper provision' was made for Mrs Cotton; she had to content herself with the seating Walpole describes. But instances like this confirm the impression that in the eighteenth century the well-to-do regarded the cathedral as their own preserve. Further evidence of this may be seen in the array of Grecian urns on the walls of the nave which date, in the main, from this period.

Chapter Meetings

The Dean and Chapter now met regularly on the first Monday of the month in the Chapter Room. Sometimes there was little business, apart from sealing a lease or two, but at other times all the usual matters came up for discussion. Legal documents to do with property and patronage were ordered to be transcribed into the Chapter Act Book, and also those dealing with the appointment of bishops, deans and prebendaries. In 1809 the Chapter ordered that 'the library be fitted up and used in future as a Chapter Room.' The library, that is the Old Chapter House, was heated by a stove in the south-east corner; a chimney had been built and a stove installed in 1743 to dry out the room. There was ample space for a large table and eight handsome chairs as part of the permanent furniture of the room. Thus, though it was still occasionally referred to as the Chapter Room, it appears that from *c*. 1810 the Dean and Chapter met in the Old Chapter House, and the Chapter Room became the song school or rehearsal room for the choir.

Property Management

One of the first things Tucker did on arriving in Gloucester was to carry out extensive repairs and improvements at the deanery (Church House). He was to manage all the precinct properties with equal efficiency as well as the estates of the Dean and Chapter. Old properties, particularly in the city, were sold off at public auction. Leases too were sold at public auction, and wherever possible he reduced the length of leases to fourteen years for the first lease and thereafter to seven years. He carried out a detailed review of all leases of precinct properties and tightened up the use leasees could make of their premises. In 1764, for example, the Chapter required an addition to leases stating that:

> . . . the leasee his or her executor's administrators or assignees shall not nor will during the continuance of such lease convert or use any part of the premises thereby demised into or as and for an Inn, Tavern, Alehouse or Coffee house or for a slaughter house or butchers shop, bakehouse or form making soap or candles therein without . . . the consent of the said Dean and Chapter or their successors in writing first had and obtained.

Later, it was also ordered that 'Whereas the making of bonfires within towns and cities may be of dangerous consequence to the contiguous buildings and give great annoyance to the inhabitance and has therefore been forbit within the City of London by divers

GLOCESTER CATHEDRAL
ICHNOGRAPHY.

O

M

H

N

E

D

I

A

B

C

L

K

G

F

50 *100 feet*

REFERENCES.

A—The Body, with its Aisles.
B—The Choir.
C—The High Altar.
D—The North Transept, or St. Andrew's Chapel.
E—St. Andrew's Altar.
F—The Vestry Room.
G—The South Transept.
H—The Audit Rooms, over which is the College School.
I—The North Aisle.
K—The South Aisle.
L—The Lady's Chapel.
M—The College Library.
N—The Great Cloister.
O—
O—} The Grove, the square part is now the Fives' Court.

Bonnor's plan of the cathedral, 1796. Note, the position of the book cases in the library (chapter house), railings in the ambulatories, the steps to the organ loft and the screen surviving round the north aisle medieval chapel

statutes of this realm: Ordered that for the future no bonfire or other fire works be permitted to be made or let off within the precincts of this cathedral under any pretence whatever.'

The Chapter felt forced to take legal action, not always with Tucker's approval, in a number of cases concerning cathedral property. But litigation did not always end in favour of the Dean and Chapter. In 1768 and 1769 fines and legal fees ran into hundreds of pounds. At the Chapter meeting in December 1768 it was agreed: 'Whereas the Chapter hath been unhappily involved of layte years in three very expensive law suits [contrary to the advice of the Dean often times repeated] whereby a heavy debt of five hundred and forty six pounds hath been incurred: It is hereby Ordered that the said debt shall be discharged forthwith in the manner following: £32 from 'among the Extraordinaries'; £128 10 s. the Dean's share of the costs and charges; £321 5 s. the shares of Dr Gally, Dr Radcliffe, Mr Malott, Dr Warren and Mr Bertie at £64. 5s. each, and the remainder, £64 5 s. the share of the late Dr Atwell 'to be demanded and recovered from his executors, making a total of £546.' Another law suit resulted in the chapter having to pay more than £302, a very considerable sum in those days, and the payment of these costs was similarly shared between the dean and prebendaries.

Precinct Improvements

Dean Tucker also carried out a number of improvements in the precincts. In 1760 the Chapter ordered that 'the precincts be measured, planned and mapped as soon as conviently may be . . .'[4] The main paths and roadways were gravelled or paved, and the drainage system improved. The College brook and the medieval drain running beneath the complex of housing around the old infirmary continued to create problems for those living in and around the tenements. In 1761 it was reported to Chapter that 'from the first mill, the stream for some time past hath been diverted out of its ancient and accustomed channel; the brook thereby and for want of being thoroughly cleansed is offensive to the inhabitants within the precincts. Brook to be well and truly cleansed and a floodgate or wall erected at the place where the stream had been diverted.'

For many years the main gates leading into the cathedral precincts from the city

WHEREAS the GATE, commonly called the INFIRMARY GATE, fituate within the Precinčts of the Cathedral Church of Glocefter, was lately broken open, in the Night-Time, by fome Perfon or Perfons unknown: Notice is hereby given, That whoever will difcover, or give Information of, the Perfon or Perfons who broke open the faid Gate, to Mr. Phillipps, Chapter Clerk, in Glocefter, fo that he, fhe, or they may be profecuted for the doing thereof, fhall receive of the faid Mr. Phillipps a Reward of two Guineas, to be paid upon the Conviction of fuch Offender or Offenders.

Advertisement in the *Gloucester Journal* of 17 March 1766

Chapter Act Book order regarding the wall in the churchyard, 1768

streets had been manned by porters. After soldiers had caused disturbances and damage in the precincts in 1762, in order to preserve the peace, the outer gates of the Upper and Lower Churchyards, King Edward's Gate and St Mary's Gateway, were ordered to be shut by the porters at 11 o'clock at night and opened again at 6 o'clock in the morning. But this ruling did not please everyone living around the precincts. One night in 1766 the infirmary gate was broken down. An advertisment was place in the *Gloucester Journal* offering a reward of 2 guineas for the apprehension of the offender or offenders. A few months later a certain 'John Pitt Esq and his associates' were charged in the Court of the King's Bench. Mr Pitt was a prominent resident, an attorney and later Member of Parliament but it was he who had organized the pulling down of the gate. Even though there had been a 'constable of the precincts' for some time, disturbances were to continue, with frequent outbreaks of trouble in the 1780s.

The wall between the Upper and Lower Churchyards, which extended from the south-west corner of the nave to the west side of King Edward's Gate was taken down (1768). By this time the two areas, which came to be called College Green, were landscaped, with walks lined with lime trees around the two central lawns. On the east side of the Upper Churchyard (College Green) there were also gardens attached to two large houses. One of them, Cathedral House (Wardle House) was given a large bow on its north front at about this time. The land on the other side of the church, on the north side of the lady chapel, known as the Grove, contained grassy walks among well

matured trees and shrubs, much as Mr Wheeler had intended it to be when he laid out the area with the help of his pupils in the late seventeenth century. In 1794 it was proposed to widen Lower College Lane (College Street): 'Whereas the entrance into Saint Edwards otherwise the lower College Lane from the Westgate Street is extremely narrow and inconvenient and a proposal has been made for widening it . . .' the Dean and Chapter agreed to support the proposal and to contribute £50 towards the cost. But the proposal came to nothing and Westgate Street was not widened until the end of the nineteenth century.

Dean Tucker realized that burials in the churchyard and in the cathedral had to be restricted. In 1768 it was ordered that 'for the future all vaults and graves within this Cathedral Church or the Cloister adjoining shall be walled and arched with brick.' The cost of such work would restrict the numbers applying. At the same time the fee for 'breaking up the ground' was increased, and restrictions were put on the erection of memorials in the choir and lady chapel. In 1771 it was ordered that 'in future no corps shall be permitted to be buried in the churchyard but in a vault or bricked grave, and that no tomb stone or other monument shall be raised or made thereon higher than the level of the ground.' The ground was levelled, and existing tomb stones laid flat in the grass. By 1788 most of the graves in the Upper Churchyard had been cleared away. Yet interments still took place, under Dean Luxmore (1800–7). Fees were doubled in 1800, and again in 1809; and in 1811 the cost of burials in the church were raised to £50. In 1808 iron railings were erected around the burial ground in the Upper Churchyard, and at the south-west corner by the porch in 1810. The Lower Churchyard, the west end of College Green, was similarly railed off in 1812.

Cathedral Repairs

Dean Tucker did not carry out any major reordering or refurnishing of the cathedral, nor indeed any major restoration of the fabric. However, each year essential repairs were put

> **GLOUCESTER CATHEDRAL.**
> WHEREAS some evil-minded and wicked Persons have of late years stolen the PAINTED GLASS from the WINDOWS of the CATHEDRAL CHURCH of GLOUCESTER; and particularly within the two months last past, several PAINTED HEADS have been taken from the East Window,
>
> IT IS ORDERED
> **BY THE DEAN AND CHAPTER,**
> That the sum of FIFTY GUINEAS shall be paid to any person who will give information against the Offender or Offenders, so that he or they may be convicted of the same.
>
> SAMUEL WHITCOMBE, Chapter Clerk.
> An Accomplice giving information will be entitled to the same reward, and interest made to obtain his pardon.

Advertisement in the *Gloucester Journal*, July 1798

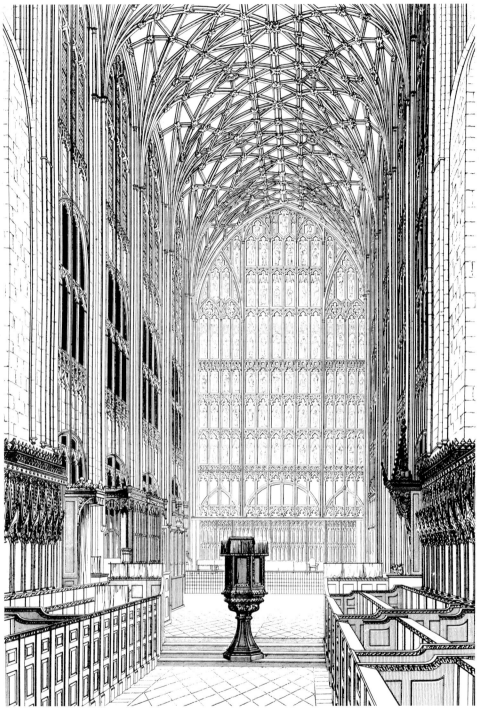

The choir, looking east. Drawing by H. Ansted, 1827. The central pulpit was removed to the nave when the present stone pulpit was put in place (1848)

in hand and a number of improvements made both to the building and the precincts. The parapet over the west end was renewed (1779) and the choir repaved (1780). A member of the Chapter was charged with seeing that each particular project was carried through satisfactorily, though the actual work was supervised by the surveyor of the works. The Dean and Chapter continued to employ masons, pavers, tilers, ironmongers etc on a contract basis for particular jobs, but the surveyor was a full-time appointment. The names of those who held the appointment are recorded in the Chapter Act Books from *c*. 1750, and they include John Floy, Stephen Dew, William Moss and John Philipotts. They received a salary and usually a bonus at the end of the year in appreciation of their work. Dean Tucker favoured the system of annual bonuses giving them to the organist, some lay-clerks and choristers, the supervisor of the works, the schoolmaster and the usher among others. These payments provided an incentive though they also caused friction.

The first mention in the records of the Dean and Chapter of Thomas Fulljames was in June 1797 when Tucker was still dean. He was described as 'Mr Fulljames of Gloucester, Surveyor'. He was asked to survey all Dean and Chapter properties and to report on their condition. His firm eventually employed an aspiring young architect, F.S. Waller, and so began the long association between the cathedral and three generations of Wallers who became architects to the Dean and Chapter.

In June 1798 it was reported at Chapter that 'a quantity of painted glass has been lately stolen from the East Window of the Cathedral.' It was ordered that 'a reward of fifty guineas be offered for the discovery and conviction of the offender or offenders – and that an advertisment be three times inserted in the *Gloucester Journal* to that effect.' The amount of the reward offered indicates that a considerable amount of medieval glass was stolen. The glass is said to have been 'from the east window of the cathedral' this could mean the east window of the lady chapel, which would have been more accessible. In this case the theft may have precipitated the restoration and present arrangement of the glass in the window, which was completed by 1802. If the glass was stolen from the great east window of the choir, it was probably taken from the south side which required extensive patching by Charles Winston in his restoration of the window *c*. 1860 though at that time the glass was in an extremely precarious condition. Fosbrooke noted in 1819 that the glass was 'extremely decayed and mutilated as to appear like a tissue of a carpet.'

Dean and Chapter Patronage

In 1777 it was ordered that a living or minor canonry, or the office of schoolmaster, organist or usher should not be filled for fourteen days in order to allow time to notify absent prebendaries, but it should not be left vacant for more than two months 'to avoid too numerous or improper sollicitations.' The two main areas of Dean and Chapter patronage were the appointment of minor canons at the cathedral and incumbants to Dean and Chapter livings. In common with other cathedrals the Dean and Chapter often appointed men, at ordination, to a minor canonry though they were required to serve a probationary period. In 1763 Tucker had insisted that minor canons should not hold a curacy or incumbancy in addition since this might be incompatible with their duties at the cathedral. This was amended in 1775 to state that if a minor canon, schoolmaster or

usher held such an appointment 'more than ten miles from Gloucester' involving parochial duties he should be required to relinquish the appointment. If, however, a minor canon were to be considered for a Dean and Chapter living more than ten miles from the city, he would be required to resign his minor canonry. However, if a minor canon was nominated for the livings of St Mary de Lode, Matson, Churcham or Brookthorpe, or to the curacy of Barnwood (parishes near Gloucester) he would be required to sign a declaration to the effect that whenever and for whatever cause he should resign the living or curacy he would at the same time resign his minor canonry. Some years later, in 1818, a minor canon who had been appointed to Matson wanted to resign his minor canonry and retain the living of Matson. He refused to move and the Dean and Chapter had to take legal advice. They were told that the signing of a statement in the Chapter Act Book was not sufficient, and that in future a legal bond should be drawn up and sworn.

In 1808 the Chapter agreed the procedure to be followed in appointments to livings in their gift:

> It is the sense of this Chapter that whenever any living shall in future becomes vacant the Chapter Clerk do inform the absent members thereof, and that the Dean in the first place, and after him the prebendaries in succession according to seniority shall be entitled to claim the same for himself personally – the person so claiming not possessing or not continuing to possess either by himself or his representative any other Chapter preferment in consequence of any former arrangement. That in the event of their all declining, the minor canons and schoolmasters according to the discretion of the Dean and Chapter shall be the next objects to be provided for. And that after they are provided for the Dean in the first place, and after him the prebendaries in succession according to seniority shall be permitted to recommend to the Chapter any relation or friend to the vacant preferment.

This procedure was followed regularly in appointments to Dean and Chapter living, as for example in 1828 when it was minuted in the Chapter Act Book: 'The Vicarage of Fairford having become vacant by the death of Doctor Michell a presentation of the same was offered to each member of the Chapter in turn (except Mr Finch who has already had an option) who all severally declining the same for themselves; it was then offered to the Dean (the Hon. and Very Reverend Edward Rice, Doctor of Divinity) as an option for a friend and by him accepted.'

CATHEDRAL AND PRECINCTS 1800–1840

In November 1805 the dean, Dr John Luxmoore, produced at Chapter 'a plan and estimate for removing the present skreen at the altar and substituting a new one in lieu thereof. Ordered that the Dean be authorized to have the same completed in conformity with the plan proposed.' Michael Bysaak's 'skreen at the altar' (high altar reredos) erected in 1716 was dismantled and sold to Cheltenham Parish Church in 1807. The screen which took its place was very plain, consisting of panelling attached to the outer wall of the feretory. This was to remain in position until the present reredos, designed by George Gilbert Scott, was erected in the early 1870s. In November 1817 Dr Griffiths, one of the prebendaries, proposed that a new choir screen be erected. The Chapter approved the design, and asked him to superintend the removal of the old

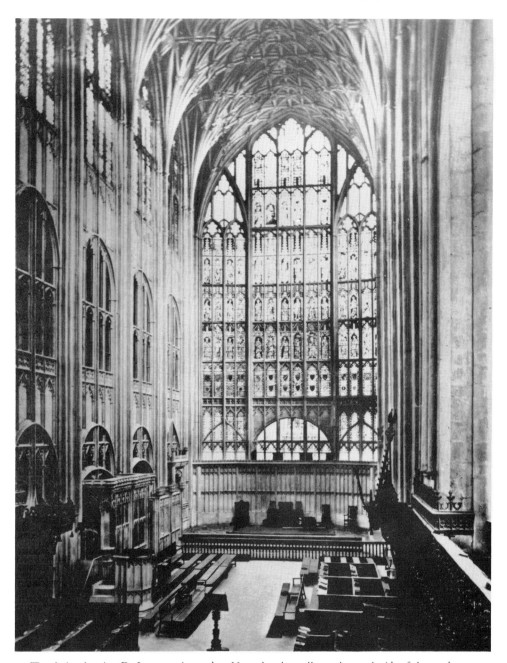

The choir, showing Dr Luxmoore's reredos. Note also the stalls on the south side of the presbytery and the gallery seats (bottom right) with books on the rest above the south choir stalls. Photograph *c.* 1862 shows the choir before G. Scott's restoration and refurnishing.

The eighteenth-century reredos in the chancel of
Cheltenham Parish Church. Detail of a nineteenth-
century painting

screen and the erection of the new one. Work went on through the summer of 1819 and
early the following year the Chapter recorded its thanks for his work and generosity. The
screen was designed by (Sir) Robert Smirke (1780–1867), the leading Greek Revival
architect, and in place by 1823. It makes no pretentions of being a choir screen in the
medieval sense. Instead it provides a plain, perhaps rather dull, background to the nave
altar distracting neither from floral arrangements or altar frontals and furnishings.

The roof of the south transept was the next major project. It was surveyed in 1822,
and a 'new roof and slating put on' between 1822–4. This was followed in 1826 by work
in the library (Chapter House) where a new stove was installed. An iron gate was erected
at the entrance (1827) to allow air to circulate through the room during warmer
weather, and provide greater security for the books. A 'library servant' was appointed to
be in constant attendance. It had been proposed in 1787 to take down the disused
fourteenth-century stair case in the south-west corner of the room in order to open up
the window on the south side of the doorway, but no action was taken.

An iron gate was also erected 'near the north transept leading to the cloisters' (1829),
the work of William Moss, the ironmonger who was given a gratuity of £5 'for his care
and attention in overlooking the state and repairs of this church during the preceeding
year.' He was asked 'to continue iron railings round the Whispering Gallery' i.e. across
the arched openings of the tribune gallery. Among other repairs carried out at this time
were the renewal of eighty stone steps in the tower, to the first landing (1827), and the
repair of pinnacles and battlements on the tower (1829). The east walk of the great
cloister was repaired in 1833, and subsequently the other walks over a period of two or
three years. In 1833 the 'inner enclosure of the Consistory Court at the west end of the
south aisle) was boarded up and a close door made.' A few years later the Consistory

The entrances to the crypt and ambulatory with the back of the choir gallery on the left. The parclose screen of the chapel is boarded. Photograph *c.* 1856

Court was removed. Part of the wooden rail which surrounded the Court was eventually placed around the tomb of Edward II in the north ambulatory.

In 1825 a monument, by the distinquished sculptor, Sievier, to the memory of one of Gloucestershire's most famous sons was erected at the west end of the nave. Edward Jenner was born at Berkeley on 17 May 1749 where his father Stephen Jenner was the vicar. He began his professional training under Daniel Ludlow of Sodbury before going on to St George's Hospital as a resident pupil in the house of John Hunter. In 1788 Jenner introduced to the medical profession in London the hypothesis that a person who had had cowpox could not contract small pox; and in 1796 he put it to the test. The practice of vaccination gained ground only slowly, but as time passed its extraordinary effectiveness was proved, and Jenner's discovery received recognition and royal patronage. In 1802 he was granted £10,000 by parliament, and in 1806 the House of Commons voted £20,000 after the Royal College of Physicians of London had reported on his discovery. In 1788 he was elected to a Fellowship of the Royal Society, and in 1813 the University of Oxford conferred on him the degree of Doctor of Medicine. Jenner died on 26 January 1823 and was buried at Berkeley. There was some controversy about Sievier's statue. Some who knew Jenner well, while admiring the simple dignity of the figure thought the facial features and expression were not at all true to life.

At this time the houses on the east side of the little cloister, known as Babylon, were in a deplorable condition. In 1808 one of the occupants, James Nash, was given £2 16 s. by way of compensation for damage caused by the fall of a chimney. In 1829 the Chapter considered plans for pulling the tenements down, and in the following year it was agreed that 'such part of the building in and about Babylon considered dangerous, or as the prebendary in residence shall think right' be pulled down. Fulljames attended the Chapter meeting in April 1831 'to advise with them upon the subject of the alterations

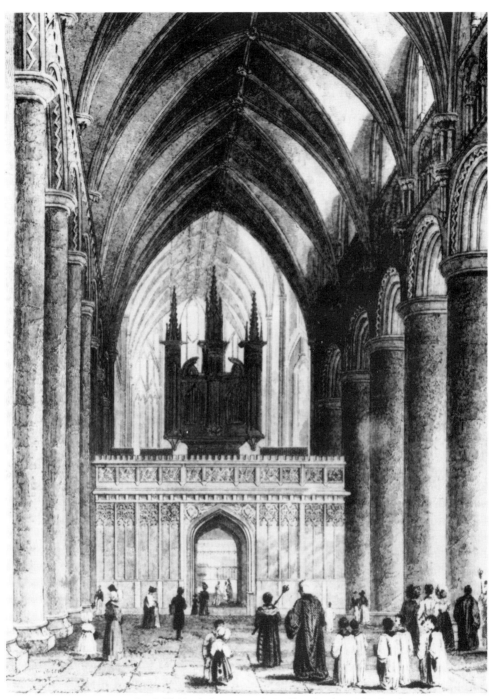

The nave, showing Dr Griffith's choir screen (1819). Drawing by W.H. Bartlett, 1829

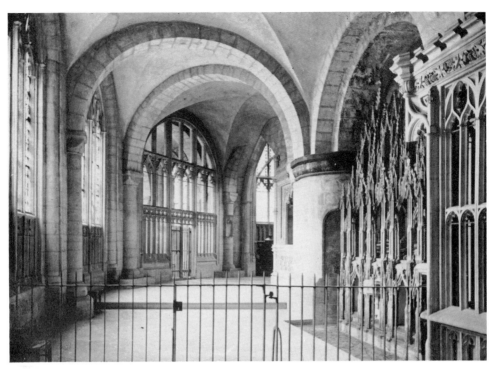

The north ambulatory *c.* 1885, with iron railings and slatted gates to the north-east chapel where the effigy of Robert, Duke of Normandy, was sited

proposed to be made in the Little Cloisters.' It was ordered 'that Joseph Hill be engaged to take down all that part of Babylon lying between the Registrar's Office and the houses occupied by the Reverend Arthur Evans and Mr Allen, leaving the outer walls standing. And also the buildings above that part of the cloisters coloured pink in Mr Fulljames's plan.' The plans approved were modified a few months later (June 1831): 'that part of the order which directs that the east side of the Little Cloisters be covered with a leaden roof be rescinded.'

There were eighteen gas lamps around the precincts, for which the Dean and Chapter paid £60 per annum, and in 1831 £80 per annum, to the local gas company. The constable of the precincts was assisted by a night watchman, who lit and extinguished the lamps. There were also porters at the two main gates, though the great wooden gates at the end of College Street, at King Edward's Tower, were removed in 1805. In 1810 it was minuted in the Chapter Act Book that the dean and resident prebendary were 'authorized to treat for the erection of a building over King Edward's Gate'.

The Choral Services

In November 1782 Dean Tucker had agreed with the members of the Chapter, Dr Benson, sub-dean, and prebendaries J. Warren, J. Leech, E. Wilson and W. Adams:

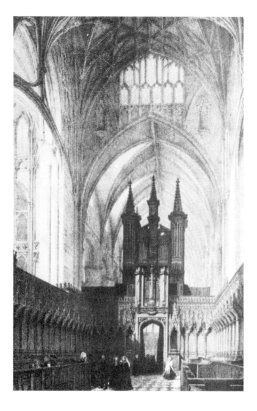

The choir, looking west *c*. 1830, showing the
eighteenth-century pinnacles on the organ towers

. . . that in future all the Morning and Evening Prayers and the whole Litany and communion service be read in this Cathedral Church in the same manner as in parish churches and not chanted except the psalms, hymns and anthems which shall continue to be chanted and sung with the organ as heretofore. And whilst the officiating clergy are retiring from the communion table a short voluntary shall be played or a psalm or portion of a psalm sung accompanied with the organ at the discretion of the Dean and Resident prebendary for the time being.

But under pressure from the Bishop, Dr Samuel Hallifax (bishop of Gloucester from 1781 until his translation to St Asaph in 1789) the Dean and Chapter reconsidered the matter, and in June the following year minuted:

Whereas the Dean and Chapter had ordered some months ago that the Exhortation, Confession, Absolution Prayers, Collects, Responses, Creeds and Litany should be read in a solomn and devout manner according to the nature of the case and the reason of the thing and in conformity to the Usage of all Parochial Churches throughout the Realm, also of all his Majesty's Chapels Royal and even of Cathedrals themselves both at the Communion Service and at early Prayers, in consequence thereof had abolished the mode of chanting [a mode of recitative in Divine Service first introduced by Italian Ecclesiasticks into England the better to conceal their foreign accent and pronunciation from the observation of the People and in order to colour their Usurpations of the richer benefices in Cathedrals granted to them by the Pope under the pretence of their great adroitness in *plano cantii*, also to devise some excuse for using Prayers in an unknown tongue]. But whereas divers Persons through an attachment to old custom appear to be much prejudiced against this alteration or rather restoration of Divine Service to its primitive simplicity and Propriety, The Dean and Chapter influenced by the

superior motives of Charity and Condescension towards weak brethren (which require the sacrifice of private opinion regarding the Forms of Public Worship where the Essentials of Religion are not at stake, and being also supported by the authority of the Lord Bishop their Visitor actuated by the same good motives do now revoke their late Order for parochial prayers and hereby establish the former mode of Recitative or Chanting.

The advice of the bishop was that 'all reasonable persons must be contented if the Cathedral Services were restored on Sundays and great Festivals and that the present mode of parochial Prayers be continued on the Week Days.' He added 'I do not approve the way of chanting the Litany in the middle of the choir.' As a result the week-day services appear to have been said until 1808, when it was minuted that 'the Dean [Dr John Plumtree] and Subdean having lately caused the Services to be chanted on Weekdays in the same manner as on Sunday, and having since received the Approbation of the bishop of Gloucester [Dr G.J. Huntingford, Bishop of Gloucester 1802–15] for so doing desire to express to the Chapter their reasons for this deviation from the former Order' . . . in the bishop's own words:

I prefer chanting in cathedrals for these reasons:

1st. The Service of Cathedrals was always intended to be *sui generis* and equally different from Parochial Services as the buildings themselves are different from parochial churches.
2nd. From the immensity of Cathedrals there is a flatness in reading which there is not in chanting so that the prayers go on in a manner dull and heavy.
3rd. For one man who can be well heard in Cathedrals when reading, twenty can be found who will be better heard when chanting.
4th. By continual chanting the voices of all the choir are kept in better force and tune.

All this I know by experience of very many years, and therefore I am decidedly against that innovation which made Cathedral Service less interesting and less striking than parochial.

Apart from the controversy over what should be said or sung in services, the discipline and standard of singing of the choir was steadily rising (1760–1840). The repertoire of the choir was expanding as new choral settings of the canticles were being written and new anthems published. Copies of new works were frequently bought for the choir. There was the stimulus of the Annual Music Meeting which helped to keep the cathedral organists in touch with the musical establishment. There was also a sense of stability and continuity since there were only two organists of Gloucester Cathedral between the years 1740 and 1832. Martin Smith, organist 1740–82, was a 'man of first eminence in his profession'. Dr Boyce acknowledged Smith as greatly his superior in the theory of music.'[5] One of his three children, John Stafford Smith (1750–1836) baptised at the cathedral and educated at the College School, made a name for himself locally as a boy-singer, became a chorister at the Chapel Royal in London and studied under Dr Boyce. He became 'an able organist, an efficient tenor singer, an excellent composer, and an accomplished musical antiquary' (Grove). He was successively a gentleman of the Chapel Royal, a lay-vicar of Westminster Abbey, and an organist of the Chapel Royal. He was elected to the exclusive Anacreontic Society, founded in 1766, which met fortnightly at the Crown and Anchor Tavern in the Strand, London. The constitutional song, sung at all the Anacreontic Society meetings was 'To Anacreon in Heaven', written by John Stafford Smith about 1780, which as 'The Star-Spangled Banner' was

officially adopted in 1931 as the United States National Anthem. There is a plaque to both father and son at the east end of north aisle of the nave. William Mutlow, one of Martin Smith's pupils succeeded him as cathedral organist holding the office for fifty years (1782–1832). He was constantly being commended by the Dean and Chapter for his abilities, and devotion to his work. He was conductor of the Gloucester Meetings of the Three Choirs from 1790 until his death in 1832.

Roman Catholic Emancipation

The first United Parliament of Great Britain and Ireland met in the spring of 1801. The Irish Roman Catholics had been agitating for some years for political rights, and the Prime Minister, William Pitt, had promised to back their cause. Yet when Pitt brought a measure before parliament, which was designed to give Roman Catholics full emancipation, feelings ran so high that he had to resign. The proposal continued to generate bitter controversy until, in the spring of 1829, Wellington announced his intention of granting complete equality of civil rights to all Roman Catholics. This was fiercely opposed by most of the hierarchy of the Church of England. Nevertheless, with Whig support and against the votes of many of his own Tory party, Wellington carried his Emancipation Bill through and it became law on 14 April 1829.

The Dean and Chapter of Gloucester were outspoken in their opposition to the measure. Not for the first time they petitioned the House of Lords in 1822. They declared 'Our words are few but our sentiments are firm.' They had:

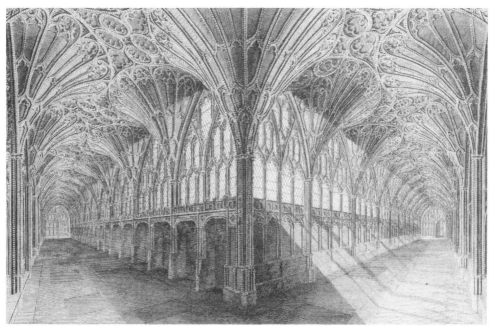

The great cloister, from the south-east corner, showing how the windows in the carrels and the lower lights of the window in the cloister walks were bricked up. T. Bonnor, 1796

. . . in repeated instances submitted . . . that concessions to the Church of Rome can never be made but with a proportionate disadvantage to our own Church, nor have we any reason for believing, however loyal and respectable as individuals many of that persuasion must be allowed to be, that in their Ecclesiastical capacity and as a Church the Roman Catholics of the present day have in the slightest degree departed from those peculiar articles in their System on account of which their exclusion from situations of power and trust was deemed necessary by the Government of this Country and which exclusion the laws of the land still judiciously maintain. We humbly Pray therefore that your Lordships will not endanger the general welfare of our Protestant Establishment by giving power to its direct opponents the members of the Church of Rome, and especially by so important a concession as that of admitting Roman Catholics into the Legislative body of this Kingdom.

Again, in 1825 they wrote 'We humbly beg leave to express our sincere regret in being thus repeatedly laid upon the necessity of obtruding ourselves on your Lordships' honorable House, upon the subject of Popish claims and Romish importunities – inconsistent as they [the Chapter] esteem them with the welfare, rights and ascendancy of the protestant Church in these dominions . . .' They expressed themselves 'fully convinced of the Equity of Toleration and of that perfect freedom which is due to all religious sentiments held in sincerity and exercised within the bounds of lawful and safe practice.' However, so long as:

. . . the religious creed of the Roman Catholics continued to be what it is well known to be, while it [is] the very boast of the papal church to be unchanged and incapable for ever of change as a society or religious system . . . while we see the incessant and unwearied industry and activity displayed in procuring converts to their purposes by erecting schools, chapels and other seminaries of Popish instruction, which we consider to be infinitely exceeding the limits of proper Toleration, and safe permission, we cannot dissemble our apprehension that security to our established church is not to be hoped for if encouragement is further given to the papel Interests by concessions of any kind. Should the time ever arrive that a revisal of their own system shall have been made and their objectionable tenets rescinded upon the grounds of public and acknowledged authority as a church carefully reforming its own errors then, but not until then, do your petitioners humbly suppose that applications for a further extent of freedom may be safely thought of.

In 1827 the Dean and Chapter yet again petitioned the House of Lords and expressed that 'with all Christian Charity for their fellow countrymen of the Roman Catholic Communion . . . they rejoice to see them in the full and perfect enjoyment of Religious Liberty.' But they must 'intreat your Lordships to oppose any further grant of political power to those whose allegiance is divided between the King and a foreign State and Potentate whose religious views and opinions are so totally in opposition to those of the Protestant Church.' On 2 February 1829 when the Emancipation Bill was before parliament this same petition was sent to both Houses, but in spite of the concerted efforts of a well-organized opposition in the country, the measure became law and Roman Catholics were given full political and civil liberty.

CONTEMPORARY DESCRIPTIONS

Evidence of the growth of antiquarian interest in the latter part of the eighteenth century is reflected in the setting up of two 'Repositories for Curiosities' in the east cloister walk either side of the entrance to the library (1789). These were to be made 'of

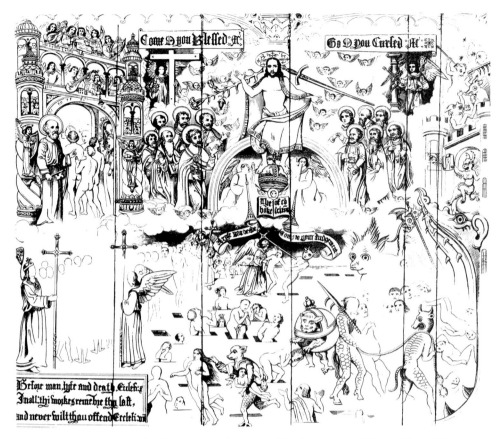

A late-medieval 'Doom'; found *c.* 1720 'behind some old wainscot on repairing and beautifying the choir where it had been hid since 1541' (Browne Willis). It was destroyed in London during the Second World War. Drawing by G. Scharl Jr. Etching by C.H. Jeans 1856, published by the Society of Antiquaries, London, 1858

Dutch oak with shelves and brass gratings.' In the library the Repository for Manuscripts and Choice Books was enlarged two years later. It was a time when many donated valuable works to the library. The empty shelves noticed by visitors earlier were filling up. Drawings and etchings of ancient buildings, particularly cathedrals and old abbeys, were coming into vogue with the work of Francis Grose (1772–87) and Charles Wild (1807–23), of John Britton (1814–35), James Storer (1814–19) and Thomas Bonnor (1796). In place of diary entries, which often recorded merely local lore, these engravings were accompanied by brief descriptions of the buildings based on the best contemporary historical writing and the artists own observations. Of particular interest in the study of Gloucester Cathedral in the early decades of the nineteenth century is the *Account of the Cathedral Church of Gloucester with Plans, Elevations, and Sections of that Building* published by the Society of Antiquaries of London in 1809, and the work of Thomas Bonnor (1796), James Storer (1816) and John Britton (1829).

Nave: Bonnor shows the wooden rail around the Consistory Court, near the south porch entrance. When the Consistory Court was dismantled and the font designed by Sir Gilbert Scott installed in that area, a part of the railings was placed in the north ambulatory around the tomb of Edward II, and part taken into store. At the entrance to the cloister Bonnor shows recently installed light iron gates (1792). He explains that 'these admit a current of air necessary to the preservation of the cloister.' He also noted that the recently opened window (1793) at the far end of the west walk, which Dr Small, one of the prebendaries, had filled with medieval glass saved from various windows around the building, made an attractive vista through the open doorway. 'The striking termination of the perspective at the northern extremity, enriched by the display of the painted glass window, is very justly admired for its simplicity and good taste.' Bonnor shows that memorial tables had spread to the Romanesque piers. At the east end of the nave is Kent's controversial choir screen. Of this he wrote: 'The good Bishop Benson erected the screen, which at the east end of the body separates it from the choir. Kent was the designer; but its proportions are objectionable, and its parts are composed of several orders, without being true to one.' The organ, he thought, 'forms an appropriate and conspicuous ornament' in its position over the entrance to the choir.

Choir: Bonnor's view of the choir shows the oak pews of *c*. 1710 in position backing onto the monastic stalls. The bishop's throne is on the south side and the stall shared for a while by the mayor and the archdeacon of Gloucester is on the north side. In 1803 the bishop requested that the Chapter should allocate the stall beside his throne to the archdeacon. The pulpit is placed centrally at the top of the presbytery steps. This pulpit was later to be moved to the nave during the Victorian restoration, when a new stone pulpit was erected on the north side. Bysaak's impressive reredos was still in position; but Bonnor criticized it as being out of place. 'The high altar [reredos] is composed of

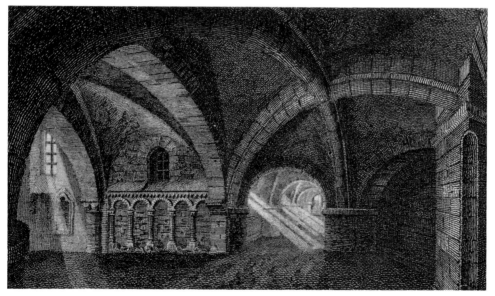

The crypt, the south-east chapel and ambulatory. T. Bonnor, 1796

oak. It consists of an arrangement of fluted pillars etc, after the Corinthian order of architecture, and is therefore ill suited to its station.'

North Ambulatory: In Bonnor's etching no wooden rail surrounds Edward II's shrine. The raised paving of the ambulatory, not long laid down, is clearly distinguished from the medieval tiled area around the tomb itself. The drawing suggests that the windows of the ambulatory were filled mainly with clear glass. Bonnor noted that 'the wooden tomb of the unfortunate Duke of Normandy' was in the north-east chapel. Sir Humphrey Tracey had preserved it during 'the troublesome times' and restored it; it was then placed 'above the choir', that is in the presbytery, but Dean Chetwood (1707–19) had 'removed it to this place.'

North Transept: Bonnor noted that the reredos in St Andrew's Chapel was once ornamented with twenty-one figures, only the tabernacles of which remained (1796). 'Within the last few years, a figure of St Andrew, with his cross, in stained glass, occupied the middle part of the window above it.' The door on the left of the chapel led to the chapter room. A large memorial, surrounded by an iron railing, occupied the wall outside the chapel on the right. The thirteenth-century screen on the north side of the transept appears to be enclosed with iron bars, but these bars were in fact made of wood. Bonnor commented: 'The cells within the grating . . . were places of punishment previous to the dissolution of monasteries in England; but they are now appropriated to the harmless use of depositories for the choristers' surplices.' According to other contemporary writers, the singing men, or lay clerks, kept their robes here throughout the eighteenth century. On the south side of the transept, beneath the crossing arch was 'St Anthony's Chapel and clock-house, with a gallery to the choir over them.'

Tribune Gallery: In Bonnor's day the common name for the tribune gallery was The Whispering Place. He explained that the actual Whispering Gallery, entered through the door at the east end of the gallery, was 22.5 m (73 ft 9 in) long but 'a whisper delivered at either entrance may be heard at the opposite end almost as distinctly as it is uttered.' At the time, the late medieval *Doom*, which was destroyed in London during the Second World War, was stored in the tribune gallery. 'In this gallery a picture is placed representing the Resurrection at the last day. It was discovered behind some

The tribune, south side. T. Bonnor, 1796

wainscoting, where it was supposed to have been concealed at the time of the Reformation.'

Crypt: Bonnor shows in the far distance in the centre of his drawing the steps leading down into the crypt from the south transept. He noted that 'this hypogeum is converted into a bone-house', with human bones piled up in the central space. In the north-east chapel there was a door opening to the Grove. A window in the south-east chapel is blocked up, but light floods in from other windows along the ambulatory.

Lady Chapel: Bonnor's view of the lady chapel shows Bishop Benson's Radiance behind the altar, and the reredos remodelled on either side. Surprisingly, he refers to this as a 'neat piece of stucco'. 'The seats which now furnish this chapel formerly belonged to the choir.' He draws attention to the portrait of King Richard II seated, with his crown and septre, in stained glass, in the east window. Among the numerous inscriptions which appear here, he pointed out the monument to Robert Wise which was repaired by his twentieth child, sixty-nine years after his father's interment.

Chapter House: Bonnor noted and recorded the names 'inscribed against the walls in black letters' of Robert, Duke of Normandy and others who were thought to have contributed

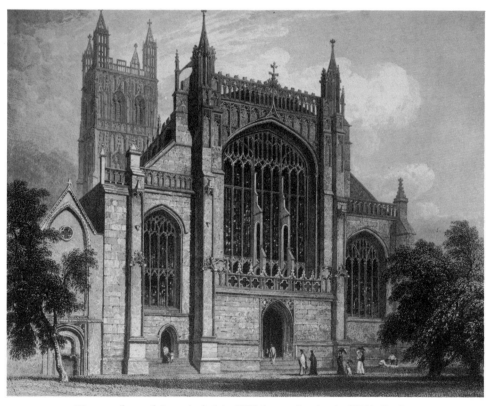

The west front of the cathedral in 1828 from a drawing by W.H. Bartlett

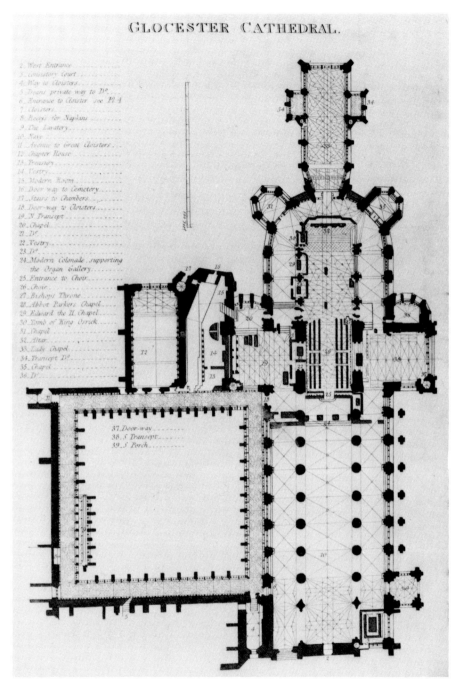

GLOCESTER CATHEDRAL.

2. West Entrance
3. Consistory Court
4. Way to Cloisters
5. Deans private way to Do
6. Entrance to Cloister see Pl 4
7. Cloisters
8. Recess for Napkins
9. The Lavatory
10. Nave
11. Avenue to Great Cloisters
12. Chapter House
13. Treasury
14. Vestry
15. Modern Room
16. Door way to Cemetery
17. Stairs to Chambers
18. Door-way to Cloisters
19. N Transept
20. Chapel
21. Do
22. Vestry
23. Do
24. Modern Colonade supporting
 the Organ Gallery
25. Entrance to Choir
26. Choir
27. Bishops Throne
28. Abbot Parkers Chapel
29. Edward the II Chapel
30. Tomb of King Osrick
31. Chapel
32. Altar
33. Lady Chapel
34. Transept Do
35. Chapel
36. Do

37. Door-way
38. S Transept
39. S Porch

Plan of the cathedral, 1815, showing the consistory court, remains of north aisle chapel, the
Kent screen and eighteenth-century choir seating, the cope chests in choir vestry, medieval
buttress across south transept chapel, north entrance to Abbot Parker's chapel and the
Bysaak reredos

to the building of the Norman abbey, and who lie buried in the chapter house. He noted that 'officers of the garrison' during the Civil War and Commonwealth period converted it into a library and became its guardians. 'In 1688 Mr Wheeler began to stock it with books.'

Great Cloister: Bonnor's view of the cloister interior is from the south-east corner. It shows the carrels or study recesses of monastic times; he noted that 'in each there were formerly a window' but these had long since been blocked up. The lower lights, below the transoms, of the windows in the east walk are also shown bricked up. Of the fan-vaulting he wrote somewhat fancifully that:

> The object of the design is evidently to imitate in stone work the sacred groves where, in former times, the Deity was worshipped; the upper branches of which being engrafted together, give the whole an appearance suited to the supersitition of those times, of one immense tree arising from many stalks. The wonderful success with which the arduous task is accomplished places the work itself above the reach of wordy praise, and equally defies both description and comparison.

Because of the vogue of illustrated historical introductions to English cathedrals in the early decades of the nineteenth century it is possible, particularly in the case of Gloucester, to have a fairly accurate idea of the internal furnishings of the building and its external appearance before the Victorian restoration. But the description of the building contained in these folios of etchings, whether by Thomas Bonnor, James Storer or John Britton reveal little about the structural state of the building. Some information about the condition of the fabric may be extracted from chapter act books, treasurer's accounts and architect's reports, though they leave many questions unanswered. But fortunately, at Gloucester at the beginning of the Victorian period, there was a young architect, F.S. Waller, who had a keen interest in antiquarian and archaeological matters. From 1847 he was involved, with his senior partner, Thomas Fulljames, in the care of the building, and built up an unrivalled professional knowledge of the structure and its history. This led him to record the condition in which he found the cathedral and the claustral buildings, as well as the houses around the precincts, before undertaking restoration work.

THE VICTORIAN RESTORATION – I
1832–1867

'To retain as much as possible of the old work, restoring only where actually perished . . . and to take all precautions to prevent further decay in the external stonework.'
F.S. Waller, Principles of Restoration, 1855

The years 1832–52 saw the rise of two movements which were to stir the hearts and minds of many during the Victorian era, and profoundly affect the internal arrangement and furnishing of many medieval churches and cathedrals. The first, the Oxford Movement, arose as a reaction to prevailing trends in the Church of England, and from a concern to recover her essential catholicity. The bench of bishops was still filled with the younger sons of the aristocracy, promoted royal chaplains, men whose style of life was far removed from the poverty endured by many of their people. The parish clergy, though genial, honest men, were neither learned, zealous nor spiritually-minded, differing often only by the colour of their coats from the squires with whom they associated. But the population was leaving the countryside, and going to live and work in the fast growing towns and cities of the Midlands and the North, and was losing touch with organized religion. There were some in the Church who thought the only way forward was to broaden and popularize the Church by bringing its teaching into line with the latest discoveries in science and history, and by giving it a basis in philosophy rather than in dogma. They set dogma aside, and encouraged the widest possible expression of opinion on matters of faith and morals.

Reacting against such an attitude were others who declared that the ineffectiveness of the Church stemmed from a neglect of dogma and a lack of appreciation of the unity and historical continuity of the Church. For them the Church did not date from the Reformation, nor was the Bible the only basis of its doctrine. The leaders of the Oxford Movement, John Henry Newman, John Keble and Edward Pusey, all resident Fellows of Oxford colleges, argued that the Church of their day was the Church of Anselm and Augustine; it was still bound by all the dogmas that could be traced back to the early

Fathers. They believed, in particular, in the Real Presence in the Sacrament, and the sacrificial priesthood of the clergy. Only submission to authority in matters of doctrine and a return to the liturgical practice of the early Church could effect a revival in the spiritual life of the nation.

But where did authority in matters of doctrine lie? The question led some, like Newman in 1845, to embrace what they regarded as the undoubted orthodoxy and authority of the Roman Church; but the majority of the Tractarians, as they were called because of the series of Tracts they published, continued to believe the Church of England was a true branch of the Catholic Church and remained within it. Keble married in 1835 and resigned his Fellowship at Oriel College, Oxford. In 1836 he became Vicar of Hursley, near Winchester, where he remained until his death in 1866. The disciplined and holy life of men like Keble, and the devoted work of 'catholic-minded' priests in neglected and depressed areas gradually won over many of the laity to their views, and their influence in the Church grew. They strove to restore decency and order in public worship in marked contrast to the careless and slovenly practices of the eighteenth century.

At the same time, largely through the work and writings of Augustus Welby Northmore Pugin (1812–52), there was a revival of Gothic architecture, and a movement to recover the 'Catholic setting' of worship. His influence can be seen in the early work of a number of young architects at the time including George Gilbert Scott, whose first major commission, St Giles', Camberwell was begun in 1842. For Pugin, Gothic architecture was 'not a style but a principle'. He wrote a series of passionately

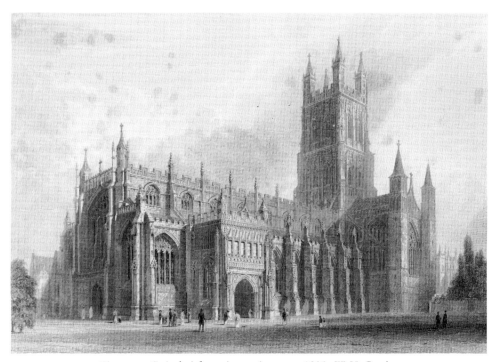

Gloucester Cathedral from the south-west *c*. 1825. W.H. Bartlett

argued and influential books, such as *The True Principles of Pointed or Christian Architecture* (1841) and *An Apology for the Revival of Christian Architecture in England* (1843), which were to have a profound effect not only on architectural style, but on liturgical practice. In Watkins' words:

> For him the Gothic style expressed the unchanging truths of the Catholic Church. As a convert to Roman Catholicism, which had been suppressed in England from the sixteenth century until the Emancipation Act of 1829, he saw in the pointed arch and other features of Early English Gothic an assertion of the revival of true Catholicism and all that went with it in the way of ornament and liturgy. The Catholic Revival in the Church of England was therefore promoted from the 1830s by the Oxford Movement which emphasized the sacraments and the spiritual role of the church, and the Cambridge Camden Society (known as the Ecclesiological Society from 1845) which emphasised the correct, that is medieval, forms of church building and liturgy. [1]

EARLY RESTORATION WORK 1838–1855

The revival of interest in Gothic architecture led to the restoration of many medieval churches. Anything which was not Gothic was swept away. At Gloucester the process had already begun with the removal of Kent's choir screen in 1819, and the construction of the present screen which Dean Spence (1886–1917) considered 'heavy, plain and ugly . . . utterly devoid of any beauty or grace.' Other features and furnishing introduced by Bishop Benson had also been removed.

The Architects Responsible for the Work

The architects responsible for advising the Dean and Chapter during the Victorian restoration of the cathedral were F.S. Waller, a partner of Thomas Fulljames who had been surveyor of Chapter properties for a number of years. From 1847 Messrs Fulljames and Waller jointly advised the Dean and Chapter, with Fulljames usually reporting to the Chapter. But in 1852 Waller was appointed Supervisor of the Works, and from 1857 he was referred to as 'the Architect'. For a short time, while Waller was recovering from a riding accident (1863–65) Fulljames attended Chapter meetings. George Gilbert Scott then took over and was in charge of the restoration of the choir from 1868 until 1873, with John Ashbee as clerk of works. Waller was appointed Supervisor of Works in June 1872, his duties being 'those previously fulfilled by Mr Ashbee'. From 1873 Sir George, as he then was, pulled out of the work at Gloucester and on his death, early in 1878, Waller was appointed Resident Architect, a post he held until 1905, though his son, F.W. Waller was associated with him in his cathedral responsibilities from 1890. J.L. Pearson (1817–97), the London-based architect, was asked to advise on the restoration of the lady chapel in 1892.

The Victorian restoration of the cathedral was carried out in phases. The first phase (1839–55), under the direction of Fulljames and Waller, was little more than the continuation of normal repair work. But in retrospect it is clear that Waller was working to a plan which, although not fully formulated until 1855, was taking shape in his mind. The funds available each year for repairs and restoration increased steadily, due in

Frederick Sanham Waller, 1822–1905

The choir in the late eighteenth century showing
the furniture removed during the nineteenth-
century refurnishing

part to the sale of Dean and Chapter lands to various railway companies laying tracks across the countryside. It was also due to Waller's persuasive powers and passionate desire to save the building from its ruinous condition. Much of the funding, however, particularly for the reglazing of windows *in memoriam*, and for the restoration of the choir came from donations for specific work. Other work involved chapter funds, such as the iron railings which were put across the entrances to the transepts from the nave (1839); the stone pulpit erected on the north side of the presbytery (1849); the restoring and capping of the 'arches near the cloister'(1846); the chapter room and treasury which had to be repaired and refurnished after a fire there (1849), and plans for a new schoolroom on the north side of the chapter house which were approved in 1849–50. The stone pulpit in the choir 'which is in course of erection, was designed by the well-known architect, Mr Carpenter, and worked in Sheepscombe stone. It is in perfect accordance with the other portions of the fabric nearby.' (Power's *Illustrated Handbook of Gloucester*, 1848.)

The Cathedral Before the Work Began

Two other brief descriptions of the condition of the fabric and the internal arrangements of the cathedral are of particular interest in assessing the extent of the Victorian restoration. They are John Coney's plan of the cathedral in the 1846 edition of Sir William Dugdale's *Monasticon Anglicanum* (1655), and Power's *Illustrated Handbook of Gloucester* (1848), with its brief but valuable section on the cathedral. With other earlier descriptions and with Waller's own report of 1855, these serve to show just how radical was the reordering of the interior during the early phases of restoration work. Some of the last remnants of the medieval lay-out of the building were swept away. The modern interior, in many details, dates from this early period of the work rather than the later refurbishing under Sir Gilbert Scott which was largely confined to the choir.

Waller became involved in work at the cathedral in 1847. At that time, as Coney and Power make clear, part of the medieval screen across the east end of the nave was still in place. At the ends of both aisles the screen extended from the Norman piers to the outer walls. On the north side the medieval chapel, known in the eighteenth century as the mayor's chapel, still contained seating for the mayor and corporation. There was a screen in front of the chapel (possibly the wooden screen now in the tribune gallery), and the floor of the chapel was raised two steps up from the floor of the nave. The chapel must have been somewhat cluttered with the Blackleech memorial occupying half the space. With the dismantling of the chapel the memorial was removed to the south transept. Beneath the north and south crossing arches there were chapels, but on the south side part of the organ loft remained, with steps leading up to it, and the parclose screen was somewhat differently arranged. Beneath the crossing arches there were galleries on both sides facing into the choir.

The Seabroke tomb was against the south-west crossing pier, and Bishop Benson's memorial was still in place, backing onto the eastern chapel in the south transept. As on Carter's plan (1807), Coney indicates, in dark hatching, the medieval buttress behind the memorial. In the south-west corner of the transept there was a 'blank door which probably opened originally into the churchyard, and each side is ornamented with large

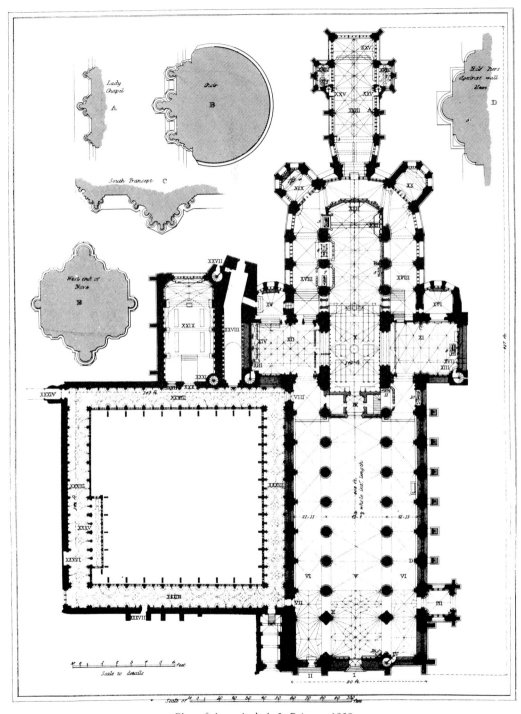

Plan of the cathedral, J. Britton, 1829

statues of angels, now much injured, which by their posture seem to pay submissive attention to the person passing through.' In the east chapel of the north transept the Restoration font is shown standing centrally, the chapel being known as the 'Baptistry'.

In the lady chapel 'a comparatively modern and discrepant altar-piece of stucco was removed a few years since by the late Reverend Dr Griffith, prebendary' (1848). 'Morning Service is performed in this chapel at seven o'clock, except in the winter.' In the choir, the eighteenth-century stalls and bishop's throne were still in place, and a wooden pulpit stood on the presbytery step. In the cloister, the 'lavatory is now enclosed with pallisades', and in the garth the old lay-out of the paths and beds and the tall trees are shown. But over the next few years much of this was to be changed, some medieval work was swept away, and more recent work replaced.

However, before any major restoration could get under way, a certain amount of tidying up had to be done. This was carried out mainly under the direction of Dr Francis Jeune, Master of Pembroke College, Oxford, who was installed to the Pembroke Canonry in December 1843.[2] Though the Hon. Edward Rice was dean (1825–62), Dr Jeune was the prime mover in early restoration work, encouraging F.S. Waller as he was formulating his plans for the building. Jeune was in residence during the summer vacation, but was actively involved in Chapter business at other times of the year. He served as treasurer for many years, as sub-dean, and towards the end of Dr Rice's tenure at the deanery he was his proxy. In June 1859 he became Vice Chancellor of Oxford University, Queen Victoria granting him a dispensation for non-residence for as long as he held the office. He was back in residence from 1862. In 1864 he was made Bishop of Peterborough where he died four years later.

Dr Francis Jeune, Master of Pembroke College, Oxford and Canon of Gloucester and, from 1864–8, Bishop of Peterborough

The Work in the Great Cloister

Work was carried out in the great cloister beginning with the restoration of one compartment of the south walk (1845). This led on to the restoration and glazing of the entire walk, and to the removal of the brick and plaster infilling from the lower lights in the east walk. In 1854 'designs for filling up the windows in the great cloister with painted glass were approved' and a window in memory of Dr Evans (E5), the first to be inserted, was also approved. This approval was granted on condition that the family also paid for the restoration of the stonework of the window. The Chapter invariably made this a condition in accepting offers of stained glass *in memoriam*, with the result that the stonework of windows all over the building was restored at the same time as the glass was inserted. Dr Jeune had urged that the subject of the windows in the cloister walks should follow an agreed sequence, and proposed the theme of 'Man's Redemption'. Thus, beginning at the south-east corner with the Annunciation and the Nativity, and continuing along the east and north walks, the windows would depict scenes from the life and teaching of Christ. Then there would follow the story of the Passion in the west walk, and the post-Resurrection appearances, ending with the Ascension and Pentecost in the south walk.

The Chapter was increasingly reluctant to give permission for monuments to be erected; the walls had become cluttered with them in the eighteenth century and the early nineteenth century. Instead it was suggested that a new stained-glass window might be given *in memoriam* with a suitably engraved brass plate placed on the wall beneath it. Shortly after the Evans window was inserted another was given (E7) by Mrs Claxson, and then after a break of a few years, the remaining windows of the east walk were reglazed by personal donation. The windows in the nave were also being filled with stained glass, but then interest was diverted to the choir where an extensive restoration was being proposed by George Gilbert Scott. It was not until the mid-1890s that the work of reglazing the cloister was taken up again, and by that time there was little enthusiasm or funding to complete Dr Jeune's iconographical scheme. The west and south walks were filled with clear glass, with fragments of medieval glass set in the tracery of some windows. Below the transoms, however, ornamented quarries were used. The half-windows above the lavatorium and the window at the end of the north walk (N10) were also filled with stained glass (1898–9).

The West End of the Nave

Another major work during the first phase was the restoration of the west end of the nave. Work began in 1848 and continued for four years with a total expenditure of more than £1,300. The masons worked their way down from the parapet replacing a considerable amount of stone. Although it is not recorded it is likely that the ornamental cross at the apex of the west front, copied and replaced in 1989, was designed and carved at this time. Drawings prior to 1848 show a far more simple cross. They also show an entirely different design of ballustrade at the bottom of the window. As shown, for example, in the drawing by W.H. Bartlett (1827) this consisted of a series of quatrefoils with a light wavy crocketed top. It may well have been this feature that Sir

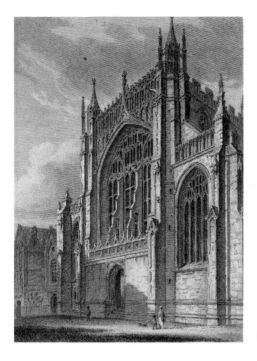

The west front. J. Storer, 1814

Hugh Walpole so admired in Gloucester's west front, and which he saw reflected in the Kent choir screen. At all events, this frilly frieze over the west door was removed at this time and replaced by rather dull castellation, more suitable for the roof level than over a main doorway. The Chapter allocated a further £350 for the restoration of part of the south porch. The west side was extensively repaired with Anstone (1853–4). A contemporary writer lamented 'that the interior of the south porch has suffered much from wanton mischief and rude repairs, while the exterior has been injured by the influence of the weather on the friable material with which it is built.' The porch was in urgent need of far more extensive repair.

The Gardens at the East End

In 1854 the Chapter asked Dr Jeune to lay out the grounds around the east end of the cathedral as a garden. The area had been known since the late seventeenth century as the Grove. Paintings and drawings before 1850 show it planted with trees and shrubs. A 'carriage drive' had been made through it from College Green around to Pitt Street. Following a report by Fulljames and Waller (1846) on the condition and restoration of the lady chapel the soil which had built up around the chapel, in places to a depth of 4 ft, had been removed. The drainage round the chapel had been improved, and decayed stone replaced. These were only the first steps in what was to prove a long struggle to save the lady chapel from ruin. The displaced soil had been thrown back around the east end, and on the south side formed a mound in front of the garden of Cathedral House

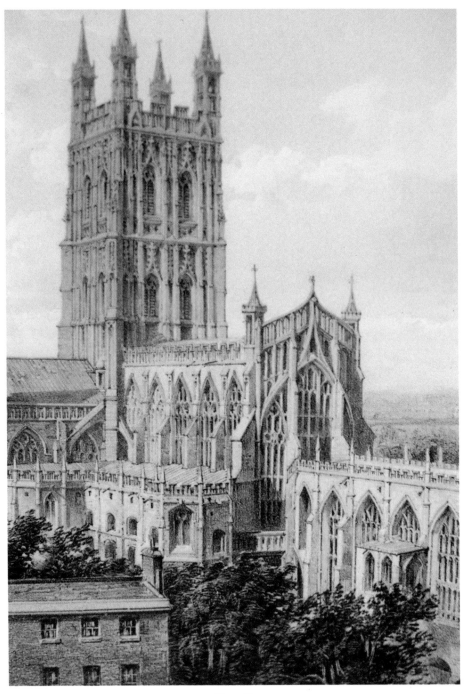

Plate 25
Gloucester Cathedral from the south-east *c.* 1860. Part of Dr Jeune's house is shown in bottom
left corner (now the King's School house)

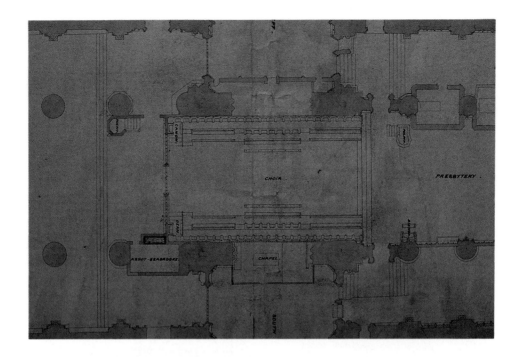

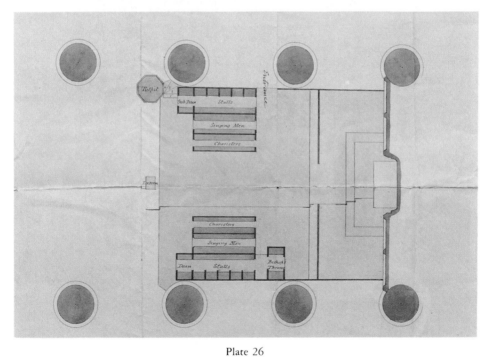

Plate 26
Top: F.S. Waller, ~~the~~ proposed reordering of the choir *c.* 1856. Bottom: F.S. Waller, 'provisional furnishing' of the east end of the nave *c.* 1873, using eighteenth-century stalls from the choir

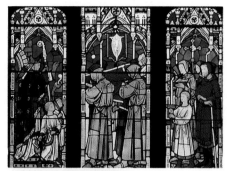

A

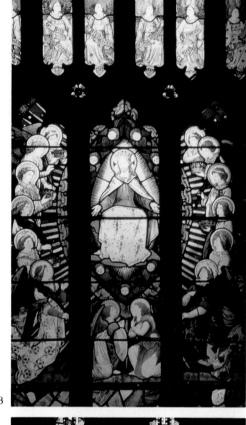

C

B

Plate 27

(A) 'Christ in Majesty' window in St Paul's Chapel, north transept, Burlison and Grylls 1870. Another outstanding window is the 'Justice' window, Hardman of Birmingham (s xii) 1865. (B) 'The Funeral of Edward II'. The body of the murdered king is received by Abbot Thokey, 1327. By Clayton and Bell (s vii) 1858. (C) 'The Miraculous Catch of Fish'. Detail from the glass, by Hardman, in the *lavatorium*. A fine example of the work of the designer, John H. Powell 1868. (D) Medieval glass, restored by Hardman in 1865. G. Gilbert Scott commented in his 1867 report to the Dean and Chapter: 'this is the most successful restoration of 15th century glass I have ever met with'

D

A

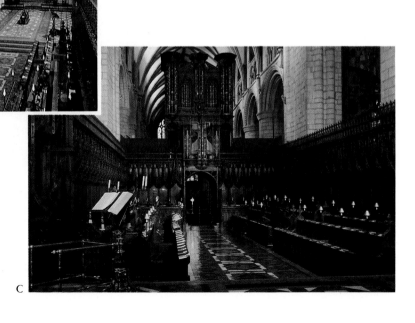

B

C

Plate 28
(A) G. Gilbert Scott's drawing for the refurbishing of the choir, 1870. (B) Part of G. Gilbert Scott's refurbishing of the choir, the tile pavement, by Godwins of Lugwardine, near Hereford. (C) G. Gilbert Scott's refurnishing of the choir 1870–72, looking west, Bentley's lectern is in the foreground

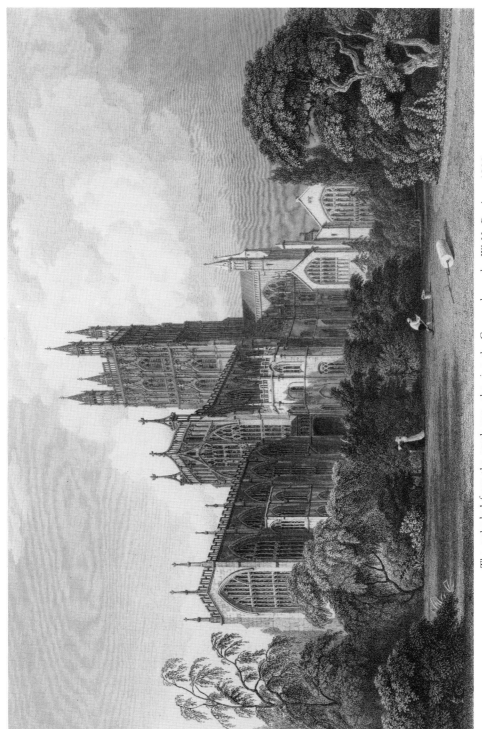

The cathedral from the north-east, showing the Grove, drawn by W. H. Bartlett, 1828

Dr Jeune's original plan for the garden at the east end

(Wardle House). From these mounds of earth Dr Jeune laid out broad beds for shrubbery and ornamental plants. He also removed many of the trees, and laid turf to form extensive lawns. A plan survives giving details of the lay-out which also included additional paths. In 1858 the wall extending across from Cathedral House (Wardle House) to the south-east corner of the transept was taken down as part of the plan to open up the east end. This, it seems, was now possible because Mr Benjamin Disraeli, the future prime minister, had surrendered his lease on Cathedral House. The lay-out of the area at the east end of the building and the gardens created by Dr Jeune are today much the same as they were when the work was completed in 1858.

WALLER'S DESCRIPTION OF THE CATHEDRAL (1855) AND PROPOSALS FOR ITS RESTORATION

In June 1855 Waller was asked to report on 'the present state of the cathedral' and to indicate the 'repairs and restoration desirable . . . in order to place the cathedral in as perfect a state as practicable.' His report was to be 'submitted to Sir Charles Barry or some other eminent architect for his opinion and suggestions thereon.' In the event George Gilbert Scott was asked for his comments. Waller described the condition of each part of the building, and alongside set out his suggestions for restoration work. The majority of his recommendations were implemented, but by no means all. Nevertheless the report set the course for the restoration of the cathedral during the next fifty years.[3]

The south transept and gates leading to the Grove
c. 1830

Taken with his folio *General Architectural Description of the Cathedral Church . . . at Gloucester, with plans and sketches of its peculiarities and beauties*, published 4 August 1856, the report gives an accurate and detailed description of the state of the building before major restoration began. The total cost of the proposals in the report was estimated at £66,235 (including £18,000 to be spent on restoring and inserting stained glass).

The crypt had been thoroughly cleaned out and levelled in 1850. A great accumulation of rubble and earth had been removed and the floors laid with concrete. The windows had been repaired and glazed. Some of the windows appeared never to have been glazed. The iron bars were much corroded. There was no evidence of an original floor level in the central chamber, water seemed to rise and fall according to the weather. The eastern slype was in a very poor condition. The stonework under the bases of the arcade shafts had crumbled away. The only access to the slype was from the east end, from either the crypt or garden. Waller proposed 'to open a doorway from the cloisters for the use of the Deanery.'

The south porch vault was 'much covered with lime wash', and though the west side had been restored, the east side and the south face were much decayed. There were no figures in the niches. Waller proposed to reinstate the stonework inside and out, remove all lime wash, lay the floor with stone paving and reglaze the east window with flowered quarries. The ancient oak doors were covered with thick paint. The wicket door was not original and not oak. Waller proposed a new oak wicket be made, and the main door cleaned of all paint, varnished and the iron work 'made good'. Outside, the wall and windows of the south aisle of the nave were 'much perished' and only two figures 'remain perfect'. He proposed restoring the buttresses 'with extreme care' and filling the windows with painted glass. Inside the building, at the west end of the south aisle, he proposed removing the woodwork of the Consistory Court which was 'in a style ill adapted to the building.'

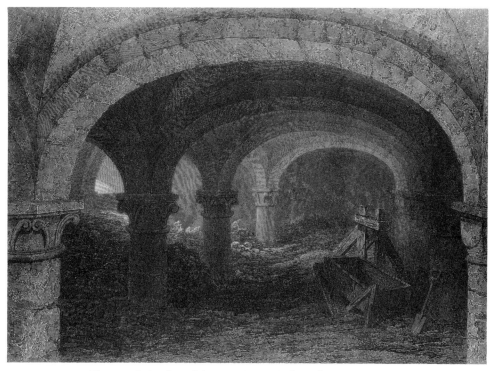

The central chamber of the crypt in 1828, drawn by W.H. Bartlett

In the nave he noted that 'part of the piers are calcined by the burning of the ancient wooden roof which existed before the present vaulting.' The whole of the interior was 'completely covered up with a succession of coats of lime wash.' 'The bases of the large piers are modern placed against the old stonework; the whole floor is 10 inches higher than its original level. The original square base [sic] of the columns and what is left of the original floor of encaustic tiles lies below the present paving. The piers are for the most part defaced with monuments.' The west window had painted glass in the upper lights partly collected from various other windows, and the clerestory windows had remains of painted quarries with borders enriched. The vaulting shafts with their capitals and bases, and the bosses at the intersection of the ribs all had old colouring left on them which could be detected when the lime washes were carefully removed. The wooden roof in many places was 'sunk and irregular, the badly constructed timbers were defective and lead work was out of place.' Waller proposed a floor of encaustic tiles in the nave 'of the old arrangement and pattern if it can be discovered.' The west window should be filled with painted glass reusing as much of the old glass as possible. The clerestory windows should be reglazed with flowered quarries with enriched borders.

In the choir the walls and vault were covered with limewash and dirt. The windows were in a sad state of repair, the iron work in many parts eaten through and the glass retained in its place by mortar only. Parts of the old glass were left, sufficient to show its original design of figures in niches in the lower lights of the clerestory windows and

The south porch in 1814 and 1827. Drawing by (left) J. Storer 1814 and (right) W.H. Bartlett
1827

flowered quarries, patterns and borders in the upper lights. The east window was
'sufficiently perfect to be interpreted.' A sketch for its restoration by Messrs Hardman of
Birmingham had already been obtained (1855). The glazing, in Waller's judgement,
was one of the first things that should be attended to. All the stalls with their miserere
seats were 'very much mutilated and defaced.' The canopies were of oak, but painted.
The organ was 'raised high . . . obtruding itself as a great tasteless mass between the
nave and the choir.' The screen erected by Dr Griffith had been made 'from parts of old
screens in the aisles'. The central part of the choir was 'floored with stone, but some of
the original floor remains under the floor of the modern seats.' The presbytery was
paved, in part, with encaustic tiles of the old pattern and arrangement. Those
immediately around the altar were 'a collection from different parts of the cathedral.'
Waller noted that the space between the crossing arches on the north and south sides of
the choir were originally chapels, one enclosed by a wooden and the other by a stone
screen. They were now (1855) 'converted into closets of different sorts with staircases
leading to galleries above.' In both chapels there were remains of old paintings,
reredoses etc.

The 'modern stalls' in front of the monastic stalls should be removed together with
the organ screen and gallery. The organ should be removed to the north side of the
tribune gallery 'allowing one portion of it to show in the archway opening into the
north transept . . . and other parts in the first compartment eastward of the tower.' It
would be interesting to know whether he had consulted John Amott, the organist
(1832–65) before making these proposals. But Amott's opinion would have carried

little weight since, as Dr A. Herbert Brewer noted, 'his ability as an organist was . . . of an elementary character. The pedals were rarely used, and when he did play on them he would allow the choristers, as a special favour, to go to the organ-loft to see how it was done. As a rule a board was placed over the pedels on which his feet rested.' Waller proposed that the choir screen should be removed and an open screen substituted, opening up the choir to the nave. The return stalls, apart from those of the dean and canon-in-residence should be removed. (See pp. 469–70.) The wooden galleries on the north and south sides, below the crossing arches, should be taken down. What was defective in the ancient stalls should be made good, and all paint removed. The choir and presbytery should be paved throughout with encaustic tiles of the same design and arrangement as the original medieval floor.

The transepts were also covered in limewash. Waller noted the monumental slabs in the north transept 'many of which have been inlaid with handsome brasses.' The slabs should be lifted, and the more important ones relaid in a floor of encaustic tiles. There was ancient glass in the clerestory windows, sufficient to suggest the pattern for reglazing. The roof timbers were in bad condition, being 'spliced and tied up with iron straps..the ends of the beams rotted on the walls.' These repairs dated from the late eighteenth century when, for a time, an iron-worker was the clerk of the works. The stonework of the windows, parapets, buttresses and coping was badly decayed. The south transept roof was 'put in about forty years ago' and was in good condition, but the external stonework was in poor condition. Waller noted that 'the oldest work is in the best state of preservation.' In the transept itself access to the eastern chapel was blocked by a wall on which there were several monuments including a large monument to Bishop Benson. The chapel was used as a vestry with access from the ambulatory. Waller recommended that the memorials should be removed, and the chapel opened up to the transept and restored. As in the north transept, the windows should be filled with painted glass, and the floor paved with encaustic tiles of medieval design. Waller does not refer to the huge buttress across the entrance to the chapel, though he shows it on his plan of the cathedral (1856). Abbot Seabroke's monument and chapel had been much altered and mutilated. Waller suggested the screen around Abbot Seabroke's monument should be restored, and the effigy of the abbot placed in its 'proper position' on the north side.

The vaults of the ambulatories and tribune gallery were in a bad condition and needed plastering. All limewash should be removed. The surface of the stone should be left in its medieval condition showing the tooling of the Norman masons. Again, the floor should be paved with tiles, though the brick floor in the gallery could be left. The north-east chapel of the tribune had a tile floor. Waller was concerned that the tracery in the ambulatory windows had led to the exterior of the window arches being 'cut up in a most unsightly manner'. The ambulatory chapels, at both levels, contained interesting features, niches, piscinas and reredoses, which should be carefully preserved. He was concerned at the evidence of settlement outwards 'which appears still inclined to go further' on the south side of the choir. Once the soil had been removed from outside, the foundations were examined.

Waller considered the lady chapel to be 'in good general repair'; this is surprising in view of it being 'ruinous' twenty years later. The sedilia was 'handsome and in good preservation'. Once the limewash had been removed he believed a considerable amount

The lady chapel, the south side. Photograph, *c.* 1865, after the Grove was laid out as a garden by Dr Jeune

of medieval painting would be revealed. The reredos should be left as it was. 'Any successful restoration being almost impossible, and the remains of the painting being so interesting and uncommon that it would be most undesirable to attempt removal or restoration'. Waller proposed placing a curtain or drapery in front of it 'in such a way as to form an appropriate back ground to the altar.' Although it was much worn, sufficient of the old floor remained to show its original design. Many memorial stones had been inserted in the floor. Parts of the choir fittings had been converted into seats running east to west on each side. The glazing was in a bad condition; in the east window and in other windows there were remains of medieval painted glass. All the windows should be 'filled with painted glass, taking care to preserve the old glass'. A curtain should be put across the screen dividing the lady chapel from the choir 'for greater warmth'. The external stonework was 'in bad condition particularly on the south side. The parapet had been lowered, and the cusped heads removed. The pinnacles were all modern [eighteenth century] and incorrect except in two instances near the choir'. The pinnacles and battlements should be restored.

The external stone work of the tower was 'in excellent general condition, better than

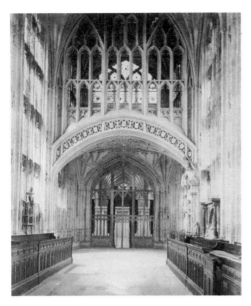

The lady chapel, looking west. Photograph *c.* 1860

any other part of the cathedral'. The pinnacles, however, were in many parts perished and patched. The stonework of the cloisters was 'very delapidated, and the roof bad, propped up in many places'. The floor of stone slabs was 'very unsightly and irregular'. Drainage was bad, with the result that rising damp was a continual problem. He proposed relaying the paving on concrete, and carrying the water from the roof by gutters into proper drains. The glazing was in a poor condition, with the lower compartments of the windows and the windows in the carrols filled with bricks and plastered on the inside. Waller urged that the windows be filled with painted glass 'continuing the series begun with the Evans memorial window.' The chapter house was covered in limewash. The floor was of oak, carried on sleepers resting on the original tiled floor 'which is in some parts very perfect'. The windows at the west end are 'fitted up with modern wood mullions'; the glazing in all of the windows was very bad. Waller proposed removing the wooden mullions, reinstating stone mullions and removing the floor and reinstating a tiled floor to match the old.

The room above the eastern slype (choir vestry) has two 'very ugly windows, and a modern brick chimney spoiling the view from the new garden'. Waller proposed they be removed and others 'in character with the building' be inserted. He proposed the room be altered 'to provide good vestries for the use of the canons and minor canons together with a room for muniments.' The roof of the room above, the school room (library), was very bad. The windows on the north and south sides should be opened and reglazed; and the door opened to give access from the cloisters via the stone staircase at the west end.

WALLER'S PRINCIPLES OF RESTORATION

F.S. Waller was the first architect to the Dean and Chapter to formulate principles for the restoration of the building. At the beginning of the 1855 report he stated that the

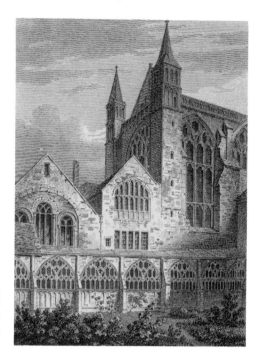

The great cloister, J. Storer, 1814. The garden before being laid out as at present, the blocked lower lights of the windows, and note the steep pitched roof of the east cloister walk adjoining the chapter house

general principle in restoration work should be '. . . to retain in all cases as much as possible of the old work, restoring only where actually perished . . . to take all precautions to prevent further decay in the external stonework by carrying the water from the building.' Yet, he argued, contemporary liturgical needs had to be taken into consideration in restoration and reordering. He wanted to 'keep the choir as at present as regards all the old work, with one or two exceptions . . . in order to more thoroughly adapt it to the requirement of the present day.' But '. . . all matters really misplaced in the cathedral should be removed,' whereas 'all chapels, monuments and other interesting portions should be cleaned and put in order, without any attempt at restoration of features . . . to leave them as well cared for but beautiful remains and architectural reminiscances of bygone ages.' Apart from leaving unresolved the tension between the preservation of certain ancient features and the need possibly to remove them to accommodate modern liturgical practice, his underlying 'principles for restoration' accord remarkably well with present day conservation policy.

Waller's 'one or two exceptions . . .' with regard to the restoration of the choir, would have destroyed 'the medieval arrangement'. He wanted to restore the monks' stalls to their original condition, but he also wanted to remove the return stalls and the screen to open up the choir to the nave. In this instance Waller proposed a far more sweeping solution than would now be considered acceptable. To open up the choir to the nave would have been tantamount to destroying the medieval choir.

With the support of G. Gilbert Scott, he proposed the removal of the surviving medieval tiles between the choir stalls and in the presbytery, and the laying down of a new pavement using tiles of the same patterns and roughly the same arrangement. The remaining medieval tiles were to be preserved by being used to restore and complete the

pavement in the *sacrarium*. The remainder were carefully laid in the south-east chapel of the tribune gallery together with a miscellaneous collection of other tiles from different parts of the building. This in fact proved a sensible solution to a difficult conservation problem. Much the same solution was applied to the fragments of medieval stained glass which had survived in many of the windows in the cathedral. Though many fragments were undoubtedly lost when Victorian stained glass firms filled practically all the windows with new glass, some fragments were left or leaded up in the cusping, and other fragments were used in the restoration of the great east window and the lady chapel east window. Waller's practice was to restore medieval stained glass or tile pavements if there was sufficient medieval material around the building to do so, and then to preserve remaining fragments of tiles or glass in some appropriate place.

WALLER'S RESTORATION 1855–1865

In the second phase of restoration (1855–65), the Dean and Chapter instructed Waller to begin to implement some of the recommendations in his 1855 report. When the College School moved out of the old monastic library into their new school room on the north side of the chapter house, the Dean and Chapter decided to restore the old school room, renewing the roof (1556–7) 'preserving as much of the old timber as was found to be

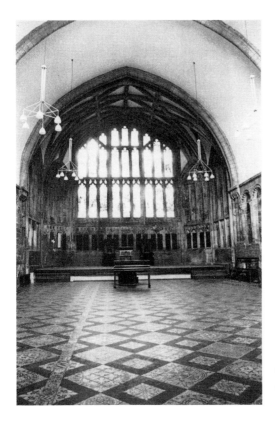

The chapter house looking east, with the tile floor as laid down by F.S. Waller (pendant lighting is of a later date)

sound' and laying a new oak floor. The windows on the north and south sides had already been opened, the staircase from the east walk of the cloisters was repaired and a new doorway opened. New oak doors were made for all three doors into the library, book cases removed from the old library and refitted in the new room, and five new bookcases made. The Old Library was then restored (1856–8) to become a chapter house once more. It was entirely reroofed with new timber and tiles, and the external stonework repaired. The limewashed walls were cleaned, and the shields and names in Lombardic script of some of the abbey's early benefactors in the wall arcading were again revealed. The vault was replastered and stonework renewed as necessary. The seventeenth-century wooden floor was taken up and an encaustic tile floor of 'exactly similar description to what remained of the old tile floor both as to patterns and levels' laid on a solid concrete foundation. A buttress had to be built at the north-east corner to prevent further settlement.

The Great West Window

In January 1858 the Chapter accepted the offer of Canon Thomas Murray Browne to fill the west window of the nave with stained glass as a memorial to the late Dr James Henry Monk, bishop of Gloucester 1830–56 (and bishop of the united see of Gloucester and Bristol from 1836). Ten years earlier a writer noted that the window 'was once ornated with painted glass which was probably reduced to its present imperfect state during the interregnum' (the Commonwealth). There were fragments of medieval glass at the top of the window, and a few fragments scattered among the much patched plain glass in the rest of the window. Canon T. Murray Browne's donation was so generous that the

Dr J.H. Monk, Bishop of Gloucester 1830–56

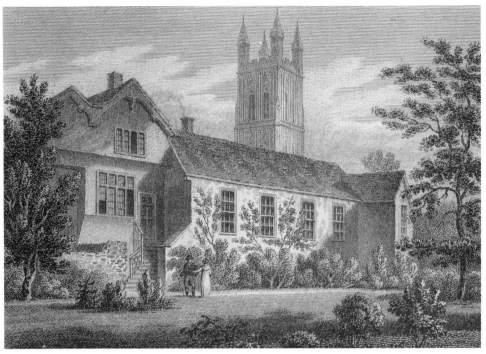

The bishop's palace. J. Storer, 1815

Chapter decided to waive its usual requirement, and instructed the treasurer (Dr Jeune) to provide funds for the restoration of the stonework and a wire lattice for the window to protect the glass. The commission was given to the Newcastle firm of William Wailes (1859).[4]

The theme of the window was the Nativity of Christ and the Doctrine of Baptism. In the tracery lights there are six crowns and below these fourteen angels, eight playing musical instruments. In the lights above the upper transom, three occasions of baptism recorded in the *Acts of the Apostles* are depicted, each scene occupying three lights: the Baptisms of Paul, Cornelius and the Jailor of Philippi. Above the lower transom in the central three lights is the Nativity scene, and on the left the Angels appearing to the Shepherds, and on the right the Magi adoring the infant Jesus. No transom divides these scenes from those above, which depict, from left to right, the Presentation in the Temple, the Baptism of Jesus and John the Baptist preaching by the River Jordan. Below the lower transom, are 'types' of baptism from the Old Testament: Noah after the Flood, the Israelites after passing through the Red Sea and Naaman washing himself in the Jordan. (On the nineteenth-century glass throughout the cathedral, see Appendix X.)

The Great East Window

In 1860, on the advice of the architect F.S. Waller and the stained glass restorer, Charles Winston, the Chapter decided to restore the great medieval window at the other end of

Alterations and restoration of the deanery (Church House) in 1863

the building. Writers in the early part of the nineteenth century describe the glass as being so blackened with polution that it was barely possible to make out its general outline, yet alone any detail. The leading was much decayed and the whole structure extremely fragile. 'This magnificent window still retains stained glass, but in so decayed a condition that it has been aptly described as resembling, in its present state, the tissue of a carpet.' (Power's *Illustrated Handbook of Gloucester* 1848). The chapter entrusted the restoration to Charles Winston who left a detailed account of his work in *The Great East Window of Gloucester Cathedral*.[5] He stated that he personally had supervised the restoration and had succeeded in persuading the Dean and Chapter to preserve the historical veracity of the glass by undertaking a straightforward re-leading. Thus even though the figure of St Clement in the apex and the Madonna and Child among the angels were recognized as fifteenth-century insertions, Winston left them alone. 'The archaeological inquirer has therefore precisely the same means of investigation now as he would have had before the present repairs.'

When the glass was removed in 1861 it was estimated to amount to 2,000 ft, and to weigh, with the lead, 35 cwt. Waller reported that, on removing it, 'a large portion of the stone work of the window was found to be much decayed and so defective as to render it necessary to introduce a larger portion of new stonework than had been at first contemplated. Great care was taken to preserve as much of the old stonework as possible, but the mullions and tracery of the compartments on the south side had to be

replaced with new work.' The parapet and pinnacles were also replaced. By mid-summer 1862 all the new stonework had been completed and cleaned down ready to receive the restored glass. Before the end of 1862 Messrs Ward and Hughes had reinstated the glass and the restoration of the great east window was complete.

Although Winston's words about 'the historical veracity of the glass' were undoubtedly true in 1863 when he and his colleague, Henry Hughes, had completed their task, unfortunately it is not true today. At the end of the Second World War there was another major restoration of the glass, this time carried out by Wallace Beck of Cheltenham. As Kerr points out 'comparison between the excellent photographs taken by Sydney Pitcher before the war and the present state of the glass [1981] reveal that Beck was an exponent of the type of "tidying up" restoration Winston castigated so fluently in his account of the glass.' Beck removed many interpolated fifteenth-century fragments and pieces of unrecorded inscription which may well have originally belonged at the base of the unidentified figures, and he also made up missing areas of figures from carefully chosen fifteenth-century fragments which read as areas of drapery from a distance.

A story is told of Professor Willis when he visited Gloucester for the meeting of the Archaeological Institute in 1860. Walking around the cathedral with members of the Institute after his lecture, he pointed to the way the stained glass of the great east window was carried down the face of the wall over the entrance of the lady chapel. But it was 'pointed out to the learned professor that it had been done by one of the vergers about thirty years ago, and that the only tool used in the painting was a common brush.' Professor Willis frankly admitted that he had mistaken it for an 'ingenious device of medieval times to feign a light where there was none and to create uniformity.'

At the same time other minor works and improvements were being carried out in various parts of the cathedral. In 1859 one of the buttresses of the south aisle of the nave, the second from the east end, was restored; all the ball-flower decoration having been eroded by wind and rain. A figure was placed in the restored niche. 'It is to be hoped that before long funds will be available to complete the series, and to restore this southern aspect of the nave to its medieval splendour.' A fine brass lectern, described as 'a spirited piece of Victorian craftsmanship' was given to the cathedral in 1863. It stands in the presbytery. It is an early design of J.F. Bentley and was made by Hart & Son. It was shown at the 1862 Exhibition in London.

In January 1863, Dr Henry Law became dean, but before he could live at the deanery extensive work had to be carried out. This included restoring old features, taking down the octagon tower containing the staircase and rebuilding it from the foundations, and the provision of a new domestic wing. It was in 1862 that Waller met with a riding accident and was severely injured. His senior partner, Thomas Fulljames, took over as architect but he had to retire at the end of 1865. The vacant post was offered to George Gilbert Scott. The nave having been transformed in the previous ten years (1858–67), there was talk of restoring the choir. The Dean and Chapter looked again at Waller's 1855 report, and consulted their new architect. A restoration fund was immediately set up, and detailed plans were made for a major restoration and reordering of the choir.

CHAPTER TWENTY-TWO

THE VICTORIAN RESTORATION – II
1867–1905

*'Others may have soared to loftier flights or produced special works
of more commanding power; but no name within the last thirty years has
been sowidely impressed on the edificies of Great Britain, past and
present, as that of Sir Gilbert Scott'*
Dean Stanley at Scott's funeral, Westminister Abbey, 1878

When George Gilbert Scott (1811–78) was appointed architect to the Dean and Chapter
of Gloucester he had been working on cathedral restorations for more than twenty years.
He worked on the restoration of Ely Cathedral in the mid-1840s and was appointed
architect to Westminister Abbey in 1849. With such prestigious commissions he found
himself in constant demand in other cathedrals and parish churches. Though he greatly
admired Pugin's work, Scott was far more practical, even mercenary, in his approach.
He wrote of himself:

> I am no mediaevalist, I do not advocate the styles of the middle ages as such. If we had a distinctive
> architecture of our own day worthy of the greatness of our age, I should be content to follow it; but we
> have not. The middle ages having been the lastest period which possessed a style of its own . . . I
> strongly hold that it has greater prima facie claims to be used as the nucleus of our developments than
> those of ancient Greece or Rome.

But though Scott was very much part of the Gothic Revival, as a son of a low church
parson his sympathies were never with the more excessive demands of the Camden
Society. As Kenneth Clark observed, in his essay on *The Gothic Revival*, 'Scott learnt the
importance of ecclesiology' and as a result 'his churches were faultless in arrangement.'[1]

At the same time as working on the restoration of cathedrals and parish churches,
Scott was heavily involved in designing secular buildings, such as St Pancras station,
and monuments including the Albert Memorial. In his *Personal and Professional
Recollections* (1879) published after his death he reflected on his work in some of the
39 cathedrals and ministers, 476 churches, 25 schools, 26 public buildings, 25 colleges

Sir George Gilbert Scott

or college chapels and on 58 monumental works which he had restored or designed. Of course, Scott had and still has his critics. It is said he was 'ruthless and insensitive' though Scott himself claimed he was often conservative in his judgements. At the time of his death many pointed out that he had frequently 'waived ecclesiological propriety on account of an object's age and beauty.' Scott, however, was concerned with restoration not conservation; that is, making things as they were, and not leaving things as they are. In making things as they were he had to use his judgement, but this was informed by years of careful observation and research. Thus, at Gloucester, in designing a new canopy for the choir sedilia he took into consideration not only what the fragmentary remains of the sedilia told him, but the style of the period and all available historical and archaeological evidence.

SCOTT'S RESTORATION OF THE CHOIR

Scott had been consulted in 1855 about Waller's proposals including his plans for the restoration of the choir. After ten years a fresh look at the problems produced one of Gilbert Scott's more successful programmes of restoration and refurnishing. He set out his proposals in a report to the Dean and Chapter in April 1867, and published in the *Gloucestershire Chronicle* on 20 April 1867. He knew of Waller's proposal to remove the choir screen and return stalls and open up the choir to the nave, removing the organ to the north gallery, but he argued this would be 'inappropriate'. 'The ancient stone screen has given place to two generations of modern successors, but the stalls of the days of the

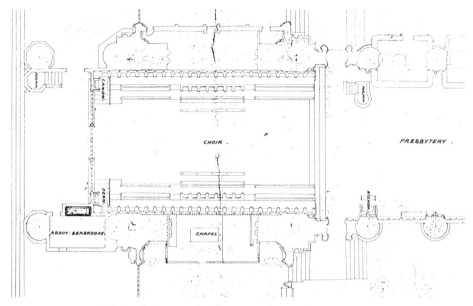

F.S. Waller's 1855 plan for the reordering of the choir

old monastery remain intact. I should then feel little compunction at removing the stone screen, but much at tampering with the historical arrangement of the choir and its stalls.' He does, however, concede that 'if the panels were removed from the back of the returned stalls, and an open screen substituted for the present obstructive one, the Services would be well heard and fairly seen by persons in the nave.' If this were done, the organ should be placed under the north, not the south, crossing arch.

The seating in the choir was 'out of character' with the monastic stalls and should be replaced 'with new fittings agreeable in character with the stalls.' The plain screen behind the high altar, which was attached to the outer feretory wall, should be taken away, and the feretory restored with a new reredos set forward of the outer wall. 'The ancient and beautiful sedilia have been sadly mutilated. These should be restored to as close an approach to their original form as can be arrived at.' The tile pavement was as fine a medieval pavement as he had seen, and should be carefully preserved. But in the rest of the presbytery and choir he was 'disposed to make use of a pavement consisting of both marble and encaustic tiles.' As to the vault 'a moderate amount of colour in the ceiling will do more than almost anything to add that warmth of effect which the choir so much needs.'

Outside the choir, he felt the lady chapel was the next priority. The whitewash should be removed from the walls and vault with the utmost care, for he was certain ancient decorative painting would be found beneath it. He was 'disposed to think that the reredos should be left as a speciment of ancient art, without any attempt at its restoration.' He noted that 'there are in this chapel ancient stall seats, partly ancient and partly of the 17th century. I would advocate as little alteration as possible. Every care should be taken to preserve every fragment of ancient work of whatever date.' The windows required reglazing, and he urged the Dean and Chapter to consider giving the

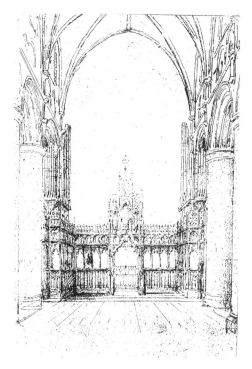

Sketch for a choir screen based on Waller's proposed rearrangement of the return stall. Undated and unsigned

commission to Hardman of Birmingham. He had never seen windows, with some medieval glass, 'more beautifully or more expertly restored than those recently done by Hardman in the nave.'

Scott's recommendations were accepted by the Chapter, and an appeal for funds was launched. Various firms, mainly of Scott's choice, were asked to prepare designs for the restoration of the woodwork of the choir, the tiling of the floor, the carving of the reredos and so on.

The Clerestory Windows and Vault

Plans were already in hand to scaffold the north clerestory windows (1867–8), and to repair stonework and ferementa in preparation for new stained glass which was to be supplied by Clayton and Bell. This was not part of Scott's proposals for the choir. He preferred the glass in the south clerestory windows which Hardman had put in in 1865–6. But in the north clerestory windows there had been 'sufficient old painted glass to show that the original design consisted of figures in niches in the lower lights with flowered quarries, patterns and borders in the upper lights' (Waller). Winston had suggested (1863) that the fragments of royal figures in the Great East Window and in the east window of the lady chapel might have come originally from the clerestory windows in the presbytery. The figures are altogether out of place and out of proportion in their present position, but would fit well into the larger lights of the clerestory windows. Although there were fragments of medieval glass preserved in the tracery of

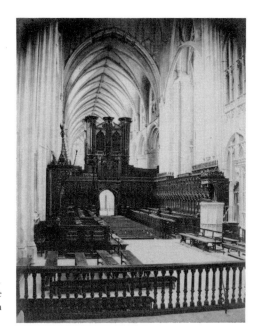

The choir, looking west (1865), before the G. Gilbert Scott reordering and refurnishing. The pinnacles on the organ towers had already been removed

the clerestory windows no attempt was made to reproduce the impressive array of royal figures in niches. Instead, set against alternating blue and red backgrounds, Clayton and Bell put twenty figures from the New Testament.[2]

More than one firm was approached for advice on the painting and gilding of the vault. When the limewash was removed no trace of medieval painting could be found. Scott, in the style of Victorian restorations, still recommended that the vault be polychromed. With no pattern to follow, the design could be no more than an informed guess and at worst a pure Victorian invention. In March 1870 the design and quotation of Clayton and Bell, at a total cost of £557, were accepted and the work proceeded. The firm was instructed to carry out the work 'in tones sympathetic with the glazing'. One of the painters involved inscribed his name on the flying span beneath the north crossing arch: 'A Bivand, painter signed 1870'. Reaction to the work was mixed. A contemporary writer noted that 'some critics contend that the effect has been, as at Lichfield, to lower considerably the apparent height of the building, while others maintain that the appearance of the vaulting has been relieved, warmed, and altogether improved.'[3] But when the vault becomes even more faded and shabby than it is at present it is to be hoped the paint work will be removed, and the stone of the intricate and lofty lierne vault once again exposed to view.

The Tile Pavement

Scott turned to the Godwins of Lugwardine, near Hereford, to tile the floor of the choir.[4] William and his younger brother Henry began making so-called encaustic tiles at Lugwardine in 1852. Between them they had sufficient knowledge of the chemistry

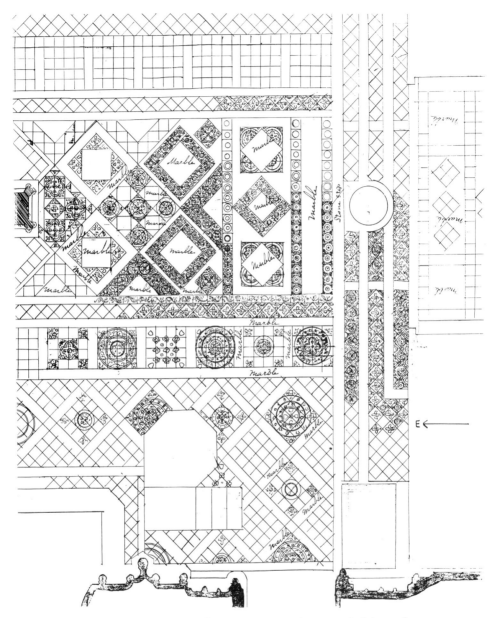

G. Gilbert Scott's sketches for the pavement at the west end of the presbytery

involved in handling and firing clays, artistic skills to design and copy tiles, and commercial acumen to make their business a success. They advertised and displayed their wares widely, and by 1857 they were making such good tiles that Scott used them in the restoration of Hereford Cathedral. By 1868 they were able to advertise their tiles as: 'Patronised by Her Majesty. Encaustic and Tessarae Tiles . . . including a large number carefully imitated from the best Ancient Examples. More than 300 Churches have been paved with these Tiles . . .' At Gloucester, Scott commissioned them to pave the entire choir (with the exception of the *sacrarium*) with copies of medieval tiles found around the high altar and elsewhere in the building. The tiles in the *sacrarium* had a narrow escape in the mid-eighteenth century when it was proposed to pave the presbytery with marble. Scott now completed the Seabroke pavement with spare tiles from the presbytery floor and elsewhere, and added a further step up to the high altar, paving the area around the altar with Godwins' reproductions. (See Appendix V.)

The Godwins were obviously proud of their tiles and of the success of their business. In William Godwin's obituary in the *Hereford Times*, 25 August 1883 it was stated '. . . he was able to say at the finish of the laying of the tile pavement in Gloucester Cathedral, "I made and carried, navigated and unloaded many of the bricks that were used to build the early warehouses in Gloucester docks and now I have completed the tiling in the choir of this noble cathedral".' But Masse, writing in 1899, expressed the reaction of many to the new paving:

New tiles, ostensibly copied from the old ones, but of a different size, with an excessive glaze, and very stiff design and execution have been put down. It is hard to judge what the effect of the tiles would have been, as it has been quite killed by the while marble which has been mixed with them. The glaring white marble in the floor of the presbytery has been inlaid with biblical scenes filled in with

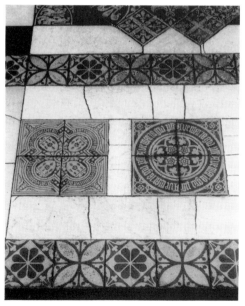 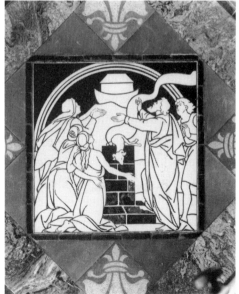

Godwins of Lugwardine tiles and one of G. Gilbert Scott's sgraffito scenes

black cement. It is possible from the triforium to get a general idea of the crudity and tastelessness of the pavement, which is so composed and arranged that time – the softener of all things – can never make it look appreciably better.[5]

Scott himself probably designed the black and white sgraffito scenes which are considered by many to be extremely fine and of a very high quality.

The Choir Stalls

Messrs Farmer and Brindley were responsible for making, at a cost of £2,775, the new oak choir stalls, including a new seat for the mayor and a bishop's throne. The superbly carved ends and finials of the stalls are varied and full of interest. At the same time, the monastic stalls and the misereres were repaired. New oak was spliced into the seats, into backs, arms, standards, and the misereres or misericords and carved as necessary. Since the new wood still lacks the patina of the medieval work the extent of the repairs can be seen. The stalls must have been in a very decayed and precarious state. All the misericords were made to lift on iron hinges which necessitated the replacement of the cross members at the back of the seats. Fourteen new misereres were carved to complete the series. As noted earlier, Tracey has pointed out a curious feature of the repair work:

> The seating was thoroughly but well restored by Gilbert Scott, and in every case a piece of new wood had been let into the standards below the arm rest. This tends to give the impression that the standards have been deepened, but this is not so because otherwise the panel at the bottom with its inset trefoil would be correspondingly narrower. It is admittedly difficult to envisage the problem that necessitated this particular method of repair.[6]

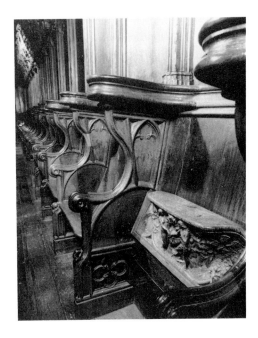

The medieval choir stalls, extensively restored *c* 1870

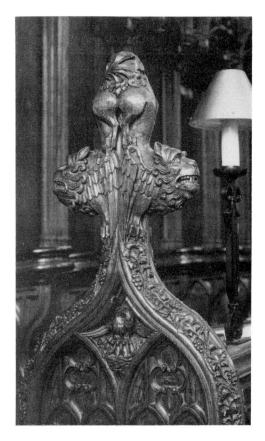

G. Gilbert Scott's stalls for the choir: detail of
carving

The Reredos and Sculptures

In March 1871 Scott's design for the reredos was accepted and J.F. Redfern, who had
just completed figures for the restored south porch, was commissioned to carve groups
and figures for the main niches. James Frank Redfern (1838–76), one of the most gifted
English sculptors of his day, particularly of religious subjects, was born and brought up
at Hartington in Derbyshire. As a boy he showed a taste for art by carving and
modelling from the woodcuts of illustrated papers. At the suggestion of the Vicar of
Hartington, he modelled in alabaster a group which included a warrior and a horse. This
was brought to the notice of A.J. Beresford-Hope, on whose estate Redfern was born.
Hope arranged for him to study in Paris for six months. His first work exhibited at the
Royal Academy, *Cain and Abel*, attracted the notice of J.H. Foley. Redfern exhibited a
Holy Family in 1861, and *The Good Samaritan* in 1863, and other sculptures almost every
year for the rest of his life. These were, at first, chiefly of a religious character, and
afterwards portrait statues. His larger works were principally designed for Gothic
church decoration. He executed sixty statues on the west front of Salisbury Cathedral,
statues of the Apostles at Ely, in the Chapter House at Westminster *Our Lord in Majesty*,
and at Gloucester, among other works, the three groups of figures in the reredos. He
died at the age of thirty-eight 'in the midst of a promising career.'[7]

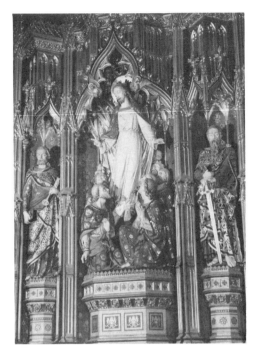

High altar reredos; central group depicting the
Ascension, with St Peter and St Paul

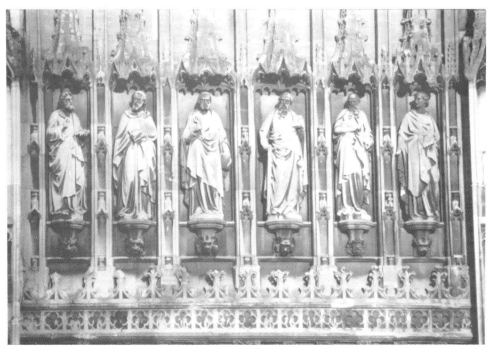

Figures by J.F. Redfern (1870) over the south porch entrance

Dr Charles John Ellicott, Bishop of Gloucester and
Bristol 1863–97, and after the separation of the See
from Bristol, Bishop of Gloucester 1897–1905

The seven main recesses of the reredos, filled alternately with figures and carved groups, are surmounted with elaborate canopies, and above these are three pierced pinnacles filled with statuettes of angels. The central pinnacle has a cross as the final. The central group of the reredos is a boldly carved representation of the Ascension. From left to right, on the extreme left is Moses with the tablets of the law, and then a beautiful group depicting the Nativity, with St Peter holding the keys of the Kingdom of God in the niche alongside. On the right of the central group is St Paul, and then a most sensitively carved group depicting the Entombment. In the outside niche on the right is David with his harp. St Peter (1.3 m (51 in) high) is carved from Painswick stone, and the other figures and groups from a neighbouring quarry at Cooper's Hill. The nine angels in the canopy are carrying the emblems of the Passion, the cup, crown of thorns, scourge and pillar, hammer and nails, reed and sponge, dice and coat, spear and ladder, and in the centre the cross. The architectural part of the reredos was executed by Messrs Farmer and Brindley. The reredos is 5.5 m (18 ft) wide, and 8.2 m (27 ft) high from floor to topmost finial. The architectural detail, the ogee arches and trifoil cusping, the canopy work and decorative buttresses set on the angle, owes much to the fourteenth-century work all around the choir, and in particular to the canopy over the tomb of Edward II. The reredos cost £1,400 and was the gift of the Freemasons of the Province of Gloucestershire. It was unveiled on 5 June 1873 in presence of Lord Sherborne, Grand Master, and Dr C.H. Ellicott (Bishop of Gloucester 1863–1905). At the time it was in natural stone, without any colour or gilding. Clayton and Bell polychromed the architectural work of the reredos in 1888, but the Redfern sculptures were left as they were, in natural stone.

The Restored Sedilia and New Font

In September 1872, Scott, now Sir Gilbert, asked Redfern to produce twelve small figures to enrich the canopy of the sedilia, which he had designed. The old canopy had been entirely removed, so there was little for Scott to go on. In fact there were only the footings of the main shafts of the canopy and traces of medieval colour on the panels behind the seats. Redfern's figures represent Abbot Edric, Bishops Wulstan and Aldred, and Abbots Serlo, Foliot, Thokey, Wygmore, Horton, Froucester, Morwent, Seabroke and Hanley. Over the canopy three angels sit playing on a tambour and trumpets. The rod and entwined ribbon with TO are supposed to refer to Thomas Osborne, Sheriff of Gloucester, 1512–22 and mayor in 1526. Scott's design for new communion rails and a new altar table were also accepted. A credence table was added in 1881. The lectern had been given earlier, in 1866, by Mr J. Coucher Dent of Sudeley Castle.

By the end of 1873 the restoration was nearly complete. In its arrangement and furnishings the choir had been transformed. A few years earlier it was still a rather shabby relic of early Georgian days. It was now restored and refurnished in a style which was homogeneous and not entirely unsympathic to the medieval setting. Not so

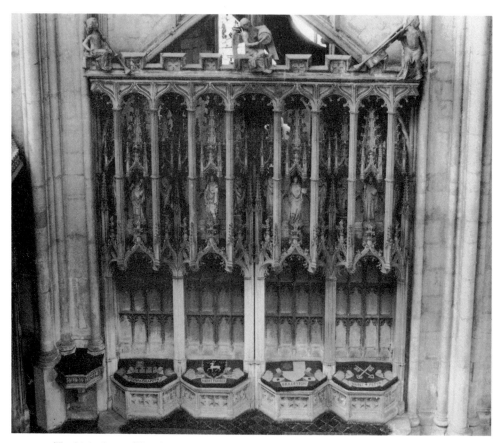

The high altar sedilia; the canopy was largely reconstructed by G. Gilbert Scott, 1872

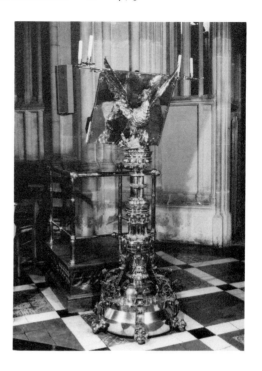

The choir lectern (1861), an early work of J.F.
Bentley (1839–1902)

sympathetic to its setting was the massive font Scott designed, which was set on the site of the old Consistory Court at the west end of the south aisle of the nave as a memorial to Mr William Gibbs of Tyntesfield. Dedicated by Bishop Ellicott on Easter Sunday 1878, the font was made by Messrs Farmer and Brindley of London from Inverness granite at a cost of £800. It was richly carved in low relief and highly polished. Although the design of the font was Norman in character, the granite did not harmonize with the limestone of the nave, so that after standing for many years at the west end of the nave, it was moved to the crypt. There it remains awaiting a move to another church which could provide it with a more suitable setting, or to a permanent exhibition of Scott's work.

F.S. Waller Takes Over Again 1873

In June 1872 Ashbee had resigned as Clerk of Works, and F.S. Waller was appointed 'Supervisor of Works, his duties to be the same as those previously fulfilled by Mr Ashbee.' In September of that year he purchased the lease of 18/19 College Green in order to continue and develop his architectural practice. From the spring of 1873 Waller was again presenting his annual report to the Dean and Chapter, but it was not transcribed into the *Chapter Act Book* until he was appointed 'Resident Architect', after the death of Sir Gilbert Scott in March 1878. While helping to supervise Scott's restoration of the choir, Waller was also carrying out stone repairs and drainage improvements around the building. One of his first tasks, after Scott had pulled out,

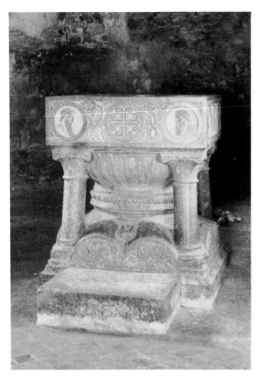

G. Gilbert Scott's font, 1872

was to opened a doorway from the east walk of the cloister into the *locutorium* or eastern slype (1874).

From his office in College Green, Waller was responsible for far more than the fabric of the cathedral and the maintenance of the houses in the precincts. He dealt with all matters affecting the 'chancels' of Dean and Chapter livings and other property owned by the Chapter in Gloucester. Waller saw to the payment of wages, bills for gas, coal and coke, and directed the day-to-day work of the gardeners and other employees, as well as the masons and carpenters. He saw to the ordering of materials and equipment, and closely supervized the work in the maintenance yard. Until the mid-1850s it was usual to erect a shed, as in medieval times, near the site of whatever work was in progress. There was also a shed, mostly for storage, permanently sited against the wall of the north ambulatory. But the shed was removed *c.* 1850, and a yard was rented in Pitt Street, at £10 pa. Here all materials were stored, stone banked and carpentry work carried out.

AFTER SIR GILBERT SCOTT'S RESTORATION

The final phase of the Victorian restoration of the cathedral (1878–1905) was carried out under the direction of F.S. Waller, assisted in the last years by his son, F.W. Waller, with J.L. Pearson, the London architect, advising on the restoration of the lady chapel in 1892, and again in 1895.

Sep 27. 1871

Estimates for Font. Pulpit. Altar Table
& Litany Desk. for
Gloucester Cathedral
G. F. Scott Esq R.A. Architect

Altar Table. Pip. Marmol £ 300 0 0

Pulpit. including Steps and
Metal Rail. (Pip. Marmol,) £ 400 0 0

Litany Desk £ 100 0 0

Font. 1 Serpentine with all Steps £ 650 0 0

Do. Hard Cumberland Alabastr 300 0 0

Farmer and Brindley's estimate for font, pulpit, etc

Financial Difficulties

The pinnacles, parapet and cornice of the tower were repaired in 1878–81, using Minchinhampton stone, at a cost of £3,447. But by November 1881 work was so slack that Waller proposed to the Chapter that 'since the work on the cathedral was so much diminished his salary as Architect should be reduced to £60 per annum.' His suggestion was accepted, and in 1891 his salary was reduced still further to a 'retainer' of £21 pa. The reduction in work was due largely to financial difficulties. By 1887 the financial position was such that the Dean and Chapter had to impose a 10 per cent reduction in salary on the minor canons, organist, lay clerks, bedesmen and organ blower. In 1893, Canon Tinling, the treasurer, was asked to reduce expenditure still further. The full salaries of the minor canons and others were not restored until 1896.

This meant that from 1881 until the late 1890s, very little restoration work was carried out, however urgent. The stonework of windows was renewed for the insertion of new stained glass, but this was paid for by the donors of the glass. After the rediscovery of an old 'water tank', 'reservoir' or 'drain' in the north-west corner of the cloister garth, a quantity of soil was removed from the garth, and a garden was laid out (1887). Trees were removed, gravel paths and turf laid down and flower beds made along the cloister wall. The garth, which was still primarily the dean's garden, took on the appearance it has today. St Anthony's Chapel beneath the north crossing arch was made into a vestry for the dean, and curtains were fixed across the dean and vice-dean's stalls to exclude the draught.

In 1889 the large west window of the south transept (S X) was filled with glass by Clayton and Bell, in memory of Thomas Gambier Parry (1816–88) of Highnam, near Gloucester. He was widely acknowledged as an authority on stained glass and on other forms of art and design. Hence the subjects treated in the window: Abbot Seabroke, discussing the construction of the tower with a group of masons; St Barbara, whose prayers in medieval times were sought for protection against thunderstorms and fire, a

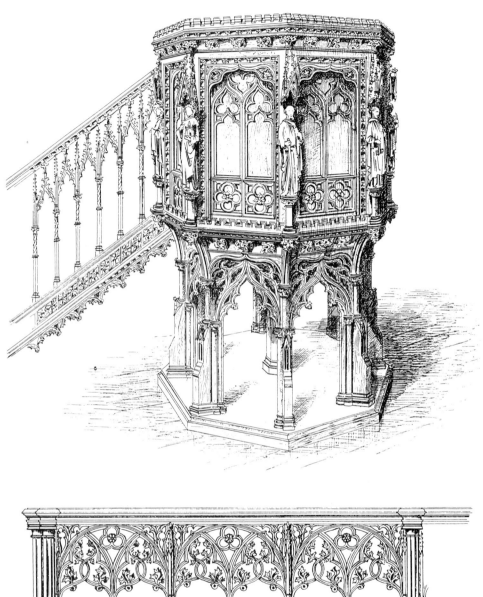

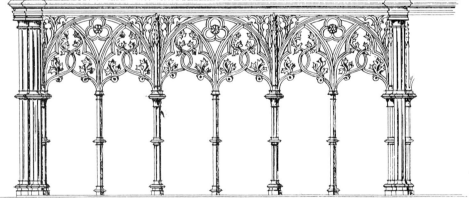

G. Gilbert Scott's design for a pulpit (compare with that at Salisbury) and altar rail, neither of which were accepted

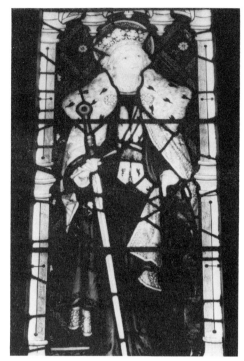

In loving memory of the
aged 87 years. Christ is All
being dead yet speaketh.

Detail of Kempe glass in the ambulatory

constant hazard in buildings works; St Luke, who according to early tradition was a
sculptor and painter; and Fra Angelica, the master of the Florentine school. He had
bought the estate at Highnam in 1838 and lived there for the rest of his life. He built a
church on the estate (1848–51), dedicated to the Holy Innocents in memory of his
children who died in infancy, and painted its interior. His murals were carried out in
spirit fresco, instead of water fresco, which was his own invention. He also painted the
walls and vault of the east chapel in the south transept of the cathedral (1866–8). He was
working on another piece for the cathedral when he died. 'The last of the angelic figures,
forming part of a composition which he was painting for Gloucester Cathedral was only
completed on the day of his death' (DNB).

The Kempe Windows

During the ten years from 1878 the masons were again mainly employed on repairing
the stone work of windows in preparation for new stained glass, particularly in the choir
ambulatory. The ambulatory windows, donated between 1887 and 1892, are the work
of C.E. Kempe.[8] Kempe belonged to a well-to-do Sussex family. His mother's father,
Sir Charles Eamer, had been Lord Mayor of London. After his education at Rugby and
Pembroke College, Oxford, he had to give up thoughts of ordination because of a speech
impediment. He was deeply influenced by the Tractarians, and decided that if he could
not 'minister in the sanctuary he could use his gifts in the adornment of the sanctuary.'

He studied architecture with G.F. Bodley, and served an apprenticeship with Clayton & Bell in the making of stained glass. It was while he was with this firm that he made a window for the north aisle of the nave (n vii), a bequest of his aunt, Mrs Claxson (1865). In 1868 Kempe opened his own studio, and developed his own very distinctive style. Business expanded and he eventually employed a large staff, at one time as many as seventy. With the growing popularity of his work, particularly in High Church circles and with the nobility and, later, the Royal family, he could do no more than sketch out what he wanted, and leave the detailed drawing to one of his senior draughtsmen, such as John W. Lisle (1870–1927).

Kempe's biographer, Margaret Stavridi, has drawn out the principles which guided the work of this most fashionable of Victorian stained-glass artists. Stained glass windows should have affinity with the architecture of the building; they should not disturb worship by dramatic passion in drawing or colour; their intention should be to adorn and teach, and not to be an exhibition of an artist's individual talent. Of his style, Stavridi comments: 'though distinctive it was never quite original, but always influenced by the glass of northern Europe of the 15th century.' Yet Professor Owen Chadwick has stated that, in his judgement, 'the art of stained glass attained its Victorian zenith, not with the aesthetic innovations of William Morris or Edward Burne-Jones, but in the Tractarian artist Charles Eamer Kempe.' Apart from the beautiful series of windows in the ambulatory, Kempe also supplied a small window, drawn by John W. Lisle, in the north chantry window of the lady chapel (1885), and the

Sketch by F.S. Waller (1856) of the north end of College Street

large memorial window to William Philip Price, MP in the north transept (1894). The draughtsman for this window was a skilled craftsman and fine artist who for many years was Kempe's chief glass-painter, A.E. Tombleson. Kempe often signed his windows with a wheatsheaf, from the ancient Kemp family arms, but in this instance Kempe allowed Tombleson to add his own initials in a shield in the tracery. (See plate 29.)

The Widening of College Street

In 1883, Andrew Knowles of Newent Court, Highnam, the High Sheriff of the County, drew attention to 'the inadequacy of the approach to the cathedral' from College Street. A public meeting in 1890 called for the setting up of a company to 'widen and improve the approach'. It was commented that 'many strangers who come to Gloucester for the express purpose of visiting the cathedral were surprised to find so very sordid a bye-way should lead to so noble a structure.' On 5 April 1890 the *Gloucestershire Chronicle* commented that at the Music Festival crowds 'from all parts of the world poured into the cathedral through its only two narrow passages from Westgate Street.' Mainly through the 'enterprise, foresight and generosity' of Mr Knowles in purchasing property for demolition on the east side of College Street it was now possible to plan for the widening of the street, and the construction of a more worthy approach to the cathedral.

The Dean and Chapter gave their support to the proposal but only on certain conditions. These were that 5 College Green, a house facing the Green on the east side of College Street, which would have to be demolished, 'be reconstructed and put into tenantable order by the promoters of the scheme to Mr Waller's satisfaction.' The

Way into Lower College Street, from Westgate Street *c.* 1890, before the road was widened

Sketch of Lower College Street by F.S. Waller
(1897)

chapter also insisted 'that the lighting of the College precincts be undertaken by the Corporation, and that College Green be not allowed to become a thoroughfare for carts, carriages, or other vehicles.' The revised scheme, in its entirety, was to be 'submitted to them and approved by them.' Other objections on detail were raised, but the Dean and Chapter eventually backed the plan and the scheme went ahead.

THE RESTORATION OF THE LADY CHAPEL 1892–1903

The financial position of the cathedral began to improve with the appointment, in September 1889, of J.W. Sheringham as Archdeacon of Gloucester and Residentiary Canon. Largely through his exertions funds were raised which enabled the Dean and Chapter to plan a further programme of restoration, including the urgent task of rescuing the lady chapel from ruin. As Secretary of the Appeal Fund, launched at the end of 1891, he set out to raise £6,000. Priority was to be given to repairing the roofs 'east of the tower'. But after six years he had raised over £9,000, much of it given specifically for the restoration of the lady chapel.

Sheringham noted that 'the lady chapel has been shut up, as almost ruinous, for nearly 20 years.' One writer described the condition of the building more dramatically. 'In 1873 the lady chapel was finally closed for any divine service. The rain poured through the broken roof, the wind drove through the beautiful stonework in which the vast windows were set and through the ill-arranged common glass. It had become almost a ruin, and was finally completely shut off from the choir to keep out the cold draughts of air which chilled the main building.' There were 'shattered mullions and ruined transoms' and 'the dust and dirt of years of neglect.' According to Sheringham the stonework of the windows 'was so decayed that it broke in pieces to the touch.' The leading and glass of the windows let in the rain which fell on to the floor in puddles. The glass was in danger of falling out, so nets were hung to catch the pieces.

It was decided to call in John L. Pearson, the London architect, to advise on the restoration. But even before Pearson presented his first report (1892) a stained glass window, by Kempe, had been put into the east window of the north chantry, and a window on the south side (S IV), containing fragments of medieval glass, had been

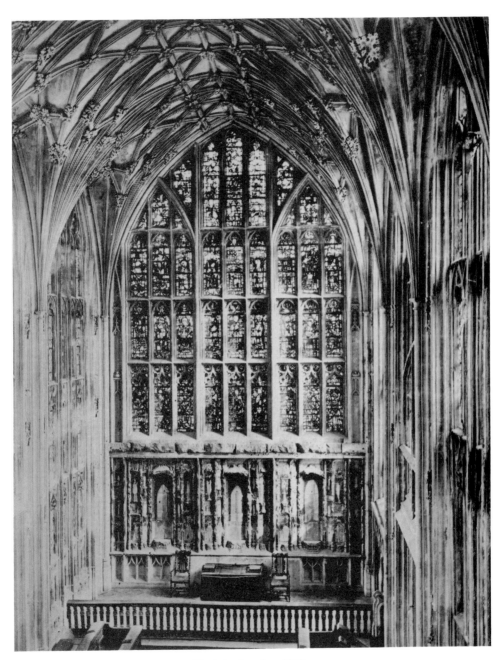

The lady chapel, c. 1870,

The lady chapel, looking west, after it was boarded
up (1880)

taken out and was being restored by C.H. Dancey (1892).[9] But little was done until
Pearson's second report (1895) in which he recommended that work on the parapet at
the east end of the lady chapel, which was already in hand, should proceed; and that the
roof should be repaired and releaded. The vault and interior walls were to be cleaned, all
limewash removed and the floor relaid. The work on the parapet and roof was
completed, and the floor relaid by 1897. 'Some of the coffins were within a few inches of
the surface of the floor. It was found necessary to remove the old flooring and lay down a
bed of concrete over the whole, and then the memorial stone slabs and ancient tiles were
replaced *in situ*.' The Chapter agreed 'to the screen at the west end being filled with plate
glass and an oak door made.' This work was not carried out, but just a hundred years
after it was first agreed in Chapter, it is now being done. The Powell statue was 'to
remain for the time being'. After the structural work had been completed on the roof,
parapets, walls and floor, the lady chapel was reopened on St Michael's Day 1897.

But what was to be done about the reglazing of the windows? The Dean and Chapter
had been discussing the matter for several years. It was decided that the Dean, Dr H.D.
Spence (1886–1917) with Canon Bazeley and William St John Hope, Secretary of the
Society of Antiquaries, should approach Christopher Whall and invite him to submit
sketched designs for the two windows in the vestibule.[10] On the basis of these sketches
he was commissioned 'to reglaze the windows of the lady chapel excluding the windows
in the sanctuary.' Whall, by this time, was one of the acknowledged leaders of the Arts
and Crafts Movement. Since exhibiting two windows, *Fire* and *Water* at the Arts and
Crafts Exhibition in the autumn of 1888, he had enjoyed a high reputation for original
and inventive work. He was not content to be part of the 'production-like' approach of

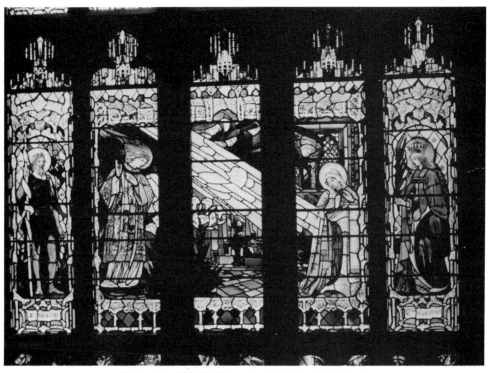

Christopher Whall's 'Annunciation' in the lady chapel

so many of the Victorian glazing firms. As he explained in his book, *Stained Glass Work* (1905), he wanted to be involved personally in every stage of the production of his windows. He favoured the new Prior's Early English glass, a slab glass with a subtlety of hue and texture, combined with a brilliance and wide range of colour. Peter Cormack, an authority on Whall's glass, describes how he 'chose every piece of glass to be used and supervised each stage of the craft process.'

Whall, in describing the iconography of the lady chapel windows, explained that his general conception was 'the dignity to which Human Nature has been raised by the Incarnation of Christ through the Virgin Mary.' The subject of the windows in the vestibule are, on the north side, the Fall and Expulsion from Paradise, and on the south side, the Restoration in the Sacrament of the Eucharist. Each of the large windows in the body of the chapel follows a similar plan. In the light at the top of the windows is an archangel, and in some cases, carefully arranged, fragments of medieval glass. In this way most of the fragments surviving in the lady chapel windows were preserved. In the top tier of five lights are one or more of the nine angel choirs. In the main tier, below the angels, an incident in the story of the Incarnation is depicted, occupying one or more lights in the centre of the window, flanked by figures of appropriate saints. The Annunciation on the north side (N IV) and the Nativity on the south side (S IV) are exceptionally fine. Below are figures of British saints, northern saints on the north side and southern saints on the south side. In the large window on the north side of the *sacrarium* (N II) there are saints from biblical history, and in the bottom of the window

miniatures of incidents connected with the Incarnation (1909). After Whall's death in 1924 his daughter Veronica, an accomplished stained glass artist who, like his son, Christopher, had worked with her father for many years, designed a delightful window, above the south gallery, in his memory (S III). The cherub on the extreme right is depicted kneeling, painting on the quarry. Cormack, with every justification, has said that the Whall windows in Gloucester's lady chapel 'are arguably the finest post-medieval stained glass in any of our cathedrals.' By 1905 the restoration of the lady chapel was completed, apart from the insertion of some small windows in the south chantry chapels and the need for further refurnishing.

Though Whall prepared a cartoon for the window on the south side of the *sacrarium* (S II) which fitted into his iconographical scheme, he was unable to make and insert the window because in 1898 the dean had allowed the family of Sir Joseph Lee of Ross in Herefordshire to insert a window of their own choice in this position *in memoriam*. It is by Heaton, Butler and Bayne, and is an appalling example of late-Victorian trade glass, its sickly tones clashing terribly with the brilliance of the Whall windows and the medieval glass in the east window. The heads of angels in the top tier, and of figures from the Gospels in the lower tier, are from photographs of members of the Lee family, as are also the five cherubs at the foot of the window. What possible justification could be found for allowing an album of family photographs to adorn a lady chapel it is hard to imagine. Sir Joseph was a financier, one of the original partners of the clothiers Tootal, Fowler and Lee, known later as Tootal.

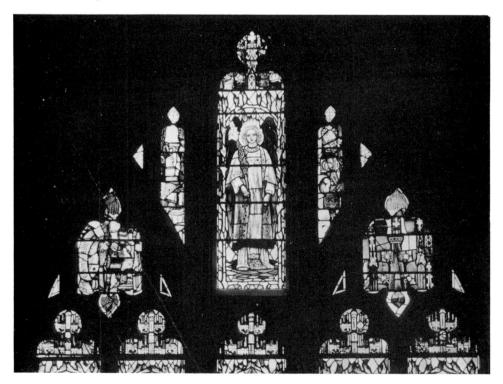

Design detail by Christopher Whall, with fragments of medieval glass in tracery

Other Enrichments

In 1896 the north walk of the cloister was restored, at a cost of £526, by the Freemasons of Gloucestershire, during the time that Sir Michael Hicks Beach was Grand Master. Sir Michael (1837–1916) devoted much of his life to politics and was twice Chancellor of the Exchequer. The terminal window in the north transept, by Hardman (1876), was given in his memory, by the family. At the east end of the north walk the small windows below the transoms, which were blocked up, were curiously restored. The Baron de Ferrieres, grandson of a Napoleonic general, who lived at Cheltenham from 1860 until his death forty-eight years later gave the glass in these five bays and, later, Whall's Annunciation window (N IV) in the lady chapel (1899).

In 1905 Dr Charles John Ellicott died, after the longest episcopate in the history of the diocese. He had been bishop of the united See of Bristol and Gloucester since 1863, and of Gloucester from 1 January 1898 when the two sees were separated. Ellicott was appointed bishop by Palmerston on Lord Shaftesbury's advice because of his share in answering *Essays and Reviews*. In 1868 Disraeli wished to appoint him to Canterbury. Bishop Ellicott was chairman of the New Testament Revision Committee. Frederick Sandon Waller, architect to the Dean and Chapter for so many years, also died in 1905, having handed over his responsibilties to his son. He had done more for the restoration and conservation of the cathedral than anyone else in the long history of the building.

THE CATHEDRAL IN PEACE AND WAR
1905–1952

*'The great cathedrals are probably the Church
of England's most valuable
surviving public asset*
Adrian Hastings, A History of English Christianity, 1987

Adrian Hastings in his *History of English Christianity 1920–1985* sums up the position of the Church of England at the turn of the century:

> The apparent institutional and pastoral well-being of all the main churches continued well into the Edwardian age. The Church of England itself was still advancing in clerical numbers and, even more, clerical efficiency; the theological colleges, quite recently founded, were just beginning to dint the general impression of gentlemanly amateurishness which characterized the Anglican priest. Anglo-Catholics, in particular, equipped with an army of curates were demonstrating in some big town parishes an extremely disciplined pastoral professionalism. There was Portsea, the dockyard Portsmouth parish where Cosmo Lang and then Cyril Garbett presides over a dozen or more unmarried, very poorly paid, ever busy curates; or St Mary's, Bramall Lane, Sheffield, where from 1893 R.H. Hammond was vicar for many years. He had a Bible class of 270 women, and one for up to 700 men, 145 open-air services a year, 135 teachers in his Sunday schools, while his Watch-Night service could pack the church with over 2,500 people. Parishes of this sort were not uncommon around 1900.[1]

Statistics suggest, however, that the mid-Victorian boom was over and that in many parts of the country a heavy decline had already set in. During the early decades of the twentieth century the Church of England, together with all the main-stream churches, had to come to terms with declining influence and membership. Two world wars had increased social mobility, and rapid developments in technology loosened the hold of tradition. The Church felt the need to adapt itself to a rapidly changing world, particularly after the trauma of the First World War. Reforms initiated in the 1920s included the setting up of the Church Assembly in which the bishops consulted with elected laymen and women, who formed the House of Laity, and the clerical members of

Dr Arthur Caley Headlam, Bishop of Gloucester
1923–45

the ancient Convocations of Canterbury and York, who formed a House of Clergy. In 1927–8 a conservative revision of the *Book of Common Prayer* (1662) was put forward, but though approved by the Church Assembly it was rejected by parliament. It was therefore 'not-legal'; nevertheless, the book was widely used before and after the Second World War.

Before the First World War there was a growing concern for Christian unity. This arose from the churches' involvement in evangelistic and missionary activity abroad as much as from any consideration of self-preservation at home. The circumstances and convictions which had led to the break up of the Church in England into well-established denominations seemed totally irrelevant and indeed a hindrance in the missionary work of the Church overseas. The churches' common experience of ministering to the men and women of the armed forces during the First World War, the increasing secularization of society after the war and the decline in the numbers attending Sunday worship were all factors which led the churches to question the grounds for their continuing separation. Yet the unity of all Christians in witness and worship was not a matter of pragmatism, but of principle. Christians recalled that Christ had prayed that his followers 'may be one that the world may believe.' It was this conviction that led to the emergence of the ecumenical movement, in which Dr A.C. Headlam (Bishop of Gloucester 1923–45) played a leading part, and led to the creation in 1948 of the World Council of Churches.

CHANGES AFFECTING CATHEDRAL CHAPTERS

Changes had also taken place over the years in the constitution of cathedral chapters and in their ways of working. The changes began with the appointment in 1835 of the Ecclesiastical Commission. From 1835 until 1948 the Commissioners managed the estates and revenues of the Church. This meant that from the late 1830s cathedral chapters no longer managed their own estates and no longer relied on them, directly, for their stipends. Most retained a certain amount of property, including the houses around the cathedral close, the revenue from which paid the cathedral staff and any surplus was usually devoted to the repair and maintenance of the properties and the cathedral itself. But with the rising cost of maintaining, adapting and modernizing domestic property this asset became at times a liability, leaving the chapter with very little to spend on the fabric of the cathedral. In these circumstances any major restoration depended entirely upon the response of the public to periodic appeals.

With the country distracted by war and faced with economic depression, the early decades of the twentieth century was no time to launch major appeals. The result was that few cathedrals embarked on ambitious schemes of restoration until after the Second World War. There were notable exceptions, but Gloucester was not one of them. There were, however, other than economic reasons for the low level of restoration work, particularly during the inter-war years. In the second half of the nineteenth century there had been widespread interest in the cathedrals as ancient buildings, with learned societies such as the Society of Antiquaries of London, and local societies such as the

Precinct properties: Nos 7 & 8 College Green *c.* 1900

Gloucester Cathedral Society (1882–97) and the Bristol and Gloucester Archaeological Society constantly focusing attention on them through visits, seminars and published papers. All this brought pressure on cathedral authorities and surrounded them with enthusiasts for stained glass, medieval tiles, mural paintings and every conceivable aspect of the architecture and furnishings of ancient buildings. It also provided them with a growing body of professional and expert advice. For various reasons there was nothing like the same intensity of interest in the earlier years of this century.

As Tatton-Brown has pointed out, the beginning of the twentieth century saw the first phase in architectural and archaeological investigation of the cathedrals drawing to an end.[2] Francis Bond published his *Gothic Architecture in England* in 1905, and Dr John Bilson later carried out valuable work on the vaults of Durham Cathedral and on the elevations and architectural history of Wells, but the First World War marked the end of almost all cathedral archaeology for half a century. In the inter-war years, Sir Alfred Clapham published his two volumes on *English Romanesque Architecture* in 1930 and 1934, and Professor A. Hamilton Thompson his *Cathedral Churches of England* in 1925. D. Knoop and G.P. Jones, drew attention to the crucial importance of the medieval master mason in their study of *The Medieval Mason: an Economic History of English Stone Building in the Later Middle Ages* (1933), and Dr John Harvey in 1954 published his invaluable *English Medieval Architects: A Biographical Dictionary down to 1550*. Important though these works were, and still are, for the study of medieval buildings, they represent a modest output compared with the volume of research and writing in the second half of the nineteenth century.

There may have been another reason for this comparative lack of interest in cathedral architecture and archaeology after the First World War. The Ancient Monument Act of 1913 for the first time exempted 'cathedrals and churches in use' from its provisions of ancient ruined buildings statutory protection. Tatton-Brown considered 'the exemption of cathedrals . . . from its stipulations meant that deans and chapters could carry on as before in a closed world from which most archaeologists felt excluded.' But this was not always so, and in any case if ever deans and chapters lived in a 'closed world' it was in the second half of the nineteenth century when antiquarians and gentlemen-archaeologists gathered round cathedrals, like bees around a honey pot, and cathedral clergy were often involved with them, encouraging their interest and research. In the case of Gloucester, the records of the *Gloucester Cathedral Society* and the *Transactions of the Bristol and Gloucester Archaeological Society* during these years are sufficient proof of this. The truth is, after F.W. Waller's restoration work before the First World War, there was not only a shortage of funds, but little stimulus from the academic world or pressure from antiquarian societies to carry out further restoration or excavations. Happily the situation was to change later on, when the cathedrals once again provided subjects for research for architectural historians and a major focus of interest for archaeologists, such as Martin and Birthe Biddle at Winchester (1962–9).

F.W. WALLER'S REPORT AND RESTORATION WORK 1905–1920

Back in 1905 the cathedral community at Gloucester suffered a double loss in the deaths, first of the architect F.S. Waller, who had been involved with the conservation

Frederick William Waller 1846–1933, architect to the Dean and Chapter of Gloucester

Noel Huxley Waller 1881–1961, architect to the Dean and Chapter of Gloucester

and restoration of the cathedral for more than fifty years; and then of the diocesan bishop, Dr Charles John Ellicott, bishop of Gloucester for forty-two years. On the occasion of the bishop's retirement earlier in 1905, the dean, Dr H.D.M. Spence-Jones had written to him on behalf of the Chapter in the most appreciative and affectionate terms. He died on 15 October 1905 at the age of eighty-six and was buried at Birchington-on-Sea. His memorial in the cathedral remembers 'his blameless life and his wise administration' and refers to his work as a biblical scholar, of 'his fruitful study of the Scriptures and his able guidance of the company of divines and scholars who in 1880 completed the revised version of the New Testament'. The bishop had requested that 'a simple recumbant form in stone should be placed somewhere in the cathedral, preferably on the south side of the choir more eastward than the recumbant figure already there, and similar in support and structure.' The Chapter felt unable to agree to this particular wish, but a fine memorial was erected (1909) in the south ambulatory of the choir, the work of W.S. Frith, a well-known and gifted local sculptor.

Following the death of F.S. Waller, the repair of the cathedral continued at first under the direction of his son, F.W. Waller, appointed Resident Architect in July 1905, and then of his grandson, Noel Waller. As a commemorative plaque in the south walk of the cloister records 'from 1847–1960 the fabric of this Cathedral received the skilled and devoted care of three members of one family of architects.' F.W. Waller presented a report to the Dean and Chapter in the autumn of 1905 detailing the repairs which needed to be carried out without delay.[3] These included completing current work on the pinnacles at the west end of the nave (1905), taking down and rebuilding in new stone the conical roof of the south-west turret of the south transept (1906), repairing panelling in the west walk of the cloister (1906–7) and the stonework and releading of the clerestory windows on the north side of the nave. Waller stressed the damage being done to the stonework by the gas jets used for lighting the nave, and the very bad condition of the timbers and lead of the nave roof, the south aisle roof and the tower roof. Rain was

constantly coming through. He expressed particular concern about the condition of the tower roof. Waller presented sectional drawings and plans, and explained the need to calculate wind pressures and measure the effect on the fifteenth-century structure of ringing the bells. Photographs had been taken of the arches of the louvred openings and of external cracks. It was clear F.W. Waller's approach to the restoration of the building was not to be so archaeological as his father's had been, but with advances in architectural methods and in the materials available, more technical and scientific.

The Restoration of the Tower 1907–1911

As in the nineteenth century, restoration work during the twentieth century has been preceeded by an architect's reports and followed by appeals for the necessary funds. Thus, after F.W. Waller's report in 1905 an appeal, headed by the Earl of Ducie, enabled work to start in 1907, on a major restoration of the central tower. The programme of work was wound up during the First World War with substantial repairs to the vaults and windows of the choir and presbytery.

Scaffolding, still consisting of wooden poles lashed together which had to be moved from one face of the tower to another as the work progressed, was put up and work began on the south face (1907). Anxiety about possible settlement at the south-east angle of the tower, led to the external flying buttress being taken down, and rebuilt to an increased width (1908). After scaffolding the south-west angle, Waller reported that the 'flying arch was not affected, and there was no evidence of continued settlement' on that side (1909). Work on the tower continued until 1911 by which time the restoration of the north face was completed. At the same time in the choir casements were fitted to the

The King's School mustered on the tower scaffolding, 1908

clerestory windows on the south side in order to improve ventillation. These windows had just been glazed with glass supplied by Messrs Powell of Whitefriars (1907–8). In the cloister a course of asphalt was introduced to stop damp rising up the wall of the north walk (1907), and in the east walk the buttress opposite the eastern slype was taken down and rebuilt (1911). Edward VII visited the cathedral on Wednesday 23 June 1909 to inspect the progress of the work. He signed the Chapter Act Book, and was shown around by the bishop, Dr E. Gibson, and the dean, Dr H. Spence-Jones.

The Work of Henry Wilson, Art Nouveau Designer 1864–1934.

Additional windows by Christopher Whall were inserted in the years leading up to the First World War. These included the South African War Memorial window in the chapter house (1905), the Monk memorial window in the lady chapel (N II 1910) and the Dorington window (N III 1913). The clock on the west wall of the north transept, which had been given in memory of the Revd Bartholomew Price, a notable astronomer, Canon of Gloucester and Master of Pembroke College, Oxford, had given continuous trouble since its installation in 1903. But in 1910 it was attached by means of copper rods with universal joints to the clock in the tower. This solved the problem for a while, but it was not until 1916 that the canon's son handed the clock over to the Dean and Chapter satisfied that it 'had worked well for the past five years.' The clock face, designed by Henry Wilson, whose work reflects the influence of the Art Nouveau movement, is somewhat unusual. The hours are represented by bronze medallions depicting the signs of the zodiac, and the centre piece shows a woman standing in front of a gateway, crowned and with a nimbus. There is also a helmeted man wearing a short tunic and sandals holding a spear or lance in his left hand. The woman seems to be restraining him from using it. On the gateway are the words *PORTA MORTIS JANOA COELI.* Wilson also designed the striking memorial to Canon E.D. Tinling, who died in 1897, on the wall beside the Machen memorial in the north aisle of the nave, a memorial tablet, in brass and marble, in the south transept to Canon Evan Evans, who died in

Henry Wilson's clock face, in the north transept, 1905

The Tinling Chalice, designed by Henry Wilson
c. 1900

1891 and a chalice *c.* 1900, in memory of Canon Tinling, of a most unusual design, in silver, parcel gilt, enamel, niello and semi-precious stones.

The Installation of Electricity

When it was proposed to introduce electric lighting in the nave (1907) the Chapter agreed rather reluctantly and on 'the strict understanding that no charge whatever should be made in the event of the Dean and Chapter not using any power.' Apart from concern about the cost of installation and use, it seems some members of the Chapter had genuine fears about its effects. Notwithstanding, electric cables were brought into the cathedral in 1910, and the lights were switched on the following year much to the delight of the architect who had warned the Chapter, as his father had done in 1872, of the damage being done to the stonework of the building by the gas jets, and the danger to the staff involved in lighting them. The gas lighters had to make their circuitous way up to the triforium and lean out to light each of the jets. F.S. Waller reported in 1872 that he was so concerned that he had been in touch with 'the Patentee of a new process of lighting by galvanism which is said to be about to be introduced on a large scale in Berlin.' In the meantime he had removed 'all the burners except those opposite the openings in the triforium.' With the installation of electric lamps, the nave vault and walls were cleaned down, using 'only soap and water and scrubbing brushes' (1911). While the scaffolding was up all gas piping and fittings were removed, and the bases of the pillars of the triforium, where they had been cut away to take the gas piping, were made good. The stonework and glazing of the clerestory windows was also repaired (1912), and defective stonework in the Early English vault renewed.

In 1912 Waller drew the Chapter's attention to the ruinous condition of St Mary's Gateway and the property adjoining it on the south side. The Ecclesiastical Commissioners were asked for a loan to help meet the cost of restoration. At the same time, the masons were hard at work in the north transept. The tracery of the windows

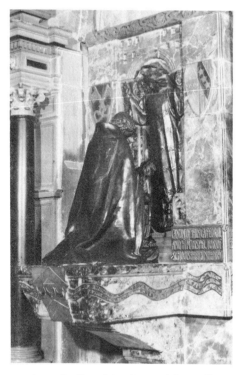

Henry Wilson's memorial to Canon E.D. Tinling

was 'very bad' and in the vaulting 'ribs were loose and groins detached from the arches'. A number of the bosses were loose 'being fixed after the groining was in place; they were not worked out of the solid stone forming the junction of the ribs.' Dr Oscar Clarke was given permission to photograph the bosses of the nave and north transept (1913).[4] The scaffolding was then moved into the choir, where similar work was carried out in 1913 and 1914. Cracks were found 'extending down the whole length of the choir, varying from 1 in to $1\frac{1}{2}$ in in width; numerous pieces of groin were loose, and filler used in the colouring of the vault was coming away; in places the openings were such that the timber of the roof above could be seen through the groining.' The work was completed by the end of 1914. Electric lighting was installed in the choir in 1914, at a cost of £250, the gift of the Revd J.E. Symons. A Chubb strong room was built in 1913 and the fire hydrants were installed in 1914.

CATHEDRAL LIFE DURING THE FIRST WORLD WAR 1914–1918

In 1914 it was reported that the 1906 appeal had raised nearly £10,000. But with the outbreak of the First World War it was clear that very little would now be added to this as there were other more pressing calls on people's generosity. Accordingly, repair work was scaled down. Yet there are surprisingly few references to the war in the Chapter Act Book. Outwardly the war seems to have affected the cathedral and its precincts very little. On 26 September 1914 the Chapter ordered that 'No motor vehicles of any description shall be allowed to remain for any lengthy period in the Green.' On 8 June

Repairs to St Mary's Gate interior (Photograph by
Sydney A. Pitcher)

the following year 'The Chapter Clerk was instructed to inform the owners of motor
charabancs in the surrounding district who were in the habit of bringing parties to visit
the cathedral and to warn them that heavy traffic in the College Green is forbidden.' One
of the houses (13 College Green) was used, from September 1915, as a 'War Hospital
Supply Depot.' In February 1916 the Chapter congratulated their architect, on the
award of the Military Cross to his son, Major Noel Huxley Waller.

The Tinling Memorial chalice was lent to an exhibition in Paris, on the understand-
ing that it was to be kept 'in vaults in the Louvre during the present "emergency"' and
only sent back when 'the situation improved'. One of the minor
canons, the Revd Percy Rowlands, enlisted in the North Somerset Imperial Yeomanry
much to the consternation of the Chapter. The Archbishop of Canterbury had written in
the *Guardian* on 10 September 1914 that 'the position of an actual combatant in our
Army is incompatible with the position of one who has sought and received Holy
Orders.' However, this was not the reason for the Chapter's annoyance which was due
mainly to the inconvenience caused by a reduction in the number of minor canons from
three to two. When the matter of paying the arrears of Rowland's meagre stipend was
raised one of the canons, the Master of Pembroke, strongly objected on the grounds that
'the fellow didn't deserve it after treating the Chapter with so little respect and
consideration'

Services were held from time to time for battalions of the Gloucestershire Regiment,
and to mark various national occasions. The daily services continued, though in 1915
the dean wondered what could be done to make 'Cathedral Matins less of an unreality
than it is at present.' From March 1917 matins on weekdays was said and not sung, but

Regimental colours laid up in the north ambulatory

this was to be for the duration of the war only. Even so, two members of the Chapter objected strongly and refused to vote in order to register their disapproval. The Chapter also considered how provision could be made for 'private devotions' in the cathedral, and decided that the only provision that could be made was to 'rope off space between the font and the west wall', that is in the south-west corner of the nave, by the main entrance. If anyone asked for a quieter place the verger was to 'take them to St Andrew's Chapel'. Access to the transepts and to the east end of the building had been restricted for some years. Iron railings had been placed across the entrances to the transepts so that visitors were confined to the nave. The public was not always allowed into the great cloister since the garth was still the deanery garden.

In the autumn of 1915 the Chapter considered the possibility of 'damage by aircraft.' They were particularly anxious about the electric lighting in the nave and what might happen in the event of an air raid. Nave services were discontinued. The possible dangers were brought home to the Chapter by a Zeppelin raid on the night of 3 January 1916. They were advised to reduce immediately the number of precinct lights and not to have any lights on in the cathedral at night. In March 1916 the Chapter asked HM Office of Works for advice about protecting the tomb of Edward II, whose responsibility it would be to restore it if it were damaged. The Office of Works admitted that they had 'repaired the tomb in 1875/6', but they now disclaimed all responsibility

for it. It was up to the Dean and Chapter to protect the tomb. Consequently the architect was instructed to surround it with a wooden cradle and a thousand or more sandbags, and to removed the effigy of Robert of Normandy to the crypt and to protect that with sandbags as well. The Master of Pembroke thought all this was 'futile and ridiculous; if there were an explosion in the choir it would cause more damage to the great east window than anything else.' Waller had advised the Chapter that there was no practical way of protecting the medieval glass.

Some repair work continued through the war years, even though from September 1915 there was a reduction in the maintenance staff. Work on the windows and vault in the choir went on through the autumn of 1914 and the spring of 1915. The great east window was inspected from scaffold erected on the inside and out, and many rusty iron bars and cracked mullions were repaired. This work was completed by June 1915. Attention was then concentrated on the vault over the crossing. It was proposed to examine the vault from a cradle lowered through the bell-hole in order to avoid erecting scaffold. A consultant engineer, J. Fielding, was brought in to advise on the stability of the vault and the tower, but he concluded there were 'no further indications of movement' (1915).

In 1907 it had been reported that St Mary's Gateway was in a worse and more dangerous condition than had been anticipated'. Traffic through the gateway had to be restricted as the vault was supported by wooden poles. Little was done, however, until September 1916 when Waller persuaded the Chapter that 'the gateway was a most interesting structure and worthy of careful study and conservative preservation.' In November work began on the adjoining house, Waller reporting that 'the foundations of an older building have been laid bare on the south side of the gateway; this building was not on the same line as the present one but at a rather different angle.' It was discovered that the building rested 'on fine running sand 5 ft [1.5 m] deep, and then on a bed of gravel 4 ft [1.2 m] deep which rested on blue clay.' To secure new foundations it would be necessary to go down at least 10 ft (3 m). In spite of the war, underpinning work was carried out in the spring of 1917. 'The south-west pier carrying the great arch towards St Mary's Gateway was securely "pinned up".' The superstructure of the house was then largely rebuilt, leaving the actual gateway still in need of major reconstruction. In 1918 the Ecclesiastical Commissioners were approached for a further grant (they had already given £500) towards the restoration of the gateway itself.

On 2 November 1917 the dean, Dr H.D.M. Spence-Jones, died suddenly after thirty one years in office. He was born and was appointed to the deanery in the name of Spence, but from 1904 he assumed his wife's surname and arms in accordance with the provisions of a family will, so that thereafter he was always known as Spence-Jones. He was at Gloucester through years of momentous change (1886–1917). His love of the city and its cathedral shows through in his books, notably the *Dean's Handbook to Gloucester Cathedral* (1913). Dr Henry Gee succeeded him as dean in January 1918.

Later that year the First World War came to an end. Adrian Hastings reflects that the war:

> . . . was entered into almost with disbelief, quickly transformed into a transient crusading euphoria, but its lasting mood had been one of grim endurance, of the most senseless carnage, mounting hatred of the enemy,an almost complete incomprehension as to what it was all about. In intention it was the

last of the old wars of dynastic Europe, a cavalry war between emperors and old-fashioned patriotism with some new techniques thrown in for good measure. In fact it was an infantry and conscript war, a mechanized war, a total war involving the systematic destruction of human life by the million and smashing the political structures that had produced it and hoped to feed on it.[5]

THE INTER-WAR YEARS 1918–1939

Dr Henry Gee presided over the Chapter during the inter-war years. Immediately after the war the Chapter was mainly concerned with putting precinct properties in order and little was done by way of repairs, yet alone planned restoration, to the cathedral itself. The Chapter minutes are taken up with domestic matters: such as where the anthracite required for the three Gurney stoves should be stored. These stoves provided the first form of heating the building had ever known. They had been installed in the 1860s and continued in use until 1971, when they were converted to oil. The Chapter also noted that the Tinling chalice had been returned from the Louvre in Paris in February 1919. A year or two later the Chapter declined to loan it to a London exhibition as it had been 'away for too long already.' But other more important matters were causing the Chapter concern during the post-war years, not least the future of the King's School. The school was under threat because of new legislation requiring improved buildings and a broader curriculum.[6] (See Appendix 11.)

The war memorial in the Lower Green, 1925: detail of bas relief by Adrian Jones. After service as an army veterinary surgeon, in his retirement from 1882, modelled horses (see other reliefs on the monument) and exhibited at the Royal Academy in 1883

There was a long drawn out discussion with the city corporation and the Gloucestershire Hussars about erecting a war memorial. The first proposal (1919) was that the memorial should be erected at the west end of the north aisle in the position occupied by the Trye monument. But the Gloucestershire Hussars wanted to erect a memorial in the form of a cross with bas relief beneath it in the 'old churchyard'. Discussion of this proposal continued well into 1922. Meanwhile, the Gloucestershire Freemasons asked if they could erect a memorial in the north walk of the cloisters, which they had helped to restore some years earlier. The city authorities then requested permission to erect a memorial with all the names of Gloucester's dead on it 'somewhere in the cathedral'. The Dean and Chapter offered the porch, but after further discussion the idea was dropped (March 1923). While these negotiations were going on the Chapter issued *Rules for Memorials in the Cathedral and Precincts* (1920). The Chapter restated the principle that useful commemorative gifts were more welcome than memorial plaques. Even so they found it hard to refuse permission for at least some memorial tablets to be erected, such as the beautifully designed and executed plaque to Sir Hubert Parry, the composer (1920), and a commemorative tablet placed on the wall of the south walk of the cloister to Bishop Jeune and his son, Chancellor Jeune (1920).

The architect, N.H. Waller, now reported regularly to the Chapter, his report being typed and added to the Chapter minutes from 1921. But he repeatedly began with the words 'Nothing of importance to report . . .'; or, as in 1923, 'The usual routine work has been done in connection with the building, leaks being stopped in the leadwork and other small matters of a like kind . . .' In the margin of his report he recorded the decisions of the Chapter which, between 1918 and 1925, was almost invariably 'Work not to be done at once but considered further' or 'Decided to do nothing at present.' The reason why the Chapter so often decided to do nothing was that it had no money. In 1922 there was less than £600 in the Restoration Fund. Nevertheless, the roofs of the chapter house and library were retiled (1922–3), and repairs were later carried out on the pinnacles and buttresses of the south aisle of the nave (1924–5).[7]

Gradually, however, as the situation improved after the war, and before the Depression and General Strike hit the country, other work was undertaken as a result of specific donations. This included the insertion of the Wilton memorial window (in the north walk of the cloister) by H. Dearle of W. Morris & Co. of Merton Abbey (1923–4), and the erection of new stone altars in the north-east (1924) and south-east (1925) ambulatory chapels. An examination of the transverse arch in the crypt below the north-east chapel, which would have to support the weight of the new altar, revealed that it was 'only 9 in [22 cm] thick at its apex and was constructed of thin rough stones interspersed . . . with Roman tiles.' It was therefore necessary to take up part of the tile pavement in the chapels and insert two light steel girders about 7 ft (2.1 m) long in the thickness of the floor above the arch. This meant, in the case of the north-east chapel, laying ferre-concrete, about 4 in (10 cm) thick, over the sanctuary area and relaying the tile floor. The altar slab was made to rest on the existing corbels below the reredos, and the supporting colonettes were set into the tile pavement.

Much of the work was put out to contract between 1918 and 1924 because of the lack of masons on the maintenance staff. Even when it was decided to engage extra masons (1924) action was halted for a while. 'It has been thought better not to increase the cathedral staff until the dispute in the building trade has been dealt with as there is at

present a great deal of trouble not only here but in various districts in consequence of the strike.' The General Strike of 1926 was looming. However, with a legacy from Sir William Marling of £1,000, masons were taken on and for a year or two restoration work was resumed on St Mary's Gateway and on the roofs of the cathedral. St Mary's Gateway was again surveyed (1926) and estimates obtained. Messrs Thompson of Peterborough were brought in (1927) to secure the foundations of the medieval structure, at one stage 'injecting 34 more cwts of cement into the foundations at new points.' The west side of the gateway was treated first, and then the east side was shored up and repaired by the cathedral's own maintenance staff (1928–30).

While this work was in progress, there was a scare about the damage being caused by death-watch beetles to the roofs of ancient buildings. All the roofs of the cathedral were immediately examined and the extent of the damage was found to be considerable. The timbers were treated (1926–7), but it was clear that this would only postpone the day when all the roofs would have to be reconstructed. Throughout the 1930s repairs to the tracery of windows in various parts of the building, fractured by the corrosion of iron bars, continued. In the south walk of the cloisters and stonework of eight of the carrel windows was renewed, and the west and east buttresses were repaired (1931). Work resumed for a while in 1932 on St Mary's Gateway, in the east wall, gable and chimney, but between 1933 and 1936 attention was diverted to the choir. Here urgent work was needed to repair defective stonework in and around the windows, including the great east window (1935). Similar work was carried out in the south transept (1936), the lady chapel (1937) and the nave (1938), with some minor repairs to the external stonework. The impression given by the Chapter minutes and architect's reports is that the maintenance work of the 1930s was a 'holding operation', moving from one site to another wherever the repairs were most urgent. There was no planned restoration programme and no public appeal for funds.

In 1936 an organization known as The Friends of Gloucester Cathedral was formed, publishing its first report in 1937. Over the years the 'Friends' have contributed many thousands of pounds for the furnishings and enrichment of the cathedral, and towards the restoration of the fabric. Every year the 'Friends' Festival' on St Peter's Day (29 June) has focused attention on the cathedral and its needs. Groups of members have done valuable work in designing and working vestments, kneelers and hangings, while others have been involved in arranging flowers and welcoming visitors. But there was little time between the formation of the organization and the outbreak of the Second World War for it to make any major contribution towards restoring the fabric. Each 'Friends' Day' Mr Waller expressed his anxiety about the roofs, particularly the south transept, nave and choir roofs, but nothing was done. Yet, substantial donations were being received and growing enthusiasm augured well for the future.

Dr Harold Costley-White succeeded Dr Gee as dean in 1938, and Colonel N.H. Waller gradually took over from his father as architect to the Dean and Chapter. He stressed the urgency of doing something about the tower roof. 'The main beam supporting the roof, a single oak beam 38 ft 3 ins long, by 17 ins deep and 13 ins wide had to be replaced by a ferro-concrete beam, and the lead taken up and relaid.' A report by the consultant architect, W. H. R. Blacking (June 1938), identified the extent of the repairs which were needed. In 1940, in spite of the outbreak of war, work on the tower roof was completed, but after that only urgent and essential repairs were carried out.

The installation of Dr H. Costley White as Dean of Gloucester 1938. The Revd Eric Noott is on the dean's right

THE CATHEDRAL DURING THE SECOND WORLD WAR 1939–1945

With the declaration of war on 3 September 1939 came the fear of mass air attacks on targets all over the country, including Gloucester with its railway rolling stock works and aircraft industry. The maintenance staff were at once involved, with glaziers, in removing glass from the great east window and boarding up the openings (September 1939–February 1940). With the increase in the number and ferocity of bombing raids in the West Midlands in 1940, the Chapter gave instructions for the remaining glass to be removed 'as soon as possible'. Every panel was carefully packed and labelled. Roughly half the glass was taken to Miserden Park, about eight miles from the city, and deposited in the wine cellars which were specially strengthened; the other half was stored in the cathedral crypt. The effigy of Robert, Duke of Normandy was also removed to the crypt, to join a mysterious wooden case received on 2 September 1939 from Westminster Abbey in London. They were bricked up for the duration of the war. The case from Westminster Abbey contained the Coronation Chair. Harry Pearce, one of the masons, recalled how he 'put Robert on top of the case', which prompted Bernard Ashwell, architect to the Dean and Chapter 1960–85, to remark that Duke Robert got nearer to the throne of England in the twentieth century than he ever did in his own life.

Christopher Whall's Annunciation window from the lady chapel was also stored in the crypt from October 1939. In March 1940 a lead font was received from 'an undisclosed source'. It was said to be Saxon, but it was of Norman date *c.* 1140, originally from Lancaut Church in the Wye valley, and donated by Lady Marling of Stroud. The tomb of Edward II was cleaned early in 1940, with the aid of a grant from Oriel College, Oxford. But as German bombing of the country intensified in the spring of 1940, the tomb was once again protected with sandbags. The Prinknash glass in the south walk of the cloister was protected in the same way, as were the Morley and the Blackleech monuments.

Because of the possibility of damage from water settling in pockets in the vaults drainage holes were made through the walls of the building. Smaller holes were made in the fan vaults of the great cloister. Water from the firemen's hoses could have collected in these cones, and caused more damage than German incendiary bombs. Early on 'dry-risers' i.e. pipes for water attached permanently to the side of the building and rising from ground level to the bell-chamber, were fixed on both sides of the tower. Throughout the war the roofs were patrolled at night by fire-watchers in case of incendiary attack. The dean (Dr H. Costley-White) was regularly on duty with them. But by October 1944 the danger was thought to have passed, and it was noted that the 'fire guards, whose duties are now conditionally relaxed, consist entirely of unpaid volunteers, men and women, of ages ranging from 18 to 73, and most of them by now experts in traversing with speed and in the darkness the intricate passages of the roof spaces and outside roofs of the whole building.'

The cathedral lost one of its treasures during the war. It was the *Last Judgement* or *Doom* painting which was discovered *c.* 1800 behind some wainscotting in the nave when seats were removed. It was supposed to have been an altar piece of *c.* 1540 and to have been concealed there shortly after the Dissolution. It had been stored for some years in the tribune gallery when, in 1934, Professor Tristram saw it and recommended that it be restored. The painting was taken to London. When the work was completed and the painting was awaiting collection, on the night of 23 February 1944, the restorer's studio was totally destroyed by incendiary bombs. The picture was thought to have been the work of an English artist; its particular interest lay in the fact that it was such a late medieval representation of the Judgement scene.

THE POST-WAR YEARS 1945–1953

As soon as the war in Europe came to an end the effigy of Duke Robert was returned to its place in the presbytery, and the 'wooden case' was returned to Westminster, its contents still a mystery to all but a few. It was not so easy to decide what to do with the glass of the great east window. It had to be cleaned and releaded, but who should be entrusted with the work? Messrs Whall & Whall were approached, and Mr Beck of Cheltenham, both of whom came to see the glass. The architect, Colonel N. Waller, reported that 'many of the panels would need little done to them beyond renewing the copper ties, but some would require a fair amount of repairing.' After much discussion it was decided to ask Mr Beck to undertake the work since, living in Cheltenham, he could more easily collect the glass in his car. He began work in the autumn of 1945, collecting

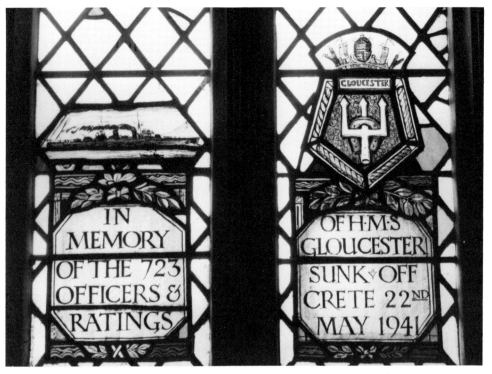

Memorial glass to the officers and men of HMS *Gloucester*, 1941. Stained glass by Edward Payne, Gloucestershire stained-glass artist and glazier to the Dean and Chapter of Gloucester Cathedral

a few panels at a time. The glass was reinstated during the summer of 1946, and the work completed by the early autumn. It amounted to 194 panels and more than 2,000 sq ft of glass, all refixed without mishap. While the scaffold was still in position Mr Pitcher, the Gloucester photographer, took a remarkable series of photographs of the glass.

As one medieval masterpiece was being restored another medieval work was discovered. During repairs (1946–7) in the building between Little Cloister and 3 Miller's Green, near the old monastic refectory, the removal of a ceiling revealed the roof of a small medieval hall, possibly the *misericord* attached to the infirmary. Part of the undercroft storage area survives at ground floor level, and the monastic kitchens are thought to have been close by. In the rafters, once layers of limewash had been removed, part of a painted ceiling was discovered. Though reported to be 'somewhat perished' its original design was clear. It was composed of angels in yellow and red, outlined in black and in a rather stylized pose, on either side of a painting of the Holy Trinity. Professor Tristram reported that the 'figure of the Almighty was about life size'! The figure, with nimbus and beard, was seated and, far smaller, in front of the Father-figure was a diminutive figure of Christ on the Cross. On the left, though not complete, was a Benedictine monk holding a scroll, inscribed with a prayer, but the only word decipherable was *Domine*. Beyond this figure a seraph held a shield of the Five Wounds. On the extreme right was another representation of the Trinity and an angel, but these

Late medieval painting of God the Father, discovered in 1946 in Little Cloister House: detail showing God the Father, the Crucified Christ and Angel holding shield

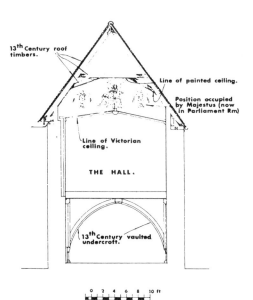

A cross-section through the centre of the thirteenth-century building where the painting was found, showing the undercroft (now used as the Junior School of the King's School) and the hall (possibly the misericord or dining hall of the infirmary)

were badly damaged and decayed. Tristram commented 'Although the painting cannot be classed as a work of the finest quality of that period, it was above the average in accomplishment'. It represented 'an illustration of the type of decorative scheme obtaining in monastic establishments towards the middle of the fifteenth century.'

In the post-war years the cathedral received many gifts, some *in memoriam* but not all. The Bathurst family of Cirencester gave a superbly carved tester, or sounding board, designed by Stephen Dykes-Bower, for the nave pulpit in memory of Lord Apsley (1949), and later Lady Apsley gave the processional staff depicting St Michael slaying the dragon, used by the dean's verger (1960). The Friends of the Cathedral provided new chairs for the nave (1948) and later kneelers, and the Embroiderers' Guild a variety of furnishings. These included kneelers for the choir stalls and embroidered cushions for the monastic stalls (1956–8), sanctuary embroideries including a seat cushion and kneeler for the bishop's throne (1959–60), similar furnishings for St Andrew's Chapel (1961) and ninety-four kneelers for the presbytery (1962–3). Book cushions for the returned stalls were designed and made, and two back-embroideries for the dean and canon-in-residence's stalls in the nave (1965). During these years members of the Embroiderers Guild also assisted with furnishings for St George's Cathedral and Westminster Abbey.[7]

The Chapter often turned to Stephen Dykes-Bower in the years after the war for advice and designs. He designed not only the Bathurst tester (1945–6), but also a

Detail of the late-medieval painting, restored and
preserved in the Parliament Room

beautiful floral frontal for the nave altar (1950). He spoke at the Friends' Festival in 1946 about 'The Surroundings of Gloucester Cathedral', an address which set the agenda for improvements in the precincts in post-war years. In 1950 various improvements were made possible in the choir *sacrarium* by the donation of Sir Francis Metford (inscription on the sanctuary step), including a new and larger altar and frontal (worked by Mary Ozanne). Dykes-Bower designed lampshades for the desks of the minor canons, the lay-clerks and choristers in the choir (1951), and kneeling desks for the sanctuary. In 1951 he designed the hanging which covered the ruined reredos in the lady chapel until the 1970s.

Work was resumed on the tower roof in 1946, and completed four years later. The old lead and boarding was taken down through the bell hole in the choir vault. Further work was carried out at St Mary's Gateway in 1947, where double gates of wrought iron, to a design of a Nuremberg artist of the mid-nineteenth century, were erected. These were the gift of the parish of Painswick. Four of the columns in the central chamber of the crypt, at the east end, were found to be fractured, possibly the result of the weight of the great stone reredos above them. The vaulting was shored up and the columns taken out. It was found that none of the four piers had any real foundation. Foundations were put in and the columns replaced with steel shafts to strengthen them. Attention then turned to the roof of the south aisle of the nave. Colonel Waller proposed replacing the lead with stone tiles with which the aisle had originally been roofed. Work began at Easter 1951, and continued, bay by bay from the east end, until it was completed a year later. The old beams were found to be seriously affected by death-watch beetle. The main roof of the

Colonel N.H. Waller, architect to the Dean and Chapter, with the maintenance staff. Mr Tom Wellard, clerk of the works, is on his left

nave was examined in 1952, and the lead and timber were found to be in urgent need of renewal. Colonel Waller noted that 'much of the timber work had been repaired or replaced in 1804.' In the nave itself the vault was 'patchy, discoloured and unsightly.' The Chapter realized that the time had come when the reconstruction of the main roofs of the building could be postponed no longer. It was decided to begin with the nave roof (1952).

This decision was taken when Dr H. Costley-White was still dean; work was well underway when the Archdeacon of Wisbech, Seiriol John Arthur Evans, was appointed dean in 1953. His appointment marked the beginning of a period of major restoration of the cathedral over the following twenty years. In 1951, Costley-White had lamented that, 'the economic revolution in this country during the past twelve years has hit the cathedrals hard. Only those few which are exceptionally well endowed have been able to meet the mounting expenses of their regular maintenance, much less to improve their equipment and repair their fabric out of their own resources.' At the same time he observed that:

> The cathedrals are more alive in every respect than at any period within living memory. They are better kept, they are more used; they are visited by larger numbers of individuals and parties from far and near; they give themselves more freely for special services and for musical recitals of the highest quality; they aim at and largely attain more exacting standards for the worship of God in the beauty of holiness.

THE CATHEDRAL YESTERDAY AND TODAY
1952–1990

'The cathedrals are one of England's greatest tourist attractions.'
British Tourist Board Report, 1979

In the autumn of 1952 when Dr Harold Costley-White was still dean, Colonel N. Waller, reported on the condition of the fabric and, in particular, on the condition of the roofs which had been causing anxiety for some time. The report made clear that a major restoration programme involving the repair or replacement of practically all the roofs would have to be undertaken without delay. The Duke of Beaufort, Dr C.S. Woodward (Bishop of Gloucester 1946–53) and the Dean and Chapter launched an appeal for £100,000, a figure which was subsequently raised to £150,000.

THE RESTORATION OF THE CATHEDRAL 1952–1972

Work that was going on at this time, including the rebuilding of the exposed north and east walks of the little cloister in Hartham Park stone (1952–3) was completed before work on the nave roof was begun. No medieval timbers remained in the roof trusses. A great deal of soft wood had been used in repairs early in the nineteenth century, which was confirmed by the date '1804' burnt on the tie beam of one truss. Steel trusses were erected, and planking laid on the new framework; the lead on the roof was recast and laid, with gutters constructed of pre-cast concrete (1953–4). To ensure the new steel trusses and rafters had a sound bearing, a continuous reinforced concrete beam was formed on the north and south walls. This necessitated the removal of some of the stones at the top of the wall on the inside. While this was being done, a large number of worked stones were found buried in the south wall. They had been used simply as filling; some were Norman with dog-tooth decoration and others were from the Early English period, capitals and arch mouldings. Among them was a carved head (*c.* 1240), a striking piece of work which had been damaged at the time it was being carved and so

Thirteenth-century head discovered, during roof repairs, set into the wall at the west end of the nave

abandoned. It was, however, mostly in pristine condition, and is now exhibited in the Gallery Exhibition.

Dr H. Costley-White died in 1953, and Bishop Woodward resigned in the same year. Seiriol J. A. Evans, Archdeacon of Wisbech, was appointed dean (1953–73) and Wilfred Marcus Askwith, bishop (1954–63). Restoration work went on apace through out Seiriol Evans' years at the deanery. He already knew and loved the cathedral, having served as an assistant master at the King's School (1922–3). Later, he was appointed headmaster of Ely Choir School, and during the Second World War he served as a naval chaplain (RNVR). He became archdeacon of Wisbech after the war. In 1954 he became chairman of the Central Council for the Care of Churches, an office he held with distinction until 1971. He was awarded the CBE in 1969 in recognition of his services to the arts. During his years as dean he commissioned, and encouraged others to commission, works by a number of local craftsmen and leading designers of the post-war years. Among them were Stephen Dykes-Bower, Professor L. Evetts of Newcastle University, Brian Fedden, Leslie Durbin and George Hart.

Reroofing the Cathedral and Cloisters

In 1955, the nave roof having been completed, the roof of the south walk of the cloister was found to be in a most precarious state through beetle and wet rot. A new type of roof was devised (1955–7) consisting of pre-stressed concrete beams every 3.6 m (12 ft), with similar concrete purlins and planking laid over the top. The old lead was removed and recast, and then relaid on the new roof. The pitch of the reconstructed roof was lowered to the original level to provide a proper flashing below the sills of the north aisle windows. Later (1964–6) when B. J. Ashwell had taken over as architect to the Dean and Chapter the roofs of the east, north and west walks were treated in a similar way. Meanwhile attention turned to the choir roof. Again, the old timber roof was in a very poor condition with the tie beams resting on the crown of the vault. A new roof, of the same type of construction as that used on the nave, was built (1956–8). But in this case the medieval gutter behind the parapet walls was not disturbed since it still 'bound together the whole of the top of the wall' (Ashwell).

On 3 May 1955 HM the Queen and HRH Prince Philip visited the cathedral to see the progress of the restoration work. At the time work had begun on the defective parts

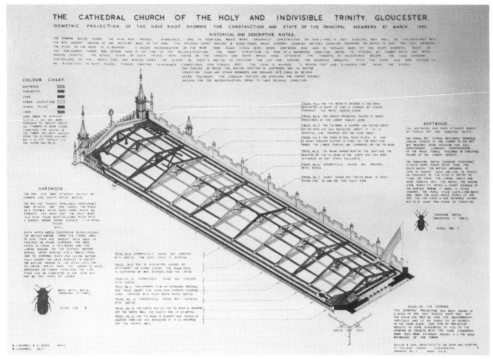

B.J. Ashwell's drawing of the nave roof, before reconstruction 1953–55. Hardwood (oak) in dark, and softwood (from *c.* 1800 repairs) in lighter shading

of the nave wall above the south walk of the great cloister, which was being refaced with Tetbury and Painswick stone. The next major work on the roofs was the reconstruction of the north transept roof (1961–2). The roof was clearly of considerable age since it followed the line of the drip course on the tower. But the design of the trusses confirmed that a major reconstruction had been carried out in the early eighteenth century. 'A window which originally let light into the Norman roof space was just above the apex of the roof' (Ashwell). In this case the reconstruction was conservative, steel trusses were erected but oak was used for the purlins and, of course, for the rafters.

The reroofing of the remaining cloister walks continued from 1963 using a lightweight concrete, a modified form of the technique devised for the south walk (1956). During work on the east walk, it was found that in the northern section beyond the chapter house the conoids of the vaults were filled in with rubble. Had there been a floor above this walk extending from the chapter house entrance to the north wall of the cloister? 'This possibility was confirmed by the evidence of a doorway on the north side of the north wall which clearly gave access to the space above the Dark Cloister or could possibly, by a short flight of stairs, have descended to the frater floor level at the dais end. Access to the two storey portion at the south end could very easily have been provided from the first floor vestibule of the dorter' (Ashwell). An old arch of Norman stones was found in the wall of the cloister walk just beyond the entrance to the chapter house. Ashwell later reported (1968) that while repairing the roof of the chapter house

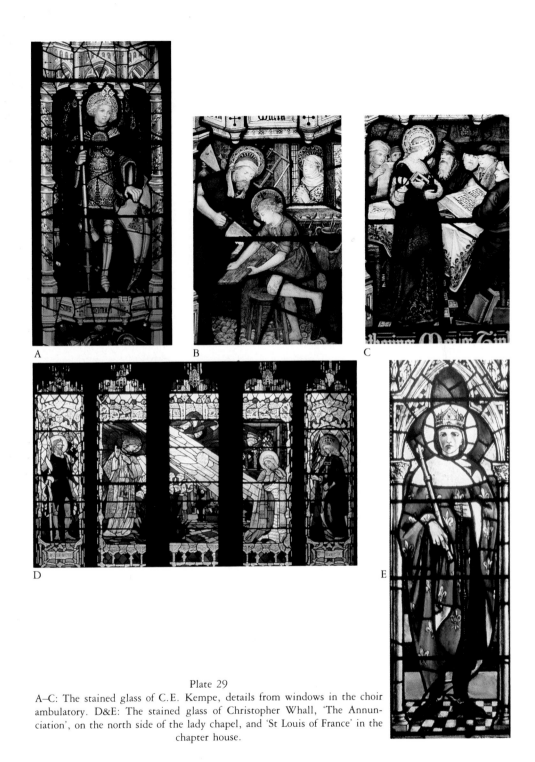

Plate 29
A–C: The stained glass of C.E. Kempe, details from windows in the choir ambulatory. D&E: The stained glass of Christopher Whall, 'The Annunciation', on the north side of the lady chapel, and 'St Louis of France' in the chapter house.

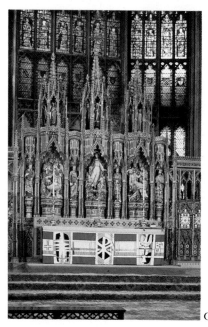 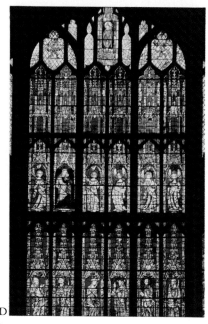

Plate 30

(A) Early nineteenth-century painting of the gates to the Bishop's Palace, on the north side of Palace Yard (Miller's Green). (B) North side of Miller's Green today. (C) G. Gilbert Scott's reredos (1872/3) today, after polychroming, with Professor Evett's frontal on the altar. (D) The great east window, a detail of the upper tiers. Restored by Charles Winston *c.* 1860

Plate 31
Top: The lady chapel reredos, panels designed by Leonard Evetts and made by Maureen Palister. (Photograph by R.J.L. Smith of Much Wenlock). Bottom: The festal copes designed by Belinda Scarlett (1989): Canon Alan Dunstan is on the left, Michael Heather, head verger, on the right. (T. Dorrington)

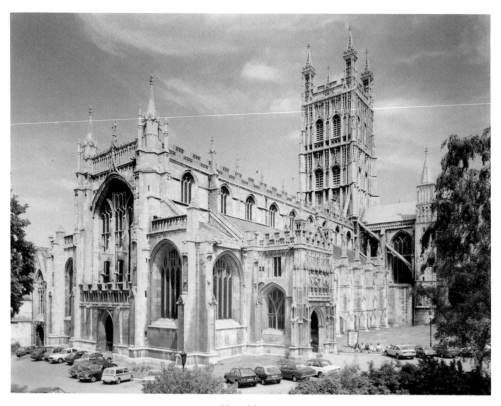

Plate 32
Gloucester Cathedral from the south-west, 1985. (Jones Photography)

Roof repairs: the lady chapel, the choir and the south aisle of the nave

he had found 'on top of the west wall at the north corner below the roof, the base of a flight of steps which were oriented southwards. Access to them would have been from the vestibule of the dorter; presumably the steps were for maintenance purposes.'

The grey-blue slates on the roof of the south transept, which had been laid down *c*. 1825 were removed in 1966 and replaced with lead, and the slate roofs of the library and the chapter house were relaid 1968–9. The roof over the dark cloister was also renewed. This marked the completion of the programme of reroofing apart from relaying the slates on the north aisle roof in 1975–8. No medieval timbers remain in the roofs, with the exception of the lady chapel.

Other Restoration and Improvements

Colonel N.H. Waller retired as architect to the Dean and Chapter in 1960, and Bernard Ashwell, MC, FRIBA, who had been assisting him for some years, took over from him. Waller died the following year. From 1953 to 1969 Dr W. Godfrey Allen was consultant architect. He had been responsible for suggesting the use of new techniques in the reroofing of the nave and of the great cloister, and worked closely with Bernard Ashwell from the mid-1950s.

Dr Wilfred Askwith, Bishop of Gloucester 1954–63 in procession after his enthronement, flanked by the Archdeacons of Canterbury and Cheltenham (the Ven. R. Sutch)

The Bishop's Palace was adapted to become the main teaching and administrative block of the King's School (1954–5). A small part of the garden containing the bases of the north infirmary arcade was taken into the area around the infirmary, turf and a path were laid down, and a hedge planted. The bishop and Mrs Askwith moved into Palace House, the new episcopal house in Pitt Street (1958), which was renamed Bishopscourt in 1975. With the increasing numbers of boarders at the school Cathedral House was taken over, and renamed Wardle House after the Venerable Walter Wardle, a residentiary canon and archdeacon of Gloucester (1900–83). He was closely associated with the school's recovery in the 1950s and 1960s.

New lighting was installed (1956–8), and a new heating system was put in (1958) in place of the old Gurney stoves, which were removed. The nave vaults were cleaned, repaired and replastered as necessary, and then whitened with three coats of limewash. The first section to be treated was the vault of the south aisle (1957), then the western bays (1959), and the rest of the vault from a 'bridge' erected across the nave. Either the type of limewash used or the preparation of the surface to which it was applied proved far from satisfactory. It began flaking less than ten years later and had to be whitened again using Sandtex (1974). While cleaning the bosses no trace of colour was found either on them or the ribs. In the north aisle, however, colour was found on the fifteenth-century bosses at the west end, and nearby on the transverse arches of the Norman work at the west end.

From 1956 further work was carried out on St Mary's Gateway, funded by a grant of £2,000 from the Pilgrim Trust. The work, which was completed in 1961, involved the entire reconstruction of the interior. Similarly, the Parliament Room was completely gutted, with the removal of the flat ceiling and the exposure of the medieval trusses. Early nineteenth-century sash windows were removed and two oriel windows were added on the north side 'based on evidence remaining in the medieval timbers' (Ashwell). A new outside staircase was built on the south side (1958–62). Major repairs to the battlements and the pinnacles of the tower were put in hand in 1961 and continued until 1965. Aluminium scaffolding tubes were used around the pinnacles which were said to be 'still quite sound though needing some stone replacements and strengthening.' New Clipsham stone which had been banked in the winter months was fixed in the summer of 1962 and 1963.

In 1963 a start was made with washing the exterior of the building which had become blackened over the years as a result of emissions from factory chimneys, car exhausts and domestic coal fires. The porch was washed down (1963) and the exterior of the *lavatorium* (1964), and then the west front, below the great window (1965). Different stone preservatives where used in cleaning this section of the west front. It was applied in 'panels' in the hope that twenty years later their relative effectiveness could be judged. The washing continued some time later, using water only, along the nave south aisle, bay by bay (1975–6), and then around the south transept and the choir ambulatory (1984) to the lady chapel (1986–9). It is continuing along the north side of the choir ambulatory the north transept and adjoining buildings (1990). The effect of the washing is dramatic, but in places it reveals the decayed state of the stonework and hideous examples of earlier repairs, as in the window arches of the south ambulatory. Some bays of the east walk of the great cloister have been cleaned (1990) using a mild abrasive technique.

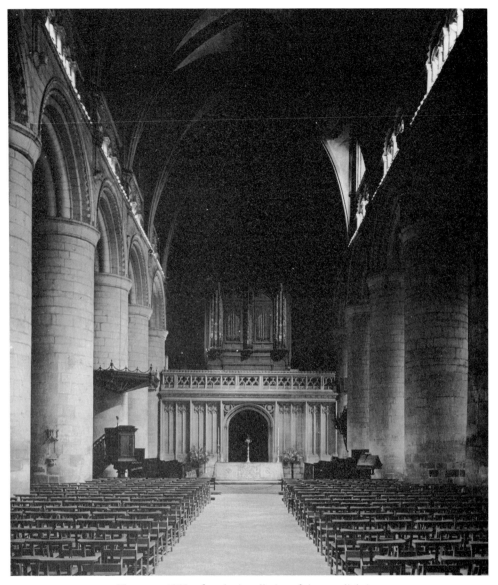

The nave, 1959, after the installation of the new lighting

Ashwell had been increasingly worried about the weathering qualities and colour match of the stone being used in repairs. The Painswick quarry was worked out, and the Dean and Chapter quarry at Burleigh, though still providing some stone, was proving inadequate for current needs. Clipsham stone from Rutland had been used for some time, but after a long search, Lepine stone from Chauvigny in France, supplied through the Chichester Cathedral Maintenance Department, was used from the early 1970s. So far its weathering qualities and colour match appear to be excellent.

St Mary's Gate 1959, during last phase of restoration

Restoring and Enriching the Interior

Inside the cathedral other work was being carried out and new furnishings fitted. The sacrament was reserved for the first time since the Reformation in the Seabroke Chapel in 1960. A silver hanging pyx made by the London silversmith, Michael Murray, was installed. A fine processional staff was donated in 1960, designed and made by Leslie Durbin; it was given by Lady Apsley in memory of her husband, Allen, Lord Apsley, who was killed in action in 1942. The shaft of the staff was made from a yew grown in Cirencester Park, and the silver gilt head was designed in the form of St Michael slaying the seven-headed dragon. In 1962 the dean told the Friends of the cathedral that the so-called reliquary in the north transept 'calls aloud to be used as a place for the exhibition of Church plate.' Plans were made for five tall burglar-proof show cases, to be made at a cost of £1,200, but sadly more urgent uses for the money prevented this imaginative proposal being carried through.

A new public address system (1961–2) and a new oil-fired heating system (1970) were installed. St John's Chapel was restored and embellished (1964–5). The parclose screen and the back of the choir stalls were cleaned. Stephen Dykes-Bower designed the stone reredos which was carved by Tom Wellard, the clerk of works. A fine cartouche (1966) in memory of Dean Costley-White was placed on the screen to the right of the altar. The restoration of the chapel was completed in memory of Dr C.S. Woodward, Bishop of Gloucester whose memorial tablet is at the entrance to the chapel. Repairs were also carried out to the vault of St Andrew's Chapel (1968), parts of Gambier Parry's mural

Silver pyx, by Michael Murray, 1960

Processional staff, by Leslie Durbin (1960)
depicting St Michael slaying the dragon

The Carne Cross. Made by Lt.-Col. J.P.
Carne, VC, DSO, Commander 1st Battalion,
the Gloucestershire Regiment while he was a
prisoner of war in North Korea. (Photograph
by R.J.L. Smith of Much Wenlock)

Dr Herbert Sumsion conducting the opening
service of the 1956 Three Choirs Festival

painting being reinstated by Bryant Fedden. The high altar reredos was polychromed
(1964) under the direction of Stephen Dykes-Bower. The sculpted groups by Redfern
had been left in plain stone when the rest of the reredos was painted. For years the
figures had seemed to many to be cold and lifeless. To add to the colour in the choir and
elsewhere, the Embroiderers Guild was busy producing scores of cushions for the stalls,
kneelers and a new altar frontal, designed by Professor Leonard Evetts, for the lady
chapel (1966). Later he designed four green copes which were made by Mrs Ozanne, a
member of the Guild (1970–4).

While the interior was being enriched and every effort was made to enhance the
setting of cathedral worship, there was growing anxiety about the future of the choral
tradition. The cost of lay-clerks' salaries and of the choristers' education was continually
rising, and it was proving difficult to find lay-clerks whose employers would make it
possible for them to attend daily Evensong. For thirty-nine years (1928–1967)
Dr Herbert Sumsion, a former chorister, had been the cathedral organist. In 1947 he
had received from the archbishop the degree of Music and in 1961 he was awarded the
CBE for his services to music. He was a fine organist, piano accompanist and conductor,
combining his cathedral duties with his appointment as director of music at Cheltenham
Ladies' College and producing a good deal of church music and other compositions. In
1967 Mr John Sanders succeeded him and fresh efforts were made to solve the problems
of maintaining and securing the future of the cathedral choir. In 1972 the dean was able
to announce that the target of the second appeal had been reached. Rebuilding the organ
(1970–1) had already cost £40,000, with £57,000 being set aside for choristers'
scholarships. To celebrate this achievement and to inaugurate the new organ the Prime
Minister, Mr Edward Heath, came and gave a recital on the new instrument.

The old deanery (from the late 1950s known as Church House, the Laud Room and the Henry Room (before the removal of the ceiling) furnished as 'The Club'

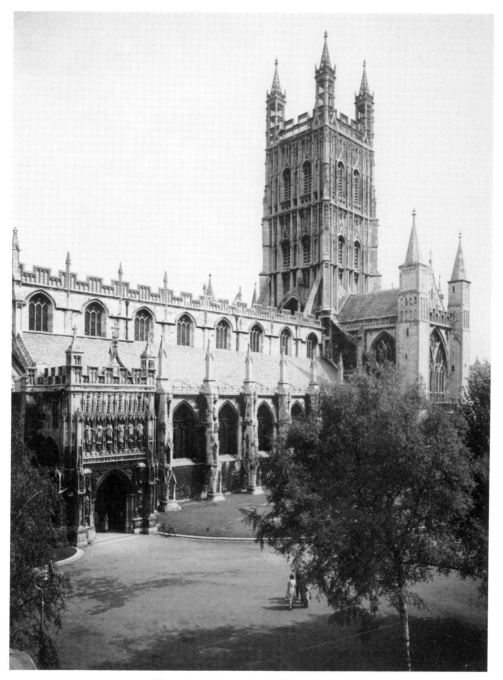

The cathedral from the south-west, 1956

Seiriol Evans retired in the autumn of 1972, but not before celebrating the 900th anniversary of the appointment of Serlo as Abbot of St Peter's. An exhibition was mounted in the Chapter House arranged by Mr Brian Smith, the County Archivist, and his staff at the County Records Office. In the same year, as a result of the labours of Miss Suzanne Eward and a generous grant from the Marc Fitch Trust, a catalogue of the Cathedral Library was published. The dean had always taken a great interest in the history and architecture of the building, writing an excellent Pitkin guide and contributing a number of articles to learned journals. He served as President of the Bristol and Gloucester Archaeological Society and was a Fellow of the Society of Antiquaries of London for many years, serving on its Council. On his retirement in 1972 he wrote: 'Together we have embellished our great church; we have cared for its structure and have made some provision for the music of its worship and the maintenance of its choristers.' After nineteen remarkable years he had every right to be proud of his achievements. As Ashwell pointed out 'All the high roofs have been renewed, complete with those of the chapter house, the library and the great cloister. The tower pinnacles and much external stonework repaired, the cathedral rewired, the organ rebuilt, a new heating system installed, and to beautify the place, St John's Chapel restored and Seabroke's Chantry, and the high altar reredos, and lovely needlework in plenty.'

The Restoration of the Bells

Gilbert Thurlow was installed as dean on 27 January 1973. He had been associated with Norwich Cathedral for many years, as minor canon and precentor (1939–55), and after nine years as Vicar of Yarmouth (1955–64) where he rebuilt the parish church destroyed

Gilbert Thurlow, Dean of Gloucester 1973–83, with 'Great Peter' (1978)

in the Second World War, as a residentiary canon and, from 1969, as vice-dean. But he identified himself completely with Gloucester; his boundless energy and infectious enthusiasm made the following decade one of exciting change and remarkable achievement.

At his first meeting with the Friends of the Cathedral, in June 1973, he spoke of the cathedral's bells, and in particular of Great Peter. In former times, he said, this great bell always swung, but for eighty years or more it had been 'dead', fixed and unable to move. It was simply 'banged with a hammer and clapper.' As a leading authority on bells and bell-ringing he was determined to do something about Gloucester's tower and its peal. In 1969 the external stonework of the tower had been inspected from a bosun's chair, and it was reported that 'there were no cracks of any consequence.' After further investigation to establish whether the structure could take the strain, it was decided to make Great Peter swing again and to increase the peal from ten to twelve.

The Whitechapel Bell Foundry removed the bells in January 1978, lowering them through the bell-hole in the vault over the choir, and the work of repairing and strengthening the tower began. The architect reported that the original fifteenth-century beams, which measured 36 cm (14 in) square and were approximately 10.7 m (35 ft) long, were still in place, though some of them were badly rotted at the ends. They had been repaired in c.1908 with cast iron plates. Once the floor had been

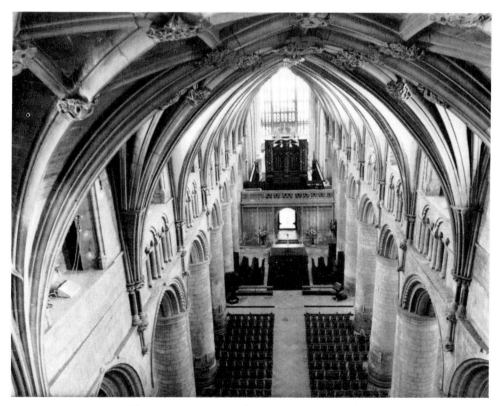

The nave interior 1987, from the great west window

strengthened and reconstructed a new bell-frame of Iroko wood was installed replacing the existing oak frame (dated 1632). Part of the old frame was kept in the tower. John Smith & Sons (Clockmakers) of Derby were involved in other aspects of the work which was completed by March 1979, just ahead of a visit by HRH the Princess Royal on 26 April when the new peal rang out in welcome. (See Appendix VII.)

A DECADE OF TOURISM 1973–1983

Much of what was undertaken by the Dean and Chapter during these years related to the great increase in the number of people visiting the cathedral. The previous forty years had seen a quite remarkable resurgence of interest in cathedrals, not only in the cathedrals of England but also of western Europe. This was due, in a large part, to the phenomenal expansion of the tourist industry. With the development of cheap air travel after the Second World War the number of English people who travelled abroad for their holidays rapidly increased. In the same way millions of overseas visitors came to this country to see, among other places of historic interest, Canterbury Cathedral, York Minster and Westminster Abbey. Before long 'middle ranking' cathedrals, such as Gloucester, also found thousands of tourists and visitors on their door-step. Cathedral authorities throughout the country were not slow to realize that tourists, like the more well-to-do pilgrims in the days of Chaucer, could prove to be a valuable source of revenue for the repair and maintenance of the cathedrals. They began to respond to the tourists' needs by providing space for car parking and for coach parties, opening or enlarging shops and restaurants, building lavatories and training guides. It seemed that the cathedrals of England had become part of the booming tourist industry.

Academic Interest: At the same time the academic world was showing renewed interest in the architecture and history of the country's cathedrals. They were seen as a valuable resource in the teaching of art and technical subjects, of history and religious studies. Provision was made at a number of cathedrals for educational visits by school children, with graded work sheets and information packs available. Exhibitions and audio-visual presentations were devised, and a good range of publications became available at the bookstalls, from the ubiquitous Pitkin to specialist books on different aspects of the history and architecture of the buildings. The cathedrals, England's most beautiful medieval buildings, containing some of the finest work of medieval craftsmen, once again became a focus of study and research.

 Not surprisingly university departments of art and architectural history, antiquarian and local archaeological societies found new interest in them. During the past twenty years, for example, the British Archaeological Association has held its annual residential conference at different cathedrals, including Worcester, Ely, Durham, Wells, Canterbury and Winchester. These week-long conferences bring together scholars with a variety of specialist interests who, in seminars on site, exchange views and study the buildings in considerable detail. The conference at Gloucester in 1981 produced a valuable series of papers on *Medieval Art and Architecture at Gloucester and Tewkesbury*. These were published in 1985 and have since stimulated further research on a number of aspects of the history and architecture of the building.

Treasury for Church Plate: In 1975 the Worshipful Company of Goldsmiths of the City of London offered to provide a treasury 'for the plate of the cathedral and diocese.' It was decided to site the treasury in the eastern slype, the monastic *locutorium*. For security reasons and for ease of access this necessitated the opening up of an entrance from the north transept though the 2.1 m (7 ft) Norman wall. The work was recorded and the stones removed were numbered and stored. The barrel vault was then repaired and whitened, a new floor laid and the wall arcading cleaned. This revealed a considerable amount of medieval decoration on the north side. An oak bench was constructed over the much decayed *sedilia*. The cases were installed, and silver plate dating from the fifteenth century to the present day which Mr Owen Parsons, the first curator, had selected from the plate offered on loan by a number of parishes in the diocese, was displayed in a beautiful setting and in secure conditions. The treasury was opened on 25 October 1977.

Restaurant Facilities: By the late 1970s it became clear that the refreshment and lavatory facilities were far from adequate for the ever-increasing number of visitors coming to the cathedral through the summer months. The undercroft of Church House was therefore equipped with a preparation room and refreshments were served. To make the refectory more accessible to visitors a passage was made to the undercroft from the small doorway in the west walk of the cloisters. With steps down, this passage passed the new lavatory block, a patio and a shop (1980–1). For many years the crypt had not been open to visitors except by special arrangement. In 1974, however, it was cleaned and its vaults limewashed, and the public were invited to go down to see it in the company of a chaplain or guide.

Bookstall and Cloister Shop: The bookstall was moved to its present position in 1974, and a new parclose screen erected around it in 1976. Later new display and counter cabinets were installed (1988–9). The manageress, Mrs W. Beart, developed a wide range of quality gifts and souvenirs, and with her voluntary staff has made a valuable contribution over the years not only to cathedral funds, but in welcoming visitors. A frieze around the top of the screen was decorated with shields, painted by Mr W. Bishop, containing the arms of various organizations that have played a prominent part in the life of the cathedral, city and county since 1541. Bernard Ashwell designed the screen, and as a life-long railway enthusiast ensured that among the shields were those of two early railway companies, namely the Midland Railway and the two shields of the Great Western Railway. He explained that 'from about 1845 the battle of the Gauges between the 7 ft gauge of the Great Western Railway and of the 4 ft $8\frac{1}{2}$ in gauge of the Midland Railway (and the rest of the railways in Britain) was fought out at Gloucester as in other places.'

Tribune Gallery Exhibition: In 1981, as part of the celebrations marking the founding of the first monastic house on the site by Prince Osric in *c*. 681, a permanent exhibition was mounted in the tribune gallery. Fragments of glass, scraps of metal work, wood and stone carving, tiles and other bits and pieces saved by F.S. Waller during the nineteenth-century restoration of the cathedral had been stored in the south-east chapel of the tribune behind a wooden screen. This material was used in the exhibition together with

other objects of interest, many photographs and original drawings. The exhibition, designed by Barry Mazur and mounted by Priestleys (Exhibition) Ltd of Gloucester, takes the visitor through the history of the cathedral from Saxon times to the present day, with emphasis on medieval art and crafts and the changing character of the community which has lived within the ancient precincts for more than 1,300 years.

Voluntary Helpers: One of the most remarkable developments during these years was the rapid increase in the number of voluntary helpers involved, in one way or another, in the work of the cathedral, especially in welcoming and providing for visitors. Already, 'helpers' organized by the Friends of the Cathedral, stood near the door and extended a welcome to visitors on arrival. The cathedral stewards were involved, on various occasions, and at services with the Guild of Servers. The bell-ringers formed an enthusiastic team, encouraged by the dean (Gilbert Thurlow) who was often to be found among them on practice night and before services on Sunday. Others were involved in serving coffee in the Chapter House after the Sunday morning Eucharist and in catering for a variety of functions. A growing team assisted at the bookstall. Others, not specifically associated with the visitors, were engaged each week in flower arranging, and in the Embroiderers' Guild. Still more came to help at the Treasury and Exhibition, and others to train as guides. At one time there were more than 350 actively involved, some coming in from considerable distances.

The heraldic devices on the bookstall screen were not as out of place as some thought when they were put up, for they serve as a reminder that modern tourism goes back to the development of the railways rather than to any romantic notions about medieval pilgrims. Gloucester became an important junction between the South West and the Midlands and the lines from London to South Wales. In the nineteenth century the railways brought school children and works parties to the city, especially from the Midlands. Apart from the excitement of the journey in the early days of rail travel, they came to see the city, its docks and cathedral. The first indication of such visits and of the kind of welcome that awaited them at the cathedral is contained in an entry in the Chapter Act Book, dated September 1858:

> Resolved, that the public shall be freely admitted to the body of the cathedral every week day from immediately after the close of the Midday service up to two o'clock in the afternoon during which time the south door shall be left open, and one of the subsacrists and the constable of the precincts shall be required to be in attendance to see that visitors conduct themselves with propriety and that no damage be done. The iron gates on each side leading to the tower and the crypt and the iron gate leading to the cloister may be kept closed. The Chapter reserving to itself the power of making any further changes with respect to opening to the public which they may think fit.

The welcome visitors receive today is rather different.

RESTORATION WORK 1973–1983

In 1974–6 the north aisle roof was repaired, its timbers renewed and lead relaid. During the repairs the blocked up arches behind the nave triforium were exposed to view from the garth. These arches may have been open originally to the roof space over the aisles. The pierced parapets on the south side of the lady chapel were badly eroded and a

number were renewed (1974); every upright of the parapet on the west side of the south chantry chapel had to be replaced. At the same time work began on repairing the lady chapel windows damaged by iron saddle bars rusting and breaking the stonework. The easternmost window on the north side (NII) was scaffolded and repaired in 1974–5. The bars must have been the original fifteenth-century glazing bars placed in position on the mullions as the window was being built. They extended from one side of the window to the other passing through the mullions. Pieces of stone falling from the windows on the south side in 1978–9 revealed the same problem there. These windows too had to be repaired, and the glass cleaned and cemented before the exterior was washed.

In 1974 it was proposed to install a 'permanent architectural lighting scheme' in the great cloister. Ashwell was asked to devise a scheme in conjunction with Ron Mogg of Beavan & Sons. When the lights were switched on for the first time in 1975 the effect was, and remains, dramatic. The concealed lighting reveals the intricacy and beauty of the fan-vaulting, and when the light is increased, on the dimmers, the oolitic limestone of the vault changes from a honey glow to silvery brightness. The installation was donated by Sidney Skelton of Longhope in memory of his wife, Margaret. In the summer of 1976 Edward Payne, the stained-glass artist and cathedral glazier, assisted by Peter Strong, carried out a major restoration of the great east window. Surface cracks in the glass were covered with leaf of lead, and badly cracked glass was replaced with new glass 'painted as that taken out.' All the repairs were well documented in the glazier's report, a copy of which was lodged in the cathedral library. The fifteenth-century insertion, the Madonna and Child, was removed together with the lower portion of St Catherine, and taken to York for restoration by the York Glaziers' Trust. The glass was returned and reinstated in March 1977, and the entire work completed by June that year.

In the nave, the north and south aisle vaults were redecorated in 1978–9. In the summer of 1979 the south elevation of the south transept was scaffolded so that it could be washed and stone repairs carried out. 'Only the stones which had fractured or disintegrated were replaced; we did the minimum necessary to last, hopefully, for another fifty years' (Ashwell). A measured drawing of the elevation was made showing the extent of earlier stone restoration, particularly in the arch of the window. It was noted that among the stones forming the arch were some with Norman masons' marks, and 'all these were single stones covering one inverted chevron.' New stones had been required, however, to complete the arch in 1335–6 and these were identifiable by colour and texture, and by the fact that in most cases there were two or three chevrons cut out of a single stone. The south-east turret was leaning out quite alarmingly, so a system of stainless steel tell-tales was applied which, it was hoped, would reveal any future movement. The work on the transept progressed slowly, with the scaffolding coming down four years later (1983).

CHANGES IN THE LITURGY

The decade 1973–83 was a time of liturgical experiment in the Church of England. The General Synod approved for experimental use new forms of service drawn up by the Liturgical Commission. These services, known as Series 2 and Series 3, after careful revision were brought together in the *Alternative Service Book* 1980. But for some time,

before the ASB was published, as part of the experimental process, Sung Matins and Sermon had given way to Holy Communion (Series 3) 'preceeded by those parts of Matins not duplicated in the Communion Service i.e. Psalms, Old Testament Lesson and the Te Deum.' Then, this interim form of service (1975) in turn gave way to Rite A in the *Alternative Service Book* from 1980.

The experimental services and the *Alternative Service Book* introduced modern English into the liturgy. Many lamented the loss of the dignity and beauty of Cranmer's language, but prayers which addressed God as 'You' rather than 'Thou' were already commonly used, and modern versions of the Bible had long since left Elizabethan English behind. The *Alternative Service Book* also encouraged the trend, already well-established in many parishes through the influence of the Parish and People Movement, of making the Eucharist the main Sunday service. The cathedral choir sang the Eucharist (*ASB* Rite A) to a variety of settings, from Palestrina's *Missa Brevis* to Shephard's *Gloucester Service*, retaining the Prayer Book version of the psalms and canticles, and traditional language where the music dictated it. The *Book of Common Prayer* continued to be used for sung Evensong. At the lectern the *Authorized Version* gave way to the *New English Bible*, and in 1990 to the *Revised English Bible* (1989). The *English Hymnal* in use for many years was retained but supplemented by *100 Hymns for Today* (1976) and by *More Hymns for Today* when it was published in 1980.

Alan Dunstan, who joined the Chapter in 1978 from Oxford, contributed much to the changing pattern of worship. His gifts as a teacher and preacher were widely recognized, and as precentor he was responsible, with John Sanders, the cathedral organist, for the preparation and conduct of services. With his knowledge of hymnody he enriched cathedral worship by introducing many new hymns, choosing them with care to sustain the theme of the readings and sermons. He set out the principles which guided him in this work in *The Use of Hymns*, published in 1990. He also devises forms of service for special occasions, Carol services for Advent, Christmas and Epiphany, involving the development of a theme in movement and readings.

The first Annual Civic Service, in recent times, to mark the beginning of the Mayoral Year, took place on 1 June 1974. In the same year the Mass of the Roman Catholic Church was celebrated in the cathedral for the first time since the Reformation. The occasion was the jubilee of the ordination to the priesthood of Provost Roche, the parish priest of St Peter's Roman Catholic Church in Gloucester. The welcome extended to the congregation by the dean was so warm and eirenic that his early nineteenth-century predecessors might have risen from their graves in protest.

Donations and Memorials

Many gifts have been received in recent years, some *in memoriam*, some in thanksgiving, and others through the generosity of the Friends of the Cathedral. New scarlet cassocks were provided for the choir (1973), a new nave altar frontal (1975), and a Pascal Candlestick (1976), designed by Basil Comely, architect to the Dean and Chapter from 1985. The altar frontal, for festive occasions, was designed by Stephen Dykes-Bower. It was of cream silk damask, with a heavy gold fringe, and embroidered with

Basil Tudor Guy, Bishop of Gloucester 1963–75

a centre decoration of flowers and foliage 'somewhat in the manner of a Flemish flower painting.' It was made by Pamela Trundle, using 157 different coloured silks.

The reredos of St Andrew's Chapel was gilded and polychromed in 1976 by Peter Larkworthy in memory of Basil Tudor Guy (Bishop of Gloucester 1963–75). The bishop celebrated Holy Communion in this chapel each Friday morning. He is remembered with deep affection for his earthy good humour and love of life, his constant encouragement of his clergy, his human understanding and preaching of the Faith, and the courage he showed in facing his final, protracted illness. 'With faithfulness and joy he shepherded the flock of Christ.' As a memorial to Bishop Asquith (Bishop of Gloucester 1954–63) a Roll of Bishops was placed in the north aisle of the ambulatory and dedicated in June 1978. A Roll of Deans was given by Mrs Whitworth, daughter of Dean Costley-White, in memory of her father. Later, a Roll of Bishops Suffragan of Tewkesbury was placed in the south-east ambulatory chapel in memory of Robert Deakin (bishop of Tewkesbury 1973–87). A memorial, with exquisite lettering by Bryant Fedden, to Ivor Gurney, 'Composer, poet and chorister of the cathedral' was dedicated on 22 January 1977. A set of six copes for use at great festivals, designed and made by Belinda Scarlett and given in memory of Dean Seiriol Evans, were used for the first time on Christmas Eve 1989, and dedicated on St Peter's Day 1990, the anniversary of Dean Evans' death in 1984. (See plate 32.)

Walter Wardle died at 7 College Green in 1982. He was as old as the century and the longest serving archdeacon in the Church of England. He was appointed archdeacon by Bishop Woodward in 1948. Bernard Ashwell, architect to the Dean and Chapter 1960–85, died at the Abbey Gatehouse in Tewkesbury in 1988. He had been trained in the Waller tradition, and like F.S. Waller the attention he gave the

building far exceeded that required of him professionally. He knew and loved the building, its architecture and history, and though he continued as Consultant Architect for three years after his retirement, being parted from it 'was pain and grief to him.' He had handed over responsibility for the fabric to Basil Comely in 1985, who had worked closely with him at 17 College Green for twenty-three years. Tom Wellard had been clerk of the works for thirty-one years when he retired in April 1980. He had joined the maintenance staff from Westminster Abbey in October 1949 and was responsible, under the architect, for all the major restoration work from 1950 to 1980.

Celebrating Osric's Foundation 681–1981

Happily, a year before Gilbert Thurlow retired as dean, the cathedral celebrated Prince Osric's founding of the first monastic house on the site. During the year there were musical and dramatic events, an exhibition of embroidery, a medieval banquet in the Chapter House and medieval fayre in College Green; there was also a series of lectures on the history and architecture of the cathedral. The special services marking the year occasioned visits by the Archbishop of Canterbury (Dr Robert Runcie) and Cardinal Basil Hume of Westminster who, with the community of Prinknash Abbey, unveiled the Roll of Abbots of St Peter's in the north ambulatory. There were services for those of the Orthodox and Free Church traditions, The year 1981 also saw the mounting of the tribune Gallery Exhibition, the completion of the passage through from the west walk of the great cloister to the Undercroft Restaurant, and the refurbishing of the Chapter House. This involved the construction of a new stage and new lighting, and in order to improve acoustics, the hanging of heavy curtains over the wall arcade. The celebration of 1,300 years of life in community and Christian worship on the site was a fitting finale for a dean who, in ten years, had done so much to bring the cathedral into the 1980s, to involve so many in its life and work, and to strengthen the warmth of the welcome extended to visitors.

THE CATHEDRAL TODAY

Kenneth Jennings was installed as dean in January 1983. After seeing service in India (1959–66), he returned to England to become Vice-Principal of Cuddesdon Theological College near Oxford. In 1977 he was appointed Vicar of Hitchin in the diocese of St Albans. On becoming dean he took over as treasurer and with the chapter steward, Stewart Ward, reviewed the cathedral's financial position. After carrying through an extensive programme of repairs to precinct properties, the Dean and Chapter was faced with an architect's report which listed, among other things, urgent restoration work on the crumbling stonework of the cloister, on the tower, and the Victorian stained glass throughout the building. It was clear that a major appeal would have to be launched, and the obvious time was the year 1989, when the cathedral would be celebrating the laying of the foundation stone of the building in 1089.

Eric Evans, Canon of Gloucester (1962–89), Archdeacon of Cheltenham (1975–89), Dean of St Paul's, London (1989–)

B.J. Ashwell, architect to the Dean and Chapter 1960–85

Meanwhile, repairs and restoration continued to be carried out as funds were available and as gifts and grants were received. In 1983 the flying arches on the north and south sides of the tower crossing were scaffolded, and cleaned by Michael Heather, the head verger, assisted by Harry Heasman. The stone work of the arches was inspected and found to be 'completely sound' (Ashwell), though 'near the springing, both above and below, on the north-east pier, there is quite substantial cracking' indicating some movement. There were 'many Roman bricks built into the structure', with over a dozen inserted in the south crossing piers alone. The main members of the arches were nearly 1.2 m (4 ft) in length. The stone of the spans was found to be 'wonderfully smooth, beautifully worked and superbly erected.' A number of fourteenth-century masons' marks were noticed, lightly incised in the stonework.

In June 1986 a new lighting system in the nave, including 'orchestral lighting' at the east end, was completed at a cost of £37,000, given by the Friends of the Cathedral to celebrate the formation of the organization fifty years earlier. The Lancaut font was mounted on a dias at the west end of the lady chapel in the same year. The washing of the exterior of the building continued through 1985/6 with the west side of the south

The balustrade and cross at the west end of the nave, after restoration work 1987–8

The cross at the west end in the masons' workshop before erection. A copy of the cross erected *c*. 1850

transept and St Andrew's Chapel completed. On the north side of the nave the stonework of a clerestory window (N XVII), much decayed through water seeping from a faulty gutter, was renewed (1987). After the effigy of Robert, Duke of Normandy, had been returned from exhibition in London (1986) it was placed on a new platform, set between Norman piers, in the south ambulatory. Since the mortuary chest is not over the duke's burial place and in order to expose the more interesting side of the effigy to visitors, it was placed facing west. In 1988 the south-east ambulatory chapel was renamed the Chapter of the English Saints. Tapestries of St Aiden and St Boniface, designed by Sister Anthony of the Catholic Metropolitan Cathedral in Liverpool, were hung on either side of the chapel. It is hoped to install new stained glass, by Tom Denny, in the windows of the chapel, to restore the chapel to its Romanesque simplicity, and to furnish it for worship 'in the round.'

Improvements were made in the paving of College Green, on the south side of the cathedral, including new York paving laid outside the south porch. In 1987 major restoration work was carried out at the west end of the building, involving the renewal of the parapet and the great cross on the gable, and repairs to the tracery of the great west window were also carried out. The stained glass (Wailes of Newcastle 1859) was removed in three phases, cleaned and releaded by Solaglas Ltd. of Bristol and reinstated by May 1989. An inspection of the glazing throughout the cathedral revealed that most of the Victorian glass will require restoration over the next ten or twenty years. A start was made in 1987 with the cleaning and repair of windows in the south aisle of the nave (s.v.s.viii and s.xi), the last two windows being restored by Joseph Bell of Bristol, the same firm that designed and produced the glass in 1860–1.

In the cathedral library, following a survey of the collection in 1985 by Dr N. Pickwoad, adviser on library conservation to the National Trust, a four-year programme of conservation work was carried out and completed in January 1990. The library was thoroughly cleaned, a visitors' area formed at the west end, bookcases were repositioned and repaired, and carpeting laid down. Groups of book conservators then carried out 'a first-aid' programme of cleaning, leather and paper repairs, and making 'shoes', or acid-free cardboard cases for most of the books. In 1990 the collection was 'in a stable condition', and a rolling programme of more thorough repairs to particularly valuable and delapidated volumes began.

Celebrating the Foundation of the Cathedral 1089

In 1989 as the cathedral celebrated the 900th year of the foundation of the great church by Abbot Serlo, The 900 Year Fund was set up, under the patronage of HRH the Prince of Wales. The aim was to raise £4,000,000 for a costed programme of restoration and conservation over the next ten or twenty years. The year of celebration included the Three Choirs Festival and other musical events, special services attended by the Patron of the Fund and by HRH the Duke of Gloucester, dramatic presentations and courses of lectures on various aspects of the life and history of the cathedral. The cathedral choir, with John Sanders and Mark Blatchly, the assistant organist, toured the eastern seaboard of the United States of America, giving concerts and singing at services in various places including Gloucester, Mass. and Washington.

The cathedral organist and Master of the Choristers (Dr John Sanders) leading the cathedral choir in procession in the great cloister, 1989 (Farley Photography)

This account of the history, art and architecture of Gloucester Cathedral has turned full circle, for it ends where it began, with celebrations surrounding the laying of the foundation stone. The building has survived all the vicissitudes of our religious and national history through nine hundred years. This book, conceived, written and published, as part of the celebrations marking Abbot Serlo's life and work, is itself a celebration of that long and fascinating history, the magnificent architecture, and the treasures of art, music and literature of one of England's most beautiful cathedrals. It is, above all, a celebration of the faith and devotion of the monastic community which lived within the precincts and built and enriched the great church, and of the cathedral community which through more than 450 years has cherished and preserved it to the present day. It is offered, in thanksgiving, to all who in more recent years have shared

Top: The tower clad in scaffolding for extensive restoration, 1990. Below: The cloister garth, 1956, and the cathedral from the north-west

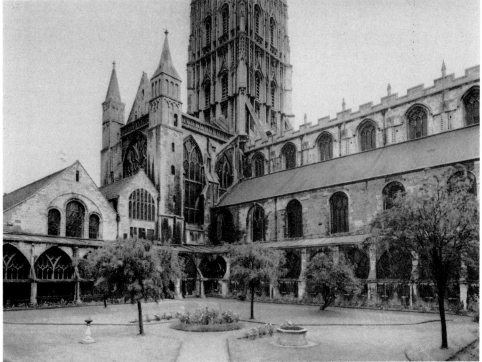

this rich inheritance of history and architecture, of music and worship, and to all who do today and tomorrow share the *Prayer of St Benedict*, a prayer which seems to be embedded in the very stones of the building:

<div align="center">

O gracious and holy Father,
Give us wisdom to perceive thee,
Diligence to seek thee,
Patience to wait for thee.
Eyes to behold thee,
A heart to mediate upon thee,
And a life to proclaim thee;
Through the power of the Spirit of
Jesus Christ our Lord.

Amen.

</div>

ABBOTS, DEANS AND BISHOPS OF GLOUCESTER

Saxon Abbesses: The first abbess was Kyneburga, sister of Osric, the founder of the first monastic house on the site *c*. 681. She died in 710, and was succeeded by Eadburga (710–35); the third and last abbess of the double foundation was Eva who died in 769. After a long period when the monastery was in the possession of secular priests, Benedictines were introduced *c*. 1022. The first abbot of the new foundation was Edric, a former secular priest. Later, Aldred, Bishop of Worcester 1044–60, built the community a new church, consecrated in 1058, and appointed Wulstan as abbot. Wulstan was succeeded by the first Norman abbot, appointed by William the Conqueror in l072.

Abbots of St Peter's Abbey

1072	Serlo	1337	Adam de Staunton
1104	Peter	1351	Thomas Horton
1113	William Godemon (Godeman)	1377	John Boyfield
1131	Walter de Lacy	1381	Walter Froucester
1139	Gilbert Foliot	1412	Hugh Morton
1148	Hameline	1420	John Morwent (Marewent)
1179	Thomas Carbonel	1437	Reginald Boulers (Butler)
1205	Henry Blond (Blunt)	1450	Thomas Seabroke
1224	Thomas de Bredon	1457	Richard Hanley
1228	Henry Foliot	1472	William Farley
1243	Walter de St John (+1243)	1498	John Malvern
1263	Reginald de Homme	1500	Thomas Braunche
1284	John de Gamages	1510	John Newton (*alias* Browne)
1307	John Thokey (Tokey)	1514	William Parker (Malvern)
1329	John Wygmore		

Note: Dugdale W., *Monasticon Anglicanum*, vol. 1, 1817, 531–6; and Fosbrooke, T.D., *An Original History of the City of Gloucester*, 1819, 80–92, give biographical details of the abbots.

Deans of Gloucester

1541	William Jennings
1565	Thomas Cowper (Cooper) (+1568)
1570	Laurence Humphrey
1584	Anthony Rudd
1594	Lewis Griffith
1607	Thomas Morton
1609	Richard Field
1616	William Laud
1621	Richard Senhouse
1624	Thomas Wynniffe
1631	George Warburton
1631	Accepted Frewen
1644	William Brough
1671	Thomas Vyner
1673	Robert Frampton
1681	Thomas Marshall
1685	William Jane
1707	Knightley Chetwood
1720	John Waugh
1723	John Frankland
1729	Peter Allix
1730	Daniel Newcombe
1758	Josiah Tucker (+1799)
1800	John Luxmore, resigned 1807
1808	John Plumptree
1825	Hon. Edward Rice
1862	Henry Law (+1884)
1885	Edward Henry Bickersteth
1885	Henry Montagu Butler
1886	Henry Donald Maurice Spence-Jones
1917	Henry Gee
1938	Harold Costley-White
1953	Seiriol John Arthur Evans
1973	Gilbert Thurlow
1983	Kenneth Jennings

Note: For biographical notes on deans to 1808, see Fosbrooke, T.D., *An Original History of the City of Gloucester*, 1819, 105–110.

Bishops of Gloucester

1541	John Wakeman (+1549)
1550	John Hooper, deprived 1554
1554	James Brookes (+1558)
	James Bowshier, nominated 1558
1562	Richard Cheyney* (+1579)
1581	John Bullingham†
1598	Godfrey Goldsborough
1604	Thomas Ravis
1607	Henry Parry, translated 1610
1611	Giles Thompson
1612	Miles Smith
1624	Godfrey Goodman, deprived 1640
1660	William Nicolson
1672	John Pritchett (Prichard)
1681	Robert Frampton, deprived 1690
1691	Edward Fowler
1714	Richard Willis
1721	Joseph Wilcocks
1731	Elias Sydall (+1733)
1734	Martin Benson
1752	James Johnson
1759	William Warburton
1779	James Yorke
1781	Samuel Halifax
1789	Richard Beadon
1802	George Isaac Huntingford
1815	Henry Ryder
1824	Christopher Bethell
1830	James Henry Monk‡
1856	Charles Thomas Baring
1861	William Thomson
1863	Charles John Ellicott
1905	Edgar Charles Sumner Gibson
1923	Arthur Cayley Headlam§
1946	Clifford Salisbury Woodward¶
1954	Wilfred Marcus Askwith
1963	Basil Tudor Guy
1975	John Yates

Note: For biographical notes of the bishops to 1815 see Dugdale, W., *Monasticon Anglicanum* vol. 1, 1817, 538–539, and Fosbrooke, *An Original History of the City of Gloucester*, 1819, 93–99.

* Bishop of Bristol in *commendam* from April 1562.

† Consecrated to the see of Gloucester and Bristol in 1589.

‡ The Sees of Gloucester and Bristol were joined in 1836, and divided in 1897, with effect from 1 January 1898.

§ Resigned 1945.

¶ Resigned 1953.

Miles Smith

Robert Frampton

Edward Fowler

Richard Willis

Joseph Wilcocks

Martin Benson

William Warburton

Richard Beaden

George Isaac
Huntingford

Henry Ryder

Christopher Bethell

James Henry Monk

Charles James Ellicott Edgar Charles Gibson

Bishops of Gloucester from 1602 to 1905

ABBOTS AND THEIR PRINCIPAL BUILDING WORKS

Serlo	1089	Began building the Norman abbey church.
	1100	Eastern arm of the building dedicated.
	c. 1126	Nave of the abbey church completed.
Peter	1104–13	A wall built round the abbey precincts.
Carbonel	1179–1205	St Mary's Gateway.
Thomas de Bredon	1224–43	Extensive new building works and remodelling in the Early English (Gothic) style. Ralph de Wylington's Lady Chapel 1224–7. Vaulting of the nave, completed 1242. Infirmary, and screen in north transept. Undercrofts of Little Cloister House and the Parliament Room. Other work of this period: two north doors of great cloister and the dark cloister, remodelling of the north-west chapel of the crypt, windows in axial chapel in the crypt, the west front of church house. Wooden effigy of Robert of Normandy, and stone effigy of Serlo in the presbytery.
Thokey	1307–29	South aisle of the nave rebuilt 1318. New dormitory built 1303–13. Window tracery, with ball-flower, in several windows. Interment of Edward II 1327.
John Wygmore	1329–37	Shrine of Edward II. South transept re-modelled 1331–6 in London Court style including earliest surviving Perpendicular window.
Adam de Staunton	1337–51	Remodelling of the choir and presbytery including the Perpendicular panelling and lierne vault, and stalls on the north side. The great east window.
Thomas Horton	1351–77	High altar and presbytery; stalls on the south side The great cloister, as far as the Chapter House. The north transept 1368–73
Walter Froucester	1381–1412	The great cloister completed. Compilation of the *Historia*. Tomb of Knight and his Lady in south aisle of nave, and window above.

John Morwent	1420–37	West end of the nave reconstructed; new south porch, clerestory windows of the nave.
Thomas Seabroke	1450–7	Central tower begun by Seabroke, completed by Robert Tully, a monk of Gloucester and afterwards Bishop of St David's. Tiles in the presbytery *sacrarium*. Tomb of Abbot Seabroke
Richard Hanley	1457–72	Lady chapel begun by Abbot Hanley William
William Farley	1472–98	Lady chapel completed *c.* 1485. East end of Chapter House. Other work about this time, though possibly a little earlier: west doorway into great cloister from the nave, chapel and wooden screen in south transept.
William Parker	1514–39	King Edward's Gateway rebuilt, by Osberne the cellarer. Registers compiled. Tomb of Abbot Parker and Prince Osric.

Seal of the Abbey of St Peter, Gloucester

DIMENSIONS OF THE CATHEDRAL

In spite of the apparent exactness in the following metric measurements they are, in fact, only approximate being based on the conversion of measurements to the nearest foot. In tables of measurements given by different authorities there are variations. This is sometimes due to measurements being taken from the exterior or the interior.

	m	ft (approx)
Overall length	128.3	421
width, at transepts	43.9	144
Choir: length	43.9	144
height	26.2	86
width	10.4	34
Height of apex of great east window from floor	26.5	87
Transepts: length	20.1	66
width	13.1	43
height of north trans.	23.8	78
height of south trans.	26.2	86
Nave: length	53.0	174
width	25.6	84
height	20.7	68
Nave piers : height from present floor level	9.3	$30\frac{1}{2}$
Circumference	6.4	
Width between each	3.8	$12\frac{1}{2}$
		$12\frac{1}{2}$

	m	ft (approx)
Lady chapel: length	27.4	90
width	8.2	27
height	14.3	47
Tower: height	68.6	225
Great cloister: length of walks	44.8	147
width of walks	3.8	12½
Height of fan-vaulting from floor	5.6	18½

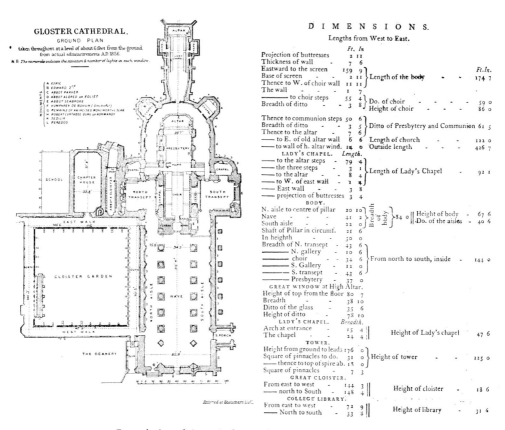

Ground plan of the cathedral, and list of dimensions, 1856

THE MISERICORDS

The misericords are numbered from the dean's stall and round to the bishop's throne, along the south side of the choir; continuing from the east end of the north side of the choir to the return and canon-in-residence's stall. For notes on each carving see Clark, O.W., *The Misericords of Gloucester Cathedral, Trans. BGAS*, vol. xxviii, 1905. Photographs of the complete series by Jack Farley (1981). An asterisk indicates a nineteenth-century carving (1872/3). Place in brackets indicates where a misericord of similar design may be found.

South Side – From the West End

1 Adoration of the Magi.*

2 Two dragons fighting (Boston Parish church).

3 Giant with a club being slain by a knight, his charger stands behind him.

4 Samson and Delilah. Samson lies sleeping as Delilah cuts off his hair.

5 Bear-baiting. Bear with collar and chain; dog with collar only. Behind them a man in a jerkin (the bear-keeper) holds stick. Two hats on the left.

6 Two bearded men running at each other; the one on the right tries to prevent his assailant, who is left-handed, plunging his sword into him.

7 The Coronation of the Virgin* (Chester Cathedral). Christ and the Virgin are crowned and seated beside each other in a canopie! *sedilia*. Turned towards each other, Christ holding an orb is blessing the Virgin.

8 The Flight of Alexander. After his conquests, Alexander the Great wanted to survey his empire from the heavens. Crowned and seated on his throne, with a griffin segreant on either side, Alexander holds aloft at the end of poles boar's heads in the hope that the griffins will be induced to lift him heavenwards.

9 Owl being pestered by other birds. Possible allusion to the persecution of the Jews (often represented by an owl in medieval art and literature).

10 Lady in an orchard; birds in the trees. Her dog, seated, looks up at something she is holding or doing. She may be shaking a branch of a tree.

11 Two monsters, one male with hands but an animal body with hind feet and bushy

Plan of the stalls in the choir showing the distribution of the two basic designs of canopy, and
the numbering of the misericords

 tail, the other female with no hands, but three-clawed feet and tail. Both bodies
feathered.

12 Knight riding at full speed bending forward on his charger's neck. His helmet is
cylindrical and closed; he holds his shield forward and wears a surcoat and rouelle
spurs. He appears to be charging a dragon. Possibly a representation of St George
slaying the dragon.

13 The Sacrifice of Isaac* (Worcester Cathedral). Compare 47. Isaac kneels on bundle
of wood; Abraham wealds large sword preparing to sacrifice his son. Hand from
heaven stays his action. Ram caught in thicket behind Abraham.

14 Mermaid swimming holds a large fish with each hand.

15 Three shepherds, with crooks and tools slung from their waists, follow a sheep,
with their dog behind them. Middle shepherd looks up and gazes intently into the
sky ahead of them.

16 Pelican in her piety. An exceptionally well-preserved and beautiful medieval
carving.

17 Man being swallowed by a monster* with only two feet (a wyvern) (Worcester
Cathedral).

18 Nude female figure, covered with a net, carrying a rabbit and riding on a goat
though with one foot on the ground. Probably the old Norse tale about Queen Disa
'riding but not riding, clad but not clad and with a gift that is no gift.'

19 Male figure riding a goat* but facing backwards blowing a horn (Worcester
Cathedral), but owing much to 28 of the Gloucester series.

20 Moses reading the Commandments to Israelites* (Worcester Cathedral).

21 Hawking.* Rider, wearing pointed shoes and rouelle spurs, with reins in one hand and a long whip in the other, pursuing hawk pouncing on a duck. Bearded beater, with tabor, following. Copied from 27.

22 King seated on throne* being raised by griffins segreant. King with finger raised points skywards. The Flight of Alexander; compare 8 and 26.

23 Two angels playing instruments* (hand and part of bow of one angel missing) (Chester Cathedral).

24 Two dragons, their necks joining in one head, that of a jester with cowl and asses ears (Winchester Cathedral).

25 Crowned figure, with long hair, reclining on right arm. Crown damaged.

26 The Flight of Alexander . Compare 8 & 22. Griffins are chained by the neck to the throne, and straining upward in flight to recover the deer's leg skewered on poles above them.

27 Hawking. Compare the nineteenth century copy 21. Medieval original far more dramatic. Hawk's claws reach forward to grab the duck. Hawk's wing damaged.

28 Male figure riding a goat, and blowing a large horn (missing). Behind rider hanging from the saddle a dead hare or rabbit. Background of foliage. Compare nineteenth century copy 19.

29 Man lying down, apparently asleep, embracing a donkey. Possibly inspired by Balaam and his ass, but more probably Aesop's fable of the ass jealous of his master's attention to his dog.

North Side – From the East End

30 A boar and swine feeding on acorns in the forest. In the branches of an oak tree a bird and a fox (or squirrel).

31 Two four-footed dragon-like monsters, one savagely biting the head of the other.

32 Two youths, possibly jougleurs, playing with balls or discs, and dice.

33 Two youths, similarly dressed as 32, playing with a large ball, apparently bouncing the ball.

34 A lion fighting a dragon, with bat-like wings clearly shown.

35 Elephant, with feet like a cart-horse, a horse's tail, and a trunk shaped like a trumpet at the end, and carrying an embattled howdah. Carver had not seen an elephant. One of the Exeter Cathedral series carved from life. Louis IX of France gave an elephant to Henry III in 1254, which was seen by many at the time.

36 Eagle, with hugh talons, attacking a beast of prey.

37 A winged human figure, probably representing St Michael, thrusting his spear through the head of a four-footed winged dragon.

38 Huntsman, with pointed shoes and rouelle spurs, riding at speed holding the reins in his left hand, and blowing a hunting-horn held in his right hand. A dog is running beneath or beside the horseman.

39 Temptation of Adam and Eve* (Worcester Cathedral), though not exactly. Eve gives Adam an apple. The serpent twined round a tree has wings and apparently a human head, with large ears and horns which peers through the tree at Eve.

40 A heavy horse, with a four-footed animal with a curling tail and semi-human face mounted on its back.

41 A lion (or a wolf) attacking a fox. Possible allusion to an Aesop fable.

42 A gentleman, reclining on his left arm. Finely dressed, with purse and dagger at his waist.

43 Lion attacks a two-legged dragon, biting its neck, and the dragon's tail curls behind and over the back of the lion.

44 A huntsman on foot, with a (broken) long-bow in his hand aims an arrow at an animal, possibly a fox, in a tree. Beneath the tree two dogs (heads missing) stand against the trunk looking up at the trapped animal.

45 Lion fighting a dragon. Dragon lying on its back. Both attacking the other's hind-quarters.

46 Presentation in the Temple* (Worcester Cathedral). Probably the presentation of the child Samuel at Shiloh.

47 A man reclining on his left arm, and holding a pole in his right hand. Compare 53.

48 A fox, with a splendid brush. carrying off a goose. Fox and geese legend often the subject of painting, stone and wood carving and painted glass in medieval times.

49 The Sacrifice of Isaac. Abraham with his hand on Isaac's head as the boy kneels on a dressed altar, holds his sword in his right hand, but he is being restrained by a winged angel. Much of the sword is missing. A ram caught in a thicket is near the altar.

50 A large griffin, a four-footed beast with the wings, head and feet of an eagle.

51 The Vintage. One man with a knife, gathers bunches of grapes from a wide-spreading vine, and places them in a basket held by another.

52 The Tournament, or Combat of knights* (Worcester Cathedral). The knights wear plate-armour, helmets and spurs. The horses' harness and the knights' armour is richly decorated and shown in great detail. The work of a gifted carver.

53 Human figure, lying down or reclining on his left arm, with staff in his right hand. Similar to 47.

54 Deer-stalker discharging an arrow (long-bow broken, in his left hand) arrows in quiver at his waist. In front of him, a large stag is brought down.

55 An angel, reclining, holding a book between the hands which are held together in an attitude of prayer. The band or scroll across the body is for the angel's message – a common device in glass painting and in sculpture.

56 Beneath the spreading branches of a tree are two boys (their heads are missing); the posture and the cut in the trunk of the tree suggest they may be felling the tree. A larger figure, possibly carrying a basket (which is also missing) moves towards them. Two animals forage close by.

57 The Wrestlers. Two men stripped to the waist, hold each other with a cloth around the neck.

58 Beast of prey, possibly a lion, attacking a winged dragon, which is lying on its back* (Worcester Cathedral). The dragon is biting the lion's throat.

THE DECORATIVE TILES

The best introduction to the subject is Eames, E.S., *Medieval Tiles: A Handbook*, British Museum. See also Eames, E.S., *Catalogue of Medieval Tiles*, 2 vols., British Museum, 1980. On the tiles at Gloucester Cathedral: Porter, A.S., 'Some Notes on the Ancient Encaustic Tiles in Gloucester Cathedral', *Archaeological Journal*, vol. 47, 1890, and Lysons, S., *A Collection of Gloucestershire Antiquities*, London, 1804, and Kellock, A.P.,*Trans. BGAS*, 1989. For illustrations of the Seabroke pavement see Shaw, H., *Specimens of Tile Pavements drawn from existing authorities*, London, 1858.

Many fine examples of medieval tiles have survived in the cathedral. There are several extensive pavements.

1. The Seabroke pavement in the choir *sacrarium* dates from 1455 though, as J.H.A. Billett noted *c.* 1880 this is 'a genuine work of restoration, the ancient tile floor having been carefully preserved and relaid.' Many tiles from various parts of the cathedral were arranged in this area by S. Lysons early in the nineteenth century. See Chapter 12.

Anne Kellock notes that 'it is almost certain that the Abbot Seabroke tiles came from Malvern. In all there are twenty-nine individual tile designs or parts of designs, and they have been put together in a variety of ways'. Heraldry was frequently used in the design of tiles; Kellock observed that 'there are six coats of arms depicted on the Seabroke tiles, incorporated in nine different designs. These are the arms of Clare, of England after *c.* 1405, of St Peter and St Paul for Gloucester Abbey, of Westminster Abbey, of Edward the Confessor and of Beauchamp. With the Seabroke arms, and the motto *fiat voluntas Dei* (God's will be done), others are associated, benefactors of the abbey such as the Brydges, and by name officers of the monastic community.'

Kellock also notes that the steps and risers from the pavement to the alter platform are tiled with designs known from Worcester Cathedral. 'These tiles were made in the Droitwich kilns about 1370, and therefore antedate the pavement. The floor of the sedilia on the south side also contains some Droitwich tiles.'

2. The pavement, less well-preserved, in the *sacrarium* of the lady chapel *c.* 1475. Fragments of the design of this pavement still exist in various parts of the chapel, particularly at the west end beneath and around the font, suggesting the pavement originally covered the entire floor area. Following the burials of the seventeenth and

Knight mounted on charger. Fourteenth-century tile in tribune gallery

eighteenth centuries, the floor was relaid and the surviving medieval tiles relaid. There is a group of tiles from various parts of the church preserved half-way down on the south side of the chapel. Among these is one containing the arms of Henry Dene, Archbishop of Canterbury 1501–3. He was Prior of Llanthony to his death, having retained the office *in commendum* during his episcopate at Bangor, Salisbury and Canterbury. See Chapter 13.

3. The pavement at the east end of the Prior's Chapel (in Church House – viewed only by appointment). This is partly made up of tiles decorated with the griffin design found also at Tewkesbury and at Broadway, Worcestershire. See Chapter 10.

4. The pavement in the south-east chapel of the tribune gallery which was laid *c.* 1873 in order to preserve tiles which would otherwise have been covered when the high altar was raised by an additional level during the Gilbert Scott restoration. These tiles were carefully laid in their original pattern as part of the Seabroke pavement. Tiles of various dates and from different parts of the building, displaced during the Victorian restoration of the building, were laid at this time in the apse of the chapel. Set among them are two thirteenth-century tiles depicting knights tilting, similar to tiles found at Romsey, Lewes and Tintern. See Chapter 10.

There are some interesting tiles elsewhere. (1) Around the tomb of Edward II. It is possible that at the same time as this area was paved *c.* 1335, as part of the reconstruction of the east end of the building, the entire choir and presbytery was also paved. Tiles of a similar design are found in the risers of the steps leading up to the high altar. (2) Around Abbot Parker's memorial, within the chantry, are tiles of a larger size (15 cm square) some containing the abbot's arms. (3) In the north-east and south-east ambulatory chapels are the remains of original pavements, but the tiles are much worn. (4) Tiles from the fourteenth-century paving of the nave survive beneath the Georgian paving stones. A few of these can be inspected *in situ* near the Raikes monument and at the foot of one of the central responds in the south aisle. Elsewhere tiles have been relaid in order to preserve them e.g. in the axial chapel in the crypt and in the Bridge chapel.

Victorian floor tiles: Those in the Chapter House are by Minton, their designs being copies of medieval tiles still surviving there at the time of the Chapter House restoration in the

nineteenth century. Those in the choir and presbytery were made by Godwin of Lugwardine, near Hereford. They are reproductions of medieval tiles found in various parts of the cathedral, as well as those in the *sacrarium*. Masse's judgement of them was shared by many at the time: 'Ostensibly copied from the old ones, but of a different size, with an excessive glaze, and very stiff in design and execution.' See Chapter 22.

In the presbytery eighteen incidents from the Old Testament are depicted in white marble on black square grounds. The subjects are delineated in black lines and arranged in pairs. Read from left to right approaching the altar:

1 Adam and Eve in the Garden of Eden.
2 The Temptation and Fall.
3 Adam and Eve expelled from the Garden of Eden.
4 The Death of Abel.
5 The Flood, with the ark floating on the waters.
6 The Ark resting on Mount Ararat; Noah and his family offering sacrifice.
7 Abraham and Isaac journeying to Mount Moriah.
8 Abraham about to offer Isaac.
9 Isaac blessing Jacob; Esau returning from hunting.
10 Joseph sold by his brothers to the Ishmaelites.
11 Joseph on his death-bed.
12 The Institution of the Passover.
13 The Song of Miriam; the Israelite women at the Red Sea.
14 Moses with the Tablets of the Law.
15 Moses showing Aaron the plan of the Tabernacle.
16 David bringing the Ark from the house of Obededom.
17 The Building of the Temple of Solomon.
18 The Dedication of the Temple of Solomon.

APPENDIX VI

THE ANGEL CHOIR

The literature on angel choirs is extensive. For the angel choir at Lincoln see Glenn, V., 'The Sculpture of the Angel Choir at Lincoln', *BAA Conference Report on Lincoln*, 103–7; at Westminster *Archaeologia*, vol. lxxxiv, 63; at Tewkesbury, *Archaeologia*, vol. lxxix, 76; at Exeter Cave, C.J.P., *Medieval Carvings in Exeter Cathedral*, Penguin, 1953, and on Gloucester's angel choir, Cave, C.J.P., 'The Roof Bosses in Gloucester Cathedral', *Trans. BGAS*, vol. 53, 99–111.

It is not uncommon to find, in medieval sculpture and stained glass, a group of angels playing musical instruments. At Exeter cathedral there is the minstrel's gallery; at Lincoln the angel choir, and a fine choir of angels at Westminister Abbey. As in other instances, the Gloucester angel choir is set among naturalistic foliage, and is associated with a 'Coronation of the Blessed Virgin'. The Gloucester choir may have been inspired by the slightly earlier series at Tewkesbury where ten of the instruments held by the angels at Gloucester are also found. Practically all the instruments which appear in angel choirs have been identified, and many of them are available as playable replicas or reproductions and used in the current revival of English medieval music.

However, the identity of some of those at Gloucester is questioned. Describing the musical instruments in the windows of the Beauchamp Chapel at Warwick, William

Plan of the angel choir above the high altar

Bentley remarks 'The various instruments have evidently been carefully drawn from actual specimens, but not by a musician, for while the general outlines are well done – wonderfully well done if we consider the limitations of the material – the details are often wrong.' The same might be said of details of the carving of the instruments in the angel choir at Gloucester. Several of the sixteen instruments are damaged, but not in the cases where identification is difficult.

The angels in the choir at Gloucester are all bareheaded, with long hair hanging down to the shoulders. They wear an undergarment with close-fitting sleeves and a loose cloak over it fastened over the chest with a diamond-shaped clasp. The upper part of the wings are bare, no feathers being indicated, except in two cases. The large primary feathers are shown in all cases. The feet are always bare. In the centre of the group is a large figure of 'Christ in Majesty'. He is bareheaded and has no nimbus. He has long hair falling over his shoulders, and a long beard. He wears a long voluminous robe with very full sleeves, fastened with a large circular clasp on the chest. His left hand rests on an orb, and the right is raised in blessing.

The plan shows the arrangement of the angels on the south side. The angels on the north side are arranged similarly but reversed, so that in each case the angel numbered 1 is nearest the great east window.

South Side – From the East End

1 As on the north side, this boss represents a grotesque, with masses of hair coming from the forehead, cheeks and chin.
2 Angel with a citole with three strings; there is a bridge, two C-shaped holes. The tuning pegs are shown. It is played with a plectrum.
3 Angel blowing a very short wind-instrument with a cup-shaped mouth and large bell, and no sign of fingering.
4 Angel blowing a long trumpet with cup-shaped mouth and large bell. Probably a buzine.
5 A short and straight wind-instrument with cup-shaped mouth, no bell, and no sign of fingering.
6 Probably a recorder, though the bell is rather large for that instrument. Possibly a shawm.
7 Angel with psaltery.
8 Angel with cymbals.
9 Angel holding a rather large tau-cross in his right hand, and three large nails in his left hand.
10 A double wind-instrument one side of which is much shorter than the other, though the end of one pipe may have been broken off. Possibly a double recorder.

North Side – From the East End

1 Angel with a gittern. The instrument is held horizontally and played with a plectrum. It has three strings and three tuning pegs. There are no signs of sound holes, but the bridge is shown.

2 Angel with bagpipe, but only the chanter and the bag remain. A small projection over the left shoulder is part of the drone.

3 Angel with rybybe with three strings, tail piece, bridge and sound holes on each side. The bow is played overhand.

4 Angel with pipe and tabor. The latter rests on the left arm instead of hanging down from it as was usual at a later date. A snare is indicated across the tabor, and the angel holds a drumstick in the right hand.

5 Angel with portative organ with about thirteen pipes. The keyboard is facing downwards and is being played by the right hand. About ten notes are shown. It is being held underneath by the left hand. It is not clear how it was blown, unless the support underneath by which it is being held is also the bellows.

6 Angel carrying timbrel with jingles.

7 Angel with symphony showing the crank for turning the wheel, three tuning pegs, and a keyboard with about twelve keys.

8 Angel with harp. The upper corner is broken away, but it probably had about a dozen strings.

9 Angel with Passion emblems. In the left hand a spear of which the point is missing; in the right hand a wreath or crown of thorns.

10 Angel carrying a palm in the left hand with the upper part resting on the left shoulder.

THE BELLS AND CHIMES

See Bliss, M., *The Church Bells of Gloucestershire*, 1984. Also Thurlow, G., *The Tower, Bells and Chimes of Gloucester Cathedral*, 1979. Lukis, W.C., 'The Bell Foundry of Gloucester', *Journal of the Archaeological Association*, vol. 27, 1871, 416f. and Sharp, F., 'Church Bells', a lecture to the Friends of Gloucester Cathedral, GCFR, 1958, 8–19. See also: *Trans. BGAS*, vol. xviii, 1893–4, and vol. xlii, 1920.

The Saxon monastery may well have had a bell. Thurlow quotes Bede (Eccl. Hist. IV,23) who recalled that when St Hilda, Abbess of Whitby (614–80), was dying a nun at Hackness 13 miles away 'heard the well known sound of a bell in the air, which used to wake and call them to prayer when any one of them was taken out of this world . . .' During excavations at St Oswald's Priory, Gloucester, in 1977 a bell-mould was discovered which was thought to date from the ninth century. The Norman abbey church with its massive tower would certainly have had several bells, probably cast near by. But nothing is known about them and none have survived. But in the fourteenth century Gloucester was well-known for its bell foundry, and in particular for the work of a master-founder called John. Master John of Gloucester was so renowned a founder that the monks of Ely sent for him in 1346, even though there were bell-foundries at Norwich. Master John cast four bells for the newly constructed octagon at the crossing, the largest called 'Jesus' weighed 37 cwt. All four were cast at Ely.

The bell-hole in the vault at the crossing at Gloucester *c.* 1345 may seem to have been designed to enable 'Great Peter', weighing more than 59 cwt, to be hoisted into position in the tower. It is an inch wider that the bell. This has often been stated, and repeated as evidence that 'Great Peter' was cast at sometime before 1345. However, in Bliss's words, 'there is no possibility at all that it was cast before 1400; it has a number of characteristics, including the black letter minuscules, which do not appear on London bells until after 1400 and later still in the provinces'. The bell must, therefore, have been cast to fit the hole, assuming, of course, that the bell-hole is part of the original design of the vault, and not opened in the vault at the time of the construction of the tower.

Abbot Seabroke's tower (1450–60) was clearly designed to house a peal of bells, perhaps as many as ten in all. But Abbot Parker in his Register records that a certain Thomas Loveday, described as a 'burgeys and blaksmyth' agreed to repair the 'eight

belles' and the chimes. After the Dissolution 1539–40 all the 'churche goods, money, juells, plate, vestments, ornaments, and bells' were entered in an inventory and handed over to the king's commissioners. But the commissioners returned to the Dean and Chapter 'to and for the use and behouf of the seid Churche, one chalys being silver and whole gilte without a paten waying xi.oz. and also one grete bell where-uppon the cloke strykithe, and eight other grete bells whereupon the chyme goethe hangynge in the towre there within the seid church save and surely to be kept until the King's Majesty's pleasure shall be therein further knowen.' This was dated 27 May 1553, and as the king died within three months his pleasure in the matter, as Masse pointed out, was never 'further knowen' and Gloucester rejoices still in its bells and chimes.

In 1632 the bells were rehung in an oak frame. This survived until the major restoration of the bells under Gilbert Thurlow in 1977–8, when it was replaced by a new frame in iroko wood. The Rudhall family made bells in Gloucester during the late seventeenth, eighteenth and nineteenth centuries, bells which went all over the country. Several of the bells in the Gloucester peal were cast by them. At the west end of the north aisle are four memorials to members of the family: Elizabeth, wife of Abraham Rudhall 'of this City, bellfounder', who died 1699. This memorial incorporates a bell; and three smaller memorials, to Abraham Rudhall, a mercer 'of this City, Gentleman' who died 1798, and Charles (1815) and Sarah (1805) 'widow of Abraham Rudhall of this City, gent.' The Rudhall bellfoundry closed in c. 1845.

The recent work (1978–9) was carried out by the Whitechapel foundry. Of the old ring of ten, the treble and second were recast, the third and fourth were taken out of the ring, but retained for their historic value, and replaced by new bells, the fifth recast and the remaining five were retuned. A new treble and second were added, one from St Nicholas' Church in Westgate Street, Gloucester, augmenting the peal from ten to twelve. The old ring of ten is described by Fred Sharpe in Report GCF, 1958, 8–19. The twelve consist of the following:

Treble	2ft 2in	Gift of F.Sharpe FSA and Mary Bliss JP. Cast from the tenor of St John Northgate.
Second	2ft 3in	Gloucester and Bristol Diocesan Ass. of Church Bell Ringers from the Banner Bequest.
Third	2ft 4in	Prosperity to the City of Gloucester 1706 Recaste at Whitechapel 1978.
Fourth	2ft 5in	Albert Estcourt, Mayor of Gloucester gave my casting at Loughborough 1898. Margaret Coppen-Gardner gave my recasting at Whitechapel 1978.
Fifth	2ft 6½in	Great Peter was rehung to swing, the ten bells rehung in a new iroko frame and augmented to twelve 1978.
Sixth	2ft 7½in	Given by the Friends of Gloucester Cathedral to mark the twenty-sixth year of service as their honorary secretary of Anne Butt, MBE, 1978.
Seventh	2ft 9½in	John Rudhall,Gloucester fect 1810. Recast 1978 by the Whitechapel Bell Foundry in mem. of M. Burella Taylor 1894–1975, Principal of the Gloucestershire College of Education 1945–56.

'Great Peter'

Eighth	2ft 11½in	John Rudhall Gloucester fect J810 (large ornamental border).
Ninth	3ft 3½in	*IN MULTIS ANNIS RESONET CAMPANA JOHANNIS +*
Tenth	3ft 6½in	*SUM ROSA PULSATA*
Eleventh	4ft 0in	(Recessed and reversed letters) sileirbaG nemoN oebaH sileC eD issiM (in relief reversed) 6261 T: W: E (On crown set correctly in relief). I: P: 1626.
Tenor	4ft 3½in	Dan: Newcombe Decan Nath: Lye Subd: Nath: Panting Thes: a (Bell) R Anno 1736 (Arabesque border).

Great Peter

Great Peter is England's only remaining medieval Bourdon or 'great bell'. Its diameter is 68½ in, and it weighs 59 cwt 3 qr 14 lb. It is inscribed: *ME FECIT FIERI CONVENTUS NOMINE PETRI*. Between each word is a shield bearing the Arms of Gloucester Abbey, and in several places are the marks of an unidentified bellfounder.

The Clock and Chimes

The clock, in the corner of the ringing chamber, has no exterior face though it used to work the clock on the west wall of the north transept. Its present function is to strike the

hours on Great Peter, the quarters on the 7th and 10th bells, and to play the chimes at 8 a.m., 1 p.m. and 5 p.m. on the back eight of the ring of twelve and on Great Peter.

The Chimes have a long history. In the Register of William Parker, the last Abbot of Gloucester, is an agreement with Thomas Loveday, Bellfounder, dated 1527, in which the latter 'hath covenaunted and bargayned with the Abbott to repayre a chyme gong uppon eight belles, and uppon two ympnes, that is to say *Christe Redemptor Omnium* and *Chorus novae Ierusalem* well-tuynable, and wokemanly, by the Feast of All Sayntes next ensuinge, for whych the seid Abbott promyseth to pay the seid Thomas Loveday four marcs sterling at the fynisshement of his seid repayre.' This implies that the abbey had a ring of eight in the diatonic scale and a clock playing tunes upon them for some time before 1527.

Charles Lee Williams, organist 1882–97, wrote a leaflet describing the tunes played by the carillon. But those played now three times each day are as follows:

Sunday	Easter Song: from the *Catholische Kirchengesange*, Cologne 1623, a well-known hymn tune, sung to 'All creatures of our God and King'.
Monday	*Chorus Novae Jerusalem*: an old Easter melody *c*. tenth century.
Tuesday	Stephen Jeffries' tune: Jeffries, organist 1682–1712/3
Wednesday	Dr William Hayes' tune 1708: a chorister of the cathedral, later organist of Worcester and Professor of Music at Oxford.
Thursday	Dr John Stephens' tune 1720: another chorister of the cathedral, and later organist of Salisbury Cathedral. He wrote the tune played by the carillon for the Music Festival 1766 which he conducted.
Friday	*Christe Redemptor Omnium*: an old Christmas melody *c*. tenth century.
Saturday	Mr Malchair's tune 1730: Malchair 1731–1812 was an Oxford drawing master and musician, and one of the principal instrumentalists at the Three Choirs Festival 1759–75.

THE ICONOGRAPHY OF THE LADY CHAPEL REREDOS

In addition to the *Oxford Dictionary of the Christian Church* (ed.) Cross, F.L., there are more popular books on the Saints of the Christian Church published by Penguin and OUP. On medieval graffiti in general see G.G. Coulton's article 'Medieval Graffiti', *Medieval Studies*, vol. 12, 1915. The following note is much indebted to Short, H.H.D., 'Graffiti on the Reredos of the Lady Chapel of Gloucester Cathedral', *Trans. BGAS*, vol. lxvii, 1946–8, 21–36.

The reredos is divided into three compartments each with a large niche which would have contained the three main figures: St Mary the Virgin in the centre with St Anne, the mother of the Virgin on her left, and probably St Peter, patron saint of the abbey, on her right. Around these figures were clustered, in smaller niches, an array of saints and martyrs. Though the niches have been empty for centuries the identity of many of them and their positions in the reredos is known because the master-mason cut their names in the stone at the back of the niches. Most of the names are written in the same bold

Plan of the lady chapel reredos

scrawl, a few are written in small, rather neater handwriting. All were probably written after the reredos had been assembled in position because certain letters are scratched on the cement between adjacent stones. Names are found in most of the seventeen vertical compartments of the reredos, though not in the three larger compartments.

The fourteen vertical compartments from left to right are divided up in a pattern of 3 x 4 x 4 x 3 with the three principle compartments (x) spaced out accordingly. In the first vertical compartment there are three niches, in the second two, and in the third three. In the group of four compartments on the left of the central niche there are three niches in the first, two in the second and third, and three in the fourth. The niches are similarly placed on the right of the central niche. Numbering the verticle compartments from left to right, and the niches in each compartment, by letters from the bottom, the names of the saints and martyrs appears to be as follows:

1	a	G[eronte]	A doubtful reading, possibly a Celtic saint.
	b	Arilda	Virgin and martyr of Gloucester.
	c	Luci[us]	King Lucius, whose body, according to Geoffrey of Monmouth, was buried in Gloucester.
2	a	Ism[a]ele	St Ismael, a sixth-century Welsh bishop.
	b	S[anct][us]	Biliffr – the only instance where one of the contracted forms of *sanctus* is prefixed to the name.
			With b replacing w the symmetry of the screen suggests St Wilfred of York.
3	a	Keneburga	Virgin daughter of Penda who assisted in the foundation of Peterborough Abbey and died there.
	b	Dorete	St Dorothy, Virgin and martyr.
	c	Hodu[l]pe	St Odulph whose relics were preserved at Evesham Abbey.
4			No name.
5	a	Blesius	Bishop and martyr, a popular saint in medieval England.
	b		No name has survived.
	c	Appolonie	St Appolonia, virgin and martyr.
6	a		Illegible.
	b	Jacobe	Presumably St James the Great, apostle and martyr.
7	a	Bon[. . .]	Or, possibly Lon. . . Probably St Boniface, Archbishop of Mainz in the eight century, born at Crediton, but no dedications in Gloucestershire.
	b	Michiel	If the archangel, there is no symmetry with the south side. Possibly the Celtic St Mechell, confessor of Anglesey.
8	a	Gabereel	Gabriel, the archangel.
	b	Lisbete	Elizabeth, mother of St John the Baptist.
	c	Eva[n]geliste	St John the Evangelist.
9			No name.
10	a	Bottope	St Botolph, the seventh century founder and first abbot of Icanhoe in East Anglia, patron saint of travellers. Popular saint with dedications in central and eastern England.
	b	Ozolde	Probably King Oswald. His body was buried at Gloucester after translation by Ethelfleda from Bardney.

Examples of the graffiti on the lady chapel reredos

11	a	Brigidde	The sixth-century Abbess of Kildare, after St Patrick the second patron saint of Ireland. St Briget of Sweden is not a likely identification for Gloucester.
	b	Barele	With l substituted for r, probably Barbara. The church of Ashton under Hill, Gloucestershire, is dedicated to her.
12	a	Beneffrida	For b read w, as often occurs, so St Winefred, patron saint of North Wales. In 1398 her feast was ordered to be observed throughout the province of Canterbury.

	b	Stevem	Probably the first martyr, St Stephen.
13	a	Elkbin	Again, for b read w, and so probably the Celtic Egwin, Bishop of Worcester and founder of Evesham Abbey.
	b	Annis	St Agnes.
	c	Ke[n]ele[m]	Probably the Celtic St Kenelm who was buried at Winchcombe.
14			No name.
15	a	Margerete	St Margaret of Antioch (possibly St Margaret of Scotland).
	b	Katrine	St Catherine of Alexandria.
16	a	Efrede	With the elision of l and the substitution of r for l Elfleda, daughter of Oswy, King of Northumbria and Abbess of Whitby.
	b	Thomas	St Thomas the Apostle, but possibly St Thomas Cantilupe of Hereford, or to correspond with St Wilfred of York on the north side, St Thomas of Canterbury.
17	a	Atius	Second letter is uncertain but if d, then by elision of l, could be Aldatus, for Aldate legendary Bishop of Gloucester in the sixth century.
	b	[H]eerolt	First letter possibly g ; but otherwise the symmetry of the girl saint, Arilda, on the north side suggests this could be St Harold of Gloucester, the boy murdered by Jews in the thirteenth century.
	c	Adrianus	Probably the African archbishop-elect of Canterbury mentioned in the Celtic calendar.

From these details certain facts emerge. 1. There was a certain symmetry in the arrangement of the saints. 2. As appropriate to a lady chapel, virgin saints and martyrs predominate. 3. There is a high proportion of Celtic saints. 4. A number relate specifically to the history of the abbey itself. 5. Dependent upon the accuracy of the identification of their names, the graffiti provide a rare instance of an iconographical scheme for such a screen. 6. Evidently the orthography was largely influenced by phonetics. Barbele for Barbara, Bottop for Botolph and Ozold for Oswald. The last example suggests the phonetics could be of local origin.

The Organ and Organists

For a history of the organs of Gloucester Cathedral see Gillingham, Michael, *The Organs and Organ Cases of Gloucester Cathedral*, and technical articles on the redesigned organ of 1968–70 by Ralph Downes, and by Herbert and John Norman, *Gloucester Cathedral Organ*, 1971. Also, in the same booklet, Brian Frith's biographical notes on *The Organists of Gloucester Cathedral*. See also Bazeley, W., *Records GC*, 1889–97, vol. III, pt I, 73–89.

History of the Cathedral Organs

It is probable that an organ or 'pair of organs' stood on the *pulpitum* of the abbey church. Some twenty years after the Dissolution Robert Leichfield was appointed Organist and Master of the Choristers, but no description of the organ he played has survived. In Dean Laud's time (1616–21) the organs were said to be 'in greate decay and in a short time likely to be of noe more use.' In the early 1630 the 'organes' were repaired, but by 1640 Dallam had provided a new organ which was set up on a loft beneath the south crossing piers. Few details survive, but Thomkins 'approved' it in 1641.

After the Restoration the Dean and Chapter appear to have bought back their Dallam organ, which had escaped destruction, for £80 from a Mr Yate. This may have been the Chaire organ, which, after two years, was resold; though the evidence is confused. However, the case was incorporated into the case of the new instrument which Thomas Harris was commissioned to make in 1663. The carving of the case of the Chaire organ is reminiscent of the woodwork of *c*. 1630. It is delicate in its detail and has a quality and elegance which the main case lacks which, by contrast, is 'heavy in outline and bucolic in detail' and 'more the work of a provincial joiner.' An appeal was successful in raising the funds for Thomas Harris to complete the work by 1665–6. The pipes and woodwork were decorated by John Campion, a local painter of exceptional talent. According to Fosbrooke the organ was moved to its present position in 1718. In 1741 William Kent, as the request of Bishop Benson, designed a new choir screen. He was responsible, in all probability, for the Gothick pinnacles shown in F.S. Waller's tracing of an early eighteenth-century painting of the choir. This shows the organ on a loft beneath the south crossing piers. The organ case at Exeter was decorated with similar pinnacles at about this time.

Dr S.S. Wesley, Organist of Gloucester Cathedral 1865–76

Dr John Sanders, Organist of Gloucester Cathedral 1967–

Robert and William Gray carried out a considerable rebuild of the organ in *c.* 1788. J.C. Bishop made improvements and additions in 1830–1. But Henry Willis carried out a complete rebuild of the organ in 1847. Later in life he was to recall that his work at Gloucester proved 'my stepping-stone to fame.' The instrument was still firmly rooted in the Classical tradition. In 1888–9 Willis again carried out a complete rebuild, and with his additions of 1899, in Gillingham's words, 'we come to a modern instrument completely different in style to that of Willis' youthful success.' Willis set out his proposals and specifications for the organ in a report to the Dean and Chapter on 6 December 1887. Canon Bazeley noted the condition of the painting on the woodwork and on the pipes (*Records GCF*, vol. III). The pipes were cleaned and touched up by a local artist named Hyett.

In 1920 Messrs Harrison & Harrison rebuilt the organ, the cost being defrayed by Sir James and Lady Horlick in memory of their son, Major Gerald Horlicks who had been killed during the war. Dr Brewer advised on the specification – this is set out in detail by Gillingham (pp. 17–20). The console was redesigned, and the latest tubular pneumatic system was applied to all the action except the manual to pedal couplers which were mechanical. The blowing was by electric motor and fans. The organ was cleaned and overhauled and the pitch raised in 1947. In 1969 Ralph Downes drew up specifications for a complete rebuilding of the instrument, retaining the old cases. The paint work was restored by the Hon. Miss Anna Plowden and Mr Peter Smith. In the words of the present cathedral organist, Dr John Sanders:

On the tonal side it was felt that there should be a return to purer, more traditional sound in preference to one which was inflated and 'orchestral': that the façade pipes, silenced for 80 years, should be made to speak again, and that the case should, as formerly, contain the whole instrument, expressing visually as well as aurally the scope of the instrument's interior composition. The cathedral now possesses a most versatile and musical instrument, speaking with equal effect into both nave and choir, and able to fulfil its role as a church or concert organ with equal ease. It has four manuals, 55 speaking stops, and all the normal couplers and accessories. The action is electro-pneumatic and electro-magnetic.

Organists of Gloucester Cathedral

1562–1582/3	Robert Lichfield
c 1594 ?	John Gibbes
c. 1600–1620	Elias Smith
1620–1637/8	Philip Hosier
1638–1639	Berkeley Wrench
1640–1663	John Okeover (or, Oker)
1663–1664/5	Robert Webb
1665–1666	Thomas Lowe
1666–1673	Daniel Henstridge
1673–1678	Charles Wren
1679–1681	Daniel Rosingrave
1682–1712/3	Stephen Jefferies
1712–1730	William Hine
1730–1740	Barnabas Gunn
1740–1782	Martin Smith
1782–1832	William Mutlow
1832–1865	John Amott
1865–1876	Samuel Sebastian Wesley
1876–1882	Charles Harford Lloyd
1882–1897	Charles Lee Williams
1897–1928	Sir A Herbert Brewer
1928–1967	Herbert Whitton Sumsion
1967–	John Derek Sanders

THE NINETEENTH-CENTURY GLASS

The bibliography on the nineteenth- and twentieth-century glass of the cathedral is considerable. For full details see Welander, D., *The Stained Glass of Gloucester Cathedral*, 1985, and the bibliography of Chapter 10.

NAVE

W II	Baptism	Wailes of Newcastle	1859

South Aisle

s v	Four Evangelists	Rogers of Worcester	1865
s vi	The Crucifixion	Warrington of London	1859
s vii	Edward II	Clayton and Bell	1859
s viii	The True Vine	Bell of Bristol	1860
s ix	Coronation of Henry III	Clayton and Bell	1860
s x	The Passion	Warrington of London	1861
s xi	Acts of Mercy	Bell of Bristol	1861
s xii	Justice	Hardman of Birmingham	1865
s xiii	Christ's Healing Miracles	Clayton and Bell	1865

North Aisle

n v	The Risen Christ	Preedy	1865
n vi	Christ's Miracles	Clayton and Bell	1861
n vii	Martyrs	Clayton and Bell	1865
n viii	Three Saints	Restored by Hardman	1865
n ix	The Nativity	Clayton and Bell	1860
n x	Three Saints	Restored by Hardman	1865
n xi	Faith, Hope and Charity	Ward and Hughes	1862

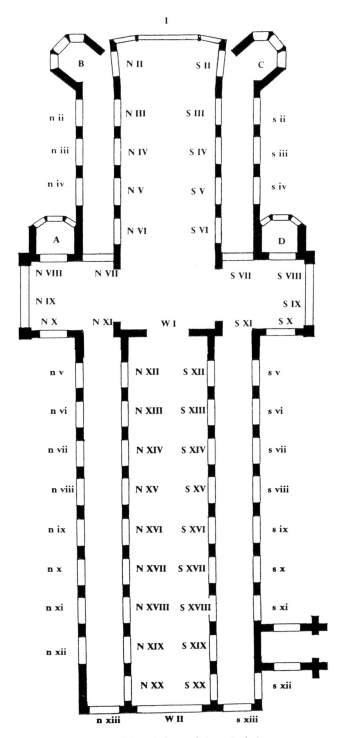

Plan of the windows of the cathedral

| n xii | The Resurrection of Christ | Clayton and Bell | 1872 |
| n xiii | Lucius Legend | Hardman of Birmingham | 1865 |

Clerestory

N XVIII – restored by Hardman 1856. Remains of medieval glass in other windows on the north side, restored by Hardman 1867 with the south clerestory windows.

GREAT CLOISTER

Facing the windows, the windows of each walk are numbered from left to right.

East Walk

1	The Garden of Eden	Hardman of Birmingham	1865
2	Prophecy of Messiah's birth	Hardman	1865
3	The Nativity	Hardman	1866
4	The Magi	Hardman	1865
5	The Boy Jesus in the Temple	Hardman	1855
6	Youthful Jesus with Baptist	Hardman	1966
7	The Baptism of Jesus	Hardman	1856
8	Christ with the children	Ballantine of Edinburgh	1864
9	The Temptations of Jesus	Hardman	1865
10	Christ's Healing Miracles	Clayton and Bell	1868

North Walk

1–5	Donated by Freemasons of Gloucester		late 1890s
6–9	*Lavatorium* – theme Water	Hardman	1868
6–9	Over the *lavatorium*	Lavers and Westlake	1896
10	Christ the Good Shepherd	Hardman	1898
11	Virgin Mary with Saints (West end of walk, on north side)	Morris and Co.	1924

West Walk

Windows glazed in late 1850s, preserving fragments of medieval glass in tracery.

South Walk

1	The Resurrection of Christ	Hardman	1868
10	The Conversion and Martyrdom of Paul	Hardman	1869
Carrels	Patterned glass	Hardman: first two	1856/7
		remainder completed	1869
6	Sixteenth-century heraldic glass from St Peter's Lodge, Prinknash		

TRANSEPTS

North Transept

N IX	The Life of St Paul	Hardman	1876
Chapel	Christ in Majesty	Burlison and Grylls	1870
N VII & VIII	Patterned glass	Restored by Hardman	
N XI	Clear glass, restored by	Clayton and Bell	
N X	Artistic Gifts and Learning	C.E. Kempe	1894

South Transept

S IX	The Life of St Peter	Hardman	1871
Chapel D	The Life of St Andrew	Hardman	1868
S X	Architects, sculptors, painters	Clayton and Bell	1889
S XI	Clear glass, some old quarries	1909	
S VII & VIII	Restored fourteenth-century glass	Hardman	1863

CHOIR

Choir Ambulatory

n ii	Four Holy Women	C.E. Kempe	1878
n iii	Four Patron Saints	C.E. Kempe	1881
n iv	Builders of St Peter's Abbey	C.E. Kempe	1892
s ii	The Lamb of God	C.E. Kempe	1882
s iii	God, our Saviour	C.E. Kempe	1886
s iv	Four saints	C.E. Kempe	1890

Kempe designed n vii in the nave while he was a pupil at Clayton and Bell 1865

Choir and Presbytery

N II–VI	Figures from New Testament	Clayton and Bell	1870
S II–VI	Patterned glass	Hardman of Birmingham	1865
W I	Christ in Majesty	Hardman	1866

Tribune gallery and the bridge chapel. Clear glass with some fragments of medieval glass.

| West window in bridge chapel | | Hardman | 1855 |

LADY CHAPEL

Windows are numbered from the east end.

N II	Reconciliation of Man to God through the Incarnation	Christopher Whall	1909
N III	St Cecilia: much old glass	Whall	1913
N IV	The Annunciation	Whall	1901
N V	Childhood of BV Mary	Whall	1901
N VI	Man's Fallen State	Whall	1899
S II	Prophets and apostles	Heaton, Butler & Bayne	1899
S III	St Christopher: some old glass	Veronica Whall	1926
S IV	The Nativity	Whall	1901
S V	The Salutation	Whall	1902
S VI	The Eucharist	Whall	1902

North chapel. Fragments of old glass, some in *situ*. East window Kempe			1895
South chapel. Fragments of old glass. Lloyd memorial window Kempe			1921
Brewer memorial window		Veronica Whall	1929
Chapter House East Window		Whall	1903/4

THE KING'S SCHOOL

For a history of the College, or the King's School, see Whiting, R., *The King's School, Gloucester, 1541–1991* and earlier histories, namely Hannam-Clark, F., *Memories of the College School, Gloucester*, 1859–1867, 1890, and Roberton, D., *The King's School, Gloucester*, 1974. For summarized details see Langston, J.N., *Headmasters and Ushers, 1541–1841, Records of Gloucester Cathedral*, vol. 3, pt 2, 1927. A copy of the Register 1684–1912, is in Gloucester City Library, which, like the Cathedral Library, has archives connected with the school. The late Dr Roger Whiting contributed the following note.

HISTORY OF THE SCHOOL

Although attempts have been made to date the school before Henry VIII's Act setting up the cathedral establishment in 1541, they have not been conclusive. The Act established a choir under the tutelage of the Master of the Choristers, and a school under a Headmaster and an Usher, who were to be graduates of either Oxford or Cambridge. The Act laid down their salaries, gown and food allowances. It is now clear that the choristers were not part of the school, although there must have been some contact between the two sets of boys. At the time of the Commonwealth, when the cathedral and choir were suspended, the school continued to function, so being the only continuous part of the Henrician establishment to survive today.

Some of the choristers (fifteen out of fifty-three in twenty-eight years) did attend the school when the outstanding educationalist, Maurice Wheeler, was headmaster, 1684–1712. The contrast seems to have been between choristers, who were mainly artisans, taking up apprenticeships while still in the choir, and the sons of the local gentry, clergy and professional people in the school. In 1854 the rules were changed so that the choristers were required to attend the school at such times as the Dean and Chapter laid down. Due to service hours and practices, this presented many difficulties. In 1876 their attendance was made compulsory at a time when their behaviour was reported to be more troublesome than that of the scholars of the school.

The school first made a national impact on the educational world under Maurice Wheeler, whose enlightened ideas were well ahead of his century. He laid out a garden

College School boys play outside their school room (now the library), before the 1849 school room was built and 'Babylon' completely demolished

recreation area to reflect the thoughtful passage of a person's life on earth, allowed boys to act as juries to hear misdemeanour cases they felt should be tried, devised a system of rewards which led to the cathedral possessing today three books of 'prize' essays written by scholars. He started the Register of new boys, a valuable archive, and what became known as the Wheeler Library. Thomas Stock, headmaster 1777–88, suggested to old boy Robert Raikes that a Sunday school should be established in the city. This eventually led to Raikes using his opportunities as a newspaper editor to develop the Sunday school movement.

The nineteenth-century school was one of contrasts. Producing a number of MPs, an explorer (Sir Samuel White Baker) and other distinguished old boys, it failed to expand at a time when the public school movement swept the country. This was due to a combination of factors – lack of space in the immediate vicinity of the school, the cathedral's shortage of endowments and the fact that successive Deans and Chapters preferred to run a 'Music School' for the choristers, rather than a school for the middle class. When numbers fell and funds were so reduced as to force them to merge the two statutory teaching posts (assistant masters extra to these posts were employed full or part-time), protests poured in. Public meetings were held calling for the need to maintain a Christian grammar school for the gentry, professional and middle class parents of the city and its vicinity. An Old Boys' Society was formed, and the Dean and Chapter relented on its 'Music School' plans. However, lack of funds led it to spend years in negotiating in vain for grants from the Ecclesiastical Commissioners, and for merger with its rival, the Crypt School. The Dean and Chapter insisted on having a major control of such a merged establishment, while the question of LEA grants fell down on the fact that recipient schools had to be non-denominational.

Thus the school, now positively called the King's, rather than the College, School, entered the twentieth century with few boys other than the choristers. The statutory requirement to maintain a school ensured its survival against heavy odds. Under Frank

Gillespy, headmaster 1922–30, it surged ahead again, only to slump once more when he was forced to resign as his degree was not considered good enough for a headmaster. It survived the Second World War, but was faced with a Ministry of Education order to close unless it made a fresh start. As a result the school's first lay headmaster, Tom Brown (1951–64) was appointed. Arriving fresh from war-time naval service he swept the decks clean and had the school shipshape in a remarkably short time. The fact that domestic servants were either not available or too expensive led to the bishop and several canons vacating their large premises round the Close, so enabling the school to expand in a way previously denied to it. The Old Palace became the heart of the school, with mid-nineteenth century 'Big School' becoming a gym. Boarding houses opened their doors to a world-wide catchment area.

The new staff brought in were young, and many stayed for their entire teaching career, so providing the stability and devotion needed to achieve real success. Numbers rose by the hundred, and academic and musical success followed. Particularly valuable was the close connection with Worcester College, Oxford, originally Gloucester Hall for the abbey's monks. Typically Tom Brown launched ISIS (Society of Headmasters of Independent Schools) at the Alpine Club in London in 1961, as an organization for independent schools not in the HMC. Girls, who had been in the Junior School for some years, finally entered the Senior School, and, in 1990, the first woman Deputy Head (Mrs Kilgour) was appointed. The school now fulfils the dreams of many famous nineteenth-century old boys and citizens who had pinpointed the need for such an establishment in the 1880s.

The Masters of the College or the King's School

1558	Robert Aufield	1788	Arthur Benoni Evans
1576	Tobias Sandford	1841	Thomas Evans
1580	Thomas Wastell	1854	Hugh Fowler
1588	Elias Wrench	1872	William Stanford
1598	William Loe	1875	John Washbourn
1605	Thomas Potter	1876	Philip Sparling
1612	John Clark	1884	John Washbourn
1616	John Hoare	1886	Ronald Macdonald
1618	John Langley	1887	Bernard Foster
1635	Thomas Widdowes	1898	Arthur Flemming
1646	Giles Workman	1903	Oswald Hayden
1646	William Russel	1920	C.B.E. Kingsford
1659	Benjamin Masters	1922	Frank Gillespy
1660	John Gregory	1930	Ernest Muncey
1673	Oliver Gregory	1942	Eric Noott
1684	Maurice Wheeler	1951	Tom Brown
1712	Benjamin Newton	1964	Geoffrey Lucas
1718	William Alexander	1969	Patrick David
1742	Edward Sparkes	1983	Alan Charters
1777	Thomas Stock		

THE
PRINCIPAL MONUMENTS AND EFFIGIES

See, Atkyns, Sir R., *The Ancient and Present State of Gloucestershire*, 1712, and Rudder, S., *A New History of Gloucestershire*. 1712, both strong on the county families, and therefore the heraldry on monuments. See also: Fosbroke's *History of Gloucestershire*, 1807 and Britton's *History and Antiquities of Gloucester Cathedral*, 1829. Among more recent studies of the monuments see: Cockerell, C.R., 'The Sculptures of Gloucester Cathedral', *Journal of the Society of Antiquaries*, 1851. Bloxam, M.H., 'Gloucester: The Cathedral Monuments', *Trans. BGAS*, vol. XIII, 1888–9, 252–259. Canon Bazeley and Margaret Bazeley, 'The Effigies of Gloucester Cathedral', *Trans. BGAS*, vol. XXVII, 1904 289–326. 'Notes on the Wooden Effigy of Robert, Duke of Normandy' in *Newcastle on Tyne Society of Antiquaries Proc* 3rd SX 301. Mrs R.C. Martin, a Location List of all the monument, effigies and ledgers (1980). For the nineteenth- century windows given in memoriam: Welander, D., *The Stained Glass of Gloucester Cathedral*, 1985. Those monuments and effigies marked with an anterisk are described earlier in the present work: see the index.

Gloucester Cathedral contains several monuments of national importance, such as the tomb of Edward II, which is one of the finest of its date and of great interest in the development of sepulcral monuments in the Middle Ages, and the wooden effigy of Robert, Duke of Normandy, which is one of the earliest of its kind and in a remarkably good state of preservation. There are a few others by some of the outstanding monumental sculptors of their periods, such as Flaxman and Sievier, and many examples of the work of sculptors such as Ricketts, Bryan and Frith. The effigies of William and Gertrude Blackleach in the south transept are the work of an unknown early seventeenth-century sculptor of genius.

Nave

At the West End: Dr Jenner* (1749–1823) of Berkeley, Gloucestershire, by R.W. Sievier (1825). Free standing marble monument at west end. Discoverer of vaccination.
John Jones*, d1630, by the Southwark workshops (Verey). Registrar to eight bishops of Gloucester, and alderman of the City of Gloucester.

Dr Jenner of Berkeley, Gloucestershire, memorial in the nave

Bishop Nicholson*, d1671, Bishop of Gloucester 1660–71. Mural tablet by the entrance from the south porch.
Bishop Martin Benson* , d1752. Mural at the west end of the north aisle, by the small door. Also, Bishop Warburton, d1779 by King of Bath.

In the North Aisle: Charles Brandon Tyre, FRS. d1811. Large mural at west end of north aisle. Surgeon at Gloucester Infirmary.
Abraham Rudhall, d1798. Three medallions to the bell-makers of Gloucester; also to Charles, d1815, and Sarah, d1805, and other members of the family.
Colonel Webb, MP, d1839 by H. Hopper of Wygmore St., London. Mural. Member of Parliament for Gloucester.
Ralph Bigland, d1784. Garter King of Arms.
Mrs Sarah Morley, d1784 by Flaxman. Died at sea after child-birth. 'Impelled by a tender and conscientious Solicitude to discharge her parental Duties in person, she embarked . . .' Three angels receive her and her baby from the waves. A beautiful and moving monument.
Thomas Machen*, d1614 and his wife, Christina, d1615, perhaps by Samuel Baldwin of Stroud (Verey). At east end of north aisle.
Canon E.D. Tinling, 1815–97, by Henry Wilson*. An interesting memorial in bronze and various stones, by a leader of the Art Nouveau movement. Beside the Machen memorial. It deserves a better position.
Ivor Gurney, 1890–1937, by Bryant Fedden (1977). Composer, poet, and chorister of the cathedral. On Norman pier opposite the Tinling memorial.

In the South Aisle: Sir George Onesiphorus Paul*, d1820, bust by R.W. Sievier. Free standing, large marble sarcophagus. Philanthropist and prison reformer.
Mary, Lady Strachan, d1770 by John Ricketts the younger of Gloucester. Mural central in the aisle. A monument well above the usual provincial level (Verey). See also Ricketts' memorial to Anthony Ellys, Bishop of St David's d1761.
The Revd Richard Raikes, d1823, by Thomas Rickman and Henry Hutchinson of Birmingham, in the Gothic style, near the Paul memorial.
The Revd Thomas Stock, d1803. Founder, with Robert Raikes, of the Sunday school movement. Monument erected *c.* 1840.
Abbot Thomas Seabroke*, d1457. Alabaster effigy, in full pontificals of a mitred abbot, in chantry chapel at the east end of the aisle. Abbot of Gloucester 1450–7. The *mitra pretiosa* was granted, according to Bloxam, to the abbots of Gloucester 'by Pope Urban VI in the early part of the 15th century.'
Unknown knight and his lady. Two recumbent effigies in a fourteenth-century recessed and canopied tomb, opposite Seabroke chantry. Tomb has ogee arch, foliated crockets and finials; it is panelled at the sides and back and has a vaulted roof without bosses, like the south transept. The knightly figure is represented in plate armour, mail gorget, collar of SS design, an under helmet, or *chapelle de fer*, and shoes of mail. His head rests upon a helmet partially covered by a drape, his hands are raised on his chest and his feet rest on a lion. His lady has flowing hair, bound in front by a fillet; over her breast falls a striped riband, and her dress reaches to her feet. At her feet is a collared dog. Earlier ascribed to Humphry de Bohun, Earl of Hereford, who died in 1361. Samuel Lysons, in

BISHOP ALDRED
in Gloucester Cathedral

Monument ascribed to LORD and LADY BOHUN *in Gloucester Cathedral*

the early nineteenth century, believed the effigy was of Sir John Brydges, who fought at Agincourt and died in 1437. Lysons thought he saw the remains of a leopard's head, the badge of the Brydges of Coberley, in the middle of the cross on the knight's belt. Niblett and Bazeley, however, pointed out that 'the armour is certainly not later than 1410', and argued that, if it represents a member of the Brydges family, it is more probably Thomas Brydges who died in 1407. The SS collar, a Lancastrian badge instituted by Henry IV (1399–1413), suggests a date *c*. 1410. On the SS collar see Appendix XIV.

North Transept

John d1615 and Anne d1613 Bower*. With their nine sons and seven daughters. Painted panels set back in large stone memorial on west side of the transept. Compare the Machen memorial, of the same date.

North Ambulatory

Henry Hugh Arthur Fitzroy, 10th Duke of Beaufort d1984. A fine memorial, erected by public subscription, and unveiled by HM Queen Elizabeth II, with other members of the royal family, on 14 April 1986.
Abbot William Parker*, d1539, the last Abbot of St Peter's, Gloucester (1514–39). A painted alabaster effigy in full vesture of a mitred abbot, resting on altar-tomb in a chantry chapel erected by the abbot himself. The initials WM for William Malvern (alias Parker) are on the tomb. On the pomegranate motif in frieze see Appendix XIV.
King Edward II*, d1327. Alabaster effigy, beneath finely carved and elaborate canopy of oolitic limestone, resting on a tomb of the same local stone clad in Purbeck. King of England 1307–27. He was deposed in 1327, and murdered at Berkeley Castle in the same year. He was buried here on 20 December 1327. 'The canopy consists of two stages of ogee-headed arches with close cusping at the sides of the arches and ogee foils – a work of a genius – surmounted by finials with buttresses placed diagonally and terminating in

pinnacles. It may well be called the most thrilling of all tomb canopies.' (Verey). The Norman piers were painted brown with a motif of white harts at the time of the visit of Richard II in 1378.

Prince Osric*, d729. Osric, a *sub-regulus* of the Kingdom of Mercia, was buried 'before the altar of St Petronilla' in the church of the Saxon monastery he founded. This is a Tudor memorial, erected by Abbot Parker *c.* 1530. In the spandrels on the north side are the arms of Abbot Parker and the attributed arms of Northumbria.

Presbytery and Tribune Gallery

Abbot Serlo* (?), d1104. The effigy on a bracket on the south side of the presbytery has been various ascribed. It may be to Serlo, the first Norman abbot of St Peter's, erected on his tomb, on the 'south side of the presbytery' (Leland) in the thirteenth century, and placed here *c.* 1340 during the reconstruction of the choir. The arch of the canopy over the head terminates in two diminutive heads. Below is a foliated boss representing maple leaves, naturalistic, not conventional. The monument cannot be earlier than *c.* 1280 (Verey). Others date it, however, to *c.* 1240.

Bishop Benson*, d1752. At the east end of the south side of the tribune gallery is part of an impressive memorial to Dr Martin Benson, Bishop of Gloucester 1734–52, originally erected against a wall built across the opening of the eastern chapel in the south transept. It was moved here *c.* 1860 when the chapel was opened again to the transept, refurnished and decorated. There is another memorial to the bishop at the west end of the north aisle of the nave.

William Lisle, d1723. At the east end of the north side of the tribune gallery, is a memorial which originally stood on the east wall of the north transept, enclosed by an iron rail, as shown in a drawing of T. Bonnor (1796).

Lady Chapel

Judge Powell*, d1713, signed by Thomas Green of Camberwell, one of the outstanding statuaries of the first quarter of the eighteenth century. A large memorial on the north side of the lady chapel, containing an imposing standing figure of Sir John Powell. Swift, who met Judge Powell at the home of Lord Oxford, called him 'an old fellow, with grey hairs, who was the merriest old gentlemen I ever saw, spoke pleasing things and chuckled till he cried.'

Elizabeth Williams*, d1622. Figure reclining on her right elbow with her new-born child, and opposite a smaller memorial to her sister, Margery (Clent) d1623, both daughters of Bishop Miles Smith, Bishop of Gloucester 1612–24. Both died in child-birth. Both memorials are by Samuel Baldwin of Stroud.

Dorothea Beale, 1831–1906, one of the outstanding educationalists of the nineteenth century, principal of Cheltenham Ladies' College; a small mural tablet beside the Clint memorial on the south side of the lady chapel. Inscription by Eric Gill (*c.* 1907), on a bronze tablet by Drury.

Bishop Goldsborough*, d1604, Bishop of Gloucester 1598–1604. Painted figure on a

table-tomb in the north chantry chapel. He is depicted wearing a white rochet and black chimere, with lawn sleeves, scarf, ruff and black skull cap, the robes of a bishop of the Church of England in the latter part of the sixteenth century.

South Ambulatory

Bishop Ellicott*, d1905, signed by W.S. Frith, the Gloucester sculptor. Dr Charles John Ellicott was Bishop of Gloucester for forty-two years, 1863–1905.
Robert, Duke of Normandy*, d1134, a painted wooden effigy, recumbant on a late fifteenth-century mortuary box. Metcalf calls the box a 'chest-tomb of fifteenth-century workmanship with an iron hearse framework for supporting a pall.' Of the date of the effigy she writes 'Robert is not wearing poleyns on his knees, and his chain-mail suggests mid-12th century. It must be earlier than 1219 and is possibly as early as 1160.' Verey considers it was 'made in Bristol in the 13th century.' Duke Robert was the eldest son of the William the Conqueror, who left him the Duchy of Normandy; the second son, William Rufus, succeeded as King of England (1087–1100).

South Transept

Unknown mason, *c.* 1335. The bracket on the east wall, by the entrance to the crypt, may have been a memorial to a mason or an apprentice killed while working on the south transept reconstruction 1331–6.
Josiah Tucker*, d1799, on the east wall, with a very long inscription extolling the virtues and recording the achievements of a distinquished eighteenth-century dean of Gloucester.
William Blackleach*, d1639 (and his wife, Gertrude). Effigies in alabaster by an unknown sculptor of outstanding gifts; ascribed by Dallaway to Le Sueur (1616–55, a French designer and painter) or Fanelli; by Mrs Esdaile to either Epiphanius Evesham or Edward Marshall. But Verey went no further than to describe them 'as good examples of the Nicholas Stone period, whomever they are by.' Others have considered they are by (the school of) Vandyke. Walpole in his *Anecotes* of Painting states that the figures are by Vandyck. The attention to detail, especially the detail of the clothing, is extremely fine.
Richard Pate*, d1588. Against the south wall. Founder of Cheltenham Grammar School. The figures, which are now missing, were of a man kneeling, in the dress of an Elizabethan lawyer, with a child behind him, and of his wife, also kneeling, with three children behind her. 'These figures have been allowed well-nigh to perish and are scarcely discernable' (Bazeley in 1902).
T.B. Lloyd-Baker, d1886, bust, in relief, by W.S. Frith on the west wall.
Canon Evan Evans, d1891, a small brass and marble tablet by Henry Wilson.

Notes on Sculptors

John Flaxman, 1755–1826: English sculptor, born in York. First professor of

sculpture at the Royal Academy of Art (1810). His sculptures include a fine statue of Burns in Westminster Abbey, and the Morley memorial in the north aisle of the nave.

Sievier, 1794–1865: Engraver and sculptor. In *c.* 1824 he gave up engraving in favour of sculpture which he practiced successfully for over twenty years. He exhibited at the Royal Academy from 1822–44. Towards the end of his life his interest in scientific invention took over and absorbed him, particularly the development of electric telegraph. He was elected FRS in 1840, and a few years later abandoned art altogether. The standing figure of Dr Jenner and the bust of Onesiphorus Paul in the nave are fine examples of his sculptural work.

Ricketts of Gloucester: Among the local firms, the four generations of the Ricketts family, who florished as sculptors between 1729 and 1795, deserve special attention. There are several examples of their work in the nave.

William Silver Frith: Sculptor, was born 30 April 1850, son of Henry Frith (1820–63), a London-born sculptor who moved to Gloucester in 1853, where he was engaged in carving on many public buildings in and around the area. W.S. Frith studied at the old Gloucester School of Art and later at the Lambeth School of Art and at the Royal Academy, being appointed Instructor of Modelling at the City Guilds Art School, Kennington. He had his Elgin Studio in Chelsea, and was in much demand throughout the country, working on Buckingham Palace, Cliveden, Dartmouth Naval College, etc., while he was regarded as being one of the finest teachers of sculptors in the country, a man of 'much artistic capacity and personal charm, he seemed to live wholly for art's sake and largely devoted his powers to the advancement of others'. Working closely with his brother, Henry Chapman Frith, a Gloucester sculptor, between them they were responsible for a number of outstanding works in the city and county. W.S. Frith was a Fellow of the Royal Society of British Sculptors. He died in London, 15 August 1924.

THE CATHEDRAL LIBRARY

For a history of the library see Eward, S.A., *A Catalogue of Gloucester Cathedral Library*, 1972, vii–xv. For a list of its medieval holding see Kirby, I., *A Catalogue of the Records of the Dean and Chapter of Gloucester*, vol. II, 1967, and of the whole library, medieval manuscripts (notes by Keil Ker), post-medieval manuscripts (notes by S.J.A. Evans and S.M. Eward) and the printed books see Eward's *Catalogue*. A list of works added since 1972 is kept in the library. See further Eward, S., Appendix A., 'The Cathedral Library from the Restoration until 1712' in *No Fine but a Glass of Wine*, Michael Russel, 1985.

The History of the Library

The present cathedral library dates back to the Commonwealth period, and to the Mayor and Burgesses of Gloucester who in 1646 petitioned parliament to 'Grant the use of the Chapter House in or belonging to the Colledge of Gloucr. as a fitt & Convenient place to be imployed as a Publique Library.' Once the 'late cathedral church' was made over to the Mayor and Burgesses 'for publick, religious and charitable uses', they took over the care of the new library, and encouraged the donation of books and furniture. Fine Baroque bookcases were installed, which are depicted in Bonnor's etching of the library (1796), and probably the gift of Thomas Pury the younger and others.

At the Restoration the Dean and Chapter repossessed the cathedral and all its property, including the library in the chapter house. They received an early windfall from the library of the famous jurist, John Selden, who had died in 1654. The majority of his books were sent to the Bodleian Library in Oxford, but Sir Matthew Hale, one of the executors of Selden's will persuaded Bodley's librarians to give duplicates from Selden's collection to the new library at Gloucester.

The librarian appointed in 1670, Clement Barksdale, left a description of the layout of the library at this time:

> The library is in three parts: facing those who go in are displayed the theological books, that is, the holy Bible, the Councils, the works of the Fathers, sacred histories etc. On the right hand appear books of Medicine, amongst which are included Mathematics etc. On the left are the books of law, amongst which may be found historical writings, politics etc. The other of the books is described within each class.

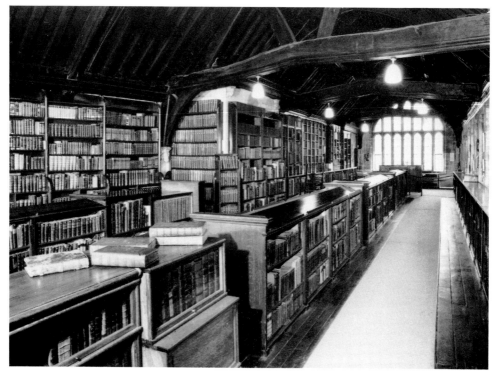

The cathedral library today, in the old monastic library

But visitors to the library at this time were far more impressed by the fine bookcases than the number of works on the shelves. John Evelyn, the diarist, alludes to them when he noted, on 31 July 1654, that 'the new Librarie is a noble tho' a private designe'; and Abel Wantner referring to the library in c. 1686 wrote: 'I speak not of books! but for the variety of imagery and carved work.' In 1695 Celia Fiennes noted in her diary: 'Here are very good Cloysters finely adorn'd with ffretwork, here is the Colledge and Library but not stored with many books.' The thousand or so books which had been donated by c. 1700 would have only sparsely filled the handsome and spacious bookcases.

From 1709 to 1712 Maurice Wheeler, headmaster of the College School was librarian. A catalogue in Wheeler's own handwriting (GCL MS 206) includes biographical notes of subscribers and donors. The school library, which he established through the gifts of the boys and their parents, has survived and is now housed in the cathedral library in separate bookcases. But the collection contains only 56 of the 161 titles originally listed.

In November 1743, the Chapter decided that because of 'the dampness and inconvenience of the old chapter house' to remove the books to 'the Isle on the south side of the Choir.' This was to be immediately 'converted into a Library and fitted up for the recepcon of the books.' But in 1764 the books were returned to the chapter house. Here they remained until a fire, in the chapter room below the College School in 1849, led to the building of a new school room on the north side of the Old Chapter House. The old school room was then restored, to house the Dean and Chapter library.

The Library Room

In January 1857, F.S. Waller reported that in accordance with the instructions of the Dean and Chapter:

> The old School Room has been re-roofed preserving as much of the old timber as was found to be sound – a new oak floor has been laid and the joists which were discovered to be very rotten at the ends have been for the most part renewed. The stonework had been restored and the windows glazed, a new fire place has been provided New oak doors have been made for the entrances and the bookcases have been removed from the old Library and refitted in this room. The staircase communicating with the cloisters has been repaired and a new doorway opened.

The following year all three stone staircases communicating with the library were thoroughly restored, and five new book cases placed in the library.

The room, built in the fourteenth century as a library for the Benedictine abbey, was now restored to its original use. The row of small windows on the north side, which had originally lit study-cubicles formed by panelling, were opened up and reglazed. Much of the fine open fourteenth/fifteenth-century roof were restored. This consists of four collared tie beam trusses with seven curved braced trusses as intermediate and end trusses. They were supported on corbels consisting of carved heads, some of stone, but most of wood. Bonnor's engraving (1796) of the old school room interior gives some idea of the extent of the alterations and restoration work which had to be carried out before the room was ready to house the books.

The Medieval Manuscripts

1. The oldest documents held are Anglo-Saxon manuscripts – seven leaves, probably written *c*. 985–1020. They were found in 1820 in the binding of one of the Abbey Registers (Reg.C). They describe miracles performed at the tomb of St Swithin, and incidents in the life of St Mary of Egypt. They were edited and translated by Professor Earle in 1861.

2. The Register in which the leaves were found is the third of five Registers of St Peter's Abbey. The first two (Reg.A & B) were compiled by Walter Froucester, Abbot of St Peter's 1381–1412. Register B is a collection of copies of more than a thousand deeds of lands (mostly in the city of Gloucester) assigned to each of the *officia* of the abbey – the sacrist, almoner of Standish, hosteller, sub-almoner, master of the works, chamberlain, refectorer, infirmerer, master of the chapel and the precentor.

3. A small volume by Walter Froucester, a history of the abbey from its foundation by Osric in *c*. 681 to his own time came into the possession of the Dean and Chapter in 1879, when it was bought from a Berlin bookseller. As well as the *Historia*, the volume contains lists of plant-names, drugs, and many pages of medical recipes, all early fifteenth century. For a translation of the *Historia*, see Appendix XV.

4. Registers D & E cover the abbacy of William Parker (alias Malvern) from 1514 to the Dissolution. The first volume has the fine illuminated armorial bearings of Abbot Parker opposite the title page.

5. Nearly 400 medieval deeds are mounted in ten large volumes of blank paper,

part of which is cut away to make protective boxes for the seals which are attached to many of the deeds. Among them is a grant (*c.* 1265) to the abbey of a water supply from Mattesknolle (Robinswood Hill), and another (*c.* 1228) provides two shillings yearly to keep a lamp burning in front of the altar of St Petronilla in the lady chapel of the abbey.

6. A collection of medieval records of the abbey was returned by the Dean and Chapter of Norwich in 1967. It consists of 18 documents in all, of which the most important were the medieval manorial court rolls. The earliest of nine membranes sewn at the head is dated 1292–3; the next, of seventeen membranes, is 1351; and three smaller ones are dated 1412–3. The 1351 roll has been badly damaged by fire. Ten medieval deeds were also returned.

The Dean and Chapter Records

1. In 1541 when the See of Gloucester was founded, the newly constituted Dean and Chapter were granted, as their endowment, vast estates which they retained until the nineteenth century. The original *Grant of Endowment* is dull and difficult to read, but within the initial letter H is an etching of the king (Henry VIII) sitting on his throne, holding the regalia.

2. The *Grant of Arms* still has some of its original brilliant colour, and a little Garter King of Arms stands within the initial letter T. Both these documents have lost their seals.

3. *Conges d'elire.* An important function of the Dean and Chapter until very recent years was to elect successive bishops. By the *conge d'elire* the sovereign officially informed the Dean and Chapter of the vacancy of the see, and gave them 'leave to elect' a new bishop. This document is followed by a *letter recommendatory*, signed by the sovereign, containing the name of the person to be elected. There is an almost complete series of these documents in the library from 1607, and most of the Great Seals attached to the conges have survived, at least in part. The earliest, of James I, names Henry Parry as bishop (1607). The conge prior to Richard Willis' election in 1714 was sent by George I, and has his portrait at the head of the document, but still has the Great Seal of Queen Anne, who had died a few months earlier. The letters recommendatory are all signed by the respective Sovereigns, except on one occasion when George III was incapable of doing so. In 1954 when Queen Elizabeth II was abroad on a world tour, the document was signed by the Queen Mother and Princess Margaret on her behalf.

4. The beginning of the first extant Chapter Act Book coincides with the arrival of William Laud as dean in 1616. He may have started the practice of formally recording the Chapter's decisions.

5. Almost all the Dean and Chapter estate records are housed in the County Record Office, but the re-endowment maps remain in the library. When the nineteenth- century reforms enabled the Ecclesiastical Commissioners to take over the vast estates of ecclesiastical corporations, it was not until 1867 that the Dean and Chapter of Gloucester were re-endowed with other, much smaller estates. Small coloured maps are bound in one volume, and show the estates in each of nine parishes, eight in Gloucestershire and one in Berkshire.

Other Records and Volumes of Special Interest

1. Early records of the King's School are kept in the library. The first King's School Register of pupils was begun in 1685 by Maurice Wheeler and continued until 1923. It gives the names and ages of entrants, and the names and places of residence of their parents or guardians. Wheeler also compiled the list of benefactors to the School Library, which starts in 1686 and was added to until 1772. Many of its pages have patterned, decorated initial letters, and drawings of armorial bearings of the benefactors.

2. Coverdale Bible: the provenance of the Gloucester copy is known. The leather bound volume is stamped on both front and back with the Royal Arms of James I, surmounted by the sovereign's crown. It must, therefore, have come from the Royal Library. A note found many years ago in Lord Spencer's library at Althorpe states that Oliver Cromwell gave a Coverdale Bible to a certain Thomas Pury. The latter, a staunch Puritan, was an Alderman of the city of Gloucester and its Member of Parliament. In 1641 during the Root and Branch debates, he delivered a strong attack on Episcopacy, proposing the abolition of Deans and Chapters. His son, also Thomas, was a captain in the Roundhead army. It was he who began the library in the chapter house during the Commonwealth, erecting fine bookcases, donating a number of books and contributing £145 towards its upkeep. Though not listed in the Benefactors' Book, the Coverdale Bible must have been among the books donated to the library by his father.

3. Other works of special interest include: the English works of Sir Thomas More, a copy of the first issue of the first edition of the Authorized Version of the Bible, some scarce tracts and sermons of Bishop Hooper, a fourth folio Shakespeare, a latin grammar printed by Wynkyn de Worde, an apprentice to William Caxton. The earliest printed book in the library is dated 1472. There are some 40 other *incunabula* , most with superb tooled bindings. There is a volume bearing the coat of arms of Henry VIII and Katherine of Aragon, and another the arms of Queen Elizabeth I. The most beautiful binding in the library is on a book which once belonged to Robert Dudley, Earl of Leicester, and which has his coat-of-arms inset among purple velvet and gold tooling. There is a large prayer book which belonged to Samuel Johnson and a small prayer book which belonged to John Evelyn the diarist. There are the 200 or so books from the Selden Library, kept as a separate collection, and containing a number of Hebrew works.

4. The subjects covered by the 6,000 volumes in the library range widely. There are works on philosophy and law, Greek and Latin classics, collections of statutes, monastic chronicles (including the Rolls Series); works on history, including local history, heraldry and genealogy, biography, diaries and correspondence. There are books on travel and topography, architecture, antiquities, music, medicine and English litera-ture. There is a valuable collection of engravings of Roman antiquities which were presented in 1753 from the library of Bishop Martin Benson. As Eward remarks: 'We can see from the Chapter Act Books that the Dean and Chapter were proud of their library and anxious to enrich it and make it into a useful, working library.'

5. With severe limitation on space, the policy over the past fifteen years (1975–90) has been to add only works which bear on the history and architecture of the cathedral, biography of persons associated with the cathedral, and published works of present and former deans and canons. Two archive cupboards have been added, for correspondence,

special services and other liturgical material, legal records, lectures, etc. and for ephemera. Also stored are: microfilms, sound recordings, transparencies and a large body of photographic material. For four years from 1985, teams of book conservators worked, for two periods of three to five weeks each year, on cleaning the entire collection, applying leather dressing as required, carrying out minor repairs to the bindings, and paper repairs, and making 'shoes' for many volumes and boxes for others. At the conclusion of the £50,000 programme, in 1990, the library was pronounced to be 'in a stable condition.' A rolling programme of specialist repairs on 300 volumes is being carried out at the present time.

THE HERALDRY IN THE CATHEDRAL

Useful introductions to the subject: Woodcock and Robinson, *The Oxford Guide to Heraldry*, OUP, 1988, and a shorter introduction is Mackinnon, C., *The Observer's Book of Heraldry*, Warne & Co., 1972. See also Dorling, E.E., *Heraldry of the Church*. On the heraldry of Gloucester Cathedral see the following articles: Niblett, J.T.D., *Heraldry of Gloucester Cathedral*, 1866, MS NR 4,17. Niblett, J., and Bazeley, W., 'Royal Badges in Gloucester Cathedral', *Records of Gloucester Cathedral*, 1882–97, pp. 112–18. Howitt, G.A., *Ancient Heraldry in Gloucester Cathedral with drawings*, 1895, MS 10770. Claxson, B.S., 'Heraldic Notices of Gloucester Cathedral', *Trans. BAA*, 1848. Drayton, T.G.D., 'Notes on the Heraldry of the East Window of Gloucester Cathedral', *Trans. BGAS*, vol. XXXVIII, 1916. Fosbrooke's *Original History of the City of Gloucester, 1819*, is particularly good on heraldic material relative to the cathedral and to Gloucester parishes.

Medieval Heraldry

Sir Anthony Wagner, Garter King of Arms, defined heraldry as 'the systematic use of hereditary devices centred on a shield.' In 1127 Henry I knighted Geoffrey Plantagenet, afterwards Count of Anjou, placing round his neck a shield decorated with small golden lions. Geoffrey of Anjou died in 1151 and on the funeral plaque from his tomb in Le Mans Cathedral there is a shield showing the same arms. This is the earliest occasion on which a shield bearing a personal device is known to have been used by successive generations of the same family.

Before the twelfth century the association of arms with an individual is almost certainly ficticious. Thus, the 'arms' of Osric which were found carved in stone and set up on the south face of the remaining tower of King Edward's Gateway are rightly described as the 'attributive arms' of Osric. They were used by Abbot Parker in *c.* 1530 on the spandrels of the tomb he erected in honour of Osric on the north side of the high altar. Similarly, the 'arms' of Edward the Confessor found in the tile pavement in front of the high altar, laid down by Abbot Seabroke *c.* 1450, were not borne by him in his life time but attributed to him long after his death.

The personal devises on banners, lance-flags and shields, known both from literary

Royal badges in the cathedral

sources and from pictorial evidence such as the Bayeux Tapestry, were used, at first, purely for the purpose of recognition. But from the second half of the twelfth century the hereditory factor is clearly discernable in their increasingly widespread use. An early example is the chevronny coat used on Clare seals of the time, which later became the three chevrons borne by this ancient family for centuries. By the thirteenth century shields of arms, particularly as seal devices, were in general use by the higher nobility. But arms in seals do not provide evidence of the colour used on the device. In early Rolls of Arms, however, colours are indicated either in blazon i.e. descriptions of arms in heraldic language, or in painted coats. Later copies of Rolls are sometimes given in trick, that is in outline with the colours shown by letters. The earliest and most famous of these English rolls of arms was painted by Matthew Paris, the monastic historian of St Albans who died in 1259. He used shields of arms in the margins of his chronicles to illustrate events described.

Rolls by professional heralds were variously arranged. The Occasional Rolls of those present on some particular occasion e.g. at the battle of Crecy and the siege of Calais (1345–48), give the shields of those who fell in the battle, beneath a genealogy of English kings to Henry IV. The shields arrayed at the bottom of the great east window are reminiscent of such a roll of honour.

Documents granting the right to bear arms are another source of information about their exact description. In 1417 the Crown sought to forbid the bearing of arms without its authority, and the heralds were given the task of regulating the use of all armorial bearings. Thereafter, it became a matter of families or corporate bodies applying for permission to bear arms, and having the proposed device approved and authorized by a 'grant of arms'. The document granting arms to the Dean and Chapter of the cathedral, following the dissolution of St Peter's Abbey, is kept in the cathedral library.

Such armorial devices whether assumed or granted were used in a number of ways, many examples of which can be seen in all parts of the cathedral. They were used on effigies and monuments. From the fourteenth century they appeared frequently on monumental brasses, but sadly practically all the medieval brasses which once adorned the floor of the abbey church have disappeared. Floor tiles, however, bear the arms of benefactors, the royal arms, the arms of abbots or of the monastic foundation itself. From about 1300, arms were also frequently displayed in stained glass, as in the great east window of the choir. It also became increasingly popular to bring heraldry into architectural projects. Arms of the founder or principal benefactors were often placed at the entrance of buildings, on the porches and gateways.

The Arms of St Peter's Abbey

From the fourteenth century shields of arms were attributed to saints and early founders of ecclesiastical houses, to religious foundations, hospitals and colleges. The arms of St Peter's Abbey were the crossed keys of St Peter (St Matthew 16.18–19), against a blue background. The Saxon monastery of Osric was dedicated to St Peter by Theodore, archbishop of Canterbury and Bosel, bishop of Worcester. When Bishop Wulfstan ejected the secular canons c.1022, and brought in his Benedictine monks, he reconsecrated it to St Peter and St Paul.

Bishop Aldred after building his church (1058) dedicated it to St Peter, as the chief of the apostles. But Abbot Serlo seems to have remembered the earlier dedication to St Peter and St Paul, in that he chose the festival of the two apostles, in June (1089), for the laying of the foundation stone of the Norman church. But in 1100 he dedicated the church to St Peter. Nevertheless, in the fourteenth century the two apostles were equally honoured in the abbey, as seen for example in the great east window where the central figures of Christ and the Virgin Mary are flanked by St Peter and St Paul. By the fifteenth century the sword for St Paul had become incorporated with the crossed keys of St Peter. The combined sword and keys are found on stonework of the period and on the late medieval bells. St Paul's sword was borne upright along with the keys, and the arms are so engraved in the fifteenth century seal of the abbey.

Memorial to Ralph Bigland, Garter Principal King
of Arms, March 1780. T. Bonnor

The Arms of the Dean and Chapter

These were granted 28 March 1542 by Sir Christopher Barker, Garter King of Arms.
They were described as Azure, on a fesse or three crosses formy fitchy of the field; on a
canton of the second a demi rose en soleil issuant from the chief line gules between two
demi fleurs-de-lys issuant from the flanks, also of the field. See: Geoffrey Briggs, *Civic
and Corporate Heraldry.*

The Arms of the See of Gloucester

At the Dissolution the arms were Gules, two keys in saltire surmounted by a sword in
pale, argent. Browne Willis, in 1727, wrote that the old arms of this see 'as used 100
years ago, were three chevronels, the middle one charged with a mitre, but the bishops

now give Azure, two keys in saltire, or.' This is borne out by the arms on the monument to Bishop Goldsborough (1598–1604) in the north chantry of the lady chapel. Here, as Papworth (p.550), records the arms of the sees are 'three de Clare chevrons with the middle chevron charged with a gold mitre.'

No formal grant of arms was ever made to the See, though the right to use a seal was expressly given in the Charter. See further: Dr Edgar Gibson *The Arms of the See of Gloucester* in *Trans. BGAS* 1917 134–145. In spite of the new dedication of Henry VIII, the cathedral has been known traditionally as 'St Peter's'. From the seventeenth century the sword of St Paul was also often shown with the crossed keys of St Paul in the supposed arms of the cathedral. It appears in this form on the organ case, in the spandrels of the west door and on the bishop's throne. Both apostles are among the statues (*c.*1870) which adorn the south porch.

Displays of Arms in the Cathedral

On the arms decorating the organ see: Michael Gillingham in *Organs and Organists of Gloucester Cathedral* (Friends of Gloucester Cathedral publication) 23–24.

On the arms in the great east window see: Welander, D., *The Stained Glass of Gloucester Cathedral* and references cited.

On the memorials in the nave, including that of Ralph Bigland, Garter Principal King of Arms, see Bigland's *History of Gloucestershire*, with notes by F. Were, 1905–6, compiled for the Bristol and Gloucester Archaeological Society; and Appendix XII and works cited.

The attributed shields of eight of the Worthies, Edward the Confessor and a shield of England quartered with France (modern) decorate the tomb chest of Robert, Duke of Normandy. The Worthies represented are: Edward the Confessor, Alexander the Great, Judas Maccabeus, Charlemagne, Godfrey of Boulogne, Hector, Julius Caesar, King David, but Joshua is not included.

There is a row of arms above the east door to the great cloister. These, from left to right, are the Revd Sir H. Darell, Canon Seymour, Bishop Ellicott, the See of Gloucester and Bristol, Dean Law, the Revd E. Bankes, the Revd M. Harvey and Nightingale impaling Darell, all nineteenth-century worthies.

Another row, forming a frieze along the top of the reredos in the north-east ambulatory chapel, contains miniatures of a number of ancient arms, from the great east window and elsewhere in the cathedral.

The memorials in the nave and elsewhere display the arms of a number of Gloucestershire families from the seventeenth century.

Royal Badges

There are a number of royal badges displayed in the cathedral:

The White Hart (A), the badge of Richard II (1377–99). There are twelve white harts chained with ducal coronets on the piers on either side of the tomb of Edward II. These

are thought to have been painted here at the time of the visit of King Richard II to the shrine in 1378.

The SS Collar (C), the badge of Henry IV (1399–1413). This is found on the early fourteenth century effigy in the tomb recess at the east end of the south aisle of the nave.

The Sun in Splendour (B&D), or the *Rose en soleil*, badges of Edward IV (1461–70/1471–83). There are examples of these in the east window, and the chantry chapels of the lady chapel.

The Pomegranate (E), the badge of Grenada, which was born by Katherine of Aragon, the first wife of Henry VIII. It is found in the Prinknash glass in the south walk of the cloister.

The pomegranate is also found in the cornice of the tomb of William Parker, Abbot of Gloucester 1514–39, in the north ambulatory. The cause of Queen Katherine (of Aragon) was plainly understood to be the cause of the Church, and more especially of the monasteries. Her divorce was quickly followed by the closure and plunder of all monastic houses. Abbot Parker took part in the proceedings relating to the divorce, and signed a petition to the pope in favour of it in 1530. This suggests the abbot erected his tomb and decorated it with the pomegranate at some time before that date.

Note: There are good examples of the royal arms on the Great Seals of the *conges d'elire* held in the cathedral library. See Appendix XIII.

The History of the Monastery of St Peter of Gloucester
681–*c.*1400

OR

Historia Monasterii Sancit Petri Gloucestriae

Translated from the Gloucester Cathedral copy by William Barber,
1988.

THE HISTORY OF THE MONASTERY OF ST PETER OF GLOUCESTER

Here follows [the history] of the monastery of Saint Peter of Gloucester from the first founding by Prince Osric with King Ethelred's permission.

Ethelred's gifts to Osric and Oswald.
AD 681

In the year 681 from the Lord's Incarnation Ethelred King of the Mercians – the fourth after Penda the first King – in the same twenty-fifth year of his reign graciously granted and gave in the province of the Wiccii to two of his ministers of noble birth, namely Osric and Oswald his brother, to Osric [the dues from] 300 tribute areas in Gloucestershire, to Oswald likewise 300 hides at Pershore. This is so that Osric might take Gloucestershire, Oswald might have Pershore.

Osric founds St Peter's monastery at Gloucester.

Osric by permission of King Ethelred from his own resources erected a monastery in noble fashion in the city of Gloucester in honour of Saint Peter the Apostle, Lord Theodore Archbishop of Canterbury and Bosel first Bishop

Kyneburga and Eadburga abbesses.	of Worcester confirming [his action], and there he appointed his sister Keneburga abbess, and after her Eadburga his kinswoman who previously was queen to Wilfred King of the Mercians succeeded as abbess. And after her Abbess Gaffe guarded well that monastery for thirty-three years blamelessly and according to ecclesiastical law and acquired much land: namely in Aller 20 hides, in Pendeswell 20 hides, [and] the flocks belonging [to those lands].
Adelred's gift. Burgred's gift. Edelmund's gift. Nodehard's gift.	Adelred, lord of the Wiccii, gave his inheritance to the same monastery: this is in Coln Saint Aldwyn [and there are] 60 tied tenants on that land. Burgred King of the Mercians [gave] in Fairford 10 hides, in Wyarkeston* 15 hides, in Chedworth in the hills 15 hides. Likewise Adelred gave outside the city of Gloucester where the Barton is now 120 hides, in Nympsfield 3 tied tenancies. Lord Edelmund gave 30 tied tenancies in Over and 38 in Northleach. Nodehard, an earl and chief citizen under the King gave 4 tied tenancies in Archenfeld.
Confirmation of gifts. Ethelred resigns, becomes a monk, dies AD 716.	All these gifts and inherited lands had been confirmed in many synods and councils. Ethelred mentioned above as King of the Mercians renounced his worldly kingdom [and] gave his kingdom to Kynred his cousin and took the tonsure at Bardney, first as a monk, afterwards [being] raised to abbot. In the 716th year from the Lord's Incarnation he [Ethelred] departed this world and entered into eternal bliss.
Kynred and Offa become monks.	In the year 708 from the Lord's Incarnation Kynred King of the Mercians and Offa King of the East Saxons gave up their kingdoms and came to Rome in the time of Pope Constantine. There they were made monks and remained to the ends of their lives and so departed to heavenly realms. They brought much wealth to the monastery of Saint Peter of Gloucester.
Kenred dies AD 707. Osric dies AD 729.	In the year of the Lord 707 Kenred King of the Northumbrians dies; to whom succeeded King Osric who a little while previously had founded the Gloucester monastery. He died on May 9 in the twelfth year of his reign and is buried in the church of Saint Peter near the altar of Saint Petronilla in the northern part of the same monastery in the year of the Lord 729.

* Wirtanstane ?

Poem on the
foundation of
the monastery.

There follows a poem on the first founding of this place,
namely the Gloucester monastery.

Here is the beginning and the first religious house about
which Gloucester offers information. At that time, it was
the 681st year of Him born of a Virgin, conceived when
'Ave' was first said noble Osric, a friend of King Ethelred,
erected the buildings, if the chronicles are to be believed.
He constructed the first monastery in the town, bringing
there the splendour of a multitude of women. So indeed he
founded a church specially to the honour of Saint Peter for
perpetual monastic worship for ever.
This man appointed his sister abbess in the town. She made
the land do her will and gave honour to the town. At the
beginning this woman, Kyneburga by name, was prelate.
So she lived until stricken down as was determined for her.
Straightway, now that Kyneburga was dead, the noble
Edburga succeeded her, and she secured very many
advantages. She was formerly the distinguished queen of
King Wolfer. She ruled with renown, but death's door
closed on her deeds. An illustrious lady patroness succeeded
in the town. Remaining single and living blamelessly she
was worthy of a heavenly crown. Walter Froucester applied
himself [to studying all this] and put in writing these notes
that they might open the doors on those who live in the
cloister.

Kyneburga
abbess.
Dies AD 710.

Kyneburga, sister of King Osric, is consecrated into the
office of Abbess of the monastery Gloucester by Bosel first
Bishop of Worcester and she ruled and watched over that
monastery blamelessly for twenty-nine years, and obtained
much wealth for the same monastery. At length she died in
the 29th year of her rule and is buried near her brother
Osric, before the same monastery's altar of Saint Petronilla.
And to her succeeded Edburga in the 710th year from the
Lord's Incarnation. Kyneburga died nineteen years before
her brother.

Edburga.
Abbess.
Dies AD 735.

Edburga, the wife and queen of Wolfer, King of the
Mercians, after the death of her husband renounced the
world [and] obtained the solace of holy religion in the
monastery of Saint Peter. At length she is consecrated
abbess there by Saint Egwin the third Bishop of Worcester
from Bosel, and ruled well and guarded that monastery in a
holy manner of life. And in the twenty-fifth year of her rule
was borne to her grave by Blessed Wilfred Bishop of

Worcester in the same monastery near her predecessor and sister Kyneburga. To her succeeded Eva in the year 735 from the Lord's Incarnation.

Eva abbess.
Dies AD 767.

Eva, who was wife and queen of Wolfer son of King Penda, is consecrated to the office of Abbess of Gloucester by Saint Wilfred Bishop of Worcester. She blamelessly ruled and guarded that monastery well according to the disciplines of the rule, and obtained much wealth for the same church, and secured confirmation of the same in many synods. At length she died in the twelfth year of the reign of King Offa and was borne to a grave near her sisters and predecessors in the same monastery, that is to say in the year of the Lord's Incarnation 767.

King Egbert.
AD 800.

After her death abbesses ceased, [as did] the keeping of the rule in the same monastery, as much because of the so great disagreement between the Kings as on account of the dying out of what had been customary in ruling, until King Egbert came He was [King] from the year 800 from the Lord's Incarnation, and the said Egbert united all his kingdoms under one rule, so that a bold and wayward people might fear warlike moves and subversion more than universal peace among themselves. And indeed the beauty of religion was wonderfully handed on by bringing to that place surviving sisters who were fleeing from war and wrongdoing under the secular power until the time of Wulfstan Bishop of Worcester who was [bishop] in the year 1002 from the Lord's Incarnation.

Of the clergy who had ruled the church of Saint Peter of Gloucester [and] were led by the nuns to be monks themselves.

AD 1022. Wolstan
Bishop of Worcester
places the
monastery under
Benedictine rule.
Edric abbot.

In the year of the Lord 1022 Wolstan the Bishop of Worcester, who later was made Archbishop of York after the resignation of King Canute, the leader of the Danes, who held Holy Church in high esteem and renewed and promoted her ancient liberties as Peter the Pict tells − this Wolstan canonically [and] under the Benedictine rule summoned the clergy who formerly had governed and guarded the church of Saint Peter with the protection of God and the Apostles Peter and Paul and consecrated one Edric as abbot and guardian of that monastery. However he lost much of its wealth, for in his time were permanently estranged and sold the manors of Badgeworth and Hatherley.

Dies AD 1058.
Wilstan.

At length he died in his thirty-seventh year in office. However he left this place and was buried elsewhere. And to him succeeded Wilstan a monk of Worcester in the year of the Lord 1058.

AD 1022.
Chirograph of
Edric.

I Edric Abbot of Aldanham give notice and declare in this public conveyance that I by sheer necessity have transferred from ecclesiastical jurisdiction to a certain Stamarcot the lands of Hegberl and Becgwid for as long as he shall have lived and this have I done for the sum of £15 which I accept as sufficient by which sum I have redeemed all other property of the monastery which was held as security from that great exaction of royal tax which was [levied] through Anglia.

To these presents the witnesses are Wolstan Archbishop of York and Lessius Bishop of Worcester Aglaf the earl and the whole assembly of the old monastery and Abbot Annas and all the brothers of the monastery of Saint Oswald and Wihiside the mayor and the whole city of Gloucester and many others English as well as Danes. Wherefore if he who holds the land transgresses let him voluntarily and from his own possessions made amends. But let the land be quit and let it be given back to the monastery after his death.

AD 1058.
Aldred Bishop of
Worcester consecrates
Wilstan abbot who
rebuilds the church
and dedicates it
to St Peter.

Aldred Bishop of Worcester consecrated Wilstan a monk of Worcester as Abbot of Gloucester in the year of Our Lord 1058 and instituted him. Indeed the said Aldred rebuilt the church from the foundations and reverently dedicated it in honour of Peter the leader of the Apostles but more on account of hospitality than of any necessity he withdrew from what was shared by all Northleach, Oddington, Standish and the Barton, keeping them as his own property. At last he is consecrated Archbishop of York and he appropriated the same manors to the church in York.

Wilstan to
Jerusalem.
Dies 1072.

But Wilstan, having set out for Jerusalem, died a pilgrim in the year of Our Lord 1072, the fourteenth of his prelacy and the seventeenth year of the reign of King Edward son of King Egelred.

Aldred goes
to Jerusalem
via Hungary.

This dedication was carried out on October 15 in the time of King Edward the Confessor. The said Bishop Aldred afterwards crossed the sea and set out for Jerusalem by way of Hungary, a thing which none of the archbishops or bishops of the English is so far known to have done.

King Burgred's
confirmation of
past gifts. AD 862.

In the year 862 Burgred King of the Mercians, with the agreement and help of Almighty God, confirmed the gifts which the Kings his predecessors gave the church of Saint Peter. That it to say, Ethelred and Ethelbald, Offa and Kenulph [each] with the unanimous agreement of [his] council and the consent of all his nobles made the same church free and not to be disturbed and all the lesser houses and places which are subject to the same church and belong to it [to be exempt] from all land transactions and tenants' duties. It was stipulated so far as this matter was concerned that their prayers and the intercessions for each and for his lawful heirs were to be offered perpetually day and night to remember each before God. These things were done and renewed in the year of Our Lord 862 with the agreement and confirmation of Burgred King of the Mercians and Archbishop Cheolnoth at Wellesbourne.

Serlo abbot.
AD 1072.

There follows about Serlo the first abbot of the monastery of Saint Peter of Gloucester after the Conquest.

In the year of Our Lord 1072 after the death of Wilstan abbot of the Gloucester church whom Archbishop Aldred had put in charge of that church there succeeded to him the same year, to be exact on August 29, the reverend father Lord Abbot Serlo, finding there only two monks of full age and about eight little boys. This same father was at first a canon of the church of Avranches under Pope Michael, then a monk in the church of Mont St Michel.

In the fifth year after he moved there, William the Conqueror having consented to ask for him, and at the suggestion of Osmund, a venerable man, at that time the King's Chancellor, later Bishop of Salisbury, he took up the office of the previously mentioned head and is consecrated Abbot of Gloucester by Saint Wolstan Bishop of Worcester with the agreement of King William, and he acquired and recovered much wealth for the same church. Indeed with the help of King William the Conqueror he obtained from the Archbishop of York Frocester with Colne Saint Alwyn which in the time of his predessors had stood alienated with other manors handed over in lieu of tax. This same father obtained for this church 1000 days of relief.

Odo
AD 1077.

In the year of Our Lord 1077 Odo who was the first Cellarer took the religious habit under the rule of the venerable

Abbot Serlo and by his hard work and industry Gloucester's church increased in lands and possessions many times over.

First stone of
church laid.
AD 1089.

In the year of Our Lord 1089 on the Feast of the Apostles Peter and Paul, in this year the foundations of Gloucester's church are marked out, the venerable and distinguished Robert Bishop of Hereford laying the first stone, Serlo being ruler as abbot.

Earthquake.

And in the same year on August 11 there was an earthquake.

Of the Barton and other manors of the church of Saint Peter which were given back.

Archbishop of York
returns lands.

In the year of Our Lord 1095 on Palm Sunday Thomas the venerable Archbishop of York gave back to Gloucester's church the villages of Northleach, Oddington, Standish [and] the Barton, emphatically exonerating himself [but] beating his breast [and] bending the knee because he had held them unlawfully for so long. These things were done in the presence of Lord Serlo the abbot in the chapter of the monks with many persons attending and rejoicing. His predecessor Archbishop Aldred had taken away these villages from the common property of the same church thirty-nine-years previously because of his [expenditure on] hospitality in the reign of King Edward the Confessor.

Of the dedication of Gloucester's church Saint Peter in the time of Lord Abbot Serlo.

AD 1100.
Dedication.

In the year of Our Lord 1100 on Sunday July 15 the church of Gloucester which Abbot Serlo of revered memory had built from its foundations was consecrated by Bishops Sampson of Worcester, Gundulph of Rochester and Heurev of Bangor with great ceremony.

And in the same year Lord Thomas the Archbishop of York, an old man, died on November 18.

Gift by Henry I.

In the year of Our Lord 1101, Henry the Clerk, King of England, gave the manor of Maisemore and its wood and open ground with everything appertaining so that the monastery might hold it with the benefits he had enjoyed.

AD 1102.

And in the year 1102 the church of Saint Peter of

Church and city
burnt.

Gloucester together with the city was burnt by fire after
Lord Abbot Serlo of revered memory, by his industry and
hard work, had acquired much land and wealth. These were
Leadon, Lynkeholt, Duntisbourne, the mill at Stonehouse,
Glasbury, Sotteshore, Nympsfield, Clehonger [?],
Littleton, Ashperton, Clifford, the church of Saint Peter in
Hereford, Seldenham in Devonshire and many others which
are contained in the Kalendar of Gifts compiled from them
in alphabetical order as will be made clear below.

Death of Serlo.
AD 1104.

In the year of Our Lord 1104, having with him Lord Odo
the Cellarer as fellow worker and helper, in about the
sixtieth year of his age [and] the thirty-third of his prelacy,
on March 3 the Thursday after Ash Wednesday, the day
now drawing to its end at the time of Vespers, he was
released from the flesh, leaving after him 100 monks in the
community. And to him succeeded Lord Peter [who was]
Prior of the same monastery.

Poem on Serlo.

There follows a poem on Serlo the first Abbot of this place
after the Conquest.

The wall of the church fell when Serlo sank down, -
Sword of courage, trumpet of justice,
Speaking truth, and not using empty words,
And, when he chided, accepted by princes.
[His] decisions [were] swift, [he was] hostile to erring from
the rule.
[With] lightness in manners he did not please himself.
In the third month from January on the month's third day,
When struck down by death, life raised him up.

Abbot Peter.
AD 1104.

Lord Peter, Prior of Gloucester, an office which he carried
out well and energetically for 11 years and 4 months, took
over ruling the church of Gloucester on August 5. And in
his time he acquired much land, as is listed in the Kalendar
of Gifts [and] as will be made clear below. And he
surrounded the Abbey with a splendid stone wall and
enriched the cloister with an abundance of books.

Dispute with
Bishop of
Hereford.

At this time there was a great dispute between Lord Abbot
Peter and Remelin Bishop of Hereford in the presence of
King Henry and Lord Anselm the Archbishop and Robert
Earl of Mellent and many bishops, abbots and nobles at

Pentecost over the taking away of the body of Radulf son of Askitil which Bishop Remelin had taken away by force. And there was a document to prove that the body should be disinterred and returned. Earl Robert declaring judgement, they had decided that from then on all, wherever they lived, should have full power of disposition after death.

With all the bishops who were there agreeing to this the said Remelin renounced all the slanders and accusations which he had upheld towards Peter [standing] before the church of Saint Peter in Hereford, with ringing of bells before the canons, only so far as this matter was concerned, that the body was not to be buried. For this reason the body was returned unburied.

Peter dies.
AD 1113.

At last he [Peter] died in the year 1113 on July 17, $7\frac{1}{2}$ years after he became prelate in the fourteenth year of the reign of King Henry I. To him succeeded Abbot William.

William the third Abbot of St Peter of Gloucester after the Conquest.

Lord Abbot William whose other name was Godemon, in his time acquired and recovered much land, as much in the city of Gloucester as outside, as is contained in the Kalendar of Gifts listed alphabetically, as will be made clear below.

Of the fire in the Gloucester monastery.

And in the year of Our Lord 1122, the twenty-second year of the reign of Henry King of the English the city of Gloucester with the principal monastery on Wednesday March 8th was once more ablaze with fire. It was indeed in the third year of the beginning of his reign on Thursday May 22 that the city was first burnt.

Celebration of Conception of BVM

In fact it was at that time that first began to be celebrated among us in England the solemnity of the Conception of the Blessed Mother Mary.

Lord Abbot William, after such great gifts had been made to the church of Saint Peter, having of his own freewill given up his pastoral care because of infirmity (and) without the agreement of his Chapter, chose a devout monk named Walter to be their abbot with the agreement of the brothers. And he is consecrated by Symon Bishop of Worcester on Sunday August 3.

William dies.
AD 1131.

In the year of Our Lord 1131 Lord Abbot William, who lived one more year after he gave up his cure, went from

this world to Our Lord on July 13, having been prelate for
17½ years, and in the thirty-first year of the reign of King
Henry I.

**Walter de
Lacey Abbot.
AD 1130.**

Walter de Lacey Abbot. In the year of Our Lord 1130
Walter de Lacey, a chaplain, succeeded the master in the
office of Abbot. And his parents offered him to God and
Saint Peter at the very tender age of about 7 years because of
their devotion to religion and the monastic way of life, and
he acquired much wealth for the same church from his
father as well as from his mother Emma.

**Death and burial of
Robert Curtehose.
AD 1134.**

In the year of Our Lord 1134 Robert Curtehose Earl of
Normandy, the son of William the Conqueror died in
Cardiff Castle on February 3. But in fact he is buried with
due honour in the church of Saint Peter of Gloucester before
the High Altar.

**Lanthony Priory,
May 25, 1136.**

And on May 25 was founded Lanthony Priory through the
efforts of Milo, Constable of England, in the year of Our
Lord 1136.

**Agreement between
Bishop of Hereford
and St Peter's.
AD 1134.**

In the year of Our Lord 1134 an agreement was made
between the Bishop and Chapter of Hereford and the Abbot
and monks of Gloucester about [their right to] enter [?]
[the church of] Saint Peter of Hereford as the canons of the
same church had had it in time past, as is made clear in the
Kalendar below in the H[ereford] document.

**Hugo gives
Kilpeck church.**

Also in the same year Hugo the son of William the son of a
Norman gave to God and Saint Peter and to the monks of
Gloucester the church of Saint David at Kilpeck with the
chapel of Saint Mary de Castello and all the chapels and
lands which belong to them as is made clear in the Kalendar
in the K[ilpeck] document.

**Walter de Lacy
blind.**

And now, William* de Lacy, in ripe old age, that he might
be worthy of those days of the life to come, was blessedly
touched by the divine chastisement, so that, as we believe,
he was being purified beforehand. And so, after he grew old
from the time he entered the service of God in all that
concerns the religious life, he was stricken in his eyes about
two years this side of his life's end. So when he had greatly

* Thus MS for Walter.

rejoiced for a while in this chastisement, as we heard from his own mouth, one night, that is to say on December 11, he was happily with the monks singing the psalms of the Saturday liturgy, chanting with the psalm-singers. He left out not a single verse. He went to bed and stayed there for a short time. And soon returning very early in the morning to the church, he was devoutly present at the Mass being celebrated in honour of Mary the Mother of God. And when, having performed the sacred mysteries, he, with his whole body prostrated, was to sing the seven Penitential Psalms with the hymn 'Jesu nostra redemptio' and adore the divine Sacramental Species, suddenly he was stricken with a paralytic illness. The Mass ended, he was carried off to his bed, and, fortified by partaking of the Body and Blood of Christ, he remained some days totally incapacitated in body. Then, having recovered somewhat his bodily strength and speech, as long as he survived he continued tireless in prayer, in confessing [his sins], in almsgiving, in making satisfaction, so far as he could, to his God and to men.

Death of Walter. 1139.

When therefore the festival of the Lord's Nativity was completed and the Purification of the Holy Mother Blessed Mary herself was upon us, the same venerable father Walter recovered enough to celebrate the said festival himself, joyfully praising God soon after dawn, whilst the brothers sang together and rejoiced, whilst he again confessed his sins and devoutly received Holy Communion. After Vespers was over, his own most personal blessing having been again requested and received, with Absolution and the Kiss of Holy Blessedness, after a short interval he was again stricken with paralysis and deprived of the use of all his members. He suffered for six days and nights. When they were over, nine and a half years after he became prelate, about the third hour of the day, he sent forth his spirit. He was buried by the venerable Abbots Reynald of Evesham and Roger of Tewkesbury on February 8 and in the year of Our Lord 1139 and the fifth year of the reign of King Stephan.*

Abbot Gilbert. AD 1139.

After he was buried, two brothers were sent to the community at Cluny to inform them we had chosen Lord Gilbert as Abbot. To whom King Stephan, when he heard

* Spelled thus in MS.

of the fame of his very great uprightness, at the petition of Milo his Constable, granted the Gloucester prelacy [at his court] in London.

Of Lord Gilbert, the fifth Abbot of the monastery of Saint Peter of Gloucester after the Conquest.

In the year of Our Lord 1139 Lord Abbot Gilbert, a monk of Cluny, a man of very great resourcefulness and wisdom was raised to the Abbacy of Gloucester as granted by Stephan, and was ordained by Robert Bishop of Hereford with great rejoicing and singing of praise on the Festival of Pentecost which that year was celebrated on June 11.

And on the following day after he was enthroned with the approbation of many of both orders [and] with joy and exultation, as befitted such a man in the Lord, who acquired as much wealth within for the same church as beyond its walls for the priories outside, as will be made more clear in various deeds in the Kalendar.

Moreover he obtained for the said church many and varied privileges, both from the Pope and the bishops, as will be made clear below in the same Kalendar.

Death of Robert Bishop of Hereford. AD 1148.

Moreover in the year of Our Lord 1148 Robert de Betone, [a man] beloved of God and men, Bishop of Hereford, went to the Council of Reims and was taken ill there. He departed this life on April 16, the Friday in Easter Week, having been confessed and absolved by the Apostolic [Legate] and many other archbishops and bishops. The venerable Abbot of Gloucester succeeded him in the bishopric. He was consecrated with great pomp by Archbishop Theobald at St Omer in Flanders with the approval of the Lord Pope on September 5 in the tenth year on his prelacy as Abbot.

Abbot Hameline.

Of Hameline sixth Abbot of the monastery of Gloucester after the Conquest.

December 5, AD 1148.

In the same year Hameline, a venerable man [and] Subprior of the same monastery, was made head of Gloucester's church, having been elected unanimously according to the Rule on September 26, and blessed by Symone Bishop of Worcester on December 5. And he obtained much wealth for the said church.

In his time the old dispute between the church of York and the church of Saint Peter of Gloucester about the alienation of the manors of Northleach, Standish [and] the Barton, after various arguings about it all both in the Papal Curia and in provincial synods, Hameline himself pursuing the case, was settled thus: That the monks conceded to the Archbishop of York, who then was Roger, the following: i.e. Oddington, Condicote [and] Shurdington, 1196 acres, and the Archbishop himself in his own General Synod retracted any item concerning a false accusation or legal right in [the matter of] the previously mentioned manors which Hameline asked to be restored to his own church.

Bromfield Priory
given to St Peter's.
AD 1155.

In the year of Our Lord 1155 the canons of Bromfeld gave their church and themselves to the monastery of the church of Saint Peter of Gloucester by the hand of Gilbert Bishop of Hereford with the authority of Theobald Archbishop of Canterbury and of the Apostolic Legate. In his time the same Hameline acquired much land and property and rents and churches for the same church and its priories, as is made plain in the Kalendar in various deeds.

The murder of
a boy by Jews.
AD 1168.

In the year of Our Lord 1168 a boy [named] Harald, who is buried in the church of Saint Peter the Apostle at Gloucester in front of the altar of Saint Edmund the Archbishop and Saint Edward the King in the northern part, is said to have been enticed away secretly by Jews, as most believe, on February 22. He was hidden until March 17. During a certain night, that of the preceding Friday, he was set before Jews who had gathered from all over England under the pretext of circumcising a boy at the celebration of a great festival according to the Law. They pretended this rather craftily and also misled the citizens of Gloucester with such deceit. They tortured him with extreme cruelty. In fact no Christian was present who might have seen or heard his torments, nor have we found out from any Jew what went on. What we do know is that, somewhat later, virtually the entire community of monks of Gloucester with almost all the citizens of the same city – an innumerable throng from all directions – ran towards the remains which were displayed. They examined the scars – the burns – on the body, and the thorns fastened on his head and under his armpits [?], and the liquid wax poured in his eyes and on his face. By carefully examining the evidence of the way his hands were clenched it was believed – or the signs pointed to it – that they had inflicted on him tortures like those of

being crucified in this way. And at length it was seen that, by placing him between two fires they severely burned his sides, his back and buttocks, with his knees, hands and feet, including the soles. They fastened thorns around his head and under both armpits. They poured hot dripping over the entire surface of his body as we do when basting a roast. They put molten wax in his eyes as well as his ears, [as was clear] from his twisted neck [?]. They also knocked out his front teeth. They put him to death and threw him into the River Severn after tying his feet with his own girdle, whilst he, in his body soon after found in the water, displayed a glorious [and] blameless martyrdom for Christ.

Truly it was by the bountiful gift of divine grace that on the Saturday, which in that year was March 18, he was brought to light about the ninth hour by fishermen and dragged out of the river. He was found near the place where God saw he was put and viewed by many during the following night. His body was shown to many clergy and to the common people who hastened there together. Indeed on the morrow, the Lord's Day – March 19 – when it was now towards sunset he was solemnly carried away to the church of Saint Peter of Gloucester, in the monastic [part], accompanied by an unnumbered throng of people of both sexes, with the Lord Abbot Hameline and the whole community going before. With the larger bells ringing he was borne aloft and carried away the same night to a more private place with lights kindled all round. He was viewed by the brothers and carefully laid out [?] and washed. And so eventually on the morrow he was buried with great reverence before the altar of the Holy Confessors Archbishop Edmund and King Edward in the northern part [of the church].

Moreover his garments as seen by the beholders bore the marks of a presumed martyrdom. For a new shirt with which he was clothed when thus displayed was seen to be scorched all around him so that about 300 holes were found in it and scarcely any part of the frayed seams was attached to [any] other part. And more of the same was found in his tunic according to one who saw his sacred little body and his clothes and [who] handled both more carefully. He bore true witness, making statements by which the truth might be made plain by putting together the salient points.

Death of Abbot Hameline.

In the year of Our Lord 1179 Lord Abbot Hameline died on March 10 after he had ruled that church for thirty-one years

AD 1179.

amid greatly increasing disturbances in the world. It was the twenty-sixth year of the reign of the second King Henry after the Conquest [and] the thirty-first of [Hameline's] prelacy.

Abbot Thomas.
September 17,
AD 1179.

Of Lord Thomas the seventh Abbot of the monastery of Saint Peter of Gloucester after the Conquest.

There succeeded to Abbot Hameline the venerable Thomas Prior of Hereford elected according to canon law by the whole chapter of the same monastery and he was received and enthroned with honour on September 17 with a great procession and a crowd of the common people.

Fire in the city.
AD 1190.

During his time, on May 11 in the year of Our Lord 1190 a fire in the city of Gloucester burned down most of the town and almost all of the workshops attached to the abbey and also set on fire two churches, Saint Mary in front of the Abbey gate and Saint Oswald adjoining the wall.

Richard I
imprisoned.
AD 1193.

Also in the year of the Lord 1193 Richard, the first king [of that name] after the Conquest, when he returned from Jerusalem, was imprisoned in harsh conditions by the Duke of Austria, it is said for three months and almost fifteen days. Then in fact he was ransomed by the Emperor of Germany and held by him for some time longer.

Meanwhile indeed over all of England there arose distressing disturbances because of plunderings and fires as well as robberies.

Tax to pay
for king's
release.

Moreover a certain tax [for paying] to have the king set free was levied on clergy and laity. As a result whatever treasure was held in any church in [the way of] chalices or other silver vessels was forcibly and completely taken away.

Death of Thomas.
AD 1205.

The said Lord Thomas died in the year of the Lord 1205 on July 21 in the twenty-sixth year of his prelacy and the sixth year of the reign of King John.

Abbot Henry.
October 2
AD 1205.

Of Lord Henry Blont the eighth Abbot of the monastery of Saint Peter of Gloucester after the Conquest.

There succeeded to Lord Thomas the Abbot Lord Henry Blond [sic], the Prior of the same place. He was blessed by Mauger Bishop of Worcester on September 29 and he was

received and enthroned by the venerable John the Arch-
bishop of Dublin on October 2 with a very great procession
of clergy and common people.

Tax for John's
French war.

In his time John King of England with [the agreement of]
the Council of his loyal subjects exacted a tax of a thirteenth
on all possessions both of the clergy and the laity
throughout England towards maintaining his war against
France.

General
Interdict.
AD 1207.

In the year of the Lord 1207 there began a General Interdict
throughout England on the day of the Annunciation of
Blessed Mary because of the quarrel which had arisen
concerning Lord Pope Innocent III and John King of
England over Lord Stephan Langton Archbishop of
Canterbury.

In the year of the Lord, 1208, the second year after the
Interdict, it was relaxed [by] allowing only one celebration
of Mass in conventual churches every seventh day.

Tax on all
churches.
AD 1210.

In the year of the Lord 1210 King John levied an entirely
new tallage on all the churches of England, [both] greater
and smaller of whatever [religious] order or [state of]
poverty, so that lepers were not exempt, nor servant girls in
courtyards. From the Abbey of Gloucester he seized 600 [?]
cartloads, each with 8 horses, and the chalices of the Abbey
were sold.

And in the following year King John extorted large sums no
less from monks as from the whole clergy of all England.

Burning of
Gloucester for the
fourth time.
Removal of Interdict

In the year of the Lord 1214 the whole town of Gloucester
was burnt on Saint Alban's day.

In the same year the General Interdict on the whole of
England inflicted by the highest pontiff because of the
disagreement between the civil power and the clergy was
relaxed on the octave of Saint John the Baptist by Lord
Nicholas Bishop of Tuscany [?] and Legate of the Apostolic
See to the great joy of the people.

Death of John.
Henry III crowned
at Gloucester.
October 28 1216.
King Henry.

John King of England died at Newark and is buried at
Worcester.

His son Henry who had been [named] his heir since he was
a boy of ten succeeded him and was crowned at Gloucester

in the church of Blessed Peter the Apostle on October 28 by Lord Peter de Roches Bishop of Winchester by authority of Cardinal Gwalo titular priest of Saint Martin and Legate of the Apostolic See, being present himself with certain bishops and many noblemen.

Wall built. End of lawsuit between Abbey and St Oswald's AD 1218.

At that time an exchange was made between us and Walter de Grey Archbishop of York and the canons of Saint Oswald, and the wall was built.

Exchange between us and the canons of Saint Oswald.

In the year of the Lord 1218 near the Festival of Saint Michael the lawsuit which Prior William and the canons of Saint Oswald had begun against the church of Saint Peter died down. It was about the church of Saint John by the north gate and the chapel of Saint Brigid. Also about the land below the Abbey wall going down in a straight line past the refectory, larder and bakehouse as far as the new wall nearest to Saint Oswald. It was also about the tithes of Peter from the King's Treasury and [the dues] of Ralph de Willington in Sandhurst, that is to say the third sheaf, and about our demesne tithes from Abload. Moreover in the time of Abbot Henry and Walter de Grey Archbishop of York the rent of 20 shillings paid to the King's Treasury was tranferred to the church of Saint Oswald to make peace. This peace was confirmed by the Abbots of Thame and Netley [?] and the Prior of Thame, who were the judges appointed by Pope Honorius.

Great eastern tower. AD 1222.

In the year of Our Lord 1222 the great eastern tower of the Gloucester church was built with the help of Helia the Sacristan of the same monastery.

Northleach Market

In the same year the market at Northleach was granted to us, as is made plain in the alphabetically arranged part.

Fire in Gloucester. Fire, July 31.

Another fire. 1223.

On July 31 the whole parish of Saint Mary before the gate of the Abbey was burned, and part of the bakehouse and brewhouse, and the house between the gate and the stable, and both sides of the main street from Saint Nicholas to the bridge, and all the little streets to our own Barton. On Sunday night, May 21, in the year of Our Lord 1223, fire attacked from the street to the castle to the gate called Lichgate on both sides of the main street, and on the following Thursday, after the first bell for Mattins, a fire started from the Great Cross of Gloucester and enveloped

the entire street of the cobblers and drapers and the church of Saint Mary of Graselove and part of Holy Trinity church, together with both sides of the main street as far as the place where the earlier fire finished.

Death of Abbot Henry. AD 1222.

The venerable Henry Abbot of Gloucester died on August 23 in the year of Our Lord 1224 in the nineteenth year of his prelacy and the ninth year of the reign of King Henry and to him succeeded Thomas de Bredone the Prior of the same place on August 31.

Abbot Thomas de Bredone. AD 1224. August 31.

Of Lord Thomas Bredone the ninth Abbot of the monastery of Saint Peter of Gloucester after the Conquest.

Lord Thomas de Bredone the Prior of Saint Peter of Gloucester was canonically elected Abbot on August 31. He was consecrated on September 22 at Kidderminster by William Bishop of Worcester and he was received with honour on September 29 by 3 abbots and 2 priors with a great procession and gathering of the common people and installed by Archdeacon Maurice assisted by Walter the Bishop's Chaplain on behalf of the Bishop.

Lawsuit about church of Slimbridge

In the same year a lawsuit was begun between Thomas Berkeley and Lord Thomas de Bredone the Abbot about the church of Slimbridge as is made plain in the Kalendar.

Chapel of St Mary completed.

The chapel of Blessed Mary in the cemetery was completed at the expense of Ralph de Willington senior and he gave rents with which were to be maintained in perpetuity two priests there to say Masses for the dead.

Death of Abbot Thomas.

Lord Abbot Thomas died and he found tribulation and sorrow in his pastoral cure, for he ruled three and a half years or longer and in those years languished for one and a half in weakness because of heart pains and [did so] until his death. To him succeeded Henry Foliet.

Henry Foliet Abbot. AD 1228.

Of Lord Henry Foliet the tenth Abbot of the monastery of Saint Peter of Gloucester after the Conquest.

After the death of Lord Abbot Thomas de Bredone there immediately succeeded him Lord Henry Foliet, Prior of Bromfeld. He was elected Abbot with the unanimous agreement of all the brothers, blessed by Lord William de Bleys Bishop of Worcester, and installed by the Archdeacon

of Gloucester according to custom with the venerable
gentlemen Lord Hugo of Hereford and John of Ireland,
former bishops, and the Abbot of Westminster assisting
him, together with very many others, in the year of Our
Lord 1228 and the thirteenth year of the reign of King
Henry III. And moreover in the year of the Lord 1231 Lord
Henry Foliet fixed [a sum of] 20 marks a year from the
church of Newbury [?] for French wine in the convent's
allowance of food.

Death of Helias.
AD 1237.

In the year of the Lord 1237 on November 9 the monk
Helias de Hereford died. He erected the tower of the Abbey
of Gloucester, constructed the old stalls for the monks [and]
made a channel for running water.

Dedication of
the church.
AD 1239.

In the year of the Lord 1239 on September 18 the church of
the Abbey of Gloucester was the dedicated by Walter de
Cantilupe Bishop of Worcester in honour of the chief of the
Apostles the Apostle Peter. Accompanying him were the
venerable fathers the Abbots of Evesham, Tewkesbury,
Pershore [and] Cirencester, and other noble gentlemen with
a huge crowd of the common people. The said bishop
granted 40 days' holiday to the same church and granted
that the anniversary of the dedication be celebrated by all in
the city of Gloucester as if it were a Sunday and that the
holiday should last 15 days.

Tallage on all
clergy.
AD 1240.

And in the year of the Lord 1240 around the time of the
Feast of the Apostles Peter and Paul he* levied a tallage on
all the religious and clerics of England to pay for the war
against the Emperor.

Dispute with
canons of Bristol.

And in the year of the Lord 1241 on the Feast of the
Apostles Peter and Paul, with the travelling justices
sitting, that is to say Robert de Laxentone and others, an
Assize called 'The Great' was held in Gloucester before
them concerning rights of pasture in Laxentone, during
which the canons of Bristol said they held rights of
common. The canons and their chief witnesses pleaded for
mercy and the rights of common were ruled free for us and
to be undisturbed by them forever.

Nave vault
completed.

And in the year of the Lord 1242 the new vault over the
nave of the church was finished, not with the help of the

* i.e the King.

AD 1242.

workmen as at the start, but indeed by the eager efforts of the monks who were there.

SW tower
begun.

And in the same year was begun by Walter de St John, the then Prior of the same place, the new tower of the church towards the west on the south side.

Death of Henry
Foliet.
AD 1243.

In the year of the Lord 1243 Henry Foliet died. He acquired and created much wealth for the monastery, both in rents and other [sources of income]. It was the twenty-seventh year of the reign of King Henry III and the nineteenth of his prelacy. To him succeeded Walter de St John the Prior of the same place.

Walter de St John
Abbot.

Of Lord Walter de St John the twelfth Abbot of the monastery of Saint Peter of Gloucester after the Conquest.

Death of Walter
de St John.

There succeeded to Abbot Henry Foliet Walter de St John, the Prior of the same place, who did not receive installation but died the same year.

In the same year Margery de Croylie gave herself and her lands of Farley to God and to the church of Saint Peter of Gloucester.

And in the same year John de Felda the Precentor of the same place succeeded him in the office of Abbot.

Abbot John de Felda.

Of John de Felda the thirteenth [sic] Abbot of the monastery of Saint Peter of Gloucester.

John de Felda succeeded his venerable master in the Abbacy. He was put in authority by the choice of all the brothers, and he created and acquired much wealth for the church.

SW tower
finished.
Dues on fishing
rights.

In his time the west tower on the south side was finished and the talks begun between us and John de Fretone about fishing dues in the Severn was settled by an agreement before the London Bench.

John de
Codestone's gift.

And John de Codestone who at once time was servant to Henry Foliet gave us the lands of Lillington and shortly after paid the debt of death.

Refectory rebuilt.

In the year of the Lord 1246 the monks' old refectory was demolished and a building begun with new material [?].*

Dispute between Abbot and Archdeacon.

In the year of the Lord 1248 a lawsuit between the Abbot of Gloucester and Thomas the Archdeacon of Gloucester over a meadow was settled.

Grant of rent by Bishop of Llandaff.

In the year of the Lord 1255 Lord John de la Ware, Bishop of Llandaff, assigned to us the rent of 30 marks from our church of Newbury, saving the portion estimated as assigned by the said bishop to the vicar of the said church for the time being.

John de Felda dies.
AD 1263.

And in the year of the Lord 1263 there died the venerable father Lord John de Felda Abbot of this place on March 27 in the forty-seventh year of the reign of King Henry III [and] the twenty-first of his prelacy. [He was] gentle in his manners, tall of stature and with a countenance commanding respect. [He was] very generous and most sweet of speech. He, with the community present and agreeing, ordered that the anniversary day of his death be observed with what was got from all the produce of the mill together with the vineyard in the monastery's food allowance and in the relief of the poor. He built the same mill from its foundations.

Abbot Reginald de Homme.

Of Lord Reginald de Homme the fourteenth Abbot of the monastery of Saint Peter of Gloucester after the Conquest.

To this John de Felda succeeded Lord Reginald de Homme his chaplain, who found the house burdened with debt to [the amount of] 1,500 marks net. This man was installed on the nearest Sunday after the [Heavenly] Birthdays of the Apostles Peter and Paul.

Dispute between St Peter's and Gilbert de Clare.
AD 1270

And in the year of the Lord 1270 between the Paschal Feast and Pentecost an Assize was held about the wood of Wylenrugge by Lord Walter de Helun who was appointed for this purpose by [our] Lord the King so that he might hold an Assize of the Realm [to determine] whether Lord Gilbert de Clare, at that time Count of Gloucester, had contrary to law deforced Lord Reginald, also Abbot of Gloucester, of the said wood. The Assize conducted by men from among the King's law officers gave sentence that the

* Or to a new plan.

Count had deforced the Abbot to his hurt, that the said wood belongs to the Abbot with full right, and the judges ordered that the Lord Abbot be dismissed in possession of the said wood. And that was done.

Bishop of Hereford grants church of Great Cowarne to St Peters. AD 1291.

In the year of the Lord 1271 Lord John de Brutone Bishop of Hereford granted the church of Great Cowarne to be converted to [our] own uses and by his episcopal authority all lands property and all greater and lesser tithes* of the priories in the same diocese at that time and obtained the confirmation of the Chapter of Hereford of what has just been set out and indeed that led to it being carried out. There had also been granted [by] the said Chapter the church of Pipe which formerly looked to the Priory of Guthlac in Hereford.

Death of Adam de Elmeley. AD 1273.

In the year of the Lord 1273 there died Adam de Elmeley and because of his holiness he was buried by popular request before the altar of the Holy Cross in the great church. For his love of God he performs many miracles at the same place.

Foundation of Oxford College AD 1283.

Our house in Oxford was founded on Saint John the Evangelist's day in the year of the Lord 1283 by the noble gentleman Lord John Gifford with the agreement of the monks of Gloucester. Lord John Gifford who was present and willing was then led in by the venerable Lord Reginald at that time Abbot of Gloucester.

Ordinance concerning Obits.

An ordinance about the Obits of the brothers.
It is laid down by the order and will of Lord Reginald the Abbot with the assent and at the request of the whole community that when any professed brother shall have journeyed on from this life immediately there shall be written short notes by those who knew him well and they shall be taken without delay to the Domestic Almoner who shall cause them to be carried out by suitable persons of his choice to all our priories and other neighbouring houses of whatsoever Order and chiefly to those where there are definite agreements between us. And since this kind of undertaking cannot be [done] quickly without expense it is laid down that the inferior officers of the monastery for the time being [who are] named later shall each made a small

* the Latin could mean:—all the priories [their] greater and lesser titles . . . This seems so astonishing that I rendered the passage as I have set out above. W.B.

contribution as is made clear below:- To wit, the Cellarer
12 d., the Almoner 12 d., the Chamberlain 6 d., the
Sacristan 6 d., the Sub-almoner 6 d., the Precentor 3 d.,
the Infirmarian 3d. And so let the stated small sum be paid
without any excuse or delay whatsoever by the day when the
dead brother is carried to his burial place. And if any of the
above named inferior officers, because he was not there to
pay as stated above may have wished to excuse himself in
some way because it was not handed in on the day ordered
he shall double his share. And he shall be forced to do so by
the Chapter. That sum stated above is to be taken to the
Subalmoner who on behalf of the monastery shall be
procurator and executor in this matter.

**Council of Lyons.
AD 1274.**

Of the General Council at Lyons. In the year of the Lord
1274 the Lord Pope Gregory held a general council at Lyons
in the month of May. He decided, among other matters
appointed there, that a tenth of all revenue temporal and
spiritual be given by the clergy for six successive years as a
subsidy for the Holy Land.

**Reginald de
Homme attends.**

In fact Lord Reginald de Homme at that time Abbot of this
monastery went there, having been specifically summoned
by a sealed letter, and he was Procurator of the whole
diocese of Worcester because Lord Godefrey the bishop of
the said diocese stayed at home on account of his infirmity.

**Statute of
Mortmain.
AD 1278.**

In the year of the Lord 1278 and the sixth year of the reign
of the first King Edward after the Conquest, King Edward
and his leading men published the Statute of Mortmain
[which laid down] that thenceforth none might give sell
bequeath or exchange or otherwise assign to religious
persons lands, feudal holdings, rents, without the King's
permission.

**Death of Abbot
Reginald.
AD 1284.**

On September 13 and in the year of the Lord 1284 and the
eleventh year of the reign of the first King Edward after the
Conquest Lord Reginald Abbot of Gloucester died in the
twenty-first year of his prelacy. [He was] a man wise and
discreet in deed and word who ruled his house with zeal and
maintained it manfully in great difficulties such as [those]
during England's bitter war by which we were all affected.
To him succeeded John de Gamages.

**Abbot John de
Gamages.**

Of Lord John de Gamages the fourteenth abbot of the
monastery of Saint Peter of Gloucester after the Conquest.

AD 1284.

Lord John de Gamages, then Prior of Hereford, succeeded his venerable master Reginald de Homme. [He was] a noble and discreet man and was installed with due honour on the next following St Andrew's day.

William de Brok monk of Gloucester becomes a Divinity student at Oxford.
AD 1298.

In the year of the Lord 1298, on the day after Saint Bernards's day, brother William de Broke, a monk of this place, was admitted to a course of studies in Sacred Theology at Oxford under Master Richard de Clyve Chancellor of the University, who [was the] first of the Order of the black monks of Saint Benedict to make a name for himself in the subject mentioned above. Towards Vespers on that day at his examination his companion Laurence Honsom, a monk graduate in the same subject [and] from this place, conducted a public dialogue with him. At his admission was present the Abbot of this place with his own monks, priors, inferior officers, people living in the monastery, clergy, squires and other noble persons up to one hundred mounted men. [Also] present were the Abbots of Westminster, Reading, Abingdon, Evesham [and] Malmesbury, many priors and other monks, who all generously supported the admission with various gifts and contributions of produce. And all the other prelates of our Order in almost the whole Province of Canterbury, [who were all absent] sent various contributions by their [representatives], and thus his admission was completed to the honour of this house and of our whole Order.

Fire at the Abbey.
AD 1300.

Of the third fire in the Abbey.
In the year of the Lord 1300, on the day of the Epiphany, towards the time of the Sequence the High Mass, a fire started in one building above the timber in the great courtyard of the Abbey. From this fire many buildings were set on fire all through the Abbey, i.e. the small belltower and the great chamber and cloister. But after folk ran together from all sides and many prayed, the entire fire was soon brought under control, so that this may be ascribed more to a miracle than to the great help [we received].

Lanthony church destroyed by fire.
AD 1301.

Of the fire at Lanthony near Gloucester.
In the year of the Lord 1301 in the month of April [and] on Easter Eve the church of Lanthony near Gloucester was completely gutted by fire, [leaving] the walls with the four bell-towers, nor did there remain any bell except what was melted or smashed to pieces.

Laurence de Honsom
at Oxford.

In the same year Laurence de Honsom began [his studies] in Sacred Theology at Oxford under Lord William de Brok, Prior of Saint Peter of Gloucester and a doctor of the same faculty.

Court of the
Honour of Lacy.

In the same year, after Michaelmas, a great court of fifty-two and a half military fiefs with other freeholders of the Honour of Lacy was held in our Priory of Hereford by Edmund de Mortimer, Lord of Wigmore and his firstborn son Roger [and] Theobald, son and heir to Lord Theobald de Genewile. This Theobald – the father – was not present at the said court, therefore the suitors refused to answer at that time to Lord Edmund and Roger [heirs of the Honour of Lacy] on behalf of [or, in the absence of] Theobald. And so that court did not begin. These are the customs of the said court:- That the lords of the Court ought to be present in person; otherwise the suitors ought not to answer or be held. And that the suitors will be cited 40 days before the day of the court by certain men who hold their lands in fee for doing this, i.e. Gilbert Hamma and Symon de Weston in the County of Hereford. And that the suitors are to come to the said court in person, and if not they will be heavily fined by the lords of the court. And that the lords provide food for the whole court on that day and for the Prior and all the monastic community of the same place.

Ordinance.
AD 1284.

Of a certain ordinance.

In the year of the Lord 1284 on the Sunday next before the Feast of St Peter the community of St Peter of Gloucester [assembled] before the Abbot's throne granted of mere goodwill and under no coercion to their venerable father in Christ Lord John de Gamages by the grace of God Abbot of the aforesaid place as a grant in aid because of various seizures and losses which made inroads into the said community at the time of the last vacancy these appended grants and remissions concerning these items which are recognized as specially pertaining to their provisions and comforts during an entire year and are as follows in order to make a complete statement. To wit:–

From the tithes of Frocester £10 in silver.

From half the incomes of the church of Newbury £6 13 s. 4 d.

Of honey 50 s. [worth].

From the master of the town for cakes [?] for the monastery 66 s. 8 d.

Also for the second course on 7 festivals in a year 79 s.

Also for the second course on 30 festivals in the year when copes are worn £4.

Also from the Sacristan for the Festival of St Dionysius 40 s.

Also from the Precentor for the Festival of St Oswald 40s.

Also for the anniversary day of Lord Gilbert Bishop of London 26 s. 8 d.

For the anniversary of Thomas of Northleach 33 s.

For the anniversary of Lucia of Putley 10 s.

For the anniversary of Lord Matthew of Besile 5 s.

For the anniversary of Walter of Barnwood 15 s.

The total of these in a year is £38 18 s. besides the fee of loaves for the refectory which are valued at 40 s. in a year and besides the daily requirement for ordinary courses in the refectory which are valued at 100 s. in a year.

And note that besides this the community ought to deserve [allowances] for two courses and a good allowance on seven festival days, that is to say of any good freshly caught fish and salted sea-fish, not full of spawn, but a good allowance as on meat days. And on all festivals with copes and white [hangings] [an allowance] for everyone's benefit of good freshly caught fish and a good allowance of good fish.

And on all anniversaries of abbots of that house the amount drawn for them [is to be] £10 [taken] from what the community requires in eggs and salt fish [to pay for] good fish for everyone.

Festivals of the Sacristan and Precentor.

Of the two festivals of the Sacristan and Precentor. Let it be remembered that the Precentor and the Sacristan were accustomed on their festivals to hold festival for three days, i.e. on the vigil, on the day and on the following day, and to do so each of them was accustomed to have one good cask of wine. The total cost of these [celebrations] is £65 18 s. The cost for those concerned with the kitchen is £32 19 s.

The solemn festival of John de Gamages. AD 1305.

In the year of the Lord 1305, around the Feast of St Hilary, Lord William Inge, Lord William Haward, Nicholas Fambur, Knights, Justices of the Lord King, sat in Gloucester to make inquisition into traylebastone primo*. During this court of justice Lord Abbot de Gamages held a solemn and sumptuous festival in the great hall in the

* Beating during questioning.

courtyard of the abbey. There were about 70 at the said festival, 30 Knights, the Priors of Lanthony and St Oswald, and other ecclesiastical persons and many others and the more honourable persons of the whole county who were present at the said court of justice. And they all were assembled in order in the hall and behaved quietly according to their feudal rank, and were summoned in very great numbers to take the oaths, with no commotion nor any absent. Whether judges or other barons who were at this festival, they said at their summoning that they never had seen such a festal and such a distinguished gathering in those parts for many years past.

Death of the Abbot.
AD 1306.

Of the death of the same Abbot.
When they left the hall there was a rumour that the Abbot had foretold his own death, according to which he was about to journey from this life very soon, nor would he again come back to hold a festival in the said hall, because he announced his coming death. For soon after Lent, when a long period of weakness due to age had come to its end, he began to be deprived of his bodily strength and laid [himself] down in his bed because of rapidly increasing weakness. And when the fame of his goodness was heard he was rewarded by being visited by the Archbishop of York, Master William de Grenefeld, and was absolved with apostolic authority. John [and] Edmund, sons of the nobleman John Giffard, who were with him, were lamenting bitterly as they left him.

Feeling therefore his death near by increasing weakness, he prepared himself for the Lord by a humble and devout confession, providing for his departure with the sacraments of the Church. And committing himself thus wholly to the Lord he passed his time in prayer and holy meditations as long as he could so that before his death he was deemed worthy to see the Lord Himself calling him in the likeness of an old man, the whiteness of whose raiment he described to those standing by.

In the year of the Lord 1306 Lord John de Gamages of pious memory, Abbot of this house, died in the middle of the night before Sunday April 17, when the Proper of the Mass was 'Misericordia[s?] Domini', which fitted the merit of him who ever flowed with bowels of loving kindness and in accordance with the Gospel of God vigorously ruled that house like a good shepherd, provident and discreet. He left

that house free of debt. At his arrival he found it burdened to [the amount of] 1,000 marks. Both locally and further afield he supplied it with sufficient manors and the greatest number of sheep whose total in his time increased to 10,000. In one year during his time there were 46 sacks of wool for sale after shearing.

He first definitely established the fine of vacancies in the abbacy of that house at 200 marks.

Likewise when he was Prior of Ewenny from a gift of Thomas de Botiler he bought one carucate of land which is called 'le Newelonda'.

Likewise at that [monastery] the Lord revealed to him in a vision the body of Saint David Bishop of Menevia whose burial place for a long time past had been unknown to the clergy of that church and the inhabitants of that land. At length after being told in the above-mentioned vision his body was found complete outside the southern entrance [of the church]. In the vision there was shown him quite clearly and exactly the precise distance in feet measured from the said entrance, as if the said Prior had been at his burial.

Likewise he greatly improved the manor of Upton by purchasing the land of Robert le Hunte and there as elsewhere many buildings were erected in his time on common lands, as [for example] the Abbot's residence at Hartpury with other new houses erected at Upleadon and the great barn of Frocester and many others. He presented the large gilded chalice valued at 60 s. for the high altar. Also a figure of the Blessed Virgin Mary in ivory. Also one vessel of crystal with a silver foot for keeping relics. Also one costly cushion. Also three costly embroidered sets of vestments with as many chasubles and apparels. Also five brocade albs for the seven Festivals, to wit for the Deacon with stole and maniple to match, for the Subdeacon and Acolyte with maniples to match and one brocade stole for the use of the Priest when he goes to meet the bodies of the dead. Also one costly brocade cope and another costly embroidered cope. Also 'Legenda Sanctorum' in one volume and in another volume 'Transcripta Cartarum' and in a third volume 'Constitutiones Domini Regis Edwardi'. And he presented other ecclesiastical ornaments and books to that monastery.

In countenance and expression he was quiet; [he was] handsome in old age. His venerable white hairs greatly adorned him. His face was suited to ruling and it everywhere gained him reverence and respect.

It is related that at Amesbury King Edward, accompanied by all the English prelates for the burial of his own mother, said of him: 'It seems to me that none in my kingdom is more venerable than the Abbot of Gloucester.'

He was buried beside his brother Lord Nicholas, a knight.

At his burial were the Lord Bishop of Worcester, the Abbots of Tewkesbury, Malmesbury, Winchcombe, Evesham [and] Hailes and many others who all bitterly lamented his death.

The new dormitory begun.
AD 1303.

Of the beginning of the new dormitory at Gloucester.

In the year of the Lord 1303, the twentieth of his prelacy, the old monks' dormitory of this place was demolished around the Feast of St Michael and the fabric of the new dormitory begun.

And John de Gamages died in the thirty-third year of the first King Edward after the Conquest [in] the twenty-third year of his prelacy and to him succeeded brother John Toky.

John Toky Abbot.

Of Lord John Toky* the sixteenth† Abbot of the monastery of St Peter after the Conquest.

Brother John Toky Subprior of this place suceeded John Gamages [and was] elected on SS Philip and James' Day. He was confirmed [as Abbot] and blessed at Hartlebury and installed with due honour on the following Feast of the Apostles Peter and Paul and he conferred and obtained many benefits [for the monastery] as much in buildings as in other ecclesiastical ornaments.

The new dormitory completed. 1313.

In the year of the Lord 1313 the new dormitory of this house is completed around the Feast of St Michael and the monk-brethren all leave their cells with their own beds and

* I am sure the MS has 16th.
† The transcript has the 15th.

transfer themselves to the new dormitory around the Feast of All Saints, [the dormitory having] first [been] blessed and sprinkled with holy water by Master David Martyn Bishop of Saint David [and] with him many clergy and monks and most of all William de Fontayne acting specifically as Procurator.

Settlement of dispute with Prior of Brecon. AD 1315.

Of Devennok.

In the year of the Lord 1315 was settled the dispute between us and the Prior of Brecon and [his] monastery over half the advowson of the church of St Kannoc of Devennok around Pentecost after a long argument in the Roman Court and in the church of St Mary of the Arches in London before various officials of the court of Canterbury. Various judgements were given for us in both courts. The execution [of the judgements] was hindered by Master John Walweyn and held in abeyance by means of various appeals until in that year it had been carried out and finally made perpetual by arrangement and amicable agreement. In the same year the Prior of Brecon restored to us the tenth from Wentorf which he said he had illegally kept for himself.

Ordinance of the Abbot. AD 1317.

Of a certain ordinance of Abbot John Thoky.

John by divine permission Abbot of the monastery of St Peter of Gloucester to our beloved sons and brothers in Christ of St Guthlac of Hereford and Ewenny, the Priors of Bromfield, Stanley, Kilpeck and Ewyas, blessing and grace and greeting. Since not without cause the evil of murmuring has for a long time arisen among the brothers in our aforementioned Priories, it has increased hitherto and, worse, to the extent that the things needful for them have not until now been supplied. Mindful that the cure of souls is committed to us by reason of the pastoral office we have decided the best remedies so that we may be able to give attention to them. Therefore having summoned the higher ranking and senior members of our house, with their consent we have decreed that it be established and also firmly observed, that to the several brethren dwelling in the aforesaid cells there shall be paid annually up to the sum stated below by their own Priors as free gifts. Therefore by firm command we do enjoin you all and singular by virtue of [holy] obedience that to each of the brethren dwelling with you you take care to give one silver mark each year, a half at the Lord's Nativity and the other half at Easter. Having in mind what we have already said, that we may rejoice with brotherly joy over your meritorious behaviour,

from a reckoning at Hilary of what was due to your brethren there must be made payment in accordance with the fulfilling of your brotherly love in this matter. You know that our purpose is not that anything should be diminished in any way on account of what is already laid down about those amounts which they are wont to give our brothers of Hereford and elsewhere under their common seal for the sake of their reputation or for any other cause. As for the Subprior of Hereford for the time being, as he precedes others in office as in responsibility, we similarly desire him to be above others to some extent in what he receives, so at the said Feasts let him receive 10s. when the payments are attended to, under a penalty of double that amount, so that we being favourably disposed to you may have no case [against] you or any one of you because of negligence or because of any omission of the payments lest a cause be argued according to law or there have to be canonical punishments for contempt.

You are to do these things all and singular more in accordance with law in the presence of your brethren so that your brethren bearing witness to the payments being attended to may be strong in devotion to you Priors. Also in addition to the matter of these payments by virtue of your [holy] obedience and under pain of suspension from the celebration of the Mysteries we lay down that none of you presume in addition to eat meats or meat dishes on any four Ferias whatsoever of the Lord's Advent or in the season of Septuagesima until Quadragesima openly or secretly, only a case of obvious illness excepted and if such can be previously explained to us. And this our mandate with our sole and our common seal [which] we have caused to be added to these presents you are to deliver that it may be carried out more diligently and more willingly. Dated in our Gloucester Chapter October 12 in the year of the Lord 1317.

Corpus Christi.
AD 1318.

A note on the Festival of Corpus Christi*. In the year of the Lord 1318 the Festival of Corpus Christi began to be generally observed in the whole English Church.

South Aisle.

Of the South Aisle.
At the same time the south aisle was built in the nave of the church during the time of the same Abbot with very great expenditure on many items.

* This sentence is in larger letters in MS.

Edward II
at Abbey.

Of Edward Caernafon.*

In the time of that Abbot, when Edward the second King [of that name] after the Conquest [and] son of King Edward I, came to Gloucester, the Abbot and community received him with honour. And sitting at table in the Abbot's hall and seeing there paintings of the kings his predecessors he was jokingly asking the Abbot whether he had him painted among them or not. To whom [the Abbot] replied, prophesying rather than merely talking, that he hoped he would have him in a more honourable place than there. And it happened like that. For after his death certain neighbouring monasteries, namely St Augustine's of Bristol, St Mary's of Kingswood, St Aldhelm's of Malmesbury, were afraid to accept his venerable body for fear of Roger de Mortuomar and Queen Isabella and others involved.

Burial of
Edward II.

The same Abbot however brought him with honour from Berkeley Castle in his own carriage painted with the arms of his own church and it was taken to the monastery at Gloucester. The abbot with the whole community being in solemn vestments, [the king] attended by a procession of the entire citizenry was received with honour and borne to his burial there in the northern part near the great altar.

John Toky
resigns.
John Wygemor
Abbot.
AD 1329

Lord Abbot John Toky, after many labours and spending much money on the different buildings, and completing other very numerous good works in our monastery, gave up his pastoral charge without the agreement of his brothers on account of illhealth and weakness. The Prior of the same church, a devout monk by the name of John Wygemor was raised to the Abbacy with the agreement of his brothers. After living for a few years [John Toky] died in the twenty-second year of his prelacy, and in the third year of King Edward the third [of that name] after the Conquest.

His
achievements.

In the year of the Lord 1329 John Wygemore the Prior of this place was elected to the Abbacy and blessed by the Bishop of Worcester. He did much good for the monastery and, as much whilst in the office of Prior as in the prelacy as Abbot, acquired in vestments as in different buildings both within as without as are noted here later. As for example green samite with winged beings in gold for the Feast of Pentecost which he wove and made with his own hands.

* In larger letters in MS.

And he provided a set of brocade for the Feast of the Apostles with various other copes with woven designs of winged beings in gold thread as well as black.

His artistic ability.

Likewise whilst he had been Prior of the same monastery he built the Abbot's Chamber beside the Infirmary garden. Likewise he adorned the re-table at the Prior's Altar with polished and gilded figures at his own expense. And he adorned the other retable which is now in the Abbot's Chapel with the same work. And he greatly delighted in various arts, so that he himself was very often involved in them and he excelled in many different undertakings concerned with the arts, as much in mechanical devices as in weaving.

The offerings at Edward's tomb. St Andrew's Aisle completed.

In his time began the offering[s] of the faithful and the devotion which [the people] showed for King Edward who had been buried in the church to the extent that within a few years there was such a crowd of the common people that the city of Gloucester scarcely held the multitude of people flowing together there from various cities of England, towns, villages and hamlets. As a result out of the offerings made there in 6 years of his prelacy St Andrew's Aisle was completed to the last detail, as may now be seen. And he totally constructed a large grange at Highnam and he completed the Abbot's Chamber near the Great Hall, with the Small Hall attached to it and the chapel there.

John's personal appearance and character.

In face and expression he was calm, in speech pleasant and affable, and with his brothers gentle and kind, so that he would often invite now these or those of his brothers to his chamber for relaxation, and would prepare different dishes and drinks, and thus he so conducted himself among his fellow monks that they all loved and respected him, not with the respect due to a father but with the love felt by sons. And indeed he increased their extra payments which had been laid down in Chapter at each Festival of the Lord's Nativity and of Easter, from every monastery servant upwards, by 2 s. above the usual amount. May God rest his soul. Amen.

John dies. AD 1337.

In the year of the Lord 1337 on February 28 there died Lord Abbot John de Wygemor, in the eighth year of his prelacy, and he was buried before the Salutation of Blessed Mary at the entrance to the Choir on the south side, [in a part] which he himself had built together with a pulpitum there,

as may be seen now. To him succeeded Lord Adam de Staunton, Prior of this place.

Adam de Staunton Abbot.

Of Lord Adam de Staunton, the seventeenth Abbot of the monastery of St Peter of Gloucester after the Conquest.

Lord Adam de Staunton succeeded his master John Wygemor, in whose time the great vault of the choir was built, at vast expense, with the stalls there on the Prior's side, from the offerings of the faithful flocking to the King's tomb. For popular opinion had it that if it had been possible that all the offerings gathered there had been used for the church, it could very easily have been completely rebuilt. So great were the offerings of those of high rank and of the wealthy at that time in garments woven with gold and other jewels that 100 garments woven in silk and gold were for sale cheaply whether of better quality or damaged.

King Edward III's gift.

At the same time King Edward the third [of that name] after the Conquest, the son of the aforementioned King, having been sorely tried by a great misfortune at sea and having been delivered through the intercession of the same father, offered a ship of gold. And another which he devoutly dedicated he redeemed at the request of the Abbot and community for a price of £100.

Other gifts.

And Edward Prince of Wales the aforementioned King's heir offered the other jewels hanging there along the [sides of the] ship [and] a cross of gold of great price containing inside itself a piece of the Holy Cross.

And the Queen of Scotland, the sister of the aforementioned Edward and daughter of the same King [who is] buried here offered a necklace with a precious stone called a ruby.

And the Lady Queen Philippa, Consort of King Edward III of England gave the heart and ear of gold which are hung there. And indeed different lords and ladies gave various offerings that were of silver or gilded.

The Abbot's Lodging.

At this time the vineyard which formerly was cultivated for fruit and the produce of various trees and for vines was first built upon. He built the Abbot's Lodging there and surrounded part of it with a wall, but his successor completed the work. And he took the courtesy-payments which his brothers were accustomed to receive from the

Town Tax Collector from the Cellarer and the Kitchen steward and these came to 20 s. a year for each member of the community.

His legacy.

This man left that house out of debt and left 1000 marks in the Treasury for his successor, for it was said that he collected the money in order to be made Abbot of Evesham.

At the same time he obtained the King's Barton together with the weirs at Minsterworth and half of Duny from the King for a fee farm.

His death.

And in the year of the Lord 1351, and in the fourteenth year and a half of his prelacy, Lord Abbot Adam de Staunton died and is buried at the altar of St Thomas the Martyr which he built from the goods and gifts of his half-brother John de Staunton in the middle where his half-brother is buried outside the enclosure of the same altar. To him succeeded the venerable Thomas Horton the Sacristan of this place.

Abbot Thomas Horton.

Of Lord Thomas Horton the eighteenth Abbot of the monastery of St Peter of Gloucester after the Conquest.

Subsequently by way of compromise* Lord Thomas de Horton was elected Abbot and was consecrated by the Bishop of Worcester. For he ruled that church vigorously for 26 years during periods in his life when worldly troubles were increasing beyond measure and he adorned it prudently and from his own funds, and by his hard work, with ornaments of many kinds, – books, different sorts of vestments, silver vessels. And by paying from his own special funds, without incurring any expense to the community for them, he very greatly increased the possessions of the same [church] with various lands [and] rents, both in the town of Gloucester and outside. Also, as will be set out below, by appropriations of benefices, for example the church of Cam, also the holding called 'le Wast' near Lettrington.

Likewise [he obtained] the silver vessels from which the community is served in the Refectory, also four basins of

* *per viam compromissi.* MS.

silver for the High Altar in the church, that is to say two big ones for the use of the Abbot and two other small ones for a priest celebrating there. Also two candlesticks of silver for the same altar. Also one chalice of gold for the same. Also a silver bowl for holy water with a silver sprinkler. Also one cross of silver and gilt to place on the altar while the Abbot celebrates there. Also one silver crozier. Also two sets of vestments of red cloth and white cloth with gold were bought from the community's funds in his time, he himself obtaining them and giving the order. He greatly increased the [extent of] the buildings both outside and inside [the monastery], as in the case of the Abbot's Chapel beside the garden of the Infirmary.

Also he built the covered chamber of the monks' Guest-house and the Great Hall in the Courtyard where later the King held his Parliament, and in the Vineyard, in the same place, he constructed a Parlour, and finished off the wall surrounding the same vineyard which his predecessor had left unfinished.

In his time, as a result of his persevering work, the Great Altar with the Presbytery there with the stalls on the Abbot's side were begun and finished. And the Aisle of St Paul in the monastery of Blessed Peter which was begun the day after the Epiphany of the Lord in the forty-first year of King Edward the third of that name after the Conquest, was, by the grace of God, fully completed at the Vigil of the Nativity of the Lord in the forty-seventh year of the above-mentioned King. The costs of this work together with all he spent were as much as £718 1 s. 2 d., out of which the said Abbot paid £444 1 s. 2 d., as is made clear in the records of the above-mentioned work. In the entry of the choir on the north side he also set up statues there with the tabernacles. And he obtained and increased many other benefits, temporal as well as spiritual, as is made clear in the registers re-written in the time of Lord Abbot Frocester.

Death of Abbot Horton. AD 1377.

And after he had obtained those benefits and many others, both temporal and spiritual, for our monastery, by his own persevering work, because of illness and bodily weakness, without taking counsel with his brothers or obtaining their consent, on his own initiative before he died he gave up his ruling [of the monastery] in the twenty-sixth year of his prelacy and in the year of the Lord 1377. He lived on for 17 weeks [and] 3 days after he relinquished his charge [and] went

his way to God out of this world on March 30, in the twenty-sixth year of his prelacy and in the second year of the reign of King Richard the second [of that name] after the Conquest.

Ordinance of Abbot Horton.

Of a certain Ordinance of Thomas Horton.

It was ordained with the agreement of the whole Chapter while he was still alive and guiding the ordering of this place that each year on the anniversary [of his death] there was to be the Office of the Dead with the solemnity which had been customary for Abbots from days long gone by, and that the Mass for him be celebrated in vestments which he himself had provided of deep red velvet woven with little moons and golden stars. The retable with statues above the altar is to be uncovered, and on the same day let there be served to the Community portions of wastel-bread, wine, and an allowance of fruits from the church of Cam. Also that the Prior of Stanley for the time being has the custody of the church of Cam, and pays each year to the Abbot and community on the anniversary of the same Abbot and on the Conversion of St Paul offerings like those which a monastic official pays them at present before the Feast of the Nativity of the Lord. May God who recompenses all souls recompense his soul. Amen.

Abbot John Boyffeld.
AD 1377.

Of Lord John Boyffeld the nineteenth Abbot of the monastery of St Peter of Gloucester after the Conquest.

On November 26 in the year of the Lord 1377 Lord John de Boyfeld Precentor of this place was elected Abbot by way of compromise* after Thomas de Horton gave up his charge and was consecrated by Lord Gilbert Bishop of Hereford at Winterborne on the Sunday before the Nativity of the Lord, and he was installed on the Vigil of the Nativity of the Lord.

Dispute with Bishop of Worcester.

In his time a great dispute arose between Henry Bishop of Worcester and the Abbot of Gloucester about a certain sum of money due because of the retirement of Lord Thomas Horton and because the consecration of Lord Abbot John Boyffeld was given contrary to Canon Law.

That Abbot was of transparent simplicity and mild, but [he was] unfortunate with the world and worldly things, for during the whole time of his prelacy his rivals were rising

* See p. 631

up against him. As a result he had hardly any rest, since the Bishop of Worcester and very many others troubled him with different vexations and disturbances, to the extent that the same bishop accused him and his brethren of loose living and various misdeeds in the Roman Court. These things came from ill-will. From there he obtained from the Pope [authority to] visit the Abbot and the monks as often and as much as he saw proper. But after the truth of the matter was known to the Pope, the Pope withdrew the same Bull which he had from the Court [authorizing his] visitation. And the same sum of money on account of which the dispute had arisen was awarded to them in full. However, at last, after the interventions of friends on both sides, peace was restored, so that all was forgiven, and so that the bishop paid none of the money but as a spiritual father he bore himself in a friendly manner towards them.

Parliament held at Gloucester.
AD 1378.

Of the King's Parliament at Gloucester.

In the year 1378, the second year of the reign of King Richard II, in the first year of the time of that Abbot, the Parliament began at Gloucester on October 22 and lasted until November 16.

King Richard stayed in turn, as he pleased, sometimes in the Abbey of Gloucester, sometimes in Tewkesbury. But when he was at Gloucester he and his whole family were lodged in the Abbey, which was so full everywhere with them and the [members of] Parliament that for some days the community ate impartially according to the circumstances in the Dormitory [and] afterwards, which was more convenient, in the School, both on meat-days and fish-days, as long as the Parliament lasted. And on some days dinner was prepared in the orchard.

Discussion of laws about arms took place in the Refectory.

However the Guest Hall was decided upon for general parliamentary matters. Moreover in the Guest Chamber, which because of its beauty was called in former times the King's Chamber, secret debates were held among the nobles, and the general debates held in the Chapter-house.

On those days the Martyrologium, except on Festivals when each went to his stall in choir, was read without announcing the daily duty roster. To be sure, all places in the monastery

being thus open to [the members of] Parliament, they were thronged, so that they looked to beholders more like a market than a house of religion. For the green of the cloister was so flattened by wrestlings and ball games that it was hopeless to expect any grass to be left there.

Meanwhile on the third day before the end of the Parliament – which they fixed on a Sunday - was also held a royal banquet, as custom demanded. It was decided to hold it in the Refectory. The Lord Abbot sang the High Mass of the day in Choir. The king, no less rejoicing and desiring this [mass for which the church was], adorned as was fitting for a service attended by royalty, listening devoutly, was giving an offering magnificently worthy of a King as a suppliant. And the Abbot, led beside him by a Duke, blessed him. At this Mass were present two archbishops, twelve bishops, the Duke of Lancaster with his two brothers, namely, the Count of Canterbury and the Count of Hereford, and an almost innumerable multitude of other counts, barons, soldiers and [both] sexes and [all] ages of the common people.

At last, when Mass had been celebrated with due solemnity, the King, packed in with the crowd of the aforesaid great men, went out to the place of the banquet.

So on the fourth day following, that is to say the morrow of St Edmund the Archbishop, having settled all the business properly and without disagreement, as was then believed to be miraculous, for God granted what pertained to the government of the kingdom, they all went to their own homes rejoicing. Indeed before the beginning of this Parliament it was commonly said that laws had been passed to overthrow the English Church – and above all the church of Westminster – for [the English Church], at that time, because of the murder of a certain man perpetrated by certain persons of the King's family, had been placed in situations of great tribulation in such remote places and so unaccustomed to it that none might resist what had been ordered by the ruling Duke. But it turned out more favourably, so that Holy Church may obtain its ancient privileges*. There was general rejoicing that there was to be no taxing of the common people, nor were ecclesiastical persons to be oppressed for any payments of tenths, but by

* MS has *reperiat*(?) = 'may obtain'.

common consent for the whole kingdom only merchants, because they were wealthy, were to provide money for a King's war.

Death of John
Boyffeld.
December 30 1381.

On December 30, in the year of the Lord 1381 and the fifth year of the reign of King Richard, John Boyffeld died as he was beginning his fourth year as prelate and he is buried in the southern part of St Paul's Aisle near the tomb of Abbot Thomas Horton who while he was Precentor of this place had been supervisor of the work on the same [part of the church]. To him succeeded a great man and [one] of profound character, the venerable father Lord Walter Froucester, the Chamberlain of this place.

Abbot Walter
Froucester.
AD 1382.

Of Walter Froucester the twentieth Abbot of the monastery of St Peter of Gloucester after the Conquest.

After Lord Abbot John Boyffeld gave up his charge by his own wish, Lord Walter Froucester was elected Abbot by way of compromise* on the Feast of St Antony the Abbot. And he was consecrated by Henry Watfeld Bishop of Worcester and installed on the Feast of St Valentine. And amid the greatly increasing changes of the world he ruled that house with vigour and prudence during his time [there]. And he sought diligently and graciously to gain the upper hand of his rivals during the whole of his life. And in all decisions in the two areas of law which involve introducing matters or carrying them out he set things in order as long as needed, to the admiration of many. For at much expense and effort he himself greatly enriched and built up that church within and without with many kinds of ornaments, books, vestments, various silver vessels [and] buildings. For example he built the monastery Cloisters in fine style at great expense. It was begun in the time of [name erased] and taken as far as the door of the Chapter house and left unfinished at that point for many years. Also all the buildings standing in the vineyard, except the Abbot's Chamber, the Parlour and the entrances. And at very great expense he surrounded them with a moat.

And on common land [he built] a house of stone for the buildings at Over. And at Abload a large building for the sheep held there. And at Hartpury a chamber at the end of

* See p. 631.

the aisle. And at various other manors he built and repaired many items, and he left the community well supplied with enough of various livestock, and most of all, sheep, the number of which increased in his time to.* Also in temporal as well as spiritual matters he acquired many items, as will be made clear below. Amd for the exemption of the church [from taxes], which had thankfully and wonderfully taken place, he pursued his efforts with great labours and very great expense, and cleverly brought the matter to a conclusion. And also he obtained a judgement in the court of the Lord Earl of Stafford about holding a court for three weeks in Newport. Also other [and] various matters, which would take much time to narrate, as is drawn up [in documents] in the chest and entitled 'Of Walter Froucester', and are more fully set out [in documents] laid up in the archives of the church.

William Bryt in Rome.

Also for many years he had a brother monk who had been professed here, William Bryt, at the Roman Curia, for enabling important and difficult matters of business to be brought to satisfactory conclusions. At very great expense he annexed and obtained various churches for the monastery, as for example the church of the Holy Trinity at Gloucester with the chapel of Graselove, the [benefice of the] Vicarage of Blessed Mary Before the Gate, and the church of Chipping Norton. And he acquired [the benefice of] the Vicarage of the church of St Peter of Hereford, with its revenue, for the Priory, in order to enlarge the community there, as is set out more fully in the 'Regulations of the Chantry' compiled there. And he obtained many other and varied privileges from the Roman bishops, some from William Corteney Archbishop of Canterbury, some from the Bishops of England, as is set out in the above-mentioned deed-chest [whose contents were] compiled at that time.

His predecessor had been the first to obtain the privileges of the mitre and ring and other pontifical insignia from the Roman Pontiff. In his time he was adorned with the same insignia obtaining them for himself as a result of the willing petition of the Duke of Gloucester. He was invested [with them] with great honour to the glory of this house in the presence of the Bishop of Worcester who ratified [the

* Number blank in MS.

grant}, in the Octave of Easter in the same year [and on] the same day that the Translation of St Kyneburga the Virgin was solemnized. [There were] a solemn procession and a crowd of many people flocking to the town for the Translation of the Virgin from Lontonia to the castle, and from the castle to the chapel of the same virgin, with the Abbot and the Bishop of Worcester going before.

At length the Mass, which was solemnly celebrated as the dignity of the day demanded by the Bishop of Worcester, with the Abbot in pontificals beside him, was brought to a glorious conclusion. When it was done, the Duke went with the Bishop and Abbot to the place of the banquet. After this was celebrated most exquisitely, as was fitting, with yet more of the finest music, all those pontifical ornaments were given to the Abbot by the Duke, and he went back to the monks' quarters.

And afterwards the Abbot adorned the church with those ornaments and others of various sorts, that is to say, a valuable mitre with different kinds of precious stones and three others of lesser value, also a pastoral staff with two amices of ermine and more rings of gold set with gems.

At the time he was made Abbot he found the said monastery in great distress, oppressed and weighed down with immense debts which exceeded a total of 8,000 florins and with divers other burdens almost past the ability of our monastery to bear, from which, by asking divine grace and by the commonsense and hard work of the said Abbot Walter, we have, in great part, been delivered, and also not a little lifted up again by him.

And because the aforementioned Abbot discreetly and cleverly acquired various gifts, revenues and large increments for us and our monastery in spiritual as well as temporal matters, with blameless intention he built a new chantry in honour of All Saints for perpetual and continuous Masses for the salvation of his own soul, and in order to increase the occasions of divine worship. And he made [a regulation] that [the Host] be consecrated daily by one monk at the hour of Prime, immediately after the ringing of the first [bell] called 'the day bell', or after the Consecration at the High Mass. Also at Hereford he ordained another chantry at the altar of St James situated in the nave of the Priory there. And, so that all and singular

matters in the confirmatory documents concerning the order for the chantry of the said Walter might be observed inviolate in future times, the matters have been confirmed by the authority of the Roman bishops, as is definitely known [and] as is made plain in the Papal Bulls drawn up there.

GLOSSARY OF ARCHITECTURAL TERMS

A number of the architectural terms used in this book are explained in the diagram, reproduced by kind permission of Dr Christopher Wilson and the publishers, Thames and Hudson Ltd of London. Full lists of such terms are given in other works, such as David Verey's volumes on Gloucestershire in the *Buildings of England* series, edited by Nikolaus Pevsner. A useful reference book on architectural and ecclesiastical terms is the Penguin *Dictionary of Architecture* (3rd edition 1980) by J. Fleming, H. honour and N. Pevsner.

Abacus A flat slab on the top of a capital
Abutment Solid masonry acting as support against the thrust or lateral pressure of an arch or vault
Acanthus A leaf form used in classical ornament
Ambulatory A passage or aisle giving access between the choir, with high altar, and the apse of the church
Apse Semi-circular or polygonal termination to a church
Arcade A range of arches supported on piers or columns, free-standing. Blind arcade, the same attached to a wall
Arch A structure of wedge-shaped blocks over an opening which support one another by mutual pressure
Architrave The lowest of the three main parts of an entablature
Ashlar Hewn and squared stones prepared for buildings

Bell-flower A globular flower of three petals enclosing a small ball. A forms of decoration used in the first quarter of the fourteenth century
Barrel vault A continuous vault in semi-circular section, like a tunnel
Battlement Parapet with a series of indentations or embrasures with raised portions or merlons between. Such a parapet is also said to be *castellated*
Bay Compartment or division in a building. Term applied particularly to cathedrals where bays are marked by vaulting shafts and pillars
Buttress Mass of masonry projecting from or built against a wall to give added strength

Canopy Projection or hood over an altar, pulpit, niches, statue, etc.
Capital The crowning feature of a column or pilaster

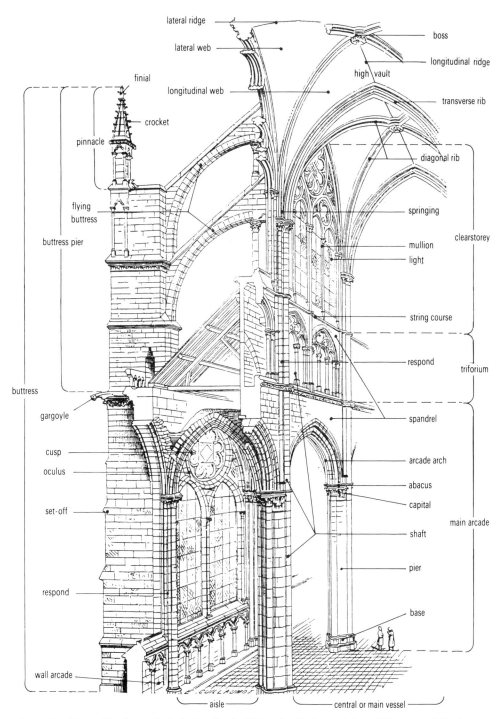

lateral ridge

lateral web

finial

longitudinal web

crocket

pinnacle

flying buttress

buttress pier

buttress

gargoyle

cusp

oculus

set-off

respond

wall arcade

aisle

boss

longitudinal ridge

high vault

transverse rib

diagonal rib

springing

clearstorey

mullion

light

string course

respond

triforium

spandrel

arcade arch

abacus

capital

main arcade

shaft

pier

base

central or main vessel

Reproduced from *The Gothic Cathedral* by Dr C. Wilson by kind permission of Thames and Hudson, 1990

Cartouche Ornament in the form of elaborate scrolled forms around shields, tablets or coats of arms

Centering A structure, usually made of timber, set up to support a dome, vault or ceiling until construction is complete

Chevet Term given (Fr.) to circular or polygonal apse when surrounded by an ambulatory from which radiate chapels

Chevron ornament Romanesque decoration in zig-zag form

Clerestory, or clearstorey The upper storey of a church generally pierced by a row of windows

Crocket A projecting block of stone carved in Gothic foliage on the inclined sides of pinnacles and canopies

Crossing The central area in a cruciform church where the transepts cross the nave and choir arms. Above this lofty space is generally a tower, with or without a spire

Cusp Point forming the foliations in Gothic tracery

Engaged column A column which is attached to the wall so that only half to three quarters of its circumference stands visible

Entablature The top part of an architectural order which consists of horizontal mouldings. These are divided into the architrave which surmounts the capital, then the frieze and last, and uppermost, the cornice

Feretory The area behind the high altar where the chief shrine was placed or the treasures of a church were kept

Finial Ornament finishing off the apex of a roof, gable, pinnacle, newel, canopy, etc.

Flute Vertical channelling in the shaft of a column

Foliated Carved with leaf shapes

Frieze The central member of the classical entablature

Gargoyle Water spout projecting from a parapet of a wall or tower; carved into a human or animal shape

Giant order Used in later classical architecture where the order spans two storeys of the facade. Not strictly applicable to Gloucester's nave

Groin Sharp edge at the meeting of two cells of a cross-vault, hence Groin vault, as in the choir ambulatory at Gloucester

Iconography The science of the subject matter of works of the visual arts

Impost The horizontal stone or mouldings on top of a pier from which the arch springs

Key stone Middle stone in an arch or in a rib or fan-vault

Label stop Ornamental boss at the end of a hoodmould

Lierne From the French *lier* meaning to tie. A short, intermediate rib in Gothic vaulting which is not a ridge rib nor a rib rising from the impost or springing. A small decorative rib not serving any structural purpose

Newel Central post in a circular or winding staircase; hence a newel-stair as in the transepts at Gloucester

Nook-shaft Shaft set into the angle of a pier or respond or wall, or the angle of the jamb of a window or doorway

Ogee A moulding incorporating a convex and a concave curve
Order In classical architecture the order comprises the column and the entablature which it supports. The column is divided into base, shaft and capital

Parclose screen A screen separating a chapel from the rest of a church
Pediment The triangular feature in classical architecture which resembles the Gothic gable. Supported on the entablature over porticoes, windows and doors
Pier A solid mass of masonry between windows, also support for a bridge and masonry from which an arch springs
Pilaster A column of rectangular section often engaged in the wall
Plinth The lowest member of base or wall; sometimes divided into stages
Presbytery The part of the church laying east of the choir; the part where the altar or high altar is placed
Pulpitum Stone screen in a major church provided to shut off the choir from the nave and also as a backing for the return choir stalls

Quarry In stained-glass work, a small diamond or square-shaped piece of glass set diagonally
Quatrefoil Four-leaf tracery opening, or decorative pattern on a wall

Rebus A pun or play on words. The literal translation and illustration of a name for artistic and heraldic purposes (e.g. Belton = bell, tun; represented by a bell and a barrel)
Reredos Structure behind and above the high altar
Respond Half pier bonded into a wall and carrying one end of an arch. In the nave aisles at Gloucester there are a series of Romanesque compound responds
Ridge rib A rib extending along the internal ridge of a vault on which the upper ends of other ribs rest. In lierne vaults at Gloucester there are parallel ribs on either side

Sanctuary The area around the main altar or high altar, the *sacrarium*
Sedilia Seats for the priests, usually three, on the south side of the chancel of a church
Shaft The column of an order between capital and base
Soffit The underside of an arch, lintel, etc. Also called *archivolt*
Spandrel Triangular space formed between an arch and the rectangles of outer mouldings as in a doorway
Stilted arch An arch having its springing line higher than the level of the impost mouldings. It is then connected to these mouldings by vertical sections of walling or stilts
String course A moulding or projecting course set horizontally along the elevation of a building
Stucco A plaster used for coating wall surfaces for moulding into architectural decoration or sculpture

Terminal window The window at the end of a transept or aisle

Tracery The ornamental stonework in the head of a Gothic window

Transept The arms of a cruciform church set at right angles to the nave and choir

Transoms Horizontal bar of wood or stone across a window or a door top

Trefoil Three-leaf decoration used in Gothic architecture, particularly in window tracery and panelling

Triforium The central, or first floor stage, of a medieval church between the nave arcade and the clerestory. The triforium is usually arcaded and may have a pasage behind at first floor level extending continuously around the church

Undercroft The chamber partly or wholly below ground generally in a medieval building. In a church this would be a crypt, in a house it would be used for storage

Vault Arched covering in stone, brick or wood

Vaulting bay The rectangular or square area bounded by columns or piers and covered by a ribbed or groined vault

Vaulting boss A carved decorative feature set at intervals in a ribbed vault to hide the junctions between one rib and another

Vault springing The point at which the vault ribs spring upwards from the capital, corbel or arch impost

Volute A spiral or scroll to be seen in Ionic, Corinthian and Composite capitals, and also in Romanesque capitals, as in the crypt at Gloucester

Voussoir The wedge-shaped stones which compose an arch

Wall plate Horizontal timber extending lengthwise on top of a wall immediately under a timber roof, or the uppermost course of stone work

Weepers Small figures placed in niches along the sides of some medieval tombs, as on the tomb of King Edward II

SOURCES

MEDIEVAL

St Peter's Abbey Registers

Register A compiled by Abbot Froucester (1381–1412).
Register B compiled by Abbot Froucester (1381–1412).
Register C of Abbots Thomas Braunche (1500–10) and Abbot Newton (1510–14).
Register D of Abbot William Parker (1514–39) for 1514–28.
Register E of Abbot William Parker (1514–39) for 1529–38.

Historia c. 1390 of Abbot Walter Froucester (1381–1412), GCL MS 34. Text of copies at Queen's College, Oxford and British Museum
Historia et Cartularium monasterii Sancti Petri Gloucestriae Rolls Series, 3 vols, (ed) W.H. Hart in Rolls Series (1863–67).

Abbey Deeds, mostly relating to property owned by the abbey dated from c.1127 to 1553, many with seals, mounted in 10 vols. For details see Kirby, I., *Diocese of Gloucester: A Catalogue of the Records of the Dean and Chapter*, 1967. These deeds are currently being edited by Prof. R. Patterson of South Carolina for the Bristol and Gloucester Archaeological Society.

Loose deeds from the late eleventh century to the end of the abbey period (1539). For details see Kirby's *Catalogue*.

Memoriale; an account of the history of St Peter's Abbey containing much legendary material. Latin original lost, but translation in Dugdale's *Monasticon*.

Rhyming History of the Abbey of St Peter, William Malverne (Parker) the last abbot of Gloucester Abbey. Text with notes in *Records of Gloucester Cathedral*, vol. 1, 148–56.

POST-DISSOLUTION

Charter of the Foundation of the See of Gloucester (1541), 1762, copy.
Grant of Endowment to the Dean and Chapter, 4 September 1541.

Illuminated Grant of Arms to the Dean and Chapter, 28 March 1542.
Statutes of Gloucester Cathedral, seventeenth-century manuscript translation.
Episcopal Visitations to the Dean and Chapter 1542–1751, transcribed by
F.S. Hockaday *et al.* See Kirby's *Catalogue*, 24–5.

RECORDS OF THE DEAN AND CHAPTER

Apart from a break during the Commonwealth (1644–60) the Chapter Act Books record
the Acts of Chapter from 1616.

1	1616–87	5	1807–38	9	1916–27	13	1963–9
2	1687–1740	6	1839–62	10	1928–39	14	1970–7
3	1740–74	7	1863–92	11	1939–53	15	1975–81
4	1775–1807	8	1893–1915	12	1953–62	16	1981–7

Details of the Cathedral Registers (Baptisms, Marriages and Burials), Conges d'elire *and
Letters Commendatory, Chapter Minute Books 1865–1939*, and miscellaneous papers
(1582–1945) of the Dean and Chapter, see Kirby's *Catalogue*, 27–37. Records relating
to title deeds and leases of former cathedral properties and to parishes, and other
financial and legal matters see Kirby's *Catalogue*, 38–169.

HISTORIES OF THE COUNTY OF GLOUCESTER

Containing sections on the Abbey of St Peter, the Cathedral Church of Gloucester.

Wantner, A.,*Notes for a History of Gloucestershire*. Bodleian Library, MSS Top Glouc c 3.
Atkyns, Sir R. *The Ancient and Present State of Gloucestershire*, 1712.
Rudder, S. *A New History of Gloucestershire*, 1779.
Bigland, R. *Collections Relative to the County of Gloucester*, 1791–1889.
Rudge, T. *The History of the County of Gloucester*, 1803.
Page, W. (Ed.) *The Victoria County History:County of Gloucester*, vol. 2, 1907.

HISTORIES OF THE CITY OF GLOUCESTER

Rudder, S. *History and Antiquities of Gloucester*, 1781.
Furney, R. *Extracts*, in preparation for a History of Gloucester,
1807, 6 folio vols, Bodleian Library MSS, Top Glouc c.4 5.
Fosbroke, T.D. *History of Gloucestershire*, 1807.
Rudge, T. *The History and Antiquities of Gloucester*, 1811.
Clark, J. *The Architectural History of Gloucester*, *c.* 1850.
Herbert, N.M. *A History of the County of Gloucester vol.* IV *The City of Gloucester*, 1988.

HISTORY AND ARCHITECTURE OF GLOUCESTER OF CATHEDRAL

Hart, W.H. (ed.), *Historia et Cartularium Monasterii Sancti Petri Gloucestriae*, Rolls Series, No. 33, 3 vols, 1863–7.
Dugdale, W. *Monasticon Anglicanum*, vol. 1, 1817.
Willis, Browne *A Survey of the Cathedrals of York, Durham, Carlisle . . . Gloucester and Bristol*, vol. 2, 1727–30.
Furney, R. *Extracts*, 1807.
Britton, J. *History and Antiquities of Gloucester Cathedral* , 1829.
Willis, R. 'The History of Gloucester Cathedral', *Journal of the Archaeological Institute*, 1860, vol. XVII, 335–42.
Bazeley, W. *Records of Gloucester Cathedral*, 3 vols, 1882–1927.
Hope, St J. 'Notes on St Peter's Abbey, Gloucester', *Antiquaries Journal*, 1897, vol. LIV, 77.
Masse, H.J.L.J. *Gloucester: the Cathedral and See*, Bell Series, 1899.
Spence, H.D.M. *Gloucester Cathedral*, 1898.
Spence Jones, H. *The Dean's Guide to Gloucester Cathedral* 1913.
Verey, D. *The Buildings of England : Gloucestershire*, vol. 2. Also revised edition by Metcalf, P., 1984.
Verey, D., and Welander, D. *Gloucester Cathedral*, Alan Sutton, 1979.

ARTICLES, PAMPHLETS, MAPS AND PRINTS

Articles
Relating to the Abbey Church and Cathedral of Gloucester in *Transactions of the Bristol and Gloucester Archaeological Society. Records of Gloucester Cathedral*, 3 vols, 1882–1927. *Friends of Gloucester Cathedral Annual Report*. British Archaeological Association. Conference Transaction *Medieval Art and Architecture at Gloucester and Tewkesbury*, 1985. (eds) Heslop, T. and Sekula, V.

Booklets and Pamphlets
Pytt, J., 1799. Cresy, J. *Gloucester Cathedral*, BAA, 1846; Power's *Handbook*, 1848; Haines, H. *A Guide to the Cathedral Church of Gloucester*, 1866; Billett, J.H. *A Visitor's Handbook*, *c*. 1880. Waller, F.S. *Gloucester Cathedral: Notes and Sketches*, 1890. Evans, S. *Gloucester Cathedral*, Pitkin, 1972.

Plans
Willis, Browne *A Survey of the Cathedrals . . .* 1730.
Carter, J. *Some Account of the Cathedral Church of Gloucester*, 1807.
Waller, F.S. *General Architectural Description of the Cathedral Church: Plans and Sketches*, 1856.
Plans and Elevations held by the Society of Antiquaries, the Royal Institute of British Architects and the Dean and Chapter of Gloucester, Cathedral Library.

Drawings and Engravings
Hollar, W. (1644) drawing of the nave.
King, D., (1665) in Dugdale's *Monasticon Anglicanum*.
Willis, Browne, 1727–30, *A Survey of the Cathedrals* . . .
Bonnor, T., 1796, Bonnor's *Itinerary*, with notes.
Storer, J., 1816, vol. 2 of four vols on the *Cathedrals of England*, also reproduces
engravings by Bonnor.
Bartlett, W. 1829 engraved by Woolnoth, W.
Waller, F.S., *General Architectural Description of the Cathedral Church at Gloucester*, 1856.

Photographs
A comprehensive collection of architectural photographs of the cathedral are held by the
Conway Library, the Courtauld Institute of Art, London. There is an extensive
collection of photographs and transparencies in the Gloucester Cathedral Library.
Note: Early photographs in Gloucester Cathedral Library collection, include those by
Wilson, G.W., published by J. Duffus, Aberdeen 1866

ABBREVIATIONS

Atkyns *Glos.*	R. Atkyns, *Ancient and Present State of Gloucestershire*, 1712.
Bigland *Glos.*	Historical, Monumental, and Genealogical Collections Relative to the County of Gloucester. Printed from the Original Papers of Ralph Bigland, 3 vols, 1791–1889.
Trans. BGAS	Bristol and Gloucester Archaeological Society Transactions, 1876–1989.
Con.Trans. BAA	British Archaeological Association Conference Transations.
J. BAA	British Archaeological Association Journal.
Cat *ACE*	Catalogue of the Age of Chivalry Exhibition, London, 1988.
Cat *ERAE*	Catalogue of English Romanesque Art 1066–1200. Exhibition, Arts Council of Great Britain 1984.
DNB	Dictionary of National Biography.
Dugdale *Mon.*	Dugdale *Monasticum Anglicanum*, (ed.) J. Caley *et al.* 6 vols, 1810–30.
Finberg *Early Chart*	H.P.R. Finberg, *Early Charters of the West Midlands*, Leicester University Press, 1961.
Finberg *Glos. Studies*	H.P.R., Finberg (ed.) *Gloucestershire Studies*, 1957.
Fosbrooke *Glouc.*	T.D. Fosbrooke, *Original History of the City of Gloucester*, almost Wholly Compiled from New Material . . . including also the Original Papers of Ralph Bigland, London, 1819.
Report GCF	*Gloucester Cathedral Friends' Report.*
Cat GCL	Gloucester Cathedral Library Catalogue.
Hart *Hist et Cart*	W.H. Hart (ed.) *Historia et Cartularium Monasterii Sancti Petri Gloucestriae*, Rolls Series, No. 33, 3 vols, 1863–7.
Joun. SAL	*Journal of the Society of Antiquaries of London*
Herbert VCH	N. Herbert (ed.) *Victoria County History: The City of Gloucester*, 1988.

Kirby *Cat D&C* — I.M. Kirby *Catalogue of the Records of the Dean and Chapter of Gloucester Cathedral*, 1967.

Masse *Glos. Cath* — H.J.L.J. Masse *Gloucester : The Cathedral and See*, Bell Series, 1899.

Records *GC* — *Records of Gloucester Cathedral*, 1882–97.

Rudge *Glouc* — T. Rudge *History and Antiquities of Gloucester from the Earliest Period to the Present Time*, 1811.

Welander *Stained Gl.* — D. Welander, *The Stained Glass of Gloucester Cathedral*, 1985.

Willis *Hist Gl.Cath.* — R. Willis, 'History of Gloucester Cathedral', *Archaeological Journal*, 1860, 335–42.

Verey *Glos* — D. Verey, *Gloucestershire*, vol. ii, *The Vale and the Forest of Dean*, The Buildings of England, (ed.) N. Pevsner, 1970.

CHAPTER BIBLIOGRAPHY AND NOTES

Chapter 1 EARLY HISTORY

Finberg, H.P.R. *The Early Charters of the West Midlands*, Leicester University Press,
 1972. Gloucestershire Studies, Leicester University Press, 1957.
Fernie, E. *The Architecture of the Anglo-Saxons*, Batsford, 1983.
Gethyn-Jones, E. *The Dymock School of Sculpture*, Phillimore, 1979.
Heighway, C. *Gloucester : A History and Guide*, Alan Sutton, 1985.
Brooke, C. 'St Peter of Gloucester and St Cadoc of Llancarfan' in *Celt and
 Saxon: Studies in the Early English Border* Chadwick, N.K. (ed.),
 Cambridge University Press, 1963.
Earle, J. 'Anglo-Saxon Fragments', *Journ.* SAL, vol. xvii, 334, and
 vol. xviii, 92.

NOTES

1 Finberg, H.P.R. *Glos. Studies*, 54.
2 Note Plan of the precincts based on W.H. St John Hope's 1891 plan
 and J. Carter, 1817 plan.
3 Finberg, H.P.R. Glos. Studies, 57–8.
4 Heighway C *Gloucester: a History and A Guide*, Ch. 1.
5 Note *Adamnan of Coldingham*, quoted by Heighway in public lecture
 January 1989.
6 Kidson, P., *et al.* *A History of English Architecture*, Penguin, 1978.
7 Finberg, H.P.R. *Early Charters*, Ch. VII.
8 Note *Rule of St Benedict*, trans. Justin McCann, Sheed and Ward,
 London, 1976, ch. 4. See also Ker, N. R. *Cat. of Manuscripts
 containing Anglo-Saxon* 1957, and Earle, J. *Gloucester Fragments*,
 1861.
9 Keyser 'A Sculptured Norman Tympanum at Gloucester',
 J. BAA, vol. xviii, 1912, 162 f. See also 'Christ in Majesty',
 Trans. BGAS, 1931, vol. 53, 99–100. Dobson, 'Anglo-Saxon
 Buildings and Sculptures in Gloucestershire' *Trans. BGAS*, vol.
 55, 1933, 27f. Talbot Rice, D., 'The Gloucester Christus', *Trans.
 BGAS*, vol. 61, 1952, 98–100. In 1951 the *Christus* was removed
 from the wall in the bishop's garden, and placed on a ledge in the
 Chapter House, where it remained until 1981. It was then put on
 display in the Gallery Exhibition.
10 Fernie, E. *The Architecture of the Anglo-Saxons*, 1983, 160.

Chapter 2		ABBOT SERLO

Knowles & Brooke — *The Heads of Religious Houses, England and Wales 940–121*, Cambridge University Press, 1972.

Harcourt Williams, R. — *Serlo* booklet published in 1972 for the commemoration of Serlo's appointment as abbot (1072).

Bates, D. — 'The Building of a Great Church: the Abbey of St Peter's Gloucester, and its early Norman Benefactors', *Trans. BGAS*, vol. 102, 1984, 129f.

Davis, R.H.C. — *The Normans and their Myth*, Thames and Hudson, 1976.

NOTES

1 Herbert, N. — *VCH*, 14–15. See also Biddle, M. *Anglo-Norman Studies*, vol. 8, 1985, 51–72.
2 Heighway, C. — *Gloucester: A History and Guide*, Alan Sutton, 1985, 44.
3 Knowles, D. — *The Monastic Order in England*, Oxford University Press, 1966, 702–3.
4 Bates, D. — 'The Building of the Great Church', *Trans. BGAS*, 1984.
5 Knowles, D. — *The Religious Houses of Medieval England*, 1940,
6 Herbert, N. — *VCH*, 1988.
7 Harcourt Williams — *Serlo*. The author is much indebted to this monograph in this section.

Chapter 3		THE ABBEY CHURCH

BAA Conference 1981, 'Medieval Art and Architecture at Gloucester and Tewkesbury', being the *Transactions of the Conference of the British Archaelogical Association* for the year 1981, published 1985, and containing the following:

Kidson, P. — *The Architecture of the Abbey of St Mary at Tewkesbury in the Eleventh and Twelfth Centuries.*

Halsey, R. — *Tewkesbury Abbey: Some Recent Observations.*

Thurlby, M. — *The Elevations of the Romanesque Abbey Churches St Mary at Tewkesbury and St Peter at Gloucester.*

Wilson, C. — *Abbot Serlo's Church at Gloucester 1089–1100: Its Place in Romanesque Architecture.*

Also

Waller, F.S. — 'The Crypt of Gloucester Cathedral', *Trans. BGAS*, vol. 1, 1876, 147–52.

Ashwell, B. — *The Crypt of Gloucester Cathedral*, Monograph, 1979.

Rice, D.T. — *English Art 871–1100*, Oxford, 1952.

Clapham, A.W. — *English Romanesque Architecture after the Conquest*, Oxford University Press, 1934.

Zarnecki, G. — 'Romanesque' in *Herbert History of Art and Architecture* series, 1989.

NOTES

1 Kidson, P. — *A History of English Architecture*, Penguin, 1979, 33.
2 Knowles, D. — *Monastic Order*, Oxford University Press, 1940, 119.

3 Fernie, E. *The Architecture of the Anglo-Saxons*, Batsford, 1983, 160.
4 Gem, R. *Westminster Abbey*, Bell & Hyman, 1986, 13.
5 Wilson, C. 'Abbot Serlo's Church at Gloucester', *Con.Trans. BAA*, 1985, 62.
6 Bayle, M. *English Romanesque Art 1066–1200*, Exhibition Cat., 1984, 152.
7 Thurlby, M. 'The Elevation of the Romanesque Churches of Tewkesbury and Gloucester',Con.Trans.BAA, 1985, 44–46, 52–83. 'The Romanesque Priory Church of St Michael at Ewenny', JSAH, 1988.
8 Wilson, C. As above *Con.Trans.BAA*, 1985, 72–3.
9 McAleer, J.P. 'Some Reused Romanesque material in the Choir Tribune at Gloucester Cathedral', *Trans.BGAS*, vol. 104, 1986, 157–73.
10 Wilson, C. As above *BAA CT*, 1985, 60–6.

Chapter 4 COMPLETING THE CHURCH

Articles in BAA Conference (1981) Transactions listed under Chapter 3.
Also
Bony, J. *Gloucester et l'origine des voutes d'hemicycle gothique*, Bull. mon. XCVIII, 1939, 329–31. *La Chapelle episcopale de Hereford et les apports corrains en Angleterre apres la Conquete*, Actes du XIX Congres International d'Histoire de l'Art, Paris, 1959. *French Gothic Architecture of the Twelfth and Thirteenth Centuries* , University of California Press, 1983.
Kubach, H.E. *Romanesque Architecture*, New York, 1975.
Boase T.S.R. *English Art 1100–1216*, Oxford, 1953.
Zarnecki, G. *English Romanesque Art 1066–1200*, Exhib. Cat., 1984, 15. *English Romanesque Sculpture 1066– 1140*, 1951. *Later English Romanesque Sculpture 1140–1211*, 1953. *Studies in Romanesque Sculpture*, Collected essays, 1979.
Prior, E. and Gardner, A. *An Account of Medieval Figure-Sculpture in England*, Cambridge University Press, 1912.

NOTES

1 Hart, W.H. *Hist et Cart Mon Glouc*, 1863, vol. I, 15, (trans W. Barber).
2 Hart, W.H. *Hist et Cart Mon Glouc*, 1863, vol. I, frontispiece.
3 Stratford N. *English Romanesque Art 1066–1200*, Exhib. Cat., 1984, 249. Dr Brownsword's analysis reported in J.BAA, cxxxvi, 1984.
4 Borg, A. 'The Gloucester Candlestick', *Con.Trans.BAA*, 1981, 84–92.
5 Oman, C. 'The Gloucester Candlestick', Victoria and Albert Museum, *London Monographs*, No. 11, London, 1958. See Harris, A., 'A Romanesque Candlestick in London', J.BAA, xxvii, 1964, 32–52.
6 Warner, M. *Alone of her Sex : The Myth and Cult of the Virgin Mary*, Picador edn, 1985.
7 Thurlby, M. *Con.Trans.BAA*, 1985, 36-51. See also Wilson, C., *Con. Trans. BAA*, 1985, 52–83.
8 Thurlby, M. *Con.Trans.BAA*, 1985, 47–8.
9 Kidson, P. 'The Architecture of the Abbey of St Mary at Tewkesbury in the Eleventh and Twelfth Centuries', *Con.Trans.BAA*, 1985, 14. See also Kidson *et al. A History of English Architecture*, 2nd edn., 1979, 57.
10 Stukeley, W. Bodleian Library, Oxford MS top gen d 13.

11	Bony, J.	*Gloucester et l'origine des voutes d'hemicycles gothiques*, Bull. mon. xcviii, 1939, 329–31.
12	Halsey, R.	'Tewkesbury Abbey : Some recent observations', *Con.Trans.BAA*, 1985, 24–7.
13	Gem, R.D.H.	'The Significance of the Eleventh Century rebuilding of Christ Church and St Augustine, Canterbury in the development of Romanesque Architecture', *BAA Con.Trans.*, 1982, 7–19.
14	Thompson, J.	*The Norman Architecture of Gloucester Cathedral*, unpublished PhD thesis Johns' Hopkins University, Baltimore, Maryland 1977.

Chapter 5 FOUR ABBOTS

Southern, R.	*Western Society and the Church in the Middle Ages*, Penguin, 1970.
Lawrence, C.H.	*Medieval Monasticism*, Longman, 1986.
Hart, W.H.	*Hist et Cart Mon Glouc*, vols. 1–3.

NOTES

1	Lawrence, C.H.	*Medieval Monasticism*, Longmans 1986, 62.
2	Zarnecki, G.	*English Romanesque Lead Sculpture*, 1957, 10 f.
3	Hart, W.H.	*Hist et Cart Mon Glouc*, vol. 1, xxvii & 16–17, Barber trans..
4	Harl, W.H.	*Ibid.*, 16.
5	Barlow, F.	*Thomas Becket*, Weidenfeld and Nicolson, London, 1984, 35.
6	Barlow, F.	*Ibid.*, 35.
7	Morley, A., & Brooke, C.N.L.	*Gilbert Foliot and His Letters*, Cambridge University Press, 1965, 1.
8	Morley, *et. al.*	*Ibid.*, 2.
9	Thorpe, W.	*Gerald of Wales : The Journey through Wales and Description of Wales*, Penguin, 1988.
10	Herbert, N.	*VCH Glouc.*, 1988, 15–16.

Chapter 6 REBUILDING AND REFURBISHING

Bilson, J.	*Journal of the Royal Institute of British Architects*, vol. 6, 1899; *Archaeological Review*, vol. 74, 1917; and *Archaeological Journal*, vol. 79, 1922, being papers on the earliest rib vaults.
Bony, J.	*Bulletin Monumental*, vol. 96, 1937 and vol. 98, 1939; *Journal of the Warburg and Courtauld Institute*, vol. 12, 1949. *Articles on Norman and Early English Architecture.*
Pevsner, N.	'Bristol, Troyes, Gloucester', *The Architectural Review*, vol. 113, 1953.
Brieger, P.	'English Art 1216–1307', *Oxford History of English Art* series, Oxford, 1957.

NOTES

1	Welander, D.	*Stained Gl.*, 1985, 82.
2	Herbert, N.	*VCH Glouc.*, 1988, 19.
3	Kidson., *et al.*	*A History of English Architecture*, Penguin, 1978, 74. See also Wilson, C., *Westminster Abbey*, New Bells Series, 1986, ch 2.
4	Watkin, D.	*The Architecture of Britain*, Thames Hudson 1975 36.

5 Van Humbeeck, D. 'Origine et Evolution des Stalles', *Les Questions Liturgiques et Paroissiales*, vol. 3, 1950.

6 Fullbrook-Leggatt, L. *Trans.BGAS*, 1964, vol. 83, 78–83. See also Bazeley, *Trans.BGAS*, vol. 26, 1892, 198; and *Records of Gloucester Cathedral 1885–1897*, vol. III, 128.

7 Froucester, Register B f110 and Hart, W.H., *Hist et Cart*, vol. 1, 27.
8 Evans, S., 'Thirteenth Century Rebuilding and the Lady Chapel of Gloucester Abbey', an unpublished paper, 1983 in GCL Archives. See also, Bazeley, W., 'Notes on the Early English Lady Chapel of Gloucester Cathedral', in *Trans.BGAS*, vol. XV, 1891–2, 196–200.

9 Masse, *Glos. Cath.*, Bell Guide series, 1899, 80.
10 Ashwell, B. Report GCF, 1977.
11 Tudor Craig, P. In unpublished paper to the British Archaeological Conference at Gloucester, 1981.

12 Hurtig, J.W. *Armored Gisant before 1400*, Garland Publishing Inc., New York and London, 1979. See also Bloxham, M., 'Gloucester : The Cathedral Monuments', *Trans.BGAS*, 1888–9, 252–9. Bazeley, 'Effigies in Gloucester Cathedral', *Trans.BGAS*, 1904, 289–326. Guise, W., ' Historic Monuments in the Cathedral', *Records GC*, 1882, vol. 1, 97–105. Hulbert, A., unpublished report to the Dean and Chapter, November 1981. Clive Rouse examined the effigy 1980; Anna Hulbert touched up paint work of tomb chest 1981; Michael Pascoe stabilized the effigy, filling cracks in the torso and neck with wax compound for transport to London for Public Records Office English Romanesque Art Exhibition, 1984, and Age of Chivalry Exhibition 1987–8. On return placed in south ambulatory of the choir.

13 Bloxham, M.H. *Trans.BGAS*, vol. XIII, 1888–9, 254.
14 Bazeley, W. *Trans.BGAS*, vol. XXVII, 1904, 294.

Chapter 7 THE THIRTEENTH-CENTURY ABBEY

Bony, J. *The English Decorated Style*, Phaidon, 1979.
Hart, *Hist et Cart.*, 1863, 22–35.
Morris, R.K. 'Early Gothic Architecture at Tewkesbury Abbey', *Con. Trans. BAA*, 1985, 93–8. 'Ball-flower Work in Gloucester and its Vicinity', *Con.Trans.BAA*, 1985, 99–115.
Devereux, R.A. *Worcester College, Oxford University*, Archaeological Society, 1951.
Daniel, C.H.O. 'Worcester College, Oxford', *Trans.BGAS*, XVI, 1891–2, 103–10.
Horner, P.J. 'Benedictines and Preaching in Fifteenth Century England', *Revue Benedictines*, Tone XCIX, Nos. 3&4, 1988.
Gordon, L.E. *Paris and Oxford Universities in the 13th Century*, New York, 1975.
Cockerell, C.R. *The Iconography of Wells Cathedral*, London, 1851.

NOTES

1 Webb, G. *Architecture in Britain: The Middle Ages*, Penguin, 1965.
2 Power, E., *The Wool Trade in English Medieval History*, Oxford University Press, 1941. See also, Simpson, J.J. 'The Wool Trade and

Woolmen of Gloucestershire', *Trans.BGAS*, 1931, vol. 53, 65–97.

3 Kidson, P. *A History of English Architecture*, Pelican, 1972, 106–8.
4 Masse *Glos.Cath.*, Bell Guide Series 1899, 8.
5 Morris, R.H. 'Ball-flower work in Gloucester and its Vicinity', *Con.Trans.BAA*, 1985, 99–115.
6 St John Hope *Records of Gloucester Cathedral*, III, 1897, 105.

Chapter 8 KING EDWARD II

Harvey, J. *The Perpendicular Style, 1330–1485*, London, 1978, 75–96.
Wilson, C. 'The Origins of the Perpendicular Style and its Development to circa 1360', Unpublished PhD thesis, London University, 1980.
Westmacott, R. 'The Monument of Edward II', *Archaeological Journal*, vol. 17, 1860, 297 ff.
Roger, I.M. *The Monumental Effigies of Gloucestershire and Bristol*, 1931. Printed privately by author. Copy in CRO Gloucester.
Bloxham, M.H. 'The Cathedral Monuments', *Trans.BGAS*, XIII, 1888–9 252–9.
Bazeley, W. and M. 'Effigies of Gloucester Cathedral', *Trans.BGAS*, XXVII, 1904, 289–326.
Rownsley, H.D. 'Did Edward II escape to Italy ?', *The British Review*, vol. 12, 1915, 92–101.
Cuttino, G. and Lyman, T. 'Where is Edward II ?', *Speculum*, vol. LIII, 1978.
Gee, L.L. *Ciborium tombs in England 1290–1330*, British Architectural Association, CXXXII, 1979, 29–41.
Biver, P. 'Tombs of the School of London at the beginning of the 14th century', *Archaelogical Journal*, LXVII, 1910, 51–65.
Starkie, W. *The Road to Santiago*, Murray, 1957.
Ward, B. *Miracles and the Medieval Mind*, Scolar Press, 1982.
Finuncane, R.C. *Miracles and Pilgrims*, Dent, 1977.

NOTES

1 Herbert, N. *VCH Glouc.* 1988, 21.
2 Richardson, L. 'The Stone Canopy of Edward II's Tomb', *Trans.BGAS*, LXX, 1951, 144.
3 Wilson, C. *Cat ACE*, 497.
4 Waller, N.H. *Report FGC*, 1946.
5 Metcalffe *The Cathedrals of England*, Viking, 1985, 131–156.
6 Kidson, P. *A History of English Architecture*, Pelican, 1978, 118–20.
7 Wilson, C. *Con.Trans.BAA*, 1985, 72–3.
8 Welander, D. *Stained Gl.*, 1985, 48.
9 St John Hope *Records of Gloucester Cathedral* quoted by Masse 44–45.
10 Cooke, J. *Archaeologica*, vol. IX, 10.

Chapter 9 REMODELLING THE CHOIR

Harvey, J.H. *The Perpendicular Style*, London, 1978.
Wilson C. 'The Origins of the Perpendicular Style and its Development to *c.* 1360', Unpublished PhD thesis, University of London, 1980.
Glenn, V. 'The Sculpture of the Angel Choir at Lincoln', *Con.Trans. BAA* on Lincoln Cathedral.

NOTES

1	Herbert, N.	*VCH Glouc.*, 1988, 35, See also Holt, R., 'Gloucester in the Century after the Black Death', *Trans.BGAS*, vol. 103, 1985, 149–61.
2	Waller, F.S.	*Trans.BGAS*, vol. 34, 1911, 175–94.
3	Wilson, C.	*Cat.ACE*, 1988, 417.
4	Kidson, P., *et al.*	*A History of English Architecture*, 1978, 120–1.
5	Kidson, P.	*Ibid.*, 122–3.
6	Wilson, C.	*Cat.ACE*, 1988, 417.
7	Coldstream, N.	'The Kingdom of Heaven: Its Architectural Setting', in *Cat.ACE.*, 92–7.

Chapter 10 SOME MEDIEVAL CRAFTS

Crewe, S.	*Stained Glass in England c.1180–1540* HM Stationery Office, London, 1987.
Coe, B.	*Stained Glass in England* 1150–1550, W.H. Allen, 1981.
Kerr, J.	'The East Window of Gloucester Cathedral', *Con.Trans. BAA*, 1981, 116–29.
Winston, C.	'The Great East Window of Gloucester Cathedral', *Archaeological Journal*, vol. XX, 1863, 239–53.
Drayton, T.G.D.	'Notes on the Heraldry of the East Window of Gloucester Cathedral', *Trans.BGAS*, vol. XXXVIII, 1916.
Rushforth, G.McN.	'The Great East Window of Gloucester Cathedral', *Trans.BGAS*, XLIV, 1922, 293.
Gambier Parry, T.	'Ancient Glass Paintings in the Cathedral', *RGC*, pt II, 1883–4, 67–75.
Dancey, C.H.	'Ancient Painted Glass in Gloucester Cathedral', *Trans.BGAS*, XXXIV.
Welander, D.	*The Stained Glass of Gloucester Cathedral*, 1985.
Remnant, G.L.	*A Catalogue of Misericords in Great Britain.*
Farley, J.	'The Misericords of Gloucester Cathedral', photographs, 1981.
Laird, M.	*English Misericords*, John Murray, 1986.
Anderson, M.D.	*Misericords*, Penguin Books, 1954.
Cox T.	'The Twelfth Century design sources of the Worcester Cathedral Misericords', *Archaeologica*, 97, 165–78.
Gardner A.	*English Medieval Sculpture* Cambridge University Press, 1951.
Phipson, E.	*Choir Stalls and their Carvings*, Batsford, 1896.
Tracy, C.	*English Gothic Choir Stalls 1200–1400*, Boydell Press, 1987.
Clark, O.W.	'The Miseres in Gloucester Cathedral', *Trans.BGAS*, 1905, vol. XXVIII, 61–88.

NOTES

1	Glenn, C.	'The Sculpture of the Angel Choir at Lincoln', *Con.Trans.BAA*, 102–8. See also, Cave, C.J.P., 'The Roof Bosses in Gloucester Cathedral', *Trans.BGAS*, 1931, 99–111.
2	Marks, R.	'Stained Glass c. 1200–1400', *Cat.ACE*, 145.
3	Kerr J.	'The East Window of Gloucester Cathedral', *Con.Trans.BAA*, 116–29.
4	Rushforth, G.Mc.	*Trans.BGAS*, 1922, 293.
5	Welander, D.	*Stained Gl.*, 1985, 25–6.

6	Tracey, C.	*English Gothic Choir Stalls 1200–1400*, Boydell Press, 1987.
7	Kraus, D. and H.	*The Hidden World of Misericords*, New York, 1975.
8	Laird, M.	*English Misericords*, Murray, 1986, 13.
9	Grossinger, C.	'Misericords', *Cat.ACE*, 122–4.
10	Varty, K.	*Renard the Fox*, Leicester University Press, 1967. See also Rouse, E. and Varty, K. 'Renard the Fox', *Archaeological Journal*, vol. 133, 1976, 104 f.
11	Eames, E.S.	*Catalogue of Medieval Tiles*, 2 vols, British Museum 1980. The author is much indebted to a note written by Miss Eames for the Gallery Exhibition (1981) on the tiles of Gloucester Abbey.

Chapter 11

THE GREAT CLOISTER

Leedy, W.C.	*Fan Vaulting: A Study of Form, Technology and Meaning*, Scolar Press, London, 1980.
Willis, R.	'On the Construction of the Vaults of the Middle Ages', *Transactions of the Royal Institute of British Architects*, I, 1842, 52. See *also Architectural History of Some English Cathedrals*, vol. 2.
Pevsner, N.	'Bristol–Troyes–Gloucester', *Architectural Review*, CXIII, 674, February, 1953, 89–98.
Jope, E.M. (ed.)	*Studies in Building History*, London, 1961, 134–216.
Shelby, L.R.	'Medieval Masons' Templates', *Journal of the Society of Architectural Historians*, XXX. no. II, 1971, 140–54.
Drinkwater, N.	'Hereford Cathedral: Chapter House', *Archaeological Journal*, CXII, 1955, 61–78.
Stukeley, W.	Drawing in *Itinerarium Curiosum*, 2nd edn., London, 1776, 71.

NOTES

1	St John Hope	Plan of the abbey precincts, *RGC*, 1891.
2	Kidson, P. *et al.*	*A History of English Architecture*, 1978, 125–6.
3	Wilson, C.	*Cat.ACE*, 1988, 417.
4	Harvey, J.	*English Medieval Architects*, sub Robert Lesyngham and Thomas Cantebrugge. See also *The Perpendicular Style*, London, 1978.
5	Leedy, W.C.	*Fan Vaulting: A Study of Form, Technology, and Meaning*, London, 1980.
6	Niblett, J.	*RGC*, 1882–97.
7	Kidson, P. *et al.*	*English Architecture*, 1978, 127–8.
8	Micklethwaite, J.	'On the Indoor Games of School Boys in the Middle Ages', *Archaeological Journal*, XLIX, 1892.
9	Eward, S.	*Catalogue of Gloucester Cathedral Library*, 1972, vii–xv. See also, *No Fine . . .*, 1985, Appendix A.

Chapter 12

THE WEST END AND TOWER

| Waller, F.S. | 'Gloucester Cathedral Tower', *Trans.BGAS*, 1911, 175–94. |
| Harvey, J. | *The Perpendicular Style*, Batsford, 1978. |

NOTES

| 1 | Herbert, N. | *VCH Glouc.*, 1988, 37 ff. See also Heighway, C. *Gloucester: A* |

		History and Guide, 1985, 86–96. And Water, G. *King Richard's Gloucester: Life in a Medieval Town*, 1983, 63–9.
2	Verey, D.	*Buildings of England*, Pevsner, N.(ed.). *Gloucestershire* vol. 2, 1970, 198–226. See also, *Gloucester Cathedral*, Verey, D. and Welander, D., 1989.
3	Thompson, D.	'The Norman Architecture of Gloucester Cathedral', unpublished PhD thesis, Johns Hopkins University, Maryland, 1977.
4	Note	The cross and crockered balustrade were renewed by masons (Alan Norton and Simon Wyatt) of the Cathedral Maintenance Dept in 1988–9.
5	Masse	*Glos. Cath.* , 1899, 86.
6	Waller, F.S.	*Trans.BGAS*, 1911, 177.
7	Harvey, J.	*Medieval Architects*, 1984.
8	Clarke J.	*The Architectural History of Gloucester*, Gloucester *c.* 1850, 79.

Chapter 13

THE LADY CHAPEL

Eames, E. *Catalogue of English Tiles*, 2 vols, British Museum Publications, 1980.

NOTES

1	Kidson, P., *et al.*	*English Architecture*, 1978, 132–3.
2	Kidson, P., *et al.*	*Ibid.*, 128, 135.
3	Welander, D.	*Stained Gl.*, 1985, 27.
4	Welander, D.	*Ibid.*, 137–8.
5	Clarke, J.	*The Architectural History of Gloucester*.
6	Kidson, P.	*English Architecture*, 1978, 131.
7	Short, H.H.D.	'Graffiti on the Reredos of the Lady Chapel of Gloucester Cathedral', *Trans.BGAS*, vol. lxvii, 1946–8, 21–36. See also Coulton, G.G. 'Medieval Graffiti', *Medieval Studies*, vol. 12, 1915.
8	Le Couteur, J.D.	*Notes on the Stained Glass of Gloucester Cathedral Lady Chapel ex libris*, Sydney A. Pitcher, 1915, Gloucester Collection, ref. V 23, Gloucester City Library. See also Rushford, G. McN. 'The Glass of the East Window of the Lady Chapel in Gloucester Cathedral', *Trans.BGAS*, vol. xliii, 1921, 191–218. And Welander, D. *Stained Gl.* for additional references.
9	Welander, D.	*Stained Gl*, 1985, 27–45.
10	Greenfield, P.H.	Note. In correspondence with the author, but see his Records of *Early English Drama: Gloucestershire*.

Chapter 14

THE END OF AN ERA

Knowles, D.	*Bare Ruined Choirs: The Dissolution of the Monasteries*, Cambridge University Press, 1976.
Parker, W.	*Register D and E;* also ' Rhythmical History of St Peter's Abbey', *RGC*, vol. I, 1882–3.
Hanbury, M.	'Abbot Parker', *Pax*, September 1929.
Bazeley, W.	*Trans.BGAS*, vol. VII, 33–5; also *RGC*, vol. I, 119–26.

NOTES

1	Moorman, J.R.H.	*A History of the Church in England*, London, 1958, 161–79.
2	Note	*Oxford Dictionary of the Christian Church*, Cross, F. L. 1961 edn., sub *Sacrifice*.
3	Lehmberg, S.E.	*The Reformation of Cathedrals*, Princeton University Press, 1988.
4	Warner, J.L.	*Archaeological Journal*, vol. 18, 1861, 116–24.
5	Herbert, N.	*VCH*, 1988, 281–3.
6	Knowles, D.	*Religious Orders*, vol. 3, 108–26.
7	Lehmberg, S.E.	*The Reformation of Cathedrals*, Princeton University Press, 1988, 66.
8	Knowles, D.	*The Religious Orders in England*, vol. 3, 136–7.
9	Hart, W.H.	*Hist. et Cart.*, vol. iii, 49.

Chapter 15 THE MONASTIC PRECINCTS

Herbert, N.	*VCH*, 1988, 275–88.
Hope, W.H. St J.	*Records of Gloucester Cathedral*, 90–131.
Eward, S.	*No Fine but a Glass of Wine*, 1985.
Brooke, C.	'Reflections on the Monastic Cloister', *Romanesque and Gothic: Essays for G. Zarnecki*, Boydell Press, 1987, vol. 1.
Horn, W.	'On the Origins of the Medieval Cloister', *The Cloister Symposium*, 1972 in Gesta, 1973, 12, 13,-52,
Horn, W., and Born, E.	*The Plan of St Gall*, 3 vols., Berkeley, 1978. See vol. 1, 243–6.
Willis, R.	*Archaeological Journal*, 1860.
Woodward, G.W.O.	*The Dissolution of the Monasteries*, 1966.
Baskerville, G.	*English Monks and the Suppression of the Monasteries*, Jonathan Cape, 1973.
Butler, C.	'Benedictine Monasticism: Studies in Benedictine Life and Rule', in *Cambridge Speculum Historiale*.
Young, J.	*The Dissolution of the Monasteries*, Allen & Unwin, 1971.

NOTES

1	Hope, W. St J.	'Notes on the Benedictine Abbey of St Peter at Gloucester', *RGC*, vol. 1, 90–130.
2	Oswald, A.	'The Old Deanery at Gloucester', *Country Life*, 1951. See also, 'The Parliament Room and Henry Room', *Country Life*.
3	Note	Froucester's *Historia*, Cott. MS, Dom A, viii, f f 137 and 140. Cp Hart, W.H., Rolls Series edn. vol. i, 55 and 48.
4	Chandler, P.E.	'The Bishop's Palace, Gloucester', *Trans.BGAS*, 1979, 81–3.
5	Brooke, C.	'Reflections on the Monastic Cloister', as above.
6	Note	Rites of Durham, 70,71.
7	Michlethwaite, T.	On the Indoor Games of School Boys in the Middle Ages', *Archaeological Journal*, xlix, 319–28.
8	Note	*Rites of Durham*, 74.
9	Note	*Rites of Durham*, 27, quoted by Hope.
10	Note	*Rites of Durham*, 72,73.

Chapter 16 CONTINUITY AND CHANGE

Note *Charter of Henry VIII founding the See of Gloucester* 1541. Episcopal

	Visitations of the Dean and Chapter of Gloucester 1541–1751, *GCL* MS 34.
Herbert, M.	*VCH, Gloucester, 1988.*
Heighway, C.	*Gloucester: A History and Guide*, Alan Sutton, 1985.
McCarthy, M.	*The Origins of the Gothic Revival*, Yale UP, 1987.
Cobb, G.	*English Cathedrals : The Forgotten Centuries*, Thames and Hudson, 1980.
Lehmberg, S.E.	*The Reformation of Cathedrals: Cathedrals in English Society 1485–1603*, Princeton UP, 1988.

NOTES

1	Atkyns, R.	Atkyns' *Glos* contains the *Statutes of Gloucester Cathedral*. See also *The Statutes of Gloucester Cathedral* with a preface by Dean Gee, published in Latin and English by the Chiswick Press, London, 1918.
2	Hockaday, F.S. *et al.*	*Episcopal Visitations of the Dean and Chapter of Gloucester 1542–1751*, translated and transcribed from the records of the diocese of Gloucester by Hockaday, F. S. Kerr, R.J. Pickthorne J.F. and Wilkinson L. 1910, GCL.
3	Evans and Eward	'The Common Kitchen', *Trans.BGAS*, 1972, 168–74.
4	Price, F.D.	'Gloucester Diocese under Bishop Hooper 1551–1553', *Trans.BGAS*, vol. lx, 1938, 51–151.
5	Lehmberg, S.E.	*The Reformation of Cathedrals*, Princeton UP, 1988, 139–63.
6	Gillingham, M.	*Gloucester Cathedral Organ*, Gloucester, 1971, 1–6.
7	Bazeley, W.	'Effigies in Gloucester Cathedral', *Trans.BGAS*, vol. xxvii, 1904, 289 ff.
8	Cobb, G.	*English Cathedrals: The Forgotten Centuries*, Thames & Hudson, 1980, 6–9.

Chapter 17		ROYALISTS AND PURITANS
Eward, S.		*No Fine but a Glass of Wine*, Michael Russell, 1985. *Catalogue of Gloucester Cathedral Library*, 1972, introductory essay.
Evans, S. and Eward, S.		'The Common Kitchen', *Trans.BGAS*, vol. xci, 1972.
Trevor-Roper, H.R.		*Archbishop Laud*, Oxford University Press, 1963.
Taylor, B.		'William Laud, Dean of Gloucester 1616–1621', *Trans.BGAS*, vol. lxxvii, 1958.
Soden, G.		*Godfrey Goodman, Bishop of Gloucester 1583–1656*, 1954.
Le Huray, P.		*Music and the Reformation in England 1549–1660*, 1967.
Langston, J.N.		'Headmasters and Ushers of the King's (College) School, Gloucester 1541–1841', *RGC*, vol. iii, 1927, 178–79.
Sprigge, J.		*Anglia Rediviva: England's Recovery*, London, 1647.

NOTES

1	Laud, W.	*Chapter Act Book*, vol. 1, f1–5.
2	Trevor Roper, H.	*William Laud*, 1963. See also Hutton, W.H. *William Laud*, Methuen, 1896.
3	Cross, F.L. (ed.)	*Oxford Dictionary of the Christian Church*, 1961, sub Laud, 790.
4	DNB	*Dictionary of National Biography* sub *Frewin*
5	Routley, E.	*A Short History of English Church Music*, Mowbray 1977, 13–3.

6 Eward, S. *No Fine but a Glass of Wine*, Michael Russell, 1985, 72.
7 Eward, S. *Ibid.*, 72.

Chapter 18 AFTER THE RESTORATION

Eward, S. *No Fine but a Glass of Wine*, Michael Russell, 1985.
Gillingham, M. *Gloucester Cathedral Organ*, Friends of Gloucester Cathedral, 1972, 1–31.
Frith, B. 'Organists of Gloucester Cathedral', *Gloucester Cathedral Organ*, 1971, 45–67.
West, J.E. *Cathedral Organists, past and present*, 1899, 34–40.
CAB Chapter Act Books, 1 and 2.

NOTES

1 CAB 1, Letter to Dean and Chapter lodged in *Chapter Act Book* 1. See also Eward, S. *No Fine . . .* , 121.
2 Note The author is grateful to Dr H.L. Lehmann of Epsom for drawing his attention to Schellinks' diary in the Bodleian Library, Oxford.
3 Welander, D. *Stained Gl.*, 1985, 57–63.
4 Hill, A. *The Organ Cases and Organs of the Middle Ages and Renaissance*, 1966, 120.
5 Note These Restoration holy communion vessels are on display in the cathedral treasury.
6 Evans S. and Eward, S. 'Dr Abraham Gregory, a Seventeenth Prebendary of Gloucester Cathedral', *Trans.BGAS*, vol. xcv, 1978, 59–66. Also Abraham Gregory's *Register of Leases, GCL*.
7 Frith, B. 'Abel Wantner, an Unpublished Gloucestershire Historian', *Trans.BGAS*, vol. xcix, 1981, 170–2. See also Finberg, H.P.R. *Gloucestershire Studies*, 267–90.
8 Note James Forbes, a Presbyterian minister who preached in the cathedral during the Commonwealth. Evicted at the Restoration in 1660, but continued to preach in the city. Buried in the Unitarian Chapel in Eastgate Street, Gloucester, demolished in 1965. His remains were interred in the south walk of the cloisters on 21 December 1966.
9 Bonner, T. *Itinerary*, 1796, 17–18. See also Eward, S. *No Fine . . .* , 278–94.
10 Note See above note 7. Also, Bodleian Library MS Top Glouc. c 3.
11 Morris, C. *The Journeys of Celia Fiennes*, Christopher Morris (ed.), 1988 (3rd ed.) 188–191. 234f.

Chapter 19 THE EARLY GEORGIAN CATHEDRAL

Summerson, J. *Architecture in Britain 1530–1830*, (5th edn) 1970,
CAB Chapter Act Books, 2 and 3. See also Cathedral Accounts of the period.
Herbert, N. *Victoria County History: City of Gloucester*, 1988.

NOTES

1	Heighway, C.	*Gloucester: History and Guide*, Alan Sutton, 1985.
2	Herbert, N.	*VCH*, 287.
3	Note	*Chapter Act Book*, 2, 1687–1740 and 3, 1740–74.
4	Frith, B.,	'Organists of Gloucester Cathedral', *Gloucester Cathedral Organ*, 1971, 55–6.
5	Lysons, D.	*Origin and Progress of the Meeting of the Three Choirs*, 1812. See also Shaw, W. *The Three Choirs Festival c.1713–1953*, Trinity Press, Worcester, 1954.
6	Simon, J.,	(ed.) *Handel: A Celebration of His Life and Times*, National Portrait Gallery, London 1983, 46–7.
7	Markham, S.	*John Loveday of Caversham 1711–1789*, Michael Russell, 1984, 219–220.
8	Cocke, T.	*Country Life*, 31 December 1981. See also, *Con.Trans.BAA*, on Gloucester and Tewkesbury published 1985, 130–2.
9	Hope, St J.	*Archaeologica*, vol. liv, 1897, pl III, opposite p. 110. See also 'Quire Screens in English Churches', *Archaeologica*, vol. lxviii, 1917, 96–7.
10		*The Origins of the Gothic Revival*, 150.
11	Dallaway, J.	Quoted by Fosbrooke.
12	St John Hope,	'Notes on the Benedictine Abbey of St Peter at Gloucester', *Archaeologica*, vol. liv, 1897, 110.
13	Fosbrooke, T.D.	*Glos*, 247.

Chapter 20 THE LATE GEORGIAN CATHEDRAL

Cobb, G.	*English Cathedrals: The Forgotten Centuries*, Thames & Hudson, 1980.
Finberg, H.P.	*Gloucester Studies*, Leicester University Press, 1959.
Note	Also Chapter Act Books 3–5, and the Cathedral Accounts.

1	Heighway, C.	*Gloucester: A History and Guide*, Alan Sutton, 1985, 141.
2	Finberg, H.P.R.	*Glos Studies*, 1957, 195–224.
3	Note	The author is grateful to Bryan Little for drawing his attention to Dean Tucker's prophetic vision.
4	CAB	Chapter Act Book, November 1757 and November 1764.
5	Note	This plan of the precincts survives; it is displayed in the Gallery Exhibition.
6	CAB	Vol. 4, f 10–11, 30 November 1775.
7	CAB	Vol. 5, f 176–7, 18 May 1822.
8	Frith, B.	'Cathedral Organists', *Gloucester Cathedral Organ*, 1971, 59–60. See also leaflet on John Stafford Smith.

Chapter 21 THE VICTORIAN RESTORATION – I

Cobb, G.	*English Cathedrals: The Forgotten Centuries*, Thames & Hudson, 1980.
Chadwick, O.	*The Victorian Church*, 2 vols, 1966, 1975.

Waller, F.S. 'Report on the Fabric of Gloucester Cathedral', CAB, 6, 1839–62.
Scott, G. *Personal and Professional Recollections*, 1879.

NOTES

1 Watkins, D. *English Architecture*, Thames & Hudson, 1979, 158.
2 Welander, D. *Stained Gl.*, 91–8.
3 CAB Chapter Act Book, 7, June 1855, ff 29–48.
4 Welander, D. *Stained Gl.*, 77–9.
5 Winston, C. *Archaeological Journal*, XX, 1863, 239–53, 319–30.
6 Kerr, J. 'The Great East Window of Gloucester Cathedral', *Con. Trans.* BAA 1985 116–127

Chapter 22 THE VICTORIAN RESTORATION – II

Scott, G.G. 'The Cathedral Restoration', *Gloucestershire Chronicle*, 20 April 1867. See also 11 & 18 November 1865, 5 December 1868 and 7 January 1884 (art. by F.S. Waller).
Note 'The Proposed Restoration of the Lady Chapel of Gloucester Cathedral', *JSA*, XXVII, 57.

NOTES

1 Clark, K. *The Gothic Revival: An Essay in the History of Taste*, John Murray, 1962, 175–91.
2 Welander, D. *Stained Gl.*, 111–12.
3 Billett, J.H.A. *Gloucester Cathedral*, c. 1880, 21–2.
4 Greene, B. 'The Godwins of Lugwardine', *Herefordshire Country Life*, January 1981. More than three hundred paintings of tiles by William Godwin are in the Victoria and Albert Museum library.
5 Masse, H.J. *Glos Cath*, 59.
6 Tracy, C. *English Gothic Choir Stalls*, Boydell Press, 1987, 44.
7 Redgrave *Dictionary of Artists*, On Redfern, see also *Royal Academy Catalogues*, 1859–76 and *The Art Journal*, 1876, 276.
8 Stavridi, M. *Master of Glass: Charles Eamer Kempe 1837–1907*, The Kempe Society, 1988. See also Welander, D. *Stained Gl.*, 105–10.
9 Dancy, C.H. 'Ancient Painted Glass in Gloucester Cathedral', *Trans.BGAS*, vol. xxxiv, 1911, 97–109.
10 Welander, D. *Stained Gl.*, 114–30.

Chapter 23 THE CATHEDRAL IN PEACE AND WAR

Hastings, A. *A History of English Christianity 1920–85*, Collins, 1986.
Wilkinson, A. *The Church of England and the First World War*, 1978.
Edwards, D.L. *Leaders of the Church of England 1828–1944*, 1971.
Tatton-Brown, T. *The Great Cathedrals of Britain*, BBC, 1989.
Iremonger, F.A. *William Temple*, 1948.
Lloyd, R. *The Church of England in the Twentieth Century*, Longmans, 1946, 1950, 2 vols.
Whiting, R., *The King's School, Gloucester 1541–1991*, 1990.

| Pritchard, | *Arthur Cayley Headlem, Bishop of Gloucester 1923–45*, Gloucester, 1989. |
| Garbett, C. | *Church and State in England*, 1950. |

NOTES

1	Hastings, A.	*A History of English Christianity 1920–1985*, 1986, 34.
2	Tatton-Brown, T.	*The Great Cathedrals of Britain*, 1989, 211.
3	CAB	*Chapter Act Book*, vol. 8, Waller's 1905 Report.
4	Clark, O.	*Trans.BGAS*, 1913.
5	Hastings, A.	*A History of English Christianity 1920–1985*, 17.
6	Robertson, D.	*The King's School, Gloucester*, Phillimore, 1974.
7	Elliott, I.	*Gloucester Cathedral Embroideries*, D & C, 1989.

Chapter 24 THE CATHEDRAL YESTERDAY AND TODAY

Note:
Sources for this chapter include: Chapter Act Books, vols. 12–16;
Ashwell, B., *Survey of Work 1960–1985*, in two vols; The Annual Reports of the 'Friends of Gloucester Cathedral,' 1937–89 and the collected papers and personal recollections of the author.

VISITORS' GUIDE

Gloucester Cathedral is one of a number of great churches in England which were built by the Normans after the Conquest. It was begun in 1089 by Serlo, the first Norman abbot of the Benedictine monastery of St Peter, Gloucester. There had been a monastic house on the site since Saxon times. Only the eastern arm of the Norman abbey church, dedicated on 15 July 1100, possibly with the two east bays of the nave, were completed before Serlo's death in 1104. The nave was probably completed by 1126.

In about 1170 the southern tower of the west front of the abbey church collapsed. There was considerable rebuilding between 1224 and 1242 in the Early English (Gothic) style, though much of the work was replaced later leaving, in the church itself, only the nave vault (1242) and the reliquary (treasury screen) in the north transept. Between *c*. 1319 and 1329 Abbot Thokey rebuilt the south aisle of the nave in the Decorated style of the West of England encrusting its windows and part of the vault with ball-flower.

In 1327 King Edward II was murdered at nearby Berkeley Castle, and three months later his body was buried betwen Norman piers on the north side of the presbytery. His son, the young Edward III, was probably responsible for the preliminary work carried out between 1331 and 1336 in the south transept in a style already developed in London through Court patronage, and later known as Perpendicular. Apart from the gifts of pilgrims, Edward III contributed substantial funds *in piam memoriam* to remodel the Norman choir transforming it into a royal burial chapel by encasing it with panelling, constructing a lofty lierne vault over the entire liturgical choir and presbytery, and replacing the Norman apsidal east end with a huge window.

The north transept was then treated in a similar way (1368–73), and at about the same time a start was made on rebuilding the great cloister. It is generally thought the bays from the chapter house to the door leading into the church were constructed first, with fan-vaulting and wall panelling repeating the window tracery, and after a break the work was completed by Abbot Froucester (1381–1412). The west end of the nave was rebuilt by Abbot Morwent (1421–37), and the central tower built between 1450 and 1460. The last major work of the monastic period was the lady chapel, completed before 1500. This echoes on a smaller scale the mid-fourteenth-century work in the choir, copying its mouldings and traceries, including, in the vault, its subsidiary longitudinal ribs either side of the main rib.

The great church of the Benedictine abbey became the cathedral church of the newly created See of Gloucester by Act of Parliament under Henry VIII on 3 September 1541. The Abbot's Lodging became the Bishop's Palace and the Prior's House became the

Deanery. During periods of religious fanaticism much of the church's medieval past was swept away; figures of saints were smashed, reredoses hacked about with axes and stained glass destroyed. At the time of the Civil War in the mid-seventeenth century the cathedral suffered less than might have been expected.

In the eighteenth century Dr Martin Benson (Bishop of Gloucester 1734–52) spent considerable sums of his own money restoring the palace and introducing innovations in the cathedral which were removed in the restorations of the following century when tastes changed. These included a choir screen designed by William Kent (1685–1748) and a 'Radiance' in front of the lady chapel reredos. He also began the paving of the church. The nineteenth-century architect to the Dean and Chapter, F.S. Waller, carried out major improvements, and worked with G.Gilbert Scott in the reordering and refurnishing of the choir 1866–73. This included a new tile floor, with sgrafitto, restoring the medieval stalls and misericords, fore-stalls and bishop's throne and mayor's seat, and reredos with figures by Redfern.

From 1953 all the main roofs were reconstructed, and from 1976 work began on cleaning the exterior, at the same time repairing stonework and glazing. Work was carried out on the bells in 1977–8, extending the peal to twelve, and a treasury for church plate and permanent exhibition established. To mark the foundation of the abbey church by Abbot Serlo in 1089, an appeal for £4m was launched in 1989, and work began on a major programme of restoration work involving the restoration of the tower (1990), the cleaning and repair of the great cloister (1990) and the nineteenth-century glazing, as well as improvements to the precincts and the erection of gates in College Street.

INDEX

Abbey Dore (Hereford), 101

Abbey of St Peter: arms, 297, 593, on bell, 561, on tiles, *291*, 296, 553; estates and produce, 124, 125, 624, 637; fishing rights on the Severn, 123, 124, 240, 616; seals, 92, *94, 96, 546*. Daughter houses *see* Colwinston; Ewenny; Hereford, St Guthlac's Priory

seventh–eighth centuries, monastery founded by Osric, 6, 8, 22, 302, 597–600, abbesses, 8, 9, 10, bell, 559, site, 7, 8–9

eighth–eleventh centuries, abandonment, 9–10, charter of 862, 10, 602, secular priests, 9–11, 593, granted Newport church, 89

eleventh century, Aldred's church (1058), 9, 15, 18, 28, 29–30, 593, 601, 602, Benedictines, 11–2, 16, 593, 600, delapidation, 16, 17, 18,, Domesday estates, *19*, 20–2, Serlo's church (begun 1089), *2*, 15–16, 18, 22, *23*, 28, 593, 603

twelfth century, building work, 23, 39, *39*, 51, 52, *61*, 74–5, *75*, confinement of Archbishop of Canterbury, 91–2, dedicated in 1100, 22, 23, 50, 51, 593, 603, disputes, 77, 79, dispute with York, 609, fires, 61, 92, liturgical calendar, 88–9, receives Kilpeck church, 57, 606, relationship with Jews, 89–90, scholastic reputation, 87–8, spreads monasticism in Wales, 79

thirteenth century, finances and debt, 124, 125, 131, 132, 617, 624, founding of Gloucester Hall (Oxford), 126–30, grant for water supply, 104–5, *105*, Henry III's coronation, 92, 98–9, Interdict (1207), 98, King John's tollage, 98, 612, licence of Edward I, 124, 126, Newburgh church, 122, 615, 617, rededicated in 1239, 113, 117, 122, 615, Statute of Mortmain, 125–6, fourteenth century, affected by Black Death,

166, agreement with St Oswald's, 329, advowson of Holy Trinity, 144–5, 229, 637, became mitred abbey, 197, 234–5, finances, 131–2, 227–8, 229, 638, fire, 620, parliament held in 1378, 20, 226–7, 308, 311–12, royal donations, 147, 630

fifteenth and sixteenth centuries, mandate to prior to keep abbey in order, 279–80, oath to Henry VIII's supremacy, 298, rebuilds New Inn and the Fleece, 238, relationship with the city, 240–1, surrenders at the Dissolution (1540), 130, 279, 291, 299, 301, 331–2

abbots: first to be mitred, 234–5; in great east window, 197; list of, 541

abbot's lodgings:

Norman, 72–3, *303, 306*, 307, *307, 308*, chapel, 307, *307*, outer parlour (western slype), 307, *315*, 316; thirteenth century, 69, 72, 307–9, *308*, 311, gable of west front, *107*, undercroft, 307, 308–9, *510*, 529; sixteenth-century repairs, 294, *295, 308*; given to prior (sixteenth century) (Church House), 306, 309, 310, given to dean in seventeenth century, 329; fourteenth century, new lodgings built (now Bishop's Palace), 150, 165, 302, *303*, 305, 306, 309–10, *310*, 629, 630, 632; fifteenth century, 307, 308, 309; seventeenth century, given to bishop, 329; nineteenth-century reconstruction, 308, *308*, 309. *See also* Bishop's Palace; Church House; Great (Guesten) Hall; Vineyard

Adams, Roger, chorister, 374

Aisgill, Henry, prebendary, 354

Aldred (Aeldred), Bishop of Worcester (1056–60), 9, 15, 18, 29, 87, *581*, 593

Alix, Dr Peter, dean (1729), 392, 542

Allen, Dr W. Godfrey, consultant architect, 518